GÖRING'S MAN IN PARIS

GÖRING'S MAN IN PARIS

The Story of a Nazi Art Plunderer
and His World

JONATHAN PETROPOULOS

Yale
UNIVERSITY PRESS
New Haven and London

Yale University Press books may be purchased in quantity for
educational, business, or promotional use. For information,
please e-mail sales.press@yale.edu (U.S. office) or sales@yaleup.co.uk
(U.K. office).

Set in Janson type by Tseng Information Systems, Inc.
Printed in the United States of America.

Library of Congress Control Number: 2020939645
ISBN 978-0-300-25192-0 (hardcover : alk. paper)

A catalogue record for this book is available from the British Library.

This paper meets the requirements of ANSI/NISO Z39.48-1992
(Permanence of Paper).

10 9 8 7 6 5 4 3 2 1

For my parents, George and Maureen Petropoulos

I think my own experience shows that you've got to be damned careful when you associate with art dealers. They're in a class by themselves—I noticed that myself toward the end.
—*Reichsmarschall (Reich Marshal) Hermann Göring,*
while imprisoned in Nuremberg (August 1945)

I regret that the initial interrogations
were not better controlled. The documents that
surfaced later showed that the culpable Nazis who
were interrogated did not always tell the truth.
—*French Monuments officer Rose Valland to a*
U.S. counterpart, Ardelia Hall (January 1965)

I was once asked what my greatest accomplishment
as an art dealer was. . . . My answer: not talking about it.
—*Walter Feilchenfeldt, former president of the*
Swiss Art Trade Association (January 2012)

Contents

Illustration gallery follows page 190

Dramatis Personae

Behr, Kurt von (1890–1945). Chief of the Einsatzstab Reichsleiter Rosenberg (ERR) in Paris, whose move to the *M-Aktion* in 1942 helped Lohse increase his influence within the plundering agency. Von Behr and his English-born wife, Joy Clarke von Behr, committed suicide at war's end.

Borchers, Walter (1906–80). Leading art historian attached to the ERR in Paris; directed Arbeitsgruppe Louvre, and then effective co-director, with Lohse, of the ERR in Paris in 1943–44. Borchers was a curator at a museum in Stettin before the war and directed a museum for cultural history in Osnabrück from 1946 into the 1970s.

Cooper, Douglas (1911–84). British Monuments officer, art historian, and collector who conducted pioneering research on the art trade in Switzerland during the war.

Dietrich, Maria Almas (1892–1971). Munich art dealer and agent for Hitler who did business with Lohse both during and after the war and trafficked in looted art.

Faison, S. Lane (1907–2006). Harvard-educated member of Office of Strategic Services' (OSS) Art Looting Investigation Unit (ALIU), last director of the Munich Central Collecting Point, and professor of art history at Williams College.

Fischer, Gisela (1929–2014). Member of the Fischer dynasty—famous for the publishing house—who pursued the family's artworks that had been looted by the Nazis, including a Pissarro that ended up in Lohse's possession.

Fischer, Theodor (1878–1957). The most important Swiss art dealer from the late 1930s through the 1950s, who trafficked extensively in Nazi-looted art, including trades with the ERR in which Lohse played a role. Lohse and Fischer maintained a relationship until the latter's death.

Göpel, Erhard (1906–66). Art historian and dealer, agent for Hitler during the war, and friend of artist Max Beckmann. He and his wife Barbara lived in Munich after the war and were well connected in the art world.

Göring, Edda (1938–2019). Daughter of Hermann and Emmy Göring and center of a circle of the Reichsmarschall's former associates based in Munich. She petitioned the Bavarian state to return some of her father's art but was turned down, most recently in 2015.

Göring, Hermann (1893–1946). Reichsmarschall (as of 1940) who served as chief of the Luftwaffe, minister president of Prussia, and head of the Four-Year Plan Office. Göring was a major art collector and patron of Lohse.

Griebert, Peter (b. 1937). Munich art dealer, and Bruno Lohse's business manager, sometime partner, and friend.

Gurlitt, Hildebrand (1895–1956). Art dealer active in occupied France who sold to the Führermuseum, especially after 1943. Gurlitt was also one of the dealers who sold off the purged "degenerate" art in the late 1930s. He deceived Allied authorities in postwar interrogations about the disposition of his art collection.

Gutmann, Friedrich ("Fritz") (1886–1944). Son of the founder of the Dresdner Bank who emigrated to Holland with his family after World War I; they nonetheless became victims of the Holocaust. Karl Haberstock took the lead in dispossessing him of his (and his family's) art.

Haberstock, Karl (1878–1956). Berlin art dealer and the leading dealer to Hitler and the Führermuseum until 1943. After the war, he lived in the same apartment building in Munich as Walter Andreas Hofer.

Haberstock, Magdalena (1892–1983). Wife of Karl Haberstock who assisted him and then was part of Lohse's circle in the postwar period. She and her husband were generous benefactors to the Municipal Gallery in Augsburg.

Höttl, Wilhelm (1915–99). SS officer in Vienna and Budapest who lived in Altaussee after the war. He was a leading figure in networks of former Nazis.

Hofer, Walter Andreas (1893–1971). Director of the art collection of Hermann Göring and a chief rival of Lohse. His wife, Bertha Hofer-Fritsch, was a highly regarded conservation expert, and both were part of the Munich network in the postwar period.

Limberger, Gisela (1893–1980). Secretary to Göring and registrar of his art collection, who after the war remained part of the Munich circle dedicated to the memory of the Reichsmarschall.

Lohse, Bruno (1911–2007). Hermann Göring's art agent in Paris, deputy director of the ERR, and postwar art dealer who possessed Nazi-looted art.

Miedl, Alois (1903–90). Banker and agent of Göring who acquired the Goudstikker estate and then sold off many of the assets at considerable profit. Miedl lived in Munich in the early 1950s and remained part of the network despite living in South Africa, among other places.

Mühlmann, Kajetan (1898–1958). Art historian and SS officer who plundered art in Vienna, Poland, and the Netherlands and was also an agent for Göring. He escaped American custody in 1947 and lived out his life as a fugitive.

Plaut, James (1913–96). Harvard educated director of the OSS ALIU. Plaut assisted Lohse in his 1950 trial in Paris. He was founding director of the Institute of Contemporary Art in Boston (1939–58) and an early author about Nazi art looting in the *Atlantic* and *ARTnews*.

Posse, Hans (1879–1942). Director of the Dresden Painting Galleries and also the Führermuseum planned for Linz.

Rochlitz, Gustav (1889–1972). German art dealer based in Paris in the 1930s and 1940s who traded for looted pictures with the ERR. Rochlitz reestablished his business in the postwar period in Cologne, although he kept property in Bavaria.

Rosenberg, Alfred (1893–1946). Nazi ideologue and nominal chief of the ERR. He was also Reich minister for the Occupied Eastern Territories during the war.

Rousseau, Theodore (1912–73). Harvard-educated member of the OSS ALIU, curator of European paintings at the Metropolitan Museum of Art and eventually that institution's deputy director. Rousseau assisted Lohse in his 1950 trial in Paris and maintained the relationship during the postwar period.

Schöni, Frédéric (1901–81). Swiss attorney for Lohse, the Wildensteins, and Hans Wendland. Schöni shipped artworks and concealed assets for clients.

Scholz, Robert (1902–81). Alfred Rosenberg's chief art expert, Lohse's superior in the ERR, and a member of the Munich network of former Nazis in the postwar period.

Tho Rahde, Mimi (1910–2011). Art and antiques dealer, daughter of Maria Almas Dietrich, and member of the postwar Munich network.

Valland, Rose (1898–1980). Curator in Jeu de Paume who observed Lohse during the occupation. Valland was a member of the French Resistance and a French Monuments officer in the postwar period.

Wendland, Hans (1880–1972). German-born art dealer who lived in Switzerland and France. Wendland engaged in many trades with the ERR involving looted art.

Wildenstein, Alec (1940–2008). Son of Daniel who, along with his brother Guy, led the next generation. Alec maintained a relationship with Lohse for over sixty years.

Wildenstein, Daniel (1917–2001). Son of Georges and subsequent patriarch of the art-dealing dynasty. He continued the relationship his father established with Lohse.

Wildenstein, Georges (1892–1963). French Jewish art dealer based in Paris and New York. He and his family had art stolen by the Nazis, yet he developed a relationship with Lohse in the postwar period.

Wüster, Adolf (1888–1972). Artist and art dealer who worked as an art plunderer for von Ribbentrop and the Foreign Office in France during the war and became part of the Munich network after 1945.

GÖRING'S MAN IN PARIS

Kaffee und Kuchen with Bruno

IT WAS JUNE 1998 and Dr. Bruno Lohse and I had agreed to meet in front of Munich's Zentralinstitut für Kunstgeschichte (Central Institute for Art History)—appropriately enough, a monumental Nazi building that had also served as an Allied Central Collecting Point—a kind of depot and clearinghouse for displaced artworks—from 1945 to 1950. I had written to Lohse in May asking to interview him for the book I was writing about the complicity of art experts in Nazi plundering (*The Faustian Bargain: The Art World in Nazi Germany*, published in 2000). Bruno Lohse had been Göring's art agent in Paris during the war, and in 1943 he became the deputy director of the Paris branch of the Special Task Force of Reich Leader Rosenberg, the Nazi art-plundering agency otherwise known as the ERR (Einsatzstab Reichsleiter Rosenberg). Lohse had responded to my letter informing me that while he had little information of use to offer, he was happy to meet for lunch in Munich. The reasons he agreed to meet were complex—as was Lohse—but at the heart of the matter was an inextinguishable self-importance deriving from his years as the self-proclaimed "king of Paris." He cared deeply about the way he was treated in historical accounts and wrote letters to authors and publishers over the years, including to Metropolitan Museum of Art director (and former Monuments, Fine Arts, and Archives officer) James Rorimer, after the latter released his memoir *Survival* in 1950. Lohse later penned a missive to Paul List, the German publisher of David Roxan and Kenneth

Wanstall's pathbreaking 1964 book, *The Rape of Art*, where he again con-
tested certain statements.[1]

For my part, I wanted information from Lohse. I hoped he would tell
me about the postwar lives of the art plunderers I was studying in *Faus-
tian Bargain*—and he did. As I gradually learned, the wartime networks
of Nazi dealers persisted after the end of the conflict, and individuals like
Lohse grew prosperous selling to museums and collectors—often cashing
in on goods with complicated wartime pasts. I met with Lohse hoping he
would tell me about the disposition of looted art that had gone missing—
and he did. For me, our meetings were fact-finding missions. Yes, I some-
times needed to have coffee or a meal with him, but that was a means to
an end. I shared much of the information I obtained from Lohse and his
friend Peter Griebert: I sent a report to the Federal Bureau of Investiga-
tion after I was shown a fourteenth-century altarpiece from a church in
Venice, turning to a friend in the Department of Justice to pass along my
concerns in this instance; and at other times, I shared my "intelligence"
with organizations like the Art Loss Register and Christie's auction house.
My meetings with Bruno Lohse were not *Tuesdays with Morrie* feel-good
visits but a kind of game—I tried to pry information from him and he at-
tempted to outfox me. I soon appreciated his charm—it's what made him
Göring's man and shaped his postwar career in profound ways. I do not
want to give the impression that I befriended him or in any way seem to
whitewash his deeds. Yes, I was friendly to him; that was necessary. But
it was motivated by my ever-increasing desire to understand him, and to
use his career as a way to comprehend not only the art world but also the
way the Nazis had persisted and often thrived in the postwar period. I en-
gaged with Bruno Lohse because it was the only way to get information
about his world—the archives becoming relatively silent after 1950 when
denazification came to an end. The Central Office for the Investigation
of National Socialist Crimes in Ludwigsburg was created in 1958 to re-
search and prosecute Nazi criminals, but the staff focused more on active
killers rather than art plunderers (even though the two were not mutu-
ally exclusive, as was likely the case with Lohse).[2] The fact remains: in
order to understand the postwar period, I had to rely on the few surviving
actors, and Lohse was one of the last. Yet I am mindful of journalist Gary
Younge's observation: "Interviewing Nazis is a tricky business, as I can
attest from personal experience."[3]

Over the decades since the war, Lohse had offered very limited co-
operation to various authors, including to Heinrich Fraenkel in 1961, who

in the course of writing a now well-known biography of Göring, inter-
viewed not only Lohse but also the latter's wartime rival, art dealer Walter
Andreas Hofer, as well as Monuments officers like Rose Valland and Pro-
fessor S. Lane Faison, who had been part of the Allied effort in the west to
safeguard cultural property and then restitute the looted objects.[4] Lohse
also spoke with author Matila Simon for her 1971 book, *The Battle of the
Louvre*, and told her many of his favorite stories, such as saving the art and
ERR card catalogue held in the Neuschwanstein castle: this *Kartei* was a
set of cards that comprised an inventory of the plundered works: each card
detailed the original owner, which proved crucial to the postwar restitution
process.[5] In the late 1990s, Lohse answered questions (in French) posed by
then filmmaker Anne Webber (who went on to co-chair the Commission
for Looted Art in Europe). Webber went to Lohse's flat in Munich, but
he would not let her in and he did not appear in her film (*Making a Killing*,
2000) about the Goodman heirs' efforts to recover their family's property.
Some of the art—a Degas landscape, for example—was evidently looted
by Lohse. As best as I can judge, Bruno Lohse spoke more freely with
filmmaker and journalist Maurice Philip Remy, and they had a relation-
ship that lasted years. Generally speaking, Lohse typically interacted with
those interested in his life. He was, after all, unrelentingly egotistical. But
Lohse was also compelled to meet with researchers because he felt unfairly
treated by history and he sought redress wherever he could find it.

Another consideration that induced Lohse to speak with me grew
out of his postwar experiences, when he was arrested by the Americans
and interrogated by the experts in the Office of Strategic Services' (OSS)
Art Looting Investigation Unit (ALIU).[6] Lohse maintained a fondness
for the Harvard-educated art historians who comprised the ALIU. The
Americans and Lohse had found a modus vivendi that helped lead to the
restitution of thousands of works, and the ALIU agents had treated him
respectfully as a professional counterpart. Lohse went on to spend five
years in confinement, an unusually long time for an art plunderer, but dur-
ing his incarceration, he kept in contact with these ALIU officers—James
Plaut (1913–96), Theodore Rousseau (1912–73), and S. (short for Samson)
Lane Faison (1907–2006). Lohse hoped that they would help him secure
an early release from the Cherche-Midi prison in Paris, and, in fact, the
three ALIU officers responded positively. They wrote letters to the French
authorities, shared what they could of their ALIU reports, and provided
some of the documentation they had collected. This assistance in the late
1940s established a foundation for relationships that continued during the

subsequent decades. In Lohse's eyes, my PhD from Harvard put me in their company, and apparently rendered me worthy of his time.

It turns out I had known two of the three ALIU officers from my time at Harvard (1983–93). James Plaut lived near Cambridge and would meet me for lunch at the Harvard Faculty Club, and Lane Faison lived in Williamstown in western Massachusetts, where I visited him on a number of occasions. Already back in 1940, Faison had been chair of the art history department at Williams College after four years as an assistant professor at Yale (1932–36) and then an additional four as an assistant at Williams.[7] In short, Faison had a stellar academic career prior to the war and he was known as something of an institution, even after his formal retirement in 1976. Lane Faison's friend and colleague James Plaut also had a promising early career at Harvard; by 1939, he was the first director of the Boston Museum of Modern Art (later the Institute of Contemporary Art, which he co-founded).[8] After the war, Plaut publicized the topic of Nazi art looting by penning important pioneering articles in magazines like *ARTnews* (August 1946) and the *Atlantic* (September and October 1946).[9] Both Plaut and Faison enjoyed telling their stories, which extended beyond tracking Nazi-looted art. I recall Plaut's account of interviewing captured U-boat crews in the North Atlantic, an assignment he had prior to moving on to direct the ALIU in November 1944. Lohse did not know of my friendships with Plaut and Faison when he agreed to meet with me in 1998, but he asked about them early on in our initial conversation. I eventually became a kind of conduit between Lohse, on the one hand, and Plaut and Faison, exchanging greetings and hand delivering the occasional letter. Among all the former ALIU officers, Ted Rousseau had grown closest to Lohse, but he died in 1973 before I could interview him.

I remember clearly my first meeting with Bruno Lohse in June 1998 at the Zentralinstitut in Munich. It was a hot summer afternoon as I sat in the shade offered by the massive neoclassical portico of the building commissioned by Hitler and designed by Paul Ludwig Troost. Looking up, I saw a mosaic of green and orange swastikas embedded in the ceiling. It seemed a fitting place to wait for a Nazi art plunderer. I was unsure what to expect. Would he be friendly or hostile? Expansive or reticent? Frank or deceitful? These and other questions passed through my mind. Finally, a large Mercedes pulled up; an elderly gentleman with a shock of silver hair and dark glasses sat in the back seat. He had an imperious air about him. A younger man, still in his fifties, drove the impressive automobile. Was this his chauffeur? Dr. Lohse was taking me to lunch in style. We were going

to a restaurant—an elegant Bavarian beer garden—but not to his home. His Munich residence, rumored to be filled with valuable artworks looted during the war, was just one of the many mysteries surrounding Lohse. But that day, we headed toward a very public beer garden; it would be several more years before I was invited to his apartment. I sat in the back seat next to him as we drove southeast, along the English Garden and into the lush green valley that cradles some of Munich's most fashionable neighborhoods.

Upon our arrival at the beer garden, the Freisinger Hof, we were escorted to Lohse's preferred table. He was well known here—I would learn that this was the case throughout much of Munich—and he held court in his self-aggrandizing manner, arranging the seating and taking the lead in ordering. He insisted that we begin with soup, a practice that would become customary when I dined with him. It was usually some *fritellen* (crêpe) soup with chicken, which I rather liked, although sometimes he insisted upon the less agreeable *Leberknödelsuppe*, or liver dumpling soup. I suffered through a bowl of the latter during several early meetings, but subsequently developed the confidence to amend the order to some other kind of soup. He was intimidating in a way that is difficult to describe, while at the same time pleasantly engaging. At our first meeting, we began with polite small talk, chatting about the splendors of Munich and the region's unpredictable weather. For all of the intrigue surrounding this notorious Nazi art plunderer, he looked more like a retiree, an elderly uncle dressed simply in a striped golf shirt and slacks. His build alluded to a past athleticism. At six foot four and now over three hundred pounds (he had gained weight since the war), he was physically imposing. But on this particular afternoon, he seemed to be playing the role of cordial older man as he told stories from what I later learned was an established repertoire.

It was not until later, when Dr. Lohse became "Bruno" to me and our meetings took place more frequently, that I saw the other side of him. His mood would shift, his face turning red as he became angry and aggressive. He spewed vulgarities that I found jarring (in part because German profanity can be so graphic: "Kiss my ass" in German is "Lick my ass"—*Leck mir den Arsch*), and language like this left me somewhat shocked and off-balance. Yet it was in these moments that the reports of his more nefarious deeds seemed not only imaginable but credible.

In spite of the many secrets he harbored, Dr. Lohse had his stories—his "safe" stories—that he felt free to tell without the danger of suffering serious consequences or disclosing incriminating information. He had

been interrogated so many times right after the war and had made such a concerted effort to prepare his defense for the Paris trial of 1950 that he had developed self-serving narratives that he retained nearly his entire life. Still, as I got to know him, he seemed to grow more open and outspoken. By 2001, the ninety-year-old Lohse felt immune from prosecution or other serious consequences resulting from his wartime activities. He was still mistrustful, but he had loosened up. At times, this volubility appeared to stem from his own sense of resignation—the good old days were over and his stories were all he had left. When I first met him, he was eighty-seven years old: still sharp in general, but prone to repetition and memory lapses. The lapses would increase in frequency and scope with age, yet his basic narratives remained the same.

My relationship with Lohse proceeded in stages, and all of our early meetings were in public places. The Freisinger Hof, or what Lohse and Peter Griebert called "the Croats," was the most common and comfortable venue for him. At these lunches, Lohse talked about his relationships with the former OSS officers who had interrogated him at war's end; he talked about Hofer and other fellow art dealers during the Third Reich—especially Karl Haberstock and Kajetan Mühlmann, figures I was writing about in *The Faustian Bargain*. Lohse offered me specific stories and details that I included in the book, especially about their activities during the postwar era. The paper trail for these art plunderers, as for most second-rank figures in Nazi Germany, largely dried up after their interrogations and denazifications in the late 1940s. The oral history offered by Lohse and other old Nazis provided one of the few ways to reconstruct the postwar experiences of this cohort. Lohse's remarks strengthened my belief that the former Nazi dealers had maintained a network in the postwar period and continued to engage in business with one another.

At the start of my sabbatical in the summer of 2000, I was living in Munich, making it easier to contact Lohse. I had his telephone number and could ring him up somewhat freely. Not long after I had settled in, Lohse invited me to his home. He suggested that I come for *Kaffee und Kuchen* (coffee and pastries). This sounded very promising indeed. He asked if I knew the address, and I told him I did. What I did not reveal is that I had bicycled by his apartment building on several occasions. As I looked up at the balcony to his flat, I had imagined the artworks housed inside. Now I might see if the rumors about the art in his apartment were true.

And so I arrived at Bruno's home for the first time in September 2000. I had brought pastry and wine from the Alois Dallmayr emporium, the

Harrods of Munich, which I knew Lohse liked. I had also brought along a micro tape recorder. Lohse greeted me at his front door and invited me in. He appeared as friendly and relaxed as could be. He had a housekeeper, Frau Goebel, but otherwise his was a fairly modest operation. The apartment was small—three rooms plus a kitchen and bathroom—although there was a neighboring unit that housed some sort of office, which I subsequently briefly glimpsed once or twice. What I found most exciting, however, was the art on his walls. Lohse had several works by Emil Nolde, including a landscape oil painting of a marsh rendered in red and black hues, as well as a watercolor of a bright sunflower. Surprised that he placed Expressionist works in this "public" room, his living/dining room, I turned around to survey vibrant watercolors by Marianne von Werefkin and Gabriele Münter, two artists associated with the Blue Rider group that flourished in and around Munich prior to World War I. His study, which was also his television room, contained a wall filled with Dutch Old Masters. There were about a dozen pictures there, mostly pieces with smaller dimensions. I thought to myself how easy it would have been to conceal the smaller works in his luggage as he traveled back from France during the war. All told, the art in Lohse's apartment was worth millions. I had to suppress the many questions running through my mind, beginning with how had he acquired these works and were any of them looted? These questions would continue to preoccupy me in the years to come.

For the moment, I was more concerned with getting Bruno to retell an intriguing story he had shared in our earlier meetings: the one about Georges Wildenstein offering him a choice of three paintings and his subsequent relationships with family members. We sat down at a table among the German Expressionist works, drinking coffee, eating *Kuchen*, and exchanging pleasantries. Before asking him about the Wildensteins, I shared my upcoming plans with Lohse: I was headed to Lake Constance for a conference on networks of persecution (it was not lost on me that Lohse himself was part of such a network). His reaction to the mention of the Holocaust, then and later, was mixed: at times he appeared remorseful and apologetic, but mostly he donned the cloak of cynicism and declared, "It is all shit" (*Es ist alles Scheisse*). He maintained that it was pointless to talk about, let alone study, the Holocaust. For him, it was best to ignore the darker side of the Third Reich. He could never understand how the men he revered—and Göring in particular—had become mass murderers, and he doubted that historians could do much to explain this history. I responded that scholars would never get it 100 percent right, but what

was the alternative? Not to study history (and this history in particular)? Lohse appeared unconvinced. His was a cynical worldview, unconcerned with ethics or moral responsibility. He was also particularly adept at suppressing parts of the past that he perceived as uncomfortable: "Es ist alles Scheisse"—as best I could tell—stood as his governing philosophy.

Because Lohse was notoriously temperamental, I expected that he would become angry if we discussed the Holocaust in depth, and so I changed the topic of conversation, at least temporarily, to something less controversial: hiking in Switzerland. Bruno brightened as we talked about the grandeur of the Alps, and then it was time. "Tell me again about Monsieur Georges Wildenstein and the three paintings in Paris after the war?" I asked. "Na, ja," Lohse responded, and we were off. The story wasn't quite as good—as rich in detail—as the first time he'd told it the previous June. But there were always new details when he retold a story. And significantly, this time I captured it on tape. I had asked for and received his permission before placing the recorder on the table that we shared, even though I did not have him sign a formal release. I had worried that the recorder might make him more reserved. Yet I thought it best to have a recording of the story in case I was challenged by Wildenstein family members, who had been known to initiate litigation to protect their reputation. Later, after I left Lohse's apartment and cycled back to my own, I took that tape out of the recorder, labeled it carefully, and then packed it away.

A key individual who was present in all my interactions with Lohse was his onetime business associate, private secretary, and friend, Peter Griebert. I had encountered Peter on the very first meeting with Lohse, when I was picked up at the Zentralinstitut by the Mercedes; but I had believed at the time that Peter was Lohse's driver, or aide, not realizing he was a successful art dealer in his own right. Peter remained a mystery to me throughout my first meetings with Lohse. I gradually ascertained from his interventions in the conversation that he was in the trade and also a longtime friend of Bruno, but beyond that he was guarded about his personal life and appeared somewhat defensive, even territorial. I didn't fully understand the relationship between the two men, and neither Bruno nor Peter made any attempt to clarify it for me. Indeed, throughout our first few meetings, I was under the impression that Peter was Bruno's nephew; perhaps Peter had said Bruno was "a kind of uncle" and I had mistranslated the German. I really did not know. I did not envision the role that Peter would play as I came to know Lohse and tried to uncover his secrets.

Peter later explained how his father, an art historian, had studied in

Berlin with Bruno in the 1930s. According to Peter, they had not been particularly close, but none of the other students really cared much for Bruno, whom they regarded as arrogant and moody. Peter recounted that his father took pity on him and made an effort to be gracious. In the spring of 1950, just after his release from prison in Cherche-Midi, Bruno called on the elder Griebert. The judges at the Paris Military Tribunal had told him he could transition back home in the French Zone in Baden-Württemberg, and the Grieberts were the only people in that part of Germany whom Bruno knew. Emaciated from years in prison and required to report in with French authorities every day, Lohse had begged the Grieberts for sanctuary. For many years, my understanding of this story was that Lohse remained with them on Lake Constance for months. It was much later, when I found Lohse's denazification files, that I realized he spent less than three weeks in the area before returning to Munich. Peter Griebert's stories, I learned, also needed to be treated with caution.

Yet over time, Peter began to help me pry information from Bruno, offering statements of clarification and even follow-up questions. Although Lohse did not supply a tremendous amount of new information as a result of Peter's interventions, I began to view the younger dealer as an ally in my efforts. I came to respect his knowledge of looted art issues. I also learned that he had helped the Goodman heirs pursue lost family property back in the 1970s and 1980s.[10] Peter certainly kept up with current publications. At one point in the summer of 2000, he made a joke about both Bruno and me being photogenic: in February 2000, Hugh Eakin from *ARTnews* magazine interviewed me regarding my contact with old Nazis who had been art looters.[11] The article featured a photo of Bruno and me at "the Croats" that Peter had taken with my camera. Both Bruno and I were smiling in the shot, and it all looked very friendly. I had never asked either Peter or Bruno for permission, and the magazine's editors had not requested that I do so. The article was harmless enough, though it did announce to the art world that Dr. Bruno Lohse was alive and well and residing in Munich.[12] Griebert was not visibly upset by the photo, but he wanted me to know that he was aware of its existence.

A topic that resurfaced a number of times with Lohse and Griebert concerned the photos and documents that the old art plunderer kept in his Munich apartment. Actually, I came to understand that there were two sets of papers: photos and selected documents he showed me on several occasions (including Göring's 20 April 1946 affidavit), and those in the so-called *Geheimkoffer* (literally, "secret suitcase"). I heard of the *Geheim-*

koffer only from Peter, but I came to understand that it contained the most compromising extant documents. It was not uncommon for individuals of that generation to keep wartime papers in contemporaneous luggage, as did Munich art dealer Hugo Helbing, whose *Nachlass* (literary estate) was found in an old leather suitcase in 2004 (the suitcase remains part of the archive housed at the Zentralinstitut in Munich). Around the time of Lohse's death in 2007, I learned that the *Geheimkoffer* also reportedly contained thirty volumes of wartime diaries, all entered in moleskin journals. But I did not know that at the time. I nevertheless asked Lohse often what he planned to do with his documents after his death and he replied that he would have them destroyed. This was part of his cynical worldview. I always averred that I would gladly take them, and Lohse, on several occasions, said, "Well, fine, you can have them."

I was caught by surprise in March 2007 when I received an unexpected call from Peter. Bruno had died—and he had left something for me. I was in Munich, trying to advance efforts to return a masterpiece by Camille Pissarro to the Fischer family, so I arranged to meet Peter for an early lunch of Bavarian *Weisswürste*. He handed me a large manila envelope and said, "Bruno wanted you to have these." The envelope contained many of his photos from the ERR days, as well as a collection of various documents from the 1930s to 1950s. It was not the *Geheimkoffer*, but to me it represented a treasure trove; I knew then that I would one day write a book about Bruno. The documents also provided a window into his personality: he had carefully selected evidence that supported his narratives as part of his attempt to shape his legacy. Lohse wanted to be known as Göring's "man in Paris," as someone acquitted by the Paris Military Tribunal, and as part of a network of international art dealers—all points reinforced by the carefully chosen documents and articles he left to me. It would be my job to read them critically and to place them in a broader context, which is the aim of this book.

Separating Lohse's stories from the truth became a central challenge in writing his biography (the dearth of archival sources, the culture of silence among the participants, and the general desire among most of those involved to conceal this history being other challenges). But I believe it to be worth the effort. Bruno Lohse's stories yielded insights that are key to understanding what transpired with regard to art looted by the Nazis during the Third Reich, as well as in the postwar period.[13]

True, we are working with incomplete information when it comes to Bruno Lohse and others in this segment of the art world. Complexity and

a paucity of information are challenges, no doubt, yet it has been possible to make progress in understanding this history. Even seventy-plus years since the war, we make new discoveries and previously closed records are opened. On 24 December 2015, for example, the French prime minister issued a decree allowing the opening of files with materials dated "as late as December 1960 that relate to matters that happened between September 1939 and May 1945."[14] This meant that for the first time, researchers could see important documents pertaining to collaboration and to the murder of some seventy-six thousand Jews who were deported from French territory, among other topics. This order proved a boon to me, as I was able to travel to Le Blanc (just south of the Loire Valley) to the Dépôt Central d'Archives de la Justice Militaire to conduct further research. The archives are housed in what feels like a rather impenetrable and sizeable military base (but in actuality serves as the facility of the local gendarmerie). To gain entry, researchers must produce a passport and have an escort. The archives of the French Military Justice authorities contain the records of the Tribunal Militaire Permanent from the Seine, a body that tried Bruno Lohse and other ERR staffers in 1950. The trial records run to hundreds of pages, and while the documents left many questions unanswered, they also provided a new perspective on Lohse's wartime years. Understanding Lohse is like peeling an onion (to appropriate the title of Günter Grass's autobiography, which seems somewhat justified considering the Nobel laureate in literature and left-leaning public intellectual revealed in the book the secret he concealed for many decades—that he had been conscripted into the Waffen SS toward the end of the war).[15] With both Nobel laureate writers and art plunderers, time has a way of exposing more layers of the onion.

Introduction

THE EVENING WAS PLANNED as a form of theater, a series of carefully staged scenes. Each room, or set, in the extraordinary eighteenth-century Parisian *hôtel particulier* featured a theme or a moment in art history. One was the French rococo of the eighteenth century with, in the words of one of the guests, "the most beautiful Fragonards and Bouchers you have ever seen situated among Louis XVI furniture."[1] After champagne and hors d'oeuvres in the first *salon*, the diners moved on to the next course among the Impressionists—Monets, Degas, and Renoirs surrounding them. White-gloved waiters served exquisite food, lifting gleaming silver plate covers in unison to reveal the gourmet repast. After the main course, the guests enjoyed dessert and drinks among the moderns—Matisse, Picasso, and Modigliani. It was a show, a lesson in art history, a display of power, and an exercise in trust, all at the same time. Very few were permitted into the Wildensteins' inner sanctum on the rue La Boétie (pronounced in the Parisian *argot* "La Bo-ay-see").

Back in the 1950s, crowds flocked to the Wildenstein showrooms a short distance away in the rue du Faubourg Saint Honoré for exhibitions on the art of Monet, Gauguin, and many others whose work they acquired and sold. As purveyors of very expensive works to elite collectors, the Wildensteins were part of the cultural life of both Paris and New York. In France, they often have been referred to simply as "Les W."[2] Monsieur Daniel, the patriarch of the world's greatest art-dealing dynasty from the death of his father in 1963 until his own passing in 2001, had carried on a family tradition of exclusivity, even as he formally shifted the business

center of Wildenstein, Inc. to New York. Their clients included J. Paul Getty, Nelson Rockefeller, Gianni Agnelli, and Walter Annenberg, but also many of the world's greatest museums, beginning with the Metropolitan Museum of Art in New York. Yet it was the Wildensteins themselves who decided to whom they would show something, and when they would sell it. They were known to hoard treasures for decades, even for generations, locking away works in their repositories dispersed around the globe. In 1978, they reportedly had ten thousand paintings in their possession, with the New York storeroom (also referred to as "The Vault") alone holding twenty-five Courbets, ten van Goghs, and twenty Renoirs, among many other works.[3]

The two guests on this evening in the mid-1980s would have warranted additional discretion. They were German colleagues, art dealers from Munich. But one in particular represented a threat to the reputation of the Wildensteins, who were of Alsatian Jewish origins. Dr. Bruno Lohse had been Hermann Göring's art agent in Paris during World War II. Göring stood as the second most powerful figure in the Nazi leadership during the early years of the war, and this helped make Lohse among the most prominent individuals in the French branch of the ERR, which ravaged the collections of French Jews. The ERR itself was a sizeable multinational organization, with branches in Belgium and the Netherlands and even more ambitious operations in the east (with a key office in Riga).[4] Lohse had helped Göring commandeer over seven hundred pictures from the ERR in Paris, with the then number two man in Nazi Germany never parting with a *Pfennig*. The young Nazi dealer organized for his powerful patron eighteen of the twenty exhibitions in the elegant Jeu de Paume museum on the Place de la Concorde — shopping sprees, if you will (without the necessity for payment). Göring sauntered among the looted works (or had them presented to him while seated), selecting those he fancied. These exercises in power proved so rife with meaning that even George Clooney and associates used the scene to open the 2014 film *Monuments Men:* the Cate Blanchett character, who calls to mind French curator and Resistance member Rose Valland, spits in the champagne glasses of the Göring and Lohse characters before serving them their drinks. In real life, Bruno Lohse, due to a long-standing stomach ailment, drank very little alcohol.

During the war, Bruno Lohse felt himself to be the king of Paris. Armed with a pass offering the sweeping support of Reichsmarschall Hermann Göring, he could travel without limitations and buy what he wanted. Nights out at Maxim's or Schéhérazade (a cabaret very much *en*

vogue during the occupation), silk stockings for his French girlfriends—such was his life until August 1944. One French intelligence report from 1945 stated that Lohse "was without scruples: he had numerous personal affairs in Paris and made a lot of money."[5] He enjoyed considerable independence. As his ERR colleague Walter Borchers testified after the war, "It was known that Dr. Lohse was the special representative of Göring in this taskforce and therefore, in a certain sense, he was feared—not because of his comportment, but because of his direct connection to Göring."[6] Granted, Lohse had a demanding boss, one who competed with Hitler and the other Nazi leaders for Europe's artistic treasures. The young art dealer, who was a member of the SS (the Schutzstaffel, or Protection Service), also had to answer to Heinrich Himmler, not to mention Alfred Rosenberg and his henchmen, who formally controlled the ERR. Lohse often found himself uncomfortably close to Jewish victims. There was no escaping the fact that he was helping steal their property and that many he plundered faced horrible fates in the east. After the war, some of the ERR staffers attempted to rationalize their behavior, such as Staff Chief Gerhard Utikal, who claimed, "We never felt ourselves to be robbers. We were of the opinion that the art action was carried out according to the law."[7]

That said, the linkage between plundering—especially taking a people's cultural property—and genocide was evident to Lohse and many contemporaries during the war, even if they did not know all the details of what was transpiring.[8] When asked in 1947 whether he had participated in the *M-Aktion* (short for *Möbel-Aktion*, or "Furniture Action") that deprived French Jews of their household property, Lohse responded, "Thank God, no! That was a matter for the Ministry of the East, with which the ERR had nothing to do."[9] His vehement denial intimated that he understood the implications of the theft: the processing of victims' property after they had been deported to the murderous east. In many ways, the plundering of property epitomized the objectives embodied in the Nazis' "Final Solution": what Nobel laureate Elie Wiesel has described as "a combination of both perverse, hate-filled idealism and convenient, cheap robbery."[10]

In 1943, Lohse allegedly boasted to a German army officer named Ehrengard von Portatius that he had beaten Jewish victims to death "with his own hands."[11] At six feet four and over two hundred pounds during the war, this was well possible for the former SS sports teacher, but the postwar report, which von Portatius penned in 1951, remains unverified—both as to what Lohse allegedly said and also its veracity. The aristocrat said he had been "astonished" when he received the report that Lohse had been

acquitted by the Permanent Military Tribunal of Paris in 1950, and this prompted him to recall the 1943 conversation as well as a subsequent visit home to his parents in Berlin late in the war. When von Portatius told his parents about Lohse, they responded, "He will be the first to hang after our defeat."[12] Portatius acknowledged that this had not happened—that "unfortunately, the big criminals have got back on their feet while the minor members of the Party, for example, and the poor prisoners of war suffer."[13] The handwritten complaint that Ehrengard von Portatius sent to French Monuments officer Rose Valland in 1951 was viewed as sufficiently serious that a transcription was typed out, but there was no will to attempt to reopen the case against Lohse. Although authorities took up an investigation into another murder charge near the end of Lohse's life, there would be no judicial determination about whether he had killed people during the war.

Undisputed, however, is the fact that Lohse helped steal a remarkable number of artworks. French curator turned Monuments officer Rose Valland told her U.S. counterpart Captain James Rorimer shortly after the liberation of Paris in August 1944, "The Germans had taken one third of the privately owned art in France."[14] The ERR in France alone had plundered about 30,000 objects: there were 21,903 counted in the main depot in Germany, the Neuschwanstein castle (of which 10,890 were paintings), but there were five other ERR repositories in the Reich—including the Kloster Buxheim monastery near Memmingen in Bavaria and Schloss Nikolsburg in Moravia (now Czech Republic)—containing an additional 10,000 objects.[15] These works came from several hundred different Jewish collections. The plundering agency stole a wide range of art: from Old Masters like Jan Vermeer's *The Astronomer* (owned by Édouard de Rothschild) to more quotidian pieces—the art that decorated the homes of the middle classes, for example. As an operative associated with the ERR headquartered in Paris's Musée du Jeu de Paume and the effective co-director of the Paris branch of the agency for a year during the war, Lohse ranks in the top five among history's all-time art looters.

Trying to satisfy the near-insatiable demand of Göring could not but help push him to greater lengths as a plunderer and dealer. Göring had remarkable power until the final phase of the war. The Reichsmarschall, who had been given this invented title after the victory over France in the summer of 1940, was also chief of the Luftwaffe, minister president of Prussia, and head of the Four-Year Plan Office (a major force in the German economy). Göring's power stretched across both the civilian and military

sectors, and it transcended international borders as well. The Reichsmar-
schall deployed agents to plunder in both western and eastern Europe, but
no city could match Paris when it came to the quantity and quality of art.
All told, Göring amassed an art collection of over seventeen hundred pic-
tures (although he sold works too and his collection fluctuated).[16] While
Hitler and his agents acquired more works for the monumental Führer-
museum planned for Linz (around eight thousand pictures), Göring had
the largest collection of any Nazi subleader, and he boasted after his cap-
ture in 1945 that it was the finest art collection in private hands in Europe
(a more dubious claim).[17] Some of the collection went missing at war's
end, with pieces bubbling up on the art market from time to time (more
on that to come).[18]

Göring's art bloodhound in Paris, "Dr. Lohse," had his full support—
both politically and financially—which made him *unantastbar* (untouch-
able). The written order from Göring that he possessed, a document dated
21 April 1941 that instructed all offices of the state, Party, and armed forces
to support his work, rarely left his body. Lohse kept the folded sheet with
the Reichsmarschall's signature in the breast pocket of his suit, and over
sixty years later, at the time of his death, the faded and torn authorization
remained among his papers.[19] American Monuments officer James Plaut
observed that "Lohse provoked the resentment and jealousy of his fellow-
workers through the enjoyment of special privileges in the execution of
his mission for Goering."[20] With his car and driver, his elegant civilian
clothes, and a healthy expense account—in addition to other advantages
he gained from Göring's patronage—his colleagues viewed him as unde-
servedly fortunate.

Lohse repaid Göring's support by sending a steady stream of art-
works to his patron. Göring acquired at least 386 pictures in France (al-
though not all came via Lohse).[21] These were purchased from the scores
of French dealers who sought to collaborate with the wealthy Germans.
The art market flourished in wartime Paris, and Lohse was a frequent at-
tendee at the auctions of the primary auction venue in the French capi-
tal, the Hôtel Drouot.[22] Additionally, Lohse helped Göring obtain most
of the 700-plus works taken from ERR stock during the Jeu de Paume
selections. Göring had removed these works from the ERR headquarters
right after his selections, then placed them on one of his private trains and
transported to his Carinhall estate outside Berlin. James Plaut stated un-
equivocally, "Goering did not pay the Einsatzstab—or any other organi-
zation or individual—for the works he acquired in this manner" (that is,

selections from the exhibitions that Lohse organized on most occasions).[23] Lohse, however, bought art for Göring from a range of sources. Some came from collaborators, paid for with devalued francs, which traded against the Reichsmark at twenty to one (compared to thirteen to one before the war). Others sellers came from Belgium and the Netherlands. The database of the German Historical Museum that documents Göring's collection lists seventy-seven such works brokered by Lohse during the war, but there were almost certainly many more.[24] It is also striking that among the seventy-seven entries in the database, the current location of fifteen works, including pictures by Jan Brueghel and Jan van Goyen, remains unknown.[25] In other words, nearly 20 percent of the works in Göring's collection linked to Lohse have gone missing, and these are only the documented losses: as noted above, it is unlikely that the database has recorded every work that Lohse helped the Reichsmarschall acquire.

Bruno Lohse took refuge after the war in the mantra that "he was just doing his job"—a variation of "just following orders." This is what he claimed he told Monsieur Georges Wildenstein in 1951 when he returned to Paris. Monsieur Georges (1892–1963), the son of Nathan (1852–1934) and the father of Daniel (1917–2001), headed the family firm during the war. Monsieur Georges had fled Paris in May 1940 and headed south to Vichy, the unoccupied zone. He then made his way to New York in 1941. Rumors circulated then and later that he had, via proxies, continued unimpeded in the art trade in Nazi-occupied Europe. His agents included his business manager Roger Dequoy, who during the war continued to occupy the Wildenstein & Cie premises in Paris on the rue La Boétie (he remained in the Wildensteins' employ after 1945). But the Wildensteins were also victims of Nazi depredations, losing scores of pictures to Lohse and his accomplices (Jim Plaut of the ALIU reported that 302 pictures belonging to Georges Wildenstein were stolen by the Nazis).[26] A stockpile of theirs in the Paris branch of the Banque de France was an early target of the ERR, and other works of theirs were taken from the Château de Sourches in the Loire Valley, as well as from the Château de Moyres near Angers.[27] Nazi art dealer Karl Haberstock told American investigators after the war that in November 1940 "the most important part of the Wildenstein collection had been loaded on a boat sailing for [the] USA, that the boat had been intercepted by a German submarine and forced back into the Bordeaux harbor, where its cargo had been unloaded and the collection seized by German authorities."[28] One OSS document titled "Pictures from the Wildenstein Collection Acquired from the Einsatzstab

Rosenberg by Marshal Goering" lists fourteen works, including paintings by Boucher, Fragonard, and van Goyen.[29] And Göring was kept apprised of the "Aryanization" of the Wildensteins' property, including their art collection, as the process played out in May 1941: Major General Friedrich Carl Hanesse (1892–1975), then the air force commandant of Paris, assured his chief that he would have first choice of all the Wildensteins' artworks—after Hitler.[30]

Lohse recounted in later years how he received orders to seize their famed archive, which included photographs and annotated cards (*fiches*) that documented the history of thousands of artworks and proved a kind of secret weapon vis-à-vis their competition.[31] The Wildensteins knew the locations of many of these artworks, and this information would have been of inestimable value to the Nazis as they searched for Jewish-owned collections. Lohse also claimed after the war that he had been ordered to destroy this archive, although this claim merits skepticism (if only for the strategic value just noted). The Nazis tended to be practical when it came to cultural property from western Europe (it was different in the east, where outright destruction occurred more frequently). A more credible part of Lohse's account was that he turned to Göring and asked permission to secure and preserve the Wildenstein archive. According to a long-time friend of Lohse's, the young art historian hatched a plot to declare the archive "without value"—and he drafted a document stating this that Göring signed—and this enabled the archive to remain on the premises of the rue La Boétie headquarters throughout the war.[32] A secretary to the Wildensteins then smuggled out many files and took them to her apartment for safekeeping. While this rendition relies on Lohse, the point is that the gallery archives evaded seizure by the Nazis and that Lohse received credit for the documents' survival.

Many questions remain regarding this account. Where is this document declaring the archive unimportant? (It did not appear in any ERR files or among postwar documents, including his trials.) Why is there also a document showing Lohse trying to purchase the archive (but not doing so) in late 1943?[33] How does this fit in with his narrative? Did Lohse himself have access to information in the archive as he helped the ERR undertake raids in France? Why would Lohse have helped the Wildensteins in the first place? The latter is perhaps the easiest to answer, with power and profit emerging as motivating factors in Lohse's life.

Despite the questions, Lohse had a clear recollection of details regarding the archives. He related that when he first arrived on the premises on

the rue La Boétie during the war, he saw the binders that "reflected close to a hundred years of work in the art business."[34] He pulled out one binder on eighteenth-century Venetian painter Francesco Guardi and recalled being astonished by the wealth of information. And this was just one of the binders on Guardi. He explained—in this account given some fifty-five years later—that there were seven other binders for the artist. Lohse nonetheless claimed he made the report to Göring about the materials, stating that the archive had little value.[35] Somehow Lohse helped to prevent the transfer of the archive to Germany. As noted by Yves Stavridès, an author who has written about the Wildenstein dynasty, "The marvelous library—books + archives—was sold by the administrator appointed by Vichy. But it never went to Germany. The whole stuff remained [at the] rue La Boétie. The library was saved by the D-Day [forces] after the Liberation of Paris!"[36] Regardless of the murky history of the archive during the war, it survived and was among the property that Monsieur Georges recovered in 1945.

According to Lohse, the Wildenstein patriarch had called him to the family's home in 1951 to thank him for this service. Lohse had been released recently from a French prison—a verdict of "not guilty" came down on 3 August 1950 after a three-day trial. But his sixty-three months in Allied prisons, including nearly three years in the Cherche-Midi lockup on the Left Bank, had been hard. He was malnourished, and the fact that he had been incarcerated longer than any of his art-looting cohort made him bitter. After stopping in Baden-Württemberg to register with the authorities (it had been the French Zone and the French still had officials there to whom he initially reported), Lohse headed to Munich. He intended to return to art dealing in some manner, although it's not clear he had a plan as to how to do this. Between 1945 and 1950, the art market in Germany had been in a deep freeze (save the beginning of the flow of works to the uniquely rich United States). While imprisoned, Lohse had not missed much in the art trade. But the landscape looked brighter in 1950 and dealers began to contemplate moves in accordance with the new realities: that the art market was poised to take off precipitously and that the pro-business government of Chancellor Konrad Adenauer would not only encourage commerce but turn a blind eye to former Nazis, who often received their pensions and also sometimes held posts in the state administration.[37] Lohse therefore plotted the revival of his career, and this included utilizing the contacts he had made in France during the war to find his new niche. Within weeks of his release, he reestablished his re-

lationship with Victor Mandl (1890–?) (sometimes rendered as Mandel-Markowsky), a collaborationist dealer who had been active in Berlin before the war and also had a gallery on the rue La Boétie, just down the street from the Wildensteins.[38]

Lohse recalled later in his life details from the 1951 visit to Paris to see Georges Wildenstein—acknowledging that the story may have been a fabrication (there is no documentary evidence to support it and it has never been confirmed by a member of the Wildenstein family).[39] Lohse nonetheless offered a wealth of detail, recalling that he stayed in the hotel that once had been favored by Luftwaffe officers, and that he had met the Luftwaffe chief for Paris, General Friedrich Carl Hanesse, there on many occasions during the war. As he told the story, Lohse recounted that he was in his room when he received a message: Monsieur Georges wanted to speak with him. Lohse made his way to the Wildensteins' *hôtel particulier* on the elegant Right Bank, and was led to a vast but empty second-story room that featured three easels, each of which held a painting. They were Dutch Old Masters, the genre most admired by Lohse. The three works were all exquisite in their own ways, Lohse recounted. After leaving Lohse alone with the paintings for a few minutes, Monsieur Georges appeared with his aides and took a seat in the corner. According to Lohse, Monsieur Georges stated in a very measured, formal manner that the doctor had rendered a great service to the house of Wildenstein by saving their archive during the war. For this he would like to thank him and reward him. He instructed Lohse to select a work from those before him. Lohse recounted some fifty years later that he was surprised, even shocked, but that he quickly regained his composure. He replied, "Thank you, Monsieur Georges, but I was only doing my duty. I cannot accept your generous offer." According to Lohse, Monsieur Georges initially insisted but ultimately relented. Yet he concluded the meeting by informing Lohse that he could always consider himself a friend of the house of Wildenstein.[40] As Lohse told the story, recalling the words of Monsieur Georges, he alternated back and forth between French and German, the former spoken in a clear, grammatically correct manner, albeit with a pronounced German accent. In fact, the rendition of the story in French may have been yet another deception; at least when Lohse met with Georges's son Daniel, the two spoke German with one another (and with the others in the room). As one person present at some of the meetings recalls, the Wildensteins hailed from Alsace-Lorraine and, taking pride in the Germanophone tradition, they all spoke excellent German.[41]

Lohse's self-serving account about his episode with Monsieur Georges concealed the fact that he still possessed looted art, including one of the last pictures ever produced by Camille Pissarro (who counted among the few Jewish French Impressionists). A rendering of the Seine River, painted in a room where Pissarro would die just weeks later in 1903, the picture had belonged to the Fischer family—the famed publishers who had started in Frankfurt but moved on to Vienna in the mid-1930s. The Pissarro had been ripped from their walls in Vienna after the *Anschluss* in 1938, and after being auctioned off in Berlin during the war, it disappeared. Yet between 1957 and Lohse's death in 2007, it had been a part of his collection. The Pissarro was among some 47 pictures found in his possession (or known to have been in his possession recently) when Lohse's estate was examined by authorities in 2007. His vault in Zurich—"Safe Number 5"—included works by Monet, Renoir, Sisley, Corot, and Wouwerman.[42] While this cache did not come close to that of Cornelius Gurlitt—the 1,258 works found in Munich and 239 pictures in Salzburg in 2012 represented a different magnitude—Lohse's collection warranted a valuation in the millions of dollars.[43]

Just the fact that Lohse rented out a large, walk-in bank vault in the Zurich Cantonal Bank (Zürcher Kantonalbank) says something about his postwar enterprise. If Lohse could afford the not inconsiderable cost of a vault of this size (with annual fees in the thousands of dollars), and if he needed such a safe, then presumably he was dealing with a significant number of artworks. Walter Feilchenfeldt, the president of the Swiss Art Trade Association from 1997 to 2007, quipped in an interview that he would not have been surprised if Franc Marc's *Tower of the Blue Horses* had been in Lohse's vault, referring to a lost Expressionist masterpiece that counts among the most sought-after works that disappeared during the Third Reich.[44] While Feilchenfeldt was being provocative, he was more serious in inferring that many in the art trade suspected that Lohse harbored looted art. News of Lohse's safe broke shortly after his death in 2007 and generated headlines around the world.[45] The safe seemed to confirm the suspicions of Feilchenfeldt and other art world insiders. Yet the discovery seemed to raise more questions than it answered—starting with: How did this art plunderer amass such a collection?

This is among the many questions explored in *Göring's Man in Paris*. Others include: What do his experiences during the war tell us about the nexus of culture and barbarism? How should we understand the postwar networks that took hold, and how does Lohse's story help us learn more

about the fate of Nazi-looted art? Why was he recounting stories about both meeting Georges Wildenstein in the 1950s and 1960s and enjoying dinners with Daniel Wildenstein in the 1980s and 1990s?[46] How did I get to know Lohse, and what kind of opportunities and dangers did these meetings pose?

And finally, a word on the structure and concept of the book: I offer first-person accounts of meeting Lohse and other old Nazis in the prologue and epilogue, but otherwise do not appear in the narrative until chapter 6, which begins 1998 when I first met Bruno Lohse. From that point in the story, there are moments where I relate personal experiences and observations that shed light on Lohse and his world.

Art Historian, Art Dealer,
Member of the SS (1911–41)

I F ONE WERE TO venture a single adjective to describe Lohse, it might be *elusive*. He did not want people to know him as a person—at least, not all sides of him—and he worked hard to keep his professional life a mystery. When I asked him in the late 1990s if he went through denazification after his return to Germany in 1950, he replied no. He claimed that after five years in a French prison and a trial before a French Military Tribunal, he could not face another judge. His refusal to go through denazification, he said, prevented him from regaining his license as an art dealer. He therefore refashioned his place in the art world as an "art adviser" (or *Kunstberater*, as he would call himself). He worked in the private sphere, a murky figure with confidential clients and contacts: as a broker, *ein Vermittler*. Yet a visit to the State Archives in Munich turned up his denazification file and revealed a different story. Lohse had lied to me—and it would not be the only time. Granted, the German judicial review in 1950 was perfunctory. The public prosecutor in Munich ruled within weeks of Lohse's release from a French prison that because he was not suspected of being in the first two categories of complicity (a "major criminal" or a "heavily burdened" figure) within the five-category scale, there was no need for a formal trial.[1] The prosecutor even ordered the state to cover the costs of the cursory process. Lohse, therefore, was formally "denazified." That he misrepresented his experiences, or told them only in a partial and

misleading way, proved typical. Indeed, piecing together the basics of his life required navigating the smoke and mirrors that he employed. I am not certain why Lohse lied to me about his denazification trial: perhaps he feared it would lead me to a paper trail. Perhaps this narrative could explain any self-perceived career failures—it was easier to say he had been banned from certain opportunities rather than admit that he just didn't achieve them. This also may have been his way of explaining how his wartime notoriety forced him into the shadows after 1950. Bruno Lohse was complicated, as even he seemed to realize.

Wilhelm Peter Bruno Lohse was born on 17 September 1911 in Düingdorf bei Melle, a twenty-house village in Lower Saxony—which, contrary to the sound of its name, is in northwestern Germany not far from the Dutch border and the Teutoburg Forest. The family did not remain there long, soon moving to Berlin, a rapidly growing metropolis with better job opportunities. Bruno's father, August Lohse, was a musician who had the good fortune to land a job as a percussionist with the Berlin Philharmonic, a position he held for some forty years. The Lohses were an upper-middle-class family. Bruno had an elder brother, Siegfried (1909–42), who went missing in combat on the eastern front during World War II, and a sister, Brünhilde (1914–2014). The names suggest a connection to the world of music and opera—specifically to Richard Wagner. The family of five resided in a comfortable apartment on the Humboldtstrasse in Steglitz, a leafy neighborhood in the southwest section of the capital, halfway between the city center and the green suburbs spreading out toward Lake Wannsee.[2] Many of the buildings on their street were elegant Jugendstil structures, with elaborate stained-glass windows and finely crafted stucco work that reflected a prosperous bourgeoisie during the fin de siècle period. The genteel suburb, which was incorporated into Greater Berlin only in 1920, developed around the vibrant retail shops on the Schloss Strasse. Those who knew the Lohses described them as *wohlhabende* (prosperous). They were members of the *Bildungsbürgertum*—the educated bourgeoisie—and as such, were connected to a wide range of artists, writers, publishers, art dealers and, of course, musicians. One family friend recounted that in the 1930s "during evenings in the Lohse house, to which I was often invited, political subjects and the like were never discussed. The conversation always concerned literary or musical topics, as well as the area of the beautiful arts." This family friend, who became an SS officer, also reported that Lohse's father was "a known art collector."[3] Bruno Lohse later recalled that his father had been friends with the legendary Berlin mu-

seum director Wilhelm von Bode (namesake for the Bode Museum), and that the two men would often examine pictures together.[4] Another family friend said that Bruno received Dutch pictures from his father, so they were sufficiently well off to collect on a minor scale.[5]

But all was not idyllic in the Lohse household. We do not know the details of the family dynamic; only refractions of problems are apparent. For example, later in life, after Bruno had married in 1958, his wife Ilse, who loved music, frequented the philharmonic and the opera. Bruno, his friends reported, disliked music and would not accompany her to concerts. She would therefore go with other friends, and this would anger him further. How could a son of a musician who played for the Berlin Philharmonic, let alone a member of the Bildungsbürgertum, dislike music? The most likely explanation is that it stemmed from his feelings toward his father. Of course, his disinterest in music might be construed as a sign of his often dour character, but such conclusions are precarious. We know little about the inner dynamics of the Lohse household, except that his father, August, was demonstrably anti-Nazi, and this probably proved a source of conflict. Bruno's older brother Siegfried also became a Nazi, joining the Party on 1 April 1933 (six months before Bruno joined the SS).[6] Bruno was devoted to his mother, Anna Catherine Hönekop Lohse. However, she died in 1938.[7] Lohse's father remarried, and Bruno did not like his stepmother.[8] Despite these tensions, both Bruno and Siegfried sustained a relationship with their father. The boys shared a fairly sizeable house three hundred yards down the street from the family home in Steglitz starting in the mid-1930s. Lohse obtained formal approval in November 1936 to turn the house at Humboldtstrasse 27 into a "Sales Venue for Old and Contemporary Masters" (*Verkaufsstelle für Gemälde alter und zeitgenossischer Meister*).[9] Lohse thus began his career as an art dealer just down the street from his family home, which continued to serve as a base for him. After the war, Rose Valland found documents and other property that Bruno had entrusted to his father to be stashed in the family home.

Lohse graduated from *Gymnasium* with an Abitur in 1930 and went on to the Friedrich Wilhelm University (later renamed Humboldt University) in Berlin to pursue his studies in art history, philosophy, and Germanic culture. At the same time, he qualified as a sports teacher, passing a state exam in 1932. Tall and athletic, Lohse developed into a seriously competitive handball player (a Continental sport that mixes elements of basketball and soccer). He and his SS teammates won the national championship in early 1935. He also recorded in his SS file that he was the "victor in the pen-

tathlon and the javelin" and that he had won the Storm Troopers' Sport
Award in Gold, among other honors (an SS man winning an SA award, no
less).[10] These were especially impressive feats considering that Lohse was
simultaneously working on his PhD in art history in Berlin. In early 1935,
he managed to arrange for a four-month stay in France, where he worked
on his dissertation and polished his French.

When Lohse returned to Germany, he matriculated at the University
of Frankfurt, where he continued his doctoral work with Professor Albert
Erich (A. E.) Brinckmann (1881–1958). A wide-ranging and astonish-
ingly prolific art historian whose many books stretched from the medieval
period to baroque sculpture to eighteenth-century architecture, Brinck-
mann moved from Berlin to the Johann Wolfgang Goethe University in
Frankfurt to take up a chair in art history, and he brought some of his stu-
dents with him.[11] Those close to Lohse later revealed how Brinckmann was
actually forced out of Berlin. He had ignored his teaching responsibilities
and engaged in romantic relationships with many of his female students,
with whom he would embark on "study trips." Even in those days, when
a powerful *Doktorvater* could take liberties that today would be regarded
as actionable, Brinckmann reportedly went too far. He later portrayed his
forced move from Berlin to Frankfurt as politically motivated, noting that
he was replaced by the "most prominent Nazi professor" Wilhelm Pinder
(1878–1947), a renowned art historian who moved to the Reich capital
from Munich.[12] Pinder would be a towering figure among art historians in
the Third Reich. Brinckmann noted that Pinder worked with Berlin au-
thorities to create "a nationalistic and Nazi art history for Germany."[13]
Pinder also supervised the theses of a number of figures mentioned in this
book, including Erhard Göpel (an art agent for Hitler and close friend of
painter Max Beckmann), Bernhard Degenhart (who went on to a success-
ful career in the museum world in Bavaria), and Benno Griebert (an art
dealer and the father of Peter Griebert).[14] Lohse was reportedly the only
male doctoral student to move with Brinckmann to Frankfurt.

Having written a dissertation on Jakob Philipp Hackert (1737–1807),
a German painter known for landscapes in a classical style, Lohse com-
pleted his studies in February 1936. The young PhD developed an ex-
tensive knowledge of Dutch Old Masters, and this would prove particu-
larly useful later in his career. As is required in Germany, his doctoral
thesis on Hackert was published as a book and appeared in 1936 from the
Lechte-Verlag in Emsdetten.[15] At 170 pages, the dissertation was com-
petent but not definitive, although it is still cited today among art histo-

rians, art dealers, and those studying the Brandenburg artist. Lohse had traveled to Riga, where he found a box of Hackert's letters in the State Library of Latvia (Hackert had a number of German-Latvian patrons). This discovery constituted a genuine scholarly contribution. The dissertation was also not an ideological tract, even though his *Doktorvater*, Professor Brinckmann, was a Nazi (and one of three art historians who were full professors to be dismissed after the war).[16] Lohse did not engage Nazi "blood and soil" or racial themes, and his analysis did not evince a pronounced nationalism. As opportunistic as he often appeared, Lohse did not use his thesis to curry favor with the Nazi authorities. Later, in his testimony given to the ALIU officers, he boasted about having studied with anti-Nazi professors (mentioning three by name).[17] The published dissertation is also interesting because Lohse thanked Dr. Hermann Voss (1884–1969) from the Nassauisches Landesmuseum in Wiesbaden. Voss went on to become the director of the Führermuseum in 1943 (no doubt a useful contact for Lohse later).[18] Lohse's was a solid monograph on an understudied artist. His work, however, was not sufficiently distinguished so as to place him on a track for a professorship or an academic career. When Lohse died in 2007, he left one of his friends a copy of the Hackert dissertation bound in gold leaf—a *Prachtband* (ornamental volume)—suggesting that Lohse, like many Germans, viewed the doctorate as means to become *salonfähig* (socially acceptable).[19] His doctor title was also central to his self-presentation as a *Kulturmensch*—a man of culture—and this conceit helped him rationalize his behavior throughout his life.

The twenty-five-year-old "doctor" returned to his parents' home in Berlin in 1936 and contemplated his next move. Lohse spent about nine months thinking about a career in the art world, and to this end, he acquired books, prints, and other art historical materials pertaining to Dutch art. As he later termed it, he amassed a "material collection" (*Materialsammlung*). His father, for all his apparent shortcomings in Bruno's eyes, put an "atelier" in the family home at his disposal. August Lohse also provided capital to buy stock as his son began to organize art exhibitions in the Steglitz house.[20] Many of the works in these exhibitions were for sale, and the young dealer had sufficient success to finance buying trips to Holland in the later 1930s. Dutch art historian Adriaan Venema documented Lohse acquiring artworks in Amsterdam in the prewar period.[21] Lohse also joined the compulsory state organizations for art dealers—most notably, the Reich Chamber for the Visual Arts. While the young art historian turned dealer scarcely counted as a player in the international art trade,

he was able to make a living. And he enjoyed the lifestyle—the travel, the social life, the freedom. As Walter Feilchenfeldt noted about being an art dealer, "There are no opening or closing hours. . . . The only fixed rule one can count on is that—in all probability—no work of art was ever sold before 10 o'clock in the morning. Therefore most art dealers tend to rise on the late side."[22]

We can manage only glimpses of Lohse's prewar business activities, but they show the early stages of a promising career as an art dealer. In March 1938, he sold *Sleeping Amor* by Friedrich Georg Weitsch, a German court painter and engraver from the late eighteenth and early nineteenth century, to the well-established Berlin dealer Karl Haberstock for Reichsmarks (RM) 1,400.[23] Haberstock had emerged after 1936 as arguably the leading purveyor of art to Hitler, Göring, Goebbels, and other Nazi elite, and this transaction suggests that Lohse was making inroads with important connections. Where he obtained the picture, or whether it came from a Jewish owner selling under duress, remains unknown. In May 1938, some two months after acquiring it, Haberstock sold Weitsch's painting to Goebbels's Reich Propaganda Ministry, along with three other pictures (including a Bismarck portrait by Franz von Lenbach) for RM 42,500.[24] The extant records do not disaggregate the latter sale in a way that reveals Haberstock's profit, but he likely did very well. After the war, Lohse reported that he himself earned about RM 3,000 per year from 1937 to 1939 (this when the average annual salary was RM 2,500).[25] With only modest housing costs that came from sharing a house with his brother Siegfried in Berlin-Steglitz, Lohse managed to maintain appearances.

The extant documents reveal that Lohse displayed considerable initiative in his new profession—for example, inquiring with Joseph Goebbels's Reich Propaganda Ministry in June 1938 whether he could buy or trade for "degenerate" artworks removed from state museums.[26] This undertaking came straight on the heels of Hitler's proclamation of 31 May 1938 giving the Nazi state the right to sell off purged art, nominally legalizing the process for all involved. That Lohse attempted to sell the purged art suggests his opportunism: he actually liked German Expressionism and many genres of modern art. In this way he was like Karl Haberstock, who had trained as a young man with Paul Cassirer, the legendary dealer who promoted and sold Impressionist art. Haberstock sold works by Impressionists and Postimpressionists over the course of his career (Pissarro, van Gogh, Liebermann, and Corinth, among others), even though he helped to defame modern art in the latter half of the 1930s.[27] Lohse's cynical

overture proved unsuccessful, however, as Goebbels's employees turned to more established dealers with international connections: most notably Ferdinand Möller, Hildebrand Gurlitt, Bernhard Böhmer, and Karl Buchholz. The four dealers took the lead in selling off the twenty-one thousand "degenerate" works removed from German museums, although a few others eventually got in on the action—including Hildebrand Gurlitt's cousin Wolfgang Gurlitt (1888–1965).[28] But as the 1930s drew to a close, Lohse continued to hover on the periphery of the Berlin art trade, still striving to forge links to the power brokers at the center.

As part of his studies at university after 1933, Lohse had been required to endure a program in "political indoctrination."[29] He claimed after the war that "in order to avoid the implications of such indoctrination . . . I volunteered to teach sports in the General SS [Allgemeine SS]." He taught sport after he joined the SS on 5 November 1933, a position he held until 1938, when ill health prevented him from discharging his duties. His assertion to postwar authorities that he was apolitical appears to have been overblown or part of a self-exculpatory defense. He joined the Nazi Party in 1937 and remained a member of the SS until 1945.[30] He was promoted within the SS on a regular basis after he formally took the oath on 29 August 1934. The promotions continued through the war, with Himmler personally approving certain advances in rank (the Reichsführer-SS was at his field headquarters when he signed a 30 April 1942 appointment of Lohse as an *Untersturmführer*, or second lieutenant).[31] His last promotion came in April 1944, when Himmler elevated him to the rank of first lieutenant (*Obersturmführer*).[32] While the rank was not extraordinarily lofty, the final elevation proves that he remained in good standing within the SS. And the fact that Himmler had him transferred from the General SS to his Personal Staff of the Reichsführer-SS in 1942 indicates that the Reichsführer-SS took a particular interest in Göring's man in Paris.[33]

In August 1942, an SS-lieutenant in Berlin by the name of Hans Leimer penned a report in which he called "SS-Ustuf. Dr. Lohse" the "representative of the Reichsführer-SS for art purchases," a designation effectively confirming that Lohse delivered works to Himmler as well.[34] The report discussed one particularly impressive collection that Leimer valued at 30 to 50 million French francs. Leimer also noted that a 10 percent commission would be paid, and invoked the names of a series of German Gestapo agents in Paris, including the notorious Paris chief Helmut Knochen. Hans Leimer also detailed the use of French informants to the Gestapo, emphasizing the role played by a particularly effective and re-

liable collaborator named Henry Rigeaux who, along with his "people," could help transport pictures over the Spanish border. The document made it appear that Lohse was siphoning off works from the seized Jewish works—Leimer is very clear that the art in question came from a Jewish collection ("an important collection of paintings from Jewish possession" was his phrasing)—and that the SS agents were using French informants (*Vertrauensmänner:* literally, "trusted men") to surreptitiously transport the works out of France.[35] For his efforts, Rigeaux wanted German citizenship. Whether the works would remain in fascist Spain or then be transported to Himmler in Germany cannot be discerned from the report. Because the works were located in the unoccupied zone in the south, and in light of the timing, SS-Lieutenant Leimer was likely discussing the famed Schloss collection, which Lohse helped plunder and liquidate. The Schloss collection went to Paris (and is discussed in more detail later), but the plans Leimer related are significant in their own right. Leimer characterized Lohse as an SS asset who continued on as a trusted member in good standing in the SS well into the war (August 1942).

Lohse always had an explanation for awkward facts pertaining to his political activities. For example, he maintained that he was automatically made a Nazi Party member in 1937 because he had been in the SS, and that he was promoted within the SS because of his "art activities." He also claimed that although he was asked to wear the SS uniform, he had never done so.[36] A photograph from the period, however, shows that on at least one occasion he wore garments with SS insignia. He had a French-Polish paramour, Jacqueline Seratzki, who reportedly loved to see him in the notorious black ensemble of Himmler's elite.[37] One encounter was documented in a photograph that Lohse retained among his papers. Wearing a sweater with the large SS symbols clearly visible (indeed, at the center of the photograph), Lohse is on a bed, his right arm nestling the heads of two women; a male comrade in uniform is on the other side, talking on the telephone. They were evidently "playacting" in setting this scene, captured by an unnamed photographer. The shot was clearly posed to document their carousing (the inclusion of empty wine bottles in the foreground may or may not have been intentional). While the image of Lohse and his German comrade with two women fits into a larger trope of photography during the German occupation of France—German men often liked to take pictures with their French girlfriends (part of what historian Julia Torrie has called the "visible trophies of war")—the SS sweater he wears remains jarring.[38] Julia Torrie adds that the "occupiers' snapshots

reveal how intimately their photographed leisure was linked to everyday systematic oppression."[39] In certain ways this photograph is akin to one of Lohse raising his arm in a Hitler salute to Alfred Rosenberg during the latter's visit to the Jeu de Paume on 4 November 1943: the image of Lohse making this Nazi gesture is unsettling, to say the least.[40] Yet the fact remains that Lohse was a card-carrying Nazi and he kept his original Party membership card with him until his death. His SS file also shows him making efforts to obtain an *SS-Führerausweis* (an SS leader identity card) in January 1943.[41] One can imagine Lohse utilizing this SS document to diabolical advantage as he pursued artworks during the war.

Lohse's earlier experiences made him a suitable fit for wartime deployment in France. In the prewar period, he had taught sport at a Renault factory in Berlin. The French automobile manufacturer sought someone to help the engineers and workers with exercise. One requirement of the position was a command of French, which Lohse had developed during his school and university years. Lohse had also spent four months in France on a language fellowship in 1933. His time at the Renault factory provided him with a knowledge of colloquial French that would afford him special opportunities during the war. Few Germans mastered the argot as he did: he could converse not only with learned French art historians but with the laborers responsible for packing, shipping, and the like. Lohse also proved adept at carrying out negotiations in French with local art dealers; on occasion he was even called upon to liaise with Vichy officials during the German occupation.

The aspiring art dealer evidently met Göring before the war, but how Lohse came into the Reichsmarschall's orbit remains a mystery. Like other men his age—twenty-eight when war broke out on 1 September 1939—Lohse volunteered for the army in late August 1939. His official date of entering the Wehrmacht, 27 August 1939, shows the German buildup prior to the actual attack on Poland. Lohse participated in the Polish campaign as a corporal (*Gefreiter*), and apparently fought as a member of a tank crew in a mechanized infantry unit (*Panzerjägerabteilung*). As part of a tank corps, he experienced firsthand the violent fighting at the front. The Germans suffered some fifty thousand casualties in the campaign (around sixteen thousand killed), and the conflict was more costly to the Germans than the quick victory might indicate. Exhibiting his personal survival instincts, Lohse managed to transfer to a medical unit, where he served as an ambulance driver attached to the Fourth Field Army Hospital.[42] Lohse nonetheless fell ill and was sent to the infirmary. He sometimes claimed he

was wounded in the Poland campaign, which left him at a reduced capacity (of 55 percent, as he said in postwar accounts).[43]

We do not know exactly what happened to Lohse in Poland in 1939, except that he was left with a scar on his right breast and lung troubles. He may have been shot while driving an ambulance, but the record is silent on the specifics. The young corporal also developed an ulcer in August 1940 and entered a field hospital in the Polish town of Siedlce, located some sixty miles east of Warsaw. He had acute pain in his lower intestine, and on 4 September 1940, he was transported to a larger hospital in Cracow.[44] Lohse recuperated sufficiently by October to be transferred to the Baltic city of Kolberg, where he joined a reserve unit. He remained on the Ostsee until early 1941, experiencing an uneventful four-month respite. In January 1941, Lohse was ordered to Paris, where he was formally conscripted into the Luftwaffe as a member of a parachute division called the Fallschirm-Panzerkorps Hermann Göring. He was given the rank of lance corporal.

Bruno Lohse's life stood at a crossroads. He would not have been reassigned to Paris without his personal assent; that is, he made a conscious choice to work for Göring. One can well (if not fully) understand the decision, even though it made him complicit in genocidal crimes. If one takes stock of the moment in January 1941, who was Bruno Lohse? What had he accomplished? What were his prospects? He was a *salonfähig* PhD with no prospects of a professorship or academic career. He was an unknown art dealer, selling from his parents' extra rooms in a Berlin suburb. He had a distinguished record as an athlete—perhaps his most notable achievement to date. The SS membership, the proficiency in French, and some helpful social connections also boded well for his career in Nazi Germany. He had served in the military and on the eastern front—a Nazi badge of honor. But up until January 1941, Lohse's potential surpassed his actual accomplishments. With high paternal expectations and the clock ticking, the nearly thirty-year-old bachelor decided it was time to take the risk and serve as Göring's agent in Paris. His life was about to change in ways he scarcely could have imagined.

The "King of Paris" (1941-43)

WHEN LOHSE ARRIVED IN Paris in February 1941, he was greeted by Baron Kurt von Behr, the manager of ERR operations in the west and later the chief of the notorious *M-Aktion*, in which the home furnishings of Jews in France were confiscated and shipped to the Reich.[1] Behr explained to Lohse that they were securing "ownerless" Jewish property in accordance with the German-French armistice signed at Compiègne in June 1940. Behr also informed Lohse that the entire operation was secret: even the provisions in the armistice granting the Germans the right to transport this ownerless property were secret. Lohse later talked about his *Schweigepflicht*, or "secrecy oath," although he also admitted to violating it on a limited basis.[2] The ERR was a kind of open secret, with a significant section of the French and German art world having some knowledge of the agency. Vichy officials issued numerous protests against the Germans' seizure of Jewish cultural property, and they had extensive knowledge of the ERR.[3] French police also handed over registration lists (*Meldelisten*) to the Germans, which helped Lohse and his cohort to locate Jewish property.[4] With regard to the official policy of secrecy, Lohse explained that Göring ordered it because he did not want the foreign press to launch propaganda attacks, especially with regard to the trade in seized works (*Tauschgeschäften*), which the media would portray falsely.[5]

Lohse was told that this was an urgent mission, and that Reichsleiter Alfred Rosenberg, who held a Nazi Party post as supervisor of the intel-

lectual and spiritual guidance of the German people, had been given the important responsibility of collecting information and cultural property relating to the enemies of National Socialism: Jews, Communists, and Freemasons. This was the origins of the ERR—collecting the archives and libraries of these declared enemies in France and other German-occupied countries—and Rosenberg expanded his mandate to include artworks in the summer and fall of 1940. As the ERR widened its operations to include art—and the agency seized many important Jewish collections in France early on—the *Reichsleiter* detailed a team of professional art historians to divide the works into categories, photograph them, catalogue them, and, in many instances, appraise them.[6] The peak of the ERR plundering came in late 1940 and early 1941, and they were desperate for trained staff.[7] The assignment was initially temporary—to last only four weeks.[8] Lohse was to work for Dr. Günther Schiedlausky (1907–2003), who headed the ERR's staff of art historians.[9] Schiedlausky, formerly in the sculpture department of the Kaiser Friedrich Museum in Berlin, was taciturn but cultured. Rose Valland described him as a Francophile who spoke the language well.[10] Lohse later recounted that Schiedlausky initially told him that his job was to provide "a scholarly inventory" of the already secured Jewish artworks and that no confiscations would take place unless the owners were known to have fled: those who left France would be deemed stateless and their property could be confiscated.[11] Lohse held fast to the notion that his job was to compile an inventory, always downplaying his role in the actual search and seizure of objects.[12] He also claimed that he frequently requested reassignment during the war—that he sought to return to a fighting unit. He certainly made this request on several occasions during the war, but it's unclear if he was earnest in every case or if this was merely a gesture for show (to suggest that he was a man of honor and possessed physical courage, among other messages).

Evidence suggests that Lohse knew that these guidelines and rationalizations were a sham. He was initially charged with inventorying the Alphonse Kann collection—one of the great collections taken by the ERR. Alphonse Kann (1870–1948) collected art ranging from Old Masters to Picasso and Matisse.[13] It was a collection of extraordinary quality, even if part of it was "degenerate" according to Nazi aesthetic policy. But Lohse protested the assignment shortly after beginning it. He claimed that "he found the work uncongenial" and "requested formally to be returned to his regiment at the end of the stipulated four weeks of duty."[14] Lohse had become aware of von Behr's operational style. As ALIU officer

James Plaut noted, "All sources are agreed that [von Behr] initiated, directed, and personally conducted the majority of the E.R.R. confiscations without fear of consequence, without legal pretext, and without respect for ownership or quality of the works of art seized. He was impatient with all suggestions for moderation in confiscation, or for orderly cataloguing of objects received."[15] That Lohse continued to suffer from an ulcer may also be an indication that he worked for an unstable chief (and, perhaps, that he had pangs of conscience). A number of the Nazi leaders, including Himmler and Albert Speer, suffered stomach ailments during the war that appeared to have psychological origins.[16] Lohse's gastric problems had begun in Poland in August 1940—his experiences in that environment, marked by violence and bloodshed, were likely factors contributing to his affliction. For Lohse to ask to return to his unit in Poland in the spring of 1941 spoke to his deep unhappiness with his new post.

Yet something extraordinary happened on 3 March 1941, two days before Lohse's transfer back to the east was scheduled to occur: Hermann Göring came to the Jeu de Paume to inspect the artworks looted by the ERR and Lohse received him for the first time in the museum turned plundering depot. This was Göring's third trip to the ERR headquarters, and as usual, he was accompanied by Walter Andreas Hofer, who that same month received the official title director of the art collection of the Reichsmarschall.[17] Göring had visited the Jeu de Paume on both the 3rd and 5th of November 1940, the latter standing out because he issued his famous—or infamous—order detailing the pecking order for recipients of the loot: Hitler was first, followed by Göring, Alfred Rosenberg's ideological schools, and then German museums.[18] Hitler had pushed back with a memo of 14 November 1940 in which he claimed the prerogative to determine the fate the of the art (*Führer-Vorbehalt* in German), but Göring, writing from his hunting lodge at Romintern on 21 November, explained to the Führer that he had a particular ability to coordinate "the recovery of Jewish art treasures."[19] Göring added that he had "resorted to bribery and hiring of French detectives and police officials to winkle these treasures out of their (often devilishly clever) hiding places."[20] Hitler did not respond and the matter simmered on unresolved.

Göring clearly had ambitious plans for the ERR in Paris, and he kept a close eye on the operation. The agency had morphed from its origins as a tool of "ideological struggle" into a unique hybrid of plundering agency and art dealership.[21] OSS investigator James Plaut believed it was the force of Göring's personality, his active involvement in the affairs of the ERR in

Paris, and his utilization of Luftwaffe motor and train transport that enabled him to overcome "the formal contradiction to the Hitler order of 18 November 1940."[22] It also helped that the director of the Führermuseum planned for Linz, Dr. Hans Posse, was sick with cancer and traveled to Paris infrequently. Rosenberg himself visited the ERR in Paris on only two occasions and, as his recently discovered diary entries show, he evinced minimal interest in the agency's operations in France. Indeed, as James Plaut observed, "The Einsatzstab was a constant source of irritation to him, and on more than one occasion he was heard to say, 'Don't ever mention the word Einsatzstab to me again.'"[23] Rosenberg understood the ERR had become more about plunder than ideological struggle. Lohse recalled in an interview at Nuremberg after the war, "I can tell you that Rosenberg wanted to get rid of this activity since 1941, because he was against it all."[24] Göring filled the power vacuum, and his March 1941 visit therefore created extraordinary opportunities for Lohse, who cultivated his new patron with energy and enthusiasm.

Another factor that contributed to the burgeoning relationship between the Reichsmarschall and the young art historian stemmed from the complex personality of ERR chief Colonel Kurt von Behr. Colonel von Behr had been adjutant to the Duke of Coburg, the English-born prince and grandson of Queen Victoria who became a Nazi. Both Charles, Duke of Coburg, and von Behr served in the German Red Cross, and von Behr continued to wear his Red Cross uniform in Paris as he directed the ERR.[25] Most of the staff wore brown Nazi uniforms, which was customary for a Nazi Party agency, so von Behr distinguished himself by his attire.[26] Some described von Behr as "elegant"—most called him pompous—but there is no disputing that Colonel von Behr was corrupt. OSS officer James Plaut helped fill out this picture, recalling that von Behr "lived in great luxury in Paris and entertained lavishly, seeking his guests in the highest-ranking military and political figures."[27] Rose Valland, who saw him in person in the Jeu de Paume during the war, recalled in 1945 that "von Behr would profit from the abundance of requisitioned Jewish property that was put at his disposal in order to lead a large and ostentatious life and to make gifts to his friends; he was notably an amateur connoisseur of quality wines and assembled a precious reserve of it."[28] Theodore Rousseau reported in a postwar lecture that von Behr "is reported to have had a secretary—Miss Potts—a beautiful girl with grey eyes and black hair, who used to wander about his office in her chemise."[29] James Plaut also noted the louche atmosphere that pervaded the ERR in Paris, writing, "It has been learned . . .

that von Behr, Scholz, Schiedlausky, and Ingram were all involved in affairs with secretaries of the Einsatzstab, the circumstances of which contributed more than any other factor to the lowering of staff morale."[30] In short, Lohse found himself answering to an arrogant, unethical, and decidedly decadent chief in von Behr.

Kurt von Behr showed Lohse how important it was to cater to Göring. He was present at most of the twenty tours of the Jeu de Paume, lending his support to Göring's selections.[31] Yet von Behr went beyond this. ALIU officer James Plaut described in his 1945 report on the ERR, "Lohse cites as an illustration of von Behr's desire to please Goering the fact that he came to Berlin for the Reichsmarschall's birthday in 1942, bringing with him as a birthday gift the original copy of the Versailles peace treaty with all signatures, and an original letter from Richard Wagner to Napoleon III. These were documents confiscated by the ERR."[32] Corruption infected the ERR from the top down, although there were individuals in the organization who, in James Plaut's words, "represented the interests of moderation in the affairs of the Einsatzstab" (citing administrator Hermann von Ingram as potentially one of them).[33]

Despite his venal ways, von Behr showed little interest in the art that his agency was plundering. James Plaut noted, "Wholly ignorant in art matters, he refused to be guided by the specialists of his staff."[34] The professional staff of the ERR became convinced that von Behr had no appreciation of the value of the assets in question, and this became a factor in the perpetual infighting and intrigue. Yet this too created an opportunity for Lohse. When Göring came to visit the Jeu de Paume on 3 March 1941, von Behr, because of his limited abilities, assigned Lohse the responsibility to act as guide. Lohse, who had been afforded the opportunity to study up in advance, dazzled Göring with his knowledge, especially with regard to an area of specialty for him, seventeenth-century Dutch painting, which he highlighted on the tour. Lohse also impressed the Nazi chief in a dispute concerning certain pictures that Walter Andreas Hofer believed were substandard.[35] Lohse realized early on that Göring valued a brash, irreverent figure as an art adviser. The Reichsmarschall was surrounded by lackeys, and for a rough and cynical military officer like Göring, it was refreshing to be in the presence of a young and self-confident PhD who spoke his mind.[36]

The following day, Lohse was ordered to report to Göring's Paris office in the Quai d'Orsay, the home of the French Ministry of Foreign Affairs.[37] Lohse and Göring talked for about an hour, and at the end of

this discussion, the Reichsmarschall gave him a new assignment: remain
with the ERR, but also seek out and recommend art objects for Göring
to purchase. Lohse later recalled the matter as an order, and pointed to
his formal transfer to Göring's Luftwaffe, but he was no doubt excited by
the prospect of representing one of the most powerful men in Nazi Ger-
many—and doing so in the French capital. With his language skills, he
knew he could thrive in Paris. But his rapport with Göring was also a key
consideration. The two got on exceptionally well. Some who knew Lohse
later described it as a father-son relationship (there was an eighteen-year
age difference). Lohse's friend Peter Griebert used the word *Männerliebe*
(love between men, but in a nonphysical way) and noted that Göring pro-
vided Lohse with a special phone number that afforded him near twenty-
four-hour access to the Reichsmarschall.[38] Göring also granted the young
art historian considerable latitude in terms of remarks and behavior:
Lohse could veer toward the brash and outspoken without negative conse-
quences. Lohse in turn grew devoted to his patron and remained so all his
life. ALIU officer Theodore Rousseau, who interviewed both Göring and
Lohse, captured something essential in a 1959 lecture when he noted that
Göring "was loved and respected by those who worked with him closely.
They believed absolutely in his sense of honor and in his generosity. He
helped many Jews and his intimates were convinced that he was opposed
to many of the atrocities committed by Himmler, yet we have found out
since that he knew of these and approved them."[39] Rousseau's character-
ization captured Lohse's thinking in many respects.

There was some debate among the postwar investigators about whether
Lohse was ever officially an employee of the ERR or just a liaison between
Göring and the agency. The members of the Art Looting Investigation
Unit determined he was "deputy director of the Einsatzstab Rosenberg"
and leader of the special staff for the visual arts within the ERR, but Lohse
himself claimed after the war that he was a Luftwaffe soldier detailed to
this agency, not a Nazi Party employee like the regular ERR staffers.[40] In
postwar interrogations and then later in life, Lohse would stress with great
vigor that he was not a member of the ERR. The fact was, however, that he
was effectively its operational chief for extended periods between 1942 and
1944, playing the key role in overseeing a staff of around eighty.[41] Lohse
rose to become head of the *Kunststab* (art staff) within the Paris branch
of the ERR and undoubtedly considered himself a part of the ERR hier-
archy. When the staff of the ERR had photographic portraits made during
the war (now housed in the Diplomatic Archives of the French Ministry

of Foreign Affairs), Lohse joined in. Images of him in half a dozen poses survive.[42] He also signed contracts on behalf of the ERR in trades involving looted works.[43] Indeed, historian Emmanuelle Polack asserted, "Bruno Lohse was the instigator of at least thirty exchanges that were carried out by the ERR from March 1941 to November 1943."[44]

It was also not uncommon for Lohse to participate in ERR seizures. As James Plaut of the ALIU wrote, "It became standard procedure to have one of the art historians accompany responsible ERR personnel where confiscations were to take place. Lohse as well as . . . other members of the art staff engaged in this activity."[45] The actual commandos who carried out the lightning raids were known for thuggery and showed little appreciation of the artworks. Notorious for their nighttime sorties, they helped evict the terrified Jewish occupants and seize their art.[46] The art historians had complained that the "irresponsible non-professionals" were preventing an orderly cataloguing of the seized objects and demanded to ride along. After the war, investigators for the French intelligence agency, the Direction Générale des Études et Recherches, concluded that Lohse's "personal actions contributed greatly to give the requisitions the character of a *grand brigandage*."[47]

Bruno Lohse mixed with the worst elements in both the German occupying forces and the French collaborators. Among the former, he had regular contact with Helmut Knochen (1910–2003), the head of the SD (Sicherheitsdienst, or the Security Service of the SS) and Gestapo in Paris (or, as one French magazine described him after the war, "the handsome Knochen, chief of the terrible Gestapo on the avenue Foch").[48] Lohse and Knochen had met back in 1936 at the Berlin Olympic Games when Knochen was a sports writer (or so Knochen testified at Lohse's postwar trial).[49] Journalist Philippe Sprang noted that Lohse had frequent contact with the Gestapo and SS in Paris, sharing information as he reconnoitered opportunities to exploit.[50] Sprang adds that Lohse was particularly adept at gaining leverage over people: the art dealer would threaten, charm, seduce—whatever was necessary to advance his interests.[51] Among the French collaborators, Lohse turned to members of the Bonny-Lafont gang, a violent criminal organization in the Paris underworld. It is also telling that the United Nations War Crimes Commission initially charged Lohse with working for the "Service Central de la Gestapo de Paris" in an August 1945 indictment: Lohse was listed as accused number twelve, with Hitler, Göring, and von Ribbentrop occupying the top spots.[52] While Lohse was not employed by the Paris Gestapo—and the initial UN charges

regarding the Gestapo were never pursued—the fact that he elicited the charges along with other high-ranking German figures is telling.

Lohse did not always appear menacing: dressed in dapper civilian clothes, he shuttled between an office in the ERR depot in the Jeu de Paume (the "Arbeitsgruppe Louvre") and one in the Dienststelle Westen (the Agency for the Occupied Countries of the West), part of Alfred Rosenberg's Reich Ministry for the Eastern Occupied Territories (or Ostministerium for short). The Dienststelle Westen was initially in the Hôtel Commodore on the Boulevard Haussmann but then moved in 1941 to 54 avenue d'Iéna (now Jena).[53] The ERR staff later moved to new quarters at 12 rue Dumont d'Urville in 1943, when Kurt von Behr shifted over to lead the *M-Aktion*.[54] The ERR had four depots in Paris (with the Jeu de Paume as the primary one) and six office complexes.[55] Lohse could work where he liked, but the fact that he had a desk at so many of these Nazi administrative facilities is suggestive of his official status. After the war, the ALIU officers and others investigating him did not buy his story that he was not a member of the ERR.

Of all of Lohse's personal interactions during the war, those he had with French curator Rose Valland were the most fraught and perhaps the most significant (other than those with Göring, of course). The two had a charged relationship and thought a great deal about one another long after the war—and well after they ceased any personal contact. But for both, the events in the Jeu de Paume during the war stood out as the apogee of their careers. Valland, in her early forties when the occupation began, wore steel-rimmed glasses and was often described as having an unassuming appearance. One author noted that "her chief asset, in view of succeeding events, was the impression she made as a punctilious, mouse-colored civil servant, a deadpan fixture of the museum whom the suspicious occupants of the building scarcely noticed."[56] This impression was reinforced by the fact that she feigned not to speak or understand German. Lohse was in the minority among the ERR staff who could speak French, which drew them together. Valland was charged with writing documents in French and communicating with the seven French workers who were responsible for heating, electricity, and the like. As such, she occupied a tiny workroom near the main entrance. This enabled her to see what objects came and went. At times she would query a French driver who delivered property as to its origins, and at times she would go through the trash baskets, looking for documents that would provide clues.[57] Whatever she found, she committed to memory and wrote up in her journal, summaries of which were

sent to Jacques Jaujard (1895–1967), director of the French National Museums. While Valland was modest in a certain sense (understandable for a woman in a man's profession in a country where women could not vote until 1945), she possessed a strength and determination that would make her a key player in the ERR facility from its inception to its liberation.

The ERR took over the Jeu de Paume in October 1940. French authorities tried to make the best of a dire situation. Baron Kurt von Behr and Dr. Hermann Bunjes (1911–45), the director of the German Art Historical Institute in Paris, had visited Jacques Jaujard in his office in the Louvre. The Germans sought storage space for the ERR-secured objects and asked to use the Jeu de Paume, a substantial building situated on the crease between the Tuileries garden and the fashionable rue de Rivoli, which housed the hotels now inhabited by German officers. Until the late 1930s, the Jeu de Paume had held works by contemporary foreign artists, but its galleries were now empty, the collection stored in the basement and in the Château de Chambord in the Loire Valley. Jaujard, who was an expert on safeguarding art during wartime (he had helped save works in the Prado during the Spanish Civil War), agreed on the condition that French curators be allowed to compile their own inventory of the objects passing through the facility.[58] A deal was struck, and Jaujard directed Valland to remain in the Jeu de Paume.[59] As noted above, she was the only French curator on-site. Indeed, it was German policy to keep the French from seeing, in the words of Dr. Hermann Bunjes, "the work methods and the results" of the ERR in the Jeu de Paume.[60] The seven French maintenance workers the Germans allowed to remain were kept on the periphery of the operations as much as possible. Eight German guards secured the facility, and Valland was constantly scrutinized.

After the ERR moved into the Jeu de Paume on 30 October 1940, its staff worked feverishly to prepare its first exhibition for Göring, who was scheduled to arrive for an inspection on 2 November. Behr and his colleagues hung the paintings.[61] Valland raced from painting to painting, scribbling in her black notebook. She did this openly, as Jaujard had negotiated permission for her to do so. But on the day before Göring's arrival she was told to stop writing. The Germans would not permit the parallel inventory. They did not want a paper trail in French. She acceded to their orders—at least outwardly—and was allowed to stay on at the facility. Valland also justified her continued presence by claiming to care for that part of the permanent collection that remained stored in the basement. ERR chief Baron von Behr disliked Valland and tried to remove her on four

occasions, with charges ranging from espionage to sabotage to communicating with the enemy.[62] Author Michael Gibson noted, "Von Behr was determined to get rid of Valland before the end of the war. In the course of a war crimes trial in 1950, she learned of his plans to deport her to Germany, where she was to be liquidated as soon as she had crossed the border."[63] Lohse confirmed as much in his testimony before a French Military Tribunal in December 1949.[64] There is no doubt that Valland's work placed her life in danger.[65] A member of the French Résistance, she made her contribution by remaining at the Jeu de Paume.

Rose Valland's two greatest wartime accomplishments were sending a regular stream of reports to the director of the Musées de France, Jacques Jaujard, and helping to prevent the departure of a train with fifty boxcars of art and other cultural property that the Germans attempted to evacuate from Paris as the city was liberated in August 1944. Valland possessed a remarkable memory. She could remember specific paintings and the depots in Germany where they were headed, and she compiled records after hours in the privacy of her home. Journalist Hector Feliciano used the phrase "spectacular information" to describe her dispatches.[66] Her intelligence about German depots, for example, was passed along to the American Seventh Army as the troops pressed into southern Germany and Austria.[67]

Valland's observations about Nazi art looting also proved valuable to historians. There is an entire archival collection in the French Ministry of Foreign Affairs devoted to her sleuthing efforts. Lohse, not surprisingly, figured prominently in her reports. Valland saw him as a leading force within the ERR. She noted that the big Jewish collections had been processed before Lohse took over, writing on 16 July 1942, "When Dr. Lohse took over the direction of the ERR in the Jeu de Paume, the majority of the great Jewish collections had already been inventoried and shipped to Germany."[68] Nonetheless, she documented many of his activities concerning seizures: "visiting" a Rothschild château in the region of Elbeuf; removing paintings from the Kann and Rosenberg collections from Bordeaux; trading paintings with dealer Leegenhoek on the Boulevard Raspail; and traveling to the Côte d'Azur to buy art.[69] She also chronicled how Lohse transported crates of his own to Germany, reporting to museum director Jacques Jaujard, for example, that he sent one to his mother's address in June 1943 and another to Kogl in the Austrian Alps in November 1943.[70] The first shipment contained, among other items, a collection of etchings illustrating the works of Goethe and Corneille that Jacques Beltrand—the French appraiser working in the Jeu de Paume—had given Lohse as a

gift.[71] Valland often displayed a dry wit in her reports, calling the room in the Jeu de Paume where the ERR kept the modern "degenerate" works the "Room of Martyrs."[72] It is easy to understand how she became a celebrated figure, even the subject of a nonfiction graphic work. Lohse, it bears mentioning, is featured in this graphic rendition of Valland's life, portrayed as her great antagonist in the Jeu de Paume. The drawings in the book are based on actual historic photographs.[73]

The wartime relationship between Lohse and Valland was undoubtedly turbulent and anything but straightforward. On the one hand, Lohse was a plunderer and Valland a member of the Résistance. But it seems that they also had some kind of personal rapport. As author Matila Simon noted about von Behr's repeated efforts to dismiss Valland: "Each time it was Bruno Lohse who insisted that she be permitted to return."[74] Over the years, Lohse developed some very curious ideas about Valland. He told me that Valland had a crush on him and would have welcomed a romantic relationship. But he would shudder and tell me he found her "ugly" (*hässlich*). He would also describe her ample bosom in a derogatory manner. Lohse told me in 2001 that Rose Valland had a relationship with Walter Borchers, who co-directed the ERR with Lohse in 1943–44.[75] This all appears to be fanciful and mostly wrong. Valland lived openly as a lesbian and had a long-term relationship with Joyce Heer, next to whom she was buried. Valland's sexual orientation was also portrayed in the French graphic non-fiction treatment of her life.[76] Lohse was clearly hurt by her efforts to aid in his prosecution after the war, although he once suggested that she had attacked him due to her own vulnerabilities: after she spent four years working closely with Nazis, certain observers had suspected Valland of collaboration, and Lohse believed her efforts to go after him were part of an effort to clear her name.

More generally, of course, Lohse was Göring's art agent in Paris. Armed with the April 1941 authorization that he was acting on "the Reichsmarschall's behalf," Lohse wielded much power—but he was under pressure to deliver. Göring had been declared Hitler's official successor in September 1939 and was at the zenith of his power, which made him impatient and demanding.[77] Much was given and much was expected. Göring testified while in Allied captivity in 1945 that he provided Lohse with the working capital. He added, "I always took enough money along on the train—I had a private train—I would give an order to the Reichsbank and they would get the money. I had to okay the order myself."[78] The almost unlimited resources were augmented by the overvaluation of the Reichs-

mark, which gave the Germans a marked advantage in all transactions in France and the other occupied lands: scholars talk of "technical looting" because the goods were so cheap.[79] Starting in the summer of 1940, the Nazi leader would load his personal train, *Asia*, with stacks of freshly minted Reichsmarks and tour the occupied western European lands in collecting mode. A technical staff handled the works, utilizing "a specially fitted out train designed for carrying works of art."[80] Scholar Mowenna Blewett adds, "There were private quarters for Göring and his entourage as they traveled in style to buy and collect works of art in Belgium, France, Holland, and Italy."[81] By no means did Göring rely solely on Lohse as an agent. He used art plunderer Kajetan Mühlmann (1898–1958) and banker turned dealer Alois Miedl (1903–90) for similar purposes in the Netherlands, to name just two. Others who helped Göring acquire art included rug merchant Josef ("Sepp") Angerer (1899–1961), Munich art dealer Walter Bornheim (1888–1971), and Dr. Hermann Bunjes, an art historian who used his position as director of the German Art Historical Institute in Paris to help his chief. But Lohse was special. He was based in Paris, the capital of the Continental art market, and the two developed a particularly close relationship. While Walter Andreas Hofer was more a factotum as he oversaw Göring's collection, Lohse represented something different: youth, ambition, adventure and, of course, the promise of artworks (some looted, some purchased).

The occasions when Göring arrived at the Jeu de Paume were grand theater for Lohse. They involved a mixture of exhilaration and anxiety. The Reichsmarschall's train would arrive in Paris, sometimes with only a few hours' notice, and Lohse would be expected to have art on the walls as well as champagne on ice. Göring liked to shop in Paris, and he pursued a "high-low" strategy, visiting upscale galleries and jewelers—including Cartier on the Place Vendôme, from which he ordered a gold- and jewel-encrusted marshal's baton when he first arrived—and also ambling through the city's famed flea markets.[82] One observer noted, "It was a rare spectacle—the highest ranking soldier in Europe trafficking with 'the shadiest' collaborationist art dealers, disreputable lawyers, quasi-dealers [and] expert valuers . . .—all the riffraff of the international art market."[83] General Friedrich Carl Hanesse accompanied Göring, packing ample reserves of banknotes. Göring flew into a rage in Ghent when Hanesse did not have sufficient cash to purchase a ring, and this led to an increase in the sums kept on hand.

During the war Lohse probably accompanied his chief on a dozen

excursions in the French capital, although they also met in Berlin and at Göring's lavish country estate, Carinhall, where the most prized works of the Reichsmarschall's art collection were displayed—along with his remarkable library, his elaborate model train set, and the wooden scale model of the Sanssouci palace of Frederick the Great that he had built for his daughter Edda.[84] In December 1942, Lohse wrote an ERR colleague in Brussels that he had been unable to make their appointment because "my chief surprised me by coming to Paris, and after staying for several days, ordered me to follow him directly to Berlin."[85] This entailed private meetings in Carinhall, where Lohse was surrounded by the collection he hoped one day to curate. Lohse would later regard his time with Göring as the apogee of his life.

Lohse's base of power, of course, was the ERR headquarters at the Jeu de Paume. For starters, he made sure to be present whenever Göring arrived for his inspections. There were twenty such events, and Lohse was present for all of them except those in November 1940, which occurred before his posting.[86] Lohse usually had Günther Schiedlausky help him prepare exhibitions of the confiscated art.[87] Desirable works were brought over from the Louvre Annex, which housed the stock that did not fit in the cramped Jeu de Paume. Lohse and his staff would decorate the former tennis court, adding rugs, palm trees, and comfortable furniture—and, of course, arranging for the fine champagne. They also went through the charade of engaging an assessor—a French professor and artist named Jacques Beltrand (1874–1977), who was also president of the Société des Peintres-Graveurs Français—to provide an appraisal. It was customary for Lohse to submit lists of paintings that Göring was taking (for example, Lohse's list of 13 March 1942 records seven paintings, including three Salomon Ruysdaels, a van Goyen, and an Albert Cuyp), and Beltrand would then provide the valuations.[88] Beltrand's appraisals were "absurdly low."[89] For the seven paintings mentioned above, he arrived at a sum of 750,000 French francs ($15,000), less than half the price they would bring on the open market. Beltrand feared Göring (Lohse described the Frenchman as "timid") and appeared susceptible to pressure.[90] Hofer certainly induced him to reduce estimates. The prices, however, were ultimately mere window dressing. Göring never transferred a *Pfennig* (or a *centime*) to cover the costs of the works he commandeered. It was outright looting, with an attempt to cover it up bureaucratically. This was not an uncommon occurrence in the Third Reich.[91] After the war, his secretary tried to explain the lack of payment, telling Allied investigators that Göring "asked Rosenberg where he should

pay and he did not get an answer."[92] Regardless, Lohse and Beltrand developed a warm relationship and this helped Göring get what he wanted. Beltrand presented Lohse with a gift during the war of two woodcuts that he himself had made.[93] We do not know if the gesture was reciprocated or how Beltrand benefited from the relationship.

Göring's decree of 5 November 1940 establishing the order of priority for the ERR loot stipulated that those works that did not end up in the hands of the top two Nazis or German museums would be made available to dealers. The proceeds, Göring stated, would go to the French state to aid the dependents of war victims, but there is no evidence this ever occurred. Nonetheless, the ERR staff had permission to sell some of the art, and Lohse took advantage accordingly, although it remains unclear to what extent. His friend Maria Almas Dietrich, a Munich dealer, purchased a number of works from the ERR stock, including one attributed to Rembrandt.[94] On at least one occasion, Alfred Rosenberg criticized these sales, complaining that works that would have gone to the Führermuseum at Linz were being lost to independent dealers.[95] In reality, there were different kinds of sales taking place. Some of the Jeu de Paume stock was "sold" to Göring. Some was taken on Göring's behalf and traded or sold by his agents (with the Reichsmarschall reaping the benefit). Certain works went straight to dealers and others with connections. Rumors abounded that Nazi Party functionaries and business leaders were able to acquire works from the ERR, often at nominal prices of a few Reichsmarks or francs. Rose Valland, who remained in the Jeu de Paume facility through the duration of the war, said that Kurt von Behr allowed Hitler's photographer, Heinrich Hoffmann, to acquire ERR-held works in 1943.[96] Other instances in which individuals received works are difficult to confirm, but clearly there was significant graft surrounding the operation. With Kurt von Behr in charge during the crucial early years of the agency's operation, one would expect little else. Artworks disappeared, but this "shrinkage" was concealed because the ERR kept its own records of losses.

Lohse's skills as a plunderer-dealer enabled him to branch out in terms of relationships and patronage. He understood that his power was enhanced by his membership in the SS. As noted earlier, he made repeated requests to the SS administrative headquarters to obtain updated SS identity papers; updated documents were provided to him as late as December 1944.[97] And indeed, he called on SS units as a show of force on several occasions as he helped confiscate "ownerless" property. He also made sure to direct artworks to Reichsführer-SS Heinrich Himmler which, at the

very least, offered partial insurance should he himself encounter serious difficulties. As Himmler's chief art agent, Wilhelm Vahrenkamp, noted to his chief in August 1942, "Many artworks are located in the Netherlands, Belgium, and France and will be offered for sale. As far as I know, the Reichsmarschall had authorized Herr Dr. Lohse with the responsibility for these tasks in the named countries. From these purchases, good works will certainly be put at the disposal of the SS."[98]

Vahrenkamp then requested funds from Himmler for the purchases, although Himmler's aide Rudolf Brandt noted that no sale could be concluded without Himmler's personal approval. The Munich-based Vahrenkamp sought out "furniture, pictures, porcelain, [and] tapestries," among other objects.[99] SS-Sturmbannführer (Major) Vahrenkamp's correspondence with Brandt shows that Lohse was not simply passing along works to one of his patrons, he was selling them. What Lohse sold to Himmler and where the payments were directed remain unclear (we know only that Himmler had a *Sonderkonto R*, or "Special Account R," that paid for the artworks). Nazi art dealer Karl Haberstock told OSS investigators after the war that Lohse "was responsible for the acquisition of works of art for Himmler," although Haberstock offered no specifics.[100]

In a sense, Lohse was like art plunderer Kajetan Mühlmann in the Netherlands. "Kai" Mühlmann was a member of the SS yet also beholden to Göring, and he navigated this challenge by directing art to both the Reichsmarschall and the Reichsführer-SS.[101] Mühlmann actually shared a house with one of Himmler's agents in The Hague—Peter Gern, the head of the SD in the Netherlands. The SS played a larger role in the administration of Reichskommissar Arthur Seyss-Inquart than it did in the military administration that prevailed in northern France and Belgium, and this found a reflection in the treatment of Jewish populations. Of the approximately 140,000 Jews living in the Netherlands in 1940, 107,000 (or 76 percent) were deported (of whom 5 percent survived), compared to a 25 percent deportation rate of the Jewish population in France (about 340,000 in 1940).[102] The Dutch Jews experienced the highest percentage loss of any Jewish community in western Europe. While Peter Gern helped round up and deport Dutch Jews, Mühlmann and his agents stole their art.[103] The Nazis required Dutch Jews to deposit their art collections, jewelry, and financial assets in the Liro bank, and so Mühlmann was part of a more systematic looting operation.[104]

The charming and polished Kai Mühlmann, who counted both Himmler and Göring as backers, had a knack for cultivating the powerful.

Mühlmann had actually helped mediate the discussions between Hitler and Austrian chancellor Kurt von Schuschnigg in February 1938 just prior to the *Anschluss*. Interestingly, in late April 1945, when Göring was arrested on Hitler's orders on charges of disloyalty, Mühlmann reportedly helped rescue him from incarceration by the SS at the Reichsmarschall's Mauterndorf Castle in the Austrian Alps.[105] Mühlmann, like Lohse, was ultimately more loyal to Göring than to Hitler or any other Nazi leader.[106] Also like Lohse, Mühlmann and his cohort not only helped "process" the looted art, they worked as freelance art dealers, buying and selling artworks in the Netherlands. Mühlmann purchased artworks from Dutch dealers like Peter de Boer (who owned an elegant gallery in Amsterdam at Herengracht 512), and he often served as a mediator between Dutch sellers and Nazi buyers. The business ledger for the Dienststelle Mühlmann, for example, showed "25 acquisitions" by Viennese governor Baldur von Schirach.[107] By catering to his patrons, especially those in his native Austria, Mühlmann enriched himself, obtaining, among other emoluments, an Aryanized villa near Salzburg for well below market value.[108]

Bruno Lohse likewise did not comport himself as the prince of darkness in occupied Paris. As noted earlier, he had a very fine war—he was, as the saying of the time went, "as happy as a god in France."[109] Photos of the ERR that he retained, many taken by his colleague Hans Simokat, show luncheons with bottles of chilled white wine, silver trays holding whole fish, and platters laden with decadent gateau. OSS investigator James Plaut noted, "Because of his special mission for Goering, he was permitted to wear civilian clothes in Paris and to drive a private car."[110] Handsome, tall, and well dressed, Bruno cut quite the dashing figure in the French capital as he bought up works for Göring and exploited the ERR. He toured the art galleries and often occupied a prominent place in the audience at the Hôtel Drouot, where he bought objects he thought Göring would like.[111] But if not, he could sell them, at a profit, to others.

Although there are reports that Lohse had several *garçonnières* (or bachelor apartments) that served as his "depots for art that he personally pilfered from Jewish collections," his primary residence in Paris starting in the summer of 1942 was an apartment at 3 avenue Matignon on the right bank, some one hundred yards from the Champs-Élysées.[112] The flat was close enough to the famed boulevard that Rose Valland mistakenly recorded the Champs-Élysées as the address of his apartment in one of her reports (she also noted that he kept there silverware and a tapestry he took from the ERR's stock).[113] He had moved there in 1942, "the great year"

(*grande année*) in his career, in the words of journalist Philippe Sprang.[114] There are no extant accounts of the domicile, although Lohse later said that it was a fine address. Ironically, a plaque on the building today identifies it as the Paris home of Heinrich Heine, the German Jewish writer who famously opined that those who burn books eventually burn people. The building now houses Alexandre, a famous hair stylist for the prominent. It is perhaps a fitting combination, Heine and the hair salon, suggesting something of Lohse's barbarism and vanity. Right after the war, Lohse explained that an ERR staffer named Dr. Helga Eggemann had renovated the apartment during one of his absences from Paris using objects from the *M-Aktion*.[115] Of course, Lohse would have known that his apartment was furnished with plundered furniture and rugs, but that did not seem to bother him.

Lohse spent some of his time in Paris with romantic interests. A curator at the Louvre Museum, Michel Martin (1905–2003), observed after the war, "A handsome and elegant man who spoke French very well, Dr. Lohse had a number of feminine conquests (*conquêtes féminines*). . . . In 1942, he was with an entertainer of the Montmartre cabaret Schéhérazade, Jeannine Senneville, and also in 1943, a young woman named Jacqueline Seratzki."[116] The latter lived on 9 rue Jean Moréas in the 17th Arrondisement.[117] We know little about her except that she met Lohse in September 1943 when he was near the apogee of his influence at the ERR. Journalist Philippe Sprang has noted that "Lohse was a sports teacher, good looking, and a person who could turn on the charm. He had many lovers when he arrived in the French capital, but . . . this behavior came to an end after he met Mademoiselle Jacqueline."[118] We also know that Jacqueline was part Polish, which could have created problems for an SS officer like Lohse. She was, Lohse recalled later, "strongly anti-Nazi and an active worker for de Gaulle," and this indeed caused difficulties for him with German authorities, although he never provided specifics.[119] When interrogated by the ALIU, Lohse said that he "regard[ed] Mlle. Seratzki as his fiancée."[120] They enjoyed a grand lifestyle, including a trip together to the French Riviera in early 1944. The fate of Jacqueline Seratzki remains a mystery.

The manner in which Lohse and Mademoiselle Seratzki lived in itself raises questions about additional income streams. Lohse claimed after the war that he had received "normal army pay of a corporal, with an additional 500 marks monthly salary from the Einsatzstab Rosenberg, and a per diem allowance of 15 marks."[121] He also recalled that he did not owe rent or pay for a car and fuel. This official remuneration translated to 10,000

francs, which was a huge sum at that time. And Lohse almost certainly supplemented his income by way of the graft associated with the ERR. Karl Haberstock told his American captors in June 1945 that Lohse was "dishonest," alleging that "his stock of art treasures is in Berlin, Schlacht-ende [*sic*], Krottnauerstrasse."[122] This was a reference to a residence Lohse had during the war in the Schlachtensee quarter of Berlin—an address that appears on several documents in his extant SS file.[123] This dwelling was located near Berlin's two lakes—the Schlachtensee and the Grosser Wann-see—outside the city center. This afforded marginally greater safety than the industrial city center, which was more often the target of the Allies' bombs. Lohse appeared to have transported artworks to Berlin during the first half of the war.

Rose Valland went to great efforts to document instances when she be-lieved Lohse absconded with property from the ERR depot. For example, she noted in a July 1942 journal entry: "A painting (very important?) and a tapestry were taken to Berlin for Dr. Lohse by the photographer Simokat. The former ordered the chief packer not to tell anyone at the museum the name of the painting and for its departure to remain a secret, but [Lohse] was still responsible."[124] The following year, in April 1943, Valland re-ported on Lohse placing a Jan van Goyen landscape in the back of his car and driving off with no explanation. She later discovered that Lohse's ERR associate took it to Berlin for him, along with a tapestry.[125] Shortly there-after, she overheard him whisper to his colleague Walter Borchers that the latter should conceal a painting from the school of François Gérard, *Leda and the Swan*, which hailed from the Walter Strauss collection, remarking conspiratorially, "It will be just for us."[126] On 3 September 1943, she re-corded that Lohse left the Jeu de Paume with five paintings by Pierre Bon-nard. Later, on 31 October 1943, she saw Lohse place four paintings in his car that she believed he was embezzling. On 1 December 1943, accompa-nied by Gustav Rochlitz, he left the Jeu de Paume with works by Matisse, Renoir, and Utrillo.[127] Valland listed at least half a dozen instances where she believed she caught Lohse stealing ERR property for personal gain. Although she provided some details about the works—including the titles of certain pictures—none of them could be identified as part of Lohse's postwar collection.

Even the German authorities during the war suspected that Bruno Lohse was siphoning off works. In January 1944, the ERR chiefs in Berlin caught wind of the disappearance of some seventy-one pictures in Paris, and Lohse came under suspicion.[128] Robert Scholz, Alfred Rosenberg's

chief art expert and the head of the fine arts section of the ERR, was Lohse's superior in the ERR bureaucracy; he wrote to ERR staff chief Gerhard Utikal, hardly concealing his outrage: "You can imagine how shaken I am over the loss that has now come to light."[129] Although based in Berlin, Scholz had learned from Dr. Borchers, the co-director of the ERR in Paris at the time, that seventy-one Impressionist pictures had vanished. Scholz wrote, "This can presumably be only a matter of an elaborately planned theft."[130] How it had occurred remained a mystery to him. He suspected that "the staff of the Louvre is involved"—that is, the French had stolen them. But he also wrote, "It is naturally a case of gross negligence on the part of Dr. Lohse and Dr. Borchers, as the directors responsible for the depots." The archives do not provide an inventory of the works that went missing. Scholz explained to Utikal that he wanted to bring in the SD, Himmler's Security Service, to investigate and that they would discuss further steps verbally as they were both in Berlin. However, the files say no more about the incident. The fate of the seventy-one Impressionist pictures remains a mystery. Yet at a minimum, the report provides an accurate description of the lax security at the ERR during the Lohse-Borchers administration in 1943–44, and the incident shows that Robert Scholz, who operated at a distance in the Reich capital, struggled to maintain order at the ERR facility in Paris.[131]

Lohse stated in 1945 that he himself had purchased only three works during the war: all seventeenth-century paintings that he acquired from Paris-based dealer Gustav Rochlitz that were sold to him "at cost" for 75,000 French francs ($1,500).[132] This assertion must be viewed with great skepticism.[133] Walter Feilchenfeldt said it was widely understood that Lohse had acquired paintings during the war and was selling them.[134] The most likely explanation for Lohse's postwar wealth is wartime theft and profiteering. He most likely embezzled works from the ERR and earned profits on side deals, including, perhaps, ERR trades with Swiss dealers, which Lohse helped initiate and engineer.

Another place where Lohse may have acquired works for his own private purposes was the Schloss collection. The remarkable Schloss collection of Old Masters—some have called it "the last of the great collections of Dutch art formed in France in the nineteenth century"—was comprised of 333 pictures whose transport was one of Lohse's most important undertakings during the war. He first participated in the evacuation of the works from the unoccupied zone in the south to Paris, where the trove was divided between French and German officials.[135] Some 284 went to the

latter, including 262 for Hitler and the Führermuseum, and Lohse over-
saw the transport from Paris to Munich on 27 November 1943.[136] These
pictures were then stored in the Munich Führerbau near the Königsplatz
(the building that contained one of Hitler's offices and stood one hundred
yards down the street from the partner structure that would become the
Central Collecting Point in 1945). Despite being a Nazi Party adminis-
trative building, the Führerbau was looted in late April 1945 by mem-
bers of the local civilian population—a melee that occurred just prior to
the arrival of U.S. troops.[137] At least 167 of the Schloss collection paint-
ings were never recovered: some most certainly were taken by local civil-
ians, but others likely ended up in the hands of the complicit plunderers
and dealers. Individual works continue to surface on the market that link
back to these figures: for example, a Schloss painting by Salomon Ko-
ninck, titled *A Scholar Sharpening His Quill*, was discovered in Chile in
2017: Christie's Restitution Research team, which investigated the picture
and brokered a settlement, stated that "the painting is believed to have
been in Chile since the 1950s, after it was sold into a private collection
there by Walter Andreas Hofer, a known purchasing agent for Hermann
Goering."[138] If Hofer ended up with a Schloss picture, it was even more
likely that Lohse, due to his direct involvement, also would have comman-
deered works.

Lohse's earlier involvement in the liquidation of the Schloss collec-
tion was recorded in a number of documents, including a September 1942
memo he wrote about an offer that came from French art dealer Jean-
François Lefranc, who was "a close associate of the French Commissar for
Jewish Affairs."[139] Lefranc proposed dividing the confiscated Jewish art.
Lohse wrote that "Lefranc maintains now to know most of the reposito-
ries and has declared himself prepared to sell us the addresses under the
condition that 25 percent of the profits from the artworks in question will
be transferred to the French Commissar for Jewish Affairs."[140] Lohse re-
ported this offer to ERR headquarters (Utikal and Rosenberg), and even-
tually the collection was divided between the French and the Germans.
According to a document dated 25 October 1945, two French investigators
reported that "it appears, however, that Lefranc [gave] or sold to Lohse a
portion of the paintings in the Schloss collection or divided with him the
remainder of this collection."[141] However, the division was not transpar-
ent; and even though the German portion was supposed to be offered first
to Hitler's agents for the Führermuseum, the process unfolded in a secre-
tive and uncertain manner. ERR staff chief Gerhard Utikal complained in

a letter to Göring in June 1943 that Lohse was not keeping him informed about the disposition of the Schloss collection, even though it involved the "seizure of the collection of the Jew 'Schloss,'" which put the property under the purview of the ERR.[142] The murkiness of the confiscation process, combined with the fact that the collection was not split cleanly in two (works were instead dispersed broadly), and that most of the German-held portion of the Schloss collection was lost at war's end when the Munich repository was ransacked, made the Schloss affair exceedingly complicated. With hundreds of Schloss pictures still missing, suspicion has pointed toward Bruno Lohse.

Bruno Lohse's "freelance" activities merit closer examination for several reasons, but two stand out. First, these activities reveal the greed that compelled him to enter into the world of plunder in the first place, and second, his private transactions shed light on the fate of looted artworks. It bears reiteration that Lohse was first and foremost a perpetrator: he entered apartments in Paris that were still "warm"—that is, the inhabitants had been recently evicted and deported to the east—and he knew what would happen to them, at least in general terms. But it was the opportunity for self-enrichment that kept Lohse going, and some of the works that passed through the ERR facility in Paris during the war ended up in his possession. Of course, this presented complications. Even Himmler promulgated regulations in the SS that at least in principle outlawed looting, and a few officers were prosecuted for stealing as an admonitory measure. In principle, it was dishonorable to profit from the persecution, but of course, many did so. This usually involved discretion, as with Lohse, who did not want to draw attention to works that had come into his possession. Without a doubt, avarice was a primary driver for Lohse—from prewar Berlin to postwar prosperity in Munich (via opportunity-rich Paris during the occupation).

In the immediate postwar years, Rose Valland tried to track individual works from the Schloss collection back to Lohse. She wrote in September 1950 to the head of the French Restitution Commission, the CRA, recalling that years earlier she personally had traveled to Berlin-Steglitz and found a group of photographs of the Schloss collection in the home of Lohse's father (she passed on the photos to the CRA).[143] Rose Valland had interrogated Lohse as early as May 1945 when she traveled to the American Zone, and it was likely that on this trip she continued on to Berlin to see what was in Lohse's home.[144] Valland was also on the trail of the Schloss collection and believed that Lohse had vital information,

if not actual paintings. The photographs were useful—and incriminating. Valland also received reports that Lohse had "two volumes bound in red Morocco leather" that contained photographs of the Schloss collection before it was divided and dispersed: "There was a printed title page in French mentioning the name[s] of Lohse and Goepel."[145] But neither she nor any other Allied official ever found the actual artworks reportedly possessed by Lohse. Historian Lynn Nicholas writes that Lohse, along with Haberstock "and even Frau Goering," was among those who turned to American Military Government officials and "asked for favors and claimed works taken from them."[146] However, Nicholas does not specify what, if any, works Lohse recovered from the Americans, and the archival record is silent on that point.

Rose Valland also asserted after the war that Lohse had access to an SS man who frequently accompanied him and at other times spied for him. The man's name was Fleicher or Fleischer, she said. Indeed, she was speaking of Walter Fleischer, and she was correct in saying that he was thirty-five to thirty-eight years old and of Viennese origin. Valland added that the SS man "was the confidant in his [Lohse's] operations and his personal profits."[147] She gave as an example a case in November 1943 where Lohse had pocketed a payment from Victor Mandl. She implied that Fleischer assisted here, although she did not specify how. In general, Valland thought, Walter Fleischer gave the impression that he had tied his fortunes to Lohse, his protector, whom he hoped would keep him stationed in Paris and out of combat.[148] With this hope motivating the SS man, Lohse had "his trusted confidant" (*son Homme de confiance*)—and a rather imposing one at that.[149] Fleischer was also involved in transporting ERR artworks from Paris to Germany, and that afforded other opportunities for graft. Fleischer added to his portfolio by basing himself in Paris, taking part in confiscation operations, and carrying out Lohse's deals on the side.

There were similar rumors about self-enrichment regarding other ERR personnel, including a Dr. Zabzeck, who went on to supervise the transportation of Jews' furniture in the *M-Aktion*. According to Ehrengard von Portatius's 1951 report to Rose Valland, Zabzeck, while working for the ERR, "enriched himself personally" and sent back treasures to his residence on the Suarezstrasse in Berlin-Charlottenburg.[150] To take another example, Dr. Annemarie von Tomforde-Ingram, with whom Lohse had studied in Frankfurt in the mid-1930s, also allegedly profited from objects she helped process. She had completed her doctoral dissertation in

art history in early 1941 and, like many recent PhDs, was in search of a job. She claimed after the war that Lohse called her from Paris in January 1942 and said he needed a colleague to assist with research and cataloguing, but that he did not disclose the agency or the true nature of the work.[151] When von Tomforde-Ingram arrived in Paris in March 1942, she "was oriented" about the ERR and compelled to stay. She later portrayed it as forced conscription and said the ERR was a branch of the Wehrmacht (which was not the case—it was a Nazi Party entity).[152] The "draftee" nonetheless adapted quickly and emerged for a time as "the reigning woman in the Paris organization."[153] She married the ERR business manager in Paris, Hermann von Ingram, and became a trusted insider at the Paris operation. Tomforde-Ingram elicited "the allegation from French sources that she appropriated objects of value for herself, such as furs, jewelry, and silver."[154] We do not know if the allegation is true, but it is consistent with the prevailing environment of theft and debauchery. Historian Günther Haase noted, "Lohse used his position to help art dealers, historians, friends, and relatives with money, provisions, the transport of goods, and whatever else was possible."[155] Lohse worked the system in Paris. Tomforde-Ingram, for her part, decided to remove herself from the French capital, which seemed an increasingly dangerous place. She arranged a transfer to the safer part of the ERR operation in Füssen in late 1943, where she cared for the ERR-looted art housed in Schloss Neuschwanstein. Because her husband was Austrian, they were granted a house in Salzburg. The couple lived there into the postwar period relatively undisturbed. Tomforde-Ingram was compelled to testify in 1949 in connection with a Swiss lawsuit involving an ERR painting, yet she was never called to address the rumors of graft.

Lohse was in almost constant motion during the war and had ample opportunity to enrich himself. He bought works on the Paris art market that he sold to other Nazi leaders (aside from Göring and Heinrich Himmler). For example, Albert Speer purchased a pair of paintings by Hubert Robert from him. Lohse had found the Old Master paintings through collaborationist French dealer Martin Fabiani (1899–1989).[156] Lohse transferred the paintings to sculptor Arno Breker, who had an apartment in Paris, and Breker in turn passed them on to his friend and patron Reichsminister Speer. The art trade in occupied Paris was based on deception and corruption, making it difficult to know the full extent of the networks or the transactions. Hector Feliciano explained, "German collectors . . . got around Berlin officials by paying dealers in cash. These dealers would return the favor by not reporting the transaction. Many of the deals were

therefore neither recorded nor honest. When he was being debriefed by
the Allies after the war, one German official told them he thought that
'the cleverest buyers and sellers never filled out forms or issued receipts.
... Many of the transactions were done in complete secrecy or using third
parties.'"[157] Such tactics also enabled the Germans to avoid submitting
the works to French authorities for export clearance: in principle, valu-
able works had to be submitted to the Louvre's Fine Arts Department
for inspection prior to any export license being granted. Clearly, as Susan
Ronald documented in her study of Hildebrand Gurlitt (1895–1956), many
savvy dealers in German-occupied France ignored or circumvented offi-
cial protocols.[158] On the French side, as Elizabeth Campbell Karlsgodt
observed, recording sales to the Germans "was as good as putting their
heads in a noose."[159] Bruno Lohse counted among these wily operators,
and many of the transactions in which he was involved were never docu-
mented.

Yet more than anything else, Lohse wanted to become the director
of Göring's art collection and supplant the incumbent, Walter Andreas
Hofer (1893–1971). The latter had formalized his position a month after
Lohse's arrival in Paris—that is, the commencement of Lohse's work for
Göring—and Lohse always felt as though he had not been given a fair op-
portunity to compete for the post. Lohse venerated the Reichsmarschall:
his power, his taste, his caustic but—in Lohse's eyes—witty repartee. He
knew that Göring was building one of the world's great collections ("the
finest private collection in the world," Göring boasted to the Americans in
1945) and he wanted to share in the glory. Hofer and Lohse also attempted
to coordinate, but with limited success. Lohse felt "hampered constantly
by his lack of independence and by Goering's ultimate reliance in all im-
portant transactions on Hofer."[160] Gisela Limberger (1893–1980), the
prim and efficient librarian and registrar for the Reichsmarschall's collec-
tion, showed a preference for Lohse and helped him navigate the byzan-
tine court. Limberger had considerable power, becoming Göring's official
private secretary in August 1942 when her predecessor, Ursula Grundt-
mann, passed away. Limberger also handled, in her words, "his private
correspondence [and] his private purse," and this included invoices for the
ERR works which, on orders from her chief, she ignored.[161] Limberger
traveled with Göring to Paris from time to time, and Lohse would social-
ize with her.[162] Lohse felt part of a team, but in his eyes, Hofer was un-
suited to such a bold undertaking.

Hofer also had not been a particularly notable art dealer in the pre-

war period. He hailed from modest roots. His father was a shoemaker, and he initially worked as a salesman for a leather company in Berlin.[163] After emerging from the army in 1919, he moved to Munich, where he worked as a volunteer in the Bachstitz Galerie in order to learn the art trade. Hofer's sister subsequently married the proprietor, Kurt Walter Bachstitz (1882–1949), an established international dealer. Bachstitz's business flourished in the 1920s, and he opened a branch in The Hague, where Hofer worked from 1922 to 1928. The firm continued through the 1930s, and Bachstitz sold over a dozen works to Hitler. But the war presented grave challenges for the Austrian-born Jewish dealer, and in 1942 Bachstitz transferred the gallery to a non-Jewish family member and fled Holland for Switzerland. He was arrested after his false "Aryan" identity card was discovered, and it was a harrowing escape to the neutral Alpine republic. To ensure safe passage, he handed over a Jan Steen picture and two necklaces to Göring.[164]

Hofer himself had left the Bachstitz Gallery in 1930 and spent four years in Lausanne assisting an art collector named Dr. Gottlieb Reber (1880–1959). Returning to Berlin in 1934, Hofer established himself as an independent dealer, but a fairly minor one who worked out of his home.[165] He met Göring in 1936, helped him acquire works (especially from abroad), and gradually insinuated himself until receiving the formal appointment as the director of the collection in 1941.[166] A key advantage for Hofer was his wife, Bertha Hofer-Fritsch, a highly regarded restorer whom he had met in Lausanne and who went on to repair numerous paintings for Göring. She was, however, deceived by the fake Vermeer, *Christ and the Woman Taken in Adultery*, that Han van Meegeren created in 1943, and then traded to Göring for some 150 pictures. Hofer-Fritsch reportedly cleaned it but did not sound any alarms. However, she had a sound understanding of art and complemented her husband in key respects.[167] Hofer himself had limited knowledge and an unremarkable eye. Perhaps the best thing said about him after the war by the American Monuments officers was that Hofer had a "stupendous memory." He recalled most works and the manner in which they had entered the Reichsmarschall's collection.[168]

Just after the German defeat in 1945, with Göring's collection on display in a temporary exhibition set up in Berchtesgaden, Bavaria, by the U.S. 101st Division, Hofer mugged for the newsreel cameras and appeared a jovial and friendly fellow, but the reality was quite different. Archival documents, for example, show Hofer referring to victims of spoliation as *Juden* in a derogatory manner, and in one report he submitted to Göring Hofer used subheadings such as "Collection of the Jew Paul Rosenberg"

and "Collection of the Jew Seligmann."[169] In this same report, Hofer described the art collection of famed Cubist artist Georges Braque, which had been seized by German forces: "Paris Braque is an Aryan, lives in Paris as a painter. His collection had been seized by the Foreign Currency Commando in Bordeaux, but must now be returned. I dealt with him personally with regard to his Cranach, a portrait of a girl, and told him that a return of his collection was in sight. If he decides to sell the Cranach [to which he added, "!!!"] he has reserved it for me."[170] In other words, Hofer was extorting the Cranach picture from Braque in exchange for the remainder of his collection, which was being held hostage in Bordeaux. Of course, Hofer also helped Göring select looted works from the ERR stock, but the point is that he did more than offer insights on art historical matters. Hofer also counts among the plunderers.

Bitter rivals Lohse and Hofer faced competition from other quarters—dealers and agents who also sought Göring's favor. Sepp Angerer, a partner in the largest carpet firm in Berlin (Quantmeyer & Eicke) specialized in rugs and tapestries for Göring's homes. Yet Angerer also sold the Reichsmarschall pictures, many of which he acquired in France.[171] The appointment book kept by Göring during the war, a copy of which is housed in the Institute for Contemporary History in Munich, shows that Angerer met with his patron on a regular basis during the early years of the war.[172] Göring, like many wealthy Europeans, had a special regard for tapestries. Angerer subsequently became the director of a Gobelin manufacturing firm in Brussels and scaled back his efforts to acquire art for Göring.[173]

Munich art dealer Walter Bornheim (1888–1971), who had a gallery at Briennerstrasse 13, also emerged as an important buyer for Göring in France. Bornheim hailed from Cologne and trained at the Lempertz auction house in his home city. In 1936/37, as part of an Aryanization process, Bornheim took over the A. S. Drey Gallery in Munich, which he renamed the Galerie für Alte Kunst (thereby removing the Jewish name and seeking another that would best whitewash the past).[174] Bornheim grew the business and by 1938, he had found his way to Göring. During the war, he convinced the Reichsmarschall to let him operate freely in France: in exchange for giving Göring the right of first refusal on all works he found, Bornheim received special travel passes and access to foreign currency. Not surprisingly, Bornheim provoked enmity from many of his competitors. Karl Haberstock described him after the war as "dishonest. Speculator. Not known to be directly connected with the theft of any paintings, though his methods of dealing were unscrupulous."[175] Bornheim

emerged as a significant German dealer operating in France during the war. Theodore Rousseau, in his ALIU report on Bornheim, wrote, "In France, Bornheim was the biggest German buyer, with the possible exception of Haberstock."[176] Bornheim did not have the kind of personal relationship with Göring enjoyed by Lohse and Hofer. Probably this, and the fact that he had never joined the Nazi Party, enabled Bornheim to evade postwar justice more easily: although he was interrogated by the ALIU (the subject of *Detailed Interrogation Report No. 11*), he did not spend significant time in jail, and was allowed to go home after being set free on 15 September 1945 from the Altaussee interrogation center.[177] After the war, Bornheim settled in the town of Gräfelfing in greater Munich and he remained part of the network of former wartime dealers. Like Lohse, Walter Bornheim had an estate on the Tegernsee, an Alpine lake south of Munich near the Austrian border, where he kept his collection.[178]

Professor Dr. Hermann Bunjes, who came to France in 1940 as part of the German army's *Kunstschutz* (art protection) unit and then became the director of the German Art Historical Institute in Paris, also counted as one of Göring's men. Like Lohse, he had the advantage of being stationed in Paris, and he used his positions to cultivate a wide range of contacts. Bunjes was also a member of the SS (promoted to SS-Obersturmführer in 1942), and he worked closely with the SD, which was also part of Himmler's empire. Yet Bunjes insinuated himself with Göring, even accompanying the Reichsmarschall on many of his visits to the Jeu de Paume, where he jostled with Lohse and Hofer to make an impression on the chief. Dr. Bunjes was a fanatical Nazi. One contemporary described him as "a pretentious person, most disagreeable, an informant for Göring."[179] At war's end, Bunjes was captured by the Americans and several months later, on 25 July 1945 — seemingly unable to endure what lay ahead — he committed suicide. However, early in the war, Bunjes had represented a real threat to Lohse. Historians Fabrizio Calvi and Marc Masurovsky have even labeled Hermann Bunjes as "the great rival of Lohse," although that distinction, judging from Lohse's postwar comments, eventually went to Walter Andreas Hofer.[180]

Bruno Lohse, of course, proved formidable in his own right, and he developed a network of colleagues and informants who brought opportunities to his attention. This included hiring Hans Bamann, a Düsseldorf art dealer who was also an expert in seventeenth-century Dutch painting. Bamann was an obscure ERR employee, but he provided Lohse with intelligence that helped him compete with his rivals. Lohse's contacts also extended to Allen (Ali) Loebl, a French Jew who directed the Galerie E.

Garin (formerly Kleinberger) in Paris, and who was part of a syndicate that included Hans Wendland (1880–1972), Gustav Rochlitz (1889–1972), and Zacharias Birtschansky (1889–1950), who worked with his brother, gallery owner Leon Birtschansky.[181] Lohse protected the Loebls (Allen and his wife Manon, among other family members), securing special privileges for them from SS-Lieutenant Colonel Helmut Knochen of the Gestapo in Paris in June 1943.[182] In return, he expected the Loebls to provide him with information concerning the French art trade, and he purchased at least five pictures from them for Göring during the war.[183] Many of the prewar art experts in Paris were Jewish, and while some fled and others were deported to a crueler fate, certain individuals like the Loebls remained in Paris and found a modus vivendi with the Germans.[184] This usually involved paying bribes or relinquishing property. Not unexpectedly, there was "much conjecture" after the war about the fate of the Loebls' famed art library. Documents showed that Loebl tried to give the library to Göring as a gift, undoubtedly in an effort to win the Reichsmarschall's protection. Göring supposedly rebuffed this offer—he did not want to be indebted to a Jew, he said—and instead ordered it "purchased." The Loebls received a painting by Utrillo as compensation for the library. The Utrillo had been confiscated by the ERR and was therefore a looted work.[185] Göring had informed his secretary, Gisela Limberger, "Lohse must see he doesn't [help the Loebls] in any way that might link the *Reichsmarschall*'s name with Jews! If possible, do it clandestinely."[186] And so he did.

Lohse, according to Helmut Knochen, supposedly intervened on behalf of some thirty Jewish individuals in France.[187] Of course, one must be wary of Knochen, himself a Nazi murderer. One is also reminded of the comment made by Dutch journalist Hans Knoop about Pieter Menten, who murdered Jews and stole their art in Poland: "It is not at all unusual for a token saved life to occur in such stories."[188] Although Knochen's figure cannot be verified and is most likely an exaggeration, Lohse helped an unusual number of Jews in Nazi-occupied Europe. He did so in certain instances due to a high regard for a colleague (like Professor Max Friedländer), but also because he wanted others to be indebted to him. Lohse was ambitious and pragmatic, and saving the life of someone useful to him, or the life of a spouse, effectively made that person beholden to him. Lohse had learned from his patron that to have power, one must wield power, and Lohse acted to affirm the status that came as Göring's man in Paris and as an officer in the SS. Bruno Lohse at that time was deeply anti-Semitic: he would have to be as an SS man and an art looter. He also

participated in violence as part of raids and police actions—and boasted that he had murdered Jews with his own hands. But Lohse, then and in retrospect, seemed more opportunistic than ideological. He did not count among the most radical Nazi ideologues and he tried to save certain Jewish individuals from what he knew was a terrible fate.

Bruno Lohse certainly aided German Jewish art historian Max Friedländer (1867–1958), a "legend" in the museum world.[189] The latter had been a fixture in Berlin for decades, arguably the foremost authority on Dutch Old Masters. Friedländer also served as director of the Prussian State Museums from 1924 to 1932.[190] He was not only the best person to authenticate most Old Masters, he also knew the locations of many coveted works. Over his long career, he had seen works in museums across the Continent. Because of his preeminence, Friedländer had the opportunity to inspect works in many private collections. His opinion was so highly regarded that a positive assessment from him would be regarded as an authoritative certification. Friedländer had fled to the Netherlands in 1939 and reportedly, thanks to Göring's support, had been able to take his library as well as all his household effects. But he again fell into the Nazis' grasp in 1940 and was sent to a concentration camp in Osnabruck. There are competing claims as to who liberated Friedländer, with Lohse, Hofer, and Karl Haberstock all making cases after the war.[191] According to Erhard Göpel's contemporaneous notes from when he was in Holland, Lohse personally transported the letter signed by Reichsmarschall Göring that exempted Friedländer from the deportation measures, and the aging art historian held on to the document as if it was a talisman—which, in a sense, it was.[192] Lohse also helped arrange for Friedländer not to have to wear the Jewish star, thereby permitting him to go to museums and libraries, crucial for his work.[193] Friedländer remained in his flat for most of the war, receiving many visitors who sought a certificate from him. Thus it is more as if the market found him, but Friedländer, in the opinion of the OSS ALIU team, became "a center of Dutch collaborationist art circles," and his contacts in wartime Europe included not only Lohse but also Walter Andreas Hofer, Hans Wendland, and Eduard Plietzsch, among other plunderers.[194]

Lohse needed Friedländer for various reasons. The first was to authenticate works, or in the parlance of the art trade, to provide the "expertises." There was a sense in the art world that Göring had deep pockets and this attracted individuals, both honest and dishonest, who hoped to profit from him. The now-famous forger Han van Meegeren, who duped Göring and his advisers regarding a Vermeer he cooked up himself, would

count as one of the latter. Friedländer was not consulted in Göring's trade for the alleged Vermeer, nor, evidently, was Lohse—or so he claimed (one must view his assertions with a certain skepticism). The fact remains that Friedländer provided Lohse not only with the vital expertises but also with market information. The émigré scholar's extensive networks produced valuable leads on artworks for sale. Friedländer would then opine on whether they were a good deal. He had also been allowed to retain his personal library of art history books, among other privileges unusual for a Jew at that time.[195] Nevertheless, Friedländer lived in fear, and it seems that Lohse always took advantage of this. It is difficult, if not impossible, to know the extent to which Lohse extorted Friedländer. One can alternatively view their relationship as mutually beneficial, with Lohse receiving wise counsel from the venerable art historian and Friedländer surviving the war.

Lohse helped other Jewish and non-Jewish French colleagues who ran afoul of the German authorities. In an early postwar interrogation from the jail in Füssen, he listed fourteen instances when he had helped save lives.[196] These included intervening to help the important art dealers Paul Cailleux (1884–1964) (president of the Art Dealers Association in Paris) and André Schoeller (1881–1955), who ran the Association of Art Publishers and Brokers in Modern Paintings.[197] Paul Cailleux's wife was Jewish, and Lohse saved her from the Drancy internment camp in 1942 (as well as from the Gestapo in 1943).[198] Schoeller's son was almost sent to Germany as a forced laborer. Only Lohse's intervention prevented his deportation.[199] Despite these troubles with the German authorities, both Cailleux and Schoeller collaborated. Cailleux's circle included at least thirteen "private German clients," including Maria Almas Dietrich, Adolf Wüster at the German embassy, Friedrich Welz in Salzburg, and Gustav Rochlitz.[200] Cailleux, according to André Schoeller, had tried to help "Aryanize" the Wildenstein Gallery during the occupation.[201] Nevertheless, he ran afoul of the German authorities (his Jewish wife no doubt proved a liability). Yet Lohse remained supportive. Schoeller himself, according to Hector Feliciano, had "been very cozy with the CGQJ [the Vichy Commissariat General for Jewish Affairs] in 1943, when it had confiscated the Schloss and Weil collections."[202] Schoeller also provided an appraisal for Lohse on one of the ERR trades, sold pictures to several German museums, and worked closely with Hildebrand Gurlitt, who became the leading dealer in France for Hitler and the Linz Führermuseum from 1943 to 1945.[203] Schoeller had trouble with the SD as a result of denunciations and

Lohse helped protect him. These interventions required Lohse to expend some of his political capital, or at least they opened him up to attacks from more zealous ideologues. ERR staff chief Gerhard Utikal testified after the war, "As various accusations were raised against Lohse in 1942 for supposedly abetting Jews and for his Francophile outlook, I had to cover for him."[204] Protecting Cailleux and Schoeller had contributed to his reputation as a Francophile.

Agents for the Nazi elite like Lohse and Hofer were viewed as lifelines by many of their Jewish colleagues. The art trade had long had many Jewish practitioners. Now, with the Nazi threat, Jewish dealers did whatever was necessary in order to survive. Letters written by those in need are often poignant. Amsterdam dealer Piet de Boer wrote to Walter Andreas Hofer in July 1942. After starting the letter, "You told me once that if you could help, I should ask," de Boer got to the point: "One speaks a great deal now about how many people must go away from here. You know that the parents of my wife came to Amsterdam already before the war. My wife cares deeply about them and the peace in our life moving forward, including also the possibility to work further in business."[205] Pieter de Boer, who had a branch of his gallery in Berlin (and hence knew many German dealers) and who enjoyed a lucrative wartime business with Germans, invoked his service to "German museums and collections" as he begged Hofer to save the lives of his in-laws.[206] He was merely asking that they have the opportunity to continue to work, even though they were aged seventy-five and seventy when de Boer wrote Hofer. His wife and parents were like Anne Frank and her family: they were among the approximately twenty-five thousand German Jews who emigrated to Holland before the war and then were caught up in the German occupation.[207] The fate of David Pressburger (b. 16 September 1866) and Berta Pressburger-Silberstein (b. 21 February 1872) remains unclear, as does whether Hofer actually helped save them. But it's evident that Hofer, like Lohse, could save individuals in certain cases. Their power was such that they sometimes made the difference between life and death. Piet de Boer concluded his letter to Hofer by invoking the Reichsmarschall and the time that Göring came to the gallery on the Herengracht; de Boer regretted that he had not been there personally and instead was represented by his wife. He did not comment on the fact that she was Jewish, but Hofer would have known this. It is possible that de Boer intended to suggest that Göring had met the Jewish Mrs. de Boer and not protested. In a sense, he was implying that his wife and her parents were socially well heeled, people for whom exceptions might be

made. In a sense, this was the case: Adolf Wüster reported after the war
that at least Mrs. de Boer had escaped to Switzerland, although there was
no word about her parents.[208]

Lohse was at the center of a network that radiated outward, like ripples
on the water when a stone is dropped in a pond. Actually, the metaphor
of ringlets spreading from a center at regular intervals is too orderly and
symmetrical an image to capture the art world in wartime Paris. Still, the
French capital offered the most dynamic art market during the war and
constituted a kind of center from which other networks branched out.
This is perhaps the most helpful way to imagine the art dealer scene in
western Europe: Paris at the center; the German dealers who either were
based there or spent considerable time there in the next ring; German
dealers back in the Reich, including Vienna, coming next; and then the
Swiss, Dutch, and other European cohort.

Paris swarmed with collaborationist dealers—the *ALIU Final Re-
port* listed over seventy-five of them, and this list was very far from com-
plete—and these French dealers were frequently eager to do business with
the Germans.[209] At war's end, a French intelligence officer reported that
"some 80 percent of [French dealers] had done significant business with
the Germans, much of which had not been entered in their books."[210] The
Great Depression had hit the art trade hard, "forcing a third of Paris's
galleries to close their doors," and depressing prices by "as much as 70
percent from what they'd been earlier."[211] Many French dealers viewed
the German customers as an opportunity to rebound and, for a variety of
factors, the art market boomed between 1940 and 1944. As one contem-
porary, Alfred Daber, noted, "People had plenty of cash, but there were
no pretty clothes, no new cars, and no vacations and cabarets in which to
spend money. All you could do was buy butter on the black market. That
was why everyone started investing in the art market."[212] In truth, there
were some nice clothes to be had (on the black market) and the cabarets
remained opened (to quote the title of Alan Riding's fine book concern-
ing Paris during the occupation, *And the Show Went On*), but the German
customers increased the demand for art and kick-started the market. Art
was fungible, transportable, and would remain valuable under different
political (and currency) regimes. Prices soared, fortunes were made, and
art changed hands in ways that we are still trying to understand today. In
the postwar denazification files, which required art dealers to report their
annual income, nearly every one reports a significant rise in earnings up
through 1943.[213]

For Lohse, there appears not to have been one specific French colleague with whom he worked. That was his nature, it seems: not being dependent on any one person (save Göring) and retaining his independence. However, it is clear that one of his key allies was German-born Parisian dealer Victor Mandl, who had a gallery on the rue La Boétie. Mandl also kept his options open. If anything, he was closest to Maria Almas Dietrich, the Munich dealer who sold prodigious quantities of art to Hitler, as Mandl stored works for her, paid bills, and helped out in miscellaneous ways.[214] The *ALIU Final Report* entry on the Paris dealer is of interest: "Victor Mandl. Paris, 9 rue du Boetie [*sic*]. German refugee dealer, formerly active in Berlin. Highly important figure in German art purchases in Paris. Close contact with Wendland, Dietrich, Voss, Goepel, Muehlmann, Lohse, Loebl, Perdoux, Birtschansky, and Wuester. Indicted by French Government for collaborationist activity."[215] Here one gains a sense of the complicated nature of these relationships. Dr. Hans Wendland was a German art dealer based in Switzerland. Armed with a German diplomatic passport and a "pass" signed by Reichsminister Goebbels, this debonair operator seemed ubiquitous in the wartime art trade. He divided his time between the Hotel National in Lucerne, the Ritz in Paris, and a luxurious chalet in St. Moritz. Ever the opportunist, Wendland joined the Nazi Party on 1 January 1942, a step he hoped would help him in his relations with Nazi leaders and their agents.[216] Dr. Erhard Göpel (1906–66) was a German art historian, art dealer, and buyer for Hitler in the Netherlands. Loebl was a French Jew whom Lohse and other Nazis protected in return for profitable information. Perdoux was a French dealer, and Zacharias Birtschansky a clothing designer who also traded in art.[217] Lohse's contacts also included Joseph Oscar Leegenhoek, a Belgian national who had a gallery on Boulevard Raspail and counted among several important Belgian collaborationist dealers in Paris (Raphael Gérard and Maurice Lagrand being two others).[218]

Of all the "German" dealers based in Paris, Lohse arguably grew closest to Austrian-born Gustav Rochlitz (1889-1972). The two men had known each other before the war—Rochlitz had a gallery in Berlin from 1921 to 1931—and they maintained their association into the postwar period. Rochlitz's daughter, Sylvia Rochlitz-Bonwil (b. 1934) also continued to see Lohse, Griebert, and many others with connections to Nazi art looting as she grappled with her father's legacy, including the discovery of looted artwork in the attic of the Füssen farmhouse near Neuschwanstein that she had inherited from her father. (She found a fourteenth-century altarpiece

taken during the war from a Venetian church.) One can say that the Lohse-Rochlitz relationship transcended not only decades but generations.

Gustav Rochlitz, who was twenty-two years older than Lohse, had been acquainted with the latter's father. Lohse therefore looked up the Paris-based Rochlitz soon after his assignment to the Jeu de Paume in early 1941. With his gallery on the rue de Rivoli, virtually across the street from the ERR operation in the Jeu de Paume, Rochlitz emerged as both physically and fiscally close to Lohse. Lohse included some of Rochlitz's pictures in the exhibitions that he organized for Göring, which proved lucrative for the dealer. The two dealers partnered on deals, working closely to barter and sell ERR pictures, mostly of the modernist variety. Rochlitz participated in eighteen of the twenty-eight exchanges of ERR-looted works, and acquired at least eighty-two stolen pictures.[219] Lohse often helped select the pictures for trade, offered his opinion about the deal, and then signed off on the final arrangement.[220] To take just one example, a painting by Georges Braque that belonged to Alphonse Kann had been seized by the ERR and traded on Göring's orders to Rochlitz for a work by the Master of Frankfurt. Lohse had helped catalogue the looted Kann collection and knew the Braque. He turned to Göring for an "order" that gave him cover before trading it to Rochlitz. The latter did not have to look far for a buyer as Rochlitz in turn sold the Braque to Paris dealer Paul Pétridès, another well-known dealer who collaborated with the Germans.[221]

Rochlitz had extensive contacts in Switzerland—he had lived there from 1931 to 1933 until certain rivals, including powerful Lucerne dealer Theodor Fischer, mounted a successful campaign to expel him from the country—and it was Rochlitz who introduced Lohse to Hans Wendland, another German who had established an international existence, an arrangement that included extensive time in Switzerland (Lucerne and Paris were Wendland's primary domiciles).[222] Wendland taught Lohse more about Switzerland than anyone else: with reason, historian Emmanuelle Polack titles one of her subchapters in her study of the French art market under German occupation "Hans Wendland École en Suisse."[223] Prior to 1941, Lohse had no discernible contacts in the Alpine republic. Yet with the opportunities presented by the war, these three German dealers living abroad—Lohse, Rochlitz, and Wendland—would form the core of a powerful network that would traffic in hundreds, if not thousands, of looted paintings. Their collaboration brought to mind Lohse's quip when asked about a report that he had played a direct role in the looting of two

thousand pictures. Scarcely missing a beat, he responded, "Only two thousand?"[224]

Another key German based in Paris was Adolf Wüster (1888–1972), an "amateur" art dealer and professional painter who was made a consul at the German embassy in Paris, which meant that he had to keep his chief, Foreign Minister Joachim von Ribbentrop, contented with a supply of pictures.[225] Nazi dealer Karl Haberstock reported the following about Wüster in June 1945: "Was involved in all art transactions of the German Foreign Office. He traveled all over Europe during the war. He shared the spoils at the Jeu de Paume in Paris. He worked with the Gestapo (reputedly). He was a German spy."[226] As Haberstock suggested, Wüster was an unsettling person. In his mid-fifties when the war broke out, he had a sharp nose, a partially paralyzed right hand, and several gold teeth. He had lived in Paris before the war, having studied with Henri Matisse (and prior to that, with Franz von Stuck and Heinrich Knirr in Munich), and he returned to the French capital in the mid-1920s. Possessed of a wide array of contacts, Wüster introduced Lohse to many key figures in the French art world, including Roger Dequoy of the Wildenstein Gallery, and Martin Fabiani, a dealer who liquidated a large part of the collection looted from Paul Rosenberg—while at the same time befriending Pablo Picasso. The famed artist sketched Fabiani during the war, and some of these portraits are in major museums, including the Museum of Modern Art in New York.[227] Fabiani was a prominent figure in the French art world who moved between respectable society (he was the protégé of legendary dealer Ambroise Vollard) and a criminal demimonde (his name was on the ALIU "red flag" list).[228] Fabiani, like his friend Adolf Wüster, was a significant contact for Lohse in wartime Paris.

Adolf Wüster trafficked in art in a relatively open manner during the war—not only serving as von Ribbentrop's chief agent but also selling to German museums, such as those in Düsseldorf and Krefeld, among others. Hector Feliciano noted, "In spite of his diplomatic status, he always required a healthy 20-percent commission from his clients."[229] Wüster also obtained a significant number of pictures for Goebbels, reportedly working with his colleague at the German embassy, Dr. Knothe, so as to assure that the Reich propaganda minister shared in the French spoils.[230] Wüster obtained a number of pictures looted by the ERR from the Paul Rosenberg collection, which was stored in Bordeaux in a château at Floirac and in a bank vault in Libourne. He sold and traded pictures by Degas, Picasso,

and Braque, and around fifty have never been recovered.[231] Although early
on Wüster was in competition with the ERR (which induced him to enter
into an "informal alliance" with the SD), he cooperated increasingly with
Lohse—a relationship that would endure in the postwar period.

Adolf Wüster resided in an elegant Munich neighborhood near the
English Garden on the Martius Strasse until his death in 1972.[232] A 1955
note from Wüster in Lohse's papers appeared to be responding to a re-
quest for information about a picture. Wüster wrote, "Unfortunately, it's
a hot iron" (heisses Eisen) and reported that the work came from the col-
lection of Paul Rosenberg.[233] Wüster added that it had passed through the
German embassy in Paris during the war—that is, his own bailiwick. It is
not clear how Lohse responded to Wüster's warning in this instance—it's
not even known whether Lohse possessed the looted Rosenberg picture
or whether someone had offered it to him. In either case, Wüster's hand-
scrawled message to Lohse attests to a network of former Nazi art plun-
derers. Adolf Wüster nevertheless lived a fairly public life in Munich in the
1950s and 1960s, even allowing journalists to see his collection prior to his
death. As Wilhelm Christlieb noted in 1968, "Whoever enters the home of
Adolf Wüster in the Munich Martius Strasse feels transported to a small,
intimate museum of the 'École de Paris.' There, hanging among Wüster's
own works, are pictures by Jean Dufy, André Derain, and Maurice Utrillo,
among others."[234] We do not know the provenance of these works or how
many were looted. Yet Wüster conformed to the paradigm of the dealers
who worked with the Nazis and amassed (or added to) valuable collections
that they preserved for the rest of their days.

Among the German dealers who traveled to Paris to conduct business
and who became close to Lohse, Maria Almas Dietrich (1892–1971) stands
out. The daughter of a Bavarian butcher, she became a force in the French
art market. Dietrich was not the sole female German art dealer who
worked in Paris. Maria Gillhausen of Munich, for example, was also active
in the French capital (and she was also close to Adolf Wüster). However,
Dietrich was extraordinarily active during the war. The OSS list of French
dealers with whom she did business runs to 111 names, including, of course,
major figures like Roger Dequoy (Wildenstein), Paul Cailleux, and Victor
Mandl.[235] Karl Haberstock described her as "attractive and vivacious."[236]
She was also, he admitted in 1945, "an ardent Nazi"—even though Die-
trich had conceived a child out of wedlock in 1910 with a German Ameri-
can Jew, Arthur Reinheimer, and then had married Ali Almas-Diamant,
a Turkish Jewish journalist, in 1921. In order to validate the marriage, she

had converted to Judaism. The couple worked together, running a carpet shop in Munich that grew into an art gallery. They separated in 1925, and Almas-Diamant emigrated to Paris.

Maria Almas Dietrich returned to Munich, where, despite lacking formal training in art, she continued the business, operating from an elegant building on the Ottostrasse in the heart of Munich's arts quarter. Due to her marriage to a Jew, she experienced harassment from the Nazi authorities after 1933, even after she formally obtained a divorce in 1937.[237] However, Dietrich gradually shed this baggage as she sold to Hitler and other Nazi leaders. From the mid-1930s onward, Dietrich was a friend and protégée of Hitler's photographer Heinrich Hoffmann, and Dietrich's daughter grew close to Eva Braun, who also worked in Hoffmann's Munich establishment. These relationships remain striking because Dietrich's daughter, who went by the name Mimi tho Rahde, was considered Jewish according to the Nuremberg Laws of 1935; indeed, she endured discrimination, such as being forced to relinquish her car. Yet both mother and daughter managed to insinuate themselves into the inner circle surrounding Hitler at the Berghof. Maria Almas Dietrich received invitations to socialize with the dictator, as evidenced by photos of her and Hitler's court in evening dress at various New Year's and wedding celebrations.[238] Despite a limited knowledge of art—Dietrich was sharply criticized by museum directors such as Ernst Buchner in Munich and Hans Posse in Dresden/Linz for peddling forgeries—she sold more works to Hitler and the Führermuseum than any other dealer (over nine hundred).[239] These included Arnold Böcklin's iconic *Island of Death*, which Hitler acquired from her in 1936, and Anselm Feuerbach's *Portrait of Nanna*, which was one of the dictator's favorite pictures.

On a financial level, Maria Almas Dietrich's friendship with Lohse made little sense. Journalists David Roxan and Ken Wanstall noted about Dietrich, "Surprisingly, one of her strongest allies in Paris was Dr. Bruno Lohse, Goering's permanent agent. Through she bought mainly for Hitler and seldom did business with the *Reichsmarschall*, Lohse was willing to help her solely on the basis of friendship."[240] This is not entirely true. It was a commercial transaction, with Lohse making use of the seized art and Dietrich reaping huge profits (her income swelled from RM 47,000 in 1937 to RM 570,000 in 1941).[241] When Göring passed on pictures, which he often did, Lohse felt free to sell or direct the works to Hitler's agents, like Dietrich. As Hector Feliciano described, "Lohse once spent a day in her gallery [in Munich], showing her photos of recently confiscated ob-

jects. One was Pissarro's *Port of Honfleur in the Rain*. Dietrich immediately agreed to exchange it for two sixteenth-century Franco-Portuguese panels."[242] As historian Anne Rothfeld noted, Dietrich knew that the Pissarro came from the ERR: she listed the ERR as the source of the picture in her stock books, and then "sold" the Pissarro to her daughter the following year—in 1943—"because she believed 'it would be unwise to keep it on her books.'"[243] Lohse trusted Dietrich and it was good to have an ally who was one of Hitler's prize dealers.

The agents working for Hitler—not only Dietrich, but also Hildebrand Gurlitt in France and Erhard Göpel in the Netherlands—were afforded special opportunities to acquire modern artworks from the ERR stock.[244] While there were twenty-eight recognized trades (*Tausche*) of ERR work, there was an even more clandestine arrangement that applied to connected dealers. In December 1945, Rose Valland, helping the OSS ALIU team prepare for further interrogations of Lohse, noted that Erhard Göpel had been in competition with Lohse, and that when Göpel came to tour the Jeu de Paume, he did not appreciate the assistance of Dr. Lohse.[245] Of course, Göpel was there to acquire pictures, and Valland's account indicates how connected dealers like Göpel, Rochlitz, and Wendland obtained ERR-looted artworks. They could pick works from the "Chamber of Martyrs" and negotiate a price with Lohse and his staff at the ERR. The agents also did business with one another; and this trade, which commenced during the war, also continued in the post-1950 period. For example, yet another Pissarro, this one titled *View of the Seine from the Pont-Neuf* (1902), had been seized by the Germans early in the war from the safe-deposit box of Max Heilbronn—from the dynasty that owned the Galeries Lafayette—after he and his family had fled their Paris apartment. Lohse had traded the work to Rochlitz on 31 October 1942 in the twenty-third exchange. Yet the Pissarro ended up in the Gurlitt cache that came to light in Munich in 2012.[246] It is not possible to discern whether Gurlitt bought the work from Rochlitz during the war or whether it found its way to him in the postwar period. Clearly, the trafficking in looted art did not end in 1945 and both scenarios are feasible.

Although Lohse did business with Hitler's agents, it remains unclear whether Lohse ever met Hitler.[247] Lohse indicated yes. For example, he told me a story on several occasions in which he claimed to have been present when the dictator inspected pictures that he had supposedly painted in his youth. The pictures, which had been collected by Nazi functionaries, were set up in a row in the Braunhaus, the Party headquarters in Munich. Lohse

recalled that Hitler, armed with some kind of knife or razor, went down the row and violently slashed those works he deemed forgeries. Lohse told the story in such vivid detail that it sounded true. Lohse certainly met with Hitler's key subordinate in the art-collecting realm, Professor Dr. Hans Posse. In November 1941, for example, Lohse received the Führermuseum director at the ERR headquarters in the Jeu de Paume and showed him a selection of the confiscated works. An eminent art historian who oversaw Dresden Gemäldegalerie, Posse sought to keep his visit secret. But his wartime travel journal shows him meeting with Lohse at the Jeu de Paume (followed by a meeting with Kurt von Behr at the Hotel Commodore).[248] During the visit, Posse selected artworks for Hitler from the ERR cache and then arranged their transfer back to Germany. Although Lohse was Göring's man and had little to do with the Führer, he nonetheless interacted with Hitler's agents, as one would expect, considering his role in Paris and his occupation as a dealer.

Just as Lohse had moderate but limited interaction with Hitler's agents, he similarly entered the Dutch market with restraint but by no means abstinence. Lohse understood power, and he knew that he had little influence in the Netherlands compared to others, such as Kajetan Mühlmann or Alois Miedl; the latter had purchased the Goudstikker Gallery and its collection (at a highly advantageous price).[249] It was unbecoming— not to mention bad business—for Göring's dealers to be seen in competition with one another. They never bid against one another at a public auction, although they probably pursued the same paintings in the private realm. There was some attempt at cooperation. For example, Mühlmann's agency in the Netherlands sometimes passed pictures on to Göring via Lohse, as happened with a painting by Joachim Beuckelaer from the sixteenth century, which Mühlmann's agency stole in the Netherlands in 1941: Lohse served as the "agent" who sent the work on to Carinhall.[250]

Lohse nevertheless went to the Netherlands on numerous occasions during the war. He "was unable to recall exactly how many visits he had made to Holland during the war, but he believed the number was between ten and fifteen."[251] Lohse gradually built up a network of contacts there that included the aforementioned Professor Friedländer as well as Dutch dealers Jan Dik Jr. and Victor Modrczejewski. The latter two, who often worked as a team, became important business partners for Lohse. They scouted Holland for works that would please Göring. When they visited Amsterdam in May 1942, to take one example, they bought nineteen paintings (*toiles* in the French version of Lohse's postwar testimony), totaling

233,000 Dutch florins ($122,631). These included works by Pieter and Jan Brueghel as well as Adriaen Brouwer.[252] Lohse achieved enough success in Holland that Göring permitted him to travel there from Paris on several occasions aboard *Asia* and others of the Reichsmarschall's four personal trains.[253] To have access to one of Göring's trains sent a clear message about his status, even if Lohse was a subsidiary buyer for Göring on the Dutch market.[254]

As noted earlier, Bruno Lohse's network developed extensive roots in Switzerland. In part because foreign currency was in short supply in Nazi Germany—especially Swiss francs—and because it was uncomfortable going to Göring with requests for *Devisen* (foreign currency), Lohse and other complicit dealers turned to barter. Most notoriously, Lohse and his ERR cohort traded modern "degenerate" works that they had seized for more desirable traditional works. The *Verwertung* (liquidation) of modernist works completely undermined the Nazis' justification that they were safeguarding heirless property. Entering into these commercial exchanges had nothing to do with the protection of cultural property. Of course, the selections that Göring initiated at the Jeu de Paume in November 1940, with the faux payments and personal profiteering, set Lohse and his ERR colleagues down this path, but there was something particularly unscrupulous about the Swiss transactions. Perhaps it was because the works were sometimes smuggled in diplomatic pouches, which allowed them to evade the tight Swiss customs control and the steep import taxes.[255]

There was also an element of deception—and feigned deception as Swiss dealers and collectors sought plausible deniability—about the paintings' provenance. Lohse testified that Göring personally ordered the ERR stamps and inventory numbers to be removed from the pictures that were traded. Furthermore, Göring's guidelines extended to other stamps and labels (for exhibitions, previous owners, and so on), to further minimize the chances of works being identified as looted.[256] It seems that some of these markings survived: Hans Wendland, for example, recalled after the war that "he saw the name Paul Rosenberg on the backs of several of the pictures" that he acquired in trades.[257] While there was a general effort to conceal the provenance of the looted works that were passed on from the ERR, Lohse testified that "all the partners in the exchanges were informed in a general manner about the origin of the paintings, even if it was not allowed to tell them the name of the previous owner."[258] In the postwar period, Swiss authorities concluded that complicit dealers, like Theodor Fischer (1878–1957), acted in bad faith when they acquired the ERR works,

but they did not hold the buyers accountable.[259] That the Nazis' dealings with Swiss dealers and collectors have never been completely clarified adds another dimension to this history, although the gaps in understanding are not unexpected. Back in 1945, British Monuments officer Douglas Cooper (1911–84) found that the Swiss Art Trade Association had prohibited its members from volunteering information.[260] As popular novelist Daniel Silva has quipped, "The only thing more secretive than a Swiss bank is a Swiss art gallery."[261]

Lohse worked with Gustav Rochlitz and Walter Andreas Hofer, among others, in at least twenty-eight trades to liquidate the "degenerate" art stock in the ERR repositories, with most of the works ending up in Switzerland.[262] These deals, which were concluded between February 1941 and late 1943, occurred for several reasons. First, modern works were sent to Switzerland because importing the proscribed art to Germany would have elicited outcries from anti-modernist Nazis like Robert Scholz, who wrote scathing reports to his chief, Alfred Rosenberg, about the need to keep such dangerous art out of the Reich. Even Lohse at times used this Nazi anti-modernist rhetoric, talking about "Judeo-Bolshevik" artworks that represented a threat, but that was likely posturing for other Nazis — and a way to justify the sales to Switzerland.[263] After the war, Lohse certainly evinced an admiration for modern art. Certain modern ERR works still traveled to the Reich, but many were then sent to Switzerland. Second, foreign currency proved tremendously scarce, even for Göring, and he (or his agents) took steps to conserve Swiss francs and other precious currency for instances when it was absolutely essential. Third, Göring, like many Nazi leaders, attempted to be pragmatic with artworks that clearly had value abroad. Even the rabid ideologue Joseph Goebbels had engaged German dealers to sell off the artworks purged from German state museums. The ERR trades of modern artworks, whether they went directly to Switzerland (often via diplomatic pouch) or via the Reich (the so-called indirect trades), took place in the context of these considerations.[264]

Lohse himself apparently traveled to Switzerland on only two occasions during the war. He claimed in several interrogations to have made only one trip, but was corrected by Swiss authorities. The Swiss kept very precise records about who crossed their borders.[265] He acknowledged visiting Basel and Zurich in 1942 but, he said, he didn't go to traffic in ERR works. Rather, Lohse sought to ascertain whether a work he had acquired for Göring, attributed to the Dutch Old Master Adriaen Brouwer, was authentic. Hofer claimed it was a fake and Lohse therefore traveled

to Basel to consult with an expert, Dr. Hans Schneider, a former cura-
tor of the Mauritshuis museum in The Hague. Lohse later testified with
considerable pride that Dr. Schneider supported his attribution — it was
an early work of Brouwer.[266] Lohse also admitted, after prodding, a sec-
ond trip: this time to Lucerne, where he met the dealer Count Alexander
von Frey (1882–1951), who had done business at the ERR in Paris and was
a close associate of Gustav Rochlitz. On this second trip, Lohse also trav-
eled to Zurich, where he visited the Galerie Neupert (also known for traf-
ficking in looted art).[267] At the latter, he insisted on being introduced as
Göring's plenipotentiary, which is how he customarily identified himself
(the ERR was nominally secret and he was, first and foremost, an agent of
Göring). Despite the posturing, Lohse did not acquire anything from any
of the Swiss establishments he visited on this trip. Nonetheless, the short
tour had helped him develop relationships and, he no doubt knew, increase
his own notoriety.

In various postwar interrogations, Lohse denied any involvement in
trading the ERR looted works in Switzerland, but this clearly was not true.
Other witnesses contradicted specific points of his testimony. For ex-
ample, Lohse stated he did not know Theodor Fischer and had not visited
the dealer's Lucerne gallery, while another Swiss dealer, Hans Trainé, tes-
tified in a Swiss court under oath that he met Lohse at Fischer's gallery
in either 1943 or 1944.[268] Then there were specific exchanges, such as the
Ludwig Knaus for a Renoir trade discussed below, where Lohse's nego-
tiated on behalf of the ERR and gave his name and contact information
should there be a problem. When there was an issue regarding a trade and
the complaint came to Robert Scholz in Berlin, Scholz directed the person
to Lohse, who, he said, was better informed about these matters. Scholz
disavowed any responsibility for the exchanges and identified Lohse as the
key figure.[269] While Göring, Hofer, and others helped drive the process,
Lohse remained the local operative who made sure things ran smoothly.[270]

The origins of the ERR-Swiss trades actually proved more complex.
The arrangement grew out of two simultaneous initiatives, although both
featured Göring at the center. The first ERR trade in Paris in March 1941
involved eleven modern works (by Braque, Cézanne, Degas, Matisse,
Picasso, and others) traded to Rochlitz for a northern Italian portrait of a
bearded man and a hunting still life by Dutch painter Jan Weenix. Lohse
had seen the first picture in Rochlitz's gallery on the rue de Rivoli and be-
lieved it to be a Titian. It had the vivid colors used in portraits by the Vene-
tian master, and Lohse hoped he would further impress his patron with this

discovery (Rochlitz had not exhibited it on the gallery floor but brought it out of a back room).[271] After showing photos to Göring and securing his approval, Lohse first attempted to purchase it. But some ten days later, he returned and changed the terms of the offer to a trade: Göring, he said, refused to pay the high price and had instructed him to engineer an exchange.[272] Rochlitz accepted the new terms. He later claimed he did not know the works came from the ERR. He stated in 1946 that as soon as he found out their origins he protested to Lohse, but the latter calmed him by saying, "I am acting on the order of Göring. You have nothing to worry about; the confiscations were permitted according to the terms of the armistice and the exchanges are in order."[273] Rochlitz was clearly not telling the truth: he had visited the Jeu de Paume himself to select eleven works from an exhibition that Lohse, Schiedlausky, and other ERR staffers had organized.[274] This first exchange entailed other complications, however, because Rochlitz did not own the Titian outright: he possessed a one-third share, with Hans Wendland and Zacharias Birtschansky as equal partners. The latter initially showed recalcitrance about the trade, and Wendland bought out his share, but Lohse still had to sweeten the deal with cash.[275] However, the concept of trading works from the ERR stock had been established.

At the same time, Walter Andreas Hofer arranged to acquire six Old Masters from the Fischer Gallery in Lucerne for Göring. This included four Cranachs as well as a picture from the Master of Frankfurt that had once been in the collection of Prince Lippe of Bückeberg. A consolidated price was agreed upon, and Fischer sent the works to the German border at Basel via the Bronner transport firm. From there they went on to Carinhall, some sixty miles northeast of Berlin in the Schorfheide forest. Because it was widely known that foreign currency was difficult to procure, Göring used the shortage of Swiss francs as a reason for requesting a trade. In fact, Göring could have obtained the foreign currency, but he did not want to expend the political capital. He also had appropriated modern artworks that he wanted to trade away (although a few of the tamer variety found their way into his personal collection).[276] Furthermore, he recognized that he had the ability to ship works through the diplomatic pouch, thereby circumventing customs authorities and others who might raise questions. Hofer therefore traveled to Lucerne in June and secured an agreement from Theodor Fischer to accept compensation for the Cranachs and Master of Frankfurt picture in the form of French Impressionist works. Fischer already had plans to travel to Berlin, and the ERR staffers

made arrangements to ship the works from the Schloss Neuschwanstein depot in rural Bavaria to the Reich capital. In mid-July, Fischer came to Göring's Staff Office (Stabsamt) at the Reich Aviation Ministry on the Leipzigerstrasse and inspected the twenty-five French Impressionist works that Göring and his team proposed. Their offer included four by Corot, five by Degas (four of which came from the collection of Alphonse Kann), and two pictures by van Gogh. Hans Wendland, who was also present, later described the effect of these French masterpieces lined up in a row: they dazzled. The presentation worked, and Fischer accepted the deal. Göring arranged the export permit, and the works arrived in Switzerland on 22 October 1941.[277]

The Swiss-ERR exchanges were thus established, and they expanded from there—with Lohse playing a key role in the process. The lopsided trades, which seem laughable today—especially with the rise of the market for Impressionist works—yielded huge profits for the Swiss dealers and their partners. Indeed, as early as March 1941, as the trades were still being worked out, Theodor Fischer was so pleased with his dealings with Göring that he presented the Reichsmarschall with a gift: a picture by the fifteenth-century Alsatian artist Martin Schongauer, few of whose paintings have survived.[278] Fischer made huge sums from the Nazis. The Lucerne-based dealer sold approximately 148 paintings and drawings to Hitler and the Führermuseum, and at least 36 pictures to Göring, not to mention the looted works he received from the ERR that he passed on to Swiss collector Emil Bührle and others.[279] Hans Wendland, who participated in numerous ERR trades and worked with Theodor Fischer to sell Bührle paintings during the war, earned an income of approximately 3 million Swiss francs in 1942 and 2.5 million in 1943—a stunning amount at the time.[280] Wendland told James Plaut in a January 1946 interrogation held at the Fischer Galerie in Lucerne that "he has had a 33⅓ interest in all pictures acquired during the war for Fischer through exchange or purchase."[281] The Wendland-Fischer partnership proved highly profitable. Another significant part of Hans Wendland's income came from deals with Göring. Between 1940 and 1944, Wendland and Hofer reportedly transacted business valued at 258,000 Swiss francs and 7.4 million French francs, and their trades were sometimes massive: twenty-five modern paintings confiscated from French Jews for four by Lucas Cranach the Elder, and twenty-eight Impressionist paintings for Rembrandt's *Portrait of Old Man with a Beard* and two Flemish tapestries, to take two examples.[282] Göring reportedly provided Wendland with a letter stating that

the Reichsmarschall would help protect Jewish sellers from deportation if they sold him and his agents desirable artworks, and Wendland realized part of his significant profits by purchasing from western European Jews under duress.[283] Wendland did not possess papers licensing him as an art dealer in Switzerland and therefore had to tread lightly. He fashioned himself an adviser or consultant, but in fact acted as a dealer without a physical gallery.[284] Utilizing the diplomatic pouch available to Göring—and this "pouch" could be as large as a container—not only allowed him to expedite shipping and avoid taxes, it also kept him below the radar of the Swiss authorities. The works would go to the German embassy in Bern and then could be passed on to him in a clandestine manner.[285] The ALIU said of Hans Wendland in the *Final Report* that he was "probably the most important individual engaged in quasi-official looted art transactions in France, Germany, and Switzerland in World War II."[286]

The "formal" ERR trades, of which the ALIU documented twenty-eight, grew to include at least six dealers.[287] There seem to have been backroom deals as well, and the ranks of the business associates may have been larger. In addition to Hans Wendland, both Alexander von Frey (a Hungarian dealer living in Lucerne and Paris) and Parisian dealer André Schoeller came to the Jeu de Paume to transact business.[288] The latter partnered with German dealer Max Stoecklin to select Henri Matisse's *Woman in a Yellow Chair* and Pierre Bonnard's *Coffee Table* at the ERR depot in the Jeu de Paume; the works eventually made their way to the Neupert Gallery in Zurich.[289] Frankfurt dealer Alfred Boedecker and Dutchman Jan Dik Jr. (1916–circa 1990) also came to Paris and traded for looted works from the ERR stock with Lohse.[290] Dik, for example, provided a Brueghel and two other Dutch Old Masters, which went to Göring, and in exchange received an Isaac van Ostade (or "school of") that hailed from the Andriesse collection.[291] When one was selling multiple works to Göring (recall that Dik sold nineteen pictures to the Reichsmarschall in May 1942), it was a natural step to explore opportunities for exchange. Yet clearly the works offered by Göring and his agents more often than not were looted.

Lohse and his cohort at the ERR preferred to have the cadre of agents come to them in the Jeu de Paume depot itself, where they could see the actual artworks. As Lohse testified in 1950, there was an established procedure for visiting the nominally secret facility. The visitor was met at security and received a onetime identification card with a number, which was signed by Colonel von Behr. After von Behr's transfer to the *M-Aktion* in 1943, Lohse himself signed the passes, at least according to Dr. von

Tomforde-Ingram in her postwar testimony.[292] The pass number was then entered into the "watch book" (*Wachtbuch*), and the visitor was escorted to the showrooms.[293] Works were brought in from a staging area in the so-called Louvre Annex, and the trusted few would behold the stolen art, furniture, and rugs—an Aladdin's cave, to use an oft-cited image. The commerce most often entailed barter, but there were also works sold for currency. These cash transactions lacked receipts, making them difficult to track (but that was the point).

While the cadre of dealers who dealt with Lohse and his colleagues in the Jeu de Paume was fairly limited, the works radiated outward to a host of ancillary dealers. Allied intelligence agents Douglas Cooper and James Plaut identified sixteen Swiss dealers in 1946 who were suspected of having bought and sold looted art during the war, but there were clearly many more, as Hofer and others attested in 1949 and later.[294] The final OSS "red flag list" of Swiss individuals in the art world believed to have dealt in looted art consists of sixty-one names.[295] Some Swiss dealers apparently rationalized their actions by believing they were getting the better of the Nazis: after the war, stories surfaced that Swiss dealers took second-rank works done in masters' ateliers or by their students and added signatures to make the paintings appear to be the works of the famous artists themselves: thus cheating the bad guys.[296] The stolen art that flowed into the Alpine confederation was often sold publicly. Theodor Fischer, who hosted, in the words of a Swiss lawyer, "big auctions . . . visited by well-known dealers and connoisseurs of art from all over the world," sold off the works he received from Hofer in March and September 1942.[297] When one dealer from Basel asked Fischer about the origins of the works, Fischer told him, as was customary, that they came from the "French art trade" (and this would explain stamps from Rosenberg and others).[298] The ERR looted art therefore circulated quickly in Switzerland, and in doing so, a process unfolded in which the works radiated outward to a broader circle of dealers and collectors. It is no coincidence that twenty-four paintings stolen from European Jews that were discovered in São Paolo, Brazil, in 1998 had passed through the hands of Theodor Fischer.[299] The works were by Monet and Picasso, among others. The Allies found that Fischer acquired fifty-seven ERR works, although the actual number may have been higher.[300] The members of the ALIU nonetheless concluded in 1946 that "Fischer is the focal point in all looted art transactions in Switzerland, and recipient of the greatest number of looted paintings located to date."[301] It is therefore not surprising that Fischer also sold works to Hitler and

the Führermuseum, including twenty-two etchings by Albrecht Dürer and Martin Schongauer, among others, which he sold in March 1943 with the help of Darmstadt dealer Karl Buemming (1899–1963).[302] Even with certain behavior well documented, Allied investigators were aware there was much they did not know about Theodor Fischer; the *ALIU Final Report* noted that "Allied and Swiss authorities [were] conducting continued investigation[s] into his activities."[303]

While the ERR staff compiled impressive records of the plunder, including the extensive card catalogue file (which art historian Iris Lauterbach describes as "the predecessors of our modern databases"), and although they documented the major trades, the scope of the disorder should not be underestimated.[304] James Plaut summarized the testimony of several ERR staffers, writing that after the initial wave of seizures by the German military and German embassy, "it was stated that the Einsatzstab employed a number of irresponsible men who would simply collect a truckload of objects and carry them off to the Jeu de Paume. Schiedlausky and the other art historians would be working in the Jeu de Paume on inventories, when some stranger would come in with a carload of works of art and simply say, 'These are from Rothschild,' or 'These are from the avenue du Bois,' leave them, and disappear. More often than not, Schiedlausky would never again see the same man."[305] The ERR staff utilized French informants, including, according to James Plaut, "following leads which they received from the collaborationist French police."[306] The ERR's confiscation process was subsequently professionalized and made more orderly, but the art historians in the Jeu de Paume still faced daunting tasks sorting and identifying the plunder. They complained about a dearth of art reference books on hand; the looted ones were being studied elsewhere by another Rosenberg unit evaluating printed sources and archival documents. In short, the ERR staff was left with "a large quantity of material, which remained classified 'unknown.'"[307] This was especially the case for the objects seized early on in the ERR operations at the end of 1940 and beginning of 1941, when most of the major French Jewish collections were seized.[308]

Lohse had significant periods of hands-on management of the ERR operations. In August 1942, Alfred Rosenberg's chief art expert, Robert Scholz (1902–81), drafted a document that came to be called "the Revision Report." Basically, Scholz criticized the existing ERR operation in France. At times, Scholz advocated the termination of the entire operation, seeing the looting as antithetical to what he believed were Nazi ideals regarding

honor.[309] Rosenberg accepted the report and then appointed Scholz the new chief of the ERR, although since his base was in Berlin, this created a power vacuum in Paris that Lohse helped fill. In June 1943, Kurt von Behr finally relinquished control over the ERR in Paris and turned to a related operation, the *M-Aktion*, or the confiscation and processing of looted Jewish furniture from over sixty-nine thousand residences (thirty-eight thousand in Paris alone).[310] Colonel von Behr nonetheless spent most of his time back in Germany. With Scholz also preferring to stay in Berlin—closer to Rosenberg and others with power—the three who ruled in Paris after mid-1943 were Rosenberg aide Hermann von Ingram, a highly decorated soldier who handled administrative matters, Bruno Lohse, and Walter Borchers (another art historian). As James Plaut noted, "Lohse enjoyed a quasi-executive position, sharing his professional responsibilities with Borchers."[311] Plaut added, "All seizures conducted by the ERR subsequent to von Behr's departure were directed by Lohse and/or Borchers."[312] One therefore can describe Lohse as what postwar scholars of the Holocaust call a *Schreibtischtäter*—a "desk-bound perpetrator."

Dr. Borchers (1906–80), one of Göring's minions and a corporal in the Luftwaffe, was actually a capable scholar with a good knowledge of art. He was not a Nazi and was often critical of the regime, which landed him in trouble on several occasions. Before the war, he had been a curator at a museum in Stettin on the Baltic.[313] Rose Valland described Borchers as "very erudite, rather Francophile."[314] The Gestapo arrested him in early 1944 for defeatist statements: he had said in the presence of other ERR staffers, who were nearly all Nazis, that the Germans "would lose the war and that it would not even last much longer."[315] Even though Lohse and Borchers often clashed, Lohse did not want to see his colleague suffer the tribulations of the Nazi penal system.[316] Only the intervention of Lohse and Robert Scholz, Borchers recalled later, saved him from a concentration camp. Lohse evidently barged in on the Gestapo agents' interrogation of his colleague, interrupting the proceedings and then bringing them to an end, an experience that proved harrowing for the two art historians.[317] Borchers got away with a reprimand and returned to the Jeu de Paume, where he continued to oversee the day-to-day cataloguing work. Lohse himself continued to gallivant around Paris and western Europe more generally, making his deals.[318] Because Göring's stature and power diminished from 1943 onward with the failures of the Luftwaffe and his own descent into drug use and bizarre behavior, Lohse freelanced more. One of the ironies of the ERR is that at the time Lohse reached the zenith

of his influence, Göring retreated from the agency. The Reichsmarschall's last visit to the Jeu de Paume came on 27 November 1942; granted, he continued to commandeer works, but at a diminished rate.[319]

Lohse's tenure as co-director of the ERR did not last long as he eventually became alienated from his ERR colleagues. James Plaut, in addition to noting how Lohse's "special privileges" provoked the "resentment" of his fellow workers, remarked that Lohse was "known to have clashed with his colleagues on several occasions" and even broke with Borchers, with a major altercation coming over the firing and then rehiring of an art historian named Fräulein Dr. Eggemann.[320] The soap opera continued against a backdrop of power politics: Lohse was Göring's creature and his fortunes had declined along with the Luftwaffe. Hitler had become aware of Göring's usurpation of the ERR and had taken steps to seize control of the agency: on 21 April 1943, Martin Bormann, private secretary to Hitler and head of the Nazi Party Chancellery, had written Rosenberg that "the Führer wished that all the artworks secured by your Einsatzstab should be handed over to the experts of the Führer," identifying Hermann Voss for art, Friedrich Wolffhardt for books, and Helmut von Hummel for all other objects.[321] In other words, Hitler and Bormann wanted the Linz staff to take over the ERR inventory, and as a first step, pressured Rosenberg to regain control of his agency. One can imagine Bormann writing the letter the day after Hitler's birthday when they were still processing all the gifts, including artworks, that would go to the Führermuseum or to his various residences; this missive was certainly born of the vainglorious desire to build the collections. The counterattack against Göring made the situation untenable for Lohse and, when combined with the reports of poor management and low morale, this precipitated talk of Lohse's removal beginning in mid-1943. Yet he hung on as co-head of the ERR Jeu de Paume facility until June 1944, when Scholz replaced him with a functionary named Walter Rehbock.[322] All told, Lohse had been "in power" for about a year, although his staff proved so fractious that some could argue in hindsight that Lohse "was not as influential in the ERR as sometimes maintained."[323] While this is perhaps true—Lohse and Borchers did not micromanage operations and permitted "freelancing" under their regime—Lohse remained a dangerously powerful figure.

What happened next stretched the limits of credulity. Lohse later recounted that with the appointment of Walter Rehbock as his successor in June 1944, he prepared to go to the front. Before he resumed his active army service, however, he decided to take a holiday in the mountains in

eastern Europe. There Lohse proceeded to "break" his ankle, rendering him unfit for combat. Many believed that Lohse faked the injury, but regardless, Göring ordered him back to Paris, and Lohse returned—crutches and all.[324] Although relieved of his duties with the ERR, Lohse continued to work in the Jeu de Paume and avenue d'Iéna facilities.[325] As Rose Valland noted in June 1944, "Dr. Lohse is no longer the direct chief of the operations at the Jeu de Paume . . . but he is still well-regarded by the powerful ones. He is still, as they say, in on the 'secret.'"[326] During the last eight months of the German occupation of Paris, Lohse himself "freelanced" a great deal. He continued to buy for Göring (the selections from the Jeu de Paume were a thing of the past) and he pursued whatever side deals he could arrange. Indeed, many of his most controversial episodes, including his roles in seizing the Schloss collection and helping determine the fate of August Liebmann Meyer—occurred during the latter half of the war.

Darker Hues and War's End

(1943–45)

A RÉSUMÉ OF LOHSE'S WARTIME activities represents what for Lohse was a time of adventure—indeed, the high point of his life—yet his exploits were criminal. In order to understand his life, one must consider his most grievous offenses. What were his most nefarious activities? Well, for starters, Lohse personally participated in a number of confiscation actions. Initially, the ERR operations were carried out by the "confidential assistants" of Kurt von Behr, with no art historians present on the premises of the spoliated Jewish properties. However, this changed in 1942—and certainly by the time Lohse and Borchers ran the ERR—when it became customary for art historians to participate in the lightning raids.[1] The art historians would guide the laborers, telling them, among other things, which pieces were "legitimate 'ownerless' targets" and which were worthless and hence perhaps not worth taking.[2] Lohse had his grip on the ERR. As James Plaut noted, "All seizures conducted by the ERR subsequent to von Behr's departure [he formally relinquished control in June 1943] were directed by Lohse and/or Borchers."[3]

The single looting operation for which Lohse has had to answer the most questions concerns the Schloss collection. Adolphe Schloss (1842–1910), who made a fortune as a commodities broker in fin de siècle Paris, amassed a magnificent collection of over three hundred Old Masters, in-

cluding four works then thought to be by Rembrandt. He also had a strong collection of Flemish and Dutch "primitives" (Petrus Christus and Adriaen Isenbrandt, among others), as well as works by Rubens, van Dyck, and Jan Steen, all of which he kept in his townhouse at 38 avenue Henri-Martin.[4] After his death in 1910, Adolphe Schloss's widow and children "maintained his collection with religious devotion."[5] During the "Phony War" in the autumn of 1939, the eldest of the four children, Lucien, moved the pictures to the château of Chambon near Limoges. The collection was placed in the imposing edifice belonging to a friend, banker Jacques Renaud, and appeared relatively safe. The family also departed Paris for the south. Early in the war, the Germans found it difficult to obtain travel passes to the unoccupied zone in the south, and property there was relatively immune to seizure—at least by the Germans. But this gradually ceased to be the case. The confiscation of the Schloss collection, like the Germans' mission to nab the van Eyck brothers' altarpiece *The Mystic Lamb*, which occurred in Pau near the Spanish border in July 1942, signaled an erosion of this defensive barrier even prior to the Germans' occupation of the south in November 1942—their response to the Anglo-American offensive in North Africa (Operation Torch).[6]

Nazi art experts who had arrived in France with the German occupation forces in the summer of 1940 knew about the Schloss collection, but had no clue as to its location. Karl Haberstock came the closest when he was approached by a female member of the Schloss family (in his later words, "an astonishing woman with a German-Jewish name") at the Hôtel Negresco in Nice in early 1941.[7] She raised the possibility of the paintings becoming available and wanted to explore his interest, which was indeed strong, but she was not yet in a position to show him the artworks. Nothing much came of this approach, but rumors of the meeting attracted the attention of the collaborationist Vichy regime militia, the Milice, which launched an investigation.[8] Of course, Vichy agents, including officials working for the Vichy commissioner general for Jewish affairs, Louis Darquier de Pellepoix (1897–1980), had been among those looking for the famed collection and scarcely needed Haberstock to prompt them. Lohse later claimed that the Vichy agents had been the instigators of the liquidation action, and indeed a French court backed him up with its findings.

The Vichy regime had passed laws beginning in June 1940 that enabled the French government to sequester the property of Jews who had emigrated (very similar to Nazi laws enacted earlier in Germany).[9] Embracing a nationalistic outlook, they sought to protect French cultural

patrimony from the Germans, especially with regard to the treasures in the Schloss collection. This served as an example of what historian Elizabeth Campbell Karlsgodt termed "institutional opportunism."[10] Vichy prime minister Pierre Laval therefore had assigned officials to pursue the matter, including Jean-François Lefranc, a well-connected art dealer and partner of Darquier de Pellepoix.[11] Lefranc and three French officials eventually located one of the Schloss children, Henri, and his wife in Nice and arrested the couple in early April 1943. Although Henri tried not to divulge any information, he had bad luck. For example, a telegram from his brother Lucien arrived while he was being interrogated by Darquier de Pellepoix's men from the Commissariat General for Jewish Affairs—and the telegram had a return address.[12] The Vichy authorities soon located Lucien and the paintings at the château near Limoges. In truth, Jean-François Lefranc was the driving force on the French side—even getting himself appointed "provisory administrator" (trustee)—of the collection, as he did for several other art collections and galleries. Lefranc in turn secured the support of Darquier de Pellepoix.

Shortly after the paintings were located, Bruno Lohse attended a meeting in Paris that included Darquier de Pellepoix and Lefranc. The meeting took place in Kurt von Behr's office, although Lohse later stressed that it came at the initiative of the French officials who, he claimed, had already decided to sell some of the paintings. Lohse maintained that Göring ordered him to participate—to help decide the fate of the collection— because von Behr could not appraise the artworks and because the primary negotiators were von Behr and Darquier de Pellepoix.[13] The latter agreed that the Germans would not confiscate the collection once it was brought to Paris. Both sides also came away with the understanding that if there were no acceptable offers, they would not be obliged to sell the paintings. The French reserved the right to transport the artworks back to the unoccupied zone at any time. The collection would be deposited in the Dreyfus Bank in Paris, which would remain fully controlled by the French (the Jewish bank had been seized by the Commissariat Général, which used the property on the rue de la Banque as its Paris headquarters). Furthermore, officials from the Louvre would be the first to inspect the collection and could block any sales.[14] It is important to keep in mind that there was considerable cooperation between Vichy and German officials with regard to cultural treasures. The Germans, for example, knew precisely where works from the Louvre were stored (and even helped guard the châteaux in the Loire Valley).[15] The Schloss collection, which was pri-

vate and owned by Jews, was different. Lohse immediately reported on the meeting to Göring, who was, unsurprisingly, very interested in obtaining what he could. Göring agreed to the terms, and wheels were set in motion.

Lohse's role at this stage in the seizure of the Schloss collection remains unclear. Journalist Stefan Koldehoff alleges that "Lohse had no problem with the arrest of two members of the [Schloss] family immediately after they were discovered and the plundering of the château by SS officers [continued]."[16] The extant evidence seems to corroborate this interpretation. A contemporaneous telegram from Rudolf Schleier, a senior diplomat at the German embassy in Paris, to Martin Bormann reported: "The Jews, 'Schloss,' the former owners of the collection, were arrested by German authorities in the Italian occupied part of France due to their Gaullist activities. They are now in German police custody in Lyon. This information is thanks to Dr. Lohse (in the offices of the ERR and also Göring's representative for art purchases in Paris), and to the SD, who briefed me with complete openness. In case it is necessary, we can go back to them for further reports."[17] Whether Lohse bears direct responsibility for these acts is uncertain, but he was clearly liaising with the Security Service, the SD, in an action that entailed the arrest of members of the Schloss family. This telegram is also striking because the recipient was Martin Bormann, then Hitler's official secretary and one of the most powerful men in Nazi Germany. Lohse was part of an operation that was monitored at the highest levels. Schleier credited Lohse with finding the collection, telling Bormann, "The most arduous detective work on the part of the representative for art purchases in Paris, Dr. Lohse, has resulted after years of searching for the hiding place of the Jewish 'Schloss' collection, in the determination of its location, which, as he communicated, is in a château near Limoges."[18]

Securing the Schloss art was only one part of the operation; transporting the works back to Paris to determine their final disposition presented its own challenges. Bringing the paintings to Paris was complicated by the arrival of various factions at the Chambon château in southern France. These included agents from the Vichy Commissariat General for Jewish Affairs, local officials, members of the German SD, and French collaborators known collectively as the "Bonny-Lafont gang" (or as La Carlingue). The members of Bonny-Lafont were both fascists and criminals whom the Germans had purposely released from French prisons. They were then recruited by the Gestapo to become its eyes and ears in Paris, and they worked especially closely with the French Gestapo unit at the rue Lauri-

stan. Pierre Bonny was actually a police officer known for cruelly torturing suspects, while Henri Lafont was a pseudonym for Henri Chamberlain, widely known as a Gestapo collaborator. The Gestapo, then, recruited Bonny-Lafont to do the hardest, darkest work in Paris (and France more generally) during the occupation. That Lohse and von Behr turned to such individuals speaks to the violent nature of their work and is reminiscent of Lohse boasting that he killed Jews with his own hands.[19]

Lohse and von Behr arranged for the Bonny-Lafont group to meet those handing over the collection in the town of Tulle near Limoges, and Jean-François Lefranc was supposed to arrive independently to facilitate the transfer. Yet Lefranc did not arrive in time—or not before Bonny and his cohort convinced those holding the pictures to relinquish them. With one of the original custodians from the château at Chambon accompanying the truck, they set off for Paris but were stopped by the local French police. A tense standoff ensued; in Lohse's words, "An armed SD guard arrived on the scene shortly, took over the cases, and brought them back to Limoges."[20] In other words, Lohse was helping negotiate between a gang of Gestapo collaborators and Himmler's Security Service, who arrived in numbers and with considerable firepower. This was a rough situation for Lohse, showing that he knew how to handle himself in dangerous and potentially violent situations. After all, he had experienced combat in Poland in 1939 and he knew how to handle a gun, should it come to that.

While cooperating with Hitler's representatives, Lohse made sure to keep Hermann Göring apprised of events. The Reichsmarschall instructed him to hand the artworks over to the French local authorities and, with the approval of Lefranc and Darquier de Pellepoix, the art soon headed to Paris, where the works were placed in the Dreyfus Bank—the Paris headquarters of the Commissariat Général—on 10 August 1943. Lohse recalled later, "However, word of the events which took place got out, and the impression persisted in French quarters that the collection had been confiscated by the Germans."[21] As historian Ernst Kubin noted, "The matter became too hot for Göring and he declared that he was no longer interested in any purchases."[22] The Schloss affair was also playing out at a time when Lohse was being elevated within the ERR Jeu de Paume facility, as he took over the Special Staff for the Visual Arts in early April 1943.[23]

The Schloss collection drew the attention of leaders of the highest rank not only among the Germans but on the French side as well. President Philippe Pétain and Premier Pierre Laval conferred and decided in late April 1943 to send the collection to Paris and proceed with its liqui-

dation.[24] Back in Germany, Hitler had been briefed about the paintings as well, and he believed that they could help fill important gaps in the Führermuseum collection. He even suggested in August 1943 that artworks confiscated by the ERR be traded for the desirable Old Masters in the Schloss collection, although this never came about.[25] Either Hitler or—more likely—Führermuseum director Hermann Voss appointed Dr. Erhard Göpel as the Führer's representative in the matter. Göpel was an authority on Dutch Old Masters and a sophisticated art historian who had studied under Wilhelm Pinder. He clearly understood the importance of the collection. Hitler's strong interest in the Schloss collection induced Göring to back off, and at a certain point in mid-1943, Göring issued an order prohibiting updates on the disposition of the collection.[26] With the Luftwaffe failing, Göring did not need any other entanglements.

After months of discussions between German and French officials, both sides agreed on a process. In October 1943, without the Germans present, French experts arrived at the Commissariat Général in Paris, opened the cases, and compiled an inventory. The French team included Louvre curators René Huyghe and Germain Bazin. After taking inventory of the collection, the two curators selected 49 works for the Louvre, including pieces by Jan Brueghel, Adriaen Brouwer, and Jacob van Ruysdael. They settled on a price of 18,975,000 French francs ($379,500 at the 1939 rate of exchange) as compensation, to be paid into a Vichy-controlled account.[27] Göpel and Lohse were the next to inspect the collection: the former representing Hitler, the latter serving the Reichsmarschall. Lohse was aware of Göring's statement that he did not want to purchase works from this collection, but he was keeping a lookout just in case. Göpel earmarked 262 works for the Führermuseum.[28] Lohse ultimately did not buy anything for Göring, who often backed away when affairs became too controversial, as he did later in 1944 with works seized by the Hermann Göring brigade from the abbey at Monte Cassino.

Even though Göring retreated, Lohse continued to play a key role in securing the paintings for the Germans. Rose Valland described the transfer of the 262 paintings that took place at the Commissariat General for Jewish Affairs on 2 November 1943: "The Schloss collection [was] returned to the Banque Dreyfus [the Commissariat Général, and] 262 paintings brought to the Jeu de Paume. Delivery of these paintings [was] in the presence of Darquier de Pellepoix, Lohse, Lefranc (responsible for the collection), and Dr. Erhard Göpel, who arranges painting deliveries for the Führer. Lefranc animates the reunion with vulgar pleasantries.

Darquier de Pellepoix utters niceties to Lohse. Lefranc leaves the Banque
Dreyfus with a painting under his arm."[29] The scene therefore featured
Lohse bantering with the Vichy minister for Jewish affairs while the loot,
after the agreed-upon reapportionment, was brazenly being carried away.
All this in an elegant Paris bank—a scene of occupation grandeur with a
hint of desperation, what with the Anglo-American invasion of Italy and
the reversals of the German armed forces post-Stalingrad. It was as if the
fruit was overripe.

In addition to the 262 paintings earmarked for the Führermuseum in
Linz, the Germans bought an additional 12 from the French state.[30] The
Germans agreed to pay 50 million French francs for these works ($1 mil-
lion in 1939 but today over $25 million), and deposited the funds in a spe-
cial account set up with French authorities.[31] This was a specious arrange-
ment in a sense, because the Germans were charging the French onerous
sums to pay for the occupation. The armistice agreement of June 1940
specified that the French would pay the Germans 20 million Reichsmarks
(400 million French francs or $8 million) *per day* to cover the costs of the
occupation.[32] With regard to this specific case, the members of the Schloss
family never received any compensation for their world-caliber art collec-
tion.

Whatever worries and dread the Germans may have felt about the
progress of the war after the division of the art at the bank in Novem-
ber 1943, they did not show any panic with regard to the art. The works
remained in Paris until the end of November 1943 when, with Lohse's
help, they were transported to Munich. He went so far as to travel ahead
to prepare for their arrival.[33] The Schloss paintings were housed in the
air-raid shelter of the Führerbau, the Nazi Party building where the Mu-
nich Conference about the Sudeten crisis had taken place in the autumn
of 1938. The structure also housed many members of the Führermuseum
Linz staff, including Friedrich Wolffhardt, who oversaw the library, and
Helmut von Hummel, who handled collections other than painting and
sculpture (those were run by Posse and Voss out of Dresden). The Führer-
bau and its counterpart across the street, the Verwaltungsbau (which later
served as an Allied Central Collecting Point in Munich), remained largely
unscathed by Allied bombs.[34]

Even before war's end, in April 1944, Rose Valland blamed Lohse for
the liquidation of the Schloss collection. She recalled a long conversation
with Lohse, after which she concluded: "It was Lohse who tried to orga-
nize the removal of the Schloss collection (clandestine removal by truck).

On the truck, there was an SS officer, one of his friends. This adventure had been attempted against the will of Göring, who had telegraphed him to stay out of this affair, that it did not interest him."[35] Valland portrayed Lohse as the instigator, but Lohse subsequently rejected these charges, maintaining that it was the Vichy officials who decided to liquidate the collection. Many others also assented to dismemberment of the collection, and many profited. After the war, Lohse admitted that he had taken control of a "certain number of works" that he had hoped to sell to Göring through Hofer and then offered to Maria Almas Dietrich.[36] There were rumors, Jim Plaut of the ALIU reported, that Lohse received three paintings from the Schloss collection as compensation for his efforts; the allegations stated that he acquired the works "in company with the dealer/agent Lefranc."[37] Lohse in turn denied receiving any works for his efforts in connection with the Schloss collection. Plaut may have been referring to three works that Lohse directed to Maria Almas Dietrich, including small-format works by Rembrandt and Judith Leyster. The episode turned sour for Lohse when Dietrich sold these latter two works to Alfred Rosenberg. The nominal chief of the ERR, ironically, did not significantly enrich himself from the looting agency, or at least not as conspicuously as others, and when he discovered the works' origins, he castigated Lohse, saying the works should have been offered to the Führermuseum.[38] The third of these pictures, a Dutch Old Master portrait of a woman, indeed went to Linz via Erhard Göpel.[39] The episode shows both the chaos and the corruption that characterized the division of the Schloss collection. In the 1950s it was discovered that the daughter of Vichy prime minister Pierre Laval had one work from the Schloss collection.[40] It is probably fair to say that both Lohse and Vichy officials acted as perpetrators in helping seize and disburse this Jewish-owned collection, and that both sides engaged in corrupt behavior as well. Lohse told me in 2001 that after the paintings were all packed up in November 1943 and ready for transport, he, his colleagues, and French curators went to a fancy French restaurant to celebrate: he recalls that they toasted their own "nobility" (*Ritterlichkeit*).[41] What this meant exactly is not clear, but Lohse always enjoyed sarcasm.

There are many reasons why the Schloss case was especially important: the complicity of the Vichy agents, the way in which the notion of an autonomous unoccupied zone in the south increasingly became a fiction, and the fact that many of the 262 works in the Führerbau were lost at war's end, when a mob of civilians looted the building. All told, some 723 pictures disappeared from the premises of the Munich repository.[42]

This occurred just before the Americans arrived to liberate the Bavarian capital. The GIs appear to have exacerbated the situation, with some soldiers taking "souvenirs." The Schloss collection pictures are among the most sought after by restitution experts. Right after the war, they were included in the seven-volume *Répertoire des Biens Spoliés*, the French catalogue of lost artworks, and in 1998, the French government went so far as to publish a book listing each work and providing an accompanying photograph.[43]

While Lohse saved certain Jews who proved helpful to him—Paul Cailleux and his wife, André Schoeller, and the Loebl brothers offer examples—his broader objective was to seize Jewish property, and the easiest way to do that usually involved arrest and deportation. In most cases, the fate of the owner had been decided before Lohse's arrival. But there were several occasions when Lohse witnessed or participated in the process of dispossession. When certain wealthy Jewish collectors appeared on his radar, he would monitor their situations—jumping in if the opportunity afforded itself. One important example concerns the Gutmann family: Fritz, Louise, and their two children, Bernard and Lili, who emigrated from Germany to Holland in 1918. Fritz Gutmann was the youngest son of the founder of the Dresdner Bank, and the Gutmanns were a prominent German Jewish family (although both Fritz and his wife Louise had become Protestants). Both of Fritz's sisters wed ambassadors and his cousin married the head of the German Rothschild branch.[44] Fritz, Louise, and family lived peacefully in a villa called Bosbeek outside the town of Heemstede near The Hague until the German invasion in May 1940. The family resided amid an array of treasures: paintings, furniture, and valuable objets d'art. The family trust also featured a magnificent collection of Renaissance and Baroque silver: elaborate and sometimes massive cups and ewers, and intricate, gleaming artifacts once the possessions of royalty.

The advent of war induced the Gutmanns to disperse their collections. Fritz sent some pieces to New York and Switzerland, and about thirty pictures (along with various sculptures and antique furniture) to Paris in the care of Paul Graupe et Cie.[45] This included a Renoir (*Apple Tree in Bloom*) and two works by Degas. Paul Graupe (1881–1953), a German émigré dealer who had a gallery on Place Vendôme near the Ritz, entrusted these and other works to the Paris storage and shipping company owned by Madame Wacker-Bondy. It was one of Graupe's last acts before he fled to America via Switzerland in 1939.[46] Despite having pictures in Paris, the bulk of the Gutmanns' collection remained in Heemstede.

The contents of the Gutmanns' house were bought jointly by Karl Haberstock and Munich art dealer Julius Harry Böhler (1907–79).[47] Haberstock, according to Simon Goodman, "presented Fritz with an offer that was a nonnegotiable demand. Sell me the paintings I want, at my price, or they will be confiscated as 'enemy property' . . . and you'll wind up with nothing."[48] Haberstock and Böhler purchased twenty-five paintings, including a prized Holbein and a Guardi, as well as scores of sculptures and objets d'art. The German dealers permitted the Gutmanns to remain in their home with some of their property until they received travel permits. With their high-level contacts, including an Italian brother-in-law, Senator Luca Orsini Baroni, who had previously been the ambassador to Berlin, Fritz and Louise Gutmann remained confident that they would be able to find safe passage out of Nazi-occupied Europe. On 31 March 1942, the Italian ambassador to Germany, Dino Alfieri, had written to Heinrich Himmler about the Gutmanns, and the Reichsführer-SS had replied in June, "According to your wishes, I have ordered my office at The Hague to leave Gutmann in his house and to exempt him and his wife from any kind of security police measures."[49] They appeared to receive safe passage out of German-occupied Europe; although Italy was still part of the Axis, in the first half of 1943 the Jewish population there was still faring better than most counterparts elsewhere in occupied Europe.

Yet not all was working in favor of the Gutmanns. Already in early 1941, Haberstock "managed to extort a letter from Fritz Gutmann addressed to the Paris art company allowing the German dealer to take possession of some of his best paintings held at Wacker-Bondy's in Paris. Haberstock took the Cranach and the Memling, among six other paintings."[50] Haberstock also used Erhard Göpel, who was based in the Netherlands, to keep an eye on the Gutmanns' Heemstede home and protect his interests.[51] As Haberstock wrote to Dutch art dealer Gustav Cramer in April 1943, "Everything that is in the house belongs to the Böhler firm and me."[52]

Lohse also turned (or returned) his attention to the Wacker-Bondy warehouse, a vast facility on the Boulevard Raspail where he had seized artworks before on behalf of the ERR.[53] It is not clear if he was searching specifically for the Gutmanns' artworks or just stumbled upon them while in the warehouse, but in an October 1942 raid he found the important cache of Gutmann pictures. Hector Feliciano wrote that Lohse seized Gutmann works at the Wacker-Bondy warehouse, but only after Karl Haberstock had been there, absconding with eight paintings.[54] Lohse and

his ERR accomplices removed the pictures they took without a receipt. When the Wacker-Bondy employees asked Lohse what they should do if Jewish owners came to them and asked for a receipt for the removed objects, Lohse responded, "Send them directly to us."[55] Of course he had no intention of providing the requested documentation. Lohse and his commandos took the artworks back to the Jeu de Paume, but thereafter many disappeared.[56] One work, a small Dosso Dossi painting, *Portrait of a Man*, ended up in Göring's collection. It was registered as entering on 25 November 1942, about a month after the raid in which Lohse participated.[57]

Another work from the Gutmann collection in Paris, a Degas pastel landscape titled *Landscape with Smokestacks*, became the subject of a high-profile lawsuit in the mid-1990s. The Gutmann heirs became aware that the work was in the Art Institute of Chicago—on loan from Daniel Searle, a wealthy pharmaceutical baron. Provenance research revealed that Searle had bought it from Margo Pollins Schab, a New York art agent, for $850,000. She in turn had bought it from Emile Wolf of New York, who had purchased it in 1951 from a Swiss textile merchant, Hans Fankhauser from Basel. The latter had acquired it from . . . Hans Wendland.[58] The date of this transaction—whether during the war or in the early postwar period, prior to 1951—is not known. But it is possible that Lohse was involved. Wendland was a key business contact for Lohse both during and after the war and may have obtained the Degas from him.[59] The Degas picture eventually became the subject of a creative compromise arrangement, an example of alternative dispute resolution, whereby the Art Institute of Chicago kept the picture, the Gutmann heirs received financial compensation, and the donor, Daniel Searle, received additional tax credit for the gift.[60]

With most of the Gutmanns' paintings seized and dispersed by the end of 1942, attention turned to their famed collection of silver objects. Lohse was emboldened after the earlier warehouse raid, which had proved profitable, and he now focused on the family's silver. Göring wanted this treasure and Lohse took it upon himself to deliver it. Fritz Gutmann had transferred all the shares in the Gutmann trust, which controlled the family silver collection, to his non-Jewish brother-in-law, Luca Orsini Baroni, and the silver itself was entrusted to Julius Böhler in Munich for "safe-keeping" in March 1942.[61] The task for Göring was to induce Fritz Gutmann to void the transfer: as Jewish property again, the silver could then be seized. In the spring of 1943, the Gutmanns believed they had

found a way to safety and finally undertook their journey from Holland to Italy, a trip for which they had so carefully prepared. They were provided with first-class tickets and escorted to the railway station for the journey to Florence, where their daughter Lili was living. Much of what happened afterward remains unclear. Fritz and Louise departed the Netherlands, wearing their finest clothes, but they clearly did not make their connection to Florence. Instead, they were taken off the train in Berlin. They were then interrogated.

Certain individuals close to Lohse in the postwar period indicated that the plunderer went to Berlin to inquire about the status of the silver collection. But this remains unconfirmed. According to Simon Goodman, who researched this chapter in his family's history with great care, his grandparents were met in Berlin not only by the Italian ambassador Dino Alfieri but also by "two civilian representatives, one from [Reichskommissar Arthur] Seyss-Inquart's office and the other from Göring's—their instructions were plain: obtain a release for the Eugen Gutmann Silver Collection" (recognizing that the silver legally belonged to the Gutmann family trust).[62] It is still unclear if Lohse was the representative referenced here and whether he participated in the Berlin interrogation of the Gutmanns. What is undeniable is that Fritz Gutmann was severely beaten during the Berlin questioning—and that Fritz did not sign a release for the family's silver. The Gutmanns were then sent to Theresienstadt, the fortress turned concentration camp thirty-five miles from Prague. They remained in Theresienstadt for about a year, but in April 1944, Nazi authorities again beat Fritz Gutmann—this time to death. He had refused to sign a document handing over his assets to the Reich. Two months later, on 1 July 1944, Louise, like most others incarcerated in Theresienstadt, was deported to Auschwitz, where she perished on arrival in a gas chamber.[63] The silver (and some gold objects) remained with Julius Böhler for the remainder of the war (he buried the Orpheus and Reinhold clocks on the grounds of his villa on Lake Starnberg just before the collection was to be delivered to restitution authorities at the Munich Central Collection Point). It is still not certain if Lohse participated in the interrogation of Fritz Gutmann in Berlin, or if he directed selected pieces of the family's property to Göring, but both appear distinctly possible.

Lohse also evidently played a role in the persecution of August Liebmann Mayer (1885–1944), a former curator at the Bavarian State Paintings Collection, specifically, the Alte Pinakothek, where he specialized in Spanish Baroque art. Mayer was forced to resign in 1931 amid allegations

that he had falsified certifications of artworks and profited from the art trade—neither charge was ever proven. The distinguished art historian immigrated to Paris in 1935 and did well writing expertises for the Wildensteins, for the influential British art dealer Baron Joseph Duveen, and even for Karl Haberstock, among others.[64] This enabled him to fill his apartment with valuable artworks. With the onset of war in 1940, Mayer, who was Jewish, fled to the unoccupied zone in the south of France, leaving most of his possessions in Paris. Lohse and the ERR seized most of Mayer's art in 1941, with select pieces directed to Göring. Other works disappeared, sold off by Lohse and the ERR staff. Works from this collection continue to be discovered and restituted some seventy years after war's end.[65] Mayer was eventually arrested in Monaco on 3 February 1944, when he was betrayed for money to the Gestapo by art dealer Louis Declève. To this day, Lohse's role in the persecution remains unclear. Lohse traveled to the south of France to interrogate Mayer, seeking information about other artworks.[66] The source for this is Erhard Göpel, who wrote to Hermann Voss, the director of the Führermuseum, on 20 February 1944 about the fate of certain works from the Schloss collection, which he was helping Bruno Lohse liquidate; Göpel wrote Voss about August Liebmann Mayer, or, as he called him, "the Jewish art historian in prison." Göpel continued in his letter, talking about a picture by Rogier van der Weyden: "I would appreciate it if the Sonderauftrag [the Führermuseum] could acquire it. The author of the expert opinion [Mayer] has now been arrested in Monte Carlo—on the same day as Dr. L[ohse] was there! I saw him [Mayer] in a hotel in Nice before his removal and he was allowed to remain there a week at my request and he gave me valuable information before being sent to camp Drancy (near Paris). He [Mayer] asked me to inform you of his fate with the request that you could perhaps put in a word for him at a higher level."[67] In other words, after Lohse interrogated Professor Mayer and pressured him to divulge information about the location of the remainder of his collection—which he did not—Mayer was sent to Drancy and then transported to Auschwitz, where he was murdered on 12 March 1944 (or so the date is given by French authorities).[68]

Erhard Göpel and the south of France figure in another episode in which Bruno Lohse may or may not have been involved. Among Göpel's closest friends was artist Max Beckmann, whose painting *A Bird's Hell* from 1937–38 sold in June 2017 for over $45 million, setting a record for a work of German Expressionism.[69] According to Beckmann's widow Mathilde or "Quappi" Beckmann, who wrote on behalf of Göpel and his

application to become a curator at the Bavarian State Painting Collections in 1954, the artist and the art historian shared a common bond.[70] In the postwar period, Göpel and his wife Barbara emerged as authorities on the artist, publishing catalogues and critical studies. Beckmann had emigrated to the United States in 1947 after spending a decade in Amsterdam, where he enjoyed one of the most productive periods of his life. During the war, the German authorities had permitted him to continue with his painting, and one of the works he completed in 1943 was titled *Dream of Monte Carlo*. According to the analysis of art historians Christian Fuhrmeister and Susanne Kienlechner, the two central figures in Beckmann's painting represent Göpel and Lohse.[71]

The two plunderers are rendered as threatening croupiers, each holding a dagger in his oversized hand. Göpel, on the left, and Lohse, on the right, are flanked by dark figures who appear to be knights in armor holding bombs with lit fuses. Fuhrmeister and Kienlechner interpret these figures as symbolizing members of the Dutch Resistance, who had blown up a population registration office in Amsterdam (used by the Germans to track down Jews) in late March 1943, around the time Beckmann created the work. The artist occasionally depicted members of the Resistance in his works, using their likenesses as part of his complex imagery. In *Dream of Monte Carlo*, one bomb-wielding terrorist's hands are on the shoulders of the Lohse character while the other slides his hands into the jacket pocket of "Göpel." The two croupiers, although they control the game, are shadowed by these dangerous figures. Beckmann suggests that members of the Resistance are watching these players—and are closing in. The croupiers handle what look like cards at first glance, but on closer inspection could be some other kind of symbol: Christian Fuhrmeister suggests they are more like miniature paintings. The Lohse figure at the right has red blotches of paint on his left hand covering the cards/paintings: seemingly a literal representation of blood on his hands. Further below in the canvas, Beckmann placed in the foreground a sultry woman with exposed breasts. She stretches out on the gaming table as she plays a card (holding it between her legs) with a black heart on it. This may be a reference to "horizontal collaboration" or some other transactional form of sex. The man crouching in the lower right of the picture bears a striking resemblance to Pierre Bonny (1895–1944), the collaborationist French police inspector who assisted Lohse in the seizure of the Schloss collection. The figure wields a mallet (*massu* in French), an instrument which the French Gestapo utilized to torture and kill. Regardless of the specific meanings, the

images come together in Beckmann's dark and critical picture: the game, the intrigue, the violence, the art, the glamour, and the sex, among other elements. Whether intentional or not (more likely the former), Beckmann captured the world of Lohse, Göpel, and their cohort during the war.

While there is some uncertainty whether Beckmann actually meant the figures to represent the two plunderers, it appears likely to be the case. The picture, which Beckmann completed in March 1943, was made at a time when Beckmann was not only close to Göpel but in many ways was reliant on him. Göpel brought the artist critical supplies of paint, canvas, and food, and transported both correspondence and artworks back to friends and dealers in Germany.[72] Göpel was also involved in the "transfer" of the Gutmann collection of art and other valuables from their estate, Bosbeek.[73] He assisted Haberstock and Julius Böhler in their acquisition of the Gutmann artworks—a process that played out in the spring of 1943, just prior to their transport to Theresienstadt. Even though this played out after the completion of the painting, Beckmann seemed to understand what was happening: paintings were being traded for lives. Fuhrmeister and Kienlechner have shown that Beckmann painted real-life figures in his works—often members of the Dutch Resistance. For security reasons, Beckmann often painted from photographs provided to him. The artist, known for obscure and difficult allegories, explored themes of cruelty and suffering, culture and barbarism, sex and power. Placing Göpel and Lohse in *Dream of Monte Carlo* would be consistent with his iconography. We know that Lohse traveled to the Netherlands on ten to fifteen occasions during the war, and that he was collaborating with Göpel on the seizure of the Schloss collection around the time the painting was made.[74] Lohse went to the south of France "on five or six occasions" in order to acquire works for Göring.[75] So it is likely that Beckmann had knowledge of Lohse, and that he knew of the latter's trip to Monte Carlo, even if Beckmann ended up relying on a photograph, as he often did.

The Train became the title of a 1964 film with Burt Lancaster and Paul Scofield dramatizing the events surrounding a moment of glory for the Résistance, when its members, Valland included, waylaid a German transport belonging to the Ministry of the East (Ostministerium). Valland was at the center of the efforts to prevent the departure of the train (or at least its contents) at the time of the liberation of Paris in late August 1944. First, she compiled a list of the paintings that would be shipped. She then contacted the head of the French railway workers' union, who was also in the Résistance, and secured his help. He informed her that the train

was headed for Abbeville and then on to Germany.[76] Valland called other members of the Résistance to help prevent the train's departure from the marshaling yard at Aulnay-sous-Bois. The train consisted of fifty-two wagons, the last three filled with art. There were twelve hundred paintings, including nearly the entirety of the Paul Rosenberg collection (Cézanne, Matisse, Braque, Picasso).[77] The pragmatic Germans were transporting "degenerate" modern art into the Reich, which revealed some level of desperation. Previously, they sent the "degenerate" works to Nikolsee in Czechoslovakia, a maneuver that gave them control over the works but allowed the more ideological types (who were not uncommon in Rosenberg's offices) to maintain that they were not importing the proscribed art into the Reich itself. In fact, Germans had privately transported modern art back to the Reich throughout the war. The "Schenker Papers," comprised of documents from the Paris office of the firm Schenker International Transport that were found by British Monuments officer Douglas Cooper in 1944, showed that works by Gauguin, Maillol, Pissarro, Seurat, Signac, Vlaminck, and Vuillard were shipped to Germany from 1940 onward. But this was done quietly.[78]

We do not know Lohse's precise role in the disposition of the train, but it appears to have been limited—by his own choice. Lohse was in Paris—at least sporadically—in August 1944. We know that Rose Valland was tracking him. On 9 August 1944 she wrote to Jaujard that Lohse had left Paris.[79] But Lohse came back on the 19th of August and would have been aware that the train had not yet departed. When Lohse met with Göring in Berlin on 13 August, the Reichsmarschall had actually issued an order freeing up Lohse and Walter Borchers so that they could offer "all possible support" to the "evacuation" of the ERR stockpile of art.[80] Alfred Rosenberg followed up the next day with an order placing Lohse and Borchers in charge of the shipment of ERR art out of Paris, calling them the "leading officials" (*Haupteinsatzführern*) in the matter. Despite the dual orders from Göring and Rosenberg, the two men were pushed out of the way by Colonel von Behr. They clearly were pleased to relinquish responsibility for the undertaking; otherwise they would have turned to Göring and Rosenberg and this would be documented in the files. It helped that the train that held the art belonged to the Ostministerium, which was not only part of Rosenberg's administrative empire but a ministry where von Behr had particular influence.[81] Ignoring Göring's and Rosenberg's orders, Lohse regarded the train as von Behr's problem. Instead, he focused on other challenges facing the few remaining ERR staffers, who continued to

evacuate their files to the Reich, while also trying to position himself as the war turned against Germany.

Colonel von Behr personally oversaw the train and worked to hasten its departure from Paris before the liberation of Paris, which finally played out by 25 August. Behr had also traveled to Germany in the summer of 1944. Rose Valland later gave him credit for having the courage to return to Paris to retrieve the art, but she stressed that he was motivated by greed (in her words, "personal profit").[82] The undertaking did not go well for von Behr. French workers repeatedly thwarted the Germans, as the train suffered all kinds of setbacks that prevented its departure. Members of the Resistance went so far as to pull up railway tracks, thereby blocking routes out of Paris. The Germans responded by making the repairs and the train headed out, only to return due to engine problems. Railway workers had sabotaged the engine, and they did the same with the air brakes, requiring the train to return to the station once again. The railway was just one sector among a widening general workers' strike in the days leading up to liberation. Police, postal employees, and civil servants, among others, halted work in an effort to stymie the Germans. The situation reached a climax as the Allied armies reached the outskirts of Paris. It would be too much to say that chaos reigned, but there was an air of desperation. The Germans had begun mining the bridges and monuments of Paris on 17 August 1944. In a now-famous incident, the commander General Dietrich von Choltitz disobeyed Hitler's orders to detonate the charges and Paris survived intact.[83]

Behr made one last push to set the train on its way. He commandeered a new engine, rounded up an adequate number of French railway workers, and threatened to have his troops shoot them if they did not cooperate.[84] Behr and his armed guards were actually aboard the train, making final preparations to depart, when a detachment from General Leclerc's French Second Armored Division arrived at the rail yard.[85] These were among the first Allied troops in the French capital. Word of the train had been sent to the Allies, and Jacques-Philippe Leclerc had dispatched a group of six volunteers commanded by Lieutenant Alexandre Rosenberg, the son of art dealer Paul Rosenberg.[86] It was a triumph for the French: saving their cultural patrimony as "they" liberated Paris. For Lieutenant Rosenberg, who boarded the train and helped open the doors to the cargo wagons, it was an even more emotional experience. In the words of his niece, journalist Anne Sinclair, "Alexandre had last seen [these family pictures] on his parents' walls at 21 rue La Boétie in 1939."[87]

Around the same time, in early August 1944, the German defense command in Paris ordered male employees of the ERR to make themselves available to defend the city on forty-eight hours' notice (at a time when most of the able-bodied men were already at the front). The ERR staffers may have manned other posts, but they did little to defend the Jeu de Paume. As James Plaut noted, "Headquarters of the Einsatzstab were abandoned well before the American entry into the city, the staff having effected a somewhat disorderly and hysterical evacuation of the premises."[88] And so ended the ERR operations in Paris in August 1944. Valland later suggested in her reports that Lohse was a coward—that by the 18th of August he was no longer at the Jeu de Paume or at the avenue d'Iéna headquarters but rather was looking out for himself.[89] She was undoubtedly correct. The Americans ascertained from the wife of the concierge at the building where Lohse had lived (3 avenue Matignon) that "the Germans left the building a few days before the liberation of Paris with a truck or trucks containing works of art."[90] Some of these likely would have "belonged" to Lohse. Lohse claimed after the war that he departed Paris "during the night of 18/19 August"—that is, about a week before the liberation of the city on 25 August—and that he headed to Brussels, where he had evacuated some of his personal possessions.[91] Presumably, these included artworks he had acquired on the side during his tenure in Paris. Lohse later told the Americans that these possessions "were lost in the transfer, and that he recovered nothing."[92] This statement must be viewed with skepticism.

As the Americans, British, and French approached Paris in August 1944, the German military ordered all male employees of the ERR to report for active military service. Lohse later claimed to be "apprehensive" about the order—perhaps not so much out of concern for his own safety (although that was probably also a consideration) but because he feared that the artworks controlled by the ERR would be endangered without guards. Lohse reportedly appeared at the Dienststelle Westen in Paris in the summer of 1944 to argue that the Rosenberg ministry should order all art experts to be withdrawn from the front so they could help care for the endangered art. He later reiterated this plea for, in a sense, more Monuments officers, in Berlin when he met on 13 August with ERR staff chief Utikal.[93] Lohse also expressed particular concern for cultural property in Normandy and in western France, recognizing the danger posed by the advance of the western Allies. Robert Edsel relates that "in late July, with the fighting at a critical stage, Lohse left for Normandy with a revolver stuck in his belt. His parting words were 'off to battle!' but when he re-

turned two days later, his truck was filled with chickens, butter, and a whole roasting lamb. There was even a big party at his Paris apartment."[94] The situation at the Jeu de Paume also grew dire as the Germans prepared to evacuate the facility. Walter Rehbock, who succeeded Lohse as head of the Paris operations, had left the city and not returned, and Walter Borchers, who had stayed on, had dismissed all the French workers.[95]

Lohse had left Paris for Berlin on 8 August 1944, and he remained in the Reich capital until 19 August, taking the time to consult with a variety of German officials to solicit their advice about how to wrap up the ERR operations in France. Lohse's desire to meet with his chief was stymied when Göring suffered a bout of angina, but after four days Lohse was eventually granted an audience on 13 August.[96] They were both aware that Paris was endangered, and Göring likely knew of Hitler's orders to General von Choltitz to destroy the city prior to the German withdrawal. But Göring did not support the draconian plan. A Reich Finance Ministry official named Arthur Garbas reported after the war that "Lohse communicated to me in a delighted manner that Göring had assured him that Paris would not be defended."[97] Lohse proceeded to return to Paris, determined to help preserve the city. He visited the ERR depot in the Jeu de Paume but found it largely empty, the contents being on "the train." There is no record of whether he saw Valland or not, but one assumes not. She was keeping a low profile during this dangerous last phase of the German occupation, and he was anxious to move on to other matters.[98] It is unclear what Lohse did during his last week in the French capital—whether, for example, he joined von Choltitz in opposing Hitler's notorious order—but after the war he took credit for, in Garbas's words, "having succeeded in saving the artistic treasures in Paris from destruction."[99]

Rose Valland, however, remained until the liberation. As Parisians rose up on the 24th, the Louvre was incorporated into the defense of the various German military and administrative headquarters in the luxury hotels on the rue de Rivoli. Fighting erupted around the museum, with machine guns and small artillery making it dangerous and noisy. A violent thunderstorm also broke at nightfall.[100] Valland and a few other colleagues hunkered down in the museum until General Leclerc's forces arrived the following afternoon. The crowds of delirious citizens celebrating their liberation represented yet another threat to the Jeu de Paume, as a mass of people engulfed the area adjoining the Place de la Concorde. Rose Valland had moved back to the Jeu de Paume to guard the collections stored in the basement. When she blocked people from entering, she herself

came under suspicion as a collaborator—a very serious predicament amid the passions of the moment.[101] Scholars estimate that about ten thousand French citizens were killed at war's end through purges and vigilante measures.[102] *L'épuration sauvage* could be a sudden and violent affair—lining up and shooting alleged collaborators. Valland was accused of harboring Germans and was compelled to lead a search party through the building— a gun pointed at her back the whole time.[103] Fortunately, she managed to clear herself, but she admitted later she was "sincerely delighted that no German soldier was found hiding there."[104] The endgame of the war was precarious for her, but she found her way and eventually secured a posting to the French First Army as a Monuments officer. Rose Valland traveled with the advancing Allied forces all the way to Germany and, after initially being based in Baden-Baden, she established herself as a key figure in the postwar French restitution administration.[105]

Bruno Lohse's war came to an end near the castle of Neuschwanstein in Füssen, the main repository (among six) of ERR loot.[106] In April 1945, Lohse returned to Neuschwanstein from Merano, Italy. The reasons for this trip remain unknown. Around this time, Lohse had an operation for kidney stones, and he may have gone to Merano either for the operation or as part of the recuperation. The concealment of art cannot be excluded since the SS stored looted art in a castle, called Schloss Labers, in Merano. Lohse returned to rural Bavaria on 2 April and recovered in a nursing home operated by nuns. The Bethanien Convent stood in the shadow of the Neuschwanstein castle, nestled below the Hohenschwangau mountain. At the castle, he found, among some ten other ERR colleagues, Günther Schiedlausky, his closest friend on the ERR staff. Schiedlausky and Lohse gravitated to one another and formed a kind of partnership as they prepared to surrender to the approaching Americans. The nominal Berlin chief of the ERR, Gerhard Utikal, and a number of the Berlin staffers had been at the Neuschwanstein castle a few days earlier, at which time Utikal had ordered "all ERR personnel to leave Füssen [Neuschwanstein] and attempt to escape."[107] Most had complied with the order, but Schiedlausky, nominally in charge, chose to stay in order to protect the stockpile of 21,903 artworks (10,890 of which were paintings, watercolors, drawings, and the like), plus the card catalogue and ERR records.[108] Lohse decided to stay with his comrade—he was still recovering from the operation and had no desire to take flight.

Lohse was nevertheless strong enough to travel to see Robert Scholz in Kogl, Austria. Scholz claimed after the war that he had received an

order from Dr. Helmut von Hummel, the adjutant of Martin Bormann, to blow up all the art secured in the occupied regions. Bormann was secretary to Hitler and head of the Nazi Party Chancellery—a kind of power behind the throne. But it is not clear the order came from Bormann, let alone Hitler. It may have been von Hummel taking the initiative, and indeed Scholz's postwar account may have been embellished to make him and his ERR colleagues look more heroic. Or the order may have stemmed from radical elements in the SS. After the war, an SS general (*Gruppenführer*) named George Ebrecht testified that he had been attached to a unit commanded by another SS general, Jürgen Stroop.[109] The latter has gone down in history as the commander of the unit that razed the Jewish ghetto in Warsaw (and then assembled a photographic report, *The Stroop Report*, for Reichsführer-SS Himmler). In the wake of the Warsaw operation, Stroop had been appointed the special delegate of Reichsführer-SS Himmler for southern Germany.[110] Ebrecht stated that he and Stroop were sent to Neuschwanstein at war's end with orders to prevent the artworks from falling into enemy hands. He understood this mission to include wiring the castle for destruction, a measure General Stroop appeared prepared to enact. Ebrecht testified after the war that as he was a painter by profession, he found Stroop's plans particularly objectionable.

Scholz himself caught wind of the various plans to destroy artistic treasures at war's end. He telephoned Lohse in Füssen and told him to come to him in the Austrian Alps, a distance of several hundred miles along often treacherous mountain roads.[111] Scholz handed over to Lohse the card catalogue and corresponding photos of ERR works seized in France, as well as key documents about the evolution of the ERR's mission. These records, Scholz knew, would be key to the restitution work that would invariably come after the end of hostilities. Lohse claimed in an interview at the Nuremberg trials after the war, "I rescued at least 20,000 photographs, against the order of Bormann, who had ordered us to destroy them; we brought them to Neuschwanstein."[112] Because these records constituted evidence of Nazi looting, it is plausible that Bormann issued such an order (as compared to ordering the destruction of the actual works). Transporting the *Kartei* and the photos required Lohse to make three trips to Kogl, where he removed the materials in installments from the local castle.[113] Lohse was ultimately able to relocate the records to the ERR repository in the Neuschwanstein castle, a measure that also protected against the possibility of a Red Army raid. The Soviets proved more destructive than the western Allies: their "Trophy Brigades" seized and transported to the

USSR an enormous quantity of cultural property. The Soviets had moved into Austria but would never make it so far west as Bavaria and Neuschwanstein. On the last of Lohse's three trips to Kogl, Scholz handed him a folder with key ERR documents—Hitler's authorization and Göring's 5 November 1940 "pecking order" document, among other materials—and made "the request that Lohse turn them over to the Americans."[114] Scholz also issued an order to Lohse, dated 24 April 1945, that stated in writing that under no circumstances should the artworks or the card catalogue be destroyed.[115] Scholz hoped the order would help Lohse contend with the radical SS forces intent on the destruction of the art, and also create a paper trail showing that the ERR staff really had tried to safeguard the cache. Orally, and confidentially, Scholz told Lohse that he had been ordered to destroy all the ERR materials (but not the actual art). Scholz reportedly said that this was "an order which he saw fit to ignore."[116] Most of the documents were published in 1965 in the *Vierteljahrshefte für Zeitgeschichte*, a prestigious German scholarly journal, just as historians were beginning to understand the Nazis' art-plundering programs.[117]

Robert Scholz had also been cognizant of the threat to the Altaussee salt mine repository—"a shelter for what was possibly the largest collection of Western art ever assembled" because it held treasures from museums in Munich and Vienna as well as most of the Führermuseum's contents. The local Gauleiter, August Eigrüber, who was also an SS general, had arranged for eight aerial bombs to be placed inside the mine—in huge wooden cases bearing the stenciled phrase, "Marmor, nicht stürzen" (Marble, don't disturb). These bombs would have buried the paintings deep in the mountainside, and probably unleashed a torrent of water that would have ravaged the thousands of artworks. Scholz managed to secure an order from Martin Bormann (through Helmut von Hummel) that said "the mine was not to fall into enemy hands, but care should be taken not to damage its contents." Scholz communicated this order to the local authorities in Altaussee (the mine director and a curator from Berlin), who arranged for local workers to remove the bombs. The following day, 4 May 1945, two trucks with SS men arrived and removed about two hundred paintings (including Titians and Dürers) and fifty tapestries.[118] They challenged the local authorities to stop them, which did not happen. After they left, the mine director and curator gave the order to seal the entrance in order to prevent further looting. They detonated smaller explosives, causing a limited cave-in, and the tunnel remained blocked until the American Third Army arrived a short time later.[119]

Lohse, along with Schiedlausky, evidently confronted the SS troops that arrived at Neuschwanstein just before war's end. George Ebrecht said that he and General Stroop met with the two art historians.[120] According to Ebrecht, Stroop produced an order from Himmler to carry out the necessary measures, including the demolition (*Sprengung*) of Neuschwanstein. After inspecting the castle and its contents, Stroop ordered that the art stored there should be removed to the Alpine huts (*Almhütten*) in the surrounding hills. Lohse told them an evacuation was impossible — there were too many works and conditions were adverse, with significant snow still on the ground. He also warned against harming Neuschwanstein, which he deemed "a national monument." Ebrecht recounted that he and Stroop backed off and moved on, trying to avoid capture by the Allies. Ebrecht credits the "sharp protests" of Lohse with helping save Neuschwanstein, the ERR-looted art, and the ERR card catalogue. He said Lohse, in taking this stand, risked his life. Of course, Ebrecht's testimony came after the war when he was imprisoned by the Americans at Dachau, which had become a detention center. Ebrecht knew that his testimony was intended for Lohse's denazification trial, and thus his account must be treated with considerable skepticism.

Moreover, General Ebrecht's narration does not jibe entirely with other accounts. As the Americans approached, Lohse's courage failed him. He and Schiedlausky fled the castle and took refuge in a nearby nursing home. A friend of Lohse's in the postwar period stated that Lohse was not a hero: "He sat on a wall, feeling nervous and with his feet dangling, wondering who would arrive first — the SS or the Americans."[121] Fortunately for Lohse, it was the latter. The American Monuments men who inspected Neuschwanstein had received a tip about Lohse's whereabouts. On 4 May 1945, Captain James Rorimer and Lieutenant John Skilton made their way to the convent turned nursing home, where they found the two German art historians sitting in the garden. Rorimer, who along with Rose Valland had visited Lohse's apartment in Paris in late August 1944, just after Lohse had fled the French capital, and who had seen photos in Valland's possession of Lohse with Göring, von Behr, and others, had effectively tracked the Nazi plunderer hundreds of miles across western Europe. Lohse at first maintained he was merely a corporal in the Luftwaffe, which technically was true.[122] Of course, Rorimer saw through this ploy and arrested Lohse, along with Dr. Schiedlausky. The plunderers put up no resistance. John Skilton recounted in his memoirs, "We took Lohse away with us in our jeep and placed him in the local jail at Füssen. When he left the nursing

home to get in the jeep, I was interested to note that the book he carried with him was a French work on Jeanne d'Arc."[123] The episode is telling. Lohse was already crafting an image to project to the Allies. Here was an educated man, with a love of art and a sincere interest in French culture.

There are indications that Lohse had much to conceal. A fellow ERR staffer told American Monuments officer Edgar Breitenbach that "Lohse, in connivance with Schiedlausky, had hidden in the ground during the night of 28–29 April 1945 two medium mixed metal containers. . . . The two boxes, he believes, contained 1) the correspondence between Goering and Rosenberg, and 2) small paintings by Dutch Old Masters."[124] The informant went on to say that "he thinks that Lohse has paintings still hidden somewhere," and reported seeing Lohse coming down a mountain near Neuschwanstein three years later—"in the early morning hours of 29 April 1945"—"carrying a spade in his hand."[125] The informer was not entirely reliable, as Edgar Breitenbach made clear in his report to Rose Valland, but he provided quite an image: Lohse coming down a hillside with a shovel. The question remains what he did with the spade prior to taking his place on the wall at the nearby convent. This is among the questions that remain about Lohse, but once Captains Rorimer and Skilton arrested him on 4 May 1945, the war had come to an end for Bruno Lohse. In fulfilling their duties as Monuments officers, Rorimer and Skilton also secured the ERR *Kartei* from Paris as well as the cache of documents detailing the ERR's history. The latter were immediately translated into English and used by the OSS officers who sought to understand the history of Nazi looting, while the card catalogue proved instrumental in the actual restitution process.[126]

Called to Account (1945–50)

HOUSE 71 IN ALTAUSSEE—in this Alpine village, as in many others in Europe, houses were simply identified by a number and featured no street address—appeared a conventional, if stately, home. The town of Altaussee had always attracted the nobility and the *grand-bourgeois* from Vienna and other parts of the Habsburg Empire, and this small villa harkened back to a more glamorous era. At war's end, Haus 71 served as the ALIU's primary interrogation center, and in the summer of 1945, it held approximately a dozen of the most prodigious art plunderers in history: Kajetan Mühlmann, who had looted in Vienna, Poland, and the Netherlands; dealers Karl Haberstock, Walter Andreas Hofer, and Gustav Rochlitz; museum directors such as Ernst Buchner of Munich and Hermann Voss of the Führermuseum in Linz. Bruno Lohse was also there, and from 15 June until 15 August 1945, he took turns answering questions posed by James ("Jim") Plaut, Theodore ("Ted") Rousseau, and S. Lane Faison, although he spent more time with Jim Plaut, as each ALIU officer took special responsibility for specific detainees, and later drafted those individuals' *Detailed Interrogation Report*. There were translators on hand: American policy was to conduct all interrogations in English but the detainees, even when they had a facility with English, almost always spoke in German.[1] After the war, however, Lohse spoke French with Faison and German with Rousseau and Plaut, the latter two being fluent in Lohse's native language.

Lohse initially made a favorable impression on the Americans, espe-

cially James Plaut, who wrote, "The apparent candor of his statements and the directness of his answers have at all times impressed his interrogators favorably. On no occasion has he attempted to deny his personal responsibility for acts committed under orders as a member of the Einsatzstab Rosenberg, nor has he shown any inclination to minimize the significance of his activity on behalf of Goering. His statements concerning colleagues and business associates . . . appear to have been made truthfully and without bias."[2] Lohse was treated respectfully, as a member of a kind of exclusive club—that is, as a recognized figure in the art world. He, in turn, showed his best side and was charming, helpful, and professional. Plaut recalled later that Lohse's "knowledge was encyclopedic and, hoping to please his captors, he held nothing back."[3] But there were limits to the extent to which he could repair his reputation. Plaut added sympathetically, "Whereas Lohse appears to have been victimized in larger measure by the jealousy of his colleagues, there can be no doubt that he played a leading part in the confiscation of Jewish art properties conducted by the Einsatzstab Rosenberg in Paris."[4] The "victimization" here came in the form of fraught interpersonal relations—including a dissatisfaction with his leadership; Plaut did not really place Lohse in the category of victims.

Lohse, of course, also put his own spin on his account of wartime events. It did not hurt that his secretary in Paris, Erna Steubner, whom he described as "a remarkably efficient individual," seems to have disappeared at war's end. She was last seen with other ERR staffers in Füssen in April 1945. Steubner knew a great deal about his affairs—certainly professionally, but also probably personally. The Americans tried to locate her to no avail. Plaut wrote with regard to Steubner in August 1945, "present whereabouts unknown; recommend for interrogation."[5] She did not surface in time for the Americans, who wrapped up their work in 1947, to utilize her as a witness. Other witnesses contradicted parts of Lohse's testimony, but at least he did not have his chief aide refuting his answers.

When the ALIU officers completed their interrogations in Altaussee in September 1945, they appeared ambivalent about Lohse. While he impressed them, they retained doubts about the veracity of his accounts. Plaut and his colleagues took the approach that more research was needed, suggesting in one document that Lohse's "own participation in German looting be considered in the light of any judgment brought against the ERR as a criminal organization."[6] They also recommended that Lohse "be held as a material witness in the Goering and Rosenberg trials."[7] Plaut

concluded his report on Lohse in a similar vein: "If Lohse's statement that he received no personal profit whatsoever from the transactions conducted on behalf of Goering is finally confirmed, his activity for Goering may be regarded in the same light as his duty with the ERR—namely, the performance of an assignment under orders."[8] The ALIU team members realized that they did not know the whole story about Lohse. They wanted to keep him in American custody as the investigation continued. While most of those incarcerated in Altaussee at Haus 71 were transferred to the Freising prison located just north of Munich, Lohse, along with Walter Andreas Hofer and Karl Haberstock, was sent to Nuremberg. Interestingly, they sent Mühlmann back to Austria—to the Civilian Internment Camps in Peuerbach near Linz—rather than bring him to Nuremberg.[9] They did suggest that Mühlmann be "placed at the disposal of the French, Polish, and Dutch Governments in connection with restitution."[10] The most prolific of the Nazi plunderers (Mühlmann) was therefore absent from the proceedings of the International Military Tribunal (IMT). It is all the more striking that Lohse was there. This spoke to his stature in the Nazi-plundering agency, to the relationship he had with Göring, and to the nature of the information he possessed.

Lohse therefore joined some 250 Nazis, suspected war criminals, and complicit witnesses in the three-tiered prison that abutted the Palace of Justice in Nuremberg. The Americans scrambled to refurbish, and to some extent reconstruct, the imposing structure, one of the few large enough to house the coming International Military Tribunal. German POWs, some reportedly still wearing SS uniforms, were enlisted to help make the repairs—even as the Nazi leaders and certain of their accomplices sat inside.[11] While the most senior Nazi leaders, including Göring, Rosenberg, and von Ribbentrop, had their own cells, in which they were guarded round the clock by Allied guards wary of suicide attempts, those lower in the hierarchy were forced to share an enclosure with others. Lohse recalled in 1998 that Gauleiter August Eigruber, the radical Party leader for the Upper Danube region who had arranged for the aerial bombs to be placed in the Altaussee mine, was in his communal pen for a time. Lohse said they stayed out of each other's way.[12] Eigruber's postwar trial by the Americans before the Dachau Military Tribunal resulted in a death sentence. He was executed at the Landsberg prison in Bavaria in May 1947.

While in Nuremberg, Lohse reconnected with Göring. The Reichsmarschall was permitted to interact with the other prisoners in the exercise

yard, and this gave the two ample opportunity to talk.[13] On 1 November 1945, Lohse was subjected to a one-hour interrogation by U.S. lieutenant colonel Thomas Hinkel, who asked some tough questions.[14] Why Göring hadn't paid for the ERR works was one of them. Yet Lohse had an elaborate explanation: Göring had tried to pay, but neither Rosenberg, Nazi Party treasurer Franz Xaver Schwarz, nor anyone else would accept the money. Back in May 1945 when James Rorimer arrested Lohse and told him that the Reichsmarschall had never paid for the pictures and other objects he took (despite "absurdly low prices"), Lohse had reportedly been "disillusioned."[15] But now, in his interrogation at Nuremberg, he provided a sophisticated response. Clearly, Lohse and Göring shared defense strategies. Göring's attorney, Dr. Otto Stahmer, planned to call Lohse as a witness in an effort to address the charges of art looting, but in the end decided not to: as Stahmer told the court on 22 March 1946, "I abstain from calling Dr. Lohse because the defendant [Göring] has in my opinion already made sufficient statements on that subject."[16] With this decision, Lohse was deprived of his moment on the grand stage of the Nuremberg trials. But he could say that he had been prepared to do so, and Göring recognized this.

Lohse in turn asked his former chief for a letter that would exonerate him of charges that Lohse had profited from his activities or done anything illegal. Göring dated this letter 20 April 1946—Hitler's birthday and the first since his death, a date surely noted by both Göring and Lohse. The statement read,

> I drafted Corporal Dr. Bruno Lohse as a scientific colleague to the art staff of the ERR. Dr. Lohse was a soldier until he was taken prisoner. His last unit was to the liaison staff of the parachute regiment Hermann Göring in Berlin-Reinickendorf. Dr. Lohse repeatedly asked me to be declared fit for active service instead of extending his tenure at the ERR. He was named the liaison between me and Colonel Baron Kurt von Behr of the German Red Cross, the chief of staff of the ERR. The task of Dr. Lohse extended exclusively to the acquisition of art objects that were offered on the open market. He had no authority to conclude independent purchases and did not earn any money from his activities on my behalf. The commandeering of Dr. Lohse did not extend to the Dienststelle Westen of the Ministry for the Occupied Eastern Territories.[17]

This letter was intended to exonerate Lohse, and Göring did so by blaming von Behr, who was already dead. As the Americans had closed in on him at his castle, Schloss Banz near Bamberg, he and his English-born wife—Joy Clarke (the daughter of Godfrey Clarke) had consumed cyanide-laced vintage champagne (1928, a very good year) in crystal glasses as they embraced one another, supposedly an aristocratic form of suicide.[18] Göring also stressed that Lohse was drafted, suggesting that he was only following orders. Lohse also utilized this now-infamous approach associated with the IMT, alleging that it was von Behr who was "responsible for all the confiscations."[19] Of course, the "just following orders" defense was rejected by the justices at the IMT, but it was worth a try. Lohse undoubtedly guided Göring in the drafting of the letter, and the assertion that the dealer had no formal position within the ERR helped propagate a fiction that Lohse maintained the rest of his life. He kept this letter from Göring in his possession until his death. It ranked among his most treasured mementos and he looked at it, as well as old photos and other documents, on an almost daily basis in his old age. That Göring had touched this letter (it is typed, but signed by Göring in his own hand), and that it was written so close to the end of his life, made it a kind of sacred relic for Lohse. It is notable that there were no letters from Alfred Rosenberg in Lohse's extant papers. Lohse never viewed himself as part of Rosenberg's camp and in his testimony at Nuremberg, Lohse placed much of the blame on the ERR's namesake.

When the ALIU officers dropped Lohse off in Bavaria in mid-September 1945, they had a relatively positive impression of him; however, as they spoke with others, their views changed. In January 1946, while Lohse sat in a military prison in Nuremberg—at the disposition of the U.S. chief of counsel—Plaut and Rousseau wrote, "Recent investigations in Paris have revealed that some of the subject's original declarations were false and that he made deliberate omissions in his testimony. Documents have come to light signed by him as an SS officer. French witnesses who were in contact with him during the period of his activity in Paris now contradict many of his statements."[20] Plaut continued, "The solution of the Lohse case and the truth concerning the organization which he represented cannot be obtained without further interrogation. Such interrogation should be carried out in Paris, where subject can be questioned by individuals who were present at the time of his activity. . . . It is the recommendation therefore of the undersigned that the subject be turned over to the French services concerned with the investigation of

German looting."[21] The recommendation they published in May 1946 in the *ALIU Final Report* was more succinct: "Recommended for transfer to French custody for further interrogation and confrontation with French accomplices."[22] It is therefore striking that Plaut and Rousseau endorsed, and perhaps even precipitated, Lohse's transfer to French custody in early 1946 (even though this would not happen for nearly another two years). They would eventually take a very different view of Lohse's imprisonment by the French, although they continued to grapple with what James Plaut called "the whole Lohse question."[23]

Lohse's transfer from American to French custody was more easily recommended than arranged, especially because most of the ALIU officers were in the process of demobilizing during the first months of 1946, and those few who remained largely ignored him. Lohse sat idly in a Nuremberg prison as Göring cheated the hangman with cyanide and the other Nazi leaders condemned to death were sent to the gallows in October 1946. He was then transferred to a Civilian Internment Enclosure in Dachau, just outside of Munich—which he described as a *Dachauer Bunker* in a letter to Karl Haberstock the day before his transfer to France in January 1948.[24] Lohse suffered health problems at this time, including an acute kidney condition that required an operation at the clinic of the Dachau facility in July 1947, and this only added to his misery.[25] That same month, a French judge transmitted a report on Lohse to a magistrate, thereby initiating judicial proceedings in France.[26] Although it took six months to secure Lohse's transfer, the French got their man. Lohse was supposedly transferred to French custody "after a long ride across France in an unheated Jeep."[27]

After Lohse's extradition in January 1948, the French incarcerated him in the Cherche-Midi prison in Paris. The nineteenth-century facility located on the Boulevard Raspail on the Left Bank had once housed Captain Alfred Dreyfus. During World War II, the Germans had used it to incarcerate political enemies. It was conveniently located across the street from the Hôtel Lutetia, which served as the Paris headquarters of the Abwehr counter-espionage operations. The notorious prison, which was torn down in the mid-1960s, consisted of some two hundred cells meant for solitary confinement. Lohse later described the conditions as harsh. In 1947, French authorities had transformed the prison into a military courthouse and, in the process, transferred most of the inmates to other facilities. Nevertheless, Lohse, Wendland, and the few remaining ERR staffers still in custody stayed on in the stone-clad prison on the Left Bank. Lohse

had little to eat, despite receiving care packages from a Berlin-based organization that aided German prisoners of war who remained incarcerated. A French priest named Professor Michaelis, whom Lohse came to like and trust, delivered these packages to him.[28] He also developed a regular correspondence with one of the organizers of the prisoner aid society, Dr. Margarethe Bitter, to whom he wrote highly emotional letters in which he admitted his "deep depression" and his longing to return to Berlin.[29] One such missive, written in the Cherche-Midi prison on New Year's Eve in 1949, began, "As the bells of Notre Dame ring in the new year, I will think of the five years spent in a narrow cell and the kindness you have shown from your station in faraway Berlin, and send sincere thanks for the great joy with which you have improved this past year."[30] These often-poetic letters grew out of some kind of inner need, although Lohse was also documenting his harsh conditions. He wrote of suffering in "an unheated cell" and having only a "broken pen with which one could hardly write."[31] Of course, it is impossible to prove that the wily opportunist crafted his letters with future benefits in mind, but he later received compensation from the German state for having been a French POW.[32]

Lohse, along with five other ERR staffers, faced charges before the Second Military Tribunal of the Seine (Paris) on the charge of violating article 221 of the Code of Military Justice, which brought with it penalty of ten years' imprisonment for pillaging during a time of war.[33] The French authorities, relying on Rose Valland, had investigated twenty-seven ERR staff members, but only five were still in detention in October 1947 when the charges were brought.[34] Six individuals were charged as participating in the ERR's plundering of cultural property, including Lohse, Professor Georg Ebert (1898–?), who had plundered libraries in Paris and then served for a time as ERR staff director in the Berlin office; his successor Gerhard Utikal (1912–82); and Arthur Pfannstiel (1901–84), a painter and art dealer who had lived in Paris for years. Pfannstiel had married a French woman, and the pair had a deep knowledge of the French art world. Pfannstiel reportedly furnished von Behr with the names of Jewish collectors and later in the war worked as an agent for the SD.[35] These four ERR staffers were the only ones physically present at the trial. The other two who had been charged—Robert Scholz and Walter Andreas Hofer—were not compelled to attend and were tried in absentia. The hapless quartet of ERR staffers appearing in the dock in Paris made for a rather pitiful spectacle.[36] Pfannstiel even had his head wrapped in a white gauzy bandage, which only heightened the effect. French press reports stated that Pfann-

stiel suffered from a liver ailment, but did not explain the head bandage.[37] The trial documents show that the French knew they were missing many culpable individuals: in one list of ERR personnel, the words *en fuite* (on the run) appear time and again; this applied to Lohse's SS lackey Walter Fleischer as well as to Walter Borchers.[38]

Robert Scholz and Walter Andreas Hofer, like most Nazi art plunderers, spent little time behind bars. Scholz had been interned for two years and then gone underground—at least temporarily. This was also the case for Hofer, who was then living quietly in Unterstein bei Berchtesgaden on the Bavarian-Austrian border (near the Berghof complex, in fact). Hofer claimed in 1951 that the French had never contacted him either before or after the trial (he said he learned of his sentence from an article in *Le Figaro*).[39] Yet French authorities put out a warrant for Hofer, and it is clear from the documents of the Paris Military Tribunal that authorities had his precise address (he lived in Haus Maria-Martha, a village so small the houses were named, not numbered). Hofer had spent a great deal of time at the Munich Central Collecting Point in the late 1940s and had for the most part won over the Americans.[40] He had never been a member of the Nazi Party or a Nazi agency, like the ERR.[41] The efforts made by French authorities to pursue him in 1950 were desultory, and Hofer never faced any justice in France.[42] The same applied to Robert Scholz; although French authorities had his hometown address in Olmütz and his postwar address in Fürstenfeldbruck outside of Munich, he evaded the French court.[43] Neither the French nor the Americans (nor the nascent West German administration) lifted a finger. Hofer and Scholz also sailed through the denazification process in the American Zone of Germany in 1948, with Hofer declared a "fellow traveler" (category IV) and Scholz exonerated (category V).[44] Lohse knew that most of his cohort had avoided justice and it embittered him that he remained in a French prison. In much the same way, he lamented years later that he was the last of the looters still alive and had to answer for them as well as himself.

Lohse remained imprisoned in France for about two and a half years, from 28 January 1948 until 4 August 1950. In the spring of 1950, he was transferred to a penitentiary in Fresne on the southern edge of the French capital, which he claimed in one of his letters to Margarethe Bitter was the largest in France (it housed some two thousand prisoners, among whom only seventy-five were German).[45] Lohse later recounted that he once succeeded in escaping into the countryside. However, he found that he could not obtain food and he was weak from an extended period of malnourish-

ment. He therefore returned to the prison and turned himself in. Allied officials investigating Nazi art looting continued to interrogate him, although less frequently. On 11 May 1948, for example, several Dutch investigators arrived to ask him about his friend Amsterdam dealer Jan Dik Jr. Lohse appeared to cooperate, confirming his purchases for Göring and stating that Dik knew the works he sold were being shipped to Germany.[46] The Dutch investigators wrote up Lohse's statement, which he signed, and it was entered as evidence in Dik's trial. Jan Dik Jr. ultimately was arrested and released three times; he fled the Netherlands, first to Munich, and then to Vevay, a town on Lake Geneva near Lausanne in Switzerland. He set up an atelier there and lived undisturbed well into the 1980s.[47]

Lohse, for his part, languished in his cell, complaining in a letter to Theodore Rousseau in July 1948 that he had seen his lawyer only three times during the past six months.[48] Probably the only consolation was that he forged a better relationship with Hans Wendland, who spent one and a half years with him in the Cherche-Midi facility.[49] Although the two men had met in 1942 and participated together in several exchanges involving ERR loot, they had a much better opportunity to get to know one another while incarcerated. Indeed, they shared a cell for several months.[50] In 1998, when Lohse's memory was still quite good, he exhibited precise knowledge about Wendland's life. The latter had worked at the Kaiser Friedrich Museum in Berlin before World War I, but had been dismissed for stealing objects and then pilfering Persian artifacts while on an excavation; he had gone on to serve in the German army in 1914 and had been wounded; he had made a fortune in the Soviet Union in the 1920s while attached to the German embassy in Moscow as he took advantage of Stalin's sales of national treasures; he had married a much younger woman (twenty-eight when he was sixty-three in 1943), and they lived in the best hotels in Europe (mostly Switzerland); and Wendland had worked as a dealer after the war.[51] Perhaps unsurprisingly, their time in jail together may have fostered future criminal activity, as Lohse and Wendland appear to have collaborated in postwar deals involving looted art.

The French authorities slowly but gradually collected evidence for Lohse's trial. As noted above, the most damaging witness was Rose Valland, who had earlier recommended Lohse's transfer from Nuremberg to France. The curator and Resistance member turned restitution expert had strong feelings about Lohse. As Lohse explained to Rousseau in a letter of 1 March 1949, "Mademoiselle Valland declared that it was I who was responsible for the affairs of the ERR for the simple reason that

she always saw me with my colleagues and because I always had shown a zeal for Göring. My friendship with Göring was certainly a source of the blame. Another source of the blame was that I had discovered the Schloss collection. You know very well that . . . the collection had been seized by the Vichy Government."[52] Valland's damning deposition certainly caused great difficulties for Lohse and most likely prevented an early release on bail. She was not only already a legendary member of the French Résistance but also, with her precise, bookish ways, a credible witness. Lohse, it seems, was present when Rose Valland issued her accusations. Rousseau wrote to Plaut in March 1949 that he had received "another lengthy letter from Lohse himself with an account of his confrontation with Mlle. Valland."[53]

There is no doubt that Lohse resented the recognition Valland received after the war. She was awarded the Légion d'Honneur and the Médaille de la Résistance by the French state, as well as the U.S. Medal of Freedom, and was generally celebrated as a national heroine.[54] In fact, she became a legendary figure, her deeds portrayed in the 1964 John Frankenheimer and Arthur Penn film *The Train* (the character Mademoiselle Villard is largely based on her) and then again in George Clooney's 2014 *Monuments Men* where, as noted earlier, Cate Blanchett played the Valland character. In short, Lohse thought Valland unduly honored. It is also important that Valland proved instrumental in keeping Lohse behind bars longer than almost any of his cohort. The documents involved in Lohse's 1950 trial before a Parisian Military Tribunal were unsealed in late 2015. Located in an archive on a military base in the town of Le Blanc, south of the Loire Valley, the trial materials show Valland's central role in Lohse's prosecution. She had returned from her work as a Monuments officer in Baden in order to participate in the investigation of Lohse and the other ERR staffers. The records include dozens of protocols of the interrogations signed by both Valland and Lohse (each party had to sign every page). There was an intense spell of questioning in late December 1948, as she tried to make Lohse answer for his wartime deeds.[55] While some observers, such as journalist Yves Stavridès, believe that Lohse and the other art plunderers and complicit dealers got the better of Valland and the Allied Monuments men—Stavridès points out the latter had no police training and no knowledge of how to conduct interrogations and were thus easily duped by the likes of Lohse—the fact is that Lohse and the other ERR staffers sat in jail for five years. Lohse was also rankled by the fact that the French government had decorated two German officers from the

Kunstschutz Unit (the army's art protection squad)—Count Franz von Wolff Metternich (1893–78) and his successor Bernhard von Tieschowitz (1902–68)—recognizing their efforts to safeguard art and mitigate the damage done by the ERR. They had been awarded the Légion d'Honneur.[56] Lohse's case for his exoneration rested upon the cliché that he was just doing his duty; the ERR confiscations were mandated from the highest level of government, and it was Lohse's misfortune that his job differed somewhat from that of Count von Wolff Metternich and von Tieschowitz. Moreover, Lohse, the bourgeois Berliner, was offended that the two aristocrats emerged from the war as they did. Bernhard von Tieschowitz, for example, became a member of the West German diplomatic corps and returned to Paris in the 1960s as the cultural attaché at the German embassy; and von Wolff Metternich served as director of the Bibliotheca Herziana in Rome, a renowned research institute for the study of Italian art history, from 1952 to 1962.[57]

Rose Valland, however, may not have been correct in all her assertions. For example, she wrote to Jaujard on 23 July 1943 that ERR personnel had burned between five hundred and six hundred modernist paintings in the Tuileries gardens.[58] More specifically, she wrote in a wartime account, "The massacred paintings housed in the Louvre were brought back to the Jeu de Paume (an outdoor oven, approximately five or six hundred [pictures]) and burned under the watchful eyes of the Germans in the garden of the museum between 11 a.m. and 3 p.m."[59] While Valland's contemporaneous account of the burning is important in terms of determining what actually transpired, she did not reiterate the story until much later—in her 1961 book, *Le Front de l'Art*—and when she did, there were discrepancies in the date of the event.[60] Her wartime report was dated 23 July 1943, while the date in her book was 27 July (and in the first edition, she mistakenly stated 27 May—a date she corrected in subsequent editions).[61] The precise date aside, journalist Michael Gibson summarized her vivid postwar account: "A dark pillar of smoke rose over the Tuileries Gardens throughout the day. An armed sentinel stood watch over it, and a number of men kept the fire briskly burning, while others carried the mutilated remains of the condemned works and fed them to the flames."[62] Valland also produced a list, or a partial list, of works she believed were burned in the auto-da-fé: pictures by lesser-known artists like "Lowell" and "G. Michel," but also works by Picasso, Paul Klee, and Max Ernst (Valland's list has thirty-two entries).[63] Additionally, the chief of personnel for the gardens of the Musée de France, Gaston Petite, provided an account of the immolation.

Petite also described the selection of the actual pictures to be destroyed, and claimed to have seen pictures by Manet, Sisley, and Picasso among the condemned. Historian Emmanuelle Polack is among those who believe that the ERR staffers burned artworks in the Tuileries that July.[64]

While Rose Valland was generally a reliable witness, this bonfire may never have occurred. ERR staffers Robert Scholz and Walter Borchers responded vigorously to the charges of burning art in the Louvre gardens in the early 1960s, when the allegations first surfaced publicly in the German journal *Das Schönste*. Scholz and Borchers rebuked Valland for her "fantasy-filled constructs" (*fantasievollen Kombinationen*), maintaining that only packing boxes and some damaged frames were burned on that one occasion. They characterized the incinerated items as "completely worthless things."[65] They also arranged for attorney Konrad Voelkl, who defended many former Nazis (including Lohse), to write to the publisher of the journal, Wilhelm Arntz; Voelkl pointed out that the French Military Tribunal that tried the ERR staffers had paid no attention to the charge of burning artworks.[66] This burning of damaged frames and packing materials may have been what Valland saw, and it would then be understandable that she construed the scene as she did. But the charge of destroying creations by Picasso, Miró, and Paul Klee, among others, is a very serious one and may have been leveled too hastily.

One intriguing possibility has been offered by Hildebrand Gurlitt's biographer, Susan Ronald, who suggested that the burning of materials served as a cover for graft on the part of Lohse and other ERR personnel.[67] Valland and the other French employees at the facility were *meant* to believe that the Nazis had yet again resorted to barbarism, when in fact the conflagration was a means of embezzlement—a tactic of self-enrichment.[68] There are other instances where the ERR card catalogue listed works as "destroyed"—only for the work to turn up in a French museum: such was the case of three works belonging to Fédor Löwenstein that are now in the care of the Musée des Beaux-Arts in Bordeaux.[69] It may have been that the burning of boxes, broken frames, and perhaps even artworks took place in an oven (*camion*), which was the wording of Valland's original report. This more controlled environment could have transpired without the notice of professional firefighters: Dr. Didier Schulmann, a curator at the Centre Pompidou in Paris and an expert on restitution, has studied the matter and he does not believe that genuine artworks were incinerated. As Schulmann noted when I met him in a café across the street from the Louvre, "It is difficult to conceal the burning of six hundred can-

vases in the heart of a city in the middle of the day [as Valland reported]. If there had been a fire, people would have seen it."[70] Schulmann even consulted the archives of the Paris fire department to see if there was a report of the immolation. He said there was nothing in their logs, adding, "One does not burn hundreds of pictures in the Tuileries without officials at the fire department taking notice."[71]

Yet the fact remains that Valland genuinely believed that "degenerate" artworks had been incinerated. She also surmised that when she told this story, it would grab headlines. Rose Valland optioned the rights for her book, *Le Front de l'Art*—or more precisely, for chapter 20, "Liquidation des Tableaux d'Art Dégénéré"—for the film *The Train*, and she showed herself a formidable negotiator in her dealings with Hollywood types (some of whom she came to know very well). The screenwriters for *The Train*, Monique and Frank Coen, wrote to Valland in the mid-1960s, "I must tell you that you received more than either of us individually. . . . Frank Davis and I know how you feel about the money, Rose, but I must tell you . . ."[72] In other words, Valland had sold the story about the "martyred" modern artworks, and this may have influenced the way she approached the topic of the alleged immolation.

While in prison in France, Lohse wrote frequently to all three American ALIU officers, asking for their help. Some of these letters went unanswered, but the American trio kept track of him. Having resumed his position as a curator at the Metropolitan Museum of Art, Rousseau wrote to Lane Faison in November 1948 on museum stationery, "This may amuse you. They make me all the more angry when I think of the wretched Lohse. According to the latest news even Rochlitz is out and doing business! It was nice to see you—Come down again soon. Yours, Ted."[73] After war's end, Rochlitz had been extradited to France, put on trial, found guilty, and "stripped of all civil rights and all possessions." He in particular had provoked the ire of the ALIU officers. James Plaut offered more specific observations about the art dealer in his August 1945 *Detailed Interrogation Report:* "Rochlitz has impressed his interrogators consistently as a weak and cowardly individual. Reports from several sources that he is a morphine addict are believed to be well founded. Politically, Rochlitz had no genuine convictions. He appears to have acted at all times in his own interest as an unscrupulous opportunist."[74] The American investigators recommended that Rochlitz be handed over to the French authorities, "inasmuch as Rochlitz committed crimes against France and Frenchmen through his leading part in the German looting of French-owned works of

art." But, they added, "in the event that it is not feasible to effect transfer of Rochlitz to French custody, it is recommended that he be tried as a war criminal by the U. S. authorities."[75] While it was common for the ALIU to recommend that the art experts be tried as war criminals, this rarely, if ever, happened. Rochlitz was transferred to the French authorities in 1946, incarcerated at the Fresne prison in Paris, and tried before Judge Frapier of the Seine Tribunal.[76] But ever the skilled opportunist, Rochlitz spent minimal time in jail and soon returned to the art trade.

It is not entirely clear why the three ALIU officers developed such a favorable impression of Lohse. Perhaps it was the realization that others had committed graver crimes and yet had been let off; perhaps it was their humanity and good manners. Lohse's charm and persistence clearly played a role, as did his self-portrayal as a principled individual. Lohse wrote Rousseau in 1948 noting, "Hofer, Scholz, Rochlitz and many others are free now. However, I do not envy their liberty, since it was very expensive. The conviction to stay true to myself has given me the strength to wait patiently for the decision, even though it is difficult for my family."[77] Plaut had praised Lohse as early as August 1945 in his *Detailed Interrogation Report*. He, like Rousseau, had had a change of heart about Lohse at one point (if not more often than that): with Rousseau, Plaut coauthored the 12 January 1946 memo that reported Lohse's falsehoods and "deliberate omissions."[78] The Plaut and Rousseau memo also said, "Documents have come to light signed by him as an SS officer. French witnesses who were in contact with him during the period of his activity in Paris now contradict many of his statements." In this light, Plaut and Rousseau recommended that Lohse be turned over to the French "for further questioning." But shortly thereafter, their view of Lohse improved.

By the time Lohse was in French custody in early 1948, Plaut and his ALIU cohort had begun to help him. Granted, Ted Rousseau continued to express misgivings. The Met curator wrote Jim Plaut at the Institute for Contemporary Art in Boston on 21 March 1949, noting how Rose Valland had confronted Lohse with damning testimony: "I feel quite strongly that we should not stick our necks out unless we are absolutely sure of our facts. It would be quite natural for Lohse to use the good impression he made on us to the utmost regardless what may have happened since."[79] Yet the three former ALIU officers repeatedly helped Lohse. Lane Faison offered the following in a letter to Lohse in September 1946: "It is my belief after talking to you on many occasions at Alt Aussee and at Nuremberg in 1945 (July to November) that you conducted yourself with reasonable decency

in the Paris years (1940–1944) under the conditions of military orders by which you were bound."[80] Plaut subsequently assured the imprisoned Lohse in June 1948: "My friends, Rousseau and Faison, and I have all been working in your interest for some time and you have been very much in our thoughts. We would like to do anything in our power to facilitate your release and we all wish that you could have had your freedom long before now."[81] Plaut had written to a French official a week earlier expressing similar sentiments, adding, "Messrs. Rousseau, Faison, and I have made consistent efforts, somewhat hampered by our present unofficial status, to recommend Dr. Lohse's release."[82] That was the caveat: while they wanted to help, they no longer had an official position in which to do so.

Lohse remained desperate and continued to press them to help. He sounded pathetic, telling them that he would have written more often, but he did not have funds for postage.[83] Yet he continued to write, and the paper trail shows him penning a series of letters to Plaut, Faison, and Rousseau. Most often, he wrote in a tiny script, packing in as many words on to a page as possible. One can imagine Lohse in his cell, crafting these "miniatures" (letters) almost like a monk. Rose Valland loomed large in his invectives, as did Hofer, Rochlitz, Borchers, and Schiedlausky. Lohse claimed he needed fifty affidavits attesting to his good character.[84] He also asked for copies of documents they had collected.[85] The three Americans usually corresponded among themselves before responding to Lohse, and these letters provide an interesting chronicle of a transitional period for Lohse, as he extricated himself from Allied custody and began his life anew.

James Plaut, who had been the chief ALIU interrogator of Lohse as well as the leader of the unit, often took the lead. He responded to Lohse on 16 March 1949. Early on in the letter, Plaut tried not to raise Lohse's expectations, "I am sure that you realize that we have all returned to private life and enjoy no official position whatever today. Thus we are quite powerless to act in anything like an official capacity."[86] Yet he assured him that he and his ALIU colleagues "will do everything possible to make certain that the documentation bearing on your case which was prepared by the units under our control during the wartime period will be made available to the French courts. We have given the matter a great deal of thought and are doing everything within our limited power to see that you receive a fair hearing."[87] The three Americans also corresponded with Lohse's French lawyer, Albert Naud, in an effort to assist with his defense. Rousseau captured the general outlines of their thinking when he wrote, "I have

had on several occasions the opportunity to formally question Dr. Lohse
and I have in my possession all of the relevant documents. I can thus af-
firm that the results of the investigation demonstrated a way in which his
role in Paris in the ERR was secondary and purely of an official nature."[88]
Professor Faison wrote to Albert Naud on Williams College stationery
(identifying himself as the "Chairman, Art Department"), concluding his
letter, "Dr. Lohse was at all times cooperative, and to the best of my belief
always told the truth. I believe Dr. Lohse's release is long overdue."[89] And
this was in June 1948, some six months after the Americans handed Lohse
over to the French. Rousseau also supported what was described as "a pro-
visional bill of liberty for Dr. Lohse"—a kind of temporary bail while his
case was prepared.[90]

Rousseau and Plaut then jointly wrote to Albert Henraux, the head of
the French government's restitution body, the Commission de Récupéra-
tion Artistique (CRA). This was the agency that received some sixty-one
thousand cultural objects from the Americans' Central Collecting Points.
The CRA then decided on the rightful owners, returning some 80 percent
of the objects recovered by the Monuments, Fine Arts, and Archives staff.
(They sold off the rest or dispersed the works to national museums.)[91] The
two Monuments men proceeded carefully, stating, "Although we do not
wish in any way to interfere in the handling and disposition of Dr. Lohse's
case, we would like to make the following statements on his behalf." They
went on to discuss the three months of daily interrogations at Altaussee
in the summer of 1945 and how, "during this period, all evidence which he
[Lohse] presented was, to the best of our knowledge, entirely truthful."[92]
They added, "Moreover, Dr. Lohse's apparent integrity and his desire to
be of service to the Allies proved exceedingly helpful in the solution of
many problems leading to the recuperation of looted art and the prose-
cution of culpable individuals." Despite considerable gratitude toward the
Americans for their efforts to recover French cultural patrimony, Hen-
raux was terse and uncooperative in his response. He stated that the CRA
concerned itself with works of art and "does not take care of individuals."
Henraux added, "With this in mind, if you continue to want to intervene
on behalf of one of the greatest pillagers of France's artistic patrimony
and one who is most responsible for its impoverishment, you will have to
follow the usual legal procedures."[93] As Plaut told Faison, "Rousseau and I
wrote a letter to Henraux recently, asking politely that he do what he could
to intercede in the Lohse case. Rousseau has just had a very sharp answer,
indicating as we feared that the French are not too happy about our inter-

est in their prisoner at this time."[94] Rousseau wrote Plaut, "I enclose Henraux's answer to my letter. As you can see, it has had no result and the idea does not seem to have been a good one."[95] About two weeks later, Rousseau again wrote Plaut, observing, "The French are very touchy about this kind of thing, as they already feel that we are unnecessarily lenient with the Germans."[96] In fact, by the time of this correspondence in 1949, many of the French had grown weary of the postwar trials: the time of the épuration, or purges, was over, and a quiet tolerance for those who had collaborated had begun to set in.

The ALIU officers' willingness to help Lohse with his French trial may also have been related to a deal, or a perception of a deal, around the time Lohse was captured by the Americans. Lohse recounted in March 1947, when his transfer to the French was being contemplated, that at Altaussee in the summer of 1945, "French interrogators were not allowed to question me, since the French interests in this matter were delegated to American and British representatives."[97] Subsequently at Nuremberg, he was questioned by the French only in the presence of American officers. Lohse then stated, "In Nov. 1945 I was visited, while in Nuremberg, by Lieut. USNR Plaut and Faison, who told me that investigations had substantiated my reports and that Washington had decided that I under no condition would be extradited to France."[98] This appears to have been the quid pro quo for Lohse: he helped the Americans with the restitution work (and Lane Faison was the one to recommend that Lohse work at the Munich Central Collection Point—or CCP—in September 1945), and in return, they would not extradite him to France where, to quote him from the document above, "I anticipate trouble."[99] This was actually his calm formulation: U.S. prosecutor Benjamin Ferencz reported in late 1947 that Lohse "is wanted by the French government for trial as a war criminal and has expressed the opinion that the French have sentenced him to death."[100] This, of course, was not the case, but there was still the general sense that the Americans had not followed through on the deal, which likely factored into their motivations to assist him.

Despite certain misgivings, the three ALIU officers continued to help Lohse, and this included sending documents from their reports. Plaut contacted an official named Charles Grey in the State Department, who now had authority over the ALIU materials. As Plaut mentioned in an aside to Faison noted on a copy of Plaut's letter to Lohse that he was sending to his former colleague, "I have today written a long letter to Charlie Grey, asking him to do what he can, provided that he is interested in helping. I have

a feeling that it is our best bet at the moment."[101] Plaut also wrote to Ardelia Hall (1899–1979), the famed restitution expert for the State Department, explaining the situation and asking if she could send him copies of the ALIU reports. He maintained that they were now declassified, at least within the government.[102] Plaut had also written Rousseau back in February 1949, "I am really quite distressed at our delay in the Lohse business. I wish you would really take a few minutes to wind this thing up and see it through. After all, the guy is still behind bars, and I think we have delayed long enough. I am counting on you to do this, John."[103] While the final part of this note appears to reference an inside joke (Rousseau was Ted to his friends, not John), Plaut was clearly serious in his desire to assist Lohse.

Lane Faison, as noted above, had not been responsible for Lohse and therefore felt no special obligation to help him in 1949. Faison did not respond to Lohse's 1 March 1949 letter until 17 July. But he did not neglect Lohse completely. As Faison had written Plaut back on 8 March 1949, "The enclosed letter came from Bruno Lohse today. There were others I haven't answered because they weren't my baby and I had previously told him to ask from you anything to do with ERR and re findings on B.L. himself; and from Ted on anything re Göring."[104] Faison, however, was interested in the fate of the Schloss collection—the 333 Dutch and Flemish Old Masters, of which 171 were still missing.[105] As Faison confided to Plaut, "The Schloss part of this one *is* my baby and it seems to me that something ought to be done by the two of us."[106] Faison was even more specific, asking Plaut's advice on whether to send ALIU documents to Lohse's lawyer or, as he put it, "Would you recommend sending the enclosed pages from you-know-what to L's lawyer?" Faison also noted in this letter, "The references to DEGER [Direction Générale des Études et Recherches, a French government agency] report bother me a little though and R[oger] Dequoy will be dragged in again." The latter, of course, was a reference to the Wildenstein employee who had operated the Aryanized Paris gallery during the war. More Faison did not say; but it is interesting that he mentioned Dequoy in listing his concerns about intervening in Lohse's trial.

It is not clear what materials Faison sent to Lohse or his attorney. In the 17 July 1949 response to Lohse, he said that he could not help with documents, but he was encouraging nevertheless, observing that certain documents relating to the Schloss case were favorable to Lohse.[107] Yet covertly, Faison appears to have helped Lohse obtain the documents he sought. If the documents that comprise a file in Faison's papers are a guide (the papers he donated to the Center for Advanced Studies at the National

Gallery of Art in Washington, DC), then he sent Lohse excerpts from his ALIU *Consolidated Interrogation Report No. 4* (on the Führermuseum at Linz) and, more specifically, the section "Schloss Affair."[108] In this section, Faison supported Lohse's contention that the matter was driven largely by the Vichy government. Faison included the original statements of many of the other relevant parties, including Führermuseum director Hermann Voss, Nazi dealer Karl Haberstock, and French dealer Georges Destrem, all of whom were cognizant of developments as the Schloss affair unfolded. In other words, the ALIU officers found a back-channel way to make their documents available to Lohse, and this included Plaut's *Detailed Interrogation Report No. 6: Dr. Bruno Lohse*, a copy of which Lohse's lawyer possessed as early as May 1948.[109] Lohse needed these materials for several reasons: the authority of the U.S. investigators carried great weight, but also, as he wrote to Rousseau in March 1949, because many of his own documents had been "lost at Nuremberg"—that is, prior to his transfer to French custody.[110]

A big question in Lohse's life is why the Paris Military Tribunal acquitted him on 3 August 1950.[111] Although the recently opened archives offer thousands of pages on the trial, it is not clear what led to the unexpected decision to let him go. The surprising verdict, rendered after a three-day trial and an hour of deliberations, came about due to the shortcomings of the prosecution, the effectiveness of the defense, and some indeterminable factors that influenced the panel of judges. The prosecution appeared to build a solid case based on a thorough investigation (despite the fact that his name was misspelled throughout the proceedings as "Lhose"—an error repeated by newspapers like *Le Monde*).[112] Lohse, for example, had been interrogated in December 1949 by Judge R. Harlin.[113] Dozens of interrogation protocols of Lohse—intense rounds of questioning over months and months—formed the basis of the record. In these sessions, Harlin was often joined by Rose Valland, who traveled back to Paris several times from Baden-Baden, where she continued to head up the French restitution efforts in Germany. The prosecution also had historical records: sales receipts by the hundred, ERR documents, the ALIU reports (including *Detailed Interrogation Report No. 6* on Lohse by James Plaut), and much more. Rose Valland testified during the three-day trial, as did Otto Abetz, the former German ambassador in Paris, and Helmut Knochen, the former SD chief in Paris. The latter two were brought in to testify from the prison at Fresne and served as witnesses friendly to the defendants.[114] Knochen, for example, stated that "Lohse always told the

truth" and described how Lohse frequently came to him to help rescue Jews.[115] Valland, on the other hand, tried to implicate Lohse—alleging that he was the one most responsible for the artworks in the Jeu de Paume.[116] She explained clearly that he trafficked in stolen Jewish property and conveyed the scope of the ERR operations—regarding not just art but also books, archives, and other cultural property. She estimated that 500–600 works went from the Jeu de Paume to Göring, thanks to the "diligences de Lhose [*sic*]."[117] We now can document 594 such works, and the actual total number was likely higher—over 700.

Yet it is questionable whether Valland successfully made the case that Lohse was personally responsible for what transpired in Paris, or whether she simply captured his venality. Much of the information about his self-enrichment and other misdeeds came out later—in her book *Le Front de l'Art* and in other publications. Valland was much tougher on Lohse in the decades after the trial. As she admitted to fellow Monuments officer Ardelia Hall in early 1965, "I regret that the initial interrogations were not controlled better. The documents that surfaced later showed that the culpable Nazis who were interrogated did not always tell the truth."[118] Journalist Philippe Sprang, who has written about Lohse, believes that the tall and imposing former SS man intimidated Valland—especially when they were physically close to one another, as they were in the Paris courthouse. Another French journalist, Yves Stavridès, made the point that Valland and the other Monument officers had not received the proper training to conduct interrogations. They had no background in police work, and the Nazi art dealers had little difficulty in outmaneuvering them. Theodore Rousseau, who counted among the Monuments officers deceived by Lohse and his cohort, had written that Lohse's "activity in the Einsatzstab Rosenberg was confined to execution of orders, and . . . there was no extracurricular activity for personal profit, as has been alleged in reports from French sources."[119] In other words, even though there was evidence from French colleagues to the contrary, Rousseau and his ALIU colleagues remained oblivious to Lohse's personal financial gain.

Valland had witnessed his thefts and knew firsthand about his profiteering during the war, but she and the prosecution did not bring it out during the trial. Granted, the theft for personal gain was difficult to prove, but prosecutors did not make use of what they had, such as the five works Lohse stashed with a friend, which had come to light in 1949.[120] In the summer of that year, a Munich art dealer named "Kessinger" reported being offered "some valuable paintings" from a barber named Gabler that

he believed were stolen.[121] Kessinger went to the authorities and the trail led to Willi Schweiger, who lived near Füssen. Schweiger was found with five paintings that he said his friend Lohse had given to him to safeguard "in 1943 or 1944." The five works (three nineteenth-century paintings, a seventeenth-century Italian "family portrait," and an Old Master drawing) were of undetermined origin: they may have been stolen, of ERR provenance, but Lohse claimed they were his own private property acquired before the war.[122] The Americans and French seized the pictures in a joint operation in Füssen on 8 August 1949.[123] The works were by middling artists, the subject matter generic—which may have been a conscious tactic of Lohse's as he embezzled ERR works: don't take anything too easy to trace. And that was the problem: the Americans sent the works to Paris, but there was no conclusive match with ERR works. They came back to Munich, but with the Americans closing down the Central Collecting Point in the summer of 1950, the works came into the custody of the Bavarian state. Lohse persisted with his claim, and in 1952, the Bavarian minister president ordered them restituted to him. Of course, Lohse was not alone among old Nazis to recover works from the Bavarian state in these years—Henriette von Schirach, her father Heinrich Hoffmann (Hitler's photographer), and Emmy Göring all had success with claims—and he seems representative in that the authorities gave the old Nazis the benefit of the doubt.[124]

What Lohse did with the art in his possession remains a mystery. The five works in Füssen were a rare example of the Allies recovering assets that Lohse may have "owned." Most Allied Monuments officers, Rose Valland included, believed that Lohse, Schiedlausky, and Rochlitz had hidden more artworks at Füssen. Valland and her U.S. counterpart Edgar Breitenbach took seriously a report in November 1948 stating, "The informer firmly believes that Lohse's statement that his art property was destroyed by air raid is false. He thinks that Lohse has paintings still hidden somewhere. This belief is said to have been shared by other ERR members in Neuschwanstein."[125]

While Valland and the other Monuments officers could point to damaging reports, they came up short in trying to prove that Lohse embezzled or acquired artworks for personal gain. The five works in Füssen could not be proven to have passed through the ERR. No actual art belonging to Lohse was found in Berlin or anywhere else (with the possible exception of Füssen).[126] The home of Lohse's father in Berlin-Steglitz yielded photos of works in the Schloss collection, but not the actual works them-

selves.[127] There was talk of art at the Gipsmühl chalk mine, and of Lohse filling two cylinders with gold and jewels and burying them near Füssen. This may have been connected to an effort to conceal assets for a group of Nazis: French Monuments officer E. J. Doubinsky wrote in 1950, "When the catastrophe came, Bruno Lohse and Schiedlausky received orders to remove an important part of the precious objects from the castle and to hide them in the best possible places in the environments [*sic*], which was done in the end of 1944 and in the spring of 45. Wagner [an SS guard dispatched from Paris to Füssen in August 1944] declared that he knew the whereabouts of seven hiding-places; he thought that the total value of the hidden objects could be estimated at about 50 million dollars."[128] Doubinsky stated that Lohse and Schiedlausky were thought to have "a big lot of art-works, gold, jewels, precious stones, pictures, etc. A great part of these objects was the property of the Rothschild family."[129] The joint French-American investigation included sending a delegation to Füssen, which learned that the "Germans are now digging for the stuff"—referring to efforts to find the "entrance to the depository." There were reports that the treasure was "located in the tunnel of a trans-Alpine highway through Bavaria and Austria which had not been completed," and that it was "actually in a cave adjacent to the tunnel end."[130] Doubinsky's theory was that "the hidden Nazi party of Füssen was constantly watching the hiding places, as the hidden objects constituted a notable part of their secret treasure."[131] This would not be the only time Lohse was mentioned in connection with treasures hidden away by hard-core Nazis, which was perhaps understandable in that he was both an SS officer and an art plunderer. However, in the end, with regard to Lohse, the Monuments officers were left only with rumors. Considering that U.S. forces alone "found approximately 1,500 repositories of art and cultural objects in Germany" (with "approximately 10.7 million objects worth an estimated $5 billion"), it was easy to overlook Lohse's caches.[132]

Allegations of self-enrichment did come up in Lohse's trial, but he maintained that "he didn't keep anything for himself" and that the rumors damaging his reputation were spread due to colleagues' jealousy.[133] Lohse demanded proof of his having hidden away a fortune—and, of course, none could be produced. It is notable that Valland did not say anything at the trial about Lohse and the ERR staff burning modern artworks in the Tuileries—the charge she leveled a decade later.[134] While Valland and the prosecution offered a damning portrait of the ERR, that did not offer proof of Lohse's personal self-enrichment.

Lohse and his attorneys prepared an elaborate defense, which included his 20 April 1946 affidavit from Göring and statements from an array of prominent Nazis. One affidavit came from State Secretary Paul ("Pili") Koerner, one of the Reichsmarschall's most trusted deputies. Koerner wrote from his cell in Nuremberg in March 1949 that "Göring considered Dr. Lohse an extraordinarily knowledgeable and talented art historian and art expert. Additionally, he was convinced and impressed by his absolute scrupulousness [*Sauberkeit*] and reliable character."[135] Another exculpatory statement, which survives in Lohse's own papers, came from Dr. Wilhelm Stuckart (1902–53), the lawyer for the Reich Ministry for the Interior who played a key role in drafting the Nuremberg Laws of 1935 and then attended the infamous Wannsee Conference of January 1942, where Reinhard Heydrich communicated plans for the "Final Solution." Stuckart testified that all SS members were automatically entered into the Nazi Party and opined that this was how Lohse joined the Party in 1937.[136] Günther Schiedlausky wrote from Bonn about the exhibitions for Göring in the Jeu de Paume, stating that he, Walter Borchers, and Hermann Bunjes (who had committed suicide in July 1945)—but not Lohse—had organized them.[137] Even Robert Scholz submitted an affidavit in July 1950: although he was being tried as well (in absentia), he gave his address in Bavaria as part of his supportive note in which he talked about Lohse helping Max Friedländer and the Loebl brothers, about Lohse's battles with von Behr, and about saving art at Neuschwanstein.[138] The statements often defied credulity, as when Werner Koeppen, the adjutant of Alfred Rosenberg, wrote, "Dr. Lohse was in any case not the special representative of Reichsmarschall Göring or the latter's liaison to the ERR."[139] Heinrich Hoffmann, who had been Hitler's photographer and frequent consultant in artistic matters, testified that Lohse asked him several times to go to Hitler to shut down the ERR, and also to go to Göring and effect Lohse's transfer to the front.[140] The old Nazis generally looked out for one another and proffered the most generous accounts they could.

Lohse also obtained letters from various figures in the art world, including art historian/curator Dr. Cornelius Müller-Hofstede, and dealers Victor Mandl, J. O. Leegenhoek, Roger Dequoy, Allen Loebl, and Paul Cailleux.[141] The latter two told how he saved the lives of Jewish family members, which made a positive impression. Adolf Wüster testified that Lohse helped save an array of people due to "purely human reasons" (*rein menschlichen Grunden*), including not only Cailleux, Dequoy, and Martin Fabiani (Picasso's friend), but also the daughter of painter Henri Ma-

tisse, who was threatened with deportation.[142] Maria Almas Dietrich's letter listed individuals in France whom Lohse had reportedly helped save, including Victor Mandl.[143] And, as noted earlier, Lohse had reportedly helped save Rose Valland from Kurt von Behr, who wanted to deport her to Germany and have her shot once she crossed the border.[144] Finally, the advocacy of the American Monuments men factored into the equation. They wrote multiple letters to the French authorities whose import was unambiguous: let Lohse go. Lohse's legal team went to great lengths to construct a defense, even including statements from people who knew him as a child. All told, there were over fifty affidavits on his behalf.

While Lohse played an active role in preparing his defense, he also recognized that he had good legal counsel. He wrote Margarethe Bitter (a German official who assisted POWs) that he had "the greatest trust" in his French legal counsel.[145] Lohse had a kind of "dream team" of lawyers, both German and French. There were purportedly benefactors who supported him financially and helped cover the costs of such a vigorous defense. This French-German legal team proved very persuasive: the French lawyers had experience with "political" trials like this one; one member—Albert Naud—had helped defend Vichy prime minister Pierre Laval and collaborationist writer Louis-Ferdinand Céline.[146] German attorney Konrad Voelkl had represented Alfred Rosenberg before the International Military Tribunal, and while the Nazi leader was found guilty on multiple charges and sentenced to death, the trial provided valuable experience for Voelkl.[147] Back in 1947, one of his German attorneys, Hermann Ulmer, had outlined Lohse's defense for his time in Paris and at the ERR: he was training as an art historian (as distinct from a dealer) and, as a corporal in the Luftwaffe, had been ordered to Paris, where he merely studied artworks, trying to ascertain their origin and cataloguing them prior to their transport to Germany.[148] And Lohse always protested he was not formally a member of the ERR, although the tribunal judges rejected this claim.

It is not clear if something transpired during the trial that influenced Judge Roynard (president of the tribunal), Judge Harlin, and the four other members of the panel.[149] Philippe Sprang believes that something happened that affected the outcome. It may have been that Lohse had compromising material on French collaborators. Or it is possible that someone "got" to the judges and convinced them to issue a lenient sentence.[150] The trial came amid a concerted effort to effect Franco-German rapprochement, with both sides striving for better bilateral relations. In other words, Lohse's sentence may have been influenced by politics, or

at least, he might have benefited from a general softening in views and a desire for reconciliation. As noted earlier, by 1950, the heated emotions of the épuration had passed. Back in 1944–45, the *épuration sauvage* had entailed summary executions and other harsh punishments. This had given way to the *épuration légale*, which relied on rigorous judicial mechanisms.[151] But a few years later, there was little appetite for further efforts for justice in France, as was the case in many other countries once occupied by the Germans. In West Germany, a series of amnesties passed between 1949 and 1954 (sometimes referred to as "amnesty fever") legally absolved various constituencies, including younger perpetrators and civil servants. Put simply, it did not help that the Germans were going after their own perpetrators with so little conviction and energy—or that the Americans, with the onset of the Cold War, had lost interest in bringing Nazi officials to justice.[152] Historian Jean-Marc Dreyfus opined, "Had Lohse been tried earlier in 1946 or 1947, he certainly would have been found guilty."[153] Dreyfus also believes that the Military Tribunal had little understanding of art looting and its import: "These were soldiers, many of them hardened veterans, and for them, taking art did not seem such a grievous offense."[154] Further, the prosecution did not connect Lohse's actions to the deportations, or to the broader construct of crimes against humanity. Furthermore, as Jean-Marc Dreyfus noted, "The quality of the lawyers additionally played a role in the leniency of the verdict."[155]

At the end of the second day of the trial, just before the verdicts were rendered, the French prosecutor, Commandant Theret, pronounced his *réquisitoire* and asked for a punishment for Bruno Lohse of five years in prison, with Lohse to go free due to time served.[156] In other words, the prosecution reduced its demands. But this verdict still would have entailed a "guilty" decision for Lohse. The judges went beyond that and exonerated Lohse. He was free to walk out of the Cherche-Midi courthouse, although his formal release from the Fresne prison did not occur until the next day when the paperwork was completed. At the end of the day, there is no conclusive evidence explaining the tribunal's verdict. Judge Harlin's notes show that he believed the argument that Lohse had protected cultural property and intervened to help the politically persecuted; Harlin also placed great weight on the support of the former ALIU officers.[157]

Bruno Lohse was the only one of the defendants to be completely exonerated (although he was granted only "provisional liberty" when set free on 4 August 1950).[158] Georg Ebert and Arthur Pfannstiel each received sentences of one year. Gerhard Utikal's case was separated from those of

the others, but he was released a year later, in August 1951, whereupon he returned to Germany.[159] Scholz and Hofer, tried in absentia, received ten years each, although neither sentence was ever carried out. Still, the French acquittal meant that Lohse had escaped a career-ending verdict. As Lohse had written to Rousseau back in 1949, "A guilty verdict would be disastrous and would destroy my future because a man convicted of a war crime can no longer pursue his profession."[160]

Although the former ALIU officers supported Lohse's release from French custody, they hardly welcomed him back into the art world with open arms. In their vacillating attitudes toward him, they met his reentry into the art world with some trepidation. Lane Faison had returned to Germany in late 1949 to oversee the liquidation of the Allies' last Central Collecting Point in Munich. He was charged with handling an array of vexing and intractable problems as he distributed thousands of artworks remaining in the depot. This put Faison at the center of the restitution operation, and as such, he was exceedingly well informed about related issues in August 1951 when he wrote a British colleague: "I am very much concerned by the developments [Lohse] outlines and have evidence of my own that they are substantially true. I know that Lohse (Munich, Aiblingerstrasse 8/III) is about to run an art business in Düsseldorf which, he told me, would be supported by 'some industrialists.' I am also sure that he is in the closest connection with the firm of [Theodor] Fischer, which has a very bad war record."[161] That Faison would connect Lohse and "some industrialists" in a postwar start-up venture is interesting, but even more striking is the allegation that he was in business with the problematic Swiss dealer who had hosted the June 1939 auction of purged modern art and then acquired a significant number of looted objects in wartime trades with the ERR. Faison added in his report, "It is obvious that he has not learned to keep better company. The items which the Düsseldorf firm proposes to sell should be carefully screened against the possibility that they were looted by the Nazis."[162] Faison concluded with a more practical recommendation: "If the possibility exists of barring the license of the firm, I respectfully suggest that it should be barred."[163] This did not happen, and Lohse was back in business in 1951, less than a year after his release from prison in France. Faison, while completing his stint as the last director of the Munich Central Collecting Point, kept in touch with Lohse, as he did with Göpel and a handful of others whom he thought might be able to help with unresolved cases. (Göpel had "retreated to the German countryside

until 1948" while the ALIU searched for him.)[164] While Faison thought Göpel had "a weak character," the American seemed to warm to Lohse, writing to Rousseau in January 1951: "Lohse is also back—since this spring only (4½ years in jail). I have had lunch and one evening with him and still think well of him. I have a long story to tell you later."[165]

CHAPTER FIVE

The Amnesia Years

OR LOHSE, THE ROAD back to civilian life in Munich had been long. After his release from prison, the French authorities placed him in a program whereby he was obliged to report to French occupation officials on a daily basis. That meant that he either had to remain in France for a transitional period—which held no interest for him after his harrowing experiences—or move to the French Zone in Baden-Württemberg. He decided on the latter and asked to be taken to Konstanz on Lake Constance, where he knew an old acquaintance by the name of Dr. Benno Griebert (1909–2000) had resettled. Benno Griebert and Lohse had met at the Friedrich Wilhelm University in Berlin, and although apparently not particularly close, their friendship extended back almost two decades. Benno Griebert's son, Peter Griebert (b. 1937), was thirteen years old when Lohse arrived at his family's home in 1950. Peter Griebert, who became an associate of Lohse's and then, as the latter aged, his paid assistant, recalls Lohse as gaunt, hungry, and demoralized— a pathetic figure who had not had anything to eat for days.[1] The Grieberts took him in and helped him through the period of required daily reports to the French gendarmerie. But Lohse's probation did not last long. Within weeks, he had relocated to Munich. He had retained some real estate in Berlin, but he knew before war's end, when he had returned from Paris, that the structures had been destroyed by the Allies' bombing.[2]

One of the first things Lohse did in Munich was register for the denazification process. This trial entailed a review of an individual's record

during the Third Reich and was conducted by a nonprofessional panel of judges (the appeal process, if there was one, was handled by professionals). Lohse underwent denazification when the program was winding down. Millions had been reviewed and sentenced and by 1950, there was little political will to continue. The government of the Federal Republic had already amnestied certain groups: for example, younger people had received an initial amnesty in August 1946 that was then extended in 1951.[3] Lohse fared as well as he could have hoped, considering his history during the war. He mustered an array of testimony from figures in the ERR and the SS. The latter included Berlin-based colleagues with whom he had played sports in the 1930s, but also top figures, such as Himmler's aide General Karl Wolff, who had been Himmler's liaison to the Führer Headquarters from 1939 to 1943 and then the higher SS and police leader in Italy from 1943 to 1945. Wolff testified that Lohse was only an "honorary" member of the SS and had no official function in Himmler's order.[4] Another SS officer testified that "upon the founding of the Sports Association of the SS-Berlin, Lohse took over the leadership of the handball team."[5] Lohse's attorneys attempted to bolster their case by submitting materials from the Paris trial, including Robert Scholz's sworn statement from 1946 in which Rosenberg's aide claimed that Lohse put himself at risk to help the politically persecuted and that Lohse helped save the artworks and card catalogue at Neuschwanstein.[6] They recycled Göring's letter from 20 April 1946 wherein the Reichsmarschall sought to exonerate his art agent. Lohse himself submitted a statement denying any involvement in plunder. He wrote that the "international Art Looting Investigation Unit" determined "that I in no way perpetrated war crimes, but to the contrary, rendered a great service in the rescuing of cultural valuables."[7]

In short, it was an impressive, if untruthful, defense orchestrated by Lohse's lead attorney, Dr. Konard Voelkl.[8] The lawyer also defended Alfred Rosenberg at Nuremberg and SS general Franz Six in the Einsatzgruppen trial at the Nuremberg Military Tribunal in 1948; for the latter, he helped secure a twenty-year sentence that led to Six's release in 1952. In Lohse's case, the judges placed him in category IV as a fellow traveler (*Mitläufer*), which effectively exonerated him. The designation enabled him to return to his profession as an art dealer. The U.S. authorities had established Military Law No. 52 back in September 1944 as American troops moved across the German border, and this covered the licensing of art dealers, a responsibility that passed to the German minister presidents in the U.S. Zone in 1949.[9] The Germans proved lax in this regard,

especially in Bavaria, and Lohse had little difficulty regaining his official accreditation. He operated as a dealer without a physical gallery, and supplemented his income by receiving state benefits for having been a prisoner of war.[10]

During the period that S. Lane Faison directed the Central Collecting Point in Munich, there was some awareness among the American occupation authorities as to who Lohse was and what he was doing. However, Faison returned to the United States in late 1951 to resume teaching at Williams College, and there was no American expert left in Europe to track Lohse or the other Nazi art experts. Growing out of the increasingly perfunctory denazification and licensing procedures, German authorities showed little inclination to investigate former Nazis. While there was a document center in the Munich CCP that "stored most of the German documents pertaining to art looting," there was no West German agency to track down Nazi war criminals and others complicit in the crimes of the regime until one opened in Ludwigsburg in 1957.[11] Therefore, Lohse, like many former SS officers, drifted into relative obscurity. He resided in a modest apartment on the Aiblingerstrasse near the Rotkreuzplatz (just northeast of the Munich city center), where he remained until the late 1950s. The building, constructed in a traditional Bavarian style, sat in a well-regarded neighborhood surrounded by large single-family homes and villas. The quiet, tree-lined streets and high walls afforded privacy, which clearly appealed to Lohse. He kept the Aiblingerstrasse apartment for nine years until he needed more space.

In early 1959, Lohse married Ilse (known as Ille) Fichtmüller, who helped him with his correspondence, at least in the early years. In mid-1959, the newlyweds moved to Laplace Strasse 13 in Bogenhausen—the leafy suburb across the Isar River. This was the apartment where Lohse resided until his death. The question arises why he never moved to a grander home—say, a villa on Lake Starnberg—like many other old Nazis. Lohse instead remained in this two-bedroom flat with an adjoining office. It may have been that he did not want to attract undue attention, although that alone does not constitute a convincing reason. Lohse appeared adverse to change: he had his favorite restaurants, where he was a known and appreciated customer; he had his circle of friends, whom he saw regularly; he had his golf club in nearby Thalkirchen, just up the Isar from his flat; and he had his art, much of which he kept in the apartment. That sufficed for him. His friends reported that Lohse wanted to have children, but that Ille was unable. This may also have factored into the decision not to move

to a larger home. Ille, despite being nine years younger, predeceased him, passing away at age fifty-nine in 1979, and he spent the last decades of his life living alone. He subsequently had companions—or "girlfriends," as he called them, intermixing the English word into his German.

Lohse transitioned back into the art world by becoming a partner of Karl W. Buemming, the art dealer in Düsseldorf referenced by Faison in his 1951 report.[12] Buemming had established a gallery and bookshop in Darmstadt. Born in Milwaukee in 1899, Buemming had moved to Germany at the age of eight. He retained U.S. citizenship and said he always planned to return to the United States, even applying for an American passport after the war, but he was hardly a freedom-loving democrat.[13] He was a Nazi Party member and during the Third Reich reportedly said, "Heil Hitler!" with great frequency.[14] Buemming grew close to both Hans Wendland and Theodor Fischer, who had known each other at least since 1931 (some say 1920), and the three men collaborated on numerous deals.[15] Buemming often traveled to Switzerland during the war, sometimes trafficking in looted works.[16] Therefore, by partnering with Buemming, Lohse was effectively joining up again with certain notorious participants in the ERR trades during the war.

Little is known about the postwar relationship between Lohse and Fischer. The Lucerne dealer faced two trials at war's end growing out of the ERR trades. These featured testimony by many of the cast of characters in the Nazi looting drama. Alois Miedl, Walter Andreas Hofer, and Maria Almas Dietrich were among those compelled to testify. Lohse also traveled to Bern, the Swiss capital, to offer testimony between 18 and 20 December 1950. He did this with considerable reluctance. The Swiss authorities wanted him to testify that Hofer had profited from the objects coming from the ERR.[17] Fischer in turn was suing Hofer for the return of the works that he had received as part of the wartime exchanges. Lohse had retained his wartime animosity toward Hofer, calling him his *Todfeind* (lethal enemy) in the docket, but he had no desire to interject himself into this protracted legal struggle.[18] Lohse wrote James Plaut on the day before his departure for Bern on 12 December 1950, "This matter is particularly embarrassing for me because I am being forced to testify against Hofer, whose perjured statements [*Meineiden*] have formed the basis for charges filed by the Swiss federal authorities."[19] Lohse explained to Plaut that he had refused to testify against Walter Andreas Hofer in Paris—even though the latter was in absentia—because Lohse considered it dishonorable to testify against another German before a French Military Tribunal. But,

after deep reflection, he decided to appear before the Swiss court, "since [not doing so] would damage the reputation of the Germans—and above all, the reputation of my dead chief [Göring]—if I did not contribute to the clarification of the events of the time and therein the proper finding of fact."[20] It turns out that Hofer, who remained in Berchtesgaden and testified there, did not give testimony damning to Fischer.[21] But Lohse's support for Fischer and the latter's argument that he did not know the works he acquired were looted by the ERR ultimately helped him forge a closer bond to the Lucerne dealer. In the years that followed, Lohse attended Fischer's auctions as a buyer and also consigned works to the Lucerne dealer. Somewhat ironically, then, the Fischer trial that brought Lohse and the others to Switzerland helped foster relationships that would develop further in the postwar period. The extant photos of the Fischer trial that document Lohse testifying also show more relaxed conversation among the witnesses, including Maria Almas Dietrich and Hitler's photographer Heinrich Hoffmann. It was the last time that these individuals appeared together in a public forum. Thereafter, they faded from the limelight, even as they retained a prominence in certain circles.

As he rebuilt his life in the 1950s, Lohse found a niche consulting for wealthy collectors and helping broker sales for dealers and others he knew. When I first met Lohse, he described himself as a *Kunstberater*, an "art adviser." I asked him about his clients, but he said he could not reveal them—that was confidential information. I pushed him from time to time, and he intimated that he had helped banker Hermann Josef Abs, who indeed amassed an important collection. But he provided no details. It seemed plausible: as journalist Adam Lebor wrote about the banker, "As the head of Deutsche Bank's foreign department during the war, Abs was the lynchpin of the continent-wide plunder, directing the absorption of Aryanized banks and companies across the Third Reich. During the twelve years of the Third Reich, the bank's wealth quadrupled. Abs sat on the board of dozens of companies, including, naturally, IG Farben."[22] Abs had been arrested by the Americans in 1946 and spent three months incarcerated, but he was never charged and went on to flourish in the postwar period. Lebor calls him "the most powerful commercial banker in the Third Reich" and asserts that Abs "enjoyed similar status and acclaim in the new West Germany" prior to his death at age ninety-two in 1994.[23]

Lohse may have been connected with Günther Quandt (1881–1954), the first husband of Magda Goebbels, who oversaw a vast financial empire, including arms-related industries; he used the capital he retained after

the war to become the largest shareholder of BMW.[24] Rose Valland wrote Lane Faison in August 1951 that a "Dr. Quandt" bought pictures from the Goudstikker collection. According to Valland, Quandt was second only to Göring in having obtained the largest number of works stemming from the Dutch Jewish art-dealing dynasty. She added that "about ten" (*une dizaine*) Goudstikker pictures were found in the Quandt collection at war's end.[25] Valland's description of Dr. Quandt is specific: she notes that his former wife, Magda, had married Joseph Goebbels and that he was an arms manufacturer for the Nazi regime.[26] Valland further stated that "Dr. Quandt also acquired other paintings associated with the plundering of Jewish goods by Hitler, as they passed through the hands of galleries in Berlin (principally the Galerie Leo Spik-Union)."[27] This is perhaps not surprising considering that he was a Nazi (he joined the Party in 1933) and that the family's factories utilized slave labor. One facility had an adjoining concentration camp—Hannover-Stöcken. Quandt lived his life looking to make money. The series of interlocking companies that made him an immensely wealthy industrialist during the Third Reich, according to some reports, resulted in him becoming the richest person in Germany in the 1950s.[28] Lohse could have met Quandt in Paris during the war: as one of the Reich's leading industrialists and occupier of a senior advisory post to the Nazi government, Günther Quandt presumably had contact with Göring, and while the connection is entirely speculative, one can see how the Reichsmarschall might have directed Quandt to his man in Paris.

More interesting is speculating about the possibility of postwar contact between Günther Quandt and Bruno Lohse. It would have been very difficult for Lohse to be in touch with Quandt in the early postwar years when Lohse was incarcerated, but some communication was possible—for example, through one of Lohse's lawyers. At war's end, Quandt took refuge on Lake Starnberg outside Munich, an area that attracted many other old Nazis. Quandt hoped to avoid being included in the trial for industrialists at the International Military Tribunal. (Many believe he should have been charged there—but the British did not hand over the incriminating documents in their possession in a timely manner. Quandt was arrested in 1946 but released in January 1948; at his denazification trial, he was declared a "fellow traveler"—accepting of Nazi ideas but not a participant in crimes.) This lenient ruling allowed Günther Quandt to continue his career. The indefatigable businessman likely realized in 1951 that the art market was just resetting, and there could be advantages in establishing a company in this initial phase. According to Lane Faison, Günther Quandt

was part of an effort to set up an art gallery in Düsseldorf, an undertaking that reportedly involved not only Lohse but Alois Miedl and Theodor Fischer.[29] Back in 1946, James Plaut had written that "Fischer is the only art dealer in Switzerland with sufficient capital and inventory to conduct business on a large, international scale. . . . The entire Swiss art market has revolved about his importations, with a number of smaller dealers depending on him for their stock and taking works of art from him on commission, often not even paying him for an object until they have sold it further."[30] In the summer of 1951, Lane Faison, Rose Valland, and other Allied Monuments officers bristled at the news of this impending partnership.[31] If true, the most important dealer in Switzerland, two of Göring's art agents, and Quandt, with his fortune, would have represented a formidable team; but also one that would put into question all the efforts aimed at postwar justice. The enterprise would have been a coup for Lohse as he sought to revive his career after his release from a French prison, and one can see why he tried so desperately to travel to Switzerland to attend auctions at Fischer Lucerne in the 1950s. While the (alleged) proposed partnership in 1951 seems never to have come off, Lohse most likely became one of the "smaller dealers" in Fischer's orbit described by Plaut. In all likelihood, the participants continued to remain connected as members of a larger network or series of networks. It bears mentioning, as noted in the award-winning 2007 documentary film *Das Schweigen der Quandts* (The Silence of the Quandts), that the Quandt family archive remains off limits to researchers. This would be one avenue to explore in researching the alleged relationship between Lohse and Quandt. The latter died at age seventy-three in December 1954, which limited the period for potential contact between the two, and one should not exaggerate the importance of this relationship. Yet these allegations of a prospective art-dealing venture are suggestive of the networks that took root again at the time, and also demonstrate the initiative shown by many old Nazis as they became wealthy and powerful, if usually discreet, figures in the postwar Federal Republic.

Lohse quietly insinuated himself into circles that included corporate leaders and other professionals (often lawyers and doctors) who had the resources to amass collections. He wrote to Theodore Rousseau that he frequently represented "industrialists," including one who collected "early south German pictures."[32] This may have been Georg Schäfer (1896–1975) of Schweinfurt, who headed the Friedrich Fischer firm, famed for its steel ball bearings (often identified with the city), and who built an important art collection in the postwar period. Schäfer also forged close relations

with the former Nazi director of the Bavarian State Painting Collections, Ernst Buchner, who advised him on collecting and later sold the industrialist his photo archive. The Griebert archive, assembled by Benno and his son Peter, was sold to the Museum Georg Schäfer in Schweinfurt decades later.[33] Although the timing would be right for Lohse working with the industrialist—Schäfer began focusing on south German pictures in the late 1950s and Lohse's letter to Rousseau dates from 1960—and although there were not many industrialists collecting south German art, there is no concrete evidence linking Lohse to Schäfer. Indeed, one friend of Lohse has suggested that the dealer simply fabricated the idea of industrialist patrons in an effort to appear more credible.[34] But clearly Lohse had clients. He found them artworks to buy, brokered deals—and they went along without asking too many questions. It's not clear what these clients knew of Lohse's wartime experiences. They were probably aware that he had worked for Göring and had been detained by the Allies for some time, but not too much more than that. It seems that many of Lohse's customers had Nazi pasts (either directly or in their families) and had learned to look past this issue. In many ways, the mind-set was similar to the industrialists who patronized Nazi sculptor Arno Breker starting in the 1950s: one observer called Breker the "court artist of the German economic miracle."[35]

Another glimpse of the postwar networks in the art world comes from the documents associated with Bruno Lohse's efforts to lift a prohibition on travel to Switzerland, a process that played out over several years in the early 1950s. In October 1950, just two months after his release from a French prison, Lohse applied to travel to Switzerland. He quickly learned that the Swiss had placed him on a *Sperrliste* (blocked list) that prevented him from entering the country. The Swiss ban was directly attributable to his February 1949 interrogation by Swiss authorities, which had not gone well for Lohse. Swiss prosecutors had traveled to the Paris prison to ask him about ERR trades and his trips to Switzerland during the war. Lohse had failed to impress them with his answers, and this, combined with his membership in the SS and his connection to the ERR, formed the basis for the prohibition. Hans Wendland and Walter Andreas Hofer were among those denied entry to Switzerland.[36] Engaging a lawyer named Dr. Albert Steiner (who also represented Hans Wendland both during and after the war), Lohse applied to have the injunction lifted. More specifically, he stated that he sought to attend a series of auctions at the Galerie Fischer in Lucerne between 16 and 24 November 1951. His lawyer explained that Lohse was working as an adviser to the Paris art dealer Victor Mandl.[37]

That Mandl and Lohse had renewed their relationship within a year of the latter's release from prison is striking, as is the fact that they immediately sought to do business with Theodor Fischer. As noted earlier, Mandl had a gallery on the rue La Boétie and had close relations with German dealers, including Maria Almas Dietrich. Victor Mandl himself had been indicted by the postwar French government for collaborationist activities, but he extricated himself fairly quickly.[38] Clearly, the relationships (and networks) resumed across national borders as soon as possible. Karl Haberstock, who had relocated to Munich, wrote Theodor Fischer in Zurich in March 1948, "We have certainly maintained a pleasant and, for both sides, fruitful business relationship that has lasted decades, and if sooner or later the borders are opened again, I hope to bring the old mutually advantageous relationship back to life."[39] It took a few years for Lohse to renew his Swiss relationships: he was repeatedly turned down in his efforts to have the travel ban lifted, but he finally succeeded in 1954—after a series of appeals, including yet another one based on a request to attend a Galerie Fischer auction.[40] As noted earlier, Lohse had been granted one earlier exemption in December 1950 in order to testify in a trial involving Fischer, and he used the opportunity to visit the Foreign Police (Fremdenpolizei) in Bern.[41] But this visit had little immediate effect and it took him four years of almost constant legal activity to gain entry into the country. The costly process demonstrated the lucrative prospects in Switzerland, as well as the significant role Swiss dealers played in the international art trade.

It is not surprising that Lohse reconnected with a French dealer just after his release from prison for a number of reasons, including the fact that the Paris market was one of the first centers to revive—although *revive* may not be the best word: as Lynn Nicholas noted about the Paris art market, "By late 1944 not one dealer's door had been closed by the authorities."[42] The fact remained that German cities like Berlin and Munich were bombed out, and the currency reform of 1948, as Karl Haberstock observed, militated against a revival of the art trade. Haberstock also described how the Americans had descended upon Paris after the war and were buying at prodigious rates.[43] Dealers across Europe were anxious to return to their businesses and many did not like the interruptions and obstacles posed by the restitution work. Joseph Schaefer, a dealer in Paris, wrote to Theodor Fischer as early as 14 December 1946 complaining that Paul Rosenberg, who was searching for his looted art, "has even made himself unbeloved in America, where he has disturbed the entire [art] trade and caused all the wares in Europe to be embargoed. He is ac-

cusing everyone of theft and unlawful ownership. This has made it harder to import goods."[44] But throughout modern history the art market has shown an almost inexorable capacity to regenerate, and the post–World War II period proved no exception. ALIU officer Otto Wittmann wrote in the autumn of 1946, "It is alarming to observe that in this first year of peace in Europe, a majority of the collaborationist dealers, collectors, and agents who willingly aided in the cultural despoliation of their own countries have avoided serious prosecution. Many of them, not only nationals of neutral countries, but also of formerly occupied countries are continuing their trade."[45] In other words, the shortcomings of justice were evident to contemporaries.

Rehabilitation was the norm for Nazi art plunderers, just as it was in other sectors. Historian Tony Judt noted, "By 1952 one in three Foreign Ministry officials in Bonn was a former member of the Nazi Party. Of the newly-constituted West German Diplomatic Corps, 43 percent were former SS men and another 17 percent had served in the SD or Gestapo. Hans Globke, Chancellor Adenauer's chief aide throughout the 1950s, was the man who had been responsible for the official commentary on Hitler's 1935 Nuremberg Laws."[46] Historian Peter Hayes argued persuasively in his study of the Holocaust that the vast majority of high-ranking perpetrators were brought to justice—especially camp commandants, Einsatzgruppen commanders, and the leaders of the T-4 program—but Hayes also points out that punishment proved less common the lower one moves down the chain of command; for example, "the mid- to low-ranking personnel at most concentration camps were largely ignored or given light sentences—at least by American standards—when tried."[47]

Those complicit in the Nazi plundering campaign employed a wide range of strategies as they revived their careers. Restorer Eduard Kneisel, who worked with Kajetan Mühlmann and his colleagues looting in Poland, moved to the United States after World War II and continued to work as a restorer into the 1960s. According to Ardelia Hall, the State Department expert on plunder and restitution, Kneisel went on to ply his craft at the Frick Collection in New York, assisting William Suhr, the chief conservation expert.[48] Kneisel had helped care for the Czartoryski "big three" (masterpieces by da Vinci, Rembrandt, and Raphael in the Cracow collection) toward the end of the war, and while the Rembrandt and da Vinci survived unscathed, the missing Raphael *Portrait of a Young Man* has continued to vex researchers. Some believe the Raphael disappeared in Lower Silesia, while others believe that Hans Frank, the general gov-

ernor of Nazi-occupied Poland, managed to take it as far as his Alpine retreat in the town of Neuhaus on the Schliersee.[49] Besides Kneisel, the other person responsible for the Czartoryski "big three" was art historian Wilhelm Palézieux (1906–55), who had succeeded Kajetan Mühlmann as the chief plunderer in German-occupied Poland (the General Government). Palézieux spent five years in a Polish prison after the war, but he never divulged information about the fate of the Raphael. By the early 1950s, Palézieux was living in Switzerland and selling art in France, Germany, and Luxembourg.[50] Bernhard Degenhart (1907–99), who plundered art for Kajetan Mühlmann's agency in the Netherlands, served as curator at the Bavarian State Graphic Cabinet.[51] Another of Mühlmann's deputies in the Netherlands, Dr. Franz Kieslinger (1891–1955), returned to work at the Dorotheum in Vienna and became a kind of mentor to collector Dr. Rudolf Leopold, founder of the Leopold Museum in Vienna.[52] And Lohse's closest friend in the ERR, art historian Günther Schiedlausky, was put in charge of arts and crafts at the Germanisches Nationalmuseum in Nuremberg.[53] Dr. Leopold Reidemeister (1900–1987), who had been a Wehrmacht Kunstschutz officer in Italy during the war, served as of 1957 as the general director of the Berlin State Museums and simultaneously as the director of the National Galerie before going on to help found Die Brücke Museum in Berlin in 1964.[54] As a member of a unit in the German army responsible for protecting cultural property, Reidemeister was not a looter per se, but his official position had led him into numerous gray zones.[55] Reidemeister's distinguished postwar career included posts heading the Wallraf-Richartz Museum in Cologne and the general directorship of the West Berlin State Museums. Needless to say, this review of figures who implemented the Nazis' looting policies and then rehabilitated their careers after the war is far from complete.[56]

The success of these experts was due, in part, to their continued mutual cooperation. The Nazis had often voiced the dictum "We must stick together" (*Wir mussen zusammenhalten*), and this also applied to the postwar period. They effectively created networks centered in southern Germany, Austria, Switzerland, and Liechtenstein: "the golden quadrangle," I would call it. But they were connected to individuals in Berlin and other German cities, as well as to "associates" in foreign lands. Bruno Lohse was a part of this constellation, and indeed, a prominent individual within it. In order to understand this web of relationships, and Lohse's life and career after 1950, it is necessary to identify the key figures, starting with the Germans who managed to rehabilitate their careers. Radi-

ating out from this core group in Munich were Swiss colleagues, followed
by other Europeans, and then Americans who interacted with them. The
latter, of course, were not Nazis, and it is important to preserve distinc-
tions. But with the old Nazis at the core of these networks, ethical dilem-
mas or transgressions were unavoidable.

A discussion of the key German figures in the network begins with
Karl and Magdalena Haberstock, the former counting as arguably the
most important art dealer during the Third Reich. After the war, the
couple relocated permanently to Munich, moving into an elegant red-
brick apartment building on the Königinstrasse (number 22) abutting the
English Garden. The neobaroque residence had been built in 1893 for
Tyrolian painter Franz Defregger—a favorite artist of the dealer (and of
Hitler too). Karl Haberstock spent the postwar period retrieving what
pictures he could from the Allies. He was compelled to give up on the
works he had acquired in France and the Benelux countries during the war;
all works acquired by German nationals in occupied countries were re-
turned to the government of the country of origin. He also had some of his
property disappear after it had been confiscated by the U.S. Monuments
men—security being a constant challenge for Allied authorities. Haber-
stock alleged that U.S. soldiers were responsible for the thefts, and he was
likely correct. A great many valuables were taken by U.S. troops during
and after the war.[57] As Haberstock resolved his issues with U.S. restitution
authorities, he went through denazification and emerged, after an appeal,
as a "fellow traveler." Bruno Lohse was among those who wrote letters in
support of Haberstock—he wrote a 12 January 1948 affidavit while impris-
oned in Paris. Other letters came from Robert Scholz, Theodor Fischer,
and Munich museum director Ernst Buchner.[58] With the help of Magda-
lena (1892–1983), who was a kind of unofficial partner in his business, Ha-
berstock resumed dealing art from their home. The Haberstocks remained
very wealthy. Lohse told the story of visiting the couple in the early 1950s
when Karl Haberstock would pick his brain for the latest news. On occa-
sion, Lohse recounted, Magdalena would find a time after dinner to stuff
a roll of hundred-mark notes into his hands to thank Lohse for how much
he had done for her husband. Lohse also said he believed Karl Haberstock
had gotten off lightly because he lied his way through the Allied interro-
gations.[59] Lohse clearly preferred Magdalena to her husband.

At this time, the Haberstocks established a foundation for their art
collection. They began to loan pieces to the Augsburg municipal mu-
seum, which was housed in the resplendent Schaezler Palais on the old

Maximilian Strasse in the heart of the Bavarian city. The Haberstocks had amassed a fine collection, with works by Cranach the Elder, Canaletto, and Tiepolo, as well as a portrait of Magdalena by Nazi artist Arthur Kampf.[60] While none of these works have been identified as looted, suspicions surround several others, including a painting by Philips Wouwerman (*Outdoor Riding School* from 1665) that Haberstock supposedly bought in Nice in 1941. The picture had belonged to the Rothschild family and Alexandrine de Rothschild initiated restitution proceedings against the German state for the work in 1958. While this resulted in compensation, the painting remains to this day in the Haberstock collection in Augsburg.[61] More certain is that the Haberstocks amassed their collection with the profits they derived from selling to Nazi leaders and trafficking in looted works. Even if the individual works were not looted, they came into Haberstock's possession as a result of his collaboration with Nazi leaders. After Karl Haberstock died in 1956, Magdalena made a more permanent arrangement with the Augsburg museum, gradually loaning more pieces, including their fine library, and eventually leaving everything to the city. Museum officials named a series of galleries after the Haberstocks and placed a bronze bust of him at the entrance. The city of Augsburg even honored him (posthumously) by naming a street after him. The Karl Haberstock Strasse still exists in Augsburg today. And Magdalena Haberstock donated at least one work in honor of her deceased husband to the Bavarian State Painting Collections in the early 1960s: an early nineteenth-century portrait of German painter Johann Georg von Dillis by Moritz Kellerhoven, which General Director Kurt Martin gladly accepted.[62] The picture was placed in the stairway of the Alte Pinakothek in Munich.

Bruno Lohse adored Magdalena Haberstock, who was attractive and evidently quite captivating. Lohse was also not alone among her admirers. Back in the 1920s, Hans Wendland had fallen for her: "a dispute over Karl's wife had ended [his] friendship" with Haberstock.[63] Whereas Karl Haberstock was notoriously imperious and formal, Magdalena was friendlier and more relaxed. After the dealer's death in 1956, Lohse visited her once a week, like clockwork, at her sumptuous apartment on the English Garden. By the mid-1960s, Magdalena Haberstock had moved to another apartment, this one in an ornate Jugendstil building near the corner of the Isar River and the Prinzregentenstrasse, which put her even closer to Lohse's home—about a ten-minute walk through the charming Bogenhausen neighborhood.[64] Because she was nearly twenty years older than Lohse (born in 1892), a romantic relationship seems unlikely. Yet Lohse

cared for her. As Magdalena aged and became infirm, he would bring her groceries every week. Lohse did this until her death in 1983. During her last years, Magdalena Haberstock committed herself to sanitizing her husband's papers, which she did quite thoroughly prior to donating them to the Augsburg museum. Lohse may have helped her with this project—at least he indicated so in one of our conversations. Magdalena wrote Robert Scholz in April 1958 that Lohse had visited her with a lawyer friend of his from Nuremberg and they discussed a wide range of documents, although they were primarily concerned with how Haberstock and Lohse were being portrayed in early accounts of Nazi art looting.[65]

Magdalena Haberstock nonetheless left a great many "interesting" documents in the estate, including her husband's correspondence with the Wildensteins and materials concerning the purchase of the Gutmann property in Holland during the war. She also left intact his annotated auction catalogues in which Haberstock had in many instances noted who had bought what—including at the *Judenauktionen*, or auctions of Jews' property that occurred frequently before 1945. With lot after lot, one sees his notations as he writes that Goebbels or Hitler (usually referred to as "Linz") or some other Nazi leader prevailed in the sale. His papers proved so revealing about the art world in Nazi Germany that the Augsburg museum, backed up by the city and provincial administrations, kept them off limits to researchers until 2000. A campaign to open his estate (in which I played a role) finally induced the authorities to open the Haberstock archive, and in 2008 Augsburg museum officials sponsored the publication of a very useful scholarly volume on the materials.[66]

Living directly above the Haberstocks, overlooking the English Garden, was Walter Andreas Hofer. Lohse related an oft-told quip within the postwar network that the elegant brick apartment building where the two dealers resided was known as the "Braunhaus"—a pun on the famous Nazi Party headquarters not too far away. And indeed, it was a source of amusement that the two dealers, who were not only business rivals but also disliked one another intensely, lived in such close proximity. There were reports of friction between the neighbors, with the Haberstocks playing their radio too loudly and Hofer's voice waking up Magdalena early in the morning.[67] Hofer had worked his way out of trouble by helping the Allies at the Munich Central Collecting Point, which irked Lohse, who wrote Plaut as early as December 1950 that his rival was *"persona gratissima* at the collecting point and goes in and out there as he pleases, and so it is with Herr [Eberhard] Hanfstaengl [the director of the Bavarian State Paint-

ing Collections from 1945 to 1953]."[68] Hofer had made quick inroads back into the Munich art world. Although he had relocated to Berchtesgaden on the Bavarian border with Austria as the war ended, Hofer returned to Munich and by 1950 had resumed his activities as a dealer.[69] His postwar correspondence with the New York–based Hanns and Kate Schaeffer (who had arrived from Europe before the war), letters housed in the Getty Research Institute, reveals a thriving business and commensurate lifestyle, with Hofer traveling between Switzerland, France, and Italy.[70] Walter Andreas Hofer continued to utilize his pre-1945 network, including turning in 1962 to Ernst Buchner, the general director of the Bavarian State Painting Collections during the Third Reich, to write an expertise regarding a sixteenth-century painting by a "Swabian Master." Two years earlier he had used former Führermuseum director Hermann Voss for a similar purpose.[71] Hofer had his own business stationery with the Königinstrasse address printed at the top, and he advertised in art market periodicals like *Die Weltkunst*.[72]

Walter Andreas Hofer also exploited the contacts of his wife, Bertha Hofer-Fritsch, a world-class restorer who continued to be in demand after 1945. She had worked for Göring, repairing, for example, five canvases in 1940, including what was then believed to be a Leonardo da Vinci (a Leda picture—after the war it was deemed by experts to be "school of"). Frau Hofer-Fritsch received RM 1,475 for the five canvases, or about $30,000 today.[73] After the war, Frau Hofer reportedly carried out projects for the Frick Collection and the Metropolitan Museum of Art in New York.[74] Like her husband, she was able to continue a thriving career despite her past work for the Nazis. Walter Andreas Hofer, as the records of the Schaeffer Galleries show clearly, continued in the international art trade until his death in 1971.[75]

When I met with Lohse back in 1998, he readily volunteered—with a good measure of scorn and envy—that Hofer not only continued his art dealing well into the 1960s, he did a brisk business.[76] Some of the works Hofer sold starting in the 1950s had been in Göring's collection but had gone missing—such as a Lucas Cranach the Elder Madonna that disappeared at war's end and then was sold by Hofer in 1955 to a lawyer in Cologne.[77] Hofer, like Lohse, may have been able to abscond with a limited number of works from their chief, and this may have been one of the sources of their postwar wealth. The available evidence is inconclusive on this issue, but journalist Stefan Koldehoff noted, "Numerous other Göring pictures have remained lost up until today."[78] While some went into the art

market (with Hofer and perhaps Lohse playing a role), others works, like the aforementioned Franz Marc, *Tower of the Blue Horses* (1913), continue to elude researchers.

We know little about the Hofers' postwar activities, but it bears mentioning that the ALIU investigators had suspected that Walter Andreas Hofer had "funds and perhaps works of art concealed in Switzerland."[79] American investigators questioned him at length about an account under the name "Josef Angerer" at the Wehrli Bank in Switzerland. Angerer, of course, was another art dealer who sold to Göring, and he had traveled to Switzerland with Hofer on several occasions. The Americans suggested that Hofer forged Angerer's signature to open the account, but the dealer denied the allegations.[80] Lohse said that Hofer had made a great deal of money during the war.[81] Hofer denied this, adding that his bank account, which had been in Berlin, was seized by the Soviets. The Americans never found any assets of his in Switzerland, although they did return a few art objects to him from the Central Collecting Point in the late 1940s.[82]

Lohse never completely gave up his rivalry with Hofer, and took pleasure in deriding him. He noted, for example, that Hofer never owned a car but he rode his bicycle everywhere, as if this were déclassé. Lohse also mentioned that Hofer had never joined the Nazi Party, as though this was another sign of disloyalty. Hofer's personality tended toward the calculating, manipulative, and ingratiating, while Lohse prided himself on boldness, self-confidence, and cynicism. The friction between Lohse and Hofer therefore came down to personality and professional rivalry. The Hofers had a daughter, and she also eventually entered socially into the postwar network, although she had no formal involvement in the art trade. Born in December 1938 in Berlin, about a year after Walter Andreas and Bertha Hofer had wed, Gisela Hofer moved with her parents after the war to Munich, where she made her home, and reportedly became very close friends with Göring's daughter, Edda, to whom Lohse also remained devoted. Peter Griebert affirmed getting to know her, describing her as *sympathisch*.[83]

Peter Griebert also got to know Gustav Rochlitz's daughter, Sylvia Rochlitz-Bonwil (b. 1934), from whom he purchased a fourteenth-century Italian Master Cross that had gone missing during the war from the Church of San Pantaleone in Venice. The Master Cross had been stored in Rochlitz's Bavarian farmhouse near Neuschwanstein until Griebert purchased it in the late 1990s. The altarpiece went back to the Venetian church in 2013, a journey that in itself played out as a saga.[84] The larger point is

that the fate of this important artwork, from the wartime theft to the 2013 return, occurred due to the actions of Rochlitz and Lohse who, even when not acting directly, influenced the course of events through their kin and partners. Gustav Rochlitz had continued to deal art both from his home in Füssen and from an address in Cologne. In 1964, when Rochlitz offered an Italian Old Master picture of Saint Katherine of Sienna to Hanns Schaeffer in New York, the latter wrote back that an X-ray analysis carried out at New York University revealed that it was a "modern" picture.[85] In other words, Rochlitz was peddling a forgery—which Schaeffer, of course, refused to buy. When he passed away in 1972, Gustav Rochlitz left many unanswered questions, including one concerning the fate of his collection.

Another member of the Göring coterie with whom Lohse kept in contact was Gisela Limberger, the secretary to the Reichsmarschall and registrar of his art collection. Lohse called her "Limmi" and, like most of the others, she too lived in Munich. She was a tall, elegant woman, and clearly very discreet—if not focused on ethical issues. How else could she have worked for Göring all those years (1935–45)? She clearly had attractive personal qualities. Lane Faison of the ALIU recounted that he had worked closely with her during the postwar interrogations that had been conducted at House 71 in Altaussee. Limberger had assisted with translations and been consistently helpful as the OSS questioned the most important plunderers.[86] When the interrogations were over, Faison was charged with escorting Limberger to an internment camp in Freising, Bavaria. He related that at the sight of the facility and the women inmates in prison garb, she broke down and cried. He then offered to take her elsewhere—to the home of art dealer and ERR official Walter Borchers, who was living in a villa on Lake Starnberg.[87] Needless, to say, this episode entailed a U.S. official permitting his personal feelings to lead him to violate policy— and perhaps an order. Yet his response evidences her charm. Around the time of her release from the Altaussee interrogation center, Faison recommended Limberger to Craig Hugh Smyth, who had just set up the Munich Central Collecting Point. Faison described her to Smyth as "an extraordinarily capable person (age 52), a very fine typist, speaks good English, and has a vast fund of information. . . . I feel certain you would find her invaluable."[88] Limberger did not work for long at the Munich CCP, but she subsequently found a way to continue her profession. She was hired by the Americans to work at the Munich Military Post Special Services Library on the Tegernseer Landstrasse, where she oversaw the fifteen-thousand-

volume collection.[89] Limberger lived until age eighty-seven, passing away
in 1980. Her story also underscores how most of the ERR and Göring staff
went free just months after war's end, while Lohse spent five years doing
hard time.

The key to this Munich network clearly remained Hermann Göring.
Even though he had died in Nuremberg in 1946, he continued to cast a
long shadow over those who had worked for him. Those who had served
the Reichsmarschall felt a special bond. There were other Nazis (or those
who had assisted Nazis) in the network who had not been Göring's min-
ions, but they had to overcome a certain suspicion. Robert Scholz, for ex-
ample, never found acceptance in the Göring circle, even though he lived
just outside Munich in Fürstenfeldbruck and wrote articles in the postwar
period for radical right-wing publications such as the *Deutsche National
Zeitung* and the *Klüter-Blätter*. Publications like these glorified Hitler and
the Nazis while simultaneously avoiding federal censorship and reaching a
small but committed audience (the *Deutsche National Zeitung* had a circu-
lation of 131,000 in 1967).[90] Lohse told me that he despised Scholz, saying
with pejorative undertones that the latter was a "true Nazi"—as if this was
a sign of being vulgar or a lower-class type. Lohse also opined that Scholz
had been a "terrible painter."[91] But the real cause of the mistrust is that
Scholz had been loyal to Alfred Rosenberg, one of Göring's many rivals.
Scholz also likely suspected that Lohse had played a role in the "disap-
pearance" of the seventy-one Impressionist pictures from the ERR depot
in the Jeu de Paume, and Lohse himself may have sensed this: his hostile
remarks about Scholz may have been a kind of defensive mechanism.

One individual technically not part of Göring's circle who found ac-
ceptance in the postwar network was Maria Almas Dietrich, who had the
distinction of selling more works to Hitler and the Führermuseum than
any other dealer.[92] One scholar has noted, "The Allies suspected that Die-
trich, like many other German art dealers, had stashed away valuable art-
works in secret locations which could be sold at a later date."[93] S. Lane
Faison had recommended that her license as a dealer be suspended. How-
ever, the Allies did not locate the stashes or prevent her from resurrecting
her career.[94] As during the Third Reich, a key figure in her business and
social networks was her daughter Mimi tho Rahde (1910–2011). After the
war, mother and daughter set up shop on the fashionable Brienner Strasse,
on the corner that connects the Odeonsplatz to the Wittelsbacherplatz
in the heart of Munich. Even though tho Rahde retired as a licensed art
dealer in 1993, a brass plaque bearing the name "Galerie Almas" could be

seen at the entry to the building until 2001.[95] Maria Almas Dietrich lived in Bogenhausen on the Prinzregentenstrasse, not far from Lohse's apartment, and they saw one another often prior to her death in 1971.[96] Mimi tho Rahde, who was almost the same age as Lohse, remained a close friend for years. It is also interesting that in the Munich-based art magazine *Die Weltkunst*, which features advertisements of prominent galleries, both the Galerie Almas (with the subheading Mimi tho Rahde) and Galerie Peter Griebert—Lohse's friend and onetime business partner—shared a page in the 18 October 1976 issue: the top half promoted the Galerie Almas and the bottom half featured Griebert's establishment.[97] Both advertised their booths at the upcoming German Art and Antiques Fair (Deutsche Kunst-und Antiquitätenmesse) in Munich. Griebert explained that the Galerie Almas specialized in fine furniture, while he handled paintings exclusively.[98] The two dealers paired up, creating a joint exhibition in their booth that showcased his pictures and her antiques. Mimi tho Rahde also reportedly inherited a painting from Lohse.

There were other dealers who had been active during the Third Reich who revived their careers in Munich, although they were not linked so directly to the Göring cohort. Erhard Göpel, the art historian who had served as one of Hitler's agents during the war, settled in the Bavarian capital, where he continued his scholarship on Max Beckmann and wrote for the *Süddeutsche Zeitung*. His articles sometimes facilitated the trafficking of Nazi-looted art, as when, for example, he wrote a piece in 1964 about the Bavarian State Painting Collections acquiring Picasso's important Blue Period *Portrait of Madame Soler*.[99] Göpel quoted the newly appointed director Halldor Soehner (who had also been a Nazi), describing the history of the painting.[100] Neither Göpel nor Soehner mentioned that the work had come from the collection of Paul von Mendelssohn-Bartholdy, a Berlin banker from the famed German Jewish family who had endured persecution in the years leading up to his death in May 1935. New York–based émigré dealer Justin Thannhauser had sold the picture to the Bavarians in 1964 and notified them of the von Mendelssohn-Bartholdy provenance, but Göpel and Soehner chose not to publicize this information. The heirs of Paul von Mendelssohn-Bartholdy filed a claim for the painting in 2010, and a lawsuit ensued shortly thereafter.[101] The heirs were unable to establish jurisdiction in a U.S. court and thus far have not compelled the Germans to enter in arbitration; the magnificent Picasso portrait remains in Munich.

Erhard Göpel's papers are housed in the Bavarian State Library, with

access controlled by his widow, Barbara Göpel. She has been known to deny access to scholars whom she views as critical of her late husband.[102] This is perhaps understandable when one discovers documents such as the order signed by Reich commissar for the Occupied Netherlands, Arthur Seyss-Inquart, that afforded Göpel official status within the Nazi plundering bureaucracy. A transcription of the document from someone who was given access to the Göpel *Nachlass* (literary estate) in Munich shows Seyss-Inquart ordering that Göpel be consulted by the ERR as it removes objects seized in Holland.[103] The document, marked *Geheim* (secret), is a haunting one, with passages about seizing "all residential goods, including household items and cultural objects (pictures, carpets, art objects, etc.), that become available during the resettlement and evacuation of Jews."[104] Then there is the "confidential" 1945 OSS report titled "German Personnel Connected with Art Looting," a copy of which is in the U.S. National Archives in College Park, Maryland. Under "Erhard Goepel," the document states, "Involved in confiscations . . . Recommendation . . . That he be tried as a war criminal."[105] Göpel, not surprisingly, proved very adroit in extricating himself from this dire situation (he was listed as "location unknown" in the report), and he rebuilt his career to a remarkable extent in the postwar period. In 2018, Barbara Göpel donated to the Berlin State Museum works by Hans Purmann and Max Beckmann, including two portraits of her deceased husband.[106]

The auction house of Adolf Weinmüller (1886–1958) (which became Neumeister after the death of the namesake) also contributed to the continuity between the pre- and post-1945 periods.[107] Julius Harry Böhler remained on the Briennerstrasse, just across the street from the Galerie Almas. A letter from him to Lohse in 1972 discusses a range of artworks for sale, including a double portrait of children from the Fugger dynasty in Augsburg and a "small panel of the Master of the Coburger Roundels." What is perhaps most interesting about the latter is that Böhler states, "I would gladly view it in late summer if I come to Zurich."[108] While this document does not reveal any actual business transaction, Böhler references a number of objects potentially for sale. He concludes by sending "heartfelt greetings" to Lohse's wife, which indicates a personal relationship. The archives of the Böhler Gallery show Lohse purchasing six objects from Böhler between 1955 and 1959: they range in price from DM 12,000 to 20,000 and include works by Jan van Goyen, among others.[109]

That the august Bavarian State Painting Collections (or BStGS) contained many "brown" staff members was the cement that anchored the

Munich network. After all, the BStGS, which comprised some twenty museums and castles, was not only a mammoth collection of great artworks but also the custodian of many pictures that had been displaced during the war. Most of the directors of the BStGS had Nazi pasts—most notably Ernst Buchner, who had held the post from 1933 to 1945 and then again from 1953 to 1957. But even his successors had past chapters that took them into the world of Nazi art plundering: Kurt Martin, who followed him as general director in 1957, had been active during the war seizing artworks in Strasbourg (his official title was general plenipotentiary for the securing of artworks from enemies of the people and the Reich in Alsace), and his protégé, Halldor Soehner, who followed in 1964, had joined the Nazi Party as a graduate student back in 1941.[110] These directors then hired others who had been active in the Nazis' plundering programs, such as Hermann Voss (1884–1969), the second (and last) director of the Führermuseum. Voss, a specialist in Renaissance and Baroque painting, reputedly had an excellent eye (he had not been deceived by the van Meegeren fake Vermeer); and despite being a key figure in the Nazi plundering campaign, he rehabilitated his career as a curator at the Bavarian State Painting Collections, where he also served as a member of a key purchasing committee until 1968.[111]

Bavarian State officials sold works to former Nazi leaders and their wives: in 1963, Henriette Hoffmann, former wife of Baldur von Schirach and daughter of photographer Heinrich Hoffmann, purchased a picture of a Dutch square that had been taken from a Jewish family in Vienna. She and her husband had evidently had the picture at one point and she wanted it back. Henriette Hoffmann (she divorced Baldur in 1950) received over two dozen pictures from the BStGS in the postwar period, many through "return sales" whereby works were sold to her at prices well below market value.[112] Emmy Göring, widow of the Reichsmarschall, was also among those who recovered art from the BStGS. Journalists Catrin Lorch and Jörg Hantzschel noted that Kurt Martin, the director from 1957 to 1964, opposed the sale of Nazi leaders' art becoming publicly known, fearing that "the looted art will be once again a topic of international politics" and that "art pieces will have to be returned or compensation paid." They added, "In the meantime there seems to have been no problem with the return of looted art to Nazi families."[113]

The Bavarian State Painting Collections was a place where old Nazis felt relatively welcome. Documents show Lohse offering a painting by Bartolomé Esteban Murillo, *Scene from the Joseph Legend*, in 1966/67 for

DM 1.5 million.[114] Although the BStGS curators did not buy the work, he was clearly in their orbit. When Halldor Soehner signed off on the decision to sell the second-rank pictures belonging to Hitler, Göring, Bormann, and other Nazis, he chose to do so through auction houses Weinmüller (now Neumeister) in Munich, Lempertz in Cologne, and Leo Spik in Berlin—all of which had been major purveyors of looted art during the war. The efforts of the BStGS to sell these works quietly, without public notice, blew up in their faces, however, when investigative journalists like Reinhard Müller-Mehlis got wind of the plans and criticized the lack of transparency, not to mention the bad deals—he claimed valuable works were deaccessioned for low prices.[115] The pressure mounted in 1968 with a stream of articles in both Munich and national papers. The renewed controversy about the past of Hermann Voss broke around the same time (it was difficult indeed to explain away having been director of the Führermuseum, even if Voss never joined the Nazi Party). Voss's "retirement" was followed by director Soehner dropping dead of a heart attack in April 1968.[116] In the wake of Soehner's sudden passing, the scandal surrounding the "secret auctions" subsided, and Voss also faded from the scene; he stayed in Munich but died a year later in April 1969. The outburst of the '68ers certainly stirred things up at the Bavarian State Painting Collections, and new leadership ensued. But even in retirement, those surviving members maintained their networks, with Munich continuing to serve as the epicenter.[117]

The next ring in the web radiated outward to neighboring Switzerland. During the war, in the opinion of Hector Feliciano, "the Swiss market [had] acted as a kind of satellite to the French market."[118] Not surprisingly, relationships that had developed during the war persisted into the 1950s and beyond. The Swiss members of these networks included financiers, who used the culture of secretive banking and the shared myth of their nation's neutrality during the war to cloak their conduct. The Swiss Bankers' Association, for starters, resisted all efforts to hold individual banks accountable or to study the contents of the vaults and safe-deposit boxes. A statement from the association read, "The contents of closed deposits are not known to the banks. What is inside a bank's vaults is generally packed and sealed, with the result that it is not possible to provide the accurate description of the item that is required. Also bank officials would hardly be suitable for drawing up this kind of inventory."[119] The Swiss government was certainly not prepared to take on the country's powerful banking interests. As one Geneva banker stated recently, "It's an open

secret the Swiss vaults are absolutely filled with art and artefacts that have been illicitly got."[120]

The Swiss legal code also helped make the country a center of the trade in stolen and smuggled works. In the United States, one can never have good title to stolen property, but in Switzerland, a "good-faith" purchaser has good title to property, even if it was stolen "or otherwise came into circulation by way of illicit activities."[121] The Swiss Bundesrat had already affirmed in December 1945 that "good-faith" purchases of looted art afforded good title. Moreover, until fairly recently in Switzerland, possession of property for five years conveyed good title. This changed in 2006 after intense international pressure that also led to a settlement whereby the Swiss Bankers' Association paid $1.25 billion in compensation to Holocaust victims who had not recovered assets entrusted to their institutions. The Law on the Transfer of Cultural Property extended the five-year period to thirty.[122] Therefore, from 1945 until 2006, if one could show that one had the *Mona Lisa* in one's home for five years, and that one "remained" in good faith during that period, then there would have been no legal grounds for recovery in Switzerland. Furthermore, as Hector Feliciano explains, "In the event that a stolen painting passes into the hands of a dealer or appears in an auction, the person from whom it was stolen must reimburse whoever bought it before the painting can be returned."[123] Journalist Peter Watson has shown how Switzerland also became the center of the smuggling trade in antiquities.[124]

In addition to a legal code and a political culture that facilitated trafficking in stolen and illegally exported property, Switzerland had evolved into a commercial center, with duty-free warehouses, free ports, and the like, where customers and their agents could come and go and transfer assets without difficulty. The 2015 arrest of Swiss "art broker" Yves Bouvier prompted an article in *Forbes* that described how Bouvier "runs a set of luxury warehouses across Geneva, Luxembourg, and Singapore where the world's billionaires store their art, along with jewels, fine wines and other luxury goods legally in tax-free zones."[125] The Freeport facility in Geneva, according to journalist Yves Stavridès, "is a small city, one with incredible valuables stored there. It's unimaginable to most people."[126] A moving and storage company in the Geneva Freeport called Natural Le Coultre "rented more than twenty thousand square meters in storage space and has had well over a million objects in its care."[127] This veritable museum is just one firm (albeit the largest tenant in the complex) in one of many free ports around the world, but all together, these facilities have constituted

an important resource utilized by dealers, collectors, and their associates within the $60 billion international art market.[128] Just as the exposure of the "Panama Papers" (11.5 million pages of leaked documents) in 2016 shed light on how certain collectors and dealers have engaged attorneys, like those at the Mossack-Fonseca firm, to create shell entities to conceal artworks, we now have a greater understanding of how the freeports and warehouses have functioned in this system.[129]

A friend of Bruno Lohse's, Professor Claus Grimm (b. 1940), added other considerations that helped make Switzerland a favorite repository for valuables. Grimm said it was common for art dealers to keep bank accounts in Switzerland because commissions were often paid in cash and the deals were done outside Germany. Dealers did not want to pay taxes, and Lohse was apparently no exception. After his death, those who inherited pictures from him discovered they had to pay the back taxes if they wanted the work (and a number of the heirs supposedly renounced the property they were left). This strongly suggests that Lohse had evaded paying taxes on these works. In Lohse's case, Switzerland and Liechtenstein lived up to their reputation and helped with the concealment of stolen property and tax evasion. Yet there was also a deeper psychological reason for keeping assets in these Alpine countries. Claus Grimm noted that with the fear of a Soviet invasion during the Cold War (whether through the "Fulda gap" or some other point of attack), there was a sense that Germany would become the front line of a conflict. Many believed that the Americans would defend only the territory west of the Rhine and that most of Germany would fall to the Soviets. The older generation, who had experienced the ravages of the Red Army, internalized these fears in many ways. Grimm said he knew people who kept cars—fully gassed up—on Lake Constance, ready to make their escape to Switzerland should the need arise. Even Hitler had not sent the German armed forces into mountainous Switzerland.[130]

The trade in looted art in Switzerland during and after the war is a tantalizing subject, one in which there are still large gaps in our knowledge. The investigations at war's end had a promising beginning. The ERR trades through Wendland and Rochlitz, for example, were well documented by the ALIU investigators—not only by the "first generation" (Rousseau, Plaut, Faison) but by their successors, Otto Wittmann (1911–2001) and Bernard Taper (1918–2016). They were joined by the squadron leader, Douglas Cooper (1911–84), the most active Allied Monuments officer with regard to Switzerland. Cooper himself initially discovered

seventy-five looted works in Switzerland (two more were added, for a total of seventy-seven); but as the Swiss Independent Commission of Experts, which looked into Swiss behavior during World War II, noted in a 2002 report, "After the war, not a single work was restituted that had not already been tracked down by Cooper."[131] Cooper, Plaut, and Rousseau made trips to Switzerland from 20 November 1945 until mid-January 1946, and Wittmann returned in the autumn of 1946. They found evidence of extensive trafficking by Swiss dealers during the war—not only with ERR loot but with all sorts of plunder stolen by other agencies and by individuals.[132] There were more than a dozen Swiss dealers complicit in the trafficking in Nazi-looted art, including Fischer in Lucerne, of course (most notorious culprit, he handled at least thirty-nine of the seventy-seven paintings), Albin Neupert in Zurich, the Galerie Tanner in Zurich, the Galerie Aktuaryus in Zurich, the Galerie Benador in Geneva, and the Galerie Epoque in Zurich.[133] The ALIU investigators also received information from other agencies and government officials. The U.S. Embassy staff in Bern, the officials who were working on Operation Safehaven (economic warfare against Nazi Germany), and others contributed intelligence on Swiss trafficking in looted art.[134]

In the autumn of 1946, Otto Wittmann made the last trip by an ALIU officer to Switzerland. Wittmann developed more leads and offered a series of recommendations (including suspects to be interrogated) but, in the words of Swiss historian Thomas Buomberger, "his research trip was a complete failure."[135] It was Wittmann who added the two works to extend the Cooper list to seventy-seven known pictures, but as Buomberger observed, "This meager result is in itself astonishing. There must have been at this point in time hundreds of works of dubious origins located in Switzerland."[136] Wittmann recalled decades later that when he questioned the Swiss, the common answer was, "Who do you think we're going to be doing business with after the war—not with you Americans. We're going to be doing business with the Germans, so we're not interested in helping you with your project."[137] The Allied officers nonetheless pleaded with their superiors to be able to expand their investigation. Douglas Cooper, for example, wrote, "There are no doubt other looted works of art in Switzerland which have not yet been discovered, either because they are hidden in bank vaults or because they have passed unnoticed."[138] But with the Cold War intensifying and other priorities emerging, their pleas fell on deaf ears. Tensions arose between Douglas Cooper and the American team, which resulted in Cooper stating that he would no longer work with

the ALIU. The collaboratively authored ALIU *Final Report* states, "The abrupt and surprising withdrawal of the British representatives from the investigations being conducted jointly with this Unit has complicated seriously the continuing exploration of possible traffic in loot by members of the Swiss Syndicate of art dealers and private citizens."[139] The conclusion of the ALIU investigation in Switzerland in late 1946 brought to an end the only serious and credible attempt to bring to light the wartime practices, or to reform the system, until the late 1990s and early 2000s. The culture of secrecy, illicit goods, and big profits continued in Switzerland for another fifty years after the war.

Nonetheless, some of the victims proceeded in attempts to recover their property, and their efforts prove illuminating for scholars today. Art dealer Paul Rosenberg, for example, traveled from his new home in New York in September 1945 to file charges against industrialist Emil Bührle, who had purchased paintings that had been looted by the ERR and then traded to Fischer and to the Aktuaryus Gallery, among others. Rosenberg asked Bührle to hand over six pictures to the French embassy in Bern, but Bührle refused. Bührle said he had paid market prices and would not consider a return until the dealers refunded his money.[140] Bührle admitted that he was embarrassed by the fact that he had stolen pictures in his collection, but he was a businessman first and foremost, and he fought for his financial interests. In court, the arms manufacturer argued that the pictures had been seized in France in accordance with the laws that prevailed at the time. Paul Rosenberg had failed to register the works with the French authorities as specified by the Vichy laws, and hence the forfeiture of his property was consistent with the existing laws.[141] Bührle also claimed he had been a good-faith purchaser who did not know about the seizure of Jewish property: "The expropriation of Jewish artistic property by the Germans in the occupied lands was in no way known at the time," he testified in December 1950.[142] Such statements belied his intelligence and sophistication (reports of the seizure of Jewish property appeared regularly in the *Neue Zürcher Zeitung* and other Swiss publications), as well as his own personal experiences.[143] According to American OSS/ALIU officers after the war, Bührle had been a "close friend" of Hans Wendland, and the latter certainly understood full well the business of the ERR.[144] Bührle himself traveled to occupied Paris in July 1941, where he visited the Aryanized Galerie Wildenstein and bought five works (by Titian and Renoir, among others).[145] Could he have been in this particular gallery and not pondered the fate of the Wildensteins and French Jews more gener-

ally? On this particular visit, Bührle met with the "Aryan" trustee Roger Dequoy, with whom he negotiated the purchases. Regarding the Wildensteins' artworks, if they had not been Aryanized, they would be the property of the ERR, and if they were Aryanized, then they would be the property of the new owner (this according to a contemporaneous account by an officer in the German Military Government in Paris).[146] With both the ERR and the Dequoy/Wildenstein purchases, Bührle would have known from whom he was buying the works, and indeed, he subsequently did not convince the Swiss judges that he acted in good faith. The judges ruled in 1948 for the restitution of all the works, also requiring Bührle to pay one-quarter of the court costs.

But that was far from the end of the story, as the voluminous files on the litigation in the Swiss Federal Archives attest. There were two Fischer-Bührle trials: one in 1946–47 and one in 1951–52.[147] The first one concerned what Theodor Fischer had to return and what he owned and the second centered on his demand for compensation from the Swiss state. At war's end, Emil Bührle had turned to Theodor Fischer and demanded his money back, which he received in due course. Fischer argued that he himself had been a victim and had not realized the works had been looted. He used this claim to sue for compensation, and he won a great deal in 1952. Bührle himself went back to Paul Rosenberg and asked to purchase the pictures he had relinquished according to the ruling of the Swiss court.[148] Rosenberg assented: the nine looted works Bührle returned and then re-purchased can be found today in the Bührle Foundation collection in Zurich.[149] Recent research has indicated that Bührle sometimes entered into private arrangements with other claimants in the postwar period, such as the compensation he provided to the heirs of Alphonse Kann in the 1950s for three paintings by Degas: *Madame Camus at the Piano, Dancers in the Foyer,* and *The Dressing Table.*[150] But the lack of information about provenance provided by the Bührle Foundation has only increased suspicion that the arms manufacturer trafficked in looted art.[151]

It bears mentioning that Bührle expanded his collection during and after the war with the help of several interesting figures. In addition to the aforementioned Hans Wendland, who was his principal adviser during the war, the arms manufacturer turned to Fritz Nathan (1895–1972), a German Jewish émigré dealer based in St. Gallen and Zurich who was certainly tied into the networks of old Nazi dealers.[152] Fritz Nathan's mother was from the Helbing family of art dealers in Munich, and he pursued the same trade, first in partnership with his half brother Otto and then with

a gallery of his own in the fashionable Ottostrasse in the center of town. In 1935, the Reich Chamber for the Visual Arts, as part of the program to "de-Jewify" the chamber, issued a *Berufsverbot*, or a ban on practicing one's profession, that prevented Nathan from pursuing the occupation, at least in Germany. Nathan, his wife, and their three children emigrated to St. Gallen in 1936, and he quickly became a fixture in the Swiss art world, especially in the postwar period, when he became a vice president of the Swiss Art Trade Association.[153] He obtained Swiss citizenship in 1948. In a sense, he showed that he adapted when, shortly thereafter, he was caught with a stolen painting, *Portrait of a Young Boy* by Wilhelm Leibl, which had been reported missing from the Munich Central Collecting Point. When Nathan offered it for sale, it did not take long for word to travel. Walter Andreas Hofer, then working with the Americans, tried to assist, writing Nathan to ask him to return the work. Nathan responded that he had purchased it in good faith just recently from a Swiss bank in Zurich and that he was protected by Swiss law. In other words, he refused to return the work.[154] Fritz Nathan's son, Dr. Peter Nathan (1925–2001), joined his father's art-dealing business in 1953, becoming a part of the next generation that continued their elders' associations.

A second key figure helping Bührle amass his collection was Benno Griebert, Lohse's university friend and postwar supporter. Benno Griebert had worked during the Third Reich for the Reich Chamber for the Visual Arts (1934–37) and the National Gallery in Berlin (1938–39). Benno Griebert had also been a member of the Nazi Party, joining on 1 January 1932—which made him an *alte Kämpfer*, or "old fighter."[155] His son Peter concealed this from me in his accounts of his father's experiences. Peter Griebert preferred to tell me about how his father ran afoul of Goebbels and Adolf Ziegler by exhibiting a modernist sculpture of a lion by Gerhard Marcks in the German pavilion at the Paris World's Fair of 1937, and how, during the war, Benno Griebert had entertained troops. The resourceful senior Griebert had two galleries on Lake Constance in the postwar period, one in a stately castle in the town of Meersburg and the other in the city of Konstanz. The spaces enabled him to capitalize on his knowledge of the local art, and with the help of his son Peter, Benno Griebert sold dozens of pictures, sculptures, and works of stained glass to local institutions on Lake Constance. One can document the business into the 1980s.[156] Yet with the art trade taking off again in Munich in the mid-1950s, Benno Griebert relocated to the Bavarian capital, where he continued as a gallerist. He became a prominent dealer, frequently purchasing illustrated

advertisements in the Munich-based journal *Die Weltkunst*. Others posting ads in *Die Weltkunst* in the 1950s and 1960s included not only Walter Andreas Hofer and Maria Almas Dietrich but also Kajetan Mühlmann's former associate Eduard Plietzsch (1886–1961), who operated a gallery in Cologne.[157] Plietzsch had been trained by legendary museum director and art historian Wilhelm von Bode and was friends with many modernist artists, including Max Pechstein, before assisting in the plundering of Dutch Jews (including reported involvement in the confiscation of the Mannheimer collection).[158] Plietzsch, according to the *ALIU Final Report*, had been the "most important professional member of the Dienststelle Mühlmann in Holland" and also had been a "consultant for Dutch and Flemish painting to the Goering Collection."[159] And Kieslinger, as noted earlier, had continued to work at the Dorotheum auction house in Vienna until his death in 1955—offering yet further examples of plunderers who revived their careers in the postwar period.

These are just a few of the many examples of the "brown" presence in the Federal Republic, and especially Bavaria, in the decades following the war. The elder Griebert emigrated to Italy in 1964, but he remained active on the international scene.[160] Benno Griebert focused his attention on expanding Bührle's sculpture collection, but he was clearly part of the brain trust advising the Swiss armaments baron. The senior Griebert had brought his son into the business—introducing him to other dealers, including many in Switzerland—and Peter Griebert nominally took over the Munich gallery in 1964.[161] As noted earlier, Peter Griebert became a confidante of Lohse's. These figures—Lohse, Wendland, the Nathans, and the Grieberts, among others—were all part of broader networks that provided continuity between the wartime and postwar periods. But they also had what one might call a "sub-network" or "ancillary network," and a collector like Emil Bührle provided the anchor for this smaller circle until his death in November 1956.[162] This arrangement would have allowed Lohse to do business with Wendland, Griebert, or Nathan rather than sell directly to Bührle, a high-profile collector. To be clear, there is no evidence showing that Lohse sold art to Bührle—just that Lohse interacted with the Swiss industrialist's agents.

Hans Wendland proved true to form and rebuilt his life as well, which was unsurprising considering his survival instincts and ability to beguile powerful people. After he failed in various schemes to escape Europe— Wendland tried to pose as a Jewish refugee and emigrate from Europe to Latin America—the Americans in Rome arrested him in July 1946. He was

released and then rearrested in Ludwigsburg, Germany, in January 1947. He was acquitted by an American military court in February 1947 but in July handed over to the French, who tried him in February 1950. A "not guilty" verdict ensued—from the same judge who heard Lohse's and the others' cases six months later—and Wendland was a free man.[163] There were other parallels between Wendland and Lohse: they both used the services of criminal lawyer Albert Steiner, they both worked with financial and tax lawyer Frédéric Schöni, and they both had vaults in the Zurich Cantonal Bank. These connections provide further evidence attesting to the existence of networks.

Despite being temporarily banned from traveling to Switzerland, Wendland managed to return to the expansive villa in Lugano with an art collection that included works by Titian, Rembrandt, Cézanne, Pierre Bonnard, and Eugène Delacroix.[164] He subsequently settled in Paris: as Jonathan Lopez writes, "After beating his collaborationist rap in court in 1950, Wendland went on selling dubious pictures and telling whopping lies for another twenty years."[165] Wendland was also known for his ties to American-based dealers, such as German Jewish émigrés Paul Graupe, Justin Thannhauser, and Georges Wildenstein, as well as to collectors— contacts he had cultivated before the war but that now proved especially valuable because of the relative wealth of elites in the United States after 1945.[166] He also used his brother-in-law, Hans Fankhauser, a Basel silk merchant, to send works to America, such as the Degas *Landscape with Smokestacks* looted from the Gutmann collection, which Fankhauser sold to New York collector Emile Wolf in 1951.[167] Wendland was a shrewd and persistent dealer who always found a way to continue in the international art trade.

Theodor Fischer, for his part, sued the Swiss state for compensation regarding the works he relinquished. The Swiss government had passed a measure on 10 December 1945 that declared an aim to return property taken from war areas, with the government compensating affected private citizens. Theodor Fischer took advantage of this provision and filed for 1.1 million Swiss francs (approximately $255,000) to cover the thirty-nine paintings he had relinquished. Fischer also used the argument that Vichy was a legally created regime and that the confiscations had occurred in a manner consistent with the laws of the land. In response to Fischer's claim, as described contemporaneously by an American diplomat, "The Confederation is now attempting to gather material proving that Fischer did not act in good faith when he bought the paintings in question."[168] The Swiss

made a compelling case that caused Fischer to appear even less convincing than Bührle. Other collectors and museum officials had been able to ascertain that works offered to them had been looted, and Fischer, according to Hans Wendland, was alerted on 25 August 1942 by dealer Fritz Nathan, who was very clear that a number of the French Impressionist works in Theodor Fischer's possession had been seized from Paul Rosenberg.[169] In October 1942, the British and the Americans first learned that the Germans were trafficking in looted art in Switzerland, and by December of that year, they had approached Theodor Fischer and threatened him with the "Statutory List," which would bring an end to his international business unless he discontinued trade with Germany.[170] Specifically, Fischer promised not to have dealings with Walter Andreas Hofer, Karl Buemming, or Emil Bührle.

Yet Fischer evidently continued to traffic in looted works; at least the Americans were compelled to warn him publicly in September 1943 via a radio broadcast on the *Atlantik-Sender*, wherein they aired charges that he was trafficking in looted art and demanded "satisfactory assurances from you that you will not handle works of art or antiquities looted from occupied territory by enemies of the United States."[171] They ended up placing the Galerie Fischer on the Statutory List on 2 October 1943.[172] This was part of the Americans' efforts to stop trafficking in victims' property, an initiative that included the 5 January 1943 "London Declaration," an important agreement on "acts of dispossession committed in territories under enemy occupation or control."[173] Fischer responded with paid advertisements in Swiss newspapers in which he denied the allegations.[174] He also told the Americans in 1943 that he had not been involved in the ERR trades, that he had received only three French paintings from Hofer as part of a debt, and that he had sold these to Bührle.[175] After the war, American investigators concluded, "Fischer did not reveal various looted pictures in which he had dealt. . . . It is now evident that Fischer is still concealing the truth about his dealings in looted pictures."[176] When Fischer also claimed "he was not acquainted with the said Hans Wendland," prosecutors had little difficulty proving otherwise, and he was further discredited.[177]

Other testimony from the trial also reflected badly on Theodor Fischer. It came out that Fischer had asked Walter Andreas Hofer (and hence Göring) in "1943 or 1944" to take back works that came from the ERR, saying that "the origins of the works had caused him great difficulties."[178] Unsurprisingly, the Reichsmarschall had not granted the request. Still, this suggested a cognizance of wrongdoing. When interrogated by

Douglas Cooper in 1945, Fischer initially said that he never sold off the pictures from Hofer (that is, ERR works) which, Cooper noted in a report to his chief, Lieutenant Colonel Leonard Wooley, "is proved to be untrue."[179] Fischer also had to answer for certain anti-Semitic statements attributed to him, including a letter he had written to Karl Haberstock in June 1941 in which he had called the Jewish art dealers who boycotted his 30 June 1939 sale of purged modern artworks from German museums a *Judenbande* (band of Jews). Fischer explained that he was "not referring to all Jews" and that the picture that had brought the highest price at the auction, van Gogh's self-portrait, was bought by "Herr Frankfurter (also a Jew)." He added that he had Jewish friends and identified by name the dealers Saemy Rosenberg and Leopold Blumka in America.[180] These were awkward formulations, to say the least. The court ultimately determined that Fischer had not exhibited great care acquiring works during the war, yet after an appeals process that lasted until 1955, he received 265,000 Swiss francs (about $61,500) from the Swiss state.[181] The Swiss, in turn, obtained compensation from the Federal Republic of Germany, including 300,000 Swiss francs (about $70,000) in 1958, that helped cover the compensation payments.[182]

The Swiss dealers themselves worked to obstruct the restitution process. James Plaut noted about Dr. Wilhelm Raeber (1897–1976), a Basel-based dealer and vice president of the Swiss Art Trade Association, that "he trafficked in looted art, and has taken the most pronounced obstructionist attitude against the return of paintings on the Allied list. He was responsible personally for an edict forbidding any member of the Association from divulging gratuitously any information about looted pictures."[183] The same syndicate ruled expressly in January 1951 that sellers were not obliged to reveal the identity of the previous owner or consigner, and that provenance should be provided in only the most general terms (for example, the work came from "an important collection").[184] In other words, the Swiss Art Trade Association encouraged its members to remain silent regarding what they knew about Nazi-looted art unless they were compelled by state authorities. Allied leaders, as we saw, were not about to compel them to talk—even though the ALIU officers wanted to continue investigation on the grounds that it would "enable the United States Government to maintain leadership in the settlement of international issues of a moral and cultural nature."[185] But this argument did not gain traction. Swiss leaders likewise did little, despite having signed the so-called Currie Agreement of 8 March 1945 that obligated them to undertake all

measures to facilitate the return of looted art (*Raubgut*).[186] Otto Witt-mann wrote in his report on his "final mission to Europe" for the ALIU in October 1946 that "it would seem that the Swiss are continuing a policy of strict neutrality in the recovery and return of looted works of art, and are taking limited action to recover such assets."[187] This was his assessment on his way out and, as historian Lynn Nicholas observed, "After the depar-ture of the Allied investigators, they lapsed into non-activity."[188] All of the records of the Swiss Art Trade Association covering the years before 1980 simply disappeared; according to its onetime president, Peter Feilchen-feldt (son of Walter Feilchenfeldt), "No one knows where they went."[189]

The Swiss indeed got off lightly for their collaboration with Nazi leaders. The government-led investigations in the 1990s looking into the restitution of Nazi-looted gold showed that the Swiss did not return all they had received—and that Swiss leaders had lied and misrepresented facts in the postwar negotiations about gold.[190] Indeed, a complex of inter-related issues emerged in the 1990s that induced a reassessment of the Swiss during and after the war, as victims and heirs pursued "unclaimed" assets in Swiss banks, accounts held by Nazi leaders were revealed, and a more complete sense of the extensive Swiss-German wartime trade be-came better understood. The investigations of the 1990s also shed light on Swiss refugee policy, which was antihumanitarian and discriminated against Jews.[191]

Bruno Lohse was active in the Swiss network both during and after the war. The wartime trades already have been discussed, and Lohse continued to traffic in looted works in the Alpine republic after 1950. The case of the Fischer Pissarro, discussed in chapter 8, offers ironclad proof that Lohse handled looted artworks in the postwar period. Moreover, Lohse's safe in the Zurich Cantonal Bank contained a landscape by seventeenth-century Dutch artist Jan Meerhout, a work that had been stolen from Jewish col-lector Alphons Jaffé in the Netherlands during the war.[192] The picture, titled *A View of a City*, had been seized by Kajetan Mühlmann's plundering agency in 1941 and counted among twenty-nine works taken from Jaffé that went missing after the war.[193] The work then found its way to Hitler, who in turn gave it to his adjutant Julius Schaub as a birthday gift during the war. Schaub (1898–1967) testified in 1947 that the work was lost. Ac-cording to Anne Webber of the Commission for Looted Art in Europe, who represented the Jaffé heirs in their pursuit of the picture, Lohse had purchased the Meerhout from Hjalmar Schacht in 1968.[194] Schacht (1877–1970) had been the Reich minister of economics and president of the

Reichsbank until he stepped down in the late 1930s (a move that helped lead to his acquittal at Nuremberg). He still counted as a member of the Nazi regime, however, and it is little surprise that he was connected to Lohse's network in the postwar period. Both Schaub and Schacht lived in Munich until their deaths and comprised part of the cohort of former Nazis who made the Bavarian capital the center of a larger transnational network that trafficked in plundered art. In short, the two looted artworks found in the Zurich bank vault used by Lohse provide glimpses of a larger picture. Lohse's Swiss ties also found expression in the aforementioned vault he kept at the Zurich Cantonal Bank as well as in his close relationship with Zurich attorney Dr. Frédéric Schöni, who in 1978 created for Lohse the deceptively named Liechtenstein Foundation, which concealed much of Lohse's art collection, including the looted Pissarro.

Lohse in North America

L OHSE'S NETWORK ALSO REACHED the United States. As is true of the rest of his postwar activities, the details remain obscure, but his contacts appear to have extended to some most unlikely places. During my interviews with Lohse between 1998 and 2007, he told me that he became good friends with Theodore Rousseau, the former OSS agent who became the Met's curator of European art and subsequently, in 1968, chief curator of the entire museum (as well as a vice director under Thomas Hoving).[1] But I was never sure if Lohse was telling the truth. Theodore Rousseau (1912–73) was a complicated person— "brilliant," in the words of fellow Monuments officer Otto Wittmann. He added, "Rousseau's father had been the head of the Guaranty Trust Company in Paris and Ted was raised in Europe."[2] Rousseau attended Eton (1925–29), and then returned to the United States to study at Harvard College (1930–35), Harvard Law School (1935–36), and the Harvard Graduate School (where he obtained a master's in art history). In between, in 1933, he found time to return to Paris to study at the Sorbonne. Rousseau had a command of Greek, Latin, French, German, Portuguese, Spanish, and Italian—he and Lohse conversed in both French and German. Described by one fellow curator at the Met as "intelligent, witty, and gentle, [and possessing] a magnificent sense of humor, an Old World good taste, and gentlemanly manners," Rousseau was also, at times, a shirker. Faison and Plaut both complained about having to cover for him (and help write his reports) while serving as ALIU officers.[3] In his best-selling mem-

oir, *Making the Mummies Dance*, Hoving told of annual buying trips to Europe he took with Rousseau. Although married for many years to his wife Nancy, Hoving admitted that he had affairs as he gallivanted across the Continent, and implied that Rousseau acted in a similar manner (although the latter was not married).[4]

Rousseau had a sophisticated, perhaps even cynical worldview. With a background in espionage—he spent the early war years in Portugal and part of 1946 in Japan on missions that have never been clarified—Rousseau took risks and gave the distinct impression that he possessed considerable savoir-faire. In 1940–41, Rousseau worked as an assistant curator for paintings at the National Gallery of Art in Washington, DC, but he left the fledgling institution in 1940 to embark on his wartime adventures as a U.S. naval attaché in Lisbon and Madrid, and then transferred over to the OSS and ultimately to its Art Looting Investigation Unit.[5] Decommissioned in late 1946 and made a chevalier of the Legion of Honor by the French state that same year, he returned to civilian life as an associate curator of European paintings at the Met. Although a buttoned-up institution, the Met allowed Rousseau to continue with some of his daring ways. Rousseau, for example, showed little compunction about circumventing European export laws aimed at preventing the loss of cultural patrimony. His acquisition of a portrait of San Sebastian then attributed to the Florentine artist Andrea del Castagno led to charges by the Italian government in 1949 that the work was "improperly exported," and an investigation led to the arrest of two employees in Italy's art export office.[6] More generally, Tom Hoving told of several instances in which the Met acquired artworks in violation of European export laws with the help of Rousseau, "one of my favorite smugglers from my Cloisters days," to whom he paid the customary commission of 4 percent. One such work was a medieval wooden sculpture from Auvergne, a twelfth-century rendition of the Madonna and child that was spirited from France to Belgium to Switzerland.[7] Hoving later called the period up to 1970 (the date of the landmark UNESCO treaty for the protection of cultural property) "the Age of Piracy"—although clearly rogue practices continued in the years that followed.[8] Hoving's mentor, James Rorimer, observed about collecting in the years before his death in 1966, "It's a great game. The only way we can win is by getting the pieces we need most."[9]

Ted Rousseau was a swashbuckling curator who used his wartime experiences to great advantage. He was not averse to associating with those implicated in Nazi art looting or to interacting with other dubious types

if it might lead to a prized artwork. One example was con man Ante Topic Mimara, who had misrepresented himself as a Monuments officer from Yugoslavia and stolen over a hundred works from the Central Collecting Point in Munich in the late 1940s. Yet not long afterward, in 1956, Rousseau arranged to meet Mimara at a Zurich hotel and the two men proceeded to a nearby bank, where the Yugoslav adventurer showed him the contents of his vault. Rousseau recalled that it was filled with forgeries and other "appalling daubs."[10] Yet he believed he had found an authentic gem and bought the *Mérode Altarpiece* by Robert Campin from Mimara. Such daring bravado made Rousseau the stuff of legend. In the words of Otto Wittmann, "He died too young. I never did know exactly what happened to him; I don't know if it had to do with intelligence work or not, but he died a rather unpleasant death."[11] Rousseau actually died of pancreatic cancer on 31 December 1973, but the fact that Wittmann, a pillar of the museum establishment, would believe that Rousseau's end was more dramatic is in itself telling. Also indicative of the life he led was that he died in the bed of his longtime paramour, society figure Berthe David-Weill.[12] As noted earlier, Rousseau was both dashing and socially prominent. It is not surprising that his funeral attracted the likes of Governor and Mrs. Nelson Rockefeller, CBS founder Bill Paley and his wife Babe Paley, and fashion entrepreneur and icon Diana Vreeland.[13] Some of his papers in the Met archives are closed until 2054 or 2058: the curator did not intend to give up all his secrets at one time.

Not all the publicity Rousseau attracted was positive. His *New York Times* obituary "recount[ed] Mr. Rousseau's social exploits and controversies of his last years with a kind of nasty relish"—or so protested then curator John Walsh in his letter to managing editor A. M. Rosenthal.[14] A year earlier, in 1973, *New York Times* journalist John Hess penned a series of nine articles in which he criticized Rousseau and his chief Tom Hoving for de-accessioning objects from the Met's collection. This scandal had elements that are relevant for our understanding of both Rousseau and Lohse. As Michael Gross described, "The museum had already started secretly selling paintings to the Marlborough Gallery, though the buyer remained anonymous for the time being. . . . The Marlborough, an international network of galleries based in Liechtenstein . . . was something new on the scene: huge, well financed, international and sharp elbowed. . . . Hess revealed that museum staffers had started calling Rousseau's department Marlborough Country."[15] Gross elaborated: "Hess's next story revealed that the museum had given Marlborough art worth about $400,000 in

trade for works worth only $238,000 at retail. Hess thought Marlborough had gotten a sweetheart deal; Rousseau countered that his valuations were exaggerated. Was Ted [Rousseau] taking kickbacks, as some thought? 'I never trusted curators,' said [architect Arthur] Rosenblatt. 'They were never well paid and their alliances with dealers [were] always so close.' He suspected, 'most curators, at some point in their lives, have received some form of remuneration from dealers. . . . They have private collections of art that they couldn't possibly afford.' An art insider even wrote to [*New York Times* art critic John] Canaday to say that Ted and Tom were on the take."[16] While none of these allegations were ever proven, their existence raised questions. The fact that Met antiquities curator Dietrich von Bothmer was purchasing illegally exported antiquities during that era, such as the Lydian Hoard from Turkey, also speaks to the mindset prevailing at the museum at the time.[17]

Another intriguing connection was provided by journalist John Hess, who followed up his series of *New York Times* articles with a 1974 book titled *The Grand Acquisitors*, wherein he chronicled the close relations Rousseau and the Met had with the Wildensteins. Hess offered the example of Alec Wildenstein bidding on Diego Velázquez's *Portrait of Juan de Pareja* at a Christie's auction in 1970: "At the end, [Geoffrey] Agnew [bidding for the National Gallery of Art in Washington, DC] fell silent and Wildenstein got the portrait for the highest price ever paid at a picture auction: $5,544,000."[18] While the Wildensteins initially made public statements indicating that they themselves had acquired it, some five months later the *New York Times* published a front-page story stating that the Met was the true owner of the Velázquez: Met officials announced that "the Museum is indebted to Wildenstein for its important assistance in the acquisition of this great picture and for its generosity in doing so at no cost to the Museum."[19] On which John Hess commented, "How the Met repaid its moral obligation is a secret between the museum and Wildenstein, its chief supplier of old masters in recent decades."[20] In that Rousseau was the curator for Old Masters, his close relation to the Wildensteins might help explain his warm response to Bruno Lohse, another satellite in the Wildensteins' orbit.

Bruno Lohse said he visited Rousseau numerous times on trips to New York. Extant records in Rousseau's papers also show Lohse visiting the curator at the Met. One can imagine Lohse entering Rousseau's grand office in the museum and sitting across from his former interrogator at his Louis XIV desk—an elaborate design by André Charles Boulle

with an ormolu veneer (later Met director Philippe de Montebello eventually took over both the office and the desk).[21] Rousseau and Lohse also would dine at lavish restaurants, sometimes in the company of Rousseau's primary romantic interest, Madame Berthe David-Weill (wife of Pierre David-Weill), who was exceptionally wealthy. Lohse had helped plunder the David-Weill collection in France (the family had over two thousand objects stolen, second only to the Rothschilds in France), and yet he also helped save "the valuable catalogue of the David-Weill collection" at war's end.[22] Now, in New York, he was the guest of Madame David-Weill, who always insisted on paying.[23] Several decades later, Lohse recalled her impressive black Rolls-Royce. He would just shake his head and say, "Man, that was some car" (*Mensch, das war ein Auto*). Lohse also often stayed in very expensive hotels while in New York, including the Hotel St. Moritz (today the Ritz-Carlton) overlooking Central Park. Living well was his revenge. With his "debonair" style, which sometimes included a cravat and always a pocket handkerchief, Lohse dressed in a manner intended to express that he was *ein Kulturmensch* (man of culture). He was dressing for a part, and also experimenting with his own self-reinvention. How ostentatious did he want to be? With the war still in recent memory, this SS man dared not act with complete impunity. He sought a balance—clothes and an address that would allow him to socialize with Ted Rousseau—while taking an approach to his work whereby he avoided a public reputation.

In his reminiscences, Lohse recalled meeting with many other major dealers in New York, including, he said, those at Rosenberg & Stiebel, the firm co-founded by German Jewish émigré Saemy Rosenberg (1893–1971) and the Stiebel brothers, Hans and Eric. This prominent firm "was involved in the sale of a number of works brought from Europe after the war. . . . Among those who sold through the gallery were the Rothschilds."[24] Even during the war, Rosenberg & Stiebel was investigated by U.S. authorities for doing business with Hans Wendland and Theodor Fischer, and hence trading with the enemy. The file does not contain any other documents on the matter, so presumably no charges were filed.[25] But Fischer admitted in 1945 that he had works he had bought from Rosenberg & Stiebel stored in the vaults of the Credit Suisse bank in New York (two pictures valued at $12,000).[26] Rosenberg & Stiebel was part of the network that led back to Munich, part of the network to which Lohse belonged. And the fact remains that Lohse had some high-quality works for sale. The Murillo painting that he offered the Bavarian State Painting Collections in 1966/67 was priced at around $1 million (DM 1.5 million).[27] It is not clear

from whom Lohse acquired the Murillo, but in one letter to Rousseau in April 1964, he discussed having acquired works in New York—among them a panel that gave him "so much joy" (*soviel Freude*)—that this may have been the source.[28] There are real limits to what we know for certain about Lohse's dealings, especially in the period after 1950.

Still, there seems to be a good deal of veracity in the stories Lohse told me, allowing for his vanity and loss of memory over time. Lohse recalled the annual visits of Theodore Rousseau and occasionally his colleague Tom Hoving, who succeeded former Monuments officer James Rorimer as director of the Met in 1966. Hoving recalled, "Rousseau was beyond chic. He traveled back and forth to Europe five or six times a year and was sought after for every cosmopolitan dinner party."[29] Rousseau's busy social life included visits with Lohse in Munich. Lohse also claimed that they made excursions together to the nearby lakes of the Bavarian Alps. Rousseau exhibited particular fondness for Lohse's very modest cabin on the Tegernsee. There were not enough beds, so someone had to sleep on the floor. Lohse implied that there was not much sleeping, as they stayed up late drinking and talking about art. While these sojourns to the Tegernsee cannot be confirmed, it is suggestive that Rousseau's address book (among his papers in the Met's archives) lists the telephone numbers for both Lohse's Munich and Tegernsee abodes. In certain letters, Lohse sent greetings from his wife to the American curator, which also suggests a kind of personal relationship.[30] Rousseau, for his part, had the contact information of a number of other dealers and museum officials who were prominent during the Third Reich, including Julius Böhler and Ernst Buchner in Munich, Hermann Abels in Cologne, and Ernst Holzinger in Frankfurt.[31] He also may have had contact with Walter Andreas Hofer: in one of Rousseau's small notebooks that he used on his frequent trips, he scribbled, "Write Feilchenfeldt, Hofer, Renoir Durand-Ruel."[32] In this context, "Hofer" probably referred to Göring's former collections manager, who had continued to work as an art dealer in Munich but sold to American dealers and museums as well.[33] That Rousseau was writing to him suggests that the Met curator also continued a relationship with the former director of Göring's collection.

Curators like Rousseau and Hoving had deep pockets and were assiduous about spending that money. It is not clear if Lohse sold directly to Rousseau and Hoving on behalf of the Metropolitan Museum of Art. Officials at the Met who consulted a database of acquisitions stated that there was no record of Lohse selling anything to the museum.[34] But Lohse

may have found a way to use a colleague as the official seller or intermediary and thereby concealed his role. One letter from Lohse to Old Master dealer Otto Naumann from September 1976 included a comment about his "friends, Dr. Frederick ('Fritz') and Mrs. Betty Mont, Park Avenue."[35] Fritz Mont (1894–1994) was a well-established dealer in New York and could have been one of the "cut-outs" used by the tainted Lohse. Fritz Mont sold to many U.S. museums, and was also selected as the agent for the prince of Liechtenstein when the sovereign, Franz Joseph II, deaccessioned certain masterpieces in the 1960s.[36] Lohse's "friends" Fritz and Betty Mont, with their very fashionable address, would have counted as formidable social allies. They were not unlike Theodore Rousseau, who actually surpassed them in terms of social "mountaineering," but who continued to interact with Bruno Lohse.

The correspondence between Lohse and Rousseau in the latter's papers in the Met's archives clearly show the former Nazi art dealer offering dozens of pictures to Rousseau and the American curator weighing their merits. Among the works offered by Lohse were paintings by Botticelli, Lucas Cranach the Elder, Hieronymus Bosch, Picasso, and Gauguin in 1953; works by Rubens, Monet, Matisse, and Cézanne in 1959; a picture by Nicolas Poussin from Nuremberg in 1964; and works by Rubens, Brueghel, and Corot in 1967.[37] Lohse had made it clear from the outset that he had a dual purpose in approaching Rousseau, writing in December 1952, "Next to the personal interest in reconnecting stands a professional element: I could use this opportunity eventually to offer certain art objects that perhaps could interest you."[38] Emblematic of their correspondence, and tantalizing in certain respects, is Lohse's letter of 8 April 1959: "As soon as I again see something really important, I shall notify you. I am sure that you will find something suitable there, since, in the last years, a number of important pictures have entered American museums and private collections through me."[39] We do not know what works Lohse sold to other American museums and collectors—or even whether to believe him in this regard. Nevertheless, the works he was offering Rousseau were of museum quality, although perhaps not quite at the level of the Met's collection. Lohse then most likely placed the pictures with other American museums or private parties.

Otto Wittmann, who went on to direct the Toledo Museum of Art, recalled in 1995 that Rousseau "became very helpful to the Toledo Museum because he couldn't buy everything he wanted to buy for the Metropolitan. He knew everybody in Europe, and much art was offered to him because

he represented the Metropolitan Museum. Ted would call us in Toledo and say, 'There is a great painting I'd like to buy, but I can't. If you want it, go and see so-and-so.' So-and-so being a dealer or an agent, usually some obscure person we never heard of, but they all went to see Ted Rousseau because of his long European connections."[40] One of the works that Wittmann recalls coming his way was "a great Rubens altarpiece, *The Crowning of Saint Catherine*, from the church in Malines, in Belgium, which came out of the church in the eighteenth century and had been in English collections." Wittmann continued, "It ended up in Goering's hands, but somehow made its way after the war to that collecting point in Munich. It was eventually returned to its rightful owner, who lived in Canada, and he had put it on the market."[41] In fact, the Rubens canvas had been returned after the war to a Jewish collector in Berlin, Albert Koppel, who sold it to the Toledo Museum of Art through Stiebel & Rosenberg in 1950.[42] But the fact remains that Rousseau, who wrote the key report on the Göring collection, and Wittmann, who succeeded him and finished up the work of the ALIU in 1946, would have known about this work from their time in Germany. It is a painting that stands out, with the museum today proclaiming that it is "widely considered the most beautifully painted religious picture by Peter Paul Rubens in the United States."[43]

Wittmann, like Rousseau, knew that a great deal of art would be for sale in the early postwar period, and both sought to build their respective collections while avoiding stolen property. Wittmann was acutely aware of the hazards. In one of the last ALIU reports to be penned, a document titled "Art Looting Investigation Unit: Final Mission to Europe" dated October 1946, Wittmann complained that the French had "made disappointingly slow progress in the prosecution of their own collaborationist dealers" and then cited the president of the French Commission de Récupération Artistique, Albert Henraux, as having "expressed the opinion that many of these dealers had already re-established their contacts with dealers in the United States and that some of the objects acquired by looting and forced sale, may already have been transferred to this country."[44] There is no documentation showing Wittmann conducting business with former Nazi dealers, and a representative of the Toledo Museum of Art stated that there is no record of the institution ever having bought anything from Lohse.[45] But this does not mean that Wittmann, like Rousseau, did not utilize the knowledge gained from his ALIU endeavors to do his job, and the Göring-owned altarpiece offers an example.

Rousseau, for his part, encouraged Lohse to show him artworks. One

letter from Lohse to the curator in October 1959 concerned "a Berlin pic-
ture" that appeared to be held by a church. Lohse had undertaken nego-
tiations with church authorities and now asked Rousseau "whether you, as
earlier, are interested?"[46] Around the same time, Rousseau wrote Lohse,
"I am, however, greatly interested in the other collection you mention and
would very much like to see a photograph of the Ensor or any other picture
you think might be desirable for our collection. With kind regards, and
looking forward to hearing from you . . ."[47] Rousseau invariably studied
the works offered to him and took careful notes; for example, in 1953 he
observed, "The Botticelli (?) is not nearly so good as the Oliven 'Verroc-
chio' I saw last week at Day & Meyer. The Gauguin looks nice enough.
The Cranach likewise, but *much* restored."[48] At times, the curator showed
a strong desire to see the former Nazi. When Lohse was visiting New York
in 1961, staying in an apartment at 11 East 68th Street, Rousseau sent him a
telegram that read, "Most Anxious See You. Please Call Museum Morning
Before Ten. Regards Rousseau."[49] But Lohse's approaches always seemed
to meet with gentle rejections: "Unfortunately, none of the things in this
group could be fitted into our collections, or duplicate what we already
have."[50] Lohse always played the role of supplicant, with Rousseau holding
the power in their relationship, which continued for over two decades in
the postwar period. It's also notable that in 1953, after Lohse had offered
works by Botticelli, Gauguin, and Picasso, Rousseau responded not di-
rectly to Lohse in Germany but to a woman named Nora Ibe, who lived in
New Hyde Park, New York. In a letter of 16 December 1953 to "Mrs. Ibe"
in which Rousseau returns photographs of the works on offer, it's clear
he knows that Lohse is the source (he asks to "please convey my cordial
greetings to Dr. Lohse"), but he seems to be utilizing Nora Ibe as a kind
of cut-out or buffer who represents Lohse.[51] Who Nora Ibe was and how
she knew Lohse remain mysteries—internet searches shed no light. Her
modest tract home in suburban New York offered a low-profile address for
a former Nazi art plunderer, and Mrs. Ibe herself stayed below the radar.

In the early years after his release from prison in France, Lohse had
to work around his precarious legal status. In 1953, for example, he still
could not obtain a visa to visit the United States, and he therefore inquired
whether Rousseau could meet him at the airport in New York, where he
would stop on his way to Canada.[52] At the time, one was permitted to re-
main in the airport for twenty-four hours while in transit.[53] But Lohse, as
a former member of the SS, was also on the U.S. Department of Justice's
watch list; and in 1951, a "State Department Despatch" listed him among

"individuals who, on the basis of information now available, should be considered as ineligible for entry into the United States because of their serious implication in art looting activities during the war."[54] Lohse was joined on this list by Kajetan Mühlmann, Walter Andreas Hofer, and Karl Haberstock, among others. Lohse had also been indicted by the UN War Crimes Commission and included in *The Central Registry of War Criminals and Security Suspects.*[55] In short, he was not legally permitted to enter the United States. An official at the Office of Special Investigations, the agency that has tracked Nazi war criminals (and endeavored to denaturalize them if they became U.S. citizens), noted, "In principle, if Lohse had arrived in Miami to visit Disney World, an alert would have popped up and the U.S. government could have taken whatever action was deemed appropriate."[56] In the days before computers, U.S. authorities did not enforce the watch list very effectively, and Lohse passed in and out of the country in the decades that followed with little difficulty.

Lohse's first trip to North America occurred on 2 April 1953, when he flew from Frankfurt to New York, arriving at 12:55 p.m. He departed at 4:30 p.m. for Toronto, so he had a narrow window to see Rousseau. Lohse had tried his best to tempt the curator, writing that he wanted to discuss a large landscape by Gauguin and two pastels by Picasso, among other works. The names Cranach the Elder and Hieronymus Bosch were also included in Lohse's bait.[57] Lohse did not bring the works with him, only photographs, but clearly he could arrange delivery should Rousseau or other Americans wish to purchase them. Rousseau appears not to have gone out to the airport, but another friend of Lohse's did; Nora Ibe wrote Rousseau in October 1953 about photographs that Lohse had given her to pass on to the curator: "A friend of mine, Dr. Lohse from Munich, was here in New York when you were away and left these pictures with me at that time, so that I could show them to you. He was disappointed not to see you."[58] Although Lohse was in New York only in transit, he was able to pass the photos to Mrs. Ibe in this, the first of many attempts to sell to the Met.

Although limited in what he could do in the United States, Lohse was equipped with a visa to Canada, and he proceeded to Tillsonburg, Ontario, where he visited Professor Stephen Bangarth. In planning this six-week trip in 1953, Lohse estimated that he would spend ten to fourteen days with Bangarth.[59] Information about Professor Bangarth (1891–1973) is scarce; however, his granddaughter, Professor Stephanie Bangarth, wrote, "Stephen Bangarth served in the Austro-Hungarian army during WWI in

the Carpathian Mountains."[60] She added, "Bangarth was an officer in the Hungarian army during the Second World War" attached to an artillery group stationed on the eastern front in the Carpathian Mountains and perhaps in other locations.[61] The Hungarians fought alongside the Germans in a brutal campaign against the Soviet Red Army, and committed mass atrocities against the Jews and Roma of the region. This campaign, in the words of historian Raz Segal, included "mass robbery"—but note that we have no knowledge whether Bangarth was involved in or witnessed such acts.[62] Stephanie Bangarth reflected on her "grandfather who fought 'on the other side,' who was assisted in his escape from Hungary by German officials, and who gratefully settled in Canada."[63] Professor Stephanie Bangarth and her father, Daniel Bangarth, reported that they had never heard Stephen Bangarth talk of Lohse, and Daniel Bangarth, who was a boy of nine in 1953, does not remember anyone visiting the family in their small apartment.[64] Yet somehow, as the extant correspondence shows, Stephen Bangarth knew Lohse. Clearly, the two could converse in German, and there was likely a wartime history between the two.

Stephen Bangarth immigrated to Canada only in 1951—coming via the International Refugee Organization in Austria, with his profession listed as "farmhand, unskilled worker," although he spoke five languages.[65] A questionnaire Bangarth filled out in 1951 explained that he had "knowledge and experience with agriculture on his own property."[66] While he likely knew something about farming (and he may have been playing to Canada's immigration policies, which favored agricultural workers), Bangarth's arrival in Canada as a "farmhand" seems suspicious. As historian Hilary Earl observed, it "was common during this period to evade the allies . . . for war criminals to take cover as a 'farm laborer.'" Earl cites the example of Erich Naumann, the leader of an SS Einsatzgruppe.[67] Another document in "Istvan" (Stephen) Bangarth's file makes reference to a "criminal record," suggesting that this had been an impediment to his immigration to the United States, to which he was denied admission in 1950.[68] He had been in Austria since April 1945 and appeared to have difficulties relocating to North America with his wife and son Daniel (born in 1944). But this "farmhand" with a collection of Old Masters persevered and found his way to Tillsonburg, Ontario.

While it's questionable whether Stephen Bangarth ever worked as a farmer in Canada—he apparently labored in a tobacco factory for a time—he did continue to draw upon his background in art to launch his new life.[69] The above-noted questionnaire from 1951 sketches out a rather remark-

able early career. Bangarth studied in Vienna, Fiume, Paris, and Kolozsvár (then in Hungary but now in Romania and known as Cluj). He held the post of assistant to Professor Horst Meder of the Albertina Museum in Vienna (1920–22), followed by a stint at the Sorbonne in Paris, where he later worked as an assistant at the Louvre Museum (1928–30).[70] Bangarth became a professor of art history at the Franz Josef University in Kolozsvár, a post he held from 1942 until 1944: he specifies 12 October 1944, which was the day after Hungary's leader Miklós Horthy agreed to surrender to the Soviet Union, which precipitated the German-engineered coup that put into power fascist Arrow Cross leader Ferenc Szálasi. Bangarth also reported that he had been a museum director at the Gräfliche Bildergalerie (the Count's Picture Gallery) in the Palais Attems in Graz from 1945 to 1949, although he provided no further details.[71] The Palais Attems museum was regarded as the "most important aristocratic collection in Steiermark," the Austrian province, but it fell victim to depredations during and after the war. Starting in 1946, much of the art collection, the library, and the weapons collection were sold off: the Counts of Attem had lost part of their property in Yugoslavia and had to sell off objects to finance the restoration of the palace, which was damaged by bombs during the war.[72] The timing suggests that Bangarth likely played a role in this liquidation. Although the single-sheet résumé from the International Tracing Service raises more questions than it answers, it suggests an intriguing individual.

When Bangarth arrived in Canada in 1951, he wasted little time before gravitating toward the art trade. For example, in the summer of 1951 he approached the Schaeffer Galleries based in New York—a firm with German émigré proprietors who spoke and corresponded in German and specialized in Old Master paintings.[73] Bangarth wrote to Schaeffer expressing his wish to sell a portrait of a woman by Jacob Elsner, and from the extant correspondence, it's clear that Bangarth also possessed works by Rembrandt, Frans Hals, and Jacob Ruisdael, in addition to at least nineteen other, mostly English paintings: by Joshua Reynolds and Thomas Gainsborough, among others.[74] Some thirteen years later, in June 1964, the auction house Christie, Manson & Woods (now Christie's) held a sale in London of "highly important paintings by Old Masters and a drawing by Rembrandt; the properties of Doctor Stephen Bangarth [among others]."[75] One of the pictures put up for auction—listed as coming from Bangarth's collection—was attributed to the Master of the Holy Blood (a sixteenth-century Netherlandish artist) and came with a "certificate

from Dr. M. J. Friedländer, 1949."[76] Perhaps not surprisingly, this was the Max Friedländer whom Lohse had helped save during the war. While Friedländer wrote many reports (or "expertises," as they're called), the fact that this one was done recently, in 1949, suggests that Bangarth knew him, and that he had reached out to the venerable but compromised expert to authenticate his painting. In short, when Lohse visited Canada in 1953, it appears that Bangarth had a significant art collection and was connected to certain networks that trafficked in Nazi-looted art. The origins of the works in the collection, like their fate, merits further research.

In many ways, the trip was the fulfillment of a dream for Lohse. Back in July 1948, when confined to a cell in Paris, Lohse had written to Ted Rousseau, "I hope to be able to come to America and meet people who do my type of work in museums over there. You could hardly understand how much I'd like to work again after all these years of misery, the only ray of sunlight being the short period I spent in Altaussee. It's been three years since I've been able to see a work of art."[77] Five years later, Lohse was able to visit Toronto, Quebec, and other Canadian cities (while having his mail sent to Bangarth's home in Tillsonburg). Lohse thereby had the opportunity to experience and study Canadian museums as well as to scout the American art market, albeit still from the periphery.

By the mid-1950s, Lohse had managed to secure a visa to the United States, and he subsequently made regular trips to New York in order to ply his trade in the thriving art market.[78] Lohse was not the only former Nazi who didn't set off alarms among U.S. immigration authorities. His counterpart in ERR trades and friend Count Alexander von Frey emigrated to the United States in 1948, and lived with his wife Erika in New York and Vermont under the name A. C. de Frey.[79] Many of those complicit in plundering or trafficking in looted art during the war gravitated to the United States, what with its opportunities and increasingly robust art market. A hallmark of the Cold War was that while the government focused on tracking Communists, many former Nazis were able to enter the country one way or another. It did not help that the U.S. government's Operation Paperclip had brought Nazi scientists to the United States to work on the space program.[80]

Another tantalizing lead in Rousseau's papers in the Met's archives concerns Lohse's efforts to meet the Met's chief curator in Switzerland. In a handwritten letter of 25 May 1964, Lohse professed his excitement about seeing Rousseau on his upcoming trip to Europe, and after asking for more precise details of the itinerary, he stated, "I would still really like to show

you some pictures in Zurich."[81] Their correspondence from earlier that spring, which referenced a recent visit by Lohse to New York, talked about a Rogier van der Weyden painting. Lohse was an intermediary in this instance, and the "difficult" owner would give him only a four-week option on the work.[82] The proposal appeared fairly well developed: Lohse quoted a price of $250,000 and was prepared to arrange an inspection in Zurich. But we know little more than this. Rousseau visited Switzerland on a regular basis—almost every year, it seems, according to his papers. The curator spent three days there between 11 and 14 June 1964, staying in the ultra-fashionable (and very expensive) Hotel Baur au Lac on Lake Zurich.[83] Yet it is not clear whether he met Lohse there in 1964, as the former Nazi had hoped. Rousseau's records also show him well connected with Swiss dealers: he had contact information for Ernst Beyeler, Christoph Bernoulli, Fritz Nathan, G. F. Reber, Nathan Katz, and others, as well as collectors like Baron Heinrich Thyssen-Bornemisza and Emil Bührle.[84] This was Rousseau's world—top dealers, rarified collectors, and, somehow, Bruno Lohse. It bears mentioning that all of the figures mentioned here have been proven to have trafficked in or acquired Nazi-looted works.

From the extant correspondence, it is also clear that Lohse and Rousseau met in other parts of Europe besides Bavaria. One 1962 letter references an earlier meeting in Paris, as Lohse requests the return of photos of a Bartel Bruyn panel that he had given Rousseau.[85] Lohse penned another contemporaneous letter, also mentioning a meeting in Paris, on stationery from the Savoy Hotel in Zurich, in which he talked about "a Liechtenstein picture" available for $900,000; the letter also requested confidentiality.[86] We have only glimpses of these encounters abroad, but the evidence of meetings in France, Switzerland, and the Federal Republic of Germany (in addition to the United States) points to a significant relationship.

There is no evidence that Theodore Rousseau purchased Nazi-looted art, and despite all the offers from Lohse, it is doubtful that the former Nazi ever tried to sell him problematic works. Lohse knew that Rousseau was one of the best-informed individuals in the world about Nazi art looting, and trying to pull one over on him would have been a needless gamble. Also, considering Rousseau's post at the premier museum in the United States and his impeccable social connections, a relationship with him offered Lohse a kind of legitimacy that the German dealer coveted. There was no reason to risk this relationship, especially when Lohse had other outlets for looted works that crossed his path. Rousseau never seemed to question whether Lohse was offering him a looted work:

the closest he came in his notes was wondering how a portrait by Adam Elsheimer, a seventeenth-century German artist who worked largely in Rome, "got loose from the Graz Museum," observing, "The *Denkmalamt* [Monuments Office] doesn't usually let even privately owned things of this sort out of Austria."[87] But this was a matter of an export permit, not a looted picture. Lohse therefore appeared content to help Rousseau in any way he could. One way appeared to be as a kind of "spotter" or intermediary. For example, Lohse helped arrange a contact with Baron von Pöllnitz of Schloss Aschbach—the castle where Hildebrand Gurlitt and Karl Haberstock took refuge at war's end—as Rousseau undertook negotiations for a Brueghel in 1959.[88] In another instance, in April 1964, Lohse wrote Rousseau, "The picture acquired from Wildenstein completely met my expectations. In this connection, I'd like to pay you a compliment. You did a fabulous job localizing [*sic*] the work. You said, 'the Master is to be found on the French-German border.' [Indeed], the Master was active in Strasbourg!"[89] Whether Lohse facilitated a sale from Wildenstein to the Met of a work by this Strasbourg Master remains uncertain, but the exchange says something about their relationship: how they consulted on the hunt for high-quality works that might be suitable for the Met.

Other clues about Lohse's postwar business come to light in an April 1964 letter to Rousseau. Lohse stated that he had heard the "controversial" picture by Vincent van Gogh, *The Portrait of Dr. Gachet* (1890), was being put up for sale by Mrs. S. Kramarsky. Lohse noted that because the attribution remained contested, it probably wouldn't be purchased by a "cautious" (*vorsichtigen*) museum director. He then recounted that he had recently seen it on exhibition and thought it was authentic. Lohse told Rousseau he would be interested to learn the price and asked the curator if he could obtain this information for him. Lohse explained, "I am looking for a van Gogh for an industrialist. With regards to its authenticity, this man is relying on me."[90] Lohse's eye proved sound in this instance: the work was authentic and later set a record price for a painting ($82.5 million) when it sold in 1990 to a Japanese paper magnate.[91]

With regard to the Met, the extant documents show that Rousseau asked Lohse in 1969 to help arrange the loan of Hans Holbein the Younger's sixteenth-century masterpiece, *The Madonna with Family*, for the museum's Centennial Exhibition planned for 1970–71. The extraordinary picture—one of Holbein's greatest—belonged to the Grand Duchess of Hesse and was housed in Darmstadt (it's also known as the "Darmstadt Madonna"). It is not clear how Lohse figured into this loan, but in one let-

ter from 20 October 1969, Rousseau wrote "to confirm our conversation last Friday concerning the Metropolitan Museum's Centennial Exhibition," and concluded this request to facilitate the loan by noting, "Thomas Hoving, the Director of the Museum, and I will be in Germany later in November and we would be delighted to come to Darmstadt to discuss this matter further. I would be grateful for anything you can do to help in connection with this request. With kind regards, and wishing you a pleasant return to Munich."[92] This implied, then, that Lohse had been in New York when the matter surfaced. Lohse responded to the inquiry about the Holbein Madonna on 13 November—now addressing Rousseau as *Lieber Ted* (indicating a degree of familiarity). He wrote that he had disappointing news: the Grand Duchess von Hessen could not loan the picture because she had promised it to another museum at that time.[93] Lohse went on to say that he looked forward to Rousseau and Hoving's visit to Munich at the end of November. This letter is also interesting because Lohse referenced Günther Schiedlausky, his former colleague from the ERR, now a curator at the Germanic National Museum in Nuremberg, a post he assumed in 1955. He was responsible for arts and crafts and also, remarkably, for the collection of Judaica. Those close to Lohse said that Schiedlausky remained one of the few people in whom he would confide—that because of their shared history at the ERR in Paris and Neuschwanstein, the two felt able to discuss uncomfortable topics. More about Rousseau's postwar relationship with Schiedlausky is not known; however, as a fellow curator, he may not have been as useful to Rousseau as an art dealer like Lohse.

Lohse told me that he facilitated certain sales to Rousseau and Hoving, including their purchase of a painting from Ante Topic Mimara— the notorious con artist who had deceived officials at the Munich Central Collecting Point in 1949 and absconded with 166 works (some say 147) that he claimed had been looted from Yugoslavia. It appears that Mimara had fabricated a list of works he claimed for Yugoslavia, using information from a German art historian, Wiltraud Meersmann, then employed at the CCP. She not only provided him with the list of works, she eventually married him. There are reports that he had been engaged as a consultant to the Yugoslav military mission in Munich and Berlin, and this may have been the case.[94] But he had no authority to represent Belgrade with regard to restituted artworks and the Munich CCP. Yet, like many others, he found a way to enrich himself. Ante Topic Mimara continued to sell valuable works after the war, including the Cross of Bury St. Edmunds, which went to Tom Hoving and the Met. At the time, the medieval ivory cross

was the most expensive work of its kind ever sold. (Hoving later wrote a best-selling book, *King of Confessors*, about his experiences, which including inspecting the cross in a Zurich bank vault rented by Mimara.) Lohse recounted that he, accompanied by Hoving and Rousseau, visited Mimara in Salzburg (his wife's hometown) in the 1960s. Lohse said that Rousseau and Hoving bought a painting from Mimara on that occasion and that it may have been looted or forged.[95] We do not know if this account is true, but when Mimara donated his collection to the Croatian state in 1973 in exchange for a generous annuity, the so-called masterpieces by Leonardo, Raphael, and Velázquez, among others, were quickly exposed as mostly fakes by art journalist Andrew Decker.[96] Hoving, of course, knew that Mimara peddled fakes, but he may have thought the painting he bought was, like the Cross of Bury St. Edmunds, among the few authentic objects in the collection. Hoving also recalled buying works for the Met from Julius Böhler, the Munich dealer who sold a considerable quantity of art to Hitler, Göring, and other Nazi leaders (as noted earlier, Böhler was also Haberstock's partner in the purchase of the Gutmanns' property in Heemstede).[97] Hoving, who stated that he would buy from the devil if he wanted the work, was very open about buying works from sketchy characters in dubious circumstances.[98]

Theodore Rousseau's papers in the Met's archives show that Lohse continued to have occasional contact with James Rorimer, although the former Monuments officer who had arrested Lohse at war's end made a conscious decision to keep his distance. A letter from Lohse to Rousseau in April 1953 references Lohse's recent trip to New York, when he had the opportunity to speak with James Rorimer about his book *Survival*, which had appeared in 1950.[99] Lohse would later take issue with the way that Rorimer portrayed him in his memoir, and a correspondence ensued. Rorimer defended his positions vigorously: the Met director (as of 1955) wrote his friend Rose Valland asking for materials that showed Lohse's official role in the ERR. Valland obliged, sending a warm letter as well as a selection of incriminating documents, including a 1943 report about Lohse's involvement in the Schloss affair. Rorimer's response to Lohse included supporting documentation: notably, an order to transport paintings to Göring on 15 August 1941 that Lohse had co-signed. In this document, it appeared that Lohse identified himself as "Leiter des Einsatzstabes Westen" (head of the ERR West), although Kurt von Behr also provided his signature, and there is some uncertainty about the title. Rorimer buttressed his account by citing an ALIU report from 12 January 1946 that listed Lohse

as the "deputy director" of the ERR.[100] Rorimer had very limited contact
with Lohse in the postwar period; he was nowhere as close to the cohort
of former Nazi dealers as Rousseau, Faison, or Plaut. Rorimer was Jewish,
and his appointment as director of the Met in 1955 had broader social im-
plications. He was aware that he was the first Jew to hold this prestigious
post and took care not to leave himself open to criticism.

James Rorimer's views about his wartime experiences differed from
Rousseau's, who looked back on the war as a great adventure. Rorimer, ac-
cording to sources, "apparently . . . kept a loaded revolver in a desk drawer
fearing reprisal from a threat received during his military service."[101] He
also continued to wear army boots "no matter how formal a suit he was
wearing," Tom Hoving recalled.[102] Rorimer left the "swashbuckling" to
his curators. Still, Met trustee (and former president) Roland Redmond
accused him in May 1966 of "very bad judgment" for accepting a gift of
a bronze and enamel Christmas card, although receiving an object valued
at less than $1,000 did not require board approval, and Rorimer donated
the card to the medieval department of the museum. Redmond's indict-
ment raised the specter of anti-Semitism, and the traumatic board meet-
ing in which the incident was discussed upset Rorimer so greatly that Tom
Hoving believed it precipitated the cerebral hemorrhage that killed him
later that night.[103] In short, James Rorimer kept his distance from the
former Nazi art plunderers, the sound of his army boots echoing in the
halls of the Met serving as a symbol of his vigilance.

The three former ALIU officers, however, kept in touch with Lohse.
Professor Lane Faison reportedly visited Lohse in Munich on a regu-
lar basis. According to those who knew Lohse, Faison even arranged for
Lohse to address his Williams College students on their summer programs
in Bavaria. Lohse's friends also said that the former Nazi visited Faison in
Williamstown, Massachusetts.[104] The idea of Lohse at Williams College
in the 1950s or 1960s is difficult to understand, as are Faison's thoughts
hosting an art plunderer and former member of the SS. Yet Rose Valland
had observed back in 1951 that "Lohse had the greatest influence on" Fai-
son.[105] They were clearly not great friends, but there was an attraction
for both. In Faison's case, he welcomed meetings with Lohse because he
had an abiding fascination with the issues surrounding Nazi art looting.
Mysteries like the Schloss case had not been fully resolved and Faison, an
academic, was one of the first scholars to study the subject. His papers at
Williams College and in the National Gallery of Art in Washington, DC,
show him researching and lecturing on the subject of Nazi art looting

and Allied restitution. It is not clear how much information Lohse pro-
vided him, but over the years, from the summer of 1945 onward, Lohse
had been an important source. Of course, this tied in with another reason
Faison continued to see Lohse. They were two veterans, clearly from op-
posing sides, but with a shared history that included the three months of
interrogation at Altaussee and the work at the Munich Central Collect-
ing Point. Their bond rested on a fascination with Nazi-looted art, a topic
that shaped their lives, as it did the lives of other Monuments officers on
both sides.

James Plaut had been the first to respond to Lohse after the latter's
release from a Paris prison, and Lohse thanked him in a December 1950
letter for the "friendly sentences."[106] However, a 1957 letter from Lohse to
Plaut (about Rorimer's book) indicated that they did not keep in regular
touch.[107] James Plaut, director of the Institute for Contemporary Art in
Boston until 1956, deputy U.S. commissioner to the Brussels World Fair
of 1958, and secretary-general to the World Crafts Council from 1967 to
1976, had no real need to be in contact with Lohse, although because he
wrote the *Detailed Interrogation Report* on Lohse, Plaut always exhibited
proprietary tendencies. Yet it was Rousseau, the audacious curator, who
appeared to maintain the closest ties, whereas the amicable Faison fostered
an almost social relationship. Whatever the tone, the fact remains: over
the years, Lohse corresponded with all three former OSS officers, often
in handwritten letters. Lohse concluded letters to Rousseau with formu-
lations such as "With many heartfelt greetings to you and our mutual ac-
quaintances there, I remain yours . . ."[108]

Despite the rich array of letters between Lohse and Rousseau that are
now housed in the Met's archives, we have only an incomplete glimpse of
what transpired between these men. One further indication is a Novem-
ber 1967 letter from Lohse to Rousseau that read, "The big project, about
which I spoke to you so secretly, has made my departure today neces-
sary. For this reason I am hereby taking my leave in writing."[109] We do
not know what this "big project" entailed and why it precipitated Lohse's
sudden departure from New York (he used stationery from the Hotel St.
Moritz). The letter discusses paintings by major artists, including Corot,
Brueghel, and Rubens, mentioning prices that were considerable for the
time—$300,000 for the Corot, for instance. Lohse also invoked names
that resonate with scholars of Nazi art looting—an authentication by
Max Friedländer, and interest in a picture on the part of Professor Robert
Oertel (1907–81), an art historian who had worked for Sonderauftrag Linz

(the Führermuseum) during the war and served as director of the Berlin Gemäldegalerie from 1964 to 1973. But we do not really know what transpired—perhaps very little of real significance from a commercial perspective. After all, it is striking that Rousseau kept the correspondence and did not purge his files, especially once he became gravely ill with cancer in 1973. He had asked a friend, Rosie Levai, to burn his cache of love letters after his death, but he issued no such instructions regarding the paper trail leading to Lohse.[110] However, the art world being what it was and remains—a place with secrets and valuable proprietary information—it is not surprising that there should be so many gaps and opaque formulations.

Ted Rousseau and Tom Hoving were typical of their generation of curators and museum directors in that they believed that everything that could have been done to address the issue of Nazi looting had been done and it was now time to move on and attend to current projects. For them, this meant acquiring art for their museum. They were not alone in this respect. The American high commissioner for Germany, General Lucius Clay, wrote General Noce on 4 April 1948 in a "top secret letter": "From the very beginning I have had serious doubts as to the real desires and intent of the directors of the National Gallery of Art. Their representatives on an early visit talked about the possibility of obtaining these pictures either in reparations or in payment of occupation costs."[111] Many in the art world, including a number of Monuments officers, believed that the United States should be able to use its unique economic clout to purchase works that had been displaced during the war. Some, like Met director Francis Henry Taylor (1903–57), did not even wait until war's end to pursue displaced artworks: he traveled in mid-1942 to Latin America; as his daughter Pamela Taylor Morton claimed, "He was really following clues he'd been given about Nazis who'd taken art from Paris and was trying to find it."[112]

Of course, art dealers in the United States were eager to get ahold of European art and expressed this sentiment right after V-E Day. Paul Rosenberg, a French émigré dealer who had many works looted by the Nazis, for example, wrote the Treasury Department in December 1946, "Since the commercial relationship between the United States and Germany has been reinstated and the rate of exchange between the dollar and mark has been established, we are writing regarding the procedure necessary to acquire works of art in Germany." Rosenberg added, "There are in Germany many great art collections . . . that the owners . . . due to lack of funds, might be interested in selling. . . . Among the pictures in ques-

tion there are celebrated masterpieces which, if they could be purchased and brought to our country, would add to the great cultural interest of our nation."[113] Although the U.S. government tried to put the brakes on dealers, curators, and collectors with regard to the Europeans' cultural patrimony—all the Allies instituted a licensing system of some kind that monitored and limited activity—there are certain laws of nature—and one of them is that art follows money. At the end of World War II, the United States was by far the wealthiest country in the world. There had been scarcely any damage to the nation's infrastructure—on the contrary, it expanded during the war and the nation grew wealthier. After the war, the Americans, armed with a strong dollar, bought prodigiously in Europe, especially once the initial postwar restrictions on the market were lifted in the late 1940s. It is not unrelated that 93 percent of American museums were created after 1945.[114] Before then, the United States had relatively few museums: the Metropolitan, of course, in New York, as well as important (if sometimes very stodgy) museums in Boston, Philadelphia, Chicago, and San Francisco. There were other fine museums too, but the amount of art in the United States before 1945 was a fraction of what it is today.

As suggested by Paul Rosenberg above, one must acknowledge that the interest in transatlantic commerce was not one-sided: in addition to the "pull" of U.S. demand, there was the "push" from Europeans who needed the income from sales. The archival files of the Monuments, Fine Arts, and Archives program (MFAA) contain letters from German nationals offering artworks to the U.S. forces, including one in which High Commissioner Lucius Clay was offered a Rembrandt.[115] Lohse no doubt sought to develop a network of American customers. The cohort of German (usually Jewish) émigré dealers in the United States greatly facilitated the commerce, with individuals like Justin Thannhauser, Paul Graupe, Curt Valentin, Otto Kallir, and Hugo Perls all bringing significant quantities of European art to America—and also trafficking in Nazi-looted artworks that had never been restituted. These German (or Austrian) Jewish dealers played a significant role in the transatlantic commerce, which only grew after the war.

Because many of the art officers came from the art world, it is not surprising that they would return to this sphere. In fact, the MFAA and ALIU officers went on to be extremely prominent in the museum field. To provide a few examples, at the Metropolitan Museum of Art alone, curator Edith Standen (MFAA), curator and chief of European paintings Theodore Rousseau (ALIU), director James Rorimer (MFAA), and cura-

tor/trustee Craig Hugh Smyth (MFAA) had all played leading roles in the safeguarding and restitution efforts. One can also point to Otto Wittmann (ALIU) at the Toledo Museum of Art, James Plaut (ALIU) at the Institute for Contemporary Art in Boston, S. Lane Faison (ALIU) at Williams College (and the Clark Gallery), and Thomas Howe (MFAA) at the Legion of Honor in San Francisco. Was it possible, then, that museum officials and the art trade in general did not know about nonrestituted victims' art in the 1950s and 1960s? The answer, as the evidence above suggests, must be no.

Theodore Rousseau and his former colleagues from the ALIU exploited Lohse as a knowledgeable art dealer. For years after the war, Lohse referred to them as his "good friends." It is interesting that the friendship should develop after Plaut and Rousseau discovered so many of his lies, as they did in late 1945 and 1946. But the art world often features fraternal feelings—people feel they are members of "the same club"—and they could rationalize the relationship by noting that Lohse had done his time in jail. They were not alone in having professional relationships with compromised individuals. MFAA officer Tom Howe was friends with the notorious dealer César Mange de Hauke (1900–1965), who had trafficked in looted works during the war. In what he labeled "my personal correspondence," Howe wrote de Hauke in a warm and friendly tone. In one letter to him, Howe referenced the Harvard Fogg Museum curator: "Agnes Mongan, [who] had seen you during her very brief sojourn in Paris and had spoken to you of my interest in the Degas portrait."[116] It is not clear whether Howe ever acquired this Degas from the collaborationist dealer, but the director of the Legion of Honor Museum in San Francisco clearly had good relations with the problematic dealer.

The MFAA and ALIU personnel behaved in a laudably scrupulous way during their years of official service, and this interaction with individuals with dubious pasts was not illegal (nor, it should be stressed, a violation of official U.S. government policy). Also, one should not exaggerate the closeness of these relationships. They were often professional business contacts. But it is a chapter of the history of the art officers that has not been acknowledged, let alone written. The fact that these individuals, who knew the history of the people with whom they were dealing, still transacted business with them, speaks to the overriding ambition with which many museum officials in postwar America built their collections.

Certain figures in the art world did indeed shy away from Lohse when they learned about his past. Bruno Lohse wrote to James Plaut in February 1957, "To my greatest disappointment, I am suffering again from the

reverberations of the past and this is the reason I am writing today. . . . A few months ago I was promised a highly compensated contract. As the signing of this was about to take place, the co-signatory suddenly withdrew, with the reason that it was impossible for him to collaborate with a man who during the war had been 'chief of the ERR in Paris' and responsible for the plundering of Jewish property."[117] Lohse went on to say that this unnamed collector cited James Rorimer's book *Survival* as the source. He also gave indications that he was preparing to engage a lawyer to pursue what he considered a historical inaccuracy and a grave insult (as well as a professionally damaging allegation), but there is no evidence that he ever did so. Nevertheless, his wartime past remained a burden. The war years, rather ironically, also stood out as the highlight of his storied life. But that was Lohse. At the same time he was protesting mightily to Rorimer, Plaut, Rousseau, and Faison about his innocence, he was obtaining the looted Fischer Pissarro and using subterfuge to conceal its ownership. Part of the complexity of Lohse was that he could maintain his innocence about his involvement with looted art while continuing to traffic in such works, just as he could consort with the elite echelon of the art world while retaining ties to his cohort of old Nazis.

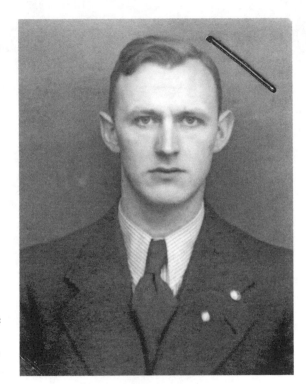

Bruno Lohse as a young art dealer in Berlin in the 1930s, wearing a Nazi Party pin. (Bundesarchiv Berlin)

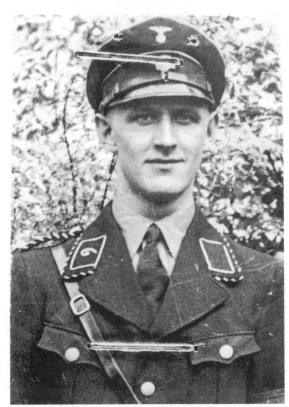

Bruno Lohse in his SS uniform, circa 1934. (Bundesarchiv Berlin)

Bruno Lohse (*left*) and art dealer/friend/assistant Peter Griebert in Munich at the Freisinger Hof restaurant in the late 1990s. (Photo by author)

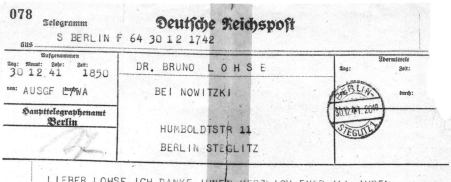

Hermann Göring's 1941 authorization to Lohse to acquire artworks for the Reichsmarschall. (Bruno Lohse papers, author's collection)

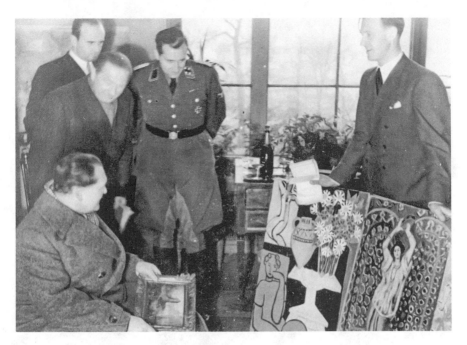

Lohse shows Göring two Henri Matisse paintings from the ERR stockpile: *Daisies* (1939), now in the Art Institute of Chicago, and *Dancer with a Tambourine* (1926), now in the Norton Simon Museum in Pasadena, California. Both works were restituted after the war and then sold. (Archives des Musées Nationaux/Archives Nationales)

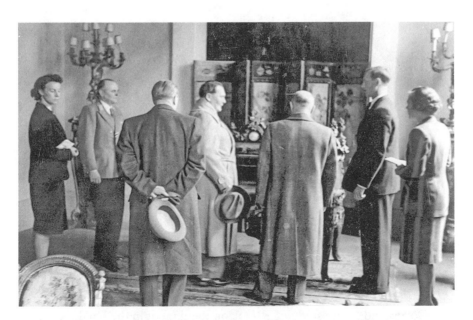

Lohse (*second from right*) leads Göring on a tour to select works from the seized loot with ERR Paris chief Kurt von Behr (*second from left*). (Bruno Lohse papers, author's collection)

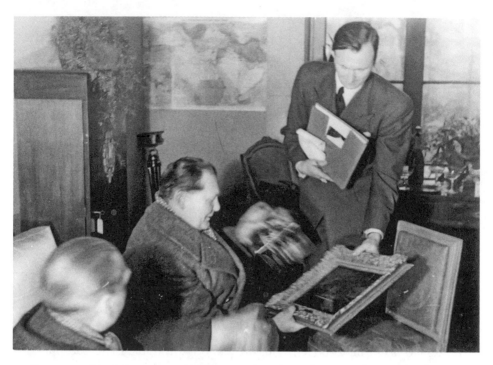

Göring and Lohse, with Walter Andreas Hofer in the foreground, at the ERR headquarters in the Jeu de Paume. Hofer was the director of Göring's art collection. (Archives des Musées Nationaux/Archives Nationales)

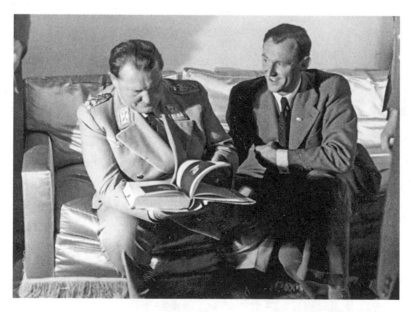

Göring and Lohse studying a book on Rembrandt in the Jeu de Paume. (Archives des Musées Nationaux/Archives Nationales)

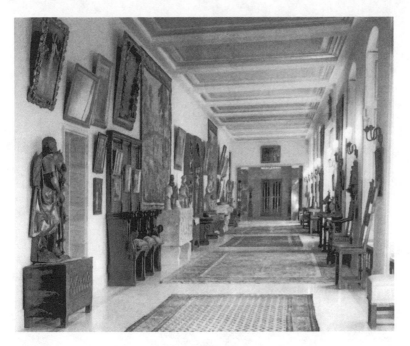

Göring's Carinhall estate, located outside Berlin, where he housed much of his collection, which numbered around two thousand works. (National Archives and Records Administration)

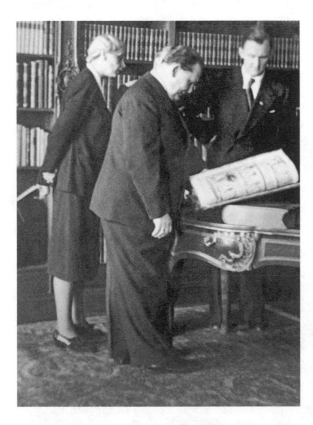

Göring's secretary, Gisela Limberger, with Göring and Lohse in Paris, March 1943. (Everett Collection Inc./ Alamy Stock Photo)

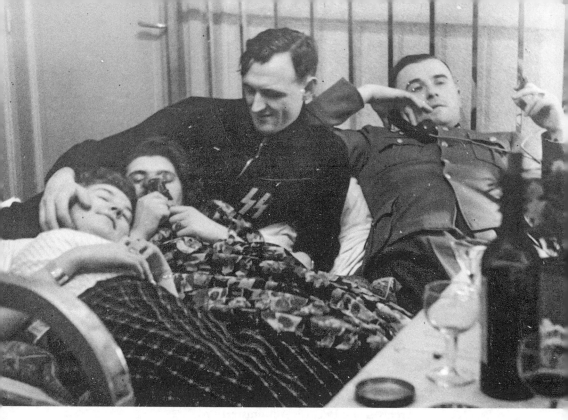

Lohse and an unknown colleague with two women in occupied Paris. Note the SS insignia on his sweater, as well as the wine bottle in the foreground. (Bruno Lohse papers, author's collection)

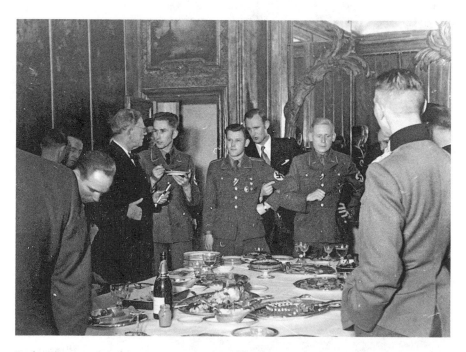

Lohse (*center, behind officers*) with ERR staffers at a lavish banquet in Paris during the war. (Bruno Lohse papers, author's collection)

Max Beckmann's *Dream of Monte Carlo* (1940–43) reportedly features Lohse (*standing at right*) and Erhard Göpel (*left*) as croupiers. Beckmann was a close friend of Göpel, an art dealer who acquired works for Hitler during the war. (© 2020 Artists Rights Society (ARS), New York/VG Bild-Kunst, Bonn, bpk Bildagentur, Staatsgalerie Stuttgart)

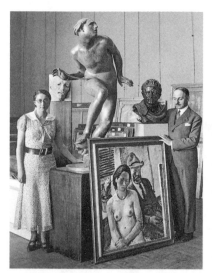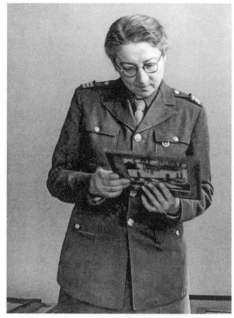

(*left*) Rose Valland in 1935 with fellow curator André Dézarrois in the Jeu de Paume Museum; (*right*) and in 1946 while serving as a French Monuments officer in occupied Germany. (Archives des Musées Nationaux/Archives Nationales; Everett Collection Historical/Alamy Stock Photo)

The ERR card catalogue Lohse saved at the Neuschwanstein castle in May 1945. (Imago History Collection/Alamy Stock Photo)

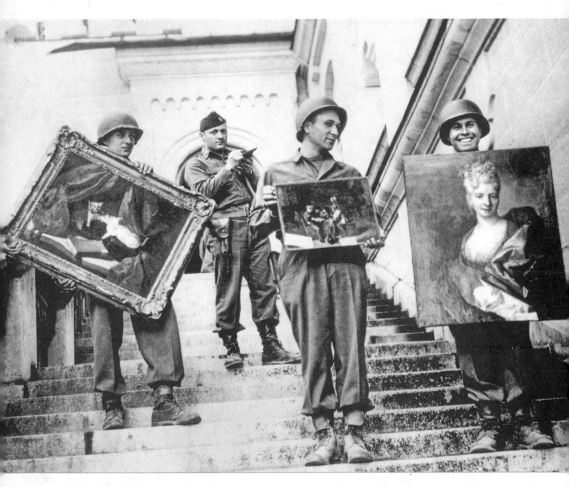

U.S. Monuments officer James Rorimer (wearing cap) and soldiers at
Neuschwanstein in 1945. Rorimer went on to become director of the
Metropolitan Museum of Art. (Shawshots/Alamy Stock Photo)

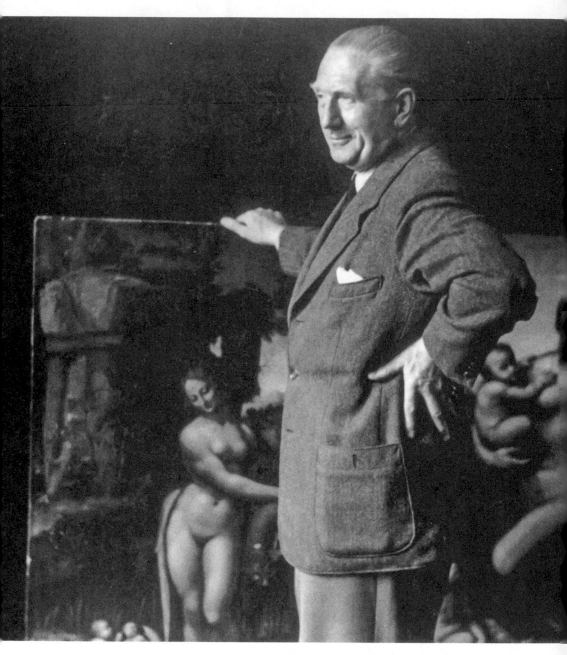

Walter Andreas Hofer in Berchtesgaden in 1945. (National Archives and Records Administration)

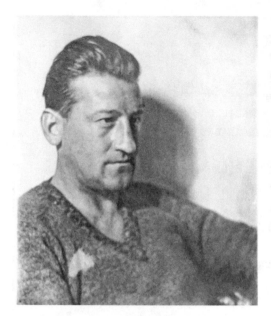

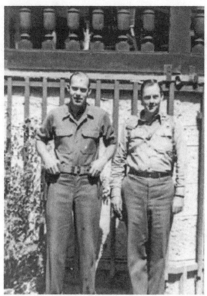

(*left*) Kajetan Mühlmann as a prisoner of the Americans in 1946. The plunderer cooperated with the American Monuments officers prior to his escape in 1947. Mühlmann reportedly supported himself as a fugitive by selling looted artworks prior to his death in 1958. (Author's collection, by permission of Hilde Mühlmann)

(*right*) OSS officers—and members of the Art Looting Investigation Unit— James Plaut (*left*) and S. Lane Faison in Altaussee in 1945. (Papers of John Nicholas Brown, John Hay Library, Brown University)

(*below*) Haus 71 in Altaussee in the Austrian Alps where the ALIU interrogated Bruno Lohse in the summer of 1945. (Photo by author)

NUERNBERG,DEN .APRIL 1946

B E S C H E I N I G U N G
=============================

ICH HABE DEN GEFREITEN DR.BRUNO L O H S E ALS WISSENSCHAFT-
LICHEN MITARBEITER ZUM KUNSTSTAB DES EINSATZSTAB REICHSLEITER
ROSENBERG ABKOMMANDIERT.

DR.LOHSE WAR BIS ZU SEINER GEFANGENNAHME SOLDAT./LETZTE EIN-
HEIT=FALLSCHIRMPANZERKORPS HERMANN GOERING,BERLIN-REINICKEN-
DORF,VERBINDUNGSSTAB./

DR.LOHSE HAT MICH WIEDERHOLT UM SEINE VERSETZUNG ZUR KAEMPFEN-
DEN TRUPPE GEBETEN.ICH HABE DIESE GESUCHE AUF GRUND DES MILI-
TAERAERZTLICHEN UNTERSUCHUNGSBEFUNDES--L.WURDE ALS =A.V.=BE-
URTEILT=UND DA VOM EINSATZSTAB R.R.STETS UM VERLAENGERUNG DER
KOMMANDIERUNG GEBETEN WURDE,ABSCHLAEGIG BESCHIEDEN.

ALS VERBINDUNGSMANN DER DIENSTSTELLE ROSENBERG ZU MIR WAR VOM
STABSFUEHRER DES E.R.R.DER D.R.K.-OBERSTFUEHRER BARON KURT
VON B E H R BENANNT.

DER AUFTRAG DR.LOHSE,S ERSTRECKTE SICH LEDIGLICH AUF DEN ER-
WERB VON KUNSTGEGENSTAENDEN,DIE IM FREIEN HANDEL ZUM KAUF AN-
GEBOTEN WURDEN.ER HATTE KEINE VOLLMACHT ZU SELBSTSTAENDIGEN
KAFABSCHLUESSEN UND HAT FUER SEINE TAETIGKEIT VON MIR KEIN
ENTGELD ERHALTEN.

DIE KOMMANDIERUNG DES DR.LOHSE ERSTRECKTE SICH NICHT AUF DIE
=DIENSTSTELLE WESTEN=DES OSTMINISTERIUMS IN PARIS.

20. April 1946

Affidavit from Göring aimed at exonerating Lohse, signed in prison at
Nuremberg on Hitler's birthday, 20 April 1946. (Bruno Lohse papers,
author's collection)

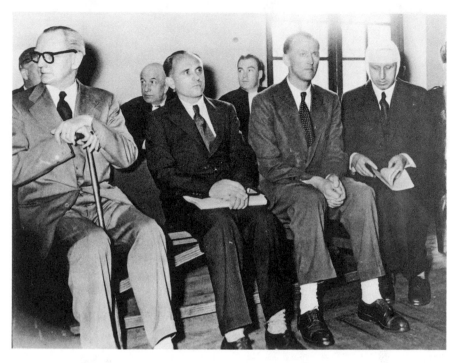

Paris trial of ERR staff members (*l–r*) Georg Ebert, Gerhard Utikal, Bruno
Lohse, and Arthur Pfannstiel in 1950. (Bruno Lohse papers, author's collection)

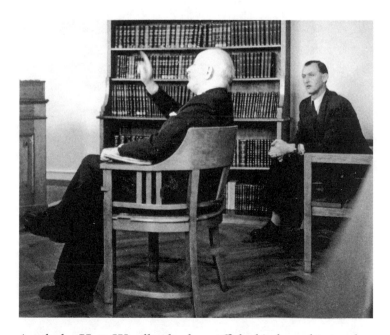

Art dealer Hans Wendland, who trafficked in looted artworks
during the war, testifying in 1950 in a Swiss court, with Lohse
in the background. (Bayerische Staatsbibliothek München/
Bildarchiv)

(*l–r*) Publisher Hermann Hess; art dealers Maria Almas Dietrich, Bruno Lohse, and Mimi tho Rahde; and Hitler's photographer Heinrich Hoffmann in Munich, 1950. (Bayerische Staatsbibliothek München/Bildarchiv)

Advertisement for the art-dealing business of Walter Andreas Hofer in *Die Weltkunst* (1966).

Königinstrasse 22–27, the Munich home of both Karl Haberstock and Walter Andreas Hofer after the war. Those familiar with the dealers jokingly called it the "Brown House," a reference to Nazi Party headquarters, which had also been in Munich. (Photo by author)

Magdalena and Karl Haberstock in the 1950s. (Kunstsammlungen und Museen Augsburg)

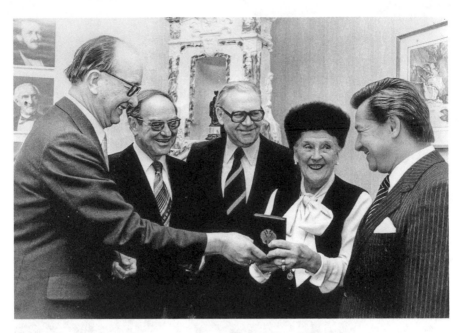

Magdalena Haberstock receiving the German Federal Cross of Merit
(Bundesverdienstkreuz) in 1978. (Kunstsammlungen und Museen Augsburg)

Dr. Wilhelm Höttl,
former SD officer in
Budapest who worked
with Adolf Eichmann to
deport Hungarian Jews,
at his home in Altaussee,
Austria, in 1998. (Photo
by author)

Alois Miedl, one of Göring's operatives, along with his wife, Dorie (who was Jewish), and children. (National Archives and Records Administration)

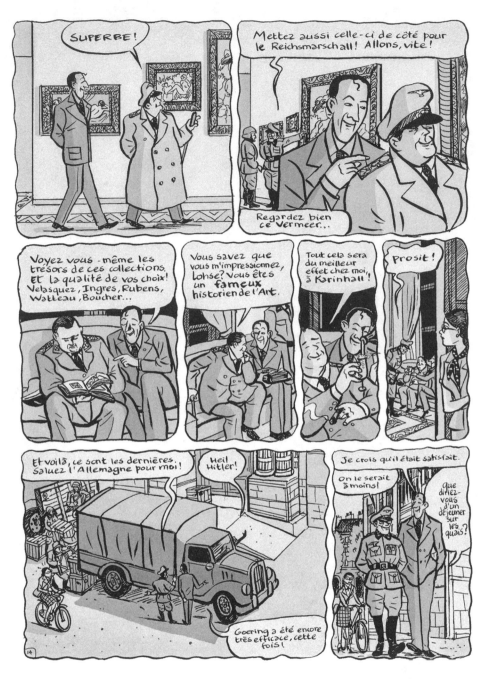

Rose Valland became well known in French popular culture. Here she is featured (along with Lohse) in a 2009 graphic narrative based on her wartime exploits. (Dupuis/Mediatoon)

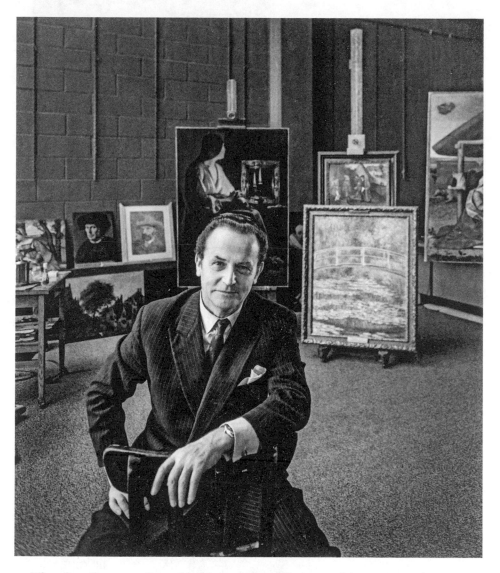

Theodore Rousseau Jr. at the Metropolitan Museum of Art in 1970: the former Monuments officer continued his relationship with Bruno Lohse for decades after the war. (Arnold Newman/Getty Images)

Bruno Lohse in the 1980s.
(Claus Grimm)

Advertisements for
Galerie Almas and
Galerie Peter Grie-
bert in *Die Weltkunst*,
where Peter Griebert
and Maria Almas
Dietrich—both part
of Lohse's network—
share a page (October
1976).

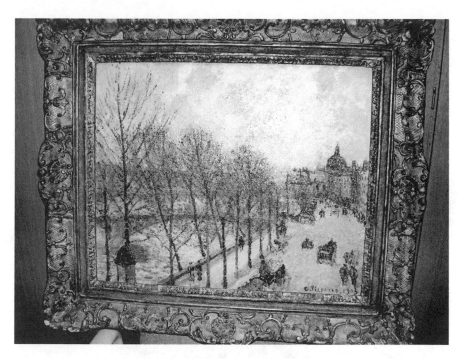

The "Fischer Pissarro" (*Le Quai Malaquais*) in a Swiss bank vault in 2007. (Photo by author)

Peter Griebert inspecting the Fischer Pissarro at the Zurich Cantonal Bank in 2007. (Photo by author)

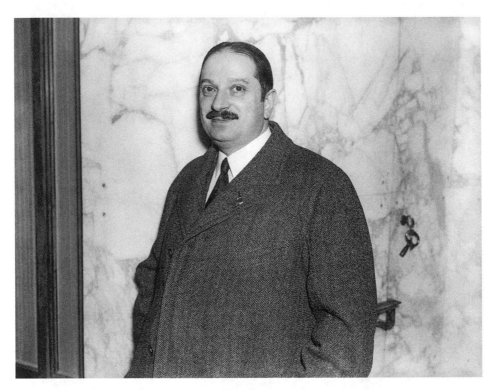

Georges Wildenstein, patriarch of the art-dealing dynasty, in New York in March 1939. (Bettmann Collection/Getty Images)

Daniel Wildenstein at his gallery in New York in 1969. (Photo by Paul Slade, Paris Match Archive, Getty Images)

Form 138
FOREIGN SERVICE
(Revised August 1941)

—Attach Additional Sheets Here—

Form Approved.
Budget Bureau No. 47–R003.1.
No expiration date.

INVOICE OF MERCHANDISE
(Before preparing this invoice, read instructions carefully)

(1) PURCHASED ☐ (1) NOT PURCHASED ☒
(Do not include PURCHASED and NOT PURCHASED merchandise in ONE invoice; use SEPARATE invoice for each)

Vaduz, November 15th, 1949.
(Place and date)

Invoice of 2 original paintings (2) {purchased from or agreed to be purchased from
(Merchandise) {shipped by

(3) S.A. de Beaux Arts of Vaduz
(Seller or consignor) (Address)

to } Messrs. Wildenstein & Co. Inc. of New York 21, N.Y. 19 East 64 Street.
(Purchaser or consignee) (Address)

4) { as per order accepted
(Date)
{ for the account of S.A. de Beaux Arts of Vaduz 327833
(Name) (Address)

to be shipped per airfreight, Welti-Furrer A.G., Zurich
(Carrier)

(5) MARKS AND NUMBERS ON SHIPPING PACKAGES	(6) MANUFACTURER'S OR SELLER'S NUMBERS OR SYMBOLS	(7) IMPORTER'S NUMBER OR SYMBOLS	(8) QUANTITIES AND FULL DESCRIPTION OF GOODS, etc.	(9) INVOICE UNIT (See questions below)	(10) INVOICE TOTAL	(11) CURRENT PRICE (Home consumption or export) PER UNIT
SADBA 103	net w.: gross w.:	12 kg. 58 kg.	François-Hubert Drouais "Les Enfants Choiseul" unframed, Packing 120$ incl.	$100.000.–	$100.000.–	
SADBA 104 New York	net w.: gross w.:	2,5 " 9,5 "	Jean de Beaumetz Christ en Croix, peinture sur bois, unframed, Packing $ 20 about incl.	$140.000.– total $240.000.–	$140.000.– $240.000.–	

Insurance unknown, covered by consignee, No rebate or drawback is allowed.
Freight Zurich-New York $ 250 about incl.

(Read carefully instructions 1 and 9 before answering the first three following questions.)
Is this merchandise shipped in pursuance of a purchase or an agreement to purchase? no
(Yes or No)
If answer to preceding question is "Yes," have you entered as item 9 the purchase price of each item in the currency of purchase?
(Yes or No)
Is this merchandise shipped otherwise than in pursuance of a purchase or an agreement to purchase? yes If answer is
(Yes or No)
"Yes," indicate below whether you have entered as item 9 the present value for each item in the currency in which the transactions are usually made: (a) the value for home consumption including all applicable taxes in the country of exportation; or (b) the export value to the United States if higher; or (c) in the absence of the foreign value and the export value, the price in such currency that the manufacturer, seller, shipper, or owner would have received, or was willing to receive for such merchandise if sold in the ordinary wholesale quantities in the country of exportation; or (d) in the absence of all of the foregoing, the cost of production "b" is applicable
(State whether (a), (b), (c), or (d) is applicable)
Is the currency, entered as item 9, gold, silver, or paper? paper
(State which)
Have you enumerated all charges and stated whether each amount has been included in or excluded from the above invoice amounts? yes If the inland freight is included in the invoice price or value, is the price or value of the merchandise the same
(Yes or No)
at the factory as at the point of delivery? — —
(Yes or No)
Have you separately itemized all rebates, drawbacks, bounties, or other grants allowed upon the exportation of the merchandise? yes
(Yes or No)
Is such or similar merchandise offered or sold in the home market for home consumption? no If so, what taxes are
(Yes or No)
applicable? none
(Rate and kind)

(When invoice is signed by an authorized agent the name of his principal must be shown.)
16–22721–8

Signature of Seller or Shipper S.A. de Beaux Arts

By Frederick Schöni
(Authorized agent)
Dr. F. SCHÖNI Zürich

Customs form from 1949 allowing the Wildensteins to import art into the United States via Switzerland with the assistance of Frédéric Schöni, whose signature is on the bottom right. (National Archives and Records Administration)

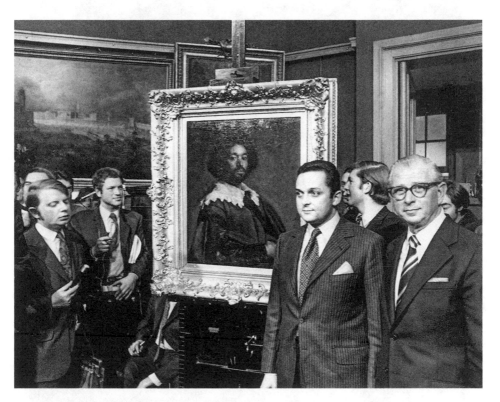

Alec Wildenstein (*foreground, left*) and colleague Louis Goldberg at the auction of Velázquez's *Portrait of Juan de Pareja* in November 1970. The Wildensteins helped the Met acquire the masterpiece. (PA Images/Alamy Stock Photo)

The *Kaiserbilder.* (*left*): Kaiser (Emperor) Karl der Grosse (Charlemagne); (*right*) Kaiser Sigismund, both by Albrecht Dürer (and/or his workshop). Lohse sold these pictures through an intermediary to the German Historical Museum in Berlin in 2003 after having previously put them on consignment with the Wildenstein Gallery in New York. (Deutsches Historisches Museum/A. Psille)

SIGISMVNDVS IMP. EL:
A°.1410:OB:A°.1437.

Professor Max Friedländer, who drafted the expertise of the *Kaiserbilder* in 1939. Lohse helped save Friedländer's life during the war in German-occupied Amsterdam. (bpk Bildagentur/Zentralarchiv, Staatliche Museen, Berlin/Art Resource, NY)

The author with Bruno Lohse on the occasion of their first meeting in Munich, June 1998. (Author's collection)

Lohse's apartment (top floor) in the Bogenhausen neighborhood in Munich. The modest home contained pictures worth millions. (Photo by author)

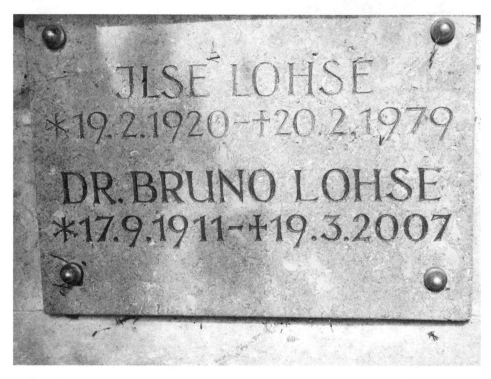

The Munich gravestone of Lohse and his wife Ilse ("Ille"). (Photo by author)

War Stories, War Secrets

THE DISCUSSION OF BRUNO Lohse's postwar career has shown that many questions remain unanswered. We see glimpses of his work as a dealer and as a member of a network of old Nazis, but these images are fleeting and partial. Peter Griebert explained to me some of the rules of Bruno's circle of friends—at least among those relationships that stretched back to the Third Reich. The circle initially included Alois Miedl, the Haberstocks, Walter Andreas and Bertha Hofer-Fritsch, Kajetan Mühlmann, and Göring's secretary, Gisela Limberger. In certain cases, as noted earlier, the children of these figures, such as Gisela Hofer, also gained acceptance. The primary reason for this group's cohesiveness was a dedication to Hermann Göring, whom they had all served in some capacity and now defended at every turn. As indicated earlier, they insisted that Göring was a great personality—brilliant, humorous, courageous, loyal, and more. A second reason was geographic: if they did not live in Munich, as most did, then they visited often. Munich was not only the capital of the Nazi movement but also the center of a network of dealers who had been active during the Third Reich (and often complicit in the Nazis' plundering campaigns). A third element concerned discretion. One spoke with those outside the circle of trust only on rare occasions, and when that occurred, it was important to be circumspect. Bruno told me many stories—self-censored, to be sure, but a form of oral history. I could spend hours relating these stories, but for the purposes

of this chapter, I will limit myself to three subjects: Edda Göring and her circle, Alois Miedl, and Hans Wendland.

The heart of the circle, of course, was Edda Göring (1938–2019), who worked for years in a dentist's office in Munich. Edda had been one of the most famous children in the Third Reich: her birth, baptism, and birthdays made the German newsreels, and she was fodder for propaganda, as the Nazi leaders tried to show how they loved children and were dedicated family types. Edda had endured considerable hardship at the hands of the Americans, who confiscated her father's property and kept her mother, Emmy, interned prior to her denazification hearing in 1946.[1] The Americans' policy, as articulated by Lane Faison in 1951, was that "any work of art given by Göring to his wife or daughter during the war, or presented by others to his wife or daughter during the war, is certainly to be regarded as in no way different from the Göring collection" (and hence confiscated).[2] The policy was hardly shocking or draconian, but while imprisoned at Nuremberg, Göring had seized upon the issue of the treatment of the Nazi leaders' families to criticize the captors, remonstrating, "You see, they are just as bad as the Gestapo themselves; don't let them pretend they are democratic."[3] Ultimately, a German review board (as compared to Allied authority) sentenced Emmy Göring to one year in prison and ordered the confiscation of 30 percent of her property. And it was the Federal Republic and the State of Bavaria that divided possession of the works Göring had forfeited (although Emmy and Edda had occasional successes in recovering property).[4] Yet this did not prevent both mother and daughter from blaming the Americans for their perceived misfortune. Edda Göring's strong anti-American feelings were connected to her father's legacy, and she harbored such views as a way to honor him.

Members of this circle surrounding Edda Göring helped her as she continued the quest to recover her father's onetime possessions, which I saw firsthand. In spring 2007, Peter Griebert, who had known Edda for decades and saw her regularly, approached me and asked if I could help her recover some property near Berchtesgaden that had been confiscated by the Americans. Peter explained that the house had belonged to the Görings before 1933 and, and due to this ownership prior to the Nazis' coming to power, should not have been confiscated after the war. Did I know a lawyer who could represent Edda Göring? Would I be interested in meeting her? If so, then I would be presented as a Greek, not an American. That was the only way that Edda would agree to meet. One simply did not talk to those outside the circle of trust, especially journalists and filmmakers.

Edda Göring worked assiduously to maintain her privacy and declined nearly all interviews, save with a Swedish journalist who she thought was sympathetic to her (Göring's first wife, Carin von Fock, was a Swedish aristocrat, and certain Swedes tended to view the Görings in more sympathetic terms than others). Even though she was shy and retiring, she was still the daughter of "the great man," and as such commanded the deep respect of Lohse and other survivors of Göring's entourage. Bruno had known Edda as a child and seen her play with Göring at Carinhall. (Lohse claimed that Göring was a devoted father.) But I had little idea that Bruno and Edda had become such close friends. Part of their relationship was based on tradition: each year, they met for a cup of tea in a ceremony in which Lohse rather formally paid homage to his former patron.[5] Other meetings occurred on a more spontaneous basis. Edda, more than anyone else, was responsible for a kind of code of silence—a variation on the Mafia's *Omertà*, as Peter explained. For Lohse, this circle of old friends—of old Nazis—was one of the things he most cherished in his postwar life.

In Lohse's last interview with me, in January 2006, he said that Göring was a father figure to him, a "great man." This was consistent with what Peter Griebert and Lohse's housekeeper had told me. Bruno venerated the Reichsmarschall and would hear nothing critical of him. Moreover, they told me that Lohse looked back on his time in Paris working for Göring as the high point of his career. He had been the "king of Paris"—respected or feared by nearly all he encountered. Lohse took comfort in thinking about those days. At least once a week, he would call for his collection of photos and documents to be brought to him. He would spread out the materials on the table in front of him and embark on a stream-of-consciousness monologue about "the good old days." Later, when his eyesight failed, he would have Peter and Frau Goebel describe what they saw. His draw to these materials was so great that even this ersatz experience—a kind of metaphorical methadone—assuaged his addiction. The fact remains that Lohse continued to live partly in this glorified past. It was this time, and the people whom he associated with during this time, that meant the most to him.

Lohse was not alone in still living in the past. Although it is the stuff of films (for example, *The Odessa File*) and popular fiction, it's true that many old Nazis continued to meet to affirm bonds and reminisce about old times. Rumor has it that a group of old SS officers convene on the last Tuesday of every month at the Löwenbräu beer cellar on the Nymphenburgerstrasse in Munich, and that one of Himmler's daughters, Gudrun Himmler Bur-

witz (1929–2018), was a regular attendee: characterized in her *New York Times* obituary in 2018 as "a dazzling Nazi princess, a deity among these believers in the old times," Gudrun Burwitz had been a staunch supporter of Stille Hilfe (Silent Assistance), an organization nominally dedicated to assisting former prisoners of war, but in fact focused more on former SS officers and their families.[6] An annual reunion of SS forces takes place in Klagenfurt, Austria, and one at Ulrichsberg, which has been held for over forty years; in the year 2000, it attracted some two thousand attendees.[7] Holocaust denier David Irving has spoken to this group, as did the right-wing Austrian politician Jörg Haider.[8] Going back to war's end, former members of the Waffen-SS created the HIAG (short for Mutual Aid Society), a "lobby group for the former Waffen-SS personnel in the Bonn Republic."[9] With 376 local branches spread across the Federal Republic by 1951, the HIAG was not inconsequential.

One document in Lohse's papers that raises questions is an anonymous and undated report, a typed copy of another document (in German called an *Abschrift*), titled "Financial Sources of Neofascist Parties."[10] The report notes that neofascist parties (that would include neo-Nazis and those seeking to revive the Third Reich) controlled assets that came from a variety of sources, including those of the former Reichsbank, the valuables of Baron de Rothschild, and resources previously controlled by Nazi agencies such as the Foreign Office and the Reich Security Main Office. The report states that "a circle of initiated"—limited in number but "of iron discipline"—knew about these assets and that "a long fully unknown organization" held the key to their disposal. The report then details how Lohse, Schiedlausky, and a Dr. Wirth controlled cultural treasures at Neuschwanstein at war's end, including Rothschild valuables, that constituted part of these hidden resources. The report elaborates on the importance of General Otto-Ernst Remer (1912–97), an officer who had helped put down the 20 July 1944 coup attempt against Hitler and after the war became known as a figure in radical right-wing circles. Remer purportedly hid a case of gold bars at war's end near Neuschwanstein. Certain members of this secret cohort supposedly pretended to be tourists visiting the Füssen area each summer in order to take control of some of the assets during these trips. The assets then "disappeared without a trace," although the author asserted they went to finance neofascist parties and war criminals on the run. The report even talked of a network that extended to Augsburg, Lausanne (Switzerland), Vaduz (Liechtenstein), and Paris, among other locations.

Even though the mysterious report resonates in certain ways with Lohse's experiences both during and after the war, and even though it contains intriguing elements (General Remer has been described as "the 'godfather' of the postwar Nazi underground"), there is little evidence proving its accuracy.[11] If it was true, why would Lohse keep it in his papers? His sense of discretion, his belief in *Omertà*, would have induced him to discard or destroy it. The report has a handwritten notation on the cover page reading, "Utikal!"—a reference to Rosenberg's former chief of staff who lived until 1982 and who may have been the source of the document. Although Lohse remained part of a network of old Nazis, he did not appear to be politically active. Others, like Robert Scholz, remained committed to extreme right-wing political initiatives; Scholz published in the radical right-wing press until his death in 1981. Lohse hailed from a family that did not discuss politics, and despite the extraordinary course of his career, he was not driven by a political agenda. He probably thought the report was historically significant and he kept it in his papers because he himself is mentioned as a key figure.

When telling stories, Lohse may have become most animated when recalling the exploits and tribulations of Alois Miedl, a favorite subject of his. Bruno met Miedl during the war and the two stayed in contact throughout the postwar period until Miedl's death at age eighty-seven in 1990. Miedl was a corpulent, ruddy-faced Bavarian businessman with legendary connections. There were persistent rumors that he had high-level contacts at the Vatican. He certainly had links to a network in Switzerland. Famed intelligence agent Walter Schellenberg summed up matters: Miedl was "a notorious profiteer, who was also a buyer of pictures, etc. for Goering, who was his protector."[12] As noted earlier, Miedl was best known for working with Göring to purchase (and therefore Aryanize) the Goudstikker estate in a forced sale; this included the art gallery in Amsterdam on the fashionable Herengracht as well as Castle Nijenroode in the town of Brekeulen and a country estate called Huize Oostermeer on the Amstel River.[13] Miedl subsequently purchased some of the famed Koenigs' collection, also in Amsterdam, and works from the Emil Renders collection in Brussels.[14] A financier from Munich who moved to the Netherlands around 1932, Miedl also controlled two banks in Amsterdam—the Buiten-Bank and the Boorkieskarrtoop Lisser, Rosenkranz & Co. (the latter had significant assets in the United States).[15] He had a range of other financial interests, such as the Schantung-Handels Gesellschaft in Berlin, which in turn had significant investments abroad (including in

a major British cement company). As one postwar report on him noted, "Miedl's approach to business has always been dangerous and risky, mixing business with politics."[16] Like Bruno, he was another art world figure who got away with a good part of his wartime fortune.

Miedl was also part of Göring's menagerie, and the relationship between the two illustrated the nature of dealings within the Reichsmarschall's circle of agents. Miedl "revered" Göring and had a friendship or relationship with the potentate's widowed sister, Olga, that has been described as "intimate."[17] But Miedl, a devout Catholic, could not entertain the notion of a divorce from his wife, Fodora ("Dorie") Fleischer Miedl, even though she was Jewish. The latter, of course, made him vulnerable, a fact that Göring used to his advantage in business negotiations with Miedl.[18] In exchange for his service, Miedl secured the protection of his family, with his wife and two children declared "honorary Aryans."[19] Though never officially affiliated with the Nazi Party due to his wife, Miedl showed pro-Nazi views. He reportedly stayed at Hitler's Berghof on several occasions, and he and Dorie organized "galas" in the Netherlands to celebrate Hitler's birthday—with Miedl wearing an SS uniform.[20] It was all quite extraordinary considering that Dorie Miedl was Jewish according to Nazi laws. However, such was their faith in their protector that they embraced their roles with gusto. Miedl was Göring's most important agent in Amsterdam (with Mühlmann based in The Hague).

Although Alois Miedl purchased many artworks from Dutch Jews, his most important transaction during the war involved the Goudstikker Gallery, arguably the most important such establishment in the country.[21] Jacques Goudstikker had died on 16 May 1940 while trying to flee the country: on board a blacked-out ship, he had fallen into an open hatch and broken his neck. His mother remained in the Netherlands, and this factored into the decision of other family members to do business with Miedl. In a series of complicated transactions involving two sales agreements, Miedl acquired a large fraction of the Goudstikker assets in the summer of 1940.[22] Göring provided much of the capital, and Miedl arranged for most of the payment in securities, which were more fungible than Reichsmarks outside of Germany. He also promised to protect Goudstikker's Jewish mother, who remained in her home and indeed survived the war. The sale involved 1,113 inventoried paintings, nearly all Old Masters, and an unknown number of other works. Miedl acquired not only the artworks but the Herengracht gallery as well as the J. Goudstikker trade name.

Göring took the best works for himself, "buying" them from Miedl.

This extended to some thirteen pictures, including two Cranach the Elder paintings of Adam and Eve that are currently in the Norton Simon Museum in Pasadena (and claimed by the Goudstikker heirs).[23] It was Miedl's job to sell off the remainder of the stock. By December 1940, Hans Lange's auction house in Berlin was selling Goudstikker works passed over by Göring. Architect Albert Speer bought two Dutch landscapes, while Goebbels and von Ribbentrop bought other works. One postwar Allied document lists Miedl approaching dozens of buyers with Goudstikker objects, ranging from eleven German museums (the Wallraf-Richartz in Cologne bought eight Dutch Old Masters) to Baldur von Schirach, who purchased rugs for his lake house in Kochel, Upper Bavaria (Oberbayern).[24] Postwar investigators estimated that Miedl made 3 million guilders in profit (some $1.6 million in 1945).[25]

For reasons that are difficult to fathom, perhaps stemming from the ostensibly large sum paid by Göring and Miedl for the estate, the Goudstikker artworks were not immediately returned by Dutch authorities after the war. But thanks to the efforts of an investigative journalist named Pieter den Hollander in the mid-1990s, and then lawyer and art sleuth Clemens Toussaint, among others, the Dutch government returned over two hundred paintings to the heir (Marei van Saher)—though not until 2006.[26] The sixty years it took to restore the paintings to their rightful heirs speaks to the complexity and mystery surrounding Miedl's business dealings as well as the restitution landscape in the Netherlands which, at least until the early 2000s, made it difficult for victims and heirs to claim looted property.[27]

One episode that remains the subject of speculation occurred near war's end, when Miedl was detained on the Spanish border.[28] He had evidently fallen out with Göring over the sale of a purported Vermeer: the picture, titled *Christ and the Woman Taken in Adultery*, had been forged by Han van Meegeren (1889–1947), and Miedl, who obtained the work, passed it on to Göring in early 1944 for some 150 mostly second-rate paintings. Miedl had failed to vet the painting properly, and when Göring discovered that it was a fake, his relationship with Miedl soured.[29] The security of his Jewish wife and children was thus endangered, and Miedl and his family left Amsterdam in May 1944, heading to Spain with exit visas that Göring had helped him obtain. Previously, in February 1944, Miedl had transported some of his art collection to the neutral (but pro-Axis) country. This evidently entailed 22 pictures, including 13 from the Goudstikker collection, which were confiscated at the Port of Bilbao. Yet

there was more. The Allies reported the following: "After D-Day Goering had commissioned Miedel [*sic*] to convey 200 paintings to Spain in two cars. Miedel [*sic*] crossed the Franco-Spanish border with the paintings just before it was closed. Difficulties were raised about the paintings on the Spanish side, and the German Air Attaché, General Kramer, had in the end to acknowledge them as Goering's personal property."[30] The Allied investigators believed that Miedl was transporting artworks to Spain for Göring, a theory supported by SS officer Otto Ohlendorf, among others.[31] They also believed that "the Nazis would use profits from the sales of artworks to fund German espionage and subversive activities in Europe and South America."[32] Spain loomed large in Operation Safehaven, the U.S.-led effort undertaken in 1944 to deny the Germans of all resources that could be used to prosecute the war (or start another one in the future). Miedl clearly had contacts in intelligence circles and with the Gestapo: he had bribed border guards as part of the effort to import the artworks and he managed to extricate himself from the custody of the Spanish authorities, and then also the Maquis, members of the French Resistance who temporarily captured Miedl as he slipped back into France to pick up more property. But Miedl managed to secure the paintings—and according to Allied reports, they included works by Rembrandt, Goya, van Dyck, Rubens, and Cézanne. He went so far as to offer them for sale, even distributing catalogues.[33] Miedl remained in Spain, out of the Allies' reach, both during and after the war.

This did not mean that the Americans did nothing; indeed, they sent intelligence operatives to investigate Miedl and his art. Most notably, OSS officer Theodore Rousseau was deployed to Spain in December 1944. Rousseau made some quick progress, tracking down Miedl and his artworks and even inducing the Spanish authorities to cooperate—at least initially. They detained Miedl until February 1945 and confiscated his paintings. Rousseau traveled to Bilbao, near the French border—which contained a free port and was a haven for illicit transactions—and examined the pictures. He noted that none of the pictures or crates had French customs markings, which confirmed they had been smuggled. Rousseau photographed each work and then filed a series of reports, including one that went directly to the U.S. secretary of state Edward Stettinius.[34] The experience with Miedl in Spain offered Rousseau a crash course in Nazi art looting. According to his January 1974 obituary in the *New York Times*, "Mr. Rousseau disclosed that many of his leads had come from Hermann Goering's banker, whom Mr. Rousseau coaxed into talking over lengthy,

brandy-laced meetings in Spain."[35] Despite the volubility and helpfulness of Miedl, Rousseau never got to the bottom of his story. The OSS leadership commandeered Rousseau to Altaussee to join the Art Looting Investigation Unit and interrogate the major art plunderers. Rousseau requested that Miedl be transferred to the ALIU facility in Austria to join Lohse and the other looters. But the request became mired in disputes between American, British, Dutch, and Spanish officials, all of whom had their own ideas about how to handle Miedl and the artworks. In the autumn of 1945, Miedl himself offered to travel to Altaussee, "hinting that he could supply useful information about confiscated paintings and Nazi leaders"; but in return, he demanded immunity and other guarantees, including that the Allies "would recognize that Miedl legally owned the paintings."[36] Rousseau counseled against such a deal, knowing that it would set a dangerous precedent at a critical time with regard to the looters and their assets. Miedl, for his part, concluded an arrangement with the Dutch authorities: he avoided prosecution in exchange for a fine of some 2 million guilders (paid in securities and assets) and the forfeiture to the Dutch state of "almost all of Miedl's paintings found in Spain," about a dozen of which came from the Goudstikker collection.[37] He also relinquished six paintings that had been looted, including four Cézannes and a remarkable van Gogh self-portrait with a bandaged ear that had been taken from Paul Rosenberg by the ERR, passed on to Göring, and then sold to Miedl at a heavy discount. Göring even arranged for the works to be transported to Switzerland via diplomatic pouch. Miedl subsequently tried unsuccessfully to use the six works to compensate Swiss authorities for visas for his family. Miedl's Swiss lawyer, Dr. Arthur Wiederkehr, handed the pictures over to the Allies once he realized how the war would end.[38] Yet Miedl apparently retained other artworks, although we do not know for certain. We have only hints, such as an August 1948 report listing ten paintings acquired by Miedl as still missing, including works by Rogier van der Weyden and Hans Memling.[39] Another American document noted that "his property (paintings, etc.) is hidden in Bad Tolz at the home of his cousin, Dr. Schneller."[40] Another report from August 1945 stated that "Miedl was later active in Italy"—although we know nothing of his dealings in that country.[41]

Alois Miedl, like most of his cohort, moved on with few difficulties in the postwar period. He was called upon to testify in the Netherlands in 1949 but, as reported in the local press, the state prosecutor for economic war crimes showed "no official interest" in him.[42] Miedl later testified in

Bern in the second Theodor Fischer trial in December 1950. The American diplomats took note of him from time to time, but hardly pursued him. We know now that Miedl lived in Madrid and also for a time in Lisbon after the war, and then in Munich from 1953 to 1957. Alois Miedl registered with the Munich Art Trade Association and resided near the Königsplatz in central Munich, a stone's throw from the Central Collecting Point/Zentralinstitut.[43] Part of the same circle as Lohse, Miedl maintained a low profile, and later moved on to the Nazi-friendly safe haven of South Africa, spending time in Pretoria, according to Griebert.[44] Lohse frequently talked about having met Miedl in Switzerland in the postwar period, and there were reports that he also traveled to the United States.[45] Miedl was famous for generosity and grand style. He would hand the maître d' sizeable gratuities and order only the most expensive meals and the finest wines.[46] Lohse called him a *Kraft-mensch* (literally, a "powerful man") and an *Ur-Bayern* (a Bavarian with long-standing family roots). Miedl had charisma, a larger-than-life personality. As Lohse described Miedl, I could not help thinking that the latter had modelled himself on his patron Hermann Göring, as did Lohse in certain ways.

Perhaps the most intriguing detail of Miedl's story was that he had a series of bank vaults, at least one of which Lohse had inspected, containing some fine pieces. Lohse, with a bit of prompting from Peter Griebert, also revealed that Miedl and his wife, Dorie, had a notoriously tempestuous relationship. More than just spouses, the two were a business team, with Dorie Miedl handling the bookkeeping. They were remembered among associates for their rip-roaring fights, in which Frau Miedl would take all sorts of extreme measures against her husband. "Well," Lohse said, laughing as he told the story, "they happened to have a row just before Frau Miedl died, and she was so mad at him that she had removed all the identifying information from her set of keys to the Swiss bank vaults that held many of their assets." Lohse described an assortment of some thirty keys, now with no tags—Miedl had raced down the Bahnhofstrasse in Zurich, going bank to bank, pleading for help from the staff. Lohse said Miedl managed to match one key to a vault and empty its contents, but it sounded as though he did not have much success with the others.[47] Lohse added, however, that since Miedl owned so many shares in a South African railway he was never in any financial distress.

The stories about Miedl in Switzerland are similar to the experiences of Hans Wendland, Lohse's wartime accomplice. Like Lohse, Wendland was apprehended by the Allies, interrogated by the ALIU, and subjected to

a judicial process. It is not clear if they crossed paths in the French prison system, but they reconnected when they both testified in the 1950 trial of Theodor Fischer. As noted earlier, they also shared the same Swiss lawyers, Dr. Albert Steiner and Frédéric Schöni. They also both were clients of the Zurich Cantonal Bank, which facilitated their business in various ways, including holding art in its vault. Lohse and Wendland may well have been partners in certain deals, but the files are silent on that point. Regardless, they maintained regular contact in the 1950s and 1960s. Lohse told me that Wendland still lived a lavish lifestyle, with a grand apartment in Paris filled with valuable pictures. Lohse marveled that Wendland was able to live in such opulence, having lost a portion of his fortune at war's end. But the shrewd dealer, who traveled easily, if sometimes out of necessity, between Germany, Switzerland, and France, had amassed such a huge fortune during the war that he could afford to lose part of it. He reportedly also induced the French state to return certain works to him after the war.[48] Lohse told me that if one wanted to find looted pictures that went missing, one should focus on Wendland. Lohse also indicated that Hans Wendland remained very well connected in the art world until his death in 1972.

I took Lohse's suggestions and researched Wendland in the archives of Switzerland and France as well as in the ALIU reports and supporting documentation. Wendland proved to be a fascinating, if mysterious, subject. By 1947, Allied authorities had found a few of his letters that reflected his chaotic efforts to hide assets. Wendland wrote to his wife, "In 1944, I entrusted 6 paintings of minor value to Hans Oppenheimer, who fled over the lake of Geneva from France in 1943/44, to help him out. It seems that he himself has returned to France without selling the pictures. Try to find out about this. . . . I am missing a suitcase where I had stored small pictures. . . . There were five in all. It is on the floor or in Luzerne or Basel. . . . In the wall safe in my work room there were many letters, others were in a suitcase which I had taken to lawyer Mauz in 1946. . . . [They] are also to be given to you."[49] The dealer in looted art clearly dispersed his papers and his pictures beginning late in the war in an effort to conceal his activities. But the fragments of what remained proved illuminating: in one letter to Emil Bührle, Wendland talked about visiting a vault in the Bankgesellschaft on Bahnhofstrasse in Zurich in 1943 to inspect a van Gogh and a Jan Steen. Wendland noted that Bührle had not purchased the works, but the image of these men inspecting them—and the fact that they went missing at war's end—appears highly suggestive.[50]

The Americans' investigations of Wendland were partially success-
ful. They found "between sixty and eighty paintings" at the Le Coultre
Warehouse in Geneva, "of which thirty or more were acquired in France
during, or since, the occupation." A further twenty works of his were
stored at the Galerie Fischer in Lucerne. A crate of pictures turned up
at the Bronner, A.G. transport company in Basel. Swiss authorities also
found several works at his former residence in Versoix. Bank accounts at
the Central Bank in Zurich and the Credit Anstalt in Lucerne were also
part of the mix. And Wendland himself delivered to James Plaut a pic-
ture by Henri Matisse depicting a seated woman in an oriental dress, a
work he acknowledged receiving from Rochlitz and believed came from
the ERR.[51] Yet they came up short in other regards. An American diplomat
by the name of Daniel Reagan wrote that "Wendland has stated that about
twenty of his best paintings, all acquired in France since 1940, are being
held for him by 'Swiss friends.' These include the following [he went on to
list works by Fragonard, Goya, Rubens, and others]." Reagan continued,
"Wendland refused to specify the names of the friends who hold these
pictures but other information available to this Legation indicates the fol-
lowing persons, known to be friendly with Wendland, may be holding
the paintings for him. Kurt Hirschland (Geneva), Franz Hirschland (New
York), Theodor Fischer (Lucerne), Emil Bührle (Oerlikon), Fritz Fank-
hauser (Basel), Frau Dr. Jennie Brin (Basel), Alfred Weinberger (Paris or
Lucerne)."[52] The Americans also suspected that Wendland had conspired
with Walter Andreas Hofer to hide "funds and perhaps works of art" in
Switzerland.[53] Wendland, like many of his cohort who hid assets in the
Alpine republic, appeared adept at concealment and subterfuge.

I pressed Lohse on the issue of assets in Switzerland. This was one of
the key themes I thought it was important to discuss. I believed that he
knew a lot more than he let on, and he did. But truth be told, he didn't
give up very much. Yes, it helped me immensely to know that Lohse and
Miedl were in contact; that they met in bank vaults in Zurich; that family
members were involved; and that they could laugh about losing large sums.
Bruno, however, gave very few details. He certainly didn't like to talk about
specific works of art. He was more comfortable with war stories. These
were, very clearly, versions of the same accounts he had given the Allied
art officers after the war. Nonetheless, that he would tell these stories at
all, voluntarily, was a sign that he had loosened up slightly with time. Ego
superseded caution; age added to a sense of immunity.

Lohse did not tell me the Miedl and Wendland anecdotes in their

entirety at our first meeting that summer afternoon in Munich. He related enough on this first meeting to whet my appetite—to induce me to ask him again—and over time he told me his stories over and over. With every telling, however, he would change certain parts and add new details, so my knowledge of his canon of stories became increasingly detailed and specific. Sadly, toward the end of his life, when I filmed him, he could scarcely recall any of the details himself. When asked, he would exclaim, "Nah, Ja!" in recognition of some person or fact, but by 2006, or perhaps even a bit earlier, his ability to recount even his most cherished stories was gone.

In addition to the "war stories" referenced in the chapter title, Lohse harbored an array of "war secrets." Sometimes the stories helped conceal the secrets; sometimes they were clues leading to the revelation of a secret. It was something of a game for Lohse, but it was not one that he controlled in its entirety. The cat and mouse game that he played with the "Fischer Pissarro" painting eventually generated enough pressure for him to undertake its return, which subsequently went awry, again exhibiting the limits of his control. But Lohse did manage for years to keep most of his secrets: he was a skilled liar, dissimulator, and schemer. He let out what information he wanted. This included, on one occasion, showing me images of a Hitler watercolor that he sought to sell. The watercolor of the Bavarian Royal Opera house in Munich had been created by Hitler just before World War I and had been gifted to a Weimar-era judge who had helped the future dictator.[54] Lohse had documentation about the picture, including an affidavit from August de Priesack, another well-known figure in extreme right-wing circles who had once worked in the Nazi Party Archive in the Brown House in Munich. De Priesack had begun a project in the 1930s to authenticate actual Hitler artworks (forgeries abounded), and he continued to offer expert reports in the postwar period. He later coauthored a catalogue raisonné of Hitler's pictures: while a catalogue raisonné is in principle a scholarly, scientific compendium of an artist's works (or a section of works, such as paintings), this volume was plagued by an abundance of forgeries, Hitler's mediocre efforts being fairly easy to imitate. Through the father of a friend, I had met de Priesack several times back in the late 1980s and early 1990s and had been able to look through his library and archive. I therefore had some experience researching the dictator's art. Lohse explained to me that he had obtained the Hitler watercolor from the family of the federal judge Ernst Hepp. The revelation of the Hitler picture was calculated: Lohse communicated that

he was connected in the circles of old Nazis, that he was still active as a dealer, and that he wanted to utilize me not just for historic purposes but for commercial ones. I had told a friend in Berchtesgaden about the Hitler painting, knowing that he had an interest in the Third Reich, and he ended up contacting the eventual buyer in New Orleans. The picture had sold. Lohse was pleased. The fact that I inadvertently played a role in the sale of the Hitler watercolor also entered into his thinking. He now prepared to use me for a more ambitious undertaking.

We now know that Lohse sold two portraits of medieval German emperors from the workshop of Albrecht Dürer to the German Historical Museum in Berlin in 2003. The pictures of Emperors Karl der Grosse (Charlemagne) and Sigismund were painted in Nuremberg around 1514 and now form part of the museum's permanent collection.[55] They are stunning, luminous pictures, with carefully crafted details, such as the jewels in the crowns. It remains unclear whether these works are by Dürer himself or his workshop, and there is a voluminous scholarly literature on the subject. A central focus of the investigation has been fingerprints found embedded in the paint, and experts have tried to compare these to traces on other paintings that were unquestionably executed by Dürer himself. The museum has taken a cautious approach, listing the *Kaiserbilder* as workshop pictures (yet adding a question mark), but as one of the experts commissioned by the museum noted, "The two panels count as the most disputed Dürer works of all."[56]

According to those close to Lohse, the Kaiser portraits had belonged to émigré dealers Nathan Katz (1893–1949) and Benjamin Katz (1891–1962), who brought them to the United States in the late 1930s. There were reports that Nathan Katz's son, David Katz (b. 1919), also played a role in the disposition of the pictures. Research conducted by scholars at the German Historical Museum indicates that they were discovered by Professor Max J. Friedländer, the Jewish art historian and expert on the Northern Renaissance whom Lohse helped protect in Holland during the war. The personal connections, the networks, always seemed to resurface in the art trade. Friedländer had reportedly discovered the *Kaiserbilder* on the London art market in 1938; he wrote a report (a *Gutachten*) stating that they had long been in an English private collection and that they were authentic works by Dürer (an "exciting surprise," he noted).[57] They were then sold to the Galerie Katz in Dieren near Arnhem, which in turn transferred the works in 1939 through the Galerie Schaeffer to New York.[58] It is likely that the pictures remained in the possession of the Katz family: Nathan

and Benjamin Katz had fled from the Netherlands to Switzerland early in the war, receiving permission from German authorities in large part because they had directed important pictures to Göring, including Rembrandt's *Portrait of Saskia*, which they sold to the Reichsmarschall in early 1941. A further twenty-five members of the Katz family received visas to Spain in return for Rembrandt's *Portrait of a Man—Member of the Roman Family*, which came from Nathan Katz's private collection.[59] Nathan and Benjamin Katz officially were not permitted to work, but they evidently continued commercial activity in a clandestine manner.[60] German Historical Museum officials say the pictures returned to Europe in 1947, but again, they have provided no specifics.

It remains unclear when Lohse acquired the works, but there are indications that he owned them by 1955.[61] He offered them to the Berlin State Museums and corresponded that year with the general director, Heinrich Zimmermann.[62] That Lohse was in touch with such a luminary in the German art establishment just five years after his release from prison is striking. Lohse also kept in touch after the war with Friedländer, the brothers Katz, and Schaeffer, and the pictures are a testament to the postwar network that grew out of the Third Reich.[63] According to Peter Griebert, Lohse kept the Kaiser portraits in his vault in the Zurich Cantonal Bank for years before selling them to the German Historical Museum. It is not clear whether museum officials knew this. According to representatives of the museum, the work was sold to them by Peter Griebert—not Lohse. Experts at the German Historical Museum spent three years studying the provenance of the two pictures prior to concluding the transaction, but they evidently did not discern that it was Lohse who sold them the works. According to an email from their provenance expert, Dr. Sabine Beneke, "There is no connection between the two Dürer pictures and the art dealer Bruno Lohse."[64] The extant documentation shows only that the museum knew the works came from a "private collection in Zurich."

The sale of the *Kaiserbilder*, I eventually discovered, sheds light on the way Lohse did business in the post-1950 period. After some initial reluctance, officials at the German Historical Museum shared the curatorial file on the works with me, and this proved very illuminating. First, Lohse used friends and partners as fronts. In this case, not surprisingly, Peter Griebert served that function. Lohse knew his own name was toxic for some curators, especially after the subject of Nazi-looted art reemerged in the late 1990s. Yet it is likely he employed such tactics earlier. Second, Griebert (Lohse) initially demanded a relatively high price for the two

works—2 million euros—but then settled for 600,000 euros.[65] The extant documentation does not reveal whether this was due to a downgrading of the works to Dürer workshop status, but that is likely the case. One can imagine that Lohse attempted to sell the pictures as works painted by the master himself, but then fell short in assuaging the doubts of other experts. Interestingly, in the scholarly literature on the creator of the paintings, one contribution came from Dr. Claus Grimm, a friend of Lohse's, who penned an article in 1987. Lohse therefore knew of the debate, even as he asked a lofty sum. Third, in Griebert's interactions with the German Historical Museum, and more specifically its director at the time, Professor Hans Ottomeyer, he claimed that the works were owned by a "family foundation" (*Familienstiftung*), and that there were two chairs of this foundation.[66] Griebert also indicated that the "family foundation" related to the collector Heinz Kisters (1912–77), a high-profile German businessman and art dealer who had lived in Switzerland.[67] Kisters amassed a remarkable collection of Old Masters, including works of Botticelli, van Dyck, and Velázquez, and so it was highly plausible that there would be a foundation of the heirs.

Peter Griebert reported that the family foundation was based in Liechtenstein and he used a local firm called Royalis Auktionen AG in Vaduz to help carry out the transaction. The family foundation story not only provided a cover for Lohse's ownership, it afforded Griebert greater room to maneuver in negotiations. Griebert ran all counteroffers from the museum by the purported dual chairs, and he himself played the role of intermediary (*Vermittler*). Royalis Auktionen AG, not surprisingly, turned out to be a strikingly opaque endeavor: the only auction house in Liechtenstein, it has no website and is located in on a narrow side street in a structure that looks more like a residence than a business.[68] The firm appears better suited to private transactions than public sales. Griebert guided the process the entire way, writing to the head of the German Historical Museum, Professor Ottomeyer, in June 2002 that the works had just been transported by a Zurich firm called Spedition Welti-Furrer. The manner in which payment was rendered proved significant. The two installments of 300,000 euros went to an account at the Liechtenstein Landesbank, but according to Griebert, Lohse created another account in Switzerland that he called the "Sigismund Konto."[69] The Swiss bank served as a counterpoint to the Liechtenstein foundation: both helped Lohse conceal his identity and his assets. The two Kaiser paintings, as shown in photographs in the curatorial file, nevertheless arrived at the German Historical

Museum in red velvet-lined transport crates in June 2003, and the trans-action was finalized seven months later. One thing Griebert evidently did not do, according to Andrew Baker, is actually transfer the revenue from the pictures back through the Schönart Foundation, which presumably would have been to the benefit of the Liechtenstein managers. In several interviews with the author, Baker spoke critically of Griebert, using word-ing such as "opaque" and "untrustworthy."[70]

When I visited the German Historical Museum in the summer of 2017 and inspected the curatorial file, I shared what I knew with curator Sabine Beneke, who in turn organized (or perhaps was already organizing) an ex-hibition on the history of the two pictures. The end product was titled *Connoisseurship and Art Plundering: Max J. Friedländer, Bruno Lohse and the Kaiser Pictures of Albrecht Dürer.* This "intervention" aimed to offer a trans-parent account of the new revelations about the history of the pictures.[71] Never mind the misleading title (the *Kaiserbilder* were not actually plun-dered), the exhibition elicited largely positive reviews in the press, with the critic for the *Berliner Morgenpost* writing, "A *Krimi* [whodunit], complex and difficult—and as an exhibition, unfortunately quite difficult to por-tray. Despite this, it is worth the attempt. Absolutely worth telling!"[72] At a minimum, the case of the *Kaiserbilder* showed in detail that Lohse sold works to a major museum.[73]

The exhibition included two other documents that I had not seen in my visit to the museum the previous summer: the first was a report by Hubert Falkner von Sonnenburg (1928–2004) about his inspection of the Dürer pictures in Munich in August 1968. Sonnenburg was both a cura-tor and a restorer who had previously worked as a conservation expert at the Bavarian State Painting Collections and at the world-famous Doer-ner Institute in Munich. In other words, von Sonnenburg was part of the Munich art scene; he returned in 1991 to serve as general director of the Bavarian State Painting Collections—the top museum post in the prov-ince. Back in 1968, when he inspected the pictures, he was working as a curator in the paintings conservation department at the Metropolitan Museum of Art.[74] Again, one sees Lohse interacting with elites in the "re-spectable" art world, even if the Met did not go so far as to purchase the work. Sonnenburg's report also shows that Lohse was able to transport the work from Switzerland to Munich for the purposes of the inspection—an undertaking that evidently did not attract the attention of either Swiss or German customs authorities. Later, I was to learn that Lohse and Hubert Falkner von Sonnenburg were good friends: Lohse visited him when he

was working in New York, and they saw one another during von Sonnen-burg's Munich engagements.

The second document featured in the small exhibition of the German Historical Museum that I found striking was a contract between Frédéric Schöni and the Wildenstein Gallery in New York dating from November 1968. This document showed that Schöni had placed the Dürer pictures on consignment with the Wildenstein Gallery, located on 64th Street near Madison Avenue. Frédéric Schöni was the Swiss lawyer who created a Liechtenstein-based foundation for Lohse and who helped conceal Lohse's pictures and financial assets. He was also an attorney for the Wildensteins. Schöni also reportedly worked for Hans Wendland, who stood out as one of the most prominent dealers of looted artwork during the war.[75] Regardless, the Dürer pictures, then, showed the link between Lohse and the Wildensteins, with Schöni as the intermediary. Lohse owned the two paintings, and he and Schöni turned to the Wildensteins to sell them for him. The Schöni-Wildenstein contract was in French, which may have helped conceal the connection to a German art plunderer. And it is possible that Schöni concealed Lohse's identity—that the Wildensteins did not know they were dealing with Lohse. But that seems unlikely. Rousseau, von Sonnenburg, and their colleagues at the Met knew well enough to stay away.

Another perspective on the *Kaiserbilder* and Lohse in 1968 has been offered by Gerda Panofsky, the wife and collaborator of Erwin Panofsky (1892–1968)—the great German Jewish émigré professor of art history at Princeton.[76] Erwin Panofsky ("EP" or "Pan," as he was often called) was one of the titans of art history, known for his pathbreaking studies of symbols and iconography, among other works. More specifically, Panofsky was an expert on Albrecht Dürer, the subject of his doctoral dissertation, and in one of his scholarly publications from 1943, Panofsky included the notation: "A partial copy [of the real *Kaiserbilder*] spuriously dated 1514—in the trade."[77] For Lohse, the attribution made by Panofsky cast a shadow over his pictures, so he came to the United States to attempt to remedy the situation. But Erwin Panofsky died on 14 March 1968, and therefore it was too late to induce him to change his mind or clarify his finding.

Lohse nonetheless turned to Panofsky's widow, Gerda, whom he located in Princeton. She relates that Lohse wrote her a letter in May 1968 asking to visit her together with Met curator Hubert von Sonnenburg. Lohse even included a letter of introduction written by her former teacher back in Germany, Professor Werner Gross. Gerda Panofsky agreed to see

them, and Lohse and von Sonnenburg traveled to her home on 30 May 1968. There was a follow-up encounter ("unannounced, seemingly coincidental" she reported) on 28 September 1968.[78] They claimed to be just passing through the neighborhood, which she found unconvincing. The purpose of their trip was to ask her to sign a statement testifying that Erwin Panofsky never saw the original "Swiss Kaiser portraits," as they called Lohse's renditions, and they wanted her to attest that her late husband had confused them with eighteenth-century Habsburg (*Rudolfinischen*) copies in the Kunsthistorisches Museum in Vienna. Gerda Panofsky recalled that "Lohse pushed me to sign the 'statement' and that he finally volunteered that she could send it to him at his luxury hotel [*Luxushotel*] on Central Park in New York."[79]

Gerda Panofsky responded on the 3rd of October by writing Lohse and demanding that she not be cited in connection with this matter. She had consulted with colleagues who had contacts in Munich to try to learn more about Lohse. She recounted, "I made inquiries and learned that Lohse was not only an art historian (as he had introduced himself) but also an art dealer, primarily on the Swiss market."[80] The former director of the Lenbachhaus in Munich, Professor Hans K. Röthel, who also had settled in Princeton, then told her about Lohse's connection to the ERR. A bit later, another friend of hers, Franz Graf Wolff-Metternich, who had been an army *Kunstschutz* officer in France during the war and had interacted with Lohse, simply told her: "My advice is as follows: avoid signing any declaration and don't give in to any of his wishes."[81]

Gerda Panofsky subsequently found more evidence that her husband had regarded these pictures as not being by the hand of Dürer and that Pan probably had seen them in the original, but Lohse had moved on. His friend and ally Heinrich Theodor Musper (1895–1976), the former director of the Württembergischen Staatsgalerie in Stuttgart, published a short (sixty-four pages) book on Dürer's *Kaiserbilder* (dedicated: "In Memoriam Max J. Friedländer") in which Musper highlighted the venerable art historian as a believer in the theory that Dürer himself painted a significant portion of the pictures.[82] As Gerda Panofsky noted, "Their trump card was the *Expertise* [report] of Max J. Friedländer (1867–1958), who inspected the panels in question and considered them authentic masterpieces of Dürer."[83] It's not clear that this tactic of trumpeting Friedländer and trying to ignore Panofsky really worked. The two pictures did not sell in the late 1960s or early 1970s and evidently were returned to a concealed location in Switzerland. Erwin Panofsky's doubts likely played a role in

the pictures going underground. But what is also so striking about the episode—and helps us paint a picture of Lohse at this time—is that Lohse had such well-connected allies as von Sonnenburg and Musper.

In an April 1970 letter that was found in Lohse's papers upon his death in 2007, Heinrich Theodor Musper wrote Lohse about Jacob Rosenberg, who was making a "confidential" visit to Germany. Rosenberg had been a curator of prints and drawings at the Berlin-State Museums before emigrating to the United States and taking up a position at Harvard University. He was also a disciple of Max Friedländer, the venerable art historian who "discovered" the *Kaiserbilder*. Regardless, or unsurprisingly, according to Musper, Rosenberg "believe[d] thoroughly in the work being by [Dürer's] own hand and even said, 'I am really enthusiastic.'"[84] Musper then encouraged Lohse to request a meeting with Jacob Rosenberg in Cambridge when Lohse traveled to New York the following week. Musper also encouraged Lohse to "bury the hatchet" (*Kriegsbeil begraben*) with Ludwig Grote, an authority on Dürer and the director of the Germanic National Museum in Nuremberg, which had another, larger, version of the *Kaiserbilder*. No record exists as to whether Lohse met with either Jacob Rosenberg or Ludwig Grote, but the fact that Lohse was consorting with museum directors and distinguished art historians was significant. For Lohse, having high-quality works, even disputed ones, brought with it a lifestyle: social connections, meetings, and a suite in a Central Park hotel.

Lohse was initially thwarted in his efforts to sell the *Kaiserbilder*, but he found a way to retreat and preserve his assets (his Zurich bank vault). One can say that Lohse played the long game. He waited another generation before he undertook to sell the pictures again in the early 2000s. Did the German Historical Museum know about Panofsky and the doubters of the works when it acquired them? Yes, absolutely, and the documentation is collected in the curatorial and object files at the museum. But by the early 2000s, the impact of Panofsky's opinion seemed to have faded. New information had superseded his work from the 1940s. Utilizing Griebert, Lohse found a way to off-load the works, even if they brought considerably less than he had hoped.

CHAPTER EIGHT

Restitution

AMILLE PISSARRO PAINTED *Le Quai Malaquais et l'Institut*
(known as the "Fischer Pissarro") as the final work in a series
of now iconic cityscapes of Paris.[1] In 1903, the artist was living
on the third floor of the Hôtel du Quai Voltaire on the Left
Bank of the Seine, with a view of the dome of the Institut de France and
the Pont-Royal, among other notable landmarks. He painted the picture
looking out the window of the room in which he died a short time later.
Pissarro, a Jewish artist, painted the picture in the midst of the "Dreyfus
Affair," a scandal about a spy among the French General Staff that riveted
the nation and gave rise to acute anti-Semitism. Captain Alfred Dreyfus
was an Alsatian Jew who was falsely accused of spying for the Germans.
Pissarro himself believed that he (Pissarro) looked stereotypically Jewish,
with a pronounced nose, and he feared for his life on the streets of Paris.
He therefore opted to paint from the safer spaces provided by the upper
floors of various Paris buildings, including the Grand Hôtel du Louvre,
which looked out on rue Saint Honoré, and the apartment he rented over-
looking the Seine. Despite the trying circumstances, the French capital
had afforded him the opportunity to work and flourish, and it served as an
aesthetically rich subject of his art. Art dealer Walter Feilchenfeldt noted,
"Inspired by the emerging spring season in April and May, these works are
filled with a sense of hope, of renewal, of new leaves and new life."[2] But
there is also a sadness, a pathos to these cityscapes. *Le Quai Malaquais* is a
reflection of the polarized, anti-Semitic atmosphere of the times, and as

one the last pictures that Pissarro created, it is a poignant work on many levels.

The Fischer Pissarro is also in many respects a Jewish picture. After the artist's death his son, Paul Émile Pissarro, who was also a painter, inherited it. To say that the younger Pissarro was not as successful as his father would be an understatement, and Paul Émile turned to family friends, the Cassirers, to sell the work. The Cassirers constituted one of the great cultural families of Germany, with a famous publisher (Bruno), art dealer (Paul), and philosopher (Ernst) among their ranks. They were prominent, assimilated Jews, a kind of role model for those who believed in a progressive Germany. In 1907, Paul Cassirer sold the painting to Samuel Fischer, head of the eponymous publishing house Fischer Verlag, which published Sigmund Freud and Thomas Mann, among other prominent authors. Samuel Fischer was also Jewish and a visible member of the European intellectual elite. The painting remained in the possession of the Fischer family from one generation to the next, continuing on to daughter Brigitte ("Tutti") and her husband, Gottfried Bermann Fischer, who took over the publishing house when Samuel Fischer died in 1934. Paintings become associated with owners, especially when they are passed down across generations. They assume additional emotional significance because family members live in close proximity to the works.[3] They often have Proustian qualities, associated with memories and identity. In short, this painting was part of the patrimony of a prominent Jewish German family that lived in Berlin until 1936. When pressure from the Nazis made life increasingly untenable, the Fischers moved to Vienna, where they established a home at Wattmanngasse 11.

Gottfried Bermann Fischer followed political events closely, including the crisis that culminated in the *Anschluss* in the spring of 1938. Indeed, he had shown savvy in his ability to export most of his stock of books from Germany several years earlier, including works by banned Jewish authors.[4] His acumen served him well in March 1938: Bermann Fischer and his family fled the country the night before the Germans rolled into Austria on 11 March 1938, catching a train headed to Rapallo, Italy. They left the Pissarro in their Vienna home at Wattmanngasse 11 in the XIII district, and the picture, as well as the remainder of the property in the house, was seized by the Gestapo as "heirless." Gottfried Bermann Fischer's daughter Gisela (1929–2014) was eight years old at the time, mature enough to remember the frightening outbursts of anti-Semitism. The violence in Vienna exceeded even the Nazi leaders' expectations. Indeed, the Berlin

authorities had to step in to restrain indigenous Austrian Nazis, who were "Aryanizing" property all over the city. Over twenty-five thousand residences in Vienna were expropriated in what the Nazis called "wild Aryanizations": that is, unauthorized seizures. Austrian Nazis often walked into Jews' homes and businesses and forcibly evicted the owners, physically throwing people out into the streets. Gottfried Bermann Fischer subsequently wrote about his experiences on several occasions, including the 1967 book, *Bedroht—Bewahrt (Threatened and Saved)*.[5]

The Fischers fled Vienna before the Nazis broke down their door. Gottfried and Brigitte Bermann Fischer and their children Annette and Gisela (another daughter had died in a car accident) kept on the move, traveling from Italy to Czechoslovakia to Sweden to the Soviet Union, and then to Japan, ultimately ending up in Connecticut.[6] Gisela Bermann Fischer, bright and ambitious, grew up in suburban New England but returned to Europe after the war, settling in Zurich in the 1950s. She came to feel at home in both the United States and Switzerland. Endowed with considerable charisma, she pursued a career as an actress. Zurich had a thriving municipal theater then, with world-class talent, including Friedrich Dürrenmatt (1921–90), one of Switzerland's greatest dramatists. Dürrenmatt and Gisela Fischer were friends, connected through theater. Gisela had some success in Hollywood, performing alongside Paul Newman in the 1966 Alfred Hitchcock film *Torn Curtain*, in which she played a character named Dr. Koska (ironically, also the name of an art dealer who once had worked for Joseph Goebbels). Despite the strong cast, which included Julie Andrews, the Cold War thriller was not critically well received and Gisela Fischer's career never ascended to the point of stardom.[7] She married and became a child psychologist, a profession she continued to practice in Zurich well into her seventies.

Back in 1938, the Fischer Pissarro had been seized by the Gestapo and "processed" by officials in the Finance Office—a Reich (central government) agency. The Nazi authorities liquidated fungible assets, and in the case of valuable artworks, this was accomplished via the state auction house, the Dorotheum. The Pissarro was sold on 21 May 1940 as object number 339. The work was purchased by Viennese art dealer Eugen Primavesi, who had a gallery in the fashionable Kärntner Ring. Peter Griebert told me that the painting was not offered as a Camille Pissarro but as one by Paul Émile Pissarro (1884–1972), the master's fifth and youngest son, and this was borne out by the extant auction catalogue, which listed a work by Paul Émile Pissarro titled *Paris Boulevard*, dated 1902 and estimated at

RM 1,200.[8] Whether this error was intentional is impossible to determine, but it is quite possible the attribution was a financially motivated ploy. An expert at the Dorotheum—perhaps with the knowledge of the Finance Office agent—may have listed the painting as a work by the lesser artist, knowing that it would bring a lower price. A partner of his would then purchase this "Paul Émile" for far less than a "Camille." The painting was then apparently "flipped." There were reports that it went to Hans Lange (1904–45), the proprietor of a well-known Berlin auction house; although after the war, Lange denied having ever received the work.[9] In all likelihood, someone (most likely Hans Lange) made a handsome profit. A comparable Pissarro Paris cityscape that also passed through the hands of the Cassirers and was relinquished under duress in 1939 sold for RM 95,000 at the Hans Lange auction house in 1943. (It has also been the subject of restitution proceedings.)[10] Works by Pissarro, despite the fact that he was Jewish, continued to command high prices throughout the Third Reich. With regard to the Fischer Pissarro, the Hans Lange sale was the last time the painting was seen in public until 1984.

Gottfried Bermann Fischer searched for the painting after the war. He advertised in art magazines with notices that he was looking for this work, as well as several other paintings: by El Greco, Paul Gauguin, and Lovis Corinth.[11] He also printed a leaflet featuring photos of the missing paintings that he circulated to various European museums. Gisela Fischer tells the story of an experience that one could imagine influencing her subsequent thinking. A dealer friend reported to her father that he had found the picture; when the dealer asked what Bermann Fischer was prepared to pay to recover it, Bermann Fischer reportedly replied, "Nothing. It's my picture and should be restituted to me without charge." The dealer called Bermann Fischer back a few days later and reported that he had made a mistake, that it was the wrong picture. The archival record indicates that the dealer was, in fact, Adolf Wüster: the Nazi plunderer for the German embassy in Paris during the war and a contact of Lohse's who lived in Munich in the postwar period. A 25 March 1950 letter from Wüster to Brigitte Bermann Fischer, then staying at a hotel in Bad Homburg, offered an apology regarding a false alarm about the Fischer Pissarro: "Four almost identical pictures by Pissarro on hand have these minor variations that therefore can lead to an error."[12] Hugo Perls, a famed German Jewish dealer who had emigrated to the United States before the war, also heard that the picture had been found and contacted the Bermann Fischers to see if they were willing to sell the paintings. This prompted a report from

Monuments officer Thomas Howe to Ardelia Hall at the U.S. Department of State in February 1951: "Now it seems more than likely that Perls merely know[s] where the picture is—but that the location may not be New York, but perhaps may be Paris. So, I think the only thing we can do is have the Customs people on the lookout for it."[13] And so the Fischer family searched—intensifying efforts in the late 1990s when art restitution reemerged as a topic of importance in the international community.

I first met Gisela Bermann Fischer in October 2000 when I was on sabbatical in Munich and she was in town taking care of some business. At the same time, I met Sarah Jackson, the historic claims director of the London-based Art Loss Register (ALR). The ALR has compiled a database of stolen artworks. Not only has the organization helped auction houses vet lots, it has undertaken active research into the fate of artworks. Sarah was an art sleuth, and she was working with Frau Fischer—as we called her—to locate the Pissarro. They had an understanding to promptly exchange any information they gained with one another, but no legal agreement about the ALR's compensation should the picture be found. Sarah and Frau Fischer searched for the picture in a partnership that lasted at least six years.

Earlier in the year, in February 2000, my interviews with Lohse had been featured in an article in *ARTnews* magazine, part of an effort to publicize my book *Faustian Bargain*. Sarah saw the piece and contacted me shortly thereafter (we had met at the Washington Conference back in 1998). She believed that Lohse had something to do with the Fischer Pissarro. Would I be willing to ask him about the picture? I said yes, but we decided to wait to talk in person before I questioned him. Sarah Jackson had come to Munich to meet with Gisela Fischer and invited me to tea at the Hotel Vierjahreszeiten, an elegant address on the Maximilian Strasse. Tea turned into dinner, and a very pleasant evening ensued. I found Frau Fischer charming and learned more intriguing details about the case. For example, they had documents showing that the picture had been exhibited in Lausanne in 1984, the lender listed as "Fondation Bruno." Did Lohse control that foundation? After this meeting, I committed myself to pursuing the Fischer Pissarro. Indeed, I promised Gisela Bermann Fischer that I would let her know if I found out anything about the picture.

I went to see Lohse the following week at his Laplace Strasse apartment. Peter Griebert was there, as usual, serving as both host (bringing in coffee and such) and as a participant in the discussion. As mentioned earlier, I liked having him there because he would often amplify

my questions (and ask them without an American accent). Both Peter and I queried Lohse repeatedly about the Pissarro. On one occasion, Lohse offered that he had seen the painting, but (not unexpectedly), he could not say where. Was it his? No. Did he once have it? No. Did he know anything about a Fondation Bruno? No. Lohse was not helpful when questioning involved matters in which he himself was complicit. Indeed, he actively obfuscated.

I reported this information back to Sarah Jackson and moved on to other projects. Sarah and Frau Fischer, as I learned later, continued to work assiduously on the project. They compiled a binder with hundreds of pages of documents. Sarah subsequently communicated to me, in the spring of 2006, that there was new evidence linking Lohse to the picture. Frau Fischer had a lawyer in Munich (Norbert Kückelmann) who was preparing charges against the aging art plunderer. Sarah still wanted my help, and I figured the most helpful step would be to ask Peter Griebert for his advice. I was in Munich in May and visited him. Sarah said I could tell him about the most recent developments regarding the picture, but he was already well informed. In the course of our discussion, Peter told me he was aware of Kückelmann's threatening letters to Lohse. But he agreed to renew the effort to learn more about the Fischer Pissarro. Peter confided that he thought there was something to the allegations—and that Bruno was not telling the truth.

In late fall 2006, Peter contacted me to say that he had made progress with regard to the painting. When would I next be in Munich? I didn't know. I usually visited in the summer and I was very busy at the time. The following week I delivered a series of lectures in New York and Connecticut and also attended Christie's auction of Klimt paintings. I had written an expert report for the plaintiffs, the Altmann family—commissioned by their counsel, E. Randol ("Randy") Schoenberg. That was a memorable evening: the greatest sale in art auction history. Well over half of the $491 million in sales that night involved objects that had been looted by the Nazis and then restituted. The numbers were dazzling. Four Klimts sold that evening for $192 million (the fifth, the *Goldene Adele*, had gone to Ronald Lauder and the Neue Galerie for $135 million)—for a combined $327 million.[14] Sitting a couple of seats away from Randy Schoenberg at the Christie's auction, I could see that he had a smile on his face—although he also appeared a bit stunned.[15] The Altmann family watched the auction together in a skybox at the Rockefeller Plaza facility, but I had an opportunity to congratulate them too, and Maria Altmann in particular. She,

besides being the only surviving direct heir of her uncle Ferdinand Bloch-Bauer, was a singular and inspiring person, as portrayed rather brilliantly by Helen Mirren in the 2015 film *Woman in Gold*.[16]

Sarah Jackson had traveled to New York for Christie's sale of 6 November 2006, and we met at several of the receptions and special events held by the auction house. We talked about Frau Fischer and potential developments in Munich. We decided it was best that we report to Frau Fischer only after my meeting with Griebert. We did not know what Peter was going to show me, but it looked promising enough for the ALR to offer to hire me as a consultant and for me to travel to Munich to follow this lead. I arrived in Munich in December and met Peter for dinner at my favorite restaurant in town, the Spatenhaus, which had the same view of the Bavarian National Theater that Hitler had painted some ninety years earlier. Peter proceeded to tell me that he had found a 1957 letter from Lohse to a Swiss collector. The letter documented that "the painting by Pissarro, formerly in the Fisher [*sic*] collection," as it was called, had sold for $10,000, and that Lohse would receive a commission of $1,500.[17] I strained to remember the names and figures so that I could record them on my computer later that evening in my hotel room. Before I left, Peter showed me a copy of the letter, but I was not able to keep it. I noticed that the letter referred to a "Fisher" (not "Fischer" with a "c") Pissarro, but I presumed this was a typo and didn't dwell on it. I was more interested in obtaining a copy of the letter, which I did about six weeks later on the subsequent trip in January 2007. As I reread it, the document appeared to show that the Fischer Pissarro had been purchased by Dr. Frédéric Schöni some fifty years earlier.

Who was this Schöni, and what kind of deal was Peter proposing? I had never heard the name—or not that I could remember—but Peter provided me with more information. Frédéric ("Fritz") Schöni was an attorney in Zurich who sometimes helped Bruno with deals. Peter had gone further in researching Schöni; Peter recounted how he had traveled to Switzerland on several occasions and, using his connections in the art world, determined that Schöni had died in 1981. Furthermore, Peter said he had discovered that Schöni had created a foundation based in Liechtenstein that held his assets, including his art collection, and that this unnamed foundation was now controlled by his heirs. The word he used *Erbengemeinschaft* (community of heirs), but he also talked about Schöni's children and I had the distinct impression that it was the lawyer's offspring who comprised this "community." Peter related that the Fischer Pissarro

was indeed part of the assets controlled by the mysterious foundation and that he had established contact with its representatives. The good news, he said, was that they appeared willing to discuss the matter of restitution and that they would permit me to inspect the painting in the near future. The "bad" news, he said, was that he had sworn to keep the identity of Schöni's heirs confidential, as well as the name of the foundation. It was a *Berufsgeheimnis* (secret of the profession)—secrets, or proprietary information, he claimed, constituted a fundamental part of the art trade. He communicated one other key item of information: for his efforts, Peter said he wanted 10 percent of the "market value" of the picture. He portrayed this as a customary fee in the art trade, explaining that he thought of himself as "Mr. 10 Percent." This was his commission when he bought works for clients, sold works, or brokered deals. And indeed, going back a century, as historian Cynthia Saltzman has noted, 10 percent was the amount "dealers customarily made even for buying a picture at auction."[18] Peter instructed me to communicate these conditions to the ALR, to Frau Fischer, and to any others involved in the settlement.

In the weeks that followed, Peter Griebert contacted the foundation to see whether it would permit us to inspect the painting. The representatives of the still unnamed foundation said yes, and in mid-January I was given the specifics. The viewing would occur in Zurich during the week of 23 January 2007. The precise time and place were to be specified later. I therefore went to Switzerland, departing Los Angeles for Zurich on 22 January 2007. Who knew what I would find? Would it even be the right picture? Well, I followed Peter Griebert's instructions, hoping for the best. I was to meet Griebert at a café and we were to proceed from there. I met Peter just before 11 a.m. at the Café Sprüngli—a landmark confectioner on the Bahnhofstrasse. I set off early for the meeting, noticing the preponderance of banks and jewelry shops, and realizing that below the street I was walking on were vaults with hidden assets. Peter arrived on time and greeted me eagerly. There was no time for *Kaffee und Kuchen*. The painting was waiting. We went less than half a block along the Bahnhofstrasse to the Zurich Cantonal Bank. Taking an escalator down a couple of floors, we made our way through various doors and into a reception area with corridors jutting out to vaults and banks of safe-deposit boxes. A wall of steel was visible in the distance, but there was wood paneling in the reception and in the conference room that had been set aside for us. It was just Peter and me—and the Pissarro—in the room. The painting was leaning on a table up against the wall. The lighting was poor.

Peter moved the picture onto a desk chair, which served as a kind of easel, and we began our examination. No holes or abrasions. Clean—just a bit of dirty varnish in part of the sky. It was in outstanding condition and much more luminescent than anticipated. As far as we could tell, it had miraculously survived two world wars and the Holocaust. The $2 million estimate that we had both heard from a representative of Christie's in Germany went out the window. One would now be looking at $3 million—or more. I had brought photocopies of the Pissarro catalogue raisonné and compared the information contained there with that provided by the picture itself. I checked the dimensions and they matched. I looked at stamps on the back of the picture. Yes, the exhibition in Lausanne in 1984 was referenced in both the catalogue and by a label on the back, although there was no mention of a "Fondation Bruno." There was enough information to confirm that this was a work by Camille Pissarro, not Paul Émile Pissarro: this was indeed the Fischer Pissarro. We spent about two hours inspecting the painting and as we left, Peter spoke with an employee of the bank. He said that the "president of the foundation" (indicating by the German form of "president" that it was a woman) had delivered the painting earlier in the day and that she would return later—after a dentist's appointment—to collect it. Because the conference room had been rented for the day, he would leave it there until she picked it up.

Frau Fischer invited us to dinner, selecting one of Zurich's most fashionable restaurants. The Kronenhalle, housed in an exquisite old building, features museum-quality art, including classic modernist works by Picasso, Klee, and Giacometti (the last designed the lamps and tables in the restaurant). Because we had called so late for a reservation (6:30), they could not accommodate us with Frau Fischer's customary table—one, she said, that she had inherited from author Friedrich Dürrenmatt, as they had often dined there together. We were nonetheless afforded an excellent place at the center of the restaurant. At the next table over was the former president of the Swiss Art Trade Association Walter Feilchenfeldt, and his family. Feilchenfeldt knew all three of us independently: Frau Fischer since childhood, Peter through the art trade, and me through conferences on art looting (we were in Vilnius together in 2000). As we sat there not ten feet from him, I wondered to myself what he thought the three of us were doing there together. I believe it was secretly comforting to each of us that we all three knew him in our own ways. Feilchenfeldt's recognition stroked our egos while it affirmed that the others also had standing in the art world. Later on, I came to realize that Frau Fischer had arranged for

him to be there. She decided it was best to have a knowledgeable old friend nearby, and Feilchenfeldt obliged.[19]

The mood at dinner was upbeat. Frau Fischer ordered champagne and we toasted our joint venture. We covered a range of topics, telling stories about ourselves, but also discussing the painting. Amid this good fellowship, Peter affirmed to Frau Fischer that he was heading off to Liechtenstein first thing in the morning to see the representatives of the foundation, whose name I still did not know. We were all discussing plans for the following day and our hopes to expedite the restitution. Neither Peter nor I was suspicious of Frau Fischer's reliability. At the end of the evening, as snow began to fall, Frau Fischer and I agreed to meet the next day. She would collect me in front of the hotel Baur au Lac on Lake Zurich.

Frau Fischer and I met as planned the following day at the Baur au Lac and headed to the Zurich Kunsthaus, where we spent several hours, mostly with the Ferdinand Hodlers and other works by Swiss artists. We did not talk about the Pissarro in public: we spoke of other artists, ourselves, what have you—but not the painting. Then she invited me to her home, a smart and spacious apartment in a fashionable quarter near the city center. As we drank our tea, we talked about the picture. She said to me at one point, "Can you imagine hanging a Pissarro in this modest apartment? Of course I will sell it."[20] She was clear that the recovery of the picture was of the utmost importance to her on an emotional level, but nonetheless she planned to monetize it. She also stated again that she was the sole heir, and would pay 10 percent of the market value of the picture to Peter Griebert and 8 percent to me. I would work on a contingency basis.[21]

While my January 2007 trip to Zurich gave me a clearer picture of Dr. Frédéric Schöni, there was a lot to process and many questions that remained unanswered. Peter informed me that Schöni had worked for the Wildenstein family. That was quite a revelation. A Swiss attorney who worked for the Wildensteins doing business with a Nazi art plunderer and buying a looted object? Whether Schöni knew it was stolen is not entirely clear. But Schöni identified it as "the Fisher [*sic*] Pissarro" in his July 1957 letter to Lohse.[22] Again, this was presumably an unintentional misspelling. It is not known what Schöni knew about the famous Jewish publishing family, but in working for his various clients, Schöni had become savvy about Nazi-looted art and most likely would have been aware of the work's problematic provenance. The Fischers had drawn attention to the missing picture after the war with a relatively sophisticated public relations campaign that included sending notices to prominent art dealers and to the

U.S. State Department. Nonetheless, it is difficult to prove that Schöni knew it was looted, although some of those in Liechtenstein who knew him believed that he had such knowledge.[23]

There are also doubts as to whether Lohse knew the work's true provenance: filmmaker and journalist Maurice Philip Remy suggested that the incorrect spelling of the Fischer name ("Fisher") would have made it difficult for Lohse to ascertain its earlier owners.[24] Again, this seems unlikely, and Lohse's concealment of the work for five decades in a Swiss bank vault challenges Remy's hypothesis. Another clue may have been the price: when I told the story to former director of the Met Tom Hoving over lunch in 2008, he opined that at the time the Pissarro should have gone for about $35,000, although he qualified the estimate by saying it depended on the condition of the painting.[25] But he was clear in stating that $10,000 appeared artificially low, and for Hoving, that set off alarm bells. And then there is the possibility (or even likelihood) that Lohse acquired the work from Adolf Wüster, who, as noted earlier, approached the Fischer family in 1950 with what appeared to be the picture.[26] If the work was offered by Wüster, a former plunderer for von Ribbentrop in France who was part of the postwar Munich network, that in itself would have constituted a red flag for Lohse. The fact that Gottfried Bermann Fischer had widely advertised his claim for the missing picture in the immediate postwar period, and that other family members had taken up the search, meant that Lohse at some point knew the picture was looted. Whether he was cognizant of this in 1957 when the deal went down remains unclear, but it is highly likely.

In the case of the Fischer Pissarro, progress toward restitution had stalled in February 2007 amid a fee conflict between Frau Fischer on the one side and Peter Griebert and myself on the other. Frau Fischer and her lawyer had written Griebert after our meeting in Zurich and demanded that he reveal all he knew about the Pissarro—without any payment—or else they would charge him with criminal extortion.[27] Griebert was shocked—he had believed a fair deal was in place (and for him, he said, a handshake was binding). I agreed with him that Frau Fischer had violated our verbal agreement, and her threat to initiate criminal charges had a deeply chilling effect. I consulted with my lawyer (as I did throughout this process), who assured me that I was doing nothing wrong. At this point, we all knew that the painting existed and was last seen in the bank vault in Zurich, but only Griebert knew who currently possessed it. In other words, I was not withholding information about the possessor of the

picture because Griebert had not shared that information with me. Regardless, he emailed me and told me that he would just wait and see what happened. I relayed this information to my lawyer, who said it was fine if I did the same, although he said he thought Frau Fischer would eventually resume contact—she needed Griebert, who knew the location of the picture and the principals involved. I recall thinking that this episode was over as far as my involvement was concerned. But I was wrong. Several weeks later, Frau Fischer surprised me by telephoning me three mornings in a row at 7 a.m., pleading with me to take up the case once again. She had questions about Peter and the "foundation of the heirs." Would I go to Liechtenstein and meet with them to obtain the answers she needed? Again, I reiterated that I did not know the identity of the foundation, just that there was a relation to Frédéric Schöni, whose name I had given to her. However, I said I would ask Peter and see what was possible.

Peter Griebert answered my email quickly, telling me he would inquire with the foundation in Liechtenstein. His answer came the following day: I would be welcome to meet with its representatives and they would answer all of Frau Fischer's questions, but I could not reveal their identity. They were prepared to return the picture—with no fee—but they required anonymity. I called Frau Fischer the following morning and told her about their response. She replied that the condition of secrecy was fine: she didn't care who they were as long as she got her painting back. We agreed that I would secure a document answering her questions about Peter's payment and about the foundation's ability to convey good title.

I went back to Europe in mid-March 2007, hoping to interview Lohse once again before heading off to Liechtenstein. The trip occurred over my spring break at the college, and I planned to use the remaining time to head to Paris and Amsterdam to trace more of Lohse's career. Yet I learned several days before my departure that Lohse had taken ill and had been committed to a hospital. When I arrived in Munich on Friday evening and telephoned Peter, he said that Lohse was in intensive care. His voice revealed a deep concern, but nevertheless we went on to finalize our plans for a trip that would commence the following day: we were scheduled to head down to Liechtenstein to meet representatives of the "foundation of the heirs." Peter picked me up the following morning in his new BMW X-5 SUV and we left the Bavarian capital, heading southwest toward the Alps on a trip lasting about four hours.

Liechtenstein is among the smallest countries in Europe, a principality (*Fürstentum*) nestled between Switzerland and Austria that takes

up half a valley (the Rhine River, which bisects the valley, constitutes the western border). With only thirty-five thousand residents, it reportedly has more foundations than people. Walking down the street in 2007, one saw houses with multiple postboxes bearing the names of various corporate entities (that had changed by the time of my most recent visit in 2017). A provincial backwater for most of its history, Liechtenstein began to develop as an asset shelter during the war and in the early postwar period. The Americans had tried to halt this process in March 1945 by concluding the "Currie Agreement" with the Liechtenstein authorities and Swiss government (the former pledged it would "prevent the concealing, disposing of, or dissipation of assets of persons falling under the varying blocking decrees"), but such efforts were futile.[28] The tax laws became legendary (no capital gains or inheritance taxes), and the secrecy was so great that even the Swiss seemed envious.[29] And the scenery could scarcely be more sublime: snow-capped mountains rim the valley that constitutes the entire country. No one minds visiting his or her money here.

We rolled into the capital, Vaduz, around noon, and Peter showed me the main street. It appeared prosperous and orderly, which came as no surprise, and the royal castle on the hill added a distinct Old World elegance. Peter suggested that we head straight to the foundation offices, and I eagerly endorsed the idea. We made a turn off the main road and headed up the hill of the valley. I noticed that he navigated the winding streets like an expert, but this did not set off alarm bells. There is not too much to Vaduz or Liechtenstein as a whole. We arrived at a pleasant-looking residential building—a typical house of the region. It was modern, yet invoked the Austro-Bavarian chalet style. At the front door, I saw brass plaques and adjoining buzzers for several establishments. Peter pushed the one that read "Schönart" and a flash of recognition came over me. "Right—Schöni, Schönart," I thought. That made sense. I finally knew the name of the "foundation of the heirs."

The door to the house buzzed open and we entered. We were greeted by two individuals—attorneys representing the foundation. One, Andrew Baker, was British. He was polished, having attended Queens College at Cambridge University, and evidently skilled at the practice of offshore banking. The other, a younger man named Stefan Mätzler, was a local from Liechtenstein who deferred to his senior partner. As part of the preliminary small talk, they explained that it was the law in Liechtenstein that all foundations registered there include at least one citizen of the country. A few minutes later, Frau Milly Sele-Vogt, the so-called president of the

Schönart Anstalt (roughly, Schönart Foundation), arrived.[30] An elegant
woman in her seventies, Frau Sele, as she was known, explained that she
had once been a ski champion in Liechtenstein and had subsequently made
a living representing different foundations (prior to her death in 2017, she
had 108 businesses registered at her office address). She lived nearby, only
about two hundred feet from the house where we were meeting.[31] Frau
Sele and the two lawyers were very professional and pleasant. Speaking in
German (and Liechtenstein German over dinner), they affirmed that the
foundation would not seek compensation for the picture; that they wanted
Peter and me to handle the return; that this should formally take place in
Switzerland; that we were to maintain complete confidentiality as to their
identity; and that they were not paying us.

I was somewhat confused by their identity as Schönart was part of a
larger entity called the Miselva Etablissement, which had taken over the
Schönart Anstalt in 2003. I later came to understand that Miselva was
indeed very complicated. Controlled by Andrew Baker and his wife, a
Liechtenstein national (and niece of Milly Sele-Vogt), Miselva was part
of a larger business operation now known as Griffin Trust. So it goes in
Liechtenstein. The overriding point is that Andrew Baker helped clients
"minimize taxes and improve [the] efficiency of international compa-
nies."[32] Prior to moving to Liechtenstein in 1992, Baker had worked in the
Turks and Caicos Islands. He apparently utilized strategies that tested the
limits of legality, having been charged with fraud and tax evasion, although
he was never convicted. Miselva nonetheless had been embroiled in liti-
gation that involved damaging accusations. Lawyers for the Fisher Island
Community in Florida, which counted Oprah Winfrey and Andre Agassi
among the "rich and famous" residents, alleged in 2010 that Baker and Mi-
selva "stole their clients' assets."[33] The ensuing investigation alleged that
Baker had ties to Russian oligarchs (or at least their spouses) and helped
manage their assets. Miselva allegedly controlled some three hundred off-
shore companies and trusts in additional places, including the British Vir-
gin Islands, Gibraltar, and Cyprus; and Miselva later came up in connec-
tion with the Panama Papers that exposed a tax evasion scheme.[34] But of
course I did not know any of this at the time. This was my first meeting
with the Schönart representatives and I had no idea that the foundation
was part of such a complex organization with shady dealings. Subsequent
research confirmed that this was not unexpected: a *New York Times Maga-
zine* article on the concealment of assets—a $21 trillion international sys-

tem—detailed the mind-boggling complexity of many of these financial instruments.[35] Griffin Trust/Miselva/Schönart hardly count as unique.

Andrew Baker agreed to draft a document spelling out the key details: that the Schönart Anstalt controlled the artwork and was not paying us. It would be ready the next day. Baker and Mätzler would write it in English, the international business language, they said. They did not want German jurisdiction over this transaction. We agreed to meet the next day. And so concluded the official business on that first day in Vaduz. Ever the gentleman, Peter invited Frau Sele to join us for dinner. She accepted and we went to a local establishment where we dined on schnitzel and white wine. It was a pleasant evening.

Dinner with Milly Sele-Vogt and Peter Griebert that night also turned out to be memorable for the information it yielded—and the disinformation. Frau Sele told me that Frédéric Schöni had died in 1981 and that his wife had passed away in 2006. Schöni, Frau Sele said, was always pushing the limits of legality; she recalled how he smuggled cigars at war's end when there was a "currency based on cigarettes" (*Zigaretten-Währung*), and this put friends in jeopardy. She recounted that Schöni loved to fight and that he was not happy unless he was embroiled in a dispute. Frau Sele added that he was a "bastard to his wife."[36] She also talked about how the residents of Liechtenstein made their living from the abundance of foundations registered there. Indeed, as one walked along the street where her house was located, postbox after postbox featured the name of one or another foundation—often dozens at one address. In fact, 2007 was the peak year in terms of the number of such outfits in Liechtenstein; after an international effort to combat money laundering, the number of these foundations declined from 14,841 to 8,461 in 2016.[37] Recent visits to Vaduz show that the chorus of mailboxes before a house are a thing of the past— the internet also playing a role in this regard.

Despite the apparent candor of Frau Sele-Vogt and Peter Griebert that evening, there was one thing never mentioned: Bruno Lohse's relationship to the Schönart Foundation. Yes, we discussed how Lohse had sold the Pissarro to Frédéric Schöni in 1957, and how he had concealed that from me. But there was not a word about Lohse's continued relationship with Schöni or his ownership of the foundation. I learned much later from Andrew Baker that Frau Sele was also Frédéric Schöni's secretary, and that Lohse would pick up money from her in Vaduz on a regular basis. In other words, Schöni was also a kind of banker to Lohse. Later, when

Lohse grew too old to travel, Peter Griebert would pick up the money, and it became a tradition for him to bring Frau Sele Bavarian *Weisswürste*; in turn, she presented him with Liechtenstein sausages.[38] But they did not tell me of the "*Würste* exchange" that evening. Indeed, I learned nothing of Lohse's connection to Schöni or Schönart that night. Frau Sele played into Griebert's fiction: confirming that Schöni had died in the early 1980s, referencing his children, and leading me to believe that Schönart was an entity controlled by Schöni's heirs. Frau Sele even talked about the picture having been in the home of Schöni's daughter for these many years. Later I found the death announcement for Frédéric Schöni from October 1981, which said he was a husband, brother, brother-in-law, and uncle, but not a father.[39] I have never found any trace of Schöni's children.

Peter and I returned to the foundation's headquarters the following day and met with Andrew Baker and Stefan Mätzler. They handed us the document that spelled out the points we had discussed the day before. Dated 13 March 2007, it listed the full details of the Pissarro and then began, "I write with reference to our meetings and, as requested, hereby confirm that I am a solicitor of the Supreme Court of England & Wales and a director with sole signature right of a corporate vehicle that currently owns the above-mentioned painting (the 'Painting')." The document spelled out the arrangements for the return: "The Painting will be handed over in Zurich, Switzerland in your presence and before a notary in return for a signed receipt from Mrs. Braun-Fischer." It also specified the conditions that Frau Fischer provide "authentic documentary evidence that a) the Painting is indeed the one stolen by the Nazis; and b) Mrs. Braun-Fischer is the sole and rightful claimant to the Painting." This all seemed fine to Peter and me. I could provide proof of the first point, and surely she could show that she was the sole and rightful heir. The document was signed by Andrew Baker, but his signature was as good as illegible. There was no other indication of the true name of the foundation. To be sure their conditions of anonymity were met, Baker suggested that we make a photocopy of the document and cover the signature at the bottom so as not to give away this clue. That was acceptable to me. The most important thing, I thought, was that we were now in possession of a document that addressed all of Frau Fischer's concerns.

Prior to our departure from the Schönart office, Peter surprised me when he pulled a folder from his briefcase and placed it on the table before the foundation's attorneys. He stated that he had reason to believe that Schönart possessed two other paintings with questionable provenance and

wanted to ask about them. One was an 1879 Monet titled *View of Vétheuil in Winter*, and the other an 1883 Renoir, *La Baie du Moulin Huet à travers les Arbres—Guernsey*. He had an array of documents concerning both works: photocopies from catalogues raisonnés and exhibition catalogues, for the most part. Did the foundation possess these paintings? he asked. Baker and Mätzler stepped away to consult, returning after a short time to say yes, the Schönart Foundation had these works. Peter then requested a contract that would empower us to research and restitute the two works. He turned to me and asked if this was acceptable. Taken by surprise but perceiving no problems, I assented. Baker and Mätzler said they would draft an agreement. If Peter and I wanted to return after lunch, they would have it completed.

As Peter and I enjoyed our lunch, I examined the documents in his carefully organized folders. First, I noted that the Monet was listed in the Wildenstein catalogue raisonné for the artist, and that the provenance mentioned it had been exhibited by Daniel Wildenstein in an exhibition that traveled from Paris to Milan to Tokyo.[40] So it appeared that Daniel Wildenstein had been in possession of the picture in the not too distant past. I was also struck that the printed provenance for the Monet listed it as belonging to a "private collection, Switzerland."[41] Was this Lohse? I wondered. The entry also stated that the painting in an earlier era had been "on consignment with Cassirer, Berlin, and seized by the German government in 1914"; although there was nothing about its provenance during the Third Reich. Still, the fact that the picture had been with Cassirer—a Jewish art dealer persecuted by the Nazis—constituted a red flag and raised further questions. The catalogue entries for the Renoir landscape in Guernsey also stated that it came from a private collection in Switzerland. That said, there were no other "red flag" names in the provenance of either work. In the case of the Renoir, the provenance listed the dealer Durand-Ruel, a "Mr. Thompson" in New York, and a "M. Bellanger" in Paris—names that did not set off alarm bells. I was struck that both works were in the Lausanne exhibition catalogue from 1984 for the Fondation de l'Hermitage.[42] Hadn't that been one of the clues for the Fischer Pissarro? I thought, reflecting back to what had tipped off Sarah Jackson and Frau Fischer regarding the loan to the exhibition by a Fondation Bruno. I was not certain, but I had a sense that Peter was up to something. We returned to the Schönart offices, picked up our "authorization" for the Monet and the Renoir, and then bade farewell to Baker and Mätzler. We headed back to Munich later that afternoon.

On the way back from Liechtenstein, Peter and I stopped by the home of his old friend, an attorney named Willy Hermann Burger. Burger was well established in Munich society. His elegant home was filled with Bavarian antiques, ancient classical sculpture, and Asian porcelain. Burger had been chief counsel for the Bayerische Hypovereinsbank, and now the seventy-some-year-old attorney represented private clients—including a longtime acquaintance, Dr. Bruno Lohse. Peter said he would have engaged Burger to sort out the legal tangle surrounding the Pissarro if Burger hadn't already had Lohse as a client. Burger explained that he could not represent both men in case there was a conflict of interest, so Peter engaged a friend of Burger's named Erich Holzherr. Nonetheless, Burger and his wife welcomed us and offered us coffee as we talked about what had transpired in Liechtenstein and what I should say to Frau Fischer. Burger allowed me to continue believing that the Schönart Foundation belonged to Schöni's heirs. I realized later that he was clearly taking the measure of me to see what I had learned about his client: Lohse. Peter Griebert told me in 2016 that with the subsequent difficulties surrounding Lohse's estate, much of the burden fell on Burger. Dealing with inquiries from prosecutors in four countries plus victims and their representatives had basically killed him the year before, Griebert opined.[43]

Burger assured us that we were doing nothing illegal in holding to the 18 percent commission agreed upon in Zurich. He added other information that proved useful: notably, in late January—that is, just days after Peter and I had met Frau Fischer in Zurich—her lawyer, Norbert Kückelmann, had approached him at the Café Luitpold (a locale he frequented for afternoon *Kaffee und Kuchen*). Kückelmann offered Burger 22,000 euros if he could secure information from Bruno about the location of the Pissarro (conditional upon a successful return). Burger said he declined this offer, and it was his opinion that such conduct on Kückelmann's part was improper and could lead to disbarment. Willy Burger also advised that we do our utmost to keep Swiss law in effect. He discussed a provision in German law that provides a "finder's fee" of 4 percent. He did not think it applied in this case (it was meant for "ownerless" property), but did not want Frau Fischer and her attorneys to argue for German law and this provision. He therefore recommended that I meet alone with Frau Fischer. Two Americans in a foreign country—the meeting wouldn't do anything to affect legal jurisdiction.

Per our prior agreement, I had arranged to meet Frau Fischer the following day. We returned to the site of our first meeting in the fall of

2000—the Hotel Vierjahreszeiten. While the document I held made me optimistic about the state of affairs, I was also wary. After the betrayal of the verbal agreement from January and the ugly accusations directed at Peter (which included "criminal extortion"), I did not know what to expect. If Kückelmann also appeared, I thought to myself, I would leave immediately; if the police were there—well, I wasn't sure what I would do. I therefore arranged for one of my best friends, an American who happened to be in Munich at the time, to observe our meeting from a distance. I waited in the lobby of the hotel, and Frau Fischer arrived on time a few minutes later. We greeted each other cordially, and after a minute or so of small talk, she asked if I had the document. I replied yes and handed it to her. She read it carefully and said it looked fine. She then surprised me by saying, "But this is a copy: how do I know it is authentic?" I gave her my word that I had an authentic version signed by a representative of the foundation, and noted, "If it isn't real, then none of us will get anything." She appeared unconvinced but said, "I understand. You want your money." I replied, "Yes, Frau Fischer." I had been working on this case for seven years and had made three trips to Europe to find the painting, without compensation. When I referenced our verbal agreement back in Zurich, she responded evasively, "I'm not saying yes, and I'm not saying no." She needed to consult with her lawyers. I would hear from her soon.

I left Munich for Amsterdam, planning to spend a couple of days at the Netherlands State Institute for War Documentation (NIOD) researching Bruno Lohse's activities in Holland. I knew that the NIOD also had copies of the Göring-Hofer correspondence that would mention Lohse. While there, I learned that Lohse had suffered a serious episode in his Bogenhausen home, a collapse that verged on a stroke. It was an ordeal trying to get him out of his apartment on the third floor. Six foot four, the man now weighed more than three hundred pounds and he was deemed too heavy to carry down the narrow stairs of his building. Eventually a fire crew, using sheets as a kind of flexible stretcher, brought him out through a window with a hook and ladder truck.

At almost the exact same time, the part Lohse played in the interrogation and subsequent treatment of August Liebmann Mayer had become a topic of increasing interest. Back in 2005, Bavarian prosecutors explored filing charges for Lohse's role in the death of the art historian, whom he had interrogated in Monte Carlo in 1944. This would have been akin to the unmasking of Pieter Menten in the late 1970s, which led to the Dutch authorities sentencing the art dealer and murderer to a ten-year term;

Menten served two-thirds of the sentence before he died at age eighty-eight in 1987.[44] In other words, Lohse effectively faced the prospect of spending the rest of his life in prison. The German authorities had written him again in November 2006 demanding that he answer questions regarding Mayer. This had alarmed Lohse, who spewed invectives (those prosecutors can "lick my ass" and the like), but most of the time appeared genuinely concerned about what might transpire. Lohse did not respond to the prosecutors' inquiries, a tactic that helped him deflect the investigation for six months. But by March 2007, the German authorities started to apply additional pressure. They had been encouraged by Gisela Fischer and her attorneys, who were claiming that he possessed the "Fischer Pissarro." A judge ordered that Lohse face questioning by a state prosecutor (both with regard to August Liebmann Mayer and the Fischer Pissarro), but the order was set aside when Lohse entered the hospital. His lawyer Willy Burger arranged for a doctor at the Grosshadern Clinic to sign an affidavit stating that Lohse was in no condition to answer questions. Gisela Fischer and her team believed this was a ruse, a tactic to avoid answering questions. These suspicions were justified: Lohse had once checked himself into a hospital to avoid being interviewed on camera, after he had previously agreed to appear in the documentary film *Rape of Europa*. However, in this case, Lohse proved this allegation to be unfounded.

Bruno Lohse died on Monday, 19 March 2007, as I was flying back from Amsterdam to Southern California. I returned home to find an email from Peter Griebert bearing the news. While Lohse's passing was not surprising on a rational level—he was ninety-five and in poor health—it still came as a shock. I felt a measure of grief, but also self-consciously questioned myself about such feelings. Was it right to mourn an old Nazi? I reflected that he had helped me with my research, and conversation with him had opened up worlds into the past that I could not find in the archives. Indeed, we had established a kind of rapport. And then I thought about the timing of his death. I wondered whether his death would change anything regarding the Fischer Pissarro. His dying seemed to simplify matters in certain respects. Or so I thought.

In May 2007, I was contacted via email by Swiss journalist Leo Müller, who asked me if was I aware that Lohse had owned the Pissarro, and that the Schönart Foundation had belonged to him too. No, I thought to myself (and later wrote to him), I had not known. I responded to the questions as best I could. Another email went to Peter Griebert. Was there any truth to these assertions? Just when I thought it couldn't get any more

complicated, news came back from Peter that Lohse and Frédéric Schöni were indeed very close. Griebert would have to ask Frau Sele, the president of the Schönart Foundation, if there was any truth to the allegation that Schönart was Bruno's partner—either in full or in part. Shortly thereafter, Peter traveled to Vaduz to meet with Frau Sele. He reported back to me that Bruno had an interest in the Schönart Foundation; but more specific details were not available. Still, I thought to myself, this is astonishing: a lawyer working for the Wildensteins in Switzerland and a former Nazi art looter as partners?

Peter Griebert warned me that a document might surface showing that Lohse had empowered Peter and another person to enter the vault holding Lohse's art at the Zurich Cantonal Bank and to dispose of his property in Switzerland. Peter said that while Bruno had signed it, he, Peter, had not, and therefore it was not legally binding. I realized that this was a formality, a ruse, to give Peter some wiggle room if things became difficult. The document also may have been an instrument to enable Peter to take over the art after Lohse's death. Peter need only add his signature and he would control the property. Peter proved somewhat more convincing about his "innocence" when he pointed out that the document had been drafted in the early 1990s, when he was still a business associate of Lohse's. They had subsequently grown apart and Peter no longer expected to inherit the property from his old friend; perhaps a painting, he said—but one picture, not a major share of Lohse's estate.

Frau Fischer and her team appeared to have been right about Lohse's longtime control of the painting.[45] I was embarrassed that I had not figured it out myself—that I continued to believe in the ruse of the Schöni heirs and their foundation. While I helped apply pressure on Lohse to compel him to relinquish the picture, and I did my utmost to effect its return, I was still in the dark in many respects. This included not knowing where the painting was kept until Leo Müller contacted me after the police raid on Lohse's vault in Zurich after his death in March 2007.[46] I had no idea that the managers at Schönart had decided to keep the painting in the bank vault. Peter had engaged in some theater when we had left the Zurich Cantonal Bank in January 2007. He had told a clerk there that the president of the foundation would come by later in the day to pick it up and added convincing details that she had a dentist's appointment that might delay her. In fact, after we viewed the Pissarro in the conference room, it went straight back into Bruno's vault which, I was told later by Andrew Baker, was just downstairs from the conference room. Baker also

told me it was the largest vault he had ever seen, and a private one (as compared to the more communal ones with sliding racks for art).[47]

As it turned out, there were other works in Lohse's vault, including the Monet and Renoir paintings that I had learned about a few months earlier when I met with representatives of the foundation in Liechtenstein. Works by Oskar Kokoschka, Alfred Sisley, and two portraits attributed to Albrecht Dürer also had been there in Zurich Cantonal Bank's Safe Number 5—or at least they were listed on a 1997 property report—among fifteen works found in the lockup at the time of Lohse's death in 2007.[48] I would subsequently have many questions, including those stemming from press reports that stated Peter Griebert had access to the vault going back to the 1980s and that he had visited it on a number of occasions.[49] I also wondered about keeping so many extraordinary paintings in an environment that was not climate controlled. I knew that there are firms that specialize in art storage and take care to keep the works in suitable conditions. Officials at the Zurich Cantonal Bank now warn customers not to keep museum-quality art in their facility and offer a referral to the appropriate specialists, but perhaps there was less concern for such "niceties" among members of Lohse's generation—and compared to what artworks endured during the war, a dark, sturdy vault seemed completely suitable. This was the opinion of Walter Feilchenfeldt, who asserted that no one would think of climate issues when placing art in the vault of a major Swiss bank.[50] But keeping the Fischer Pissarro in this non-climate-controlled environment for over fifty years nonetheless may have constituted negligence on Lohse's part. That he prevented all but a select few from viewing the painting for over half a century (with the exception of the Hermitage Lausanne show in 1984) might also be construed as insensitivity to its qualities as a work of art. In certain regards, the picture was an asset, one of the wares of his trade. A Swiss bank vault therefore served his purposes.

The Swiss press reported that because the Schönart Anstalt had been owned by Lohse, his heirs—approximately fifteen of them—had claim to the paintings held by the foundation, including the Fischer Pissarro. For there to be a negotiated settlement for the picture, all fifteen heirs would have to sign off on the deal. This, as Peter noted, was unlikely to happen. Baker and Mätzler therefore had their hands tied. It appeared that they could not give the Pissarro back even if they wanted to. But they did manage to negotiate with the Fischer heirs and agree to relinquish 20 percent of the proceeds from the sale of the painting.

After resolving a dispute among the heirs, Christie's auctioned off the

Fischer Pissarro in New York in the sale of 3 November 2009 (lot 2). By now, the Great Recession had set in and the art market had crashed. It was a decidedly different atmosphere that evening in the grand auction hall at Rockefeller Center than it had been a few years earlier when four of the Klimt paintings from the Bloch-Bauer family had sold for between $31 million and $87 million each, or over $192 million together.[51] According to the Bavarian newspaper the *Münchner Merkur*, the Fischer Pissarro was once believed to be worth 8 million euros. Now it sold for $1.85 million (with fees and commissions, $2,154,500).[52] Even though Christie's had offered a cautious estimate of $1.5 million to $2.5 million, the result represented a "big disappointment" in the words of one heir. It was probably not only the financial crisis and drop in the art market that lowered the price, but the messy restitution process and emotionally charged litigation. The beneficiary was Richard Green, a dealer with a gallery on New Bond Street in London. Gisela Fischer, after compensating her co-heirs and paying her legal costs, "went away practically empty handed"—according to Gunnar Schnabel, one of her lawyers.[53] Schnabel added, "That's the tragedy of the story."[54]

When I was in London in 2010, I went to Mayfair to visit the picture at the Richard Green Gallery and saw that it was offered at 2.5 million pounds. I could not help but pause and reflect. There were few winners here, perhaps only the Richard Green Gallery. Norbert Kückelmann even sued Gisela Fischer for nonpayment of his fees in 2012 and won some damages.[55] An article in Munich's *Süddeutsche Zeitung* noted that Kückelmann was the "former friend and attorney" of Frau Fischer.[56] In a sense, it was the modern-day equivalent of *The Maltese Falcon*—nobody gets anything and everyone falls out. For my part, I decided to step down as director of the center for Holocaust studies at Claremont McKenna College in 2008. Frau Fischer's allegations in the press had compelled my college to undertake an investigation. Although I was cleared, the press reports surrounding Lohse and the Fischer Pissarro had become a distraction, and I thought it best for the center if I stepped down.[57] This decision made news—the front page of the Calendar section of the *Los Angeles Times*—with an article titled, "Professor Ensnared in Case of Pissarro Looted by Nazis."[58] Randy Schoenberg was quoted in the piece as saying, "Academics like Petropoulos, who helped with the Klimt case, are invaluable for researching the whereabouts and ownership histories of art," but they "are out of their league if they try to negotiate a work's return."[59] He had a point. And for the record, despite my efforts over a seven-year period, I

did not receive any compensation from the recovery of the Fischer Pissarro.

In the wake of these events, I had a follow-up conversation with Griebert in 2009. Prior to the meeting, I thought long and carefully about whether I ever wanted to see him again. My initial instinct was to cease all contact with him, but I also had the need for closure, for greater understanding of what had transpired. Peter and I met at our customary place, the Spatenhaus overlooking the Bavarian State Theater. As we tucked into our *Weisswürste* and pretzels, he acknowledged that he had lied to me. He said that the pressure applied on Lohse by Kückelmann, the Art Loss Register, and my repeated inquiries compelled Bruno to return the picture. Lohse approached Griebert, the latter recounted, and said, "Sell it." Lohse said he didn't care how Griebert did it as long as he kept Lohse out of it. "Über Jonathan" (Use Jonathan), Lohse recommended. Griebert acknowledged the suggestion and said he wanted 10 percent for his efforts, to which Lohse gruffly agreed. With the deal struck, Lohse provided Griebert with the document from 1957 that afforded the cover story. Griebert then proceeded to weave his web of deception. He admitted all of this to me over brunch in 2009. Of course, I realized there were more secrets that he was not revealing. But he tackled the sensitive topics with aplomb. When I asked him about the access he had to Lohse's vault in the Zurich Cantonal Bank, he said that yes, he once had the authority to enter it and dispose of the contents as he wished, but that was earlier. He maintained that once the archives for Nazi art looting had opened up in the 1990s and he had gained a better sense of Bruno's activities during the war, he had ceased to engage in any joint business ventures, and this brought a halt to visiting the Swiss bank safe.

In conducting follow-up research for this book, I became aware of other lies that Lohse and Griebert told me regarding the Fischer Pissarro. For example, art historian Claus Grimm told me in September 2014 that he was present at the opening of the exhibition in Lausanne in 1984 that included the Fischer Pissarro as well as the highly suspect works by Monet and Renoir that Lohse kept in the Zurich Cantonal Bank. Grimm said that Bruno was proud of his artworks and liked to show them to art historians and others who cared about art. Thus, when I asked Bruno about the Fondation Bruno back in 2000 and he denied any connection to the entity, he lied to me. Griebert was present at that meeting but he did not enlighten me on this point. Grimm also said that Lohse and Griebert's father had done business together and that they jointly owned a beautiful painting by

German Expressionist Karl Schmidt-Rottluff (1884-1976). The picture had hung in Lohse's apartment on the Laplace Strasse until about 2000, when Lohse sold it.[60] This was right before I was invited inside Lohse's home, and I never saw the picture. Yet two works by Schmidt-Rottluff ended up among the forty-seven in Lohse's collection at the time of his death, and it's likely this was one of them. When I asked Peter Griebert about his father and Lohse, he said they never did business together and denied joint ownership of the Schmidt-Rottluff. It is difficult to know. The experience was like walking through a hall of mirrors—one could discern only some of the divergent reflections.

Peter Griebert endured his own tribulations in connection with the Fischer Pissarro. He was investigated by authorities in Germany, Switzerland, and Liechtenstein who seized his computer and searched his home. Because he lived in a modest one-bedroom apartment in the Grünwald neighborhood of Munich, the authorities believed that he had another, more lavish property somewhere else. They kept asking him, "Where is the villa?" He laughed as he later related this story (there was no villa), but at the time, the inquiry was a harrowing experience. When I saw him a few years later—in an attempt to obtain a more complete account of what transpired—he had aged considerably. Griebert had also given up emailing as he sought to keep a low profile. He said he came through the ordeal without ever being charged with a crime, let alone convicted. A March 2010 letter from a Munich prosecutor officially concluded the investigation.[61] Lohse's nephew Klaus Nowitzki later reported that Griebert had helped himself to a salary of 3,000 euros a month, taken from Lohse's bank account for four years after Lohse's death, and that the authorities imposed a financial penalty on Griebert, but I learned of this only much later.[62] Griebert continued his work in the art trade, cataloguing collections and assisting his clients with various projects. He decided to spend more time with his sister in Italy, a step suggestive of his desire to put this episode behind him.

If Holocaust politics can be emotional and vitriolic, the addition of the financial component represented by valuable artworks turns up the temperature to an even higher level. Restitution raises questions about profiting (or profiteering) from the Holocaust. Some have quipped, "There's no business like the Shoah business." Partly in response, philosopher Berel Lang has suggested that those who work on the Holocaust and earn money from lectures, book royalties, and other activities should tithe ourselves, donating 10 percent of our earnings to good causes.[63] I personally believe

this proposal has great merit. My experiences in connection to the Fischer Pissarro undoubtedly sensitized me even more to the ethical considerations associated with Nazi-looted art. It confirmed my belief that the artworks looted by Bruno Lohse during the war were not ordinary chattel; they were objects imbued with special significance. And, as the next chapter shows, the stakes of history continue to be extraordinarily high.

Bruno Lohse and the
Wildensteins

I HAVE LONG BEEN INTERESTED in the Wildensteins—currently the wealthiest art-dealing family in the world. On several occasions, I contemplated writing a book about them, but I was warned off by friends in the art world. Some suggested that they would do to me just what they did to Hector Feliciano—tie me up for years in unpleasant and expensive litigation. A museum curator in Los Angeles worried that writing such a book might even put me at risk of physical harm, although it's unclear to what extent she was joking. I know she did believe that if I was crazy enough to undertake a book on the Wildensteins, I should expect trouble. I took such concerns seriously, and held off on committing formally to a book. Still, I kept my eye out for material on them. And I was not the only one: there were press reports in the mid- to late 1990s suggesting that the Wildensteins were somehow involved with Nazi-looted art, so many researchers at the time were interested in learning more about the art-dealing dynasty.[1] When I served as the research director for art and cultural property on the Presidential Commission on Holocaust Assets in the United States (PCHA), my staff members and I uncovered documentation relating to the Wildensteins.[2] Over the years I built up a collection of materials relating to the French American art-dealing dynasty that I used to try to understand the Wildensteins' connection to Lohse and his network of associates.

My archive helped make a key discovery with regard to the relationship between the Wildensteins and Lohse. When I returned from Zurich in January 2007 with a copy of the sales agreement for the Pissarro signed by Frédéric Schöni, I combed through my PCHA documents looking for the name "Schöni." It came up time and again in connection with the Wildensteins. During the 1950s and 1960s, Schöni had an address on the Pelikanstrasse in Zurich and he transported pictures out of Switzerland and Liechtenstein for the New York Wildenstein branch. The records for the years between 1949 and 1954 show the movement of an astonishing array of brilliant artworks, among them paintings by Tintoretto, Titian, and Picasso. In one 1954 shipment, Schöni sent fifteen pictures by modern masters, including three paintings by Gauguin, two by Cézanne, and two by Renoir, as well as a Monet and a Courbet.[3] New York stood out as the primary destination. The works were usually sent by airfreight that originated in either Geneva or Zurich. The paperwork was elaborate, with consular certificates and an array of official stamps, but all of it featured the signature of Dr. Frédéric Schöni. Quite frequently, Schöni was listed as the seller and Wildenstein & Co. of New York as the "purchaser or consignee."[4] The documents indicated that Schöni did a great deal of work for the Wildensteins, especially import-export transactions. I began to view the receipt for the Fischer Pissarro from 1957 that Peter Griebert had given me in a new light. But at this point, I knew only that Lohse and Schöni were acquainted and that Lohse had helped Schöni buy the Pissarro. There were still missing pieces to the puzzle, as there still are.

The Wildensteins celebrated the 125th anniversary of the family business in 2000. With assets then estimated at over $5 billion (the value has certainly increased with the precipitous rise of the art market, so now it's likely a multiple of that), and real estate in Paris (their Château de Marienthal was "reportedly the largest private residence in metropolitan Paris" as of the late 1990s), Kenya (a sixty-six-thousand-acre ranch), and the British Virgin Islands ("a private island compound"), they occupy a special place in the art world.[5] Back in 1978, then patriarch Daniel Wildenstein remarked, "My grandfather said, 'Never buy a painting that you can not afford to hold on to and have your grandchildren sell.' We have now a stock of 10,000 paintings; that is the only thing that enables us to continue operating in the grand manner."[6] The National Gallery of Art in Washington, DC, as a point of comparison, has fewer than four thousand paintings. As one writer noted about Daniel, "People [do] not trifle with him or with his family."[7] The renowned art historian John Richardson commented, "No-

body's done as well as the Wildensteins in terms of cash and power and, in a way most important of all, respectability."[8]

The Wildensteins, however, have suffered blows both in terms of prestige and wealth. A *Vanity Fair* exposé in 1998 ("Bitter Spoils") featured the wife of Alec Wildenstein, Jocelyn, who has by her own admission had so much plastic surgery that she resembles some kind of feline. She is sometimes referred to as "the Bride of Wildenstein," as an example of plastic surgery gone wrong. The *Vanity Fair* article addressed her appearance, but also took up a range of other issues, including alleged financial improprieties by family members.[9] Jocelyn and Alec soon entered into a highly contentious divorce (resulting in 1999 in a settlement of $2.5 billion and $100 million a year for thirteen years) that aired more dirty laundry. But even more painful was the pair of prominent articles in the *New York Times* in July 2011 and March 2012 that raised a range of allegations against the family, including some concerning wartime improprieties.[10] Coming from such a prestigious newspaper, let alone one led by a Jewish publisher, the articles put major dents in the Wildensteins' armor.

The Wildenstein Institute, a nonprofit operation based in Paris, is one of the premier art historical research centers in the world, known for its scholarly catalogues raisonnés. The Wildensteins are also active, often innovative philanthropists. For example, borrowing "dozens of Monets" from museums, they organized an exhibition of paintings by Monet at their Manhattan gallery on 64th Street, charged $10 admission, and donated the proceeds to the Breast Cancer Research Foundation.[11] Guy Wildenstein, as president of the American Society of the French Legion of Honor, helped recognize those Americans, such as certain World War II veterans, who aided France in a meaningful way. Prince Charles is godfather to one of Guy Wildenstein's children, and the two men share an interest in charitable work.[12] But the Wildensteins are very guarded—and employ lawyers to protect their reputation. Their website, not unexpectedly, gives little information about them. One learns that there have been five generations of art dealers, that they "pride themselves in maintaining a close relationship with [their] clients," and that they have "a unique ability to locate works of art for [their] clients, either from [their] unparalleled stock, or thanks to [their] incomparable research facilities."[13]

A scholarly account of the Wildensteins in the art world has yet to be written. In France, Daniel Wildenstein and Yves Stavridès published *Marchands d'Art*, a flattering and self-interested family history/memoir (although Stavridès is more critical today when speaking about the family).[14]

The experiences of the Wildensteins during the Second World War have been discussed in books by Lynn Nicholas and Hector Feliciano, but there is still much to be added. An account by Claude Dumont-Beghi, a French attorney who represented the estranged second wife of Daniel Wildenstein, titled *L'Affaire Wildenstein: Histoire d'une Spoliation*, explores some of the business activities of the family. Dumont-Beghi sought to document the dispersal of assets to offshore accounts, among alleged claims of various efforts at tax evasion.[15] The other published accounts are in magazines and newspapers. That the most thorough account of the family in English is a 1998 *Vanity Fair* article speaks to a massive gap in the literature. Indeed, the author of this latter article, Suzanna Andrews, observed, "Over the years [Daniel] made sure very little had been written about [the family] in the press."[16] Jocelyn Wildenstein observed about the family that she had once been a part of that with regard to the uncomfortable World War II history, "There is no reaction, because they are so sure of the power they have. They think they are above it."[17] And of course they have a right to privacy.

In order to understand the implications of Lohse's involvement with the Wildensteins, one must appreciate how far the family had come in the art world. The founder of the dynasty, Nathan, was the son of a rabbi who moved from Alsace to Paris in the early 1870s, when many Jews decided they would rather live in France than the German Reich, which had annexed the region in the 1871 Treaty of Frankfurt. Nathan Wildenstein, a successful haberdashery salesman, initially collected antiques and art for his personal enjoyment. His Parisian home soon was overflowing with objects, and so he opened a shop on the rue Laffitte. Although Nathan struggled at first, he made a few key deals that established him: for example, he bought a François Boucher painting in 1872 for 200 French francs ($4) and resold it for 200,000 ($4,000).[18] Nathan had a good eye and took advantage of flea markets and thrift shops, as well as the sale of art by aristocrats who were struggling amid the changes brought on by the industrial revolution. By 1875, he had moved his establishment to the elegant rue du Faubourg Saint Honoré on the Right Bank—not far from the Élysée Palace—and in 1905 he acquired a home a short distance around the corner at 57 rue la Boétie (the formal name of the building is the Hôtel de Wailly).[19] The two buildings are reportedly connected by a passageway.[20] Nathan Wildenstein initially focused on eighteenth-century French art (Boucher, Fragonard, and the like), but soon branched out to Old Masters. He assembled a massive stock, partnering, for example, with Lord Joseph

Duveen (then the greatest dealer in the world) to buy Adolphe Kann's collection of Dutch masters in 1907 for 17 million French francs.[21] Later, in 1927, he purchased the legendary Edmond Foulc collection of Italian and French Renaissance paintings and works of art.

Nathan Wildenstein expanded the family business in 1903 by establishing a gallery on Fifth Avenue. The 64th Street gallery near Madison Avenue was completed in 1932; it also served as the family's New York home.[22] Nathan mentored his son Georges and later his grandson Daniel in the family business, imparting an approach that stressed an appreciation for art (he was famous for his ability to detect fakes), an aggressive approach to business, and the primacy of the family. Nathan warned grandson Daniel, "Men can not permit themselves tenderness. . . . The most fascinating and most painful side of your profession will be solitude."[23] Nathan stressed the study of art. He began amassing an archive and research library (which counted over 300,000 books, 110,000 catalogues, and 100,000 images), believing that knowledge provided the edge over the competition. After years of grooming, his son, "Monsieur Georges," took over the family business when Nathan died in 1934. Georges was forty-two when, in the words of one former employee, Vladimir Visson, he "inherited the crown."[24]

During the 1930s, Georges Wildenstein (1892–1963) took the family business to another level. He developed an interest in Impressionist works and began purchasing stock in the genre, then reasonably priced. He bought masterpieces from the Oscar Schmitz collection in Dresden, the Staub collection in Switzerland, and the Gustav Fayet collection in France—all during the Depression when prices were especially low. Georges, like his father Nathan, was a skilled and dedicated dealer. Monsieur Georges possessed an extraordinary memory for paintings (and horses—his other great interest) as well as a tremendous drive in business. He once noted, "I got my guiding principles from my father. . . . In our business the rule is to buy and stock only paintings you yourself would want to buy."[25] He followed this rule, for example, in buying Picasso's early work, which he admired, but shunning the artist's later efforts, including those from his Cubist period, in which he did not believe.[26]

Daniel Wildenstein (1918–2001) was next in the line of succession. He too had certain family traits, as Vladimir Visson, the longtime director of exhibitions at the Wildenstein Gallery in New York, noted: "He was formal and brusque to the point of rudeness in his dealings with associates and acquaintances; . . . following his grandfather's advice, 'Never let

people get soft.'"[27] That said, Daniel had a period in the 1950s when, in the words of his daughter-in-law Jocelyne, "he was quite a playboy" and was known to frequent Madame Claude's brothel in Paris, as well as resorts on the Côte d'Azur.[28] Like his father, Daniel was "withdrawn and reserved"; and like his father, his two passions were art and horses. Daniel once said, "I love the mysterious aesthetic element which is the same for pictures and for horses."[29] One could add a third item to the list of Daniel's passions: the reputation of the family.

Guy and Alec Wildenstein were the fourth generation to run the business and lead the family. Guy (b. 1945) became president of Wildenstein & Co. in 1990, when their father was still alive. Guy, who has a passion for polo, served as the day-to-day manager of the family's operations, but he worked in close concert with Alec (1940–2008), who was also known as an avid big-game hunter.[30] The brothers were close—educated together at the Lycée Français in New York and working together for the family firm. While their father was still alive in the 1990s, the brothers deferred to him. Guy noted, "Nothing is bought except by the three of us, but the final decisions always remain with our father, with the eldest member of the family. It has to be that way, and will be, even when our sons take over. . . . I hope the girls will also be involved; it's not just a man's game any more."[31] Although Guy has three daughters, son David seems to be moving to the fore in terms of the next generation leading the family. It is this generation, press reports state, that inherited Daniel Wildenstein's fortune. Daniel supposedly passed over Guy and Alec, who are scarcely mentioned in his family history/memoir.[32] But Guy and Alec controlled the family business, so they never lacked for funds.

There are many questions surrounding the Wildensteins' business activities. For one, they are known to store artworks for decades, keeping them out of public view. Family members readily admit this. Daniel said, "My grandfather and father never invested except in works of art—and kept practically half of what we bought, not showing the paintings for five, ten, or twenty years."[33] Guy Wildenstein (b. 1945), the current head of the family, said, "We make a point of not divulging what we buy, what we own, and what we want to keep. I remember my grandfather telling me that it is better to pass for an idiot than a blabbermouth. It is just our way of doing business."[34] There is a rumor of a long-hidden Vermeer, and according to Alex Wildenstein, Georges used to travel with a rolled-up Velázquez that was "virtually unknown."[35] While it is doubtful that Georges would have

carried such valuable and fragile stock as he traveled, the story speaks to the Wildensteins' reputation for discretion.

In France, Georges Wildenstein came to dominate the art world in several respects, not only with regard to sales but also in terms of media coverage. In 1928 Georges purchased *La Gazette des Beaux-Arts*, the oldest existing art magazine in the world (established 1859). He also financed a Surrealist magazine called *Documents*, a cutting-edge philosophical publication with close ties to the avant-garde circles of Paris. The venture fell apart after less than two years, with Wildenstein firing editor in chief Georges Bataille (1897–1962), who continued on to a brilliant career as a wide-ranging intellectual. Regardless, the Wildensteins remained at the center of the art trade, especially in Paris. The staff at the *Gazette des Beaux-Arts*, for example, received a copy of every catalogue from the Hôtel Drouot and its collective of auctioneers, and this included the war years, when over five thousand pictures were sold at the venerable establishment. Even though Monsieur Georges had escaped to the United States in 1941, his operation continued to gather information, and the catalogues remained part of the Wildenstein archives until they were sold to a New Jersey collector in recent years.[36] These catalogues remain a valuable resource for provenance researchers.

In the United States, employees of the Wildenstein Gallery used other tactics—besides the press—in order to gain an advantage over the competition. Perhaps most notably, they were accused of tapping the telephones of arguably their greatest rivals, the Knoedler Gallery, in 1955. Journalist Suzanna Andrews noted that "it was assumed" the Wildenstein Gallery bugged the Knoedler's lines "in order to find out its competitor's inventory and prices and also what customers were looking for."[37] An employee of Wildenstein, Jay Rousuck, admitted engaging a private investigator to carry out the surveillance. But the scandal reflected badly on Monsieur Georges. Andrews suggests, "The incident may have been one reason why Georges was never invited to join the Art Dealers Association of America."[38]

The Wildensteins developed a notable clientele that included most of the great collectors of the day. The Mellons, David-Weills, Annenbergs, and Rothschilds were among the most important customers. Monsieur Georges himself was not a great salesman. He had little patience with customers, whom he regarded as ignorant. Vladimir Visson recalls "how many times I heard him say to one of his associates, 'No, no, you go and

see that client. That man has no knowledge, no feeling for paintings. He makes me sick.'"[39] He therefore often turned to others, including his personable cousin Felix Wildenstein, who lived in Connecticut, to meet with potential clients.

The Wildensteins were instrumental in the growth of American museums. They sold prodigious quantities of art to the National Gallery of Art in Washington, DC, and the Metropolitan Museum of Art. A preliminary review shows that the National Gallery contains eighty-one paintings that passed through the hands of the Wildensteins. According to journalists James Tarmy and Vernon Silver, at the Met, "close to half the section [of European paintings] — 44 galleries — have at least one painting with a Wildenstein provenance."[40] The Wildensteins also sold Gustave Caillebotte's iconic *Paris Street; Rainy Day* to the Art Institute of Chicago in 1964. Because many American museums drew leadership from the ranks of the former Monuments officers, the Wildensteins ended up knowing many of the figures who investigated the plundering of their gallery during the war. Theodore Rousseau at the Met, for example, bought a great deal from the Wildensteins. His friend from the OSS, Otto Wittmann, who went on to direct the Toledo Museum of Art, recalled in the 1980s, "I've always been close to the Wildenstein firm, and I've done a lot of business with them. If I can, I'll tell you some stories about them. At any rate, they always showed me everything."[41] Wittmann was almost certainly incorrect about the last point: the Wildensteins were notorious for frustrating collectors, who knew that the family had more in its depots than it was willing to show or sell.

The Wildensteins' Jewish identity has been important to them, even as certain family members have had ambivalent views toward Israel. They are observant, with the boys going through bar mitzvahs. Yet they generally do not support "Jewish causes" (Daniel in particular was reluctant to support Jewish charities).[42] Daniel married an Israeli woman, Sylvia (his second wife, who died in 2010), yet refused to set foot in Israel. Jocelyn Wildenstein claimed that her son's bar mitzvah could not take place in Israel because Daniel would not attend.[43] That said, they view themselves as Jewish and have experienced prejudice and persecution directly. There has always been a patriarchal power structure to the family, and its members are remarkably close-knit and insular. Monsieur Georges used to go home for lunch and dinner every day, eating with his wife Jeanne, son Daniel, daughter-in-law Martine, and their two sons, Guy and Alec.

Georges insisted that his food be prepared by his private chef (he would not eat in restaurants), and he rarely attended the theater or concerts.[44]

Monsieur Georges was never well understood by most colleagues or the public. As indicated above, he had his eccentricities. He was also obsessed with his health (a doctor visited twice a week), afraid of death, and highly superstitious. Georges Wildenstein came close to cooperating on a *New Yorker* profile about him, but at the end of the meeting, when it appeared that all the terms had been negotiated, he remarked (as he was being led to the door), "Of course, I will go over the proofs to approve them before publication."[45] This demand was unacceptable to the editors, of course. Monsieur Georges died of a heart attack on 12 June 1963. His passing was widely covered in the press in both Europe and the United States. *Le Figaro* mourned "his passing as a great loss for French horse breeding."[46]

When Monsieur Georges died, he took his secrets with him, including those concerning his actions during the war years. The Wildenstein family business seemed to have avoided the worst of the Nazis' depredations, which raised questions. Two issues lie at the heart of this history: first, did Monsieur Georges or other family members collaborate with Nazis during and/or after the war?; and second, did they profit from the misfortune of other Jews? These are not the only allegations leveled against the Wildensteins. They have been charged with offenses ranging from smuggling modernist works out of the Soviet Union to fabricating entries in catalogues raisonnés. To some extent allegations can be expected in light of their power and influence, but profiting from the stolen art of Holocaust victims and continuing to consort with Nazi art plunderers during and after the war are serious charges.

It is perhaps, then, unsurprising that the Wildensteins responded to Hector Feliciano's treatment of Monsieur Georges during the war by going on the offensive and initiating legal proceedings against the author. Feliciano's book *The Lost Museum* was published first in France in 1995 and then in the United States in 1997. French law permits libel suits on behalf of the dead, and the Wildensteins turned to the French courts in 1999.[47] Feliciano had made statements such as: "Georges Wildenstein was very well known and actively involved in art circles in a number of countries, including those within the Nazi sphere of influence. Even after the French armistice and the German occupation, Wildenstein seems to have taken advantage of this network to organize a number of deals with the Germans."[48] While this formulation seems cautiously stated (and his treat-

ment of Monsieur Georges was brief), the Wildensteins demanded $1 million in damages, a huge sum for most journalists. They lost the initial decision, which went to the court of appeals in 2001 (after Daniel's death), and then took the case to France's Supreme Court, which issued the final ruling in Feliciano's favor in October 2003. According to the *New York Times*, "The two lower courts said they could not rule on whether Georges Wildenstein did business with the Nazis, but they ruled that Mr. Feliciano had not acted irresponsibly or negligently in drawing that conclusion from the documents available to him."[49] The French Supreme Court spoke to procedural issues, finding that "the suit should have been rejected in the beginning because it had not been filed within three months of the book's publication."[50] Feliciano was awarded the equivalent of $2,800 in damages—a pittance (he had tens of thousands of dollars in legal fees), but a symbolic victory. It is not clear that the journalist saw it quite that way. After the final verdict, Feliciano said he felt a sense of relief "after four years of wasted energy, time, and money. They have used big law firms, private detectives, and big sums of money to discourage me and others from doing research, but it did not work."[51] The Wildensteins themselves demonstrated the lengths that they would go to protect their family's reputation and honor, especially when it came to their history vis-à-vis the Holocaust. In their initial lawsuit against Feliciano, they argued that the author displayed a "serious and flagrant scorn for searching for the truth" by associating Georges Wildenstein with the "war crime of collaborating with the enemy," and that Feliciano's references to Georges Wildenstein "cast intolerable suspicion over his honorability that translates directly into distrust by clients and particularly by important Jewish clients."[52] This is what they thought was at stake: an understanding of family history, honor, and business.

Back in 1999, legal counsel for the Wildensteins approached me about being an expert witness on a case (*Francis Warin v. Wildenstein & Co.*) winding its way through the New York courts involving eight illuminated manuscripts from the fifteenth and sixteenth centuries that were looted by the ERR in France in 1940.[53] I told the lawyer representing them that I could not work for them because I was currently employed by the Presidential Commission on Holocaust Assets. He accepted that. I reported the approach by their lawyer to my PCHA bosses, and instructed my staff to continue to collect everything on the Wildensteins that they encountered in the archives. There was no further contact between the Wildensteins (or their lawyers) and me while I was at the PCHA.

I completed my work for the PCHA in the summer of 2000 and moved on to other projects. In the spring of 2002, that is, some eighteen months after I had left the PCHA, the Wildensteins' lawyers contacted me again. They asked me to review the case, which I did in March 2002. I read the extant documents, consulted colleagues in the field, and concluded that the Wildensteins were probably in the right—that the manuscripts in question (worth many millions of dollars) were indeed taken from them by the Nazis. I needed to do more research to prove this; it was a compli-cated case that required showing that the Nazis had made a mistake when they catalogued the manuscripts. The ERR staffers had attributed them to the collection of Alphonse Kann, who lost over twelve hundred artworks at the same time as the Wildensteins. I thought I knew how to go about researching the question of whether the ERR staffers had made a mistake, so I went to New York to discuss the case with the Wildensteins' attorneys.

The family had hired "outside" attorneys from the high-powered New York firm of Arkin Kaplan & Cohen, and one of their lawyers, Sean O'Brien, was present when I met with the Wildensteins' attorney, Richard Bernstein. We convened at the Wildensteins' gallery on 64th Street. With its impressive marble hall, a "sweeping balustrade which spiraled to the second floor," and red velvet–lined showrooms on the third floor, one ob-server described the gallery as "a cross between a restored eighteenth-century villa and a pretentious Italian funeral parlor."[54] The gallery ap-peared an intimidating atmosphere in many respects. As former employee Vladimir Visson observed, "In this velvet, gold, and marble sanctuary no voices were ever raised to disturb the precious paintings gazing down tran-quilly from their perches on the wall."[55] The paneled salon came from the Paris home of the diplomat Prince de Talleyrand.[56] I told the two lawyers that I was interested in taking on the case, but that they would have to respect my findings—whether they were favorable or detrimental to the family. I also told them that I strongly objected to the way they had treated Hector Feliciano. In particular, I expressed disappointment that they had not accepted the initial ruling but subjected him to a lengthy and costly appellate process. They duly noted my point and we moved on. I decided to take on the consulting project because I thought their claim had merit, because I wanted to learn more about the Wildensteins and their opera-tions, and because I believed that with my scholarly expertise and access to Bruno Lohse, I could determine if the ERR staff made a mistake and could resolve the dispute about who owned the manuscripts.

In the summer of 2002, I traveled to Germany to conduct research in

the Federal Archives in Koblenz and visited various experts on manuscripts, including Dr. Bodo Brinkmann, a curator at the Städel Museum in Frankfurt who knew the history of these manuscripts very well. And, of course, I talked with Bruno Lohse about how the ERR operated.[57] Lohse explained to me that there were loading docks, and that after objects arrived at the Jeu de Paume, they were sorted according to their type. In short, there was a separate department for books and manuscripts. I went on to research this department and, using documents from the German Federal Archives in Koblenz, showed that the Wildenstein and Kann collections were both looted during the same week in late October 1940.[58] Georges Wildenstein and other family members also had their safe-deposit and bank vaults raided by the Foreign Currency Commando (Devisenschutzkommando, or DSK) that Göring controlled.[59] The DSK found 157 Wildenstein works in a vault in the Banque de France in Paris, including pictures by Boucher, Watteau, and Fragonard.[60] The Foreign Currency Commando removed the art in October 1940 and handed it over to the ERR for processing. The DSK was a major source of "inventory" for the ERR, and this, combined with his Luftwaffe transport resources, afforded Göring the leverage to seize control of the ERR. This meant that the objects from the two families arrived at the ERR at the same time. I also found that both families had books and manuscripts that were separated out from the rest of the property and sent to the relevant department in the Jeu de Paume. The Wildenstein and Kann collections were then transported to Germany, to the Kloster Buxheim monastery in Bavaria, on the same train—even, in many instances, in the same crate (I found packing lists). The manuscripts in question were attributed to Kann once they arrived at Buxheim. Thus the initials "Ka" were inscribed in pencil on the manuscripts themselves.

In short, I was able to show how it was possible for the Nazis to make the error, but I still wanted more concrete information. I therefore requested permission to view the firm's stock books. This would provide conclusive proof of ownership. I passed my request through Sean O'Brien and received the response that the Wildensteins would allow me to see facsimiles of the books. When I arrived at the Madison Avenue offices of Arkin Kaplan & Cohen and was escorted to an elegant conference room— with commanding views of midtown Manhattan—I found beautifully produced and rather massive volumes (approximately three-by-five feet when opened) detailing acquisitions and sales going back to the founding of the gallery in the nineteenth century. The relevant sections had been flagged for me and I could see entries for all eight manuscripts, includ-

ing the exceptionally valuable one, an elaborate Persian manuscript called "The Boostan," which the Wildensteins acquired in November 1930 for 26,790 French francs. I recall thinking that I wished I had more time to study these books: the information they held would rewrite the history of art. I considered the possibility that the facsimile stock books might be forgeries or altered in some way, but it seemed unlikely. The entries for the manuscripts were embedded within lists of thousands of artworks. I came away with the belief that the Wildensteins had owned them and that the French authorities on the Commission de Récupération Artistique had got it right when they returned the manuscripts to Monsieur Georges after the war. I wrote my expert report and it was submitted to the court. In June 2006, the judge ruled in favor of the Wildensteins, although the rationale was based on choice of law (French law) and issues relating to the French statute of limitations.[61]

Before this ruling, a piece ran in the *New York Times* about the PCHA. The reporter, Ralph Blumenthal, found two disgruntled former employees, one of whom had worked for me and had been terminated by our bosses at the commission.[62] She told the journalist that she had been let go because she wanted to investigate the Wildensteins and museums like the Met, but they were being protected by the PCHA.[63] Blumenthal pointed out that I was now consulting for the Wildensteins, implying that I had covered for them during my tenure at the PCHA. I wrote a letter in response to these charges and it was published. I explained that I had made a career out of exposing people's criminal deeds during the Third Reich. I also pointed out that while at the PCHA, I had instructed my staff to investigate the Wildensteins, among other highly active dealers of the period. They were told to photocopy and show me every document that mentioned these historically significant figures. Often these documents contained rumors that were very difficult to substantiate. The PCHA was not going to indict anyone without solid proof, even if the reports were juicy, as they often seem to be in the art world. I was quoted on the subject in an *ARTnews* article in May 2003: "A presidential commission cannot include rumors. There was nothing we were able to prove."[64]

In the past couple of decades, the Wildensteins have had public relations challenges, with journalists subjecting them to treatment that at times has been both critical and unsympathetic. Articles in the *New York Times* and *Vanity Fair*, for example, while representing the views of both sides, implied that the Wildensteins were in the wrong with regard to their lawsuit against Feliciano and other issues; the *Vanity Fair* article included

the following quote, attributed to a "major New York dealer": "You'd think, especially with all the activity with Swiss accounts and all these new questions about looted art, that they'd admit a mistake was made, apologize, and return the manuscripts."[65]

The fact remains: there are people in the art world who suspected (and continue to suspect) the culpability of the Wildensteins. The public comments of Wildenstein family members sometimes prove unhelpful to their cause: Daniel, for example, said in a rare interview, "If tomorrow someone steals a picture from me, I make a declaration to the police that it's stolen. After 30 years, the man who stole it owns it."[66] This formulation did not evince much understanding either of the challenges faced by heirs in pursuing Holocaust-era property or of U.S. law, according to which one can never have good title to stolen property. That Guy Wildenstein accused the Kann heirs of filing a "nuisance suit" in order to provoke a payoff also suggests an insensitivity to the moral and emotional dimensions of restitution work.[67] And certain past behavior harmed the family's reputation: for example, President Charles de Gaulle and the minister of culture André Malraux criticized the Wildensteins for selling Georges de la Tour's *The Fortune Teller* (*La Bonne Aventure*) to the Metropolitan Museum of Art in 1960, accusing them not only of depriving France of its national heritage but of bribing a French state official in order to arrange the export and sale abroad.[68] Even though there were questions about the authenticity of the picture, de Gaulle went so far as to strip Daniel Wildenstein of the honor of membership in the Académie Française.[69] In short, the Wildensteins often do not elicit much sympathy from those in the art world, or the public at large, and my taking them on as clients entailed certain costs.

Yet certain allegations merit further exploration, especially in that they help provide a context for trying to understand the Wildensteins' relationship with Bruno Lohse. Four topics stand out in this regard: first, the relationship between Georges Wildenstein and Nazi dealer Karl Haberstock; second, Georges Wildenstein's relationship with Roger Dequoy and the question of whether Monsieur Georges controlled the family business in Paris during the German occupation; third, whether the Wildensteins trafficked in works of art looted from other Jews (both during and after the war); and fourth, whether they "fiddled" with the catalogues raisonnés to conceal their own problematic actions regarding certain looted paintings. If the Wildensteins did in fact do many of the things noted above, they may have been more likely to engage with Bruno Lohse in a meaningful way.

In terms of the first issue, Georges Wildenstein developed a business

relationship with Karl Haberstock back in the 1930s, before the outbreak of war. In 1939, the London branch of Wildenstein entered into an arrangement with Haberstock concerning Paul Gauguin's painting *Horsemen on the Beach*.[70] The picture had been seized from the Wallraf-Richartz Museum in Cologne as part of the "degenerate art" purges in 1937–38, and Haberstock, who was advising Hitler on how to sell the seized art, managed to get in on the action. It appears that Haberstock and Wildenstein London bought the Gauguin for RM 12,330 in July 1938—the notation in Haberstock's ledger reads, "½ *Anteil*," or "½ share." It also appears that the Wildensteins bought out Haberstock the following May 1939 for RM 22,185, which meant that the Nazi dealer earned about RM 10,000 in the deal.[71] Although the London branch of Wildenstein handled this picture—and this presumably involved office manager Roger Dequoy, who would go on to sell other Wildenstein works to Haberstock during the war—the deal had the blessing of Monsieur Georges, who corresponded with Haberstock about the picture.[72] It must be stressed that there was nothing illegal about the sale of this painting. The "liquidation" of "degenerate" works from state collections was made legal in a German law of 31 May 1938 (which Haberstock helped write). The purged works have not been subject to restitution, even though many lament the losses for German museums.[73] The Gauguin from Cologne was sold by the Wildensteins in New York to actor Edward G. Robinson, and in 1964, it entered into the collection of Greek tycoon Stavros Niarchos.

But the fact remains that Georges Wildenstein and Haberstock did business together before the war—this at a time when Haberstock was advising Hitler on the regime's plundering policies. Haberstock had traveled to Vienna in the spring of 1938 after the *Anschluss* to offer counsel regarding the art being taken from the city's Jewish population. Yet a year later, Georges Wildenstein and Haberstock were partnering in the sale of the Gauguin. They corresponded and spoke in French, and they employed rather flowery formal language in their salutations (mostly *mes salutations les plus distinguées*). Haberstock's papers now in Augsburg are filled with short notes the two men sent each other. There are also interesting documents in the National Archives (NARA) in College Park, such as Haberstock writing Monsieur Georges about using a Swiss bank corporation in the West End of London for much of their business.[74]

Journalist Yves Stavridès told me that Monsieur Georges and Haberstock did not know one another well. They were connected, he said, by Roger Dequoy, then an employee of the Wildensteins who managed their

London branch. Dequoy was charming, says Stavridès, noting, "He spoke English with a Maurice Chevalier accent."[75] He adds that "Dequoy was a brilliant salesman, but he knew little about art. His mother had worked for the Wildensteins in the 1920s and she introduced her son to Monsieur Georges, who became a kind of mentor, if a somewhat mistrustful one."[76] Yet Dequoy did well in London in the 1930s; the city was one of the few art markets that continued to be viable during the Great Depression. Haberstock also had a branch in London, and the two did business. Stavridès maintains that somehow, in the course of their dealings, Dequoy gained leverage over Haberstock; what exactly this concerned remains unclear, he says. But it was this London connection that led to the cooperation between Monsieur Georges and Haberstock concerning the Gauguin. Stavridès portrays the former as guarded yet polite as he listened to the proposal from Haberstock concerning the purged painting. He also points out that Monsieur Georges was "strongly anti-German—that he had been raised by his father Nathan to despise Germans."[77] But because Haberstock needed assistance selling the painting—his clientele primarily collected Old Masters and nineteenth-century German art—he approached his French colleague, and the latter agreed to help. Stavridès says the two men did not meet as they partnered on the Gauguin deal; rather, they exchanged letters until Monsieur Georges induced Edward G. Robinson to buy the painting.[78]

A more sensitive issue concerns the nature of the meeting between Georges Wildenstein and Haberstock in Aix-en-Provence in November 1940. This event was at the core of the Wildenstein-Feliciano lawsuit. Based on the documentary evidence, there seems to be no doubt that they met, but the questions relate to what they said and what they agreed to do. A U.S. government document titled "Special Report on the Firm of Wildenstein & Cie, Paris Art Dealers" says that Haberstock traveled with Roger Dequoy first in November 1940 to Aix-en-Provence, "where they spent 4 or 5 days."[79] According to Haberstock, he met with Georges Wildenstein at this time. In a handwritten statement from 2 September 1945 that Haberstock penned while in Altaussee, he testified that he "met Herr Wildenstein just the one time in Aix; when he returned to southern France in 1941 with Dr. Posse, [Wildenstein] was no longer there."[80] According to Haberstock, "Wildenstein was very eager to do business," and proposed to Haberstock a trade of a Tiepolo for "Impressionist pictures from Germany."[81] Haberstock elaborated in another statement he gave right after the war: "In the presence of Duquoi [*sic*] I had in the

fall of 1940 a conference with Mr. Wildenstein in Aix-en-Provence. The theme of this conference was the possibility of acquiring objects from his possessions, especially the purchase of a large painting by Tiepolo. Mr. Wildenstein expressed his great confidence in Mr. Duquoi, who was supposed to represent during his absence the interests of the firm in France. I took leave from him in good spirt."[82] According to Haberstock, "Wildenstein discussed the possibility of getting his pictures out of the Chateau de Sourches so that Dequoy could keep the gallery open."[83] He explained that in return for his help in transporting the pictures to Paris, he would have first choice. All involved knew that absent a formal Aryanization, the works would be transferred to the ERR for processing, and that this would curtail opportunities for profit (except for Göring and those allied with him).

In the months that followed, Haberstock continued to pursue the Wildensteins' art. This included turning to Paris dealer Hugo Engel (an Austrian Jew) and his friend Baron von Pöllnitz for help. In April 1941, they facilitated the transport of pictures from the Château de Sourches to Paris, with von Pöllnitz providing the trucks. Haberstock did his utmost to keep the works from the ERR, and he largely succeeded (although a few belonging to the Wildensteins at the château were taken outright by the ERR). Haberstock ended up meeting two representatives of the ERR to discuss the Wildenstein works from Château de Sourches: they convened at the Ritz Hotel in Paris on 14 May 1941: Gunther Schiedlausky and Dr. Wolff Breumüller (who, according to the *ALIU Final Report*, was "responsible for actual confiscation operations of the ERR Paris until 1943") traveled across town to Haberstock as they met to resolve the fate of the Wildensteins' art.[84] Haberstock largely got what he sought, and eighty-seven Wildenstein objects would be Aryanized and hence not go to the ERR.[85] But other works from the various branches of the family went through the Jeu de Paume facility.[86] It is fair to say that Lohse helped process the plundered Wildenstein art, and that he played a role in directing more than two dozen quality Wildenstein pictures to Göring.[87]

Haberstock claimed that not only did Monsieur Georges do business with him after the outbreak of war, he continued to utilize Roger Dequoy to run the Paris gallery after Monsieur Georges's flight to the unoccupied zone. Under the name Galerie Roger Dequoy & Cie at 57 rue La Boétie (that is, in the Wildensteins' building), he was selling pictures that had been in the Wildenstein family's possession for years. Furthermore, some of these pictures went to Hitler and his Führermuseum in Linz.[88]

Did Monsieur Georges know that these pictures were going to Hitler? It is impossible to know for sure. But U.S. officials seemed to think so. The "Special Report" quoted above, for example, noted, "Once Dequoy was thus re-established in business and with a small but freely disposable stock he set to work to carry out the rest of his chief's wishes. Sometime in 1942 he dropped the name Wildenstein & substituted his own [Roger Dequoy et Cie]."[89] The report also includes two particularly interesting points: "Haberstock states that he always understood that the money was being paid to a secret account which would ultimately have been at the disposal of M. Georges Wildenstein."[90] It is therefore almost certain that George Wildenstein met Haberstock in Aix and that he hoped the Nazi dealer could protect some of his assets. But this need not have been so nefarious. There is an interpretation of these events that is considerably more favorable to Monsieur Georges. He hoped he would be departing from Europe shortly (he and his wife fled through Portugal to New York in the first half of 1941), and Georges Wildenstein thought it better to meet with Haberstock rather than offend him. He was being prudent, especially with emigration and all the challenges it entailed (passports, visas, and sponsorship in the United States).

A similar approach is possible with regard to the second topic: whether Georges Wildenstein continued to control the business during the war through Roger Dequoy. One can say that Monsieur Georges was trying to save what could be saved—to mitigate the damage to his collection. According to Haberstock, "Herr Dequoy tried hard to save the property of Herr Wildenstein to the extent that it was possible at this time."[91] Haberstock recounted that Dequoy called on him in August 1942 to fend off "attacks by German authorities" (presumably the ERR or Wüster and colleagues at the German embassy).[92] If Dequoy really was trying to protect the Wildensteins' interests, then Georges may have tried to assist him The latter certainly kept informed of events in Europe in a general sense, even penning articles during the war titled "Works of Art—Weapons of War and Peace" and "Hitler, Art 'Collector'" (both from 1943).[93] These articles showed a deep knowledge of events in France as Wildenstein described, for example, complicit figures like "willing collaborator [and] the half blind engraver Jacques Beltrand (1874–1977)," who provided valuations for ERR looted works. The fact that Dequoy and Monsieur Georges resumed contact in the spring of 1945—that is, before war's end—and that Dequoy remained in the employ of the family until at least 1954 also suggest a relationship based on trust.[94] Lynn Nicholas has noted, "The

Wildenstein firm was one of the first to resume its international opera-
tions. Well before the fall of Germany, their man Dequoy showered both
the New York and London offices with chatty cables full of news and pro-
posed sales, and set in motion the claims process for the objects confis-
cated from the firm."[95]

A complication stems from the fact that Roger Dequoy was not just
a figurehead representing Wildenstein in Paris but an energetic collabo-
rationist dealer who hustled to maximize profits. To what extent one can
hold Georges Wildenstein responsible for the actions of his employee is a
challenging question (the logic of "transitive property" has its limits). But
the fact remains that Dequoy was one of the most active dealers in wartime
France. For example, Dequoy was among those who pursued the paintings
in the Schloss collection—the great Dutch and Flemish Old Masters that
Lohse helped liquidate. Dequoy reportedly resorted to "offering bribes to
the Schloss family and then . . . threatening them."[96] Dequoy also talked
to Haberstock about the Schloss pictures and then subsequently helped
the Nazi dealer acquire as many of the pictures as possible. Dequoy told
him that the heirs had left France and that the paintings might be avail-
able.[97] Haberstock wanted to buy all 333 pictures, imitating Alois Miedl,
who made a handsome profit liquidating the vast Goudstikker collection
in the Netherlands. Although this initiative did not pan out, Dequoy and
Haberstock continued to assist one another, and this included Haber-
stock helping Dequoy transport pictures. Haberstock also continued to
buy from Dequoy, purchasing works by Claude Lorrain, Gustave Cour-
bet, and Jan Fyt in the early summer of 1941, a Poussin and several other
pictures in November 1941, and then buying two Rembrandts (*Landscape
with Castle* and *Portrait of Titus*) for RM 3 million in May 1942 for Hitler
and Linz.[98] There are reports that Dequoy and Haberstock eventually had
a falling-out. Walter Andreas Hofer testified after the war, "Dequoy was
very close to Haberstock until they had a quarrel."[99] In any case, after the
death of Hans Posse in December 1942 and the arrival of Hermann Voss a
few months later as the new director of the Führermuseum, Haberstock's
business fortunes declined, and he spent less time in France.

Roger Dequoy also attempted to make a trade with the ERR in January
1944 for "sixty modern paintings, all from Jewish collections."[100] Bruno
Lohse supervised the deal for the ERR, and the terms had been agreed
upon in principle. In exchange for the modern paintings, Dequoy would
offer landscapes by Hubert Robert and a François Boucher, along with six
smaller works by Pannini and Guardi. The deal, however, was vetoed by

Robert Scholz, the administrative chief of the ERR, who happened to be visiting Paris from Berlin just when arrangements were being finalized. Dequoy and his associates were scheduled to make a large profit: Hector Feliciano estimated that they acquired 20 million French francs in modern art for 2 million francs, the value of the eight traditional works they gave up. Scholz found the exercise humiliating and thought that observers one day would mock the National Socialists for being duped. Feliciano notes that "this would have been the largest exchange ever executed between the ERR and a dealer."[101] He shows that Dequoy was a collaborator not only with regard to handling the Wildenstein art (there, he had little choice) but with other Jewish victims' art. Feliciano also notes that Dequoy dealt looted art to collectors in Switzerland, as he too was well acquainted with the players in both the wartime and postwar networks. Dequoy sold to Emil Bührle, the notorious weapons manufacturer who enriched himself by selling to the Germans during the war.[102]

Granted, Roger Dequoy faced a very challenging situation during the war as he tried to manage what remained of the Wildensteins' art. He was indeed very fortunate not to experience greater difficulties. While some scholars and journalists believe that he Aryanized Wildenstein & Cie, Yves Stavridès makes the compelling argument that the process was never completed. Dequoy had an office at 57 rue La Boétie and handled some of the Wildenstein stock, as discussed earlier, but he was not the formal trustee. Because he had worked for Jews before the war (the Wildensteins in London), he was unacceptable to certain Nazi officials.[103] Therefore, Stavridès believes it was a kind of partial or incomplete Aryanization. It appears there was a temporary administrator for Wildenstein & Cie— a M. Bruyer—but this was apparently not a permanent solution.[104] Earlier in 1944, discussions had heated up about completing the process of Aryanizing the Wildenstein firm, and this would have entailed the formal take-over of the buildings at 57 rue La Boétie and at 140 rue du Faubourg Saint Honoré. This threat resembled the one made back in mid-1942, when Karl Haberstock intervened and protected Dequoy's interests by writing the German Military Administration in Paris; this had thwarted any new initiatives and maintained the status quo.[105] But the threat was much greater in 1944. Haberstock had lost much of his influence (with the death of his close friend Dr. Hans Posse, the first director of the Führermuseum). Dequoy had sold most of the stock he had taken over, and there was a host of Nazi officials who had ideas for the buildings.

Among the proposals that emerged in early 1944 for the Wildenstein Gallery in Paris were the following: the German ambassador Otto Abetz suggested that the embassy take it over as a place to hold "exhibitions of German art in France" and to undertake other programs to promote German-French cultural relations. Heinrich Hoffmann, Hitler's personal photographer (and a very wealthy man as a result) wanted to open his own art gallery in the space. Hoffmann's aide, Dr. Alfred Ringer, wrote the German Military Administration to affirm that "the Heinrich Hoffmann publishing house is a serious bidder for the firm Wildenstein & Co., including its real estate."[106] Goebbels wanted the space for his own Propaganda Ministry. He also envisioned programs that would promote German-French relations. Another suggestion was communicated from a German financial official in Paris, Dr. Kreuter, to General Consul Dr. Knothe: Kreuter said that he had just met with Dr. Lohse, "an art historian colleague" of the ERR in Paris; Lohse "made the suggestion that the well-known French art dealer Lefranc who has taken over the Seligmann Gallery via Aryanization should expand and acquire [Wildenstein & Co.]."[107] In other words, Lohse suggested that his counterpart in the liquidation of the Schloss collection, Lefranc, could expand his activities to take over the Wildenstein enterprise. Lohse continued to be engaged in discussions well into 1944. He negotiated with Dequoy and M. Bruyer, the temporary administrator, and they discussed the fate of those assets of the firm not yet liquidated (including the archives and library).[108] Yet none of these plans for a final Aryanization were ever realized, and a general stalemate regarding the Wildenstein Gallery persisted. This allowed Dequoy to remain in business and keep his office on the property. And Lohse helped him do this.

Not that the threats to the Wildenstein Gallery in Paris had abated: as the episode above shows, there were many German officials active in the French capital, looking for an opportunity to make money. And it was not just the Wildensteins' real estate and art they coveted but, as noted earlier, also the archives and library. Officials from the Reich Finance Office made a play to take control of the Wildenstein archive and then sell it off. They had managed to appoint an "interim administrator" (*Kommissarischer Verwalter*) of Wildenstein & Cie. This official, M. Bruyer, apparently did not have much influence over the firm (power remained with Dequoy). But Bruyer had ambitions. A German accountant who attended some of the meetings involving Bruyer and others in late 1943 and early 1944 wrote:

In the days between Christmas and New Year's, Herr Bruyer also had another visit by Herr Dr. Loose [*sic*]. Herr Dr. Loose had entered into extensive negotiations with M. Dequoy in recent weeks. He expressed to both Herr Dequoy and Herr Bruyer that with regard to artistic questions, he alone was responsible as the plenipotentiary of the German Reich. In this regard, he has absolute authority and in no way is dependent upon the approval of the Hôtel Majestic [the German Military Command] or even the French authorities. He demanded in this regard the sale of the library, as well as the full range of documents and photographs of the firm Wildenstein & Cie for the price of 200,000 French francs. He drafted a handwritten letter of confirmation for Herr Bruyer and instructed him to send it to him immediately.[109]

Lohse even invoked the specter of the Gestapo, suggesting that he might call on Himmler's agency to resolve outstanding issues with regard to Wildenstein & Co.[110] This was Lohse behaving like the king of Paris — taking charge and dominating, and doing it with bravado. Whether the 200,000 French francs were ever paid to anyone remains doubtful. But Lohse managed to secure the Wildenstein archives — or a portion of them. According to Yves Stavridès, the secretary of Monsieur Georges, a "spinster" named Mademoiselle Griveau who was devoted to him, had smuggled thousands of cards (*fiches*) that listed the provenance of artworks from the gallery to her Paris apartment. She had taken them in batches — as many as she could each night without being noticed — and she returned them to the gallery at war's end.[111] As noted earlier, Stavridès also stated that the library and archives that Lohse helped secure never "went to Germany. The whole stuff remained [at the] rue La Boétie. The library was saved by the D-Day [forces] after the Liberation of Paris!"[112] Lohse, as discussed above, later maintained that these events would be foundational for his relationship with the Wildensteins.

Besides allegations that Georges Wildenstein met with Karl Haberstock and used Roger Dequoy to run his business in Paris, there have been rumors that the Wildensteins were trafficking in works looted from other Jews during and after the war. More specifically, the allegations concern shipping looted objects to South America (and sometimes up into North America). Nathan Wildenstein had opened a branch of the gallery in Buenos Aires in 1929, and the family therefore had a preexisting base for operations. During the war, the U.S. Postal Service opened mail

and monitored cable traffic, and some of these so-called censorship intercepts are suggestive. Many intercepts concern reports of art shipped to Latin America, and to Buenos Aires in particular.[113] In October 1941, some three months after Georges Wildenstein arrived in New York, U.S. Treasury officials explored a report that works by Corot, among others, had been shipped to Buenos Aires. The U.S. Treasury's Foreign Funds Control Division conducted an audit of the Wildensteins' finances during the war, but the particulars were so complicated, especially with the firm holding and safeguarding works owned by others, that U.S. officials remained uncertain about how to proceed.[114] Officials posed questions such as "Is this a violation, can it be used in prosecution?" but never proceeded with formal charges.[115] In July 1941, they reported that "the French agent of Georges Wildenstein" bought seventeen pictures and shipped them to the United States via Martinique.[116] That is, he managed to transport pictures across the Atlantic during the early phase of the war.[117] On a personal note: when I worked for the PCHA in the late 1990s, I had a similar reaction to the postal intercepts. While they were tantalizing in certain respects, they were inconclusive. Still, it seems likely that Georges Wildenstein moved works from Europe to Buenos Aires after the outbreak of war in September 1939.[118]

While we do not know with certainty if the Wildensteins were shipping looted art to South America during the war, in 1944 the FBI connected the Wildensteins to Paul Graupe, the dealer who continued to transact business during the war and utilized the South American route. The FBI determined that "on December 12, 1941, Paul Graupe opened a third account, entitled 'Special Rene Gempel [*sic*] Account,' with a deposit of $250 in the form of a check drawn on Wildenstein & Company, Inc., a New York art dealer."[119] Furthermore, the FBI connected Graupe and his "business associate" Arthur Goldschmidt (another German Jewish émigré who was based in Havana during the war) to Hans Wendland and also to Theodor Fischer.[120] While this wartime intelligence did not prove that the Wildensteins routed looted works through South America, it demonstrated that they were part of a network in which that did transpire. In this instance, the point is not merely that the Wildensteins had a modest financial tie to Graupe: the Wildensteins were mentioned by name in this FBI report on the smuggling of art from Europe via Latin America to the United States.[121] To be mentioned in connection with Graupe, Goldschmidt, and the other smugglers in a report says something in itself.

Another problem for the Wildensteins arose when Nazi-looted art was

eventually found in their possession. Back in 1998, *Vanity Fair* journalist Suzanna Andrews wrote, "The Wildensteins have been caught with works from the Nazi plunder only once, in the 1950s, when they were found to have a set of 15th-century enamels that had belonged to Poland's Czartoryski family before the war. The Wildensteins settled with the Czartoryskis."[122] The Limoges enamels, which actually came from the thirteenth century, had been sold to the Museum of Fine Arts (MFA), Boston. They were restituted, although the MFA required the Czartoryski heirs to sue them, presumably in order to make a claim against the Wildensteins.[123] These three works, it turns out, had been imported to the United States by Frédéric Schöni in October 1949, and on the customs forms, Schöni claimed that the "person from whom [they were] acquired" was Mr. Vala, at the Hotel St. Peter in Zurich.[124] The identity of this Mr. Vala remains a mystery, but it is notable that Schöni helped the Wildensteins import cultural property that was allegedly looted by the Nazis, and that the claim came from one of the most notable victim families. The Czartoryskis lost works by Leonardo da Vinci, Rembrandt, and Raphael—the last, a portrait of a man, stands out as arguably the most important painting that remains missing. When pressed to reveal where he had acquired items from the Czartoryski collection, Monsieur Georges said, "From a Paris dealer" and provided the name "House."[125] This did clarify the history of the enamels, but the details of the episode remain murky. Regardless, there was a settlement between the Wildensteins and the Czartoryski family members that enabled the MFA to retain the medieval treasures.[126] For the Wildensteins, a settlement was the best course, especially for objects of relatively modest value. Monsieur Georges had his attention focused elsewhere, reportedly investing sizeable resources to fund an aggressive hunt for the Czartoryski Raphael.

The Wildensteins have also been sued in connection with selling other looted works, even if they did not own them at the time that this was discovered. A Monet taken during the war from the family of a German woman, Gerda Dorothea DeWeerth, turned up on the international art market in 1983.[127] A lawsuit ensued, and an investigation indicated that the Wildensteins purchased the painting in 1956 from a Swiss dealer named François Reichenbach, although there were claims that the painting came from someone else. The Wildensteins then sold it to "a New York collector," who held it at the time of the 1983 discovery.[128] Gerda Dorothea DeWeerth filed a lawsuit to recover the work but lost in court, a verdict upheld in 1994: the decision was based on laches—on whether DeWeerth

had done enough earlier to search for the painting.[129] Nonetheless, there was no doubt that the Monet had been stolen from DeWeerth's family. Not only did the Wildensteins buy and sell this work, but in his 1992 catalogue raisonné of Monet's paintings, Daniel Wildenstein did not mention either the DeWeerth family or Reichenbach in the provenance for this contested picture, which was still the subject of a restitution claim. He suggested that the Wildensteins had acquired it directly from Monet's dealer Durand-Ruel.[130] The episode did not reflect well on the family.

A more damaging case arose in 2011 in conjunction with a lawsuit filed by Sylvia Roth, the second wife of Daniel Wildenstein, who charged her stepson Guy with concealing family assets in offshore trusts and "trick[ing] her into signing away her inheritance." In response to the allegations, French authorities raided the Wildenstein Institute on the rue la Boétie.[131] In one of the vaults, they found some twenty-nine works looted from a French Jewish family, the Goujon-Reinachs, including works by Eugène Delacroix and Edgar Degas as well as a painting by Berthe Morisot that came from the Rouart family.[132] Guy Wildenstein claimed in defense, "I didn't inspect the vault" and "We have never had an inventory of the vault"—excuses that generally elicited mocking reviews (the *New York Times* titled one article "Ignorance Is Defense in a Case of Lost Art").[133] But it is doubtless true that the Wildensteins "befriended collectors and stored their art, making it difficult for heirs to track works down after the owners died."[134] Guy Wildenstein also stated that "the Institute was properly in possession of the works that were seized and will respond to any judicial inquiries."[135] Yves Rouart subsequently helped initiate an investigation of the Wildensteins regarding three paintings by Manet that went missing from his late aunt's estate; when an investigation into the Wildensteins' "stockpile of art in the Geneva Freeport" was carried out as part of the probe, authorities found "listings of Manet paintings that arrived in 2016 of which the titles were not specified."[136] Yves Rouart stated publicly that "these could be my aunt's paintings."[137] The matter has yet to be resolved.

The following year, in part precipitated by the discovery of the thirty looted works in the Wildenstein Institute vault, Ginette Heilbronn Moulin, the eighty-five-year-old chair of the Galeries Lafayette department store chain, filed a criminal complaint alleging that the Wildensteins had knowledge about a Monet (*Torrent de la Creuse* from 1889) that had been stolen by the Gestapo from her father, Max Heilbronn, in 1941.[138] The Gestapo raided a bank vault in the southwest of France and took ten paintings from Heilbronn, a French Jewish Resistance fighter. The

work has been missing since the war, but Daniel Wildenstein had included images of it in his catalogues raisonnés of 1979 and 1996, noting in the first that it had an "anonymous owner" and in the second that the owner was "an American." Ms. Heilbronn Moulin tried to compel the Wildensteins to divulge the name of the American who was in possession of the stolen work. Guy Wildenstein referred her to the Wildenstein Institute, but the latter said it had no information on the current location of the picture.[139]

Then there are the allegations that the Wildensteins exploited the production of catalogues raisonnés for their own profit, with British Monuments officer Douglas Cooper asserting that Georges Wildenstein falsified information in his catalogue raisonné of the paintings of Paul Gauguin in order to conceal certain business transactions.[140] Cooper published the critique (at first anonymously) in the high-profile *Times Literary Supplement* in August 1965 in a review titled "Not All Painted with the Same Brush."[141] Cooper alleged, "Pedigrees and quotations have been juggled to suit private needs. . . . The Gauguin oeuvre has been shorn of some authentic works and adulterated with others that do not belong."[142] He added that Georges Wildenstein's "methods have been slipshod and misleading."[143] Furthermore, he asserted that nine of these works with questionable entries in the catalogue had been "sold or exhibited" by the Wildensteins.[144] Litigation ensued, with the Wildensteins filing suit in Great Britain.

Before reaching an out-of-court settlement with the Wildensteins in 1972, Cooper wrote a series of memoranda and letters wherein he detailed several of the allegations against the Wildensteins. Many of these papers are in the Getty Research Institute in Los Angeles, and although they may have been "sanitized" (that is, particularly sensitive documents removed), they contain remarkable allegations. As the case played out over the years, Cooper's estimates of the number of dubious works in the catalogue changed slightly in the various reports and motions, but the effect was always the same, as Cooper made a series of damning statements. Some concerned the competency of the Wildensteins, for example, "In my opinion Daniel Wildenstein would not know a fake if he saw one and I doubt whether he did even 15 % of the work on the Gauguin catalogue."[145] There were allegations of dishonesty; Cooper wrote, "I would not consider Daniel Wildenstein a particularly scrupulous dealer" and "Neither Georges Wildenstein nor his son have ever been considered particularly knowledgeable or honest."[146] Cooper even invoked the notorious episode in 1955 when "it was revealed that the telephone lines of Knoedler had

been tapped and the recorded conversations (commercially most informative) passed to Wildenstein."[147] Other statements by Cooper stressed that the Wildensteins prepared catalogues in order to make a profit: as he put it, "prostituted their scholarship for base commercial motives."[148]

In light of his harsh comments about Daniel Wildenstein, and the fact that he made them with such conviction, it is remarkable that Cooper could find a way to work with the dealers. But he did after Monsieur Daniel invited Cooper to come see him at the rue La Boétie in November 1971 to discuss a settlement. As Wildenstein noted in the letter, "I am sure that we can accomplish good work together."[149] The letters that followed began (on both sides) with phrases like "cher Monsieur et Ami," with Daniel writing in 1972, "In any case, this unfortunate affair at least had the advantage in that it gave me the opportunity to know you."[150] By 1975, Daniel Wildenstein was writing with art historian Raymond Cogniat to Cooper to ask for his assistance in preparing the catalogue raisonné of Gauguin's sculptures. Cooper replied yes, and Daniel Wildenstein arranged for him to have a secretary. One of Cogniat's letters to Cooper noted, "Regarding the material conditions arranged directly between you and Monsieur Wildenstein, I do not think they pose the slightest problem."[151] Such was the world of Douglas Cooper and Daniel Wildenstein—and of Bruno Lohse too.

More recently, Guy Wildenstein and the family faced the fight of their financial lives when they were charged by French prosecutors with parking money and other assets in tax havens around the world. In the words of journalist Michael Wise, "Guy Wildenstein has been under investigation in France since 2011 for tax fraud and money laundering in connection with the estate of his father, Daniel Wildenstein, who died in Paris in 2001."[152] Reportedly, "Upon Daniel Wildenstein's death, his sons declared an inheritance of 40 million Euros."[153] This unconvincing figure, which subsequently came up in Guy Wildenstein's divorce proceedings, was among the factors that led to the investigation, which in turn resulted in Guy spending, according to the *New York Times*, "36 hours in police custody, sleeping two nights in the headquarters of a special art-theft squad outside Paris, where he was formally charged with concealing art that had been reported missing or stolen."[154] French tax authorities claimed that the Wildensteins evaded paying some 550 million euros ($600 million).[155] A French court reportedly required a bond of 10 million euros ($12 million) bail for Guy Wildenstein.[156] The matter was referred to a criminal court in May 2015 and came to trial in October 2016.[157] The French prosecutor requested a sentence of two years in prison and a fine of 250 million euros,

calling the episode "'the longest and the most sophisticated tax fraud' in contemporary France."[158] In January 2017, according to Doreen Carvajal of the *New York Times*, there was "a surprise verdict": Guy Wildenstein was cleared. Judge Olivier Géron acknowledged that "Mr. Wildenstein and his family had demonstrated a 'clear intention' to conceal their wealth over generations," but ruled that "the behavior fell into a gray area before France enacted legislation in 2011 to require the declaration of foreign trusts."[159] The stunning acquittal saved Guy Wildenstein from time in jail—as well as a great deal of money (the family had sold off art to create a kind of war chest)—but the litigation nonetheless shed negative light on the family's business practices. The French state also managed to a secure a judge's ruling for a retrial, and prosecutors continued to pursue the $534 million in back taxes and to raise questions about works in the vault of the Wildenstein Institute.[160] In June 2018, Guy Wildenstein prevailed in the second iteration of the case, with the judge ruling, among other findings, that too much time had passed since Daniel Wildenstein's death in 2002, when the first deceptive tax declaration was generated.[161] With the second acquittal, Guy Wildenstein emerged from years of litigation much better off than most had anticipated.

So what was the relationship between Lohse and the Wildensteins, and what are the deeper implications of what we know at present? It is most probable that Monsieur Georges and Lohse met in 1951. The latter was released from prison in August 1950 and returned to Germany. It is unlikely that he would have found a way to see Georges Wildenstein before he went to Lake Constance immediately after his release. If Lohse's account has any accuracy, Monsieur Georges called Lohse back to Paris in 1951 and offered him a choice of pictures (if that is in fact what happened). According to Yves Stavridès, Monsieur Georges arranged for his son Daniel to meet Lohse around 1960, indicating that the father was prepared to initiate his son into what must have been at that time a secret relationship. Stavridès recalls that when Monsieur Daniel recounted his first meeting with Lohse, "his [Daniel's] faced turned ashen gray," but then, for some reason, his mood changed. Monsieur Daniel observed that Lohse was "charming" and that "he spoke our language very well." Daniel used the word *brilliant* several times in connection with Lohse, and said that "the German clearly knows his stuff—or something to that effect."[162] But this is merely one account, filtered through a witness long after the fact.

Lohse's relationship with the Wildensteins can also be considered through his contact with their employees. We know, for example, that

Lohse was in touch with Roger Dequoy during the war, and then also early in the postwar period. Dequoy wrote Lohse's defense in July 1947, claiming that Lohse had helped him avoid arrest by the German authorities during the occupation. Dequoy had faced charges for having "concealed property of Jews stemming from the *maison Wildenstein*" Dequoy added, "I swear under oath that Dr. Lohse never demanded any remuneration from me."[163] Of course, documents of this kind often suggest more than the short, simple statements they contain. Lohse and his lawyers first had to locate Dequoy (in the document, Dequoy gives his address as 4 rue Saint-Florentin, Paris), inquire whether he would be willing to help, and then secure the statement. Considering that Dequoy worked for the Wildensteins again after the war, and what is known about the Wildensteins' management style, it seems unlikely that Dequoy would have written in support of Lohse without first obtaining the permission of Monsieur Georges.[164] Lohse also said that he had a close relationship with another key employee, art historian Philippe Huisman (sometimes rendered as Huysmann), onetime director of the Wildenstein Institute and author of books on Henri de Toulouse-Lautrec, Berthe Morisot, and van Gogh, among others. Huisman had a personal relationship with Daniel Wildenstein, with whom he worked for several decades.[165] Huisman reportedly grew so close to Lohse that he sent his two children to stay with Lohse and his wife in Munich one summer. Lohse expressed great fondness for Huisman and said the latter's daughter suffered a tragic fate when she committed suicide. It appears that Lohse was welcomed into the Wildensteins' world, but again, there is much here we do not know.

Another tantalizing but ambiguous piece of information that may bear on the relationship between the Wildensteins and Lohse in the early postwar period comes from Karl Haberstock, who extricated himself from the Allies' scrutiny fairly quickly (he had been interrogated at Schloss Pöllnitz along with Hildebrand Gurlitt, and then subsequently went through denazification with relatively few difficulties). Haberstock wrote his close friend Swiss dealer Theodor Fischer on 3 August 1948 offering an update on the trials of German dealers in France. Haberstock explained that he had been in touch with Konard Voelkl, a German lawyer who defended many Nazis charged with crimes, including Lohse. Haberstock then told Fischer, "The attorney Voelkl indicated, among other things, that a Parisian art dealer [or art dealers—there is no article in the German original and it is ambiguous] will pay for Lohse's attorney and that Lohse's situation is in good shape, such that he can reckon on being exonerated."[166] So

the question is: what Parisian art dealer, or dealers, covered the costs of Lohse's French attorney? As mentioned earlier, Lohse was represented in Paris primarily by Albert Naud. While Haberstock may have been referring to Victor Mandl, for whom Lohse worked immediately upon release, or even Paul Cailleux (who penned an affidavit on Lohse's behalf), it is also possible that he was talking about Georges Wildenstein. There is no evidence that confirms this theory, but in my view, it is likely. Haberstock appeared to be well informed about Lohse's trial in general and proved correct about the verdict, so we cannot dismiss his claim about a "Parisian art dealer" paying for Lohse's legal defense. In any event, Lohse was set free on 4 August 1950.

Another possible piece of evidence is a February 1951 letter from U.S. Monuments officer Theodore Heinrich to S. Lane Faison, then the director of the Central Collecting Point, which reports "a top secret agreement with Wildenstein": "Our dear friend K. Haberstock [is] now in the course of installing himself in new quarters nearly opposite the Haus der Kunst. [Haberstock] is sub rosa a Wildenstein partner and . . . their secret go-between is Grace Morley's former protégé Heinz Berggruen."[167] This was some news: Karl Haberstock was *the* Nazi art dealer—he sold more works to Hitler prior to 1943 than any other dealer. Assuming any of this is true (and the Wildensteins would probably deny it), the possibility that Wildenstein would renew his business relationship with Haberstock who, like Lohse, had handled Wildenstein property during the war, makes it seem more likely that Monsieur Georges would engage Lohse.

The report is also intriguing because of others who are mentioned. Heinz Berggruen (1914–2007) was a German Jewish journalist turned art dealer who had been in the United States after 1936, but then returned to Europe after the war and created a very successful business, amassing a world-class art collection in the process. Berggruen became a famous and powerful figure in the art world and has a museum in Berlin that exhibits part of his collection (including eighty-five Picassos). In that Berggruen installed himself in Paris after the war, it is feasible that he made contact with Wildenstein. Berggruen also became a Swiss citizen, and had myriad contacts in the Alpine republic. But how he came to know Haberstock remains a mystery. Grace Morley (1900–1985) had been the founding director of the San Francisco Museum of Modern Art in 1934 (as well as Berggruen's boss there) and went on to head the fine arts division of UNESCO. While she had many international contacts, she seems not to have been caught up with the dangerous set like Berggruen. Theodore

Heinrich added in the above-quoted letter, "With the exception of Grace, any of the persons mentioned in this paragraph and any other persons who appear to be connected with them in any way should be regarded with acute suspicion. Berggruen is apt to use Grace's name by way of introduction, but she certainly knows nothing of his rather shady subsequent operations." It is also striking that Theodore Heinrich reported on the use of an intermediary (Berggruen), who presumably made it more difficult to connect Monsieur Georges and Haberstock. It is unlikely that the Wildenstein-Berggruen-Haberstock partnership ever materialized (at least no evidence of it has come to light), but it is certainly possible that the principals undertook discussions of this topic in the late 1940s and early 1950s. The Monuments officers were well informed and their reports and letters contained a great deal of "intell." Based on all of this, it seems the Wildensteins and Haberstock almost certainly remained acquainted after the war, colleagues within a network, albeit with a very complicated history.

The key intermediary for Lohse and the Wildensteins, if there was one, was Frédéric Schöni, the Zurich-based attorney who worked for the Wildensteins from the late 1940s, if not earlier. Lohse and Schöni were acquainted by the mid-1950s at the latest. Although the letter documenting the terms of the Pissarro "sale" to Schöni dates from 1957, Lohse and Schöni must have had a relationship prior to that point in order to trust one another with a looted picture. After all, they contrived the 1957 letter about the Pissarro as a cover-up. The document represented a conspiracy, a lie about the true owner of the picture (Lohse). That speaks to a relationship based on trust, and establishing such probably took time. That the representatives of Schöni's foundation in Liechtenstein subsequently concealed the partnership of the two men for decades also speaks to a degree of trust, of a deeper form of collusion. The formal founding of the Schönart Anstalt, official records in Liechtenstein show, dates to 1 June 1978, but there is clearly a prehistory going back to the mid-1950s, if not earlier.[168]

Who was Frédéric Schöni? While we encountered him in the previous chapter as Lohse's lawyer and collaborator in hiding the Fischer Pissarro and other assets, this question is not easy to answer. He is not mentioned, for example, in the official report on Liechtenstein and the international art market that the Independent Historical Commission of Liechtenstein released in 2005, and he does not appear on the Allied investigators' "List of Swiss Lawyers in Zürich Said to Be Hiding German Assets" (a com-

pendium of some sixty-five names that raises a new set of questions).[169] But the short answer is that Schöni had a law practice right in the heart of Zurich, initially on the Pelikanstrasse but, as of 1971, an establishment on the Bahnhofstrasse in the banking and retail district. Schöni opened his Zurich law practice in 1932, focusing on international law; he had written his doctoral thesis on the Great Powers and international agreements in the nineteenth century. He appeared to have ties to France. I learned later that Schöni was what Walter Feilchenfeldt called an "old school" Swiss type: by this he meant a specialist in concealing assets for the purposes of tax evasion. Feilchenfeldt added that Schöni "did things then that he could not get away with today."[170]

Frédéric Schöni gravitated toward the art trade fairly early in his career. One document from 1947 that bears the stamp of his law firm involves the Tribunal Civil de la Seine, and it mentions not only the Wildensteins but also Hofer, Haberstock, and Wendland (a copy was placed in Wendland's file in the Swiss Federal Archives).[171] Other documents in the same archive show Schöni asking the Kunstmuseum in Bern, "in the name of the Wildensteins," for the return of a Gustave Courbet painting in 1949. The picture, titled *Le Réveil*, had been sold by Roger Dequoy on behalf of the Aryanized Wildenstein & Cie to Haberstock, who then sold it to Theodor Fischer who, with the help of Basel dealer Willi Raeber, placed it with the Bern museum.[172] Schöni and the Wildensteins were unsuccessful in their claim and the picture remains in the museum to this day. But the accessible correspondence shows that Schöni represented the Wildensteins by 1948 at the latest.[173] Schöni also knew a number of artists, with Marc Chagall (1887–1985), for example, executing a sketch in 1972 on the title page to one of his books.[174] The brightly colored crayon drawing is personally dedicated to Schöni and is a casual, whimsical effort that suggests a friendship between the two men.

What did Frédéric Schöni do for the Wildensteins? The files in the U.S. National Archives and the Swiss Federal Archives (Schweizerisches Bundesarchiv in Bern) show most clearly that he helped them import paintings to the United States in the late 1940s and 1950s.[175] The documents in this file include customs forms showing Schöni arranging airfreight shipments for the family from Geneva to New York as early as 1949. In this document, Schöni listed the shipping agent as "S.A. de Beaux Arts, Vaduz." The "S.A." may stand for Schönart Anstalt. If so, then the foundation that obtained the Fischer Pissarro dates back to 1949. The cur-

rent lawyer for the Schönart Anstalt, Andrew Baker, told me in general terms that it is common for these foundations to be terminated and then reformed. We don't know if Lohse was involved at that point. The Landes-archiv in Liechtenstein has no documents relating to Schönart. Yet we know that Schöni was shipping millions of dollars' worth of art for the Wildensteins. How did Schöni obtain the works? They may have come from the Wildensteins themselves, who then had Schöni transfer the art to the Wildenstein Gallery in New York. A habitué of the rue la Boétie stated in June 2016, "Daniel W. didn't really confess the turpitudes of the family in Switzerland, but a friend of mine—who knew very well the 'old man' [Georges Wildenstein]—told me that after the war they used a pri-vate plane which used to make trips between Paris and Geneva. I guess paintings were in the plane, but we can't prove it or write it, even if I think (I'm sure) that most of the major French art dealers did it during the 1950s and at least until the '60s."[176] While this source took care here to make it clear that these assertions remained unverified, there was also confidence in this claim about the Wildensteins pioneering the use of a private plane to transport art to and from Switzerland. The Wildensteins later publicly advertised their use of private jets: a later iteration was adorned "with the family's insignia of three blue horseshoes on its tail [which] made conti-nent hopping easy."[177]

U.S. customs agents were paying attention. Schöni had to meet with the U.S. Consul in Zurich to arrange for these shipments. For example, in one set of notes from November 1949, a State Department employee named Mr. Stephens reported that "as objects were not brought in from [the] U.S. Zone of Germany in violation of M[ilitary] [G]overnment Regulations, there is no violation under current law."[178] Five years later, the same Mr. Stephens investigated the importation of a fourteenth-century French painting on wood by Jean de Beaumetz, an eighteenth-century painting by F. H. Drouais, and some reliquaries.[179] The Wilden-stein staffers said the pictures were acquired from a seller named "Pollock," but they were unable to provide an address for him. There were Pollacks who lost art in the Third Reich (for example, Ernst and Gisela Pollack in Vienna, who were fabulously wealthy and who lost many works that were never recovered), but no match was ever made with property imported by the Wildensteins.[180] Because S.A. de Beaux Arts shipped the objects, Schöni was also asked where they came from, and he told a different story. He said that he had acquired all the objects from a "Mr. Vala at the Hotel

St. Peter, Zurich, on 29 October 1949."[181] Although the two stories did not jibe, U.S. Customs officials were initially not able to make a case, and the works were allowed into New York.

The information provided by Schöni and the Wildensteins certainly appeared to be contradictory. Could this have been intentional, as it would turn out the reliquaries came from a problematic source? U.S. officials discovered that the enamels were in fact looted, having been stolen from the Czartoryski family's castle at Goluchow near Posen (Poznań) in 1939. However, this discovery came only after the Wildensteins had sold them to the MFA in Boston. As noted earlier, the Wildensteins proceeded to enter into a settlement in the early 1950s that kept the works at the museum. But the fact remains that Schöni shipped Nazi-looted art from Switzerland to the Wildensteins in New York.

Frédéric Schöni, like Bruno Lohse, was apparently a cog in the large and elaborate machine that was the Wildensteins' business. According to journalist Suzanna Andrews, "It was Georges who set up the Wildensteins' famous network of spies—notaries public in French villages, art historians, and auction house employees. For a retainer, they fed him information that made the Wildensteins legendary in their ability to know what artworks were available, where they were and at what price."[182] Andrews then quoted a former auction house official who noted, "You'd be surprised who they were—very highly placed people."[183] Indeed, some of Monsieur Georges's informants and agents hailed from surprising milieux.

The 1984 exhibition of French Impressionist paintings at the Fondation de l'Hermitage in Lausanne was a creative and symbolic expression of the Wildensteins' power.[184] Organized by respected art historian Dr. François Daulte (1924–98), the exhibition brought together remarkable and rare artworks from a variety of collectors. Five came from Lohse: the Fischer Pissarro, the Renoir and Monet later found in the Swiss bank vault, a Sisley (*L'Abreuvoir de Marly*), and a Corot (*Sitting Woman Holding a Mandolin*).[185] Those who know the art world, including Professor Claus Grimm, identified François Daulte as "a Wildenstein man."[186] The pictures on display in the Swiss Alps arrived on loan from collectors and dealers in the Wildensteins' network. With the works interspersed with paintings from the Wildensteins' own august holdings, it was a symbolic display of their power.

Bruno Lohse, like a good vassal, was honored to play his role. He invited his friends Peter Griebert and Claus Grimm to travel with him to Lausanne for the opening.[187] They both recalled his pride of place: to be

present on such a public occasion with then patriarch Daniel Wildenstein, and to have five works of such caliber that belonged to him was one of the high points of Lohse's life. Of the five works that he placed on loan in 1984, some likely came from the Wildensteins. Both Griebert and Grimm reported that Lohse sometimes took payment for his services in the form of pictures, and the Wildensteins could afford to part with lesser or "problematic" (that is, looted) works by well-known artists. It is also telling that Daulte would know to approach Lohse to borrow the five French Impressionists; he likely used intelligence from the Wildensteins. It is also significant that Lohse responded affirmatively to the invitation, thereby undertaking a risky act (and indeed, showing the pictures in Lausanne ultimately helped trip him up with regard to the Pissarro). Lohse opened himself to discovery in this Wildenstein-organized event. His precise motivations remain elusive — whether out of respect, pride, gratitude, or business reasons — but the inclusion of Lohse's long-concealed Impressionist pictures at the Hermitage Lausanne show constituted further evidence of the Wildenstein-Lohse relationship. Later on, in 2002, Lohse showed me a copy of the Daniel Wildenstein and Yves Stavridès book *Marchands d'Art*, stating proudly that this volume had been presented to him by Monsieur Daniel. Stavridès confirmed that the latter bought about three hundred copies of the book to bestow on friends, clients, and visitors — including Lohse.[188] The tome meant a great deal to Lohse — he interpreted it as yet another sign that he was appreciated by the Wildensteins — even if he was not mentioned in it.

Will the Wildensteins ever answer questions about their ties to Bruno Lohse? A French journalist, Philippe Sprang, reported that a representative of the family — or, in his words, "those responsible for the gallery" — "stated formally that Bruno Lohse never worked for Wildenstein."[189] This denial evidently came in response to an inquiry from filmmaker and journalist Maurice Philip Remy, who had also heard Lohse's stories. Remy, Sprang wrote, maintained that Lohse had worked for the Wildensteins.[190] The Wildensteins' formal response to Sprang may have entailed a parsing of words: while Lohse was almost certainly never formally an employee of Wildenstein, as the representative maintained, this formulation did not preclude his having had business and personal relations with family members. When Peter Griebert wrote to Alec Wildenstein to inform him of Lohse's death in March 2007 — "I am sorry to inform you that Bruno Lohse, good friend of you and your father, died [a] few days ago" — Alec Wildenstein responded promptly in a simple but revealing let-

ter. He wrote, "I have known Bruno for more than sixty years and he was always a good friend," adding, "With my deepest sympathy and warmest regards . . ."[191] For Alec Wildenstein to have known Lohse for sixty years would have effectively meant his entire life. This meant that Lohse knew Alec's father Daniel (as Lohse always maintained). There would be no way for a ten-year-old boy to make the dealer's acquaintance without his father. For Alec to write such positive lines about the problematic Dr. Lohse is also telling. Considering how careful family members are about their image—especially when a Nazi art plunderer is concerned—Alec's words stand out as an extraordinarily daring admission. Alec himself died the following year, in 2008, from prostate cancer and cannot provide an explanation of his remarks.

Two individuals told me of accompanying Lohse to meet Daniel Wildenstein in the 1980s. Peter Griebert offered the account rendered in the introduction of this book. The other, Professor Claus Grimm, said he traveled with Bruno to Paris on two occasions. Grimm offered a number of details that made his account appear credible. He described Daniel Wildenstein as "very self-assured, yet sincere. He had a great deal of inner energy, seemed tightly wound, yet in a very elegant environment."[192] Professor Grimm, now retired, was formerly the director of the House of Bavarian History in Augsburg. He possesses a sterling professional reputation, and his testimony about accompanying Lohse to 57 rue la Boétie appears highly credible.

Perhaps it should not come as a surprise that Lohse and the Wildensteins would find one another. Lohse had once assisted in the theft of the Wildensteins' art, and not all of it had been recovered. Maintaining a relationship with Lohse offered the Wildensteins a way to locate missing family property as well as other looted works. Lohse had remained a player in the art world in the postwar period, and the Wildensteins were in contact with many influential figures in this milieu. Daniel Wildenstein noted in 1978, "The merchandise is getting scarcer. When you sell a fine painting, you can not replace it."[193] He saw this scarcity of inventory as the key reason for the decline in the great art dealers—as part of the Darwinian struggle that characterized the profession. That an employee of their firm surveilled their chief rivals, Knoedler & Co., in the mid-1950s provides yet another sign of their tactics.[194] The Wildensteins, then, played for high stakes and evidently derived advantages wherever they could find them. In her memoir/family history, Anne Sinclair, a granddaughter of dealer Paul Rosenberg, writes of her grandmother, "Apparently, she had had an affair

with a man who was one of my grandfather's major competitors in the art world, Georges Wildenstein, who . . . for a time was Paul's business associate."[195] The question of Monsieur Georges's ethical compass remains just that—a question.

Perhaps the Wildensteins' relationships with Lohse were part of their effort to overcome the traumatic events of the war. Even though Monsieur Georges and his family got out, it was a harrowing ordeal. For the Wildensteins, a business relationship with Lohse provided a way to normalize the past. The ERR co-director was not a mythical or even historical figure, merely an ordinary individual with whom they had contact. From my discussions with Lohse, it was clear that he felt honored to have an association with the family. According to Lohse's stories, the Wildensteins clearly had the upper hand in this relationship. They determined when they met, what works they would discuss, and, by and large, what transpired. From Lohse's description, the Wildensteins had power over the Nazi who had once played a key role in determining the fate of their Paris gallery. Peter Griebert suggested that Lohse's saving their archive and library during the war formed the basis of the relationship.

One other factor that may have entered into the dynamic concerned Theodore Rousseau, the OSS officer turned Met curator of European paintings. Rousseau not only kept in touch with Lohse, but he and the Met clearly did business with the Wildensteins. The art dealers, for example, helped Rousseau and Thomas Hoving acquire Velázquez's famed *Portrait of Juan de Pareja* for the museum in 1971.[196] But there may have been more than a simple buyer-seller relationship between the Wildensteins and Rousseau. Michael Gross, who penned an unauthorized study of the Met Museum, aired the rumor that Rousseau received monetary compensation from the Wildensteins as part of the deals involving important paintings. Gross noted that Georges de la Tour's *The Fortune Teller* "remained controversial and was denounced several times as a fake—and forever after, rumors that he [Rousseau] took kickbacks from Wildenstein would dog Rousseau."[197] Gross also quoted a former Met employee, Don Holden, who explained, "You must understand, there's a lot of skullduggery and payoffs and smuggling and this is normal procedure." Holden added that Met director James "Rorimer, who had been [in the war] understood that too."[198] While such allegations remain unproven, they raise questions. If such payments occurred, did they speak to a lack of a moral compass on the part of the dealers and Rousseau himself? Were such payments from dealers to curators a part of the art world culture of the time, as Michael

Gross suggests? Was there a kind of network at play that included the Wildensteins, Rousseau, and Lohse? These questions are unanswerable at the moment, but the fact that these rumors have surfaced in recent times makes the questions worth asking. In a recent note regarding a letter that Lohse sent Rousseau in 1959, wherein he offered a Cézanne valued at 1 million Swiss francs, Walter Feilchenfeldt remarked, "Hard to say which one is more antipathetic: the sender (Lohse) or the receiver (Rousseau). I think both of them were equally criminal in their respective ways."[199] Feilchenfeldt would not talk about the Wildensteins.

There are three general theories that stand out to explain the relationship between the Wildensteins and Bruno Lohse. One centers on profit, the second considers art as a "sickness," and the third focuses on extortion (while acknowledging the importance of profit). With regard to the first theory, Lohse helped them make money. Whether this was finding missing (if sometimes looted) works, facilitating their transfer through Switzerland and Liechtenstein, or performing some other function, Lohse enhanced the Wildensteins' bottom line. At the end of the day, the relationship simply may have come down to profit, to greed.

French journalist Yves Stavridès has offered another explanation: "Art is a sickness."[200] The passion for art—to acquire, to own, to determine the fate of an extraordinary piece—blinded the Wildensteins to other considerations. Stavridès even used the word *deranged*, in the sense of losing one's bearings, or one's moral compass, when in the thrall of an artwork. For many who suffer from this "sickness," art is more important than people, more important than any other consideration. The Wildenstein family's tradition of connoisseurship, the stress on developing an "eye," and the way art served as a common bond among them, may have made them vulnerable to this affliction. Clearly, with their wealth and their status in the art world, the Wildensteins had no rational reason to engage with Lohse. But, Stavridès says, "both Monsieur Georges and Monsieur Daniel were sick in this way."[201]

The third theory focuses on the power that Bruno Lohse had over the Wildensteins. Why did they consort with Lohse, to quote Alec Wildenstein's letter of 4 April 2007, "for more than sixty years"? The answer may lie in the Wildensteins' wartime behavior. There are allegations that Monsieur Georges interacted with Nazi dealers, that he trafficked in looted works, and that he held on to and concealed Jewish collections. The family has been aggressive, and sometimes litigious, in responding to certain assertions about these issues. Yet if the allegations were true, who would have

been better positioned to know the truth than Bruno Lohse? The "king of Paris" and "savior" of the Wildensteins' archive during the war—Dr. Bruno Lohse—may have had knowledge about whether Monsieur Georges had collaborated with the Nazis and profited from their looting of art. This theory posits that Monsieur Georges recognized Lohse's power and therefore sought to keep him close. What better way to control Lohse than to keep him in the Wildensteins' orbit? The Wildensteins cultivated a sense of loyalty with their employees, and that would have been the goal with Bruno Lohse: to make him feel part of a family, honor bound, to sense the reciprocal obligations in a neo-feudal manner. The Wildensteins would take care of him, and in return, he safeguarded their secrets.

On the Trail of the
Nazi Plunderers

I T WAS JUNE 1998 and I was in Salzburg, as I was almost every summer in the 1990s. My close friends Timothy and Marie-Louise Ryback lived in Schloss Leopoldskron, where Tim served as the director of the Salzburg Seminar, and Marie-Louise headed alumni relations. The Baroque castle served as a meeting place for scholars, politicians, business leaders, and many others. The seminars usually lasted five days or so, and in between sessions, the Rybacks and other staff had their run of the place. Schloss Leopoldskron is a magnificent structure. Built by the local prince archbishop in the seventeenth century and then renovated by theater impresario Max Reinhardt in the 1920s, the castle was one of the main sets for the film *The Sound of Music*. My favorite room in the building has always been the Baroque library (although the Venetian Room with its mirrors and harlequins is also dazzling). Also impressive is the Great Hall, with its huge marble fireplace and the panoramic views it affords of the lake and Untersberg mountain behind it.

It was a typical June evening in Salzburg, dark clouds and pouring rain. Actually, it had been a beautiful day and thunderstorms had rolled in that afternoon. The lightning striking the Alps, which I had witnessed while driving back from the Salzkammergut, had been spectacular. I was now joining the Rybacks and some other staff from the seminar in the Great Hall for dinner by the fire. We had a feast of cheeses, sausages, mustards,

and all sorts of local specialties. One of the program directors, a recent PhD named Russell Riley, asked me what I did. Before I could respond, my friend Tim jumped in: "Jonathan goes and visits old Nazis."

I protested that this wasn't really true—or not completely true. I did many other things. But it was true that in the previous week, I had met with Lohse, with Leni Riefenstahl at her home in Pöcking near Lake Starnberg, and with Dr. Wilhelm Höttl (1915–99), an SS officer who lived in Altaussee. All three knew each other. Lohse had communicated to Höttl (either through post or by telephone) and vouched for me. Höttl then agreed to meet with me, and he, in turn, told me about Mühlmann and Leni Riefenstahl, the actor and filmmaker who had done so much to glorify Hitler and the Nazis. I therefore went to see Leni Riefenstahl to ask her about Mühlmann. She received me at her home. The ninety-six-year-old woman seemed frail but sharp. I brought a box of Godiva chocolates and explained my book project. After speaking with her for ten minutes or so, I asked her if she knew Kajetan Mühlmann—and she did not react in a positive manner. She effectively threw me out, suddenly saying that she didn't feel well and that I must go, whereupon her friend Horst escorted me to the door. A few days later she sent me a signed photo from the 1920s, a shot from one of her films in which she had donned a leather aviator's headgear— which seemed rather strange. I didn't know what to make of it, but a few years later I found a photo of her and Mühlmann together in Vienna at the opening of her film *Olympia* in 1938. When she had terminated our interview back in 1998, I suspected that she was concealing her friendship with Mühlmann, but the subsequent discovery of the photo still disappointed me. She had effectively lied. I was not surprised, but I had hoped for more. Nonetheless, I remember recalling that I was lucky to live in the late 1990s and early 2000s, when a number of the key figures in the Third Reich were still alive, yet enough time had elapsed for witnesses to feel more comfortable sharing their stories. The fear of prosecution had diminished and many were prepared to talk.

I therefore attempted to track down as many witnesses to Nazi art theft as I could. Hilde Mühlmann, the widow of Kajetan Mühlmann, probably the most prodigious art plunderer in World War II, was near the top of my list. Hilde Mühlmann had also been a Nazi Party member and their 1942 marriage had been personally approved by Heinrich Himmler—Mühlmann being a colonel in the SS.[1] Thanks to documents given to me by a friend in Vienna, Professor Oliver Rathkolb (he had files from the Documentation Archive for the Austrian Resistance), I had learned that

she had lived for many years in the postwar period in a village on the Attersee called Seewalchen—the town in the Austrian Alps where her husband had surrendered to the U.S. Army on 13 June 1945.[2] She had written to authorities in Vienna from the village in 1960 saying that her husband had died abroad, and I regarded this letter as a valuable clue.[3] It turned out she did not live in Seewalchen, but I had tracked her down. The year before, as I was visiting the cemetery of the town, wondering if she had been buried there (and her husband too, for that matter), I had struck up a conversation with some elderly ladies. After a bit, I asked them if they knew Frau Mühlmann, and they said yes—that she had been the math teacher at the local high school (*Gymnasium*), which was quite a distinction. They told me where to find her house, situated on a nearby lake, and I headed off to continue my search. I knocked on the door of an enchanting chalet, and the person who answered said that Frau Mühlmann did not live there anymore. However, he knew where she had gone—to a neighboring town—and provided me with an address. I thought it notable that every resident of one of Hilde Mühlmann's houses knew her next address. The communities in the Austrian Alps were tight-knit. Perhaps the most surprising thing was that the locals gave me any information at all. But they were a friendly lot and they evinced great appreciation for my German, American accent and all. In short, my efforts enabled me to find her house in the town of Kammer am Attersee. But on that occasion she wasn't home. I did not have time to wait for her to return, but these efforts paved the way for the 1998 visit.

I had also managed to obtain Frau Mühlmann's telephone number, and I called her when I was back in the United States. We had a polite chat. She was guarded, but supplied some helpful details, especially about her husband coming back to the Salzkammergut to visit her and the children when he was a wanted man in the 1950s. This was consistent with what Lohse had told me: he recounted seeing Mühlmann in the early 1950s and recalled that the latter was "nervous—always looking about as if someone might try to apprehend him." When I telephoned Frau Mühlmann a second time, she was less helpful. She clearly did not want to make our conversations a regular occurrence. I thought I might do better with her if we met in person and asked if I might visit her the following summer. She discouraged me, but did not say no. She repeated that she did not know anything, and we signed off somewhat awkwardly. I was in the final stages of completing *Faustian Bargain:* the chapter on Mühlmann had been drafted and I felt I had little to lose by paying Frau Mühlmann a visit. At worst,

she would send me packing and I would be no worse than I was before. I would have preferred not to surprise her, but perhaps, I thought, it might be easier not to announce my visit so that she wouldn't be anxious before I arrived. The reality was that I had few other choices.

As I approached the village of Kammer on the Attersee, I stopped at a local market and bought some flowers (live begonias). I jumped back in the car and headed to her home, which was in the gatehouse to a grand ochre-colored villa. Gustav Klimt often painted this castle and the lake that now shimmered behind it. (In fact, Tim Ryback had a poster of Klimt's painting of Frau Mühlmann's house back in his office at the Salzburg seminar — of course, without knowing who currently inhabited it.) I rang the doorbell and then knocked, standing nervously with my begonias. There was no answer. Just like last year, I thought.

Almost absentmindedly, as I thought about what to do, I wandered around the perimeter of the gatehouse, which gave me a better view of the villa and the lake. There was a decomposed granite path to the main entrance and I walked in that direction a few steps. Then, on my right, I saw an elderly lady in a sun hat working in a garden tucked behind the gatehouse. She looked up and said pleasantly, "Grüss Gott." I offered my American-accented reply. After commenting that it was a nice day (and it was indeed a truly glorious day in the mountains), I mentioned that I was looking for Frau Mühlmann. She smiled, blushed a bit, and said that she was Frau Mühlmann. I told her who I was, and that I just happened to be in the area as I held out the flowers to her — rather pathetically, I knew. I feared that she would refuse to talk and send me away, but she showed a flash of recognition and then said to go around to the front door and to give her a minute. I took my flowers and went around front.

The door opened about three minutes later and Frau Mühlmann appeared, wearing lipstick and a modest amount of makeup. She was about eighty and still quite attractive, with lively green eyes. When I had recently reviewed Kajetan Mühlmann's SS files from the former Berlin Document Center (now the German Federal Archives in Berlin-Lichterfelde), I had seen the description of her eyes and a report on her racial background, as well as the aforementioned letter of approval for the marriage from Himmler. I could not help but think she still looked fit, even as the SS documents haunted me. Frau Mühlmann invited me in for coffee. It was about 11 a.m. and I was delighted to accept. As we began to chat she was helpful, even expansive in her answers. It was much different than on the telephone. Hilde Mühlmann told me that she had shared a villa on the lake

at war's end with opera diva Elisabeth Schwarzkopf and that the Americans had tipped her husband off to the Poles' extradition request in 1948 and allowed him to escape.[4] Mühlmann lived quietly in Munich at Isabellastrasse 20 — in a Schwabing apartment building less than a mile from the former Munich Central Collecting Point. In fact, he devoted himself to a book on the National Socialist cultural policy, an effort that has never seen the light of day, but would be of tremendous interest to scholars.[5] Frau Mühlmann also provided more details on her husband visits in the 1950s: he remained a devoted father and took the risk of returning despite being a wanted man in Austria.

By noon I was on a ladder climbing up to peer into her attic, looking for her old photo albums. I recall smiling, imagining that I would find the Raphael portrait as well. Some fifty-five years earlier, at war's end, the ALIU had documented numerous hiding places containing looted art that Mühlmann had established in the Austrian Alps. He had dispersed objects to friends and family members: more than half a dozen stashes in all. While the Americans found many of his hidden treasures — including pictures, sculptures, and tapestries (about a dozen Dutch Old Masters in the town of Kammer), as well as liquor, cigars, and other luxury goods — they clearly did not recover all his loot.[6] Wilhelm Höttl had told me that when Mühlmann came to see him in Altaussee — often on his way to Kammer am Attersee to visit his family — the ex-plunderer would offer him artworks for sale.[7] It was therefore exhilarating to be nosing about in the attic of Kajetan Mühlmann's widow. Of course, I found only the photo albums, but it was still one of those "gold mine" visits when I felt as though I had struck a rich vein. Frau Mühlmann allowed me to copy all her photos with my camera.

Frau Mühlmann told me she did not discuss wartime events with her husband — not even at the time. She knew Kajetan's first wife, Poldi, who lived in a suburb of Salzburg until her death in the early 1970s. Hilde and Kajetan had married in 1942 soon after the divorce (they already had three children together), and Poldi had been given the villa in Salzburg-Anif. I asked Frau Mühlmann whether she knew that the house Poldi lived in had been Aryanized — that is, sold off by the state at a cut-rate price in 1941 when the owner, Helena Taussig, was deported to the east and killed.[8] She had never heard that. She knew the house in Salzburg-Anif, but nothing about the previous owner. I learned recently after finally being granted access to the Aryanization files in the local Salzburger Landesarchiv that Poldi Mühlmann herself had known about the villa's origins: Poldi wrote

to Gauleiter Friedrich Rainer in March 1941 inquiring "whether it would be possible to acquire a small house in Anif in which an Aryanization has taken place."[9] She also declared her willingness to stop by his office in Salzburg to discuss the matter. She evidently realized her objective with the Anif house. It bears mentioning that while the authorities had opened their files to an unprecedented extent in 1997 to allow me to see this and related documents, they were not prepared to permit copies of photographs. I was allowed to take notes only.[10] Frau Hilde Mühlmann on the Attersee chose to avoid this history: she said to me repeatedly that she could not understand why I was interested in her husband. One of her daughters was a much more accomplished art historian, she said, director of a gallery in Innsbruck. I told her that her husband had been involved in *Kunstraub* (art theft), or at least I implied as much, but I didn't have the heart to tell her the full extent of his deeds. I could not see how that would help. She was pleasant and I did not want to alter this friendly atmosphere.

As I told Tim, Russell, and the others this story—again, in the Great Hall illuminated by a roaring fire and candlelight—those assembled decided that I should produce a television series in which I would visit a different old Nazi in each episode—someone suggested that I call the program *This Old Nazi*. We made light of the enterprise, but also agreed that it probably would make for a compelling program. I never forgot this conversation, and it helped inspire me to write this book, wherein I have tried to present many of the characters whom I encountered in my research.

Although there is a certain entertainment value in these accounts of meeting with old Nazis, more serious purposes are also served. These aged people provided information useful for the tracking of missing artwork. No one knows how much is still missing, but one estimate from an official at the Louvre reported that of the works removed by the Germans from France, only about 80 percent were recovered. That is, 20 percent of what the Germans seized and displaced is still "missing."[11] And this is a figure similar to Otto Wittmann's in his report on his final mission to Europe as part of the ALIU: he phrased it that "75 to 80% of the works of art taken by Germany [has been] returned."[12] Even if that figure is too high: if only half that amount, 10 percent, of the Nazi-looted art remains unrecovered—that is a lot of art. These old Nazis had knowledge regarding many looted artworks in the postwar period, and they understood that Switzerland and Liechtenstein offered particular advantages. The key one concerned a business culture that prized discretion. Suffice to say, it is only recently that we have gained even the most preliminary understand-

ing of this lucrative nexus of the art trade, banking, and corporate law. The Swiss and Liechtenstein governments established historical commissions back in the 1990s that published important volumes.[13] Journalists like Thomas Buomberger have also made major discoveries about the art trade in Switzerland and Liechtenstein.[14] But much of the crucial information about the trafficking in looted art is not in archives.

There were many other benefits to talking with the old Nazi art "experts" and their spouses: one understands much more about how the art world functions: its relationships, networks, and circles of trust. One also sees how plundering was a key component of the Holocaust. Expropriation preceded deportation and murder. Taking a people's cultural property is a way of dehumanizing them, and plundering was an important station on the "twisted road to Auschwitz."[15] Although anti-Semitism is at the top of the list of the many motives that compelled perpetrators to act, greed is arguably a strong second.[16] Persecution could be profitable, and many Nazis enriched themselves during the war. It wasn't just Nazis, of course, who profited. Historian Frank Bajohr has estimated that there was an auction of Jewish property in Hamburg every day during the war and that over one hundred thousand of the city's inhabitants purchased property seized from Jews (many of whom lived outside the Reich).[17] But the art plunderers profited on a much grander scale. Not one of them appeared wanting for money in the postwar period.

A question I have often asked myself is whether I was overly sympathetic to the old Nazis. This certainly presented a danger, especially in the case of Lohse, whom I got to know quite well over the years. Historian Peter Hayes has talked about the "seductions of proximity" for historians, whether it is knowing one's subject personally, knowing their children (a challenge for me when writing about the Princes von Hessen), or being commissioned by a company to write a history (as in Hayes's case; he wrote about the DEGUSSA corporation during the Third Reich, the company that made Zyklon B and processed dental gold).[18] I tried to be conscious of the pitfalls of bias, to remain self-critical. I also aspired to show both the positive and negative qualities of subjects, to appreciate the gray zones, and to accept that there are complexities that will never be completely understood. Overall, I have tried to give readers the information to make their own judgments.

There is a debate among historians of the Third Reich as to whether it is appropriate to make moral judgments about subjects who experienced this period. Some, like Michael Burleigh, think it valid and important to

raise ethical questions in their work. Others, including Richard Evans and Ian Kershaw, are more cautious, believing that our safe positions as observers can lead to a smugness, or at least a failure to appreciate the pressures and constraints of the time.[19] I confess that I have shifted positions on this issue over time. My earlier work raised issues about ethics. Indeed, my first drafts of *Faustian Bargain* read like a prosecutorial brief against the Nazi art "experts"; it was my editor at Oxford University Press, Peter Ginna, who encouraged me to appreciate the complexity of the history, to make more of an effort to understand the perspectives of my subjects. I am now more in the Evans/Kershaw camp, but I know there is a "sweet spot" between cautious humility on the one hand and moral judgment on the other, although even this terrain is unstable, in part because it depends on the underlying facts and the quality of evidence: an air-tight case for murder, for example, allows for a different basis for judgment than an instance in which there is only the probability.[20]

I am aware of the ethical challenges that I myself have faced. I appreciate how few easy answers there are. I wondered, for example, whether I allowed Bruno Lohse to use me. Did I legitimize him in some way? Was I a channel for passing along false information? Perhaps he used me to gauge how close researchers were coming to him and his operations in Switzerland and Liechtenstein. More likely, Lohse believed that I could help him whitewash his own record. By talking to me, he thought he could influence the way he would be portrayed—not just by me but by future historians. Lohse, like Wilhelm Höttl, would often say, "I am the last." Höttl wrote me back in 1995 when I asked him about other old Nazis, "There is no other insider from back then who is still alive—I am, so to say, unfortunately the last!"[21] Whether consciously or unconsciously, both Höttl and Lohse believed that there was an opportunity for a disinformation campaign—that they would not be contradicted because they were the last of their cohort.

For me, the greatest ethical challenge arose from the mutual feeling of a sort of friendship that emerged in my relationship with Lohse. Yes, Bruno was a kind of friend, and that is problematic for a historian of the Third Reich. I told him in no uncertain terms that I thought what he did in the war was reprehensible and I in no way condoned his actions. He seemed unperturbed by this statement—indeed, it brought a smile to his face.

All of the old Nazis whom I met had a dark side that became apparent, and at times, interacting with them brought on rather disturbing thoughts on my part. I recall sitting with Wilhelm Höttl in his home in Altaus-

see—it was our first visit in 1995—and about halfway through our five-hour conversation, I became aware of how much harm this man had done. Even though I have always argued that art plundering is central to the Holocaust, Dr. Höttl was in a different league than Lohse and the other art "experts" when it came to persecution. As the second-ranking SD officer in southeastern Europe as of 1944, he caused unimaginable harm to Hungarian Jews in Budapest. He had also been close to Adolf Eichmann, the master of the deportations during the Holocaust (and who, along with Ernst Kaltenbrunner and other high-ranking Nazis, had taken refuge in Altaussee at war's end). Höttl had helped prepare the Hungarian "gold train" in late 1944, a convoy laden with valuables stolen from the Jewish population, and there was compelling evidence that he himself absconded with gold before the train was intercepted and captured by the Americans in Werfen, Austria, in early 1945. (He was also suspected of having obtained assets from his patron, Ernst Kaltenbrunner, who also had stashed gold, jewels, and other valuables at his Altaussee villa at war's end.) As historian Ronald Zweig noted, "Eventually the Americans noticed that Höttl was living at a standard well beyond any visible means of support and they began to suspect that he had access to looted Nazi gold."[22] Höttl's treasure was never found, and he continued to live comfortably in his hilltop chalet. He was one of over one thousand former Nazis used by U.S. spy agencies during the Cold War, but the Americans quickly became disappointed in his information, and that relationship withered.[23] He went on to play a key role in networks of former SS men, although scholars debate the real significance of the likes of ODESSA and Die Spinne (Spider).[24]

As I sat on his sofa, about five feet from the old man, I reflected on how easy it would be to stand up and punch him in the face. While he chatted about Ernst Kaltenbrunner and Austrian Nazis, I thought to myself, "Well, I could certainly justify the act to the police, to my students, to the victims whom I meet." But I also knew that these were just thoughts— I was not going to do any such thing. It's not my style, although I admired Beate Klarsfeld for slapping German chancellor Kurt Georg Kiesinger in 1968 for his failure to acknowledge his Nazi past. Punching Wilhelm Höttl was not the way to approach matters, I reasoned (a version of the pen is mightier than the sword). I also couldn't help but think of Albert Speer's assertions at Nuremberg, and then later in his memoirs, *Inside the Third Reich*, that he contemplated assassinating Hitler—conceiving a plan to put poison gas in the ventilation system of the Führer Bunker in the Reich Chancellery.[25] Was that story merely a part of his sophisticated pub-

lic relations campaign (one that saved his life at Nuremberg)? Were my thoughts a kind of subconscious rationalization of my actions?

Ethical considerations arise whenever one comes close to the history of the Third Reich. This is certainly the case if one develops relationships with former Nazis. Lane Faison, Jim Plaut, and Ted Rousseau faced similar challenges in their work. In the specific case of Bruno Lohse, did they go soft on him? They went from questioning the veracity of his statements at Altaussee in the summer of 1945 to helping him in his quest for release from a Paris prison to meeting with him in both the United States and Europe. In the first letter Bruno wrote to me, on 26 May 1998, he responded to my offer to photocopy the ALIU documents concerning him that I had in my archive, "I gladly accept your offer regarding the photocopies of letters from Theodore Rousseau, James Plaut, and S. Lane Faison. I have retained the best memories of these fair and sympathetic colleagues."[26]

The ALIU and Monuments officers faced a host of other ethical challenges growing out of their restitution work. Lane Faison, for example, had some very difficult decisions to make in 1950 and 1951 as he oversaw the closing of the Munich Central Collecting Point. There were still thousands of artworks there that could not be shown to have been acquired in occupied lands and that had no claimants. Most of these works were returned to the Federal Republic of Germany or to Austria (the latter kept these objects effectively hidden in the Mauerbach monastery outside Vienna until they were auctioned off in 1994 for the benefit of Vienna's Jewish community). But for Faison and most American officials, leaving looted works with the Germans and Austrians constituted a kind of failure. Faison wrote to Rousseau in 1951 pushing him to send a trunk of documents whose shipment had been delayed (using very blunt language — "I cannot understand how you could let me down this way"): "If a group of things that could be restituted on the basis of these documents is turned over to the Germans for lack of information, it will be nobody's fault but yours. But, of course, I will get the blame for it."[27]

Among the objects in the CCP in 1950 were paintings and drawings made by Nazi leaders, such as Reich Youth leader (and wartime governor of Vienna) Baldur von Schirach; Nuremberg Gauleiter and publisher of the anti-Semitic tabloid *Der Stürmer* Julius Streicher; and Party philosopher and plunderer Alfred Rosenberg. There were also a number of highly propagandistic artworks, featuring swastikas, uniformed subjects, and images of Hitler, among other subjects. Faison was confronted with

the challenge of what to do with these Nazi artifacts. The U.S. Army had already carted off thousands of paintings from Nazi Germany: a great deal of so-called combat art (done mostly by artists in a special Propaganda Ministry unit) and propagandistic works. Soldiers nabbed Herbert Lanzinger's "great" portrait of Hitler as a knight carrying a banner that once hung in Albert Speer's office—it even had a hole in Hitler's face where a GI had stabbed his bayonet.[28] The army also had four works by Hitler, and saving those provided a precedent for retaining works by other Nazi leaders. Faison thought it awkward to return such objects to the Germans, who had an explicit prohibition on Nazi artifacts, which even led to a ban on selling Hitler's *Mein Kampf*. The German government did not want to store such objects and face whatever public pressure might arise from keeping them. It was only in the 1980s that the U.S. Army returned most of the "German War Art," as it was called, to the Federal Republic, and this required an act of the U.S. Congress because it altered a postwar treaty.[29] The Germans kept the art hidden away in a fortress in Ingolstadt for many years before transferring it to the Historical Museum in Berlin, where the pieces are used for exhibitions.

Faison decided on another course of action, a most surprising one in light of what he had researched and written about as an ALIU officer. In conjunction with the high commissioner on German cultural affairs adviser, Theodore Heinrich, he ordered the destruction of these artworks by Nazi leaders and the examples of Nazi kitsch.[30] The artworks were incinerated by CCP personnel behind the former Nazi Party Administration Building (Verwaltungsbau). Did Faison think of the 10 May 1933 book burnings throughout Germany, including Munich, as his staff ignited the bonfire? Did he think of Rose Valland and her allegations about the ERR burning modern French art in the Tuileries? Back in 2002, I did ask Lane Faison about the burning of Nazi objects in 1950, but not in those terms. He was a dear old man, a venerated professor, and I was staying with him at his home in Williamstown while participating in a conference at Williams College on Hitler as an artist. I asked him in far more polite, gentle terms. Faison admitted that he wished he had done it differently. It was a mistake, he said, but he was under orders to wrap things up as quickly as possible and he had a very limited budget. To reiterate: when one gets close to the Nazis and their difficult legacies, one often comes up against ethical challenges.

The restitution of Nazi-looted art, then, is big business. Lucian Simmons of Sotheby's stated at a 2018 conference that he had helped restitute

$750 million worth of Nazi-looted art since joining the auction house in 1995.[31] With such sums involved, is comes as no surprise that information is viewed as proprietary. The *Berufsgeheimnis*—a professional secret—as Peter Griebert would call it, lies at the heart of the art world. Many art dealers and auctioneers, for example, knew about Cornelius Gurlitt and the cache of artworks amassed by his father, but they did not share this information with restitution experts. The culture of secrecy can lead to inaccurate or dishonest statements. The art trade is filled with rumors and lies, and this is even more the case with regard to Nazi-looted objects.[32] The ALIU officers were constantly frustrated by the lies of their subjects and complained to one another in memo after memo. Douglas Cooper felt the same way, writing in the December 1945 "Report of Mission to Switzerland" that "the subjects (perhaps deliberately) told a number of untruths"—to an extent that induced Cooper to question the findings of the ALIU ("The OSS interrogation reports can only be accepted with reserves").[33] This misrepresentation of history, of course, continues to this day. To take one example that I stumbled across in my papers as I prepared this book, in 1998 I wrote the current proprietor of the Kunst-handlung Julius Böhler in Munich asking a series of questions relating to the art world in Nazi Germany; he passed my letter on to Dr. Julius Gustav Böhler, then the head of the firm. J. G. Böhler wrote me, "My father and I had social contacts with the Haberstocks, but no business contacts."[34] This response came from someone who had been a participant in events—who, as he said, knew the Haberstocks personally. In my office in Claremont, I can easily find a folder containing photocopies of dozens of letters between Haberstock and Böhler, including regarding the joint purchase of Gutmann property in Holland during the war. Could Böhler "the younger" simply not have known? If my study of the art world has taught me anything it is that it is the art dealer's job to know—to amass as much information as possible about artworks, collectors, other dealers, and so on. When I asked Lohse once what he would say regarding the topic of *Kunstraub*, he replied that it was a "desert of lies" (*Wüste von Lügen*).[35] He had a point, I must admit.

Bruno Lohse, of course, used this veneer of cynicism, of nihilism, to protect himself from scrutiny. It was easier to dismiss everything as self-interested nonsense. Rose Valland had grasped the complexity, the duplicity in Lohse: she wrote James Rorimer in 1957, telling the Met director, "Lohse, who appears to you as a victim, assumes an entirely different personality when in Munich, judging from the conversations reported to me,

and once again, becomes the Nazi eager to avenge himself and to discredit the restitutions."[36] With regard to the Holocaust, Lohse said there were so many misrepresentations that it was pointless to study it. I countered that yes, historians make errors, but what other option is there but to engage this history? Did he think we could just ignore this history? His was a paradoxical stance, because he himself was obsessed by history. He did anything but ignore National Socialism and the past. But Lohse had made a career out of lying. He was not going to stop in old age. As noted above, Bruno had a dark sense of humor and relished irony. He once quipped, "I am against all corruption . . . in which I am not involved."[37] Bruno was a Berliner: coarse, cynical, worldly, and irreverent.

In answer to the question of whether we can ever really understand Lohse, I would say the situation is analogous to my conversation with him about the Holocaust. We will never get the whole story or get it all correct, but it is important to try nonetheless. Arguably, the best characterization of Bruno Lohse came just after the war from his ERR colleague in Paris, Dr. Walter Borchers, who offered a surprisingly frank appraisal as part of his testimony before the Paris Military Tribunal in 1950:

> Dr. Lohse is a man who is loved and hated: who, on the one hand, is praised to heaven because of his willingness to help and his camaraderie (no road was too dark and difficult); and on the other hand, is hated, due to his extraordinary vitality and inner strength, which results in a lack of diplomatic polish. There is no middle way. As a result, an accurate evaluation of the personality of a man like Lohse is rare. He is a man who does not shy from danger, and indeed, seeks it out; who thinks in an athletic manner and in his feelings for the world exhibits tenderness. He is a man who combines contradictory elements—who in his business practices is cool and calculating, but in his emotional life is almost primitive. Lohse's character loves the drive to dominate and his opinion makes this valid; that is simultaneously his strength and his mistake, which he himself does not always recognize. At the end of the day, his autocratic ways often led to tensions and enmity with others.[38]

Compared to the customary whitewashing found in these juridical affidavits, Borchers captured the paradoxes that comprised Lohse's character.

Bruno Lohse must be understood by his contradictions: the robust SS

man and self-styled "king of Paris" who was, according to Peter Griebert, sexually dysfunctional (the source of his misogyny, in Griebert's opinion); the art historian who had no confidence in his own eye; the brutal Nazi operative who could also laugh and who had a warm manner about him; the loner who wanted to be constantly surrounded by people; the nihilist who cared deeply about history. Bruno had few constants: secretiveness perhaps being one of his only consistent qualities. He possessed a sense of loyalty, although he broke with friends, caregivers, and others and was prone to explosive outbursts that did permanent damage to certain relationships. His longtime "girlfriend" Roswitha Krohs, whom I met during my early visits, left his life entirely when he accused her of stealing from him. Peter broke with him in a more subtle, private manner. Peter remained part of Lohse's life, but he ceased to trust him. One of the reasons for Peter's disaffection was that after Lohse's irrational allegations fractured his relationship with Roswitha Krohs, he refused to give her a painting he had promised her. Peter would not identify the artist, but said the work was significant. Peter viewed this as a mean and vengeful act: "The picture was her pension."

Throughout it all, as he declined in health and grew increasingly bitter, Bruno remained Bruno. Even though he lost the ability to recall names and details in his old stories, he retained his life philosophy, perhaps best expressed when I visited him in December 2006. In a soft but tuneful voice, he sang the first few lines of Edith Piaf's famous song "Je Ne Regrette Rien." As he sang to me, I recall thinking that he must have heard the song in Paris during the war. In what context? I wondered. Did he think back to it now? Dr. Bruno Lohse remained enigmatic all his life.

The fate of Lohse's art also remains uncertain. While Lohse had no children, he had heirs, beginning with the children of his sister Brünhilde, with whom he had been close (he had called her every Sunday until his death in 2007).[39] The heirs included his nephews, Klaus and Peter Nowitzki, who live near Koblenz, as well as Lohse's Munich-based niece Iris Lohse—the eldest child of Bruno's brother Siegfried, who died during the war.[40] Iris Lohse evidently hired journalist Maurice Philip Remy to research the paintings found after Bruno's death. Remy claimed that there were forty artworks (not the forty-seven listed in the appendix, although the latter also includes works that had recently been in Lohse's possession, but that he sold prior to his death). In July 2007, Remy stated that "of the 40 artworks in Lohse's collection, there are only three paintings he 'is not yet sure' of the provenance. 'I know every painting in the collection,'"

Remy said. "It is not a stash of looted art."[41] One must keep in mind the timing of the announcement—some four months after Lohse's death and the discovery of the artworks in his possession. Provenance research is a painstaking, time-consuming process. Scholars often work for months or even years to research just one painting. Could Remy examine an art collection of this magnitude (with works that were almost certainly in Europe during the Third Reich), and be able to render a definitive judgment in this time frame?[42] Remy engaged at least one provenance specialist, Madeleine Korn in London, but their collaboration did not prove long or harmonious, and their research results remain unclear.[43]

Others also raised questions about Lohse's collection. Following the lead of French investigative journalist Philippe Sprang, Marc Masurovsky from the Holocaust Art Restitution Project posted a blog in June 2011 in which he alleged that one of the works in Lohse's collection was a Philips Wouwerman, *Harvest Scene*, that had been looted from the Paris home of Edmond de Rothschild by the ERR in the summer of 1940.[44] Masurovsky located the ERR inventory number (R 348) from when it was catalogued in the Jeu de Paume and tracked the picture to the collection of Hermann Göring in Germany. How it came into Lohse's possession is unclear, but this presumably occurred before war's end. The Wouwerman was among the pictures in Lohse's safe at the Zurich Cantonal Bank. Complicating the matter, Masurovsky noted, is that the Rothschild heirs apparently have not pressed for restitution. This appears to be similar to the Wouwerman (*Outdoor Riding School*) taken from another branch of the Rothschild family in Nice found in the possession of Karl Haberstock and now the museum in Augsburg.[45] Masurovsky adds, "If the rightful owner refuses to claim it as his property which was looted from his family during the Nazi occupation of France, this stolen work of art will be handed over to a relative of the plunderer, Bruno Lohse."

Journalist Stefan Koldehoff identified other pictures in the vault in the Zurich Cantonal Bank as highly problematic. He pointed to a painting by Dutch Old Master Jan Meerhout, *River Landscape*, that came from the collection of Alphons Jaffé, whose art had been looted by Kajetan Mühlmann's agency in the Netherlands in 1941. At least twenty-nine pictures stolen from Jaffé remained lost.[46] Koldehoff also cited Swiss prosecutor Ivo Hoppler's report, which showed that a picture that had once been in the vault, Karl Schmidt-Rottluff's 1924 work *In the Twilight* (*In der Dämmerung*) was sold by Christie's in June 2005 for $4.5 million. But Christie's provided misleading information about the work; or, as Koldehoff noted,

"The provenance of the picture obscures its true origins."[47] Hoppler also found that Lohse had sold off at least three works from the bank vault prior to 2006 through the Galerie Fischer in Lucerne. These included works by Cranach and Renoir. The Fischer catalogue stated that they came from a "private collection in Switzerland" or "Swiss private property."[48]

The results of Maurice Philip Remy's vetting of the collection were never released to the public; that is, there was no comprehensive list of the works with all the known information about each work's provenance. Remy and the heirs did not come forward with any works they identified as looted. There may be other facets of efforts to "normalize" Lohse. I heard at great length from a gentleman in Hamburg named Ocke Rickertsen, who told of engaging in a battle with a person whom he believed to be Remy over Bruno Lohse's Wikipedia page.[49] Rickertsen told me that Remy endeavored to portray Lohse in a positive light and became a key protagonist in a "war" on Wikipedia (what the Germans call a *Wiki-Krieg*). Rickertsen's parents had bought art from Lohse back in the early 1970s, and the son now feared some of it had been looted. Rickertsen had made an extensive investigation into Lohse, which he put to use as he repeatedly posted and revised Lohse's Wikipedia page. All of this gave me cause for concern: was the collection properly and objectively vetted? Suffice to say, there are both practical and psychological challenges that often militate against the successful restitution of any artwork.[50]

Bruno Lohse's estate also proved anything but simple. He evidently created a community of heirs that he called the Ille Stiftung (Ille Foundation). Indeed, upon Lohse's death in March 2007, the Schönart Anstalt ceased to exist and its assets were transferred to the Ille Foundation. According to Lohse's nephew Klaus Nowitzki, there were at least twenty-two individuals in this "community of heirs."[51] When I interviewed Andrew Baker in June 2015, he said that the Ille Stiftung still controls two of the pictures that had been part of Schönart—the Renoir and the Monet. According to Baker, there had been heirs for the two paintings, although he did not say specifically who they were, but they had refused to accept the pictures because the German authorities intended to levy a hefty tax bill. The representatives of the Ille Stiftung had approached Christie's and Sotheby's to sell the works, he said, but the auction houses had passed, claiming there was too much uncertainty. Baker said that the representatives were now pursuing a private sale. In June 2018, Baker reported that the works had been sold in Switzerland.[52] He could not speak to the fate of the works, but they could easily be in the Middle East, Russia, China,

or with a criminal element somewhere else in the world. Considering that the works languished for years in a Swiss bank vault and then were liquidated by representatives of a foundation that had concealed Lohse's assets for decades, a sale into the "gray market" would seem a likely outcome.

Another person close to Lohse, Professor Claus Grimm, offered some insight into the plunderer's heirs. He reported that Lohse's familial heirs were not particularly sophisticated. One was a soldier in the Bundeswehr, another a police officer, but none had become scholars or art dealers. Grimm reported meeting one of Lohse's relations in the Bogenhausen apartment. The person had pointed to the oil painting attributed to Emil Nolde and asked, "Is that a Volkswagen or a Porsche?"[53] One relation of Lohse's took possession of a Dutch Old Master in June 2009 by order of a Munich court after it had been released by the Zurich public prosecutor the month before. This was the aforementioned Jan Meerhout landscape of a city with a river that Kajetan Mühlmann had stolen from Alphons Jaffé in the Netherlands: the work had then gone to Hitler and then on to his adjutant Julius Schaub and then to Hjalmar Schacht, and finally to Lohse, who kept it in the Zurich Cantonal Bank. With the assistance of Anne Webber and the Commission for Looted Art in Europe, the Jaffé family contacted the relation of Lohse and arranged its return. But Lohse's relation backed out of the deal. According to Anne Webber, it is the Lohse heir "who, it is believed, retains it to this day."[54] The list of Nazi names in the provenance freighted the picture with significance, and if the reports are true that the heir had radical right-wing political views, this might have provided an additional reason for retaining it. Some of the art in Lohse's estate, of course, was directed to his circle of friends. Lohse frequently reworked the terms of his will according to his current views about people—whether they were in favor or not. Some of his bequests were objects that had meaning family members would not have appreciated. Claus Grimm, for example, received a prized copy of Max Friedländer's multivolume study of early Netherlandish painting that the famed art historian had personally inscribed to Lohse. Recall that Bruno had helped protect Friedländer during the war, and that the latter had helped Lohse in his efforts to acquire works for Göring.

But the processing of Lohse's estate did not go smoothly. For starters, his papers were not secured. Peter Griebert said he'd heard reports from several sources that Lohse's niece purchased a shredder and spent days systematically destroying all extant papers, a part of her uncle's legacy. Klaus Nowitzki, however, disputed this: "It is not true that Iris Lohse destroyed

any files."[55] It is difficult to know whom to believe. I subsequently heard
that Lohse kept a diary during the war and that this valuable source, which
had been in a World War II–vintage suitcase (*Geheimkoffer*), was stored
in the Zurich bank vault. Andrew Baker said the Swiss authorities had
seized the suitcase and examined its contents, but there has been no public
statement about what it contained and the documents seem to have dis-
appeared.[56] Journalist Yves Stavridès believes that the Swiss investigators
made a copy of Lohse's diary before returning it and the other documents
in the *Geheimkoffer* to the heirs.[57] While it is uncertain whether Lohse's
family members have a copy of the diary and, if so, whether they will make
it available to researchers, there is additional hope that the Swiss authori-
ties retained a copy, which eventually will be placed in a state archive.

According to Professor Grimm, Bruno Lohse's heirs evidently re-
ceived very little of the art. The German authorities confiscated most of
the works as part of a tax bill. Grimm said Lohse should have gone to the
tax authorities and reported himself (*Selbst-Anzeige*), paying what would
have been a relatively small tax bill. Instead, he left a legacy that involved
legal complications and little actual property.[58] This was evidently the case
with the Renoir and the Monet controlled by the Ille Stiftung. German
and Swiss authorities had levied taxes against the works and certain heirs
renounced their inheritance rather than pay a tax bill up front.[59] The Re-
noir and Monet were sold in Switzerland in 2017, with most of the proceeds
going to the Ille Stiftung (with the heirs taking out some of those funds, or
so it appeared). But the fate of the remainder of Lohse's art remains a mys-
tery. There are reports that the heirs quietly began selling the art, but thus
far, I have seen no proof. British provenance researcher Madeline Korn
wrote me in October 2012 that "last March Edda [Göring] was definitely
trying again to employ me . . . and was definitely selling the paintings and
had not renounced her share at all."[60] But we do not know what ultimately
happened with this or any other works bequeathed by Lohse. With him,
as with many of his cohort, the observation of journalist Reinhard Müller-
Mehlis upon the death of Adolf Wüster in 1972 seems particularly appli-
cable: "He knew a great deal and took a lot with him to his grave."[61]

Bruno Lohse's actual grave represented another effort to shape his
image. His funeral itself was held at Munich's Ostfriedhof (Eastern Ceme-
tery). According to Professor Claus Grimm, who delivered the eulogy
that day in March 2007, around fifty people attended. Edda Göring stood
off to one side, but her presence loomed large. It was a short, uneventful
ceremony. But it is striking that after cremation, his remains went several

miles down the road to an arranged place in the München-Bogenhausen
cemetery, near the home where he lived for some thirty-eight years. This
cemetery is special. The graves and memorials encircle a jewel of a Ba-
roque church dedicated to Saint Georg. With its onion dome, bright fres-
coes, and sublime wood sculptures, the cemetery is a preserve for artists
and other cultural notables. Strolling among the graves, one finds the final
resting place of writers like Oskar Maria Graf and Erich Kästner. There
is also a memorial to "Putzi" Hanfstaengl, the Harvard-educated, piano-
playing intimate of Hitler until the mid-1930s. Lohse was not alone among
those buried in this bucolic sanctuary with Nazi chapters to their biogra-
phies.

What mattered more to Lohse was that his final resting place con-
veyed prestige, and that he was among artists. Lohse styled himself as a
Kulturmensch, and he took care to project this image, even if his memorial
was modest—barely large enough to hold two urns. Some in his circle be-
lieve that he received a place in the Bogenhausen *Friedhof* because he had
helped save the Neuschwanstein castle at war's end. While this theory re-
mains dubious, it is the kind of speculation that Lohse hoped would be
provoked when he arranged for his grave in the prestigious cemetery. It is
also notable that Lohse arranged to share the memorial with his wife Ilse,
who died some thirty years earlier. This suggests an effort to appear *an-
ständig* (respectable). Lohse cared a great deal about his image, about how
he would be remembered. This was the key reason he met with me over
the years and, in many respects, it constituted the driving force in his life
during the postwar period. Those who knew him best attested that he was
not good at confronting or "mastering" his past, but this did not prevent
him from trying to shape his historical persona. This book represents an
effort to respond to his mythmaking and deception, his web of lies. The
historian gets the last word, although other historians will hopefully fol-
low and add to our understanding.

This study is as much, if not more, about the postwar period as the
wartime years. My contribution has been taking the story of the Nazi art
plunderers into the years after their release from Allied custody: what hap-
pened to them, how they amassed wealth, how they insinuated themselves
into the respectable art world, and how they continued to traffic in Nazi-
looted art. We still have an incomplete picture of this postwar world. The
art world does not easily spill its secrets. I am reminded of the words of
pathbreaking Holocaust scholar Raul Hilberg who, at the end of one of his
last books, reflected on the scholar's craft: "There is no finality. Findings

are always subject to correction and reformulation. That is the nature of the empirical enterprise. Since historiography is also an art form, there is inevitably a striving for perfection. Yet the reality of events is elusive, as it must be, and the unremitting effort continues for the small incremental gains, no matter their cost, lest all be relinquished and forgotten."[62] Hilberg's modest yet determined words apply to this effort to understand Lohse as well as the related topic of Nazi-looted art that has never been restituted to the rightful heirs. While many questions remain, the story of Bruno Lohse and his world helps us understand not only the horrific depths on Nazi art looting and the necessary but complicated endeavor of restitution, but also the postwar history of those who continued to profit from the Nazis' program of cultural barbarism.

Appendix

Artworks in the Possession of Dr. Bruno Lohse and the Schönart Anstalt

According to prosecutors in Munich, Zurich, and Vaduz, the artworks listed below either belonged to Lohse and the foundation he controlled at the time of his death or had been in his possession in recent years.

1. Peter Binoit, *Dutch Still Life of Fruit*
2. Peter Binoit, *Dutch Still Life with Food and Crabs*
3. Abraham Blomaert, *Portrait of a Man*
4. Abraham Blomaert, *Portrait of a Woman*
5. Eva Bödinghaus, *Flowers in a Vase*
6. Eva Bödinghaus, *Portrait*
7. Pierre Bonnard, *Seascape*
8. Ambrosius Bosschaert, *Fruit Platter with a Half Pear*
9. Ambrosius Bosschaert, *Fruit Platter with Apples*
10. Jan Brueghel, *Basket of Flowers*
11. Jan Brueghel (copy), *Flowers in a Vase*
12. Camille Corot, *Woman Sitting Holding a Mandolin*
13. Gustav Courbet, *Seascape*
14. Lucas Cranach, *Venus with Amour*
15. Lucas Cranach the Elder, *Madonna with Doves*
16. Albrecht Dürer (?), *Portrait of Charlemagne* [Note that this work, now attributed to Dürer's workshop, was sold to the German Historical Museum.]
17. Albrecht Dürer (?), *Portrait of Emperor Sigismund* [Note that this work, now attributed to Dürer's workshop, was sold to the German Historical Museum.]

18. Albrecht Dürer (?), *Dutch Landscape*
19. Flemish School, *Peasants*
20. French School, *Grapes and Butterfly*
21. French School, *Landscape with Mill*
22. German School, *Basket of Fruit*
23. Jakob Philipp Hackert, *Grave of Cecilia, Via Appia*
24. Cornelius de Heem, *Still Life with Lemons and Orange*
25. Holland School, *Landscape with a View of the City and Birds*
26. Jan van Kessel, *Large Landscape*
27. Oskar Kokoschka, *Self-Portrait in a Landscape*
28. Jan Meerhout, *View of a City from the River*
29. Claude Monet, *View of Vétheuil*
30. Emil Nolde, *Bridge with a Marsh Landscape*
31. Emil Nolde, *Flowers (Foxgloves or Fingerhut)*
32. Emil Nolde, *Poppies*
33. Jean-Michel Picart, *Wreath of Flowers in a Vase*
34. Camille Pissarro, *Le Quai Malaquais*
35. Pierre-Auguste Renoir, *Roses in a Green Vase*
36. Pierre-Auguste Renoir, *Windmill (La Baie de Moulin Huet)*
37. Karl Schmidt-Rottluff, *Sunset*
38. Karl Schmidt-Rottluff, untitled
39. Paul Signac, untitled watercolor
40. Alfred Sisley, *L'Abreuvoir de Marly*
41. Alfred Sisley, *Girl Sitting at a Window*
42. Alfred Sisley, *The Seine Near Saint Mammes with Train of Barges*
43. Spanish School, *Still Life with Pears and Apples*
44. Harmen van Steenwyk, *Dead Bird, Peaches, and Grapes*
45. Lucas van Uden, *Landscape with Trees*
46. Marianne von Werefkin, *Flowers (Prerow)*
47. Philips Wouwerman, *Hay Harvest*

Acknowledgments

All of my books are implicitly dedicated to Jack and Kingsley Croul, who have funded my research over the years. Jack Croul served as a navigator on thirty-three missions over German-occupied Europe and is a shining example of the "Greatest Generation." Thanks to the entire Croul family for their interest in history, their generosity, and their friendship.

I could not have written this book without the insights offered by Peter Griebert in Munich, who told me a great deal about Bruno Lohse and his world, and Professor Claus Grimm, who also shared many of his experiences with Lohse from the 1980s on. Andrew Baker in Liechtenstein graciously met with me on two occasions and tried to help me understand Lohse's murky connections to Liechtenstein foundations and a vault in a Swiss bank.

My favorite research center in Europe is the Zentralinstitut für Kunstgeschichte in Munich, where Christian Fuhrmeister, Stephan Klingen, Meike Hopp, Iris Lauterbach, and Leonhard Weidinger shared their research and helped track down documents. They offered a vibrant scholarly community. I could make a similar statement about the Institute für Zeitgeschichte, also in Munich. Thanks to Professor Andreas Wirsching and colleagues for their contributions over the years. In Berlin, Brigitte Reinecke Sabina Beneke, and Anne-Dorte Krause at the Deutsches Historisches Museum guided me through the odyssey of the *Kaiserbilder.* Thanks also to Caroline Haupt at the Zentralarchiv der Berliner Staatlichen Museen and Michael Schelter, Kersten Schimmeck, and colleagues at the Bundesarchiv Berlin-Lichterfelde. Birgit Schwarz in Vienna supplied valuable documents, as did Gerhard Aalders in Amsterdam. Hubert Berkhout at the NIOD in Amsterdam facilitated several visits. Among the experts in Paris who assisted me were Yves Stavridès, Philip Sprang, Corinne Bouchoux, Isabelle le Masne de Chermont, and Didier Schulmann. I have learned a great deal from their work.

Special thanks go to James Moske and Katherine Baetjer at the Metropolitan Museum of Art. They opened the museum's archives and searched its database for clues about Lohse's activities in the postwar period. I am particularly grate-

ful for the opportunity to work with the Theodore Rousseau Jr. Papers in the Met Archives. I also appreciate the assistance of Megan Lewis and the staff at the U.S. Holocaust Memorial Museum, who also provided me with documents. Gail Feigenbaum, Sally McKay, and colleagues at the Getty Research Institute have assisted me over the years. The Special Collections of the institute provided an array of important material for this book. Thanks also to Alexandra Coleman at the Toledo Museum of Art for responding to my queries.

I owe a special debt of gratitude to Anne Webber, the co-chair of the Commission for Looted Art in Europe, who first told me that Lohse was living in Munich and helped me with the title of this book. I also frequently called upon Monica Dugot and Sarah Jackson at Christie's for advice about researching Lohse and his circle. Attorneys Tom Kline and Michael Margolis offered valuable advice at crucial moments. Thanks also to Ray Dowd, Isabel Vincent, and Herbert Gruber for helping me think about plunder and restitution. Art dealer Otto Naumann assisted by providing several letters that Lohse sent him in the 1970s. Thanks as well to Marc Masurovsky for helping locate documents. I was also able to utilize materials found when I worked at the Presidential Commission on Holocaust Assets in the United States: thanks to Ronald Lauder, Stuart Eizenstat, Kenneth Klothen, Gene Sofer, and my other colleagues at the PCHA.

I received invaluable reviews of the entire manuscript from Roger Labrie, Andrew Morton, Dennis Mulhaupt, Michael Zhang, and Cindi Guimond. Thanks as well to Simon Goodman, who read a draft of this book and helped with information about his family's tribulations. Jean-Marc Dreyfus went far beyond the call of duty, reading several drafts of the manuscript as well as offering wise counsel as I tried to understand specific issues in wartime and postwar France. My mentor, Richard Hunt, also read a draft of the manuscript and offered sage counsel. He passed away as I was completing this project, but remains with me in so many ways, including as an imagined interlocutor as I pursue the historian's craft. The shortcomings and mistakes in this book remain my sole responsibility.

I am grateful to my friends in Europe who hosted me on my frequent sojourns, including Stephan and Sigrid Lindner and Karl and Irmgard Zinsmeister in Munich, Florian Beierl in Berchtesgaden, and Timothy and Marie-Louise Ryback in Salzburg and Berlin.

I learned a great deal from my colleagues in the documentary film project associated with this book: John Friedman, Hugo Macgregor, Tina Naber, and Claire Guillon undertook part of this journey with me.

At my home institution, Claremont McKenna College, thanks go to the Dean of Faculty's office (and especially Deans Peter Uvin and Shana Levin) for the faculty research award to cover the costs of the illustrations. I am also indebted to the IT team, who saved me on a regular basis: Benjamin Royas, Richard Heffern, Aurelio Puente, Marc Anekananda, and Jeffrey Ng all went far beyond the call of duty. Student research assistants Lauren Broidy, Laleh Ahmed, Chris Agard, Claudia Taylor, and Nick Sage all contributed to this project in numerous ways.

Bridgette Stokes also helped me put out innumerable fires, for which I am thankful. Librarian Adam Rosenkranz tracked down a number of elusive sources. My colleague John Roth also helped me think through many of the issues raised in this book. CMC trustees Christopher Walker and David Hetz have also supported my research endeavors over the years, for which I am grateful. CMC President-emeritus Jack Stark and Jil Stark have always shown a keen interest in my work, and I value our discussions.

At Yale University Press, I am so appreciative of the support and guidance provided by Jaya Aninda Chatterjee and Eva Skewes, and by Robin DuBlanc, a skillful and sensitive copy editor. Fred Kameny went well beyond compiling the index. Thanks to Jeffrey Schier and the entire team at Yale University Press. Michael Carlisle and Michael Mungiello at InkWell Management have stood by me over the years and been great friends. Their belief in this project made a decisive difference. In the final stages of this project, Wendy Lower, my partner and my colleague at Claremont McKenna College, helped me steer the book in for a landing. She assisted with matters big and small. I look forward to writing future books with her.

It goes without saying that family is essential to the work that we do, and over the years I have been sustained by tremendous love and support from Kimberly, Isabel, and Astrid, and from my siblings, Christina, Renée, and Roger. My parents, George and Maureen, raised me with a sensitivity to history and an appreciation for a good story. I dedicate this book, which in many ways is the culmination of my scholarship on Nazi-looted art, to them.

Abbreviations

ALIU	Art Looting Investigation Unit, OSS
ALR	Art Loss Register
AMAE–La Courneuve	Archives Diplomatiques du Ministère des Affaires Étrangèrs (Diplomatic Archives of the French Ministry of Foreign Affairs), La Courneuve, Paris
AMN	Archives des Musées Nationaux/Archives Nationales (Archives of the National Museums, now in the French National Archives), Paris
BAR-Bern	Schweizerisches Bundesarchiv (Swiss Federal Archives), Bern
BArch	Bundesarchiv ([German] Federal Archives), Koblenz/Berlin-Lichterfelde
BHSA	Bayerisches Hauptstaatsarchiv (Bavarian Main State Archive), Munich
BSMfUK	Bayerische Ministerium für Unterricht und Kultus (Bavarian Ministry for Education and Culture, Munich)
CASVA-NGA	Center for Advanced Study in the Visual Arts, National Gallery of Art, Washington, DC
CCP	Central Collecting Point
CDJC	Centre de la Documentation Juive Contemporaine (Center for the Documentation of Contemporary Jewry), Paris
CIR	*Consolidated Interrogation Report* (from ALIU)
CRA	Commission Récuperation Artistique (Commission for Artistic Recovery)
DCAJM–Le Blanc	Dépôt Central d'Archives de la Justice Militaire (Depot of the Central Archives for Military Justice), Le Blanc
DHM	Deutsches Historisches Museum (German Historical Museum), Berlin
DIR	*Detailed Interrogation Report* (from ALIU)

ERR	Einsatzstab Reichsleiter Rosenberg (Special Task Force of the Reich Leader Rosenberg)
GRI	Getty Research Institute, Los Angeles
IfZG	Institut für Zeitgeschichte (Institute for Contemporary History), Munich
ITS	International Tracing Service, Bad Arolsen
MFAA	Monuments, Fine Arts, and Archives program
MMA	Metropolitan Museum of Art Archives, New York
NARA	National Archives and Records Administration, College Park, MD
NIOD	Nederlands Instituut voor Oorlogsdocumentatie (Netherlands Institute for War Documentation — now NIOD Institute for War, Holocaust, and Genocide Studies), Amsterdam
OMGUS	Office of the Military Governor of the United States
OSS	Office of Strategic Services
PCHA	Presidential Commission on Holocaust Assets in the United States
RG	Record Group
RM	Reichsmark
SC	Special Collections (at the Getty Research Institute)
SD	Sicherheitsdienst (Security Service of SS)
SS	Schutzstaffel (Protection Service)
UN	United Nations
USHMM	United States Holocaust Memorial Museum, Washington, DC

Notes

Page vii epigraphs: Göring: NARA, RG 260, box 172, Hermann Göring interrogation (30 August 1946); Valland: AMAE–La Courneuve, 209SUP, box 719, Rose Valland to Ardelia Hall (6 January 1965); Feilchenfeldt: Ulrich Clewing, "Der Schatz im Keller. Bibliotheksporträt: Zu Besuch beim Zürcher Kunsthändler und Verleger Walter Feilchenfeldt," *Cicero* (March 2012), 118–21, http://www.cicero.de/salon/der-schatz-im-keller/48846. The German reads, "Meine Antwort: nicht darüber zu reden."

Prologue

1. Lohse approached Rorimer through James Plaut: MMA, Rousseau Papers, box 33, folder 7, Lohse to Plaut (25 February 1957); and Lohse Papers (archive of author), Lohse to the Paul List Verlag (23 January 1966). James Rorimer, *Survival: The Salvage and Protection of Art in War* (New York: Abelard, 1950); Ken Roxan and David Wanstall, *The Rape of Art: The Story of Hitler's Plunder of the Great Masterpieces of Europe* (New York: Coward-McCann, 1965 [1964]).
2. The full name of the agency is Central Office of the State Justice Administrations for the Investigation of National Socialist Crimes.
3. Gary Younge, "How to Interview a Nazi," *Nation* (30 November 2017).
4. AMAE–La Courneuve, 209SUP, box 721, Heinrich Fraenkel to Rose Valland (8 July 1961) and Valland's response (12 July 1961). The Soviets pursued policies with regard to cultural property that differed from those in the West. See Konstantin Akinsha and Grigorii Kozlov, *Beautiful Loot: The Soviet Plunder of Europe's Art Treasures* (New York: Random House, 1995).
5. Matila Simon, *Battle of the Louvre: The Struggle to Save French Art in World War II* (New York: Hawthorn, 1971); Iris Lauterbach, *The Central Collecting Point in Munich: A New Beginning for the Restitution and Protection of Art* (Los Angeles: J. Paul Getty Trust, 2018), 11. The information on the cards

has been digitized. See Cultural Plunder by the Einsatzstab Reichsleiter Rosenberg: Database of Art Objects at the Jeu de Paume, https://www.err project.org/jeudepaume/ (accessed 10 May 2020).

6. The ALIU officers can be considered part of the larger cadre of Monuments officers, even though they technically were not part of the MFAA.

7. Lauterbach, *Central Collecting Point in Munich*, 77; entry for S. Lane Faison on the website of the Monuments Men Foundation, https://www .monumentsmenfoundation.org/the-heroes/the-monuments-men/faison -lt.-cdr.-s.-lane-jr (accessed 22 August 2019).

8. Entry for James Sachs Plaut on the website of the Monuments Men Foundation, https://www.monumentsmenfoundation.org/the-heroes/the-monu ments-men/plaut-lt.-cdr.-james-sachs-usnr (accessed 22 August 2019).

9. James Plaut, "Retrieving the Loot: The Story of the Nazi Art Thieving Machine," *ARTnews* (August 1946), 15–17; James Plaut, "Loot for the Master Race," *Atlantic* (September 1946), 60; and James Plaut, "Hitler's Capital: Loot from the Master Race," *Atlantic* (October 1946), 75–80.

10. Peter Griebert has provided the author with his correspondence with the Goodman family members dating back to the early 1970s.

11. Hugh Eakin, "The Cultural Collaborators," *ARTnews* (February 2000), 116–18.

12. A good definition of the term *art world* is provided by the Galerie St. Etienne: "The art world—an amalgam of critics, art historians, curators, collectors, dealers and artists who collectively set aesthetic standards." See the newsletter of the Galerie St. Etienne, "The Future of Art: 2018 Art Market Report."

13. See, more generally, Michael Wildt, "Generational Experience and Genocide: A Biographical Approach to Nazi Perpetrators," in Volker Berghahn and Simone Lässig, eds., *Biography between Structure and Agency* (New York: Berghahn Books, 2008), 143–61; and Hilary Earl, "Criminal Biographies and Biographies of Criminals: Understanding the History of War Crimes Trials and Perpetrator 'Routes to Crime' Using Biographical Method," in Berghahn and Lässig, *Biography between Structure and Agency*, 162–81.

14. "France Opens Access to Pétain's Vichy Regime Nazi-Collaboration Era Archives," *Guardian* (27 December 2015), https://www.theguardian.com /world/2015/dec/28/france-opens-access-to-archives-drawn-from-nazi -collaboration-vichy-era.

15. Günter Grass, *Peeling the Onion: A Memoir* (New York: Mariner Books, 2008).

Introduction

1. This account of Bruno Lohse's visit to the Wildensteins' home in Paris is based on interviews with Peter Griebert, who recalls having been there with Lohse "at least twice in the 1980s," and with Professor Claus Grimm,

who also recalls having accompanied Lohse on at least one occasion. Notes on conversation with Peter Griebert, Munich (24 September 2014); and notes on conversation with Prof. Dr. Claus Grimm, Munich (24 September 2014). The quotation in the text came from Claus Grimm, but in the narrative Griebert is the second art dealer.

2. Isaac Kaplan, "The Criminal Case against Billionaire Art Dealer Guy Wildenstein, Explained," *Artsy* (4 October 2016), https://www.artsy.net/article/artsy-editorial-the-criminal-case-against-billionaire-dealer-guy-wildenstein-explained.

3. Gina Rarick, "Family Feud Puts Art Trove for Sale," *New York Times* (3 June 2005); and the entry on Daniel Wildenstein in the *Dictionary of Art Historians*, https://dictionaryofarthistorians.org/wildensteind.htm (accessed 15 June 2016).

4. Patricia Kennedy Grimsted, "Reconstructing the Record of Nazi Cultural Plunder: A Guide to the Dispersed Archives of the Einsatzstab Reichsleiter Rosenberg (ERR) and the Postwar Retrieval of ERR Loot," *International Institute of Social History Research Paper* 47 (2015), https://errproject.org/guide/ERRguideINTRO_10.15.2015.pdf.

5. NARA, M 1944, roll 85, [Rose Valland] entry for Lohse (n.d.). The French reads, "sans scruple. Il a fait à Paris de nombreuses affaires personnelles et a gagné beaucoup d'argent."

6. Lohse Papers (archive of author), Dr. Walter Borchers, "Statement to Paris Military Tribunal" (30 May 1950).

7. IfZG, ZS 793, interview with Gerhard Utikal (4 April 1947). The German reads, "Wir haben uns niemal als Räuber gefühlt. Wir waren der Meinung, dass die Kunstaktion gesetzmässig ausgeführt wurde."

8. See Raphael Lemkin, *Axis Rule in Occupied Europe: Laws of Occupation, Analysis of Government, Proposals for Redress* (Clark, NJ: Lawbook Exchange 1944), which explores the connection between culture and genocide.

9. IfZG, MA 1569/43, interrogation 2242, "Vernehmung von Bruno Lohse durch Joseph Tancos" (24 October 1947).

10. Elie Wiesel, Opening Ceremony Remarks at the United States Holocaust Memorial Museum (30 November 1998), in J. D. Bindenagel, ed., *Washington Conference on Holocaust-Era Assets Proceedings* (Washington, DC: U.S. Government Printing Office, 1999), 14.

11. AMN, 030-438, Ehrengard von Portatius to Rose Valland (8 November 1951). The French reads, "Il se ventait même qu'il avait tué des juifs de sa proper main."

12. Ibid.

13. Ibid.

14. Michael Kurtz, *America and the Return of Nazi Contraband: The Return of Europe's Cultural Treasures* (Cambridge: Cambridge University Press, 2006), 75.

15. Michael Gibson, "How a Timid Curator with a Deadpan Expression Out-

witted the Nazis," *ARTnews* (Summer 1981), 108; and James S. Plaut, *CIR No. 1: Activity of the Einsatzstab Rosenberg in France* (Washington, DC: Strategic Services Unit, 15 August 1945), 20. Among the other repositories were the ones on the Chiemsee, at Kogl, and at Seisenegg in Lower Austria. For a study of one of the ancillary repositories, see Marc Masurovsky, "The Fate of the Nikolsburg Hoard," *Plundered Art* (25 April 2011), https:// plundered-art.blogspot.com/2011/04/fate-of-nikolsburg-hoard.html.

16. The ALIU report drafted by Theodore Rousseau on Göring's art collection estimated that he had 1,375 works (plus sculpture), but careful research by Nancy Yeide has revised our understanding of its scale and quality. See Nancy Yeide, *Beyond the Dreams of Avarice: The Hermann Goering Collection* (Dallas: Laurel, 2009); and Jean-Marc Dreyfus and Les Archives Diplomatiques, eds., *Le Catalogue Goering* (Paris: Flammarion, 2015).

17. Birgit Schwarz has documented how the most authoritative inventory for the Führermuseum (the "Dresdner Katalog") has 3,935 objects, but far more works were collected than were accessioned into the actual museum planned for Linz, and both S. Lane Faison and Lynn Nicholas estimate over 8,000 works were acquired by Hitler's agents. Birgit Schwarz, *Hitlers Museum: Die Fotoalben Gemäldegalerie Linz. Dokumente zum "Führermuseum"* (Vienna: Böhlau, 2004), 20–21; S. Lane Faison, *CIR No. 4, Linz: Hitler's Museum and Library* (Washington, DC: Office of Strategic Services, 15 December 1945), 78; and Lynn Nicholas, *The Rape of Europa: The Fate of Europe's Treasures in the Third Reich and the Second World War* (New York: Knopf, 1994), 49.

18. Stefan Koldehoff, "Auf der Jagd nach Görings verlorenem Schatz," *Die Welt* (4 July 2010).

19. Note that Göring sent Lohse a telegram dated 30 December 1941 in which he thanked Lohse for helping him build his art collection and asked him to help in the coming years. He concluded with warm greetings. Lohse kept this telegram in his papers until his death. There are similar documents in the archives, such as DCAJM–Le Blanc, Tribunal Militaire Permanent, box 984, Göring's adjutant [signature illegible], "Sonderausweis" (24 November 1942).

20. Plaut, *CIR No. 1*, 8, 23.

21. Emmanuelle Polack, *Le Marché de l'Art sous l'Occupation* (Paris: Tallandier, 2019), 44.

22. Emmanuelle Polack, "'Ravalage' at the Hôtel Drouot: The Art of Obtaining a Clean Provenance for Works Stolen in France during the Second World War," in Ana Maria Bressciani and Tone Hansen, eds. *Looters, Smugglers and Collectors: Provenance Research and the Market* (Cologne: Walter König, 2013), 35–44; Polack, *Le Marché de l'Art sous l'Occupation*, 103–14, 135; and Mickaël Szanto, "Hôtel Drouot. Le théâtre cynique de la prospérité," in Laurence Bertrand Dorleac and J. Munck, eds., *L'Art en Guerre, France (1938–1947)* (Paris: Musée de l'Art Moderne, 2012).

23. Plaut, *CIR No. 1*, 8, 23; and NARA, M1270, roll 12 (RG 238), "Testimony

of Bruno Lohse taken at Nurnberg, Germany, on 1 November 1945 by Lt. Col. Thomas Hinkel," 11, 14.

24. See "Die Kunstsammlung Hermann Göring," Deutsches Historisches Museum, http://www.dhm.de/datenbank/goering/dhm_goering.php?seite =6&is_fulltext=true&fulltext=lohse&suchen=Schnellsuche&modus=mitte (accessed 13 May 2015). A sense of Göring's activities, and Lohse's involvement, can be found in the files of the BArch-Koblenz, B 323, boxes 316–20.

25. See the entries for the missing works by Brueghel and the van Goyen, *Datenbank "Die Kunstsammlung Hermann Göring,"* https://www.dhm.de /datenbank/goering/dhm_goering.php?seite=5&fld_0=RMG00336 and https://www.dhm.de/datenbank/goering/dhm_goering.php?seite=5&fld _0=RMG00758 (accessed 28 August 2019).

26. BArch-Koblenz, B 323, box 292, ERR "Inventare der beschlagnahmten Sammlungen: Wildenstein" (n.d.); and Plaut, *CIR No. 1*, 19.

27. GRI, SC, Otto Wittmann Papers, 910/130, box 4, file 3, "Appreciation of Enemy Methods of Looting Works of Art in Occupied Territory" (20 March 1945).

28. NARA, RG 59, lot 62D-4, OMGUS, Ardelia Hall Collection, box 17, "Special Report on the Firm of Wildenstein & Cie, Paris Art Dealers" (n.d.).

29. NARA, RG 260, OMGUS, Ardelia Hall Collection, box 9, attachment "C," "Pictures from the Wildenstein Collection Acquired from the Einsatzstab Rosenberg by Marshal Goering" (n.d.).

30. NARA, M 1944, roll 88, frame 511, Gisela Limberger to Göring (16 May 1941).

31. Lohse interview with author, Munich (1 August 2000); and Daniel Wildenstein and Yves Stavridès, *Marchands d'Art* (Paris: Plon, 1999), 112–14.

32. Notes on conversation with Prof. Dr. Claus Grimm, Munich (13 June 2018).

33. CDJC, CCXCV-13, Dr. Hans Buwert, "Aktennotiz über eine Rücksprache mit dem kommissarischen Verwalter der Firma Wildenstein & Cie, M. Bruyer" (5 January 1944).

34. Lohse interview with author, Munich (1 August 2000).

35. Ibid.

36. Yves Stavridès, email to author (9 June 2016).

37. Peter Hayes, *Why? Explaining the Holocaust* (New York: Norton, 2017), 316.

38. Polack, *Le Marché de l'Art sous l'Occupation*, 54, 58, 220, 226; and ALIU, *ALIU Final Report* (Washington, DC: Strategic Services, May 1946), 113.

39. Lohse interview with author, Munich (1 August 2000).

40. Notes on conversations with Dr. Bruno Lohse, Munich (21 July 2000 and 1 August 2000).

41. Notes on conversation with Peter Griebert, Munich (26 September 2014).

42. Nicole Pellecchi, "Kunstkrimi: Wie der Kunsthändler Bruno Lohse in der Schweiz Raubkunst bunkerte," *3SAT-Online/Kulturzeit* (26 July 2007).

43. See Catherine Hickley, *The Munich Art Hoard: Hitler's Dealer and His Secret Legacy* (London: Thames & Hudson, 2015); Susan Ronald, *Hitler's Art*

Thief: Hildebrand Gurlitt, the Nazis, and the Looting of Europe's Cultural Treasures (New York: St. Martin's, 2015); Mary Lane, *Hitler's Last Hostages: Looted Art and the Soul of the Third Reich* (New York: Public Affairs, 2019); and Meike Hoffmann and Nikola Kuhn, *Hitlers Kunsthändler. Hildebrand Gurlitt, 1895–1956* (Munich: C. H. Beck, 2016).

44. Notes on interview with Walter Feilchenfeldt, Zurich (29 June 2018). A leading theory is that Göring figured in the fate of the picture, including a scenario in which it was destroyed along with his estate, Carinhall, in 1945. See Joachim Nawrocki, "Die Blauen Pferde—Görings letzte Gefangene," *Die Welt* (3 March 2001).

45. Leo Müller, "Görings Kunstagenten im ZKB-Safe," *CASH* (10 May 2007); Tobias Timm, "Beraubt und betrogen," *Die Zeit* (6 June 2007); and Stephan Koldehoff, "Pissarro Lost and Found," *ARTnews* (Summer 2007), 76–80.

46. The author wrote to Guy Wildenstein on 15 April 2015 and 6 December 2019 to request a comment on Lohse's relationship with the Wildenstein family, but received no reply.

Chapter One. Art Historian, Art Dealer, Member of the SS (1911–41)

1. Staatsarchiv München, SpkA K, 1074 (Lohse's denazification file), Lohse Bruno, Ernst Skripka, "Urschrift" (1 September 1950).

2. Note that the Humboldtstrasse in Steglitz was renamed the Selerweg in 1960 during the process of reconstruction of Berlin. The building in which the Lohses lived appears to have been revamped around that time too. A plaque adorning the façade says, "Aufbauprogramm 1960" and features an image of the Berlin bear.

3. Staatsarchiv München, SpkA K, 1074, Lohse Bruno, testimony of Georg Borg (1 December 1947).

4. Notes on conversation with Lohse, Munich (1 August 2000).

5. Notes on conversation with Peter Griebert (7 June 2015).

6. BArch Berlin-Lichterfelde, R/936/1, 2101, personnel file for Siegfried Lohse (b. 29 September 1909). Siegfried Lohse's NSDAP number was 1,740,651. He listed himself as an *angstellte* (roughly, salaried employee), but did not record a profession. However, he was a member of the Reich Chamber of Culture, which may be suggestive of work in a creative field.

7. Staatsarchiv München, SpkA K, 1074, Lohse Bruno, testimony of Georg Borg (1 December 1947). In a 1950 letter from Lohse, he writes of his devotion to his mother and gives 1939 as the year of her death. IfZG, ED 449, vol. 15, Lohse to Dr. Margarethe Bitter (4 February 1950).

8. Notes on conversation with Prof. Dr. Claus Grimm, Munich (24 September 2014).

9. Landesarchiv Berlin, Rep. 243-04, film No. 99, frame 2424, Dr. Morawski to Reichskammer der bildenden Künste (17 December 1936).

10. The sports information is loosely translated from "Siege im Mehrkampf und Wirfwettbewerbe." See BArch-Berlin, R/9361/I, 2101, Bruno Lohse, Personalangaben (15 January 1942). The German reads, "SA-Sportabzeichen in Gold."

11. See Heinz Ladendorf and Hildegard Brinckmann, *Professor Dr. Dr. A. E. Brinckmann: Verzeichnis der Schriften* (Cologne: Kunsthistorisches Institut der Universität Köln, 1961). Among other works, see A. E. Brinckmann, *Barockskulptur. Entwicklungsgeschichte der Skulptur in den Romanischen und Germanischen Ländern seit Michelangelo bis zum 18. Jahrhundert* (Berlin: Athenaion, 1920).

12. DCAJM–Le Blanc, Tribunal Militaire Permanent, box 984, A. E. Brinckmann, statement (4 June 1947). When Pinder moved to Berlin he was replaced in Munich by Hans Jantzen (1881–1967), who came from Frankfurt in 1935. This helped create the opening for Brinckmann. See Nikola Doll, Christian Fuhrmeister, and Michael Sprenger, eds., *Kunstgeschichte im Nationalsozialismus. Beiträge zur Geschichte einer Wissenschaft zwischen 1930 und 1950* (Weimar: VDG, 2005); and Jutta Held, "Kunstgeschichte im 'Dritten Reich': Wilhelm Pinder und Hans Jantzen an der Münchner Universität," in Jutta Held and Martin Papenbrock, eds., *Kunstgeschichte an den Universitäten im Nationalsozialismus* (Göttingen: Vandenhoek & Rupprecht, 2003), 17–60.

13. DCAJM–Le Blanc, Tribunal Militaire Permanent, box 984, A. E. Brinckmann, statement (4 June 1947).

14. See the entry on Pinder by the Berlin-Brandenburgische Akademie der Wissenschaften at http://www.bbaw.de/die-akademie/akademiegeschichte/historischer-kalender/mai (accessed 18 June 2015); and, more generally, Sandra Schaeff, "Absteig vom 'Olym'? Das Kunstgeschichtliche Institut der Berliner Universität zur Zeit des Nationalsozialismus," in Doll, Fuhrmeister, and Sprenger, *Kunstgeschichte im Nationalsozialismus*, 39–48.

15. Bruno Lohse, *Jakob Philipp Hackert. Leben und Anfänge seiner Kunst* (Emsdetten: Lechte-Verlag, 1936).

16. Katrin Meier-Wohlt, "Das Kunsthistoriches Seminar der Universität München zur Zeit des Natinalsozialismus," in Doll, Fuhrmeister, and Sprenger, *Kunstgeschichte im Nationalsozialismus*, 94.

17. Lohse pointed to Professors Fischel, Neumayer, and Weissbach as "deposed professors." James Plaut, *DIR No. 6: Dr. Bruno Lohse* (Washington, DC: Strategic Services Unit, 15 August 1945), 1.

18. Emmanuelle Polack, *Le Marché de l'Art sous l'Occupation* (Paris: Tallandier, 2019), 233; and Katrin Iselt, *"Sonderbeauftragter des Führers": Der Kunsthistoriker und Museumsmann Hermann Voss (1884–1969)* (Cologne: Böhlau, 2010).

19. The friend who received the Prachtband of Lohse's dissertation is Dr. Hinrich Sieverking. Notes on interview with Prof. Dr. Claus Grimm, Munich (13 June 2018).

20. BAR-Bern, E6100A-24#1000/1924#7*, Bruno Lohse "Abhörungsproto-

koll" (7 February 1949). Later, after the war, Lohse listed his address as Humboldtstrasse 11 and Humboldtstrasse 27: one appears to have been his parents' home and one his own place. He also listed Regensburger Strasse 14 in Berlin-Wilmersdorf in 1947.

21. Adriaan Venema, *Kunsthandel in Nederland 1940–1945* (Amsterdam: Uitgeverij De Arbeiderspers, 1986), 73.

22. Walter Feilchenfeldt, *By Appointment Only: Cézanne, van Gogh and Some Secrets of Art Dealing* (London: Thames & Hudson, 2006), 15.

23. See Haberstock's business ledgers, reproduced in Horst Kessler, ed., *Karl Haberstock. Umstrittener Kunsthändler und Mäzen* (Munich: Deutscher Kunstverlag, 2008), 270. The title of the painting in German is *Schlafender Amor.* Note that the work by F. G. Weitsch sold in May 1992 in Switzerland: see Artprice.com, http://www.artprice.com/artist/93157/friedrich-georg-weitsch/lot/pasts/1/Painting/191772/der-schlafende-amor?p=1 (accessed 2 April 2015).

24. Kessler, *Karl Haberstock*, 282.

25. Staatsarchiv München, SpkA K, 1074, Lohse Bruno, *Meldebogen* (21 August 1950); and DCAJM–Le Blanc, Tribunal Militaire Permanent, box 984, Lohse, "Fragebogen" (30 April 1946).

26. BArch-Berlin, R 55/76, Bl. 115, President of the Reichskammer der bildenden Künste to the Reich Propaganda Ministry (RMVP) (3 June 1938).

27. Magdalena Haberstock, *Hundert Bilder aus der Galerie Haberstock Berlin* (Munich: Privatdruck, 1967).

28. Flavia Foradini, "The Other Gurlitt: The Dealer Cherished by 'Degenerate' Artists and Nazis Alike," *Art Newspaper* 264 (January 2015), http://www.theartnewspaper.com/articles/The-other-Gurlitt-the-dealer-cherished-by-degenerate-artists-and-Nazis-alike/36666.

29. NARA, RG 239, M 1944, roll 90, frames 6–23, Plaut, *DIR No. 6*, 1.

30. Lohse Papers (archive of author), SS Number 216,377 and NSDAP Mitgliedskarte No. 5585572, Dr. Bruno Lohse; Plaut, *DIR No. 6*, 1.

31. BArch-Berlin, R/936/I, 2101, Himmler to SS Personalhauptamt (30 April 1942).

32. Ibid., Himmler to SS Personalhauptamt (21 April 1944).

33. Ibid., Himmler to SS Personalhauptamt (30 April 1942); and BAR-Bern, E4320B#1973/17#1470*, Bruno Lohse file, Berlin Document Center, U.S. Army to Swiss Delegation (18 April 1953).

34. NARA, RG 239, box 80, Hans Leimer, "Bericht" (23 August 1942). The German reads, "Beauftragten des Reichsführers-SS für Kunstankäufe." The rank of Leimer is SS-Untersturmführer.

35. Ibid. The German reads, "bedeutende Gemäldesammlung in jüdischem Besitz" and Leimer describes Rigeaux as "einer der erfolgreichsten und zuverlässigsten V Männer." Note that Rigeaux may have been Henri Lafont, who also used other names, including "Chaisse," "Monsieur Henri," and "Capitaine Henri." He evidently was born, according to different sources,

Henri Normand or Henri Chamberlin in 1902, but during the occupation, he most often went by Henri Lafont (the name he carried until his execution on 26 December 1944).

36. Plaut, *DIR No. 6*, 1. Staatsarchiv München, SpkA K, 1074, "Lohse Bruno," Lohse to Ernst Skripka, Hauptkammer München (25 August 1950).

37. One French report rendered Seratzki as Serinsky, and gave her address as 9 rue Jean Moréas, Paris, VII. See NARA, M1944, roll 85, docs. 143–45, Rose Valland, "Report on Bruno Lohse" (1945).

38. Julia Torrie, "Visible Trophies of War: German Occupiers' Photographic Perceptions of France, 1940–1944," in Jennifer Evans, Paul Betts, and Stefan-Ludwig Hoffmann, eds., *The Ethics of Seeing: Photography and Twentieth-Century German History* (New York: Berghahn, 2018), 108–37.

39. Ibid., 110.

40. Polack, *Le Marché de l'Art sous l'Occupation*, 97, 189.

41. BArch-Berlin, R/936/I, 2101, Persönlicher Stab des Reichsführer-SS to SS-Personalhauptamt (7 January 1943).

42. Plaut, *DIR No. 6*, 1. See also Staatsarchiv München, SpkA K, 1074, Bruno Lohse to Ernst Skripka, Hauptkammer München (25 August 1950).

43. See, for example, DCAJM–LeBlanc, Tribunal Militaire Permanent, box 984, Bruno Lohse to M. le Procureur Général (28 November 1949); DCAJM–LeBlanc, box 983, document 126, "Renvoi sur Avis de l'Autorité Americaine" (n.d.); and Staatsarchiv München, SpkA K, 1074, Bruno Lohse to Ernst Skripka, Hauptkammer München (25 August 1950).

44. Archive of author, Gouvernement Militaire Français de Berlin, Renscignements d'Archives "WAST" (10 October 1958). Thanks to Philippe Sprang for providing this document.

Chapter Two. The "King of Paris" (1941–43)

1. James Plaut, *DIR No. 6: Dr. Bruno Lohse* (Washington, DC: Strategic Services Unit, 15 August 1945), 5. See also Jean-Marc Dreyfus and Sarah Gensburger, *Nazi Labor Camps in Paris: Austerlitz, Bassano, July 1943–August 1944* (New York: Berghahn, 2011).

2. BAR-Bern, E6100A-24/1000/1924, Bd. 7, Raubgutsachen Bührle/Dr. Raeber/Fischer/Eidgenossenschaft: Parteiverhör, Dr. Bruno Lohse (18/19 December 1950, Abschrift dated 22 January 1951), 20.

3. For a summary of the French protests about the Germans' seizure of Jewish cultural property, see AMAE-La Courneuve, 209SUP, box 718, Hermann Bunjes, "Rapport" (18 August 1942).

4. CDJC, CXL-1-3, Robert Scholz, "Arbeitsbericht über die Zeit vom Oktober 1940 bis Juli 1944" (15 July 1944).

5. BAR-Bern, E6100A-24/1000/1924, Bd. 7, Raubgutsachen Bührle/Dr. Raeber/Fischer/Eidgenossenschaft: Parteiverhör, Dr. Bruno Lohse (18/19 December 1950, Abschrift dated 22 January 1951), 21.

6. Plaut, *DIR No. 6*, 2. See also James S. Plaut, *CIR No. 1: Activity of the Einsatzstab Rosenberg in France* (Washington, DC: Strategic Services Unit, 15 August 1945), 3, 16.

7. Plaut, *CIR No. 1*, 16.

8. NARA, M1270, roll 12 (RG 238), "Testimony of Bruno Lohse Taken at Nurnberg, Germany, on 1 November 1945 by Lt. Col. Thomas Hinkel," 9.

9. Plaut, *CIR No. 1*, 16. See also Lohse Papers (archive of author), Günther Schiedlausky, "Statement to Military Tribunal" (3 June 1950). Schiedlausky was a corporal.

10. DCAJM–Le Blanc, Tribunal Militaire Permanent de Paris, box 983, Rose Valland, "Capitaine Dr. Schiedlausky, Günther" (n.d. [1945]).

11. Günther Haase, *Die Kunstsammlung des Reichsmarschalls Hermann Göring: Eine Dokumentation* (Berlin: edition q, 2000), 36.

12. See the 1949 interrogation in which Lohse disputes Dr. Schneider's assertion that Lohse had used the phrasing that his work was to sniff out (*auszuschnüffeln*) art objects from Jewish property. Lohse says his job was to inventory already seized objects. See BAR-Bern, E6100A-24, 1000/1924, Bd. 9, Bruno Lohse Abhörungsprotokoll (3 February 1949), 5.

13. Hector Feliciano, *The Lost Museum: The Nazi Conspiracy to Steal the World's Greatest Works of Art* (New York: Basic Books, 1997), 201; see also Guido Magnaguagno, "Die Sammlung Bührle: Raubkunst und Fluchtgut," in Thomas Buomberger and Guido Magnaguagno, eds., *Schwarzbuch Bührle. Raubkunst für das Kunsthaus Zürich?* (Zurich: Rotpunktverlag, 2015), 119.

14. Plaut, *DIR No. 6*, 2.

15. Plaut, *CIR No. 1*, 48.

16. Philippe Sprang, "Dans les ténèbres du docteur Lohse," *L'Oeil* 630 (December 2010), 25–33; Albert Speer, *Inside the Third Reich* (New York: Macmillan, 1970), 425–31.

17. Thomas Buomberger, *Raubkunst-Kunstraub. Die Schweiz und der Handel mit gestohlenen Kulturgütern zur Zeit des Zweiten Weltkrieges* (Zurich: Orell Füssli, 1998), 46.

18. Göring order of 5 November 1940 in Plaut, *CIR No. 1*, attachment 2.

19. For the 5 November 1940 order from Göring and the 14 November communication by Hitler, see Wilhelm Treue, "Dokumentation. Zum nationalsozialistischen Kunstraub in Frankreich (aka, Der 'Bargatzky Bericht')," *Vierteljahrshefte für Zeitgeschichte* 13/3 (1965), 312–13; and Jean Cassou, *Le Pillage par les Allemands des Oeuvres d'Art et des Bibliothèques Appartenant à des Juifs en France; Recueil de Documents* (Paris: CDJC, 1947), 105–14.

20. Göring (21 November 1940 letter) reproduced in Cassou, *Le Pillage par les Allemands*, 105–6.

21. Plaut, *CIR No. 1*, 3.

22. Ibid., 5–6.

23. For Rosenberg's visits to Paris in late November 1940 and late February 1941, see Plaut, *CIR No. 1*, 46; and Jürgen Matthäus and Frank Bajohr, eds.,

Alfred Rosenberg. Die Tagebücher von 1934 bis 1944 (Frankfurt: S. Fischer, 2015), 336, 355–59, 522.

24. NARA, M1270, roll 12 (RG 238), "Testimony of Bruno Lohse Taken at Nurnberg, Germany, on 1 November 1945 by Lt. Col. Thomas Hinkel," 18–19.
25. Plaut, *CIR No. 1*, 49.
26. Lohse Papers, Bernhard von Tieschowitz, Kulturreferent der Botschaft der Bundesrepublik Deutschland, "Stellungnahme zu dem Film 'Le Train'" (10 October 1964).
27. Plaut, *CIR No. 1*, 13.
28. DCAJM–Le Blanc, Tribunal Militaire Permanent de Paris, box 984, tome I/II, "Affaire de l'ERR," Rose Valland, biographical notes on individuals (here von Behr) (n.d. [1945]).
29. MMA, Rousseau Papers, box 26, folder 18, Rousseau, "Lecture on German Looting" (11 March 1959).
30. Plaut, *CIR No. 1*, 13.
31. Ibid., 11.
32. Ibid., 47.
33. Ibid., 49.
34. Plaut, *CIR No. 1*, 13, 46–49; and, more generally, Jonathan Petropoulos, *The Faustian Bargain: The Art World in Nazi Germany* (New York: Oxford University Press, 2000), 111–64.
35. Haase, *Kunstsammlung des Reichsmarschalls*, 36.
36. Notes on conversation with Peter Griebert, Munich (24 September 2014); and notes on conversation with Prof. Dr. Claus Grimm, Munich (24 September 2014).
37. Plaut, *DIR No. 6*, 2. Alan Riding, *And the Show Went On: Cultural Life in Nazi-Occupied Paris* (New York: Knopf, 2010), 46. See also Göring's calendar in IfZG, ED 180/5.
38. Notes on conversation with Peter Griebert, Munich (26 September 2014).
39. MMA, Rousseau Papers, box 26, folder 18, Rousseau, "Lecture on German Looting" (11 March 1959).
40. NARA, RG 239, box 80, James Plaut and Theodore Rousseau to AC of S, G-2 (12 January 1946). The German title is "Sonderstab bildende Kunste." For an example of Lohse denying a formal affiliation with the ERR, see the statement of his lawyer, Konrad Voelkl, that Lohse "was not taken into the ERR either in a civilian or military capacity": Lohse Papers, Konrad Voelkl to Albert Steiner (3 July 1953).
41. Lohse is sometimes also described as "deputy commander of the Dienststelle Westen" within the ERR. See Marc Masurovsky, "'A Harvest Scene (Heuernte)' by Philip Wouwerman," *Plundered Art* (9 June 2011), http://plundered-art.blogspot.co.uk/2011/06/harvest-scene-heuernte-by-philip.html.
42. For the photos of ERR personnel, see AMAE–La Courneuve, 209SUP, RA 992 and 1044.

43. Plaut, *CIR No. 1*, 45; Emmanuelle Polack, *Le Marché de l'Art sous l'Occupation* (Paris: Tallandier, 2019), 44.

44. Emmanuelle Polack, "Martyrs of Modern Art: Three Paintings by Henri Matisse from the Paul Rosenberg Collection in the Turmoil of World War II," in Uwe Fleckner, Thomas Gaehtgens, and Christian Huemer, eds., *Markt und Macht: Der Kunsthandel im "Dritten Reich"* (Berlin: De Gruyter, 2017), 241.

45. Plaut, *DIR No. 6*, 4. See also James Plaut, "Loot for the Master Race," *Atlantic* (September 1946), 60.

46. BAR-Bern, E6100A-24/1000/1924, Bd. 7, Raubgutsachen Bührle/Dr. Raeber/ Fischer/Eidgenossenschaft: Parteiverhör, Dr. Hans Wendland (18/19 December 1950, Abschrift dated 22 January 1951), 12.

47. Fabrizio Calvi and Marc Masurovsky, *Le Festin du Reich. Le Pillage de la France Occupée 1940–1945* (Paris: Fayard, 2006), 258. The French reads, "Son action personnelle a beaucoup contribué à donner à ces requisitions leur caractère de grande brigandage."

48. "Le Procèes des Pillards de Goering," *L'Aurore* (3 August 1950). The French reads, "'Le beau Knochen,' chef de la terrible Gestapo de l'avenue Foch."

49. "Le Pillards Allemands devant le Tribunal Militaire," *L'Epoque* (3 August 1950).

50. Sprang, "Dans les ténèbres du docteur Lohse," 26.

51. Notes on conversation with Philippe Sprang, Paris (23 March 2017).

52. USHMM, RG 67, 041, reel 1, images 693-96, UN War Crimes Commission, "Charges against German War Criminals" (25 August 1945).

53. Lohse Papers, "Abschrift: Verzeichnis der von den Okkupationsbehörden beschlagnahmten Kunstwerke" (1 May 1948). The initial chief of the Dienststelle Westen was Dr. Georg Ebert. Plaut, *CIR No. 1*, 3, 10.

54. Plaut, *CIR No. 1*, 9.

55. NARA, RG 239, M 1944, roll 85, frame 35, "The ERR, the Dienststelle Westen and Monsieur Dupont" (n.d.). The depots are Jeu de Paume, Louvre Museum, rue de la Bruyère (near Gare St. Lazare), rue Dumont Durville; and the offices are at Gare d'Austerlitz, Gare de l'Est, rue de la Frenelle, Place des États Unis, rue Bassano, and avenue d'Iéna (Jena).

56. Michael Gibson, "How a Timid Curator with a Deadpan Expression Outwitted the Nazis," *ARTnews* (Summer 1981), 107.

57. Horsta Krum, "Görings Diebestour—Göring's Thieving Spree," *Junge Welt* (27 August 2014).

58. Gibson, "Timid Curator," 105-7. See also Michel Rayssac, *L'Exode des Musées. Histoire des Oeuvres d'Art sous l'Occupation* (Paris: Payot, 2007).

59. AMN, R 32.1, J. Jaujard, "Activités dans la Résistance de Mademoiselle Rose Valland" (n.d.), 1.

60. Lohse Papers, Dr. Hermann Bunjes, "Bericht: Betr. Sicherstellung von Kunstbesitz geflohener Juden im besetzten Frankreich" (8 August 1942).

61. Lohse Papers, "Prise de Position" (n.d.), 5.
62. Gibson, "Timid Curator," 108; and Matila Simon, *Battle of the Louvre: The Struggle to Save French Art in World War II* (New York: Hawthorn, 1971), 52–53.
63. Gibson, "Timid Curator," 108; Rose Valland, *Le Front de l'Art: Défense des Collections Françaises 1939–1945* (Paris: Réunion des Musées Nationaux, 1997 [1961]), 83–84.
64. Lohse testimony of 23 December 1949, cited in AMN, R 32.1, J. Jaujard, "Activités dans la Résistance de Mademoiselle Rose Valland" (n.d.), 8; and archive of author, Valland to Captain Harlin (31 January 1955). Thanks to Philippe Sprang for the latter document.
65. Gibson, "Timid Curator," 107–8. He uses the phrase "hideously dangerous."
66. Feliciano, *Lost Museum*, 107.
67. AMN, R 32.1, J. Jaujard, "Activités dans la Résistance de Mademoiselle Rose Valland" (n.d.), 4.
68. AMN, R 32.1, Valland to Jaujard (16 July 1942).
69. AMN, R 32.1, Valland to Jaujard (26 November 1942, 10 February 1943, 18 March 1943, and 10 November 1943).
70. AMN, R 32.1, Valland to Jaujard (23 June 1943 and 23 November 1943).
71. Lohse Papers, Jacques Beltrand to Lohse (30 December 1941).
72. Feliciano, *Lost Museum*, 222; and Polack, "Martyrs of Modern Art," 237–52.
73. Emmanuelle Polack, Catell Muller, and Claire Bouilhac, *Rose Valland: Capitaine Beaux Arts* (Paris: Dupuis, 2009). See also Emmanuelle Polack and Philippe Dagen, *Les Carnets de Rose Valland* (Paris: Editions Fage, 2011); Corinne Bouchoux, *Rose Valland: La Résistance au Musée* (La Crèche: Geste Éditions, 2006); Philippe Sprang, "Rose Valland, un Chef-d'Oeuvre de Résistance," *Paris Match* (20 February 2015), 75–81; and Sarah Wildman, "The Revelations of a Nazi Art Catalogue," *New Yorker* (12 February 2016). For more on the ERR, see Jean Cassou, *Le Pillage par les Allemands des Oeuvres d'Art et des Bibliothèques Appartenant à des Juifs en France; Recueil de Documents* (Paris: CDJC, 1947); Anja Heuss, *Kunst- und Kulturgutraub. Eine vergleichende Studie zur Besatzungspolitik der Nationalsozialisten in Frankreich und der Sowjetunion* (Heidelberg: Winter, 2000); Hanns Christian Löhr, *Kunst als Waffe: Der Einsatzstab Reichsleiter Rosenberg* (Berlin: Gebr. Mann, 2018); and the database, Cultural Plunder by the ERR: Database of Art Objects at the Jeu de Paume, https://www.errproject.org /jeudepaume/ (accessed 2 January 2020).
74. Simon, *Battle of the Louvre*, 52–53.
75. Notes on telephone conversation with Bruno Lohse (16 May 2001).
76. Bouchoux, *Rose Valland*, 98–99; and Polack, Muller, and Bouilhac, *Rose Valland*, 12.
77. Plaut, *DIR No. 6*, 3, 8. Göring issued the order to Lohse on 21 April 1941.
78. David Irving, *Göring: A Biography* (New York: Morrow, 1989), 299.

79. Gerard Aalders, "By Diplomatic Pouch: Art Smuggling by the Nazis," *Spoils of War International Newsletter*, no. 3 (December 1996).

80. Mowenna Blewett, "Institutional Restorers, Cultural Plunder and New Collections," in Tanja Baensch, Kristina Kratz-Kresemeier, and Dorothee Wimmer, eds., *Museen im Nationalsozialismus: Akteure—Orte—Politik* (Cologne: Böhlau, 2015), 154.

81. Ibid.

82. Tillar Mazzeo, *The Hotel on Place Vendôme* (New York: HarperCollins, 2014), 58.

83. Irving, *Göring*, 302, quoting OSS X-2 "Interim Report on the Art Activities of the HG" (12 June 1945).

84. Nancy Yeide's *Beyond the Dreams of Avarice: The Hermann Goering Collection* (Dallas: Laurel, 2009) is the definitive study of the Göring collection. Also useful are Jean-Marc Dreyfus and Les Archives Diplomatiques, eds., *Le Catalogue Goering* (Paris: Flammarion, 2015); and the Berchtesgaden Inventory of 4 August 1945: see NARA, RG 260, OMGUS, Ardelia Hall Collection, Records of the Wiesbaden Central Collecting Point, Restitution, Research, and Reference Records, box 169. For Carinhall, see Volker Knopf and Stefan Martens, *Görings Reich. Selbstinszenierungen in Carinhall* (Berlin: Ch. Links, 1999).

85. NARA, RG 239, M 1944, roll 92, frame 84, Lohse to Prof. G. Schilling (8 December 1942).

86. Plaut, *CIR No. 1*, 6.

87. Ibid., 7.

88. GRI, SC, Douglas Cooper Papers, box 42, "Schätzungsliste" (13 March 1942).

89. AMN, R 32.1, Valland to Jaujard (28 November 1942).

90. Plaut, *DIR No. 6*, 11.

91. Götz Aly, *Hitler's Beneficiaries: Plunder, Racial War, and the Nazi Welfare State* (New York: Metropolitan Books, 2005); Frank Bajohr, *Parvenüs und Profiteure. Korruption in der NS-Zeit* (Frankfurt: S. Fischer, 2001); and Martin Dean, *Robbing the Jews: The Confiscation of Jewish Property in the Holocaust, 1933–1945* (Cambridge: Cambridge University Press, 2008).

92. NIOD, Aalders Collection, L.3348, E. E. Minskoff, "Interrogation of Gisela Limberger" (9-12 October 1945), 11.

93. Plaut, *DIR No. 6*, 14.

94. Ibid., 10.

95. Ibid.

96. AMN, R 32.1, Valland to Jaujard (3 November 1943).

97. BArch-Berlin, R/936/I, 2101, Reichsführer-SS Persönlicher Stab to SS Personalhauptamt (7 December 1944).

98. BArch-Berlin, NS 19/3055, doc. 17, Wilhelm Vahrenkamp to Himmler (5 August 1942). The German reads, "Aus diesen Ankäufen werden sicher auch der Schutzstaffel gute Werke zur Verfügung stehen."

99. BArch-Berlin, NS 19/3055, doc. 19, Wilhelm Vahrenkamp to Himmler (14 August 1942).

100. NARA, RG 260, OMGUS, Restitution Research Records, box 446, Testimony of Karl Haberstock (12 June 1945).

101. See the business ledger for Mühlmann's looting agency for the early war years in the Netherlands at BArch-Koblenz, B 323, box 185, Geschäftsbuch Dienststelle Mühlmann (1940–41); for more on Mühlmann serving multiple patrons, see ibid., boxes 199, 200, 322.

102. Raul Hilberg, *The Destruction of the European Jews*, 3rd ed. (New Haven: Yale University Press, 2003), 3:628–29; and Jean-Marc Dreyfus, "Le Pillage des Biens Juifs dans l'Europe Occidentale Occupée: Belgique, France et Pays-Bas," in Constantin Goschler, Phillip Ther, and Claire Andrieu, eds., *Spoliations et Restitutions des Biens Juifs: Europe XXe Siècle* (Paris: Éditions Autrement, 2007), 92–93.

103. Nina Siegal, "Beyond Anne Frank: The Dutch Tell Their Full Holocaust Story," *New York Times* (17 July 2016); and Jean Vlug, *Report on Objects Removed to Germany from Holland, Belgium, and France during the German Occupation in the Countries* (The Hague: Strategic Services Unit, 1945), 24. After the war, Mühlmann claimed he rarely interacted with Himmler personally; he answered to Ernst Kaltenbrunner (Reinhard Heydrich's successor as head of the Reich Security Main Office, which oversaw the SD) and he acquired art mostly for the Nazi Order Castles (*Ordensburgen*), or ideological academies. Dokumentationsarchiv Österreichischen Widerstandes, Aktennummer 19031/1, Kajetan Mühlmann, "Vernehmung des Beschuldigten" (30 October 1946).

104. Gerald Aalders, *Nazi Looting: The Plunder of Dutch Jewry during the Second World War* (Oxford: Berg, 2004), 89.

105. IfZG, ZS 2211, Testimony of Professor Borodaykewycz (22 July 1953).

106. Mühlmann was also committed to General Governor Hans Frank, for whom he bought a great deal of art and cultural property in Paris during the war. AMAE-La Courneuve, 209SUP, box 417, "Liste des Oeuvres d'Art Achetées pour Franck [*sic*] en Pays Occupé" (n.d.).

107. Theresa Sepp, "Arbeitsbericht: Vorstudie zur Rekonstruktion des Besitzes von Kunst-und Kulturgut, ber das Baldur von Schirach und seine Ehefrau Henriette zwischen 1935 und 1945 verfügten," *Deutsches Zentrum Kulturgutverluste* (September 2018), 116, 123; and BArch-Koblenz, B 323, box 199, Geschäftsbuch der Dienststelle Mühlmann (1940–45).

108. Mühlmann sent works attributed to Vermeer (*Reading Man* from the ten Cate collection) and van Gogh (*Field of Poppies*) to Schirach and Vienna: see Petropoulos, *Faustian Bargain*, 181; and Sepp, "Arbeitsbericht," 156, 162–63.

109. Lynn Nicholas, *The Rape of Europa: The Fate of Europe's Treasures in the Third Reich and the Second World War* (New York: Knopf, 1994), 174.

110. Plaut, *DIR No. 6*, 3.

111. See, for example, the School of Lucas Cranach the Elder, *Saint Peter*, which

Lohse bought for Göring at the Hôtel Drouot on 15 June 1941 for 190,000 francs: Yeide, *Beyond the Dreams of Avarice*, 353.

112. Marc Masurovsky, "Nazi Plunderer Bruno Lohse Gets a Posthumous Re-write," *Plundered Art* (29 July 2011), http://plundered-art.blogspot.com /2011/07/nazi-plunderer-bruno-lohse-gets.html.

113. AMN, R 32.1, Rose Valland to Jacques Jaujard (18 August 1942).

114. Sprang, "Dans les ténèbres du docteur Lohse," 26.

115. Plaut, *DIR No. 6*, 14.

116. Notes on conversation with Philippe Sprang, Paris (23 March 2017). He provided a copy of the letter by Michel Martin (n.d.). The French reads, "Beau garçon, élégant, parlant très bien le français, le Dr. Lose [*sic*] faisait de nombreuses conquêtes féminines; il eut pendant près d'un an, en 1942 une entrîneuse du cabaret montmartrois Schéhérazade, Jeannine Senne-ville, puis en 1943, une demoiselle Jacqueline Serapski [*sic*]."

117. Plaut, *DIR No. 6*, 13.

118. Notes on conversation with Philippe Sprang, Paris (23 March 2017).

119. Plaut, *DIR No. 6*, 13.

120. Ibid., 13.

121. Ibid., 14.

122. NARA, RG 260, OMGUS, Restitution Research Records, box 446, Testi-mony of Karl Haberstock (12 June 1945).

123. BArch-Berlin, R/9361/III, 651275, Parteikorrespondenz (3 July 1943). Lohse lists his address and says he is living in the home of someone named "Grau" ("b. Grau"), but there is no information on this individual.

124. Sprang, "Dans les ténèbres du docteur Lohse," 26.

125. NARA, M1944, roll 85, docs. 143–45, Rose Valland, "Report on Bruno Lohse" (1945).

126. See Valland's entry for 10 April 1943 in Polack and Dagen, *Les Carnets de Rose Valland*, 71. The French reads, "Ce sera pour nous." Valland also sus-pected that Lohse took a Rembrandt drawing, *Portrait of the Father of the Artist*.

127. All these episodes are noted in NARA, M1944, roll 85, docs. 143–45, Rose Valland, "Report on Bruno Lohse" (1945).

128. NARA, M1947, roll, 73, Robert Scholz to Gerhard Utikal (25 January 1944).

129. Ibid.

130. Ibid.

131. Scholz had tried before, as early as 1940, to assert his chief Alfred Rosen-berg's control over the ERR in Paris. Rosenberg sent Scholz after Göring's landmark visit in November 1940. See Krum, "Görings Diebestour."

132. Plaut, *DIR No. 6*, 14.

133. For another case of mystery surrounding the postwar fate of a Nazi offi-cial's art collection, see Patricia Kennedy Grimsted, "Nazi-Looted Art

from East and West in East Prussia: Initial Findings on the Erich Koch Collection," *International Journal of Cultural Property* 22 (2015), 7–60.

134. Notes on conversation with Walter Feilchenfeldt, Zurich (29 June 2018).

135. Calvi and Masurovsky, *Le Festin du Reich*, 259. The French reads, "la dernière des grandes collections d'art hollandais constituées en France au XIXème siècle."

136. Ibid., 260.

137. BArch-Koblenz, B 323, boxes 186 and 256, "Sammlung Adolphe Schloss: Fotos der 1945 gestohlenen Gemälde" (1948).

138. See coverage in Artdaily, http://artdaily.com/news/112477/Christie-s -Restitution-Department-facilitates-the-return-of-Nazi-looted-painting# .XPb3fF5YZ9A (accessed 4 June 2019). Another Schloss collection picture that surfaced did not find a mutually agreeable solution. See AFP, "Nazi-Pillaged Artwork Pulled from Vienna Auction," *Times of Israel* (12 April 2016), https://www.timesofisrael.com/nazi-pillaged-artwork-pulled-from -vienna-auction/.

139. NARA, RG 239, M 1944, roll 97, frame 750, Lohse, "Aktenvermerk" (25 September 1942). The German reads, "ein enger Mitarbeiter des französischen Judenkommissars."

140. Ibid.

141. DCAJM–Le Blanc, Tribunal Militaire Permanent de Paris, box 984, Le Long and Thibault, "Affaire Schloss et Autres" (25 October 1945).

142. NARA, RG 239, M 1944, roll 87, frame 739, Gerhard Utikal to Adjutantur des Herrn Reichsmarschalls des Grossdeutschen Reichs (30 June 1943). The German reads, "Sicherstellung der Sammlung des Juden 'Schloss.'"

143. AMAE–La Courneuve, 209SUP, box 583, Rose Valland to the Chef de CRA (18 September 1950).

144. Iris Lauterbach, *The Central Collecting Point in Munich: A New Beginning for the Restitution and Protection of Art* (Los Angeles: J. Paul Getty Trust, 2018), 115.

145. AMAE–La Courneuve, RA 583-R40, Edgar Breitenbach to Rose Valland (30 November 1948).

146. Nicholas, *Rape of Europa*, 135.

147. DCAJM–Le Blanc, Tribunal Militaire Permanent de Paris, box 983, Rose Valland, "Fleicher or Fleischer" (n.d. [1945]). The French reads, "était le confident de ses [Lohse's] opérations et de ses profits personnels."

148. Ibid.

149. See NARA, M 1944, roll 85, frames 154 and 280. The phrase "homme de confiance" can mean informant, but from the second document in frame 280, it is clear that Fleischer was much more than that. The report reads, for example, that Fleischer was "absolument dévoué à Lohse."

150. AMN, 030-438, Ehrengard von Portatius to Rose Valland (8 November 1951). Now in the Archives Nationales, 201504971/215.

151. BAR-Bern, E6100A-24, 1000/1924, Bd. 9, Annemarie von Tomforde-Ingram Abhörungsprotokoll (2 May 1949), 1.

152. Ibid., 1–2. She says, "Der Einsatzstab Rosenberg gehörte zum Wehrmachtsgefolge."

153. Plaut, *CIR No. 1*, 50, 53.

154. Ibid. See also DCAJM–Le Blanc, Tribunal Militaire Permanent de Paris, box 983, Rose Valland, "Dr. von Ingram-Tomforde, Anne-Marie" (n.d. [1945]).

155. Haase, *Kunstsammlung des Reichsmarschalls*, 36.

156. Plaut, *DIR No. 6*, 9; and Polack, *Le Marché de l'Art sous l'Occupation*, 54–55, 170–75, 219. According to Plaut, Lohse also helped Martin Bormann acquire a picture by Franz Xaver Winterhalter via Maria Almas Dietrich.

157. Feliciano, *Lost Museum*, 127.

158. Susan Ronald, *Hitler's Art Thief: Hildebrand Gurlitt, the Nazis, and the Looting of Europe's Cultural Treasures* (New York: St. Martin's, 2015), 227–28.

159. Elizabeth Campbell Karlsgodt, *Defending National Treasures: French Art and Heritage under Vichy* (Stanford: Stanford University Press, 2011), 286.

160. Plaut, *DIR No. 6*, 9.

161. NIOD, Aalders Collection, L.3348, E. E. Minskoff, "Interrogation of Gisela Limberger" (9–12 October 1945), 1.

162. IfZG, OMGUS, 3/71–3/1, Karl Haberstock Interrogation by Eldon Cassoday (27 February 1945).

163. See the autobiographical sketch in BAR-Bern, J1.269, 1999/82, Bd. 2#42*, Walter Andreas Hofer Abhörungsprotokoll (30 April 1949).

164. See the Wikipedia entry on Kurt Bachstitz, http://en.wikipedia.org/wiki/Kurt_Walter_Bachstitz (accessed 10 January 2020). See also NARA, RG 239, M 1944, roll 92, frame 663, Declaration of Hans Wendland (4 September 1946).

165. BAR-Bern, J1.269, 1999/82, Bd. 2, Walter Andreas Hofer Abhörungsprotokoll (30 April 1949).

166. Ibid.; and NIOD, Aalders Collection, L.3349, J. Cassoday, "Interrogation of Andreas Hofer" (28 September 1945), 1.

167. NIOD, Aalders Collection, L.3349, E. E. Minskoff, "Interrogation of Walter Andreas Hofer" (12 December 1945), 9. See also Yeide, *Beyond the Dreams of Avarice*, 15.

168. BAR-Bern, J1.269, 1999/82, Bd. 2, Edgar Breitenbach to Dr. Sieben (16 May 1949).

169. NIOD, no. 211/3, box 5, doc. 253, Hofer to Göring (26 September 1941). Note that a copy of this document was among Lohse's papers.

170. Ibid.

171. NIOD, Aalders Collection, L.3349, J. Cassoday, "Interrogation of Andreas Hofer" (28 September 1945), 14. Angerer also had a home in Maria Gern near Berchtesgaden, to which he retreated at war's end. See Andrea Hollmann and Roland März, *Hermann Göring und sein Agent Josef Angerer*.

Annexion und Verkauf "Entartete Kunst" aus deutschem Museumsbesitz 1938 (Paderborn: Wilhelm Fink, 2014); Haase, *Kunstsammlung des Reichsmarschalls*, 30–31; and Christine Fischer-Defoy and Kaspar Nürnberg, eds., *Gute Geschäft. Kunsthandel in Berlin, 1933–1945* (Berlin: Aktives Museum, 2011), 93–98.

172. See the *Terminkalendar* and *Taschenkalendar* for Göring in IfZG, ED 180.

173. IfZG, OMGUS, 3/71–3/1, Karl Haberstock Interrogation by Eldon Cassoday (27 February 1945).

174. Haase, *Kunstsammlung des Reichsmarschalls*, 31–34; and the Wikipedia entry for Walter Bornheim: https://de.wikipedia.org/wiki/Walter_Bornheim (accessed 29 August 2018).

175. NARA, RG 260, OMGUS, Restitution Research Records, box 446, Testimony of Karl Haberstock (12 June 1945).

176. Theodore Rousseau, *DIR No. 11: Walter Bornheim* (Washington, DC: Strategic Services Unit, 15 September 1945), 3.

177. Haase, *Kunstsammlung des Reichsmarschalls*, 34.

178. NARA, RG 260, OMGUS, Restitution Research Records, box 446, Testimony of Karl Haberstock (12 June 1945).

179. Calvi and Masurovsky, *Le Festin du Reich*, 261. See also Ernst Klee, *Das Personenlexikon zum Dritten Reich* (Frankfurt: Fischer, 2007), 85; and Treue, "Dokumentation," 308.

180. Calvi and Masurovsky, *Le Festin du Reich*, 261.

181. Buomberger, *Raubkunst-Kunstraub*, 71. Other members of the syndicate included French industrialist Achille Boitel (who was assassinated by the French Resistance in 1944) and Yves Perdoux. See NARA, RG 239, M 1944, roll 90, report on the Birtschansky brothers, Leon and Zacharias (2 May 1945).

182. See Lohse's letter to Göring (15 June 1943) reproduced in Haase, *Kunstsammlung des Reichsmarschalls*, 64. The German reads, "Standartenführer."

183. Theodore Rousseau, *CIR No. 2: The Goering Collection* (Washington, DC: Office of Strategic Services, 15 September 1945), 49; and Haase, *Kunstsammlung des Reichsmarschalls*, 37.

184. Feliciano, *Lost Museum*, 124.

185. Plaut, *DIR No. 6*, 11. Lohse claimed that the barter went through Kurt von Behr. Lohse Papers, "Prise de Position" (n.d.), 5. For more on the library, including its restitution in 1948, see AMAE–La Courneuve, RA 1061, 1531.

186. Göring, quoted in Irving, *Göring*, 371. See NARA, RG 239, M 1944, roll 88, frame 58, Gisela Limberger note (22 June 1943). A different translation of Limberger's note is in NIOD, doc. 2, 685B, map F.

187. BAR-Bern, E4320B#1973/17#1470*, Konrad Voelkl statement (25 September 1953); and "Le Pillards Allemands."

188. Hans Knoop, *The Menten Affair* (New York: Macmillan, 1979), 30.

189. Simon Elson, *Der Kunstkenner. Max J. Friedländer. Biografische Skizzen* (Cologne: Walter König, 2015).

190. J. Rosenberg, "Friedlaender and the Berlin Museums," *Burlington Magazine* 101 (March 1959), 83–85.

191. Walter Feilchenfeldt told the story that his father would receive Walter Andreas Hofer after the war because Hofer had been the one to save Max Friedländer. Feilchenfeldt said that neither he nor his father would meet with Lohse. Notes on conversation with Walter Feilchenfeldt, Zurich (29 June 2018). Contact between Marianne Feilchenfeldt and Hofer is referenced in GRI, Schaeffer Galleries Records, series IVA, box 116, folder 9, Hofer to Hanns Schaeffer (8 August 1960). Simon Elson suggests that Karl Haberstock played the key role with regard to saving Friedländer. See Elson, *Der Kunstkenner*, 322.

192. Bayerische Staatsbibliothek, Erhard Göpel *Nachlass*, Ana 415, Göpel "Aktennotiz" (24 August 1942).

193. DCAJM–Le Blanc, Tribunal Militaire Permanent, box 984, Lohse statement from Füssen jail (4 June 1945).

194. Nancy Yeide, Konstantin Akinsha, and Amy Walsh, *The AAM Guide to Provenance Research* (Washington, DC: American Association of Museums, 2001), 262; and Elson, *Der Kunstkenner*, 384.

195. Simon, *Battle of the Louvre*, 42. Karl Haberstock also helped protect Friedländer.

196. DCAJM–Le Blanc, Tribunal Militaire Permanent, box 984, Lohse statement from Füssen jail (4 June 1945).

197. The French originals are Syndicat de Marchands d'art, Paris, and Syndicat des Éditeurs d'Art et Négociants en Tableaux Modernes.

198. DCAJM–Le Blanc, Tribunal Militaire Permanent, box 983, Cailleux to G. Borg (24 August 1946), and ibid., Cailleux, "Memorandum" (n.d. [1948?]). Note that the name is sometimes spelled "Cayeux."

199. DCAJM–Le Blanc, Tribunal Militaire Permanent, box 984, Lohse statement from Füssen jail (4 June 1945).

200. Feliciano, *Lost Museum*, 133–37, 216, 269.

201. Ibid., 134–37.

202. Ibid., 133–37.

203. See trade #28 in Plaut, *CIR No. 1*, 44–45; and Staatsarchiv Coburg, SPK BA Land, H 21, 154/10, denazification trial of Karl Haberstock, statement of Ingeborg Hertmann (27 November 1947).

204. Lohse Papers, Gerhard Utikal, "Eidestattliche Erklärung" (7 March 1947).

205. DCAJM–Le Blanc, Tribunal Militaire Permanent de Paris, box 983, Piet de Boer to Walter Hofer (9 July 1942).

206. Ibid.; and Sepp, "Arbeitsbericht," 123.

207. Siegal, "Beyond Anne Frank."

208. DCAJM–Le Blanc, Tribunal Militaire Permanent, box 984, Adolf Wüster, "Eidesstattliche Erklärung" (20 March 1948).

209. ALIU, *ALIU Final Report* (Washington, DC: Strategic Services, May 1946), as transcribed in Yeide, Akinsha, and Walsh, *AAM Guide to Prove-*

nance Research and also at Lootedart.com, https://www.lootedart.com/aliu
-long (accessed 6 January 2020).

210. Nicholas, *Rape of Europa*, 424.

211. Feliciano, *Lost Museum*, 123.

212. Ibid.

213. See, for example, Staatsarchiv München, K 285 and K 1953, Spruchkammer
Akten for Maria Almas Dietrich (b. 28 June 1892) and for Adolf Wein-
müller (b. 5 May 1886).

214. Plaut, *DIR No. 6*, 10.

215. Yeide, Akinsha, and Walsh, *AAM Guide to Provenance Research*, 279. This
entry for Mandl is based on the Art Looting Investigation Unit reports.

216. BAR-Bern, E4320B#1990/133, Bd. 1, anonymous memorandum (29 July
1943); and Otto Wittmann and Bernard Taper, *DIR: Hans Wendland*
(Washington, DC: Strategic Services Unit, 18 September 1946). See also
Polack, *Le Marché de l'Art sous l'Occupation*, 47–48, 51–58.

217. Zacharias Birtschansky continued his career in the postwar period, and this
included donating a portrait of Duchess von Medem by Angelica Kauff-
mann to the Los Angeles County Museum of Art in 1946: see Tobyns,
http://www.tobyns.com/the-portrait-of-duchess-dorothea-von-medem-
von-biron/ (accessed 13 March 2015). For Lohse saving the Loebls, see
Elson, *Der Kunstkenner*, 384.

218. Feliciano, *Lost Museum*, 137, 152. Feliciano notes that "Raphael Gérard
hadn't flinched at handling a number of works from the Rosenberg col-
lection." Rose Valland writes about Lohse and Leegenhoek in her reports:
AMN, R 32.1, Valland to Jaujard (4 November 1943).

219. James Plaut, *DIR No. 4: Gustav Rochlitz* (Washington, DC: Strategic Ser-
vices Unit, 15 August 1945), 11–12.

220. Buomberger, *Raubkunst-Kunstraub*, 71.

221. Yeide, *Beyond the Dreams of Avarice*, picture D7, 454. Note that there were
two abstract works by Braque traded by Rochlitz: one went to Pétridès and
the other to a Mlle. Levy.

222. Buomberger and Magnaguagno, *Schwarzbuch Bührle*, 119.

223. Polack, *Le Marché de l'Art sous l'Occupation*, 51–52.

224. Lohse interview with author, Munich (1 August 2000); and story recounted
by Peter Griebert, interview with author (4 December 2006).

225. NARA, RG 260, OMGUS, Restitution Research Records, box 446, Testi-
mony of Karl Haberstock (12 June 1945).

226. Ibid. See also, Reinhard Müller-Mehlis, "Künstler, Kenner, Konsul,"
Münchner Merkur (27 December 1968); Reinhard Müller-Mehlis, "Maler,
Kunstexperte und Diplomat: Adolf Wüster starb 83jährig in München,"
Münchner Merkur (17 February 1972); F.H., "Adolf Wüster. Zum 80. Ge-
burtstag," *Weltkunst* (1 January 1969), 14; Reinhard Müller-Mehlis, "Zum
Tode Adolf Wüsters," *Weltkunst* 42 (1972), 448; and Bernd Isphording,
Gerhard Keiper, and Martin Kröger, *Biographisches Handbuch des deutschen*

Auswärtigen Dienstes, 1871–1945, vol. 5 (Paderborn: Ferdinand Schönigh, 2014), 337.

227. See the homepage of MoMA, https://www.moma.org/collection/works /35584 (accessed 23 July 2019); and, more generally, Martin Fabiani, *Quand J'étais Marchand de Tableaux* (Paris: Julliard, 1976).

228. See Open Art Data, "Fabiani in France's MNR Provenances" (8 May 2018), https://www.openartdata.org/2018/05/looted-art-Fabiani-MNR-Linz -ALIU.html.

229. Feliciano, *Lost Museum*, 135, 140–41.

230. See Open Art Data, "Art Market Networks of Adolf Wuester during the Nazi Occupation of Paris" (27 April 2019), https://www.openartdata.org /search?q=wuester.

231. Feliciano, *Lost Museum*, 166–69; and Polack, *Le Marché de l'Art sous l'Occupation*, 77–87. See trades #24 and 25 in Plaut, *CIR No. 1*, 42–43.

232. Allan Mitchell, *Nazi Paris: The History of an Occupation, 1940–1944* (New York: Berghahn, 2010 [2008]), 38.

233. Lohse Papers, Adolf Wüster to Lohse (29 March 1955). Note that at war's end, Wüster was found at von Ribbentrop's Schloss Fuschl near Salzburg. NARA, RG 260, OMGUS, Restitution Research Records, box 446, Testimony of Karl Haberstock (12 June 1945).

234. Wilhelm Christlieb, "Adolf Wüster 80," *Abendzeitung* (28/29 December 1968).

235. S. Lane Faison, *CIR No. 4, Linz: Hitler's Museum and Library* (Washington, DC: Office of Strategic Services, 15 December 1945), attachment 51.

236. NARA, RG 260, OMGUS, Restitution Research Records, box 446, Testimony of Karl Haberstock (12 June 1945).

237. NARA, M 1946, roll 120, ALIU interrogation of Maria Almas Dietrich (January–February 1946); and Staatsarchiv München, K 285, Spruchkammer Akte for Maria Almas Dietrich (b. 28 June 1892). See also Anne Rothfeld, "Unscrupulous Opportunists: Second-Rate German Art Dealers as Nazi Functionaries during World War II" (PhD diss., American University, 2016), 55–56.

238. See Third Reich in Ruins, http://www.thirdreichruins.com/berghofvisitors .htm (last accessed 2 January 2015). One photo of Maria Almas Dietrich, Hoffmann, and Hitler dates from August 1937. See Heike Görtemaker, *Eva Braun: Life with Hitler* (New York: Knopf, 2011), 150.

239. Faison, *CIR No. 4*, 51; Theodore Rousseau, *DIR No. 2: Ernst Buchner* (Washington, DC: Strategic Services Unit, 31 July 1945), 7; and Rothfeld, "Unscrupulous Opportunists," 72–74. The Datenbank des Deutschen Historischen Museums zum Sonderauftrag Linz has 997 hits for Maria Almas Dietrich.

240. Ken Roxan and David Wanstall, *The Rape of Art: The Story of Hitler's Plunder of the Great Masterpieces of Europe* (New York: Coward-McCann, 1965 [1964]), 95.

241. Faison, *CIR No. 4*, 41, 49; and Rothfeld, "Unscrupulous Opportunists," 66, 84.
242. Feliciano, *Lost Museum*, 118–19.
243. Rothfeld, "Unscrupulous Opportunists," 89–90; and Faison, *CIR No. 4*, 50.
244. There were exceptions, too, when Lohse and the ERR would send an Old Master to one of Hitler's agents, such as Hildebrand Gurlitt acquiring Guardi's *Ruins by the Sea* in June 1944. BArch-Koblenz, B 323/134, folder 48, 255, Gurlitt receipt (7 June 1944).
245. NARA, M 1944, roll 90, frames 32–41, Albert Henraux to James Plaut (based on Valland's notes) (5 December 1945).
246. Marc Masurovsky, "A Gurlitt Painting Waiting to Be Restituted: *View of the Seine from the Pont-Neuf* by Camille Pissarro," *Plundered Art* (4 February 2015), http://plundered-art.blogspot.com/2015/02/a-gurlitt-painting-waiting-to-be.html; and, more generally, Max Heilbronn, *Galeries Lafayette, Buchenwald, Galeries Lafayette* (Paris: Economica, 1989).
247. For Lohse directing works to Hitler, see the fate of Ludwig Knaus's work *Painter Seated on the Bough of a Tree Surrounded by Children* (1877), which is part of trade #27 in Plaut, *CIR No. 1*, 44. See also the entry in the database of art objects at the Jeu de Paume, http://www.errproject.org/jeudepaume/card_view.php?CardId=13167 (accessed 25 August 2015).
248. Posse's journal reads, "Beschlagnahmte Bilder Jeu de Paumes [*sic*], Dr. Lohse" (with Lohse's telephone number). See Germanisches National Museum, Nuremberg: Hans Posse, Reisetagebücher, entry for 9–13 November 1941. See the website for Posse's travel journals (with annotations), Kommentierte Online Edition der Fünf Reisetagebücher Hans Posses (1939–1942), https://www.gnm.de/forschung/projekte/reisetagebuecher-hans-posse/ (accessed 3 December 2019).
249. Plaut, *DIR No. 6*, 7.
250. See the entry for the picture by Beuckelaer in the DHM database Die Kunstsammlung Hermann Göring: https://www.dhm.de/datenbank/goering/dhm_goering.php?seite=5&fld_0=RMG00222 (accessed 28 August 2019).
251. Plaut, *DIR No. 6*, 7. See also Adriaan Venema, *Kunsthandel in Nederland 1940–1945* (Amsterdam: Uitgeverij De Arbeiderspers, 1986), 83, 193, 286.
252. NIOD, Aalders Collection, L.2824, Directoraat-Generaal voor Bijzondere Rechtspleging, Politieke Recherche Afdeling Amsterdam, Proces-Verbal against Jan Dik Jr. (11 May 1948). There is a French translation of the document in DCAJM–Le Blanc, box 984.
253. Plaut, *DIR No. 6*, 7.
254. Ibid. See also Jeroen Euwe and Kim Oosterlinck, "Quality and Authenticity in a Market under Pressure: The Case of the Dutch Art Market during World War II," in Fleckner, Gaehtgens, and Huemer, *Markt und Macht*, 49–66.
255. Feliciano, *Lost Museum*, 156; and Aalders, "By Diplomatic Pouch."

256. BAR-Bern, E6100A-24/1000/1924, Bd. 7, Raubgutsachen Bührle/Dr. Raeber/ Fischer/Eidgenossenschaft: Parteiverhör, Dr. Bruno Lohse (18/19 December 1950, Abschrift dated 22 January 1951), 20.

257. NARA, M 1944, roll 92, Declaration of Hans Wendland (4 September 1946).

258. BAR-Bern, E6100A-24#1000/1924#7*, Lohse Abhörungsprotokoll (4 February 1949).

259. BAR-Bern, E9500.239A#2003/48, Bd. 40, anonymous, "Notiz betreffend das Begehren der Galerie Fischer" (4 July 1951).

260. Georg Kreis, "Die Schweiz und der Kunsthandel 1939–1945," in Matthias Frehner, *Das Geschäft mit der Raubkunst. Fakten, Thesen, Hintergründe* (Zurich: Verlag Neue Zürcher Zeitung, 1998), 125.

261. Daniel Silva, *The Rembrandt Affair* (New York: Signet, 2011), 152. See also Esther Tisa Francini, "Berlin, Wien, Paris: Zentren des internationalen Kunstmarkts und die Beziehungen zur Schweiz 1933–1945," in Gabriele Anderl and Alexandra Caruso, eds., *NS-Kunstraub in Österreich und die Folgen* (Innsbruck: Studienverlag, 2005), 227–334; Esther Tisa Francini, Anja Heuss, and Georg Kreis, *Fluchtgut-Raubgut. Der Transfer von Kulturgütern in und über die Schweiz 1933–1945 und die Frage der Restitution* (Zurich: Chronos Verlag, 2001); Buomberger, *Raubkunst-Kunstraub*; Mario König and Bettina Zeugin, eds., *Switzerland, National Socialism and the Second World War: Final Report of the Independent Commission of Experts Switzerland— Second World War* (Zurich: Pendo, 2002); and Georg Kreis, "Switzerland and Art Traffic, 1933–1945," in Oliver Rathkolb, ed., *Revisiting the National Socialist Legacy: Coming to Terms with Forced Labor, Expropriation, Compensation, and Restitution* (New Brunswick, NJ: Transaction, 2004), 133–50.

262. Feliciano, *Lost Museum*, 156.

263. Polack, *Le Marché de l'Art sous l'Occupation*, 43.

264. NARA, RG 84, entry 3221, box 8, Douglas Cooper, "Looted Works of Art in Switzerland" (21 January 1945), 3–15; and Rothfeld, "Unscrupulous Opportunists," 122–23.

265. Plaut, *DIR No. 6*, 8; and BAR-Bern, E6100A-24, 1000/1924, Bd. 9, Bruno Lohse Abhörungsprotokoll (3 February 1949), 6.

266. BAR-Bern, E6100A-24#1000/1924#7*, Lohse Abhörungsprotokoll (7 February 1949).

267. NARA, RG 226, entry 190, box 30, Plaut to Harry Conover (5 January 1946), 3–8; and BAR-Bern, E6100A-24#1000/1924, Bd. 9, Finanzverwaltung Bern, Eingabe der Schweiz. Eidgenossenschaft (14 May 1949).

268. H. Trainé's testimony before the Swiss Bundesgericht on 17 November 1948 is referenced in BAR-Bern, E6100A-24#1000/1924, Bd. 7, Lohse Abhörungsprotokoll (7 February 1949). See also BAR-Bern, E6100A-24, 1000/1924, Bd. 9, Bruno Lohse Abhörungsprotokoll (3 February 1949), 2.

269. BAR-Bern, E6100A-24, 1000/1924, Bd. 9, Robert Scholz Abhörungsprotokoll (4 May 1949), 1.

270. Plaut, *DIR No. 6*, 8; Plaut, *CIR No. 1*, 27; and Plaut, *Supplement to CIR No. 1*, attachment 15, Utikal to Scholz (18 February 1941).

271. Rothfeld, "Unscrupulous Opportunists," 107–10.

272. Plaut, *CIR No. 1*, 28–29; and Rothfeld, "Unscrupulous Opportunists," 108.

273. Plaut, *CIR No. 1*, 28–29; and CDJC, XIII-43, Interrogation of Gustav Rochlitz (8 January 1946).

274. Plaut, *CIR No. 1*, 28–29.

275. Ibid. See also Plaut, *Supplement to CIR No. 1*, attachment 16, exchange contract (9 July 1941); and Rothfeld, "Unscrupulous Opportunists," 107–10.

276. NIOD, Aalders Collection, L.3348, E. E. Minskoff, "Interrogation of Gisela Limberger" (9–12 October 1945), 14; and NIOD, Aalders Collection, L.3349, J. Cassoday, "Interrogation of Andreas Hofer" (28 September 1945), 13.

277. BAR-Bern, J1.269, 1999/82, Bd. 2, Walter Andreas Hofer Abhörungsprotokoll (1 May 1949); and Feliciano, *Lost Museum*, 157–58.

278. DCAJM-Le Blanc, Tribunal Militaire Permanent de Paris, box 983, Gisela Limberger, note (2 March 1941).

279. Rothfeld, "Unscrupulous Opportunists," 188; and König and Zeugin, *Switzerland, National Socialism and the Second World War,* 349–50, 357. See, more generally, Buomberger and Magnaguagno, *Schwarzbuch Bührle.*

280. Rothfeld, "Unscrupulous Opportunists," 193, 214; NARA, M 1944, roll 92, Douglas Cooper, "Report of Mission to Switzerland" (10 December 1945).

281. NARA, RG 226, entry 190, box 30, Plaut to Harry Conover (5 January 1946), 8.

282. Peter Harclerode and Brendan Pittaway, *The Lost Masters: The Looting of Europe's Treasurehouses* (London: Orion, 1999), 130–32; Rothfeld, "Unscrupulous Opportunists," 203–4; Rousseau, *CIR No. 2*, 18–19, 129–35.

283. Rothfeld, "Unscrupulous Opportunists," 195.

284. BAR-Bern, E61000A-24#100/1924#72*, Testimony of Ralph Getsinger (14 May 1947).

285. Aalders, "By Diplomatic Pouch"; and Rothfeld, "Unscrupulous Opportunists," 208–9.

286. ALIU, *ALIU Final Report*, 137.

287. See the entry for Renoir, *Boy with a Butterfly Net*, Lootedart.com, http://www.lootedart.com/search/artwork.php?artworkID=7671 (accessed 27 August 2015).

288. BAR-Bern, E6100A-24#1000/1924#7*, Lohse Abhörungsprotokoll (4 February 1949). See also the report "The Hunt Controversy: A Shadow Report," at Lootedart.com, https://www.lootedart.com/web_images/artwork/HUNT%20REPORT.pdf (accessed 7 April 2020).

289. Feliciano, *Lost Museum*, 160–61. Buomberger says the works by Matisse and Renoir were sold to French sculptor André Martin, who then passed them on to Neupert. Buomberger, *Raubkunst-Kunstraub*, 85.

290. Plaut, *CIR No. 1*, 24.

291. See exchange number 17 in ibid., 38.
292. BAR-Bern, E6100A-24, 1000/1924, Bd. 9, Annemarie von Tomforde-Ingram Abhörungsprotokoll (2 May 1949), 3.
293. BAR-Bern, E6100A-24/1000/1924, Bd. 7, Raubgutsachen Bührle/Dr. Raeber/Fischer/Eidgenossenschaft: Parteiverhör, Dr. Bruno Lohse (18/19 December 1950, Abschrift dated 22 January 1951), 17.
294. NARA, RG 226, entry 190, box 30, Plaut to Harry Conover (5 January 1946); NARA, RG 239, entry 73, box 82, Douglas Cooper, "Report of Mission to Switzerland" (18 October 1945); and BAR-Bern, J1.269, 1999/82, Bd. 2, Walter Andreas Hofer Abhörungsprotokoll (1 May 1949).
295. The OSS "red flag list" for Switzerland is reproduced in Yeide, Akinsha, and Walsh, *AAM Guide to Provenance Research*, 282–84. See Francini, Heuss, and Kreis, *Fluchtgut-Raubgut*; Feliciano, *Lost Museum*, 193; and BAR-Bern, Dossier J.1.269-01#1999/82#16*, which includes the report by the Foreign Economic Administration, Enemy Branch, "Looted Art in Occupied Territories, Neutral Countries, and Latin America: Preliminary Report" (5 May 1945): this report lists some seventeen Swiss figures engaged in the trafficking of Nazi-looted art during the war (as well a dozen German counterparts). See also the receipts for transactions between Göring's agents and Swiss dealers in DCAJM–Le Blanc, Tribunal Militaire Permanent de Paris, box 983.
296. Plaut, *DIR No. 4*, 6–8.
297. BAR-Bern, E6100A-24/1000/1924, Bd. 7, Dr. Ernst Saxer to OMGUS (18 May 1948). Note that while Fischer established himself as a major art dealer between the wars, he moved to the now iconic building at Haldenstrasse 17 (the site of many auctions) only in 1939.
298. BAR-Bern, E6100A-24/1000/1924, Bd. 7, Raubgutsachen Bührle/Dr. Raeber/Fischer/Eidgenossenschaft: Parteiverhör, Dr. Wilhelm Raeber (18/19 December 1950, Abschrift dated 22 January 1951), 8.
299. Bill Hinchberger, "Brazil Uncovers Nazi War Loot," *ARTnews* (September 1998), 67.
300. Plaut writes, "Hence, of the 76 looted French paintings thus far identified in Swiss hands, 57 have passed through his [Fischer's] hands." See NARA, RG 226, entry 190, box 30, Plaut to Harry Conover (5 January 1946), 6.
301. ALIU, *ALIU Final Report*, 130.
302. Anja Heuss, "Es ist nicht alles deutsch, was glänzt," in Matthias Frehner, ed., *Das Geschäft mit der Raubkunst. Fakten, Thesen, Hintergründe* (Zurich: Verlag Neue Zürcher Zeitung, 1998), 113. Note that Buemming sometimes spelled his first name "Carl."
303. ALIU, *ALIU Final Report*, 130.
304. Lauterbach, *Central Collecting Point in Munich*, 11.
305. Plaut, *CIR No. 1*, 15.
306. Ibid., 16.
307. Ibid., 15.

308. Ibid., 17.

309. Ibid., 13.

310. Ibid., 8–10; Jean-Marc Dreyfus and Sarah Gensburger, *Nazi Labour Camps in Paris: Austerlitz, Lévitan, Bassano* (New York: Berghahn, 2011 [2003]); and the testimonies by former prisoners in these camps in DCAJM–Le Blanc, Tribunal Militaire Permanent de Paris, box 983. Behr was given the position Leiter der Dienststelle Westen des Ostministerium on 25 March 1942, and this included overseeing the *M-Aktion*.

311. Plaut, *DIR No. 6*, 3.

312. Ibid., 5.

313. Polack, *Le Marché de l'Art sous l'Occupation*, 31.

314. DCAJM–Le Blanc, Tribunal Militaire Permanent de Paris, box 983, Rose Valland, "Borchers" (n.d. [1945]). The French reads, "très érudit, plutôt franco-phile."

315. Staatsarchiv München, SpkA K, 1074 (Lohse's denazification file), Lohse Bruno, statement of Walter Borchers (30 March 1947); and Lohse Papers, Dr. Walter Borchers, "Statement to Paris Military Tribunal" (30 May 1950).

316. DCAJM–Le Blanc, Tribunal Militaire Permanent de Paris, box 983, Rose Valland, "Borchers" (n.d. [1945]).

317. Lohse Papers, Walter Borchers, statement (9 August 1946).

318. Plaut, *CIR No. 1*, 52.

319. Ibid., 6.

320. Ibid., 13.

321. AMAE–La Courneuve, 209SUP, box 719, Martin Bormann to Alfred Rosenberg (21 April 1943).

322. DCAJM–Le Blanc, Tribunal Militaire Permanent de Paris, box 983, Rose Valland, "Rehbock" (n.d. [1945]) and "Robert Scholz" (n.d. [1945]). See also Polack and Dagen, *Les Carnets de Rose Valland*, 94, 112.

323. Notes on conversation with Peter Griebert, Munich (26 September 2014).

324. Robert Edsel, *The Monuments Men: Allied Heroes, Nazi Thieves, and the Greatest Treasure Hunt in History* (New York: Center Street, 2009), 178.

325. Plaut, *DIR No. 6*, 3.

326. AMN, R 32.1, Valland to Jaujard (2 June 1944). The French reads, "le Dr. Lohse n'est plus le chef direct du service du Jeu de Paume . . . mais Lohse est toujours bien avec les puissants du moment. Il est encore, disent-ils, dans le 'secret.'"

Chapter Three. Darker Hues and War's End (1943–45)

1. James Plaut, *DIR No. 6: Dr. Bruno Lohse* (Washington, DC: Strategic Services Unit, 15 August 1945), 4.

2. Ibid.

3. Ibid., 5.

4. See the excellent account of the collection in Hector Feliciano, *Lost Museum: The Nazi Conspiracy to Steal the World's Greatest Works of Art* (New York: Basic Books, 1997), 95–102.

5. Ibid., 96.

6. Michael Gibson, "How a Timid Curator with a Deadpan Expression Outwitted the Nazis," *ARTnews* (Summer 1981), 109; and Philippe Sprang, "Rose Valland, un Chef-d'Oeuvre de Résistance," *Paris Match* (20 February 2015), 75–81.

7. Ernst Kubin, *Sonderauftrag Linz. Die Kunstsammlung Adolf Hitler* (Vienna: Orac, 1989), 45. See also Charles de Jaeger, *The Linz File: Hitler's Plunder of Europe's Art* (Exeter: Webb & Bower, 1981), 72; and Feliciano, *Lost Museum*, 96. The German reads, "wunderliche Dame mit deutsch-jüdischem Namen."

8. De Jaeger, *Linz File*, 72.

9. Kubin, *Sonderauftrag Linz*, 45; and Feliciano, *Lost Museum*, 124–25.

10. Elizabeth Campbell Karlsgodt, *Defending National Treasures: French Art and Heritage under Vichy* (Stanford: Stanford University Press, 2011), 227. More generally, see Gerhard Hirschfeld and Patrick Marsh, eds., *Collaboration in France: Politics and Culture during the Nazi Occupation* (Oxford: Berg, 1989); and Philippe Burrin, *France under the Germans: Collaboration and Compromise* (New York: Free Press, 1996).

11. DCAJM-Le Blanc, Tribunal Militaire Permanent, box 984, Bruno Lohse, "Note d'Archives" (n.d.). The French reads "un collaborateur intime du Commissaire aux questions juives."

12. Feliciano, *Lost Museum*, 96–98. The French reads: Commissariat Général aux Questions Juive.

13. Lohse Papers (archive of author), Lohse to the Paul List Verlag (23 January 1966). See also James S. Plaut, *CIR No. 1: Activity of the Einsatzstab Rosenberg in France* (Washington, DC: Strategic Services Unit, 15 August 1945), attachment 26, "Lohse's Statement on the Schloss Affair" (10 September 1945).

14. Kubin, *Sonderauftrag Linz*, 45.

15. See the report by Dr. Hermann Bunjes on French-German cooperation (18 August 1942), in Plaut, *CIR No. 1*, attachment 9. There were, however, some secret French repositories: for example, in the mountains of central France.

16. Stefan Koldehoff, *Die Bilder sind unter uns. Das Geschäft mit der NS-Raubkunst und der Fall Gurlitt* (Berlin: Galiani, 2014 [2009]), 130.

17. BHSA, MK 60488, Rudolf Schleier to Bormann (26 April 1943).

18. Ibid. The German reads, "Der angestrengsten Spürarbeit des Beauftragten für Kunstankäufe in Paris, Dr. Lohse."

19. Feliciano, *Lost Museum*, 99; Plaut, *CIR No. 1*, attachment 26, "Lohse's Statement on the Schloss Affair" (10 September 1945); and Philippe Sprang, "Dans les ténèbres du docteur Lohse," *L'Oeil* 630 (December 2010), 25–33. See also the documentary film *Henri Lafont: Le Parrain de la Gestapo*,

https://www.youtube.com/watch?v=9MWErMiJymE (accessed 18 September 2019).

20. Plaut, *CIR No. 1*, attachment 26, "Lohse's Statement on the Schloss Affair" (10 September 1945).

21. Ibid.

22. Kubin, *Sonderauftrag Linz*, 46. The German reads, "Für Göring ist die Sache zu heikel geworden. Er erklärt sich am Kauf nicht mehr interessiert."

23. Emmanuelle Polack and Philippe Dagen, *Les Carnets de Rose Valland* (Paris: Editions Fage, 2011), 111; and Fabrizio Calvi and Marc Masurovsky, *Le Festin du Reich. Le Pillage de la France Occupée 1940–1945* (Paris: Fayard, 2006), 260.

24. Ministère de Affaires Étrangères, Direction des Archives et de la Documentation, *Collection Schloss: Oeuvres Spoliées pendant la Deuxième Guerre Mondiale Non Restituées (1943–1998)* (Paris: Ministère de Affaires Étrangères, 1998), 4. The authors cite the telegram from Schleier of 26 April 1943.

25. Lohse Papers, Helmut von Hümmel to Robert Scholz (12 August 1943).

26. NARA, RG 239, M 1944, roll 87, frame 739, Gerhard Utikal to Adjutantur des Herrn Reichsmarschalls des Grossdeutschen Reichs (30 June 1943).

27. Kubin, *Sonderauftrag Linz*, 47; Feliciano, *Lost Museum*, 101; and Calvi and Masurovsky, *Le Festin du Reich*, 259–62.

28. AMN, R 32.1, Valland to Jaujard (2 November 1943).

29. Ibid., Valland to Jaujard (3 November 1943).

30. Ministère de Affaires Étrangères, *Collection Schloss*, 5.

31. Feliciano, *Lost Museum*, 96.

32. Allan Mitchell, *Nazi Paris: The History of an Occupation, 1940–1944* (New York: Berghahn, 2010 [2008]), 14.

33. AMN, R 32.1, Valland to Jaujard (19 November 1943).

34. Ministère de Affaires Étrangères, *Collection Schloss*, 5. They cite Rose Valland's report to Jaujard (19 November 1943).

35. Rose Valland note, 18 April 1944, quoted in Ministère de Affaires Étrangères, *Collection Schloss*, 7.

36. Ministère de Affaires Étrangères, *Collection Schloss*, 7. See also AMN, R 32.1, Valland to Jaujard (18 November 1943).

37. Plaut, *DIR No. 6*, 10.

38. IfZG, ZS 793, Interview with Gerhard Utikal (4 April 1947).

39. Plaut, *DIR No. 6*, 10; Günther Haase, *Die Kunstsammlung des Reichsmarschalls Hermann Göring: Eine Dokumentation* (Berlin: edition q, 2000), 38; Kubin, *Sonderauftrag Linz*, 44–47; and Plaut, *CIR No. 1*, attachment 26, "Lohse's Statement on the Schloss Affair" (10 September 1945).

40. Feliciano, *Lost Museum*, 170.

41. Lohse to author, telephone interview (16 May 2001).

42. See CDJC, Fonds Jean Demartini about the Adolphe Schloss Collection.

43. Ministère des Affaires Étrangères, *Collection Schloss*.

44. Simon Goodman, *The Orpheus Clock: The Search for My Family's Art Trea-

sures Stolen by the Nazis (New York: Scribner, 2015); and Feliciano, *Lost Museum*, 114.

45. Feliciano, *Lost Museum*, 115. Thanks to Simon Goodman for clarifying the actions of his grandfather, Fritz Gutmann.

46. Patrick Golenia, *Paul Graupe (1881–1953): Ein Berliner Kunsthändler zwischen Republik, Nationalsozialismus, und Exil* (Cologne: Böhlau, 2016).

47. GRI, SC, Gustav Cramer Oude Kunst Papers, 2001, M5, box 8, folder 6, Karl Haberstock to Gustav Cramer (29 April 1943).

48. Goodman, *Orpheus Clock*, 125.

49. Himmler, quoted in Feliciano, *Lost Museum*, 184.

50. Ibid., 115.

51. GRI, SC, Gustav Cramer Oude Kunst Papers, 2001, M5, box 8, folder 6, Gustav Cramer to Karl Haberstock (14 May 1943).

52. Ibid., Karl Haberstock to Gustav Cramer (29 April 1943). Haberstock writes, "Alles was in dem Haus ist, gehört nämlich der Firma Böhler und mir." For more on Gustav Cramer and Göpel, see Isabella Zuralski-Yeager, "Updating Records of Nazi Art Looting from an Art Dealer's Archive: A Case Study from Gustav Cramer's Archive at the Getty," *Getty Research Journal*, no. 11 (2019), 197–212.

53. Landesarchiv Berlin, B Rep. 025-08, no. 2936/59, Hugo Perls to Frau Eylers (19 April 1960). This concerns objects belonging to the Perls family in Paris that were with Wacker-Bondy and then "removed by the ERR, Dr. Lohse."

54. Feliciano, *Lost Museum*, 184.

55. Landesarchiv Berlin, B Rep. 025-08, no. 2936/59, statement by Hugo Perls (5 April 1958).

56. Archive of author, Lili Collas Gutmann to Peter Griebert (13 March 1972).

57. Feliciano, *Lost Museum*, 115; and Jean-Marc Dreyfus and Les Archives Diplomatiques, eds., *Le Catalogue Goering* (Paris: Flammarion, 2015), 552.

58. Feliciano, *Lost Museum*, 188.

59. Ibid., 188.

60. Howard Trienens, *Landscape with Smokestacks: The Case of the Allegedly Plundered Degas* (Evanston, IL: Northwestern University Press, 2000).

61. Feliciano, *Lost Museum*, 115.

62. Goodman, *Orpheus Clock*, 134. Thanks to Simon Goodman for clarifying the fate of his family's silver collection (email to author, 16 August 2020).

63. Feliciano, *Lost Museum*, 186.

64. Renate Schostack, "Der Gutachter: August Liebmann Mayer war einer der bedeutendsten Kunsthistoriker der 20er-Jahre. Jetzt wird er wiederentdeckt," *Jüdische Allgemeine* (15 January 2009), 13.

65. Christian Fuhrmeister and Susanne Kienlechner, "Tatort Nizza: Kunstgeschichte zwischen Kunsthandel, Kunstraub, und Verfolgung. Zur Vita von August Liebmann Mayer, mit einem Exkurs zu Bernhard Degenhart," in Ruth Heftrig, Olaf Peters, and Barbara Schellewald, eds., *Kunstgeschichte im "Dritten Reich": Theorien, Methoden, Praktiken* (Berlin: Akademie

Verlag, 2008), 405–30. See also the restitution of a painting to Mayer's daughter in Laila Kearney, "Nazi Confiscated Picture Returned to Heir of Jewish Art Historian," Reuters (5 May 2015), http://www.reuters.com /article/2015/05/05/us-usa-holocaust-art-idUSKBN0NQ1YH20150505.

66. Christian Fuhrmeister and Susanne Kienlechner, "August Liebmann Mayer (1885–1944)—Success, Failure, Emigration, Deportation and Murder," in Ines Rotermund-Reynard, ed., *Echoes of Exile: Moscow Archives and the Arts in Paris* (Berlin: De Gruyter, 2014), 139–59.

67. Ibid., 157.

68. Schostack, "Der Gutachter," 13.

69. See Christie's account: http://www.christies.com/features/Results-from -our-June-2017-Impressionist-and-Modern-Auctions-8432-3.aspx?hoot PostID=a36c7bdd2105a96b68f0262396e51602 (accessed 10 January 2020).

70. BHSA, MK 60488, Mathilde Beckmann to the Ministerium für Kultur und Unterricht (12 October 1954).

71. Christian Fuhrmeister and Susanne Kienlechner, "Max Beckmann und der Widerstand in den Nederlanden," in Susanne Petri and Hans-Werner Schmidt, eds., *Max Beckmann von Angesicht zu Angesicht* (Ostfildern-Ruit: Hatje Cantz, 2011), 38–52, 351–52. The painting is in the Staatsgalerie Stuttgart. Thanks to Hugo Macgregor and Claire Guillon for identifying Pierre Bonny. See also Stew Ross, "The French Gestapo" (18 March 2017), at https://stewross.com/the-french-gestapo/ (accessed 14 August 2020).

72. Beatrice von Bormann, "An 'Entartete' Artist in the Netherlands: Max Beckmann and the German Art Trade, 1937–1947," in Jonieke van Es, ed., *"Come on, Now Buy a Beckmann Too!" Portraits of the Lütjens Family in Museum Boijmans van Beuningen* (Rotterdam: Museum Boijmans van Beuningen, 2010), 59–87.

73. GRI, SC, Oude Kunst Cramer, 2001, M.5, box 8, folder 6, Gustav Cramer to Karl Haberstock (14 May 1943).

74. Fuhrmeister and Kienlechner, "Max Beckmann und der Widerstand," 352.

75. Plaut, *DIR No. 6*, 8.

76. De Jaeger, *Linz File*, 87.

77. AMN, R 32.1, J. Jaujard, "Activités dans la Résistance de Mademoiselle Rose Valland" (n.d.), 5. See also AMN, R 32.1, Valland to Jaujard (12 August 1944).

78. Feliciano, *Lost Museum*, 130–31, 165–73; and Lohse Papers, "Note: Affaire Lohse" (n.d.).

79. AMN, R 32.1, Valland to Jaujard (9 August 1944).

80. Wilhelm Treue, "Dokumentation. Zum nationalsozialistischen Kunstraub in Frankreich (aka, Der 'Bargatzky Bericht')," *Vierteljahrshefte für Zeitgeschichte* 13/3 (1965), 336–37.

81. Ibid.

82. DCAJM–Le Blanc, Tribunal Militaire Permanent de Paris, box 983, Rose Valland, "Von Behr" (n.d. [1945]).

83. Larry Collins and Dominique Lapierre, *Is Paris Burning?* (New York: Simon & Schuster, 1965).
84. De Jaeger, *Linz File*, 87.
85. Ibid., 87–88.
86. Gibson, "Timid Curator," 111.
87. Anne Sinclair, *My Father's Gallery: A Family Memoir* (New York: Farrar, Straus & Giroux, 2014), 193–210; and Feliciano, *Lost Museum*, 165.
88. Plaut, *CIR No. 1*, 12.
89. DCAJM–Le Blanc, Tribunal Militaire Permanent, box 984, Rose Valland, "Quelques Considérations à propos de l'Interrogation de Bruno Lohse" (n.d.), 8.
90. NARA, RG 239, M 1944, roll 86, frames 274–75, "Notes from MFA&A Report for January 1945."
91. NARA, M1270, roll 12 (RG 238), "Testimony of Bruno Lohse Taken at Nurnberg, Germany, on 1 November 1945 by Lt. Col. Thomas Hinkel," 3–5.
92. Plaut, *DIR No. 6*, 3.
93. Haase, *Kunstsammlung des Reichsmarschalls*, 38–39; and Lohse Papers, Gerhard Utikal, "Eidesstattliche Erklärung" (7 March 1947).
94. Robert Edsel, *The Monuments Men: Allied Heroes, Nazi Thieves, and the Greatest Treasure Hunt in History* (New York: Center Street, 2009), 178. Edsel cites AMN R 32-1, Rose Valland note (28 July 1944).
95. Plaut, *DIR No. 6*, 3; and Lohse Papers, "Note: Affaire Lohse" (n.d.).
96. NARA, M1270, roll 12 (RG 238), "Testimony of Bruno Lohse Taken at Nurnberg, Germany, on 1 November 1945 by Lt. Col. Thomas Hinkel," 3–5.
97. Lohse Papers, Arthur Garbas, Statement to the Military Tribunal (21 March 1950).
98. Plaut, *DIR No. 6*, 3.
99. Lohse Papers, Arthur Garbas, Statement to the Military Tribunal (21 March 1950).
100. Gibson, "Timid Curator," 111.
101. Ibid.
102. Note that deaths from fighting between forces loyal to Vichy and the Resistance in the summer of 1944 contributed to the figure. Herbert Lottman, *The Purge: The Purification of the French Collaborators after World War II* (New York: William Morrow, 1986).
103. Gibson, "Timid Curator," 111.
104. Ibid. See also Michael Kurtz, *America and the Return of Nazi Contraband: The Return of Europe's Cultural Treasures* (Cambridge: Cambridge University Press, 2006), 75.
105. AMAE–La Courneuve, Service Français de Récupération Artistique, 209SUP, Dossiers de la "Série B," cartons 215–92; and, more generally, Emily Löffler, *Kunstschutz im besetzten Deutschland: Restitution und Kulturpolitik in der französischen und amerikanishen Besatzungszonen (1944–1953)* (Vienna: Böhlau, 2019).

106. Plaut, *CIR No. 1*, 21.

107. Plaut, *DIR No. 6*, 4; and Plaut, *CIR No. 1*, 4, 51. Lohse said Utikal was a vulgar peasant, but that he had been good to him.

108. Plaut, *CIR No. 1*, 19.

109. Staatsarchiv München, SpkA K, 1074 (Lohse's denazification file), Lohse, Bruno, statement of Georges Ebrecht (7 September 1947).

110. Sybil Milton, ed., *The Stroop Report: The Jewish Quarter Is No More* (London: Secker & Warburg, 1980).

111. Staatsarchiv München, SpkA K, 1074 Lohse, Bruno, statement of Robert Scholz (8 September 1946).

112. NARA, M1270, roll 12 (RG 238), "Testimony of Bruno Lohse Taken at Nurnberg, Germany, on 1 November 1945 by Lt. Col. Thomas Hinkel," 7.

113. Lohse Papers, Walter Borchers, statement (9 August 1946); Matila Simon, *Battle of the Louvre: The Struggle to Save French Art in World War II* (New York: Hawthorn, 1971), 142.

114. Plaut, *DIR No. 6*, 4. The extant ERR card catalogue is in NARA, RG 260, Property Division, boxes 2–36.

115. Lohse Papers, Robert Scholz "Anweisung" to Bruno Lohse (24 April 1945).

116. Plaut, *DIR No. 6*, 4.

117. Treue, "Dokumentation," 285–337. For an early and contemporaneous study on Nazi art plundering, see Hildegard Brenner, *Die Kunstpolitik des Nationalsozialismus* (Reinbek: Rowohlt, 1963).

118. Gibson, "Timid Curator," 111.

119. Ibid.

120. Staatsarchiv München, SpkA K, 1074 Lohse, Bruno, statement of Georges Ebrecht (7 September 1947).

121. Notes on conversation with Prof. Dr. Claus Grimm, Munich (24 September 2014).

122. Edsel, *Monuments Men*, 246–47, 404–5.

123. John D. Skilton, *Memoirs of a Monuments Officer: Protecting European Artworks* (Portland, OR: Inkwater, 2008 [1948]), 94; and Plaut, *DIR No. 6*, 4; and DCAJM-Le Blanc, Tribunal Militaire Permanent, box 984, Henri Monneray to Procureur General (16 January 1950).

124. AMAE-La Courneuve, RA 583-R40, Edgar Breitenbach to Rose Valland (30 November 1948).

125. Ibid. The text says 1948, but the informant appeared to mean 29 April 1945. Lohse was in a French jail in April 1948.

126. A copy of the ERR documents is in GRI, SC, Otto Wittmann Papers, 910/130, box 4, file 4. Note that the James Rorimer was listed as a first lieutenant, G-5 Monuments, Fine Arts, and Archives Officer, Seventh Army at the time he arrested Lohse, but he was soon promoted to captain as he headed up the MFAA Section of the Seventh Army Western Military District.

Chapter Four. Called to Account (1945–50)

1. Archives of American Art, oral history interview with S. Lane Faison (14 December 1981), http://www.aaa.si.edu/collections/interviews/oral -history-interview-s-lane-faison-12908#transcript. Note that Faison also says that Rousseau was "our boss of the three" ALIU officers. For a full collection of the ALIU reports, see NARA, RG 239, entry 73, boxes 83–85 (location: 350/77/2/07).

2. James Plaut, *DIR No. 6: Dr. Bruno Lohse* (Washington, DC: Strategic Services Unit, 15 August 1945), 10.

3. James Plaut, "Investigation of the Major Nazi Art-Confiscation Agencies," in Elizabeth Simpson, ed., *The Spoils of War: World War II and Its Aftermath; The Loss, Reappearance, and Recovery of Cultural Property* (New York: Harry Abrams, 1997), 125.

4. Plaut, *DIR No. 6*, 14.

5. James S. Plaut, *CIR No. 1: Activity of the Einsatzstab Rosenberg in France* (Washington, DC: Strategic Services Unit, 15 August 1945), 56.

6. NARA, RG 239, M 1944, roll 86, frame 572, "German Personnel Connected with Art Looting" (n.d. [September 1945?]).

7. Ibid. See also Plaut, *DIR No. 6*, 15.

8. Plaut, *DIR No. 6*, 15.

9. Ibid.

10. Ibid.

11. Jack El-Hai, *The Nazi and the Psychiatrist: Hermann Göring, Dr. Douglas M. Kelley, and A Fatal Meeting of Minds at the End of World War II* (New York: Public Affairs, 2013), 49.

12. Notes on conversation with Bruno Lohse, Munich (8 June 1998).

13. El-Hai, *The Nazi and the Psychiatrist*, 57.

14. NARA, M1270, roll 12 (RG 238), "Testimony of Bruno Lohse Taken at Nurnberg, Germany, on 1 November 1945 by Lt. Col. Thomas Hinkel," 11–13.

15. Robert Edsel, *The Monuments Men: Allied Heroes, Nazi Thieves, and the Greatest Treasure Hunt in History* (New York: Center Street, 2009), 405.

16. See the transcript for 22 March 1946 in *Nuremberg Trial Proceedings*, vol. 9, the Avalon Project, Yale Law School, https://avalon.law.yale.edu/imt/03 -22-46.asp.

17. Lohse Papers (archive of author), Göring "Bescheinigung," 20 April 1946.

18. Charles de Jaeger, *The Linz File: Hitler's Plunder of Europe's Art* (Exeter: Webb & Bower, 1981), 88; and A. B. Woodhall, *Soldier, Sailor and Airman Too* (London: Grub Street, 2008).

19. Hector Feliciano, *Lost Museum: The Nazi Conspiracy to Steal the World's Greatest Works of Art* (New York: Basic Books, 1997), 168.

20. NARA, RG 239, entry 73, box 80, Plaut and Rousseau to G-2, USFET (12 January 1946).

21. Ibid.
22. ALIU, *ALIU Final Report* (Washington, DC: Strategic Services, May 1946), 53.
23. MMA, Rousseau Papers, box 26, folder 4, Plaut to Rousseau (23 March 1949). Plaut here also reserved a lunch date with Rousseau: the three members of the ALIU stayed in touch in the postwar period.
24. Staatsarchiv Coburg, SPK BA Land, Denazification file of Karl Haberstock, Ha/L, Lohse to Haberstock (12 January 1948). See also Staatsarchiv München, SpkA K, 1074 (Lohse's denazification file), Lohse Bruno, Lohse to Hauptkammer München (25 August 1950).
25. Lohse Papers, Lohse to Tribunal Militaire Permanent de Paris (25 November 1949); DCAJM–Le Blanc, Tribunal Militaire Permanent, box 983, Lohse "Hospital-Entlassungsbefund" (17 July 1947).
26. For Judge Pierre Duval transmitting the report on Lohse on 16 July 1947, see Jean-Marc Dreyfus, "10 890 Tableaux, 583 Sculptures, 583 Tapisseries, 2 477 Pièces de Mobiliers Anciens, 5 825 Pièces de Porcelaine. Le procès de l'ERR et du Pillage des Oeuvres d'Art, Paris, 1950," *Histoire@Politique* no. 35 (May–August 2018), 3, https://www.histoire-politique.fr/index.php?numero=35&rub=autres-articles&item=113.
27. Lynn Nicholas, *The Rape of Europa: The Fate of Europe's Treasures in the Third Reich and the Second World War* (New York: Knopf, 1994), 426. Nicholas says that James Plaut delivered Lohse to Paris, but this cannot be confirmed: Plaut was demobilized in April 1946 and Lohse was transferred in January 1948.
28. IfZG, ED 449, volume 15, Lohse to Dr. Margarethe Bitter (31 December 1949).
29. Ibid., Lohse to Dr. Margarethe Bitter (3 March 1950). The German reads, "ticfcr Dcprcssion."
30. Ibid., Lohse to Dr. Margarethe Bitter (31 December 1949—dated "Sylvester").
31. Ibid. The German reads, "in der ungeheitzten Zelle und mit einer kaputten Feder kann man halt nicht schreiben."
32. Philippe Sprang, "Dans les ténèbres du docteur Lohse," *L'Oeil* 630 (December 2010), 25–33.
33. DCAJM–Le Blanc, Tribunal Militaire Permanent, box 984, Le Juge d'Instruction Militaire [Harlin] to the Ministre de la Justice (27 January 1948). Dreyfus, "10 890 Tableaux," 6. The French reads, "Deuxième Tribunal Militaire de la Seine."
34. Dreyfus, "10 890 Tableaux," 3.
35. See the trial records at DCAJM–Le Blanc, Tribunal Militaire Permanent, boxes 983–84. Note that Lohse's name is frequently misspelled as "Lhose" throughout the court proceedings. See also Plaut, *CIR No. 1*, 46–57. For more on Pfannstiel, an expert on Modigliani who authored catalogues raisonnés on the artist, see the website SecretModigliani.com, http://secret

modigliani.com/ctl-pfannstielmi.html (accessed 14 September 2018). For Ebert, see Patricia Kennedy Grimsted, *Library Plunder in France by the Einsatzstab Reichsleiter Rosenberg: Ten Seizure Lists of Confiscated French Libraries* (2017), https://www.errproject.org/docs/ERRParisLibraryLists2017.03.01 .pdf.

36. CDJC, CCIII-6, "Des Criminels de Guerre Allemands, Transférés en France," *Combat* (27 January 1948).

37. "Au Procès des Pilleurs Nazis," *Liberation* (2 August 1950).

38. DCAJM–Le Blanc, Tribunal Militaire Permanent, box 983, "Réquisitoire Définitiv" (n.d.).

39. BAR-Bern, E6100A-24/1000/1924, Bd. 8, Hofer to Alexander Sieben (24 January 1951).

40. BAR-Bern, E6100A-24/1000/1924, Bd. 8, Hofer to Schweizerische Finanzverwaltung (12 December 1948); and ibid., J1.269, 1999/82, Bd. 9, anonymous, Transcript of report on Hofer (27 September 1949), citing p. 128 of an American report designating Hofer a "liar."

41. Dreyfus, "10 890 Tableaux," 4.

42. BAR-Bern, J1.269, 1999/82, Bd. 9, anonymous, Transcript of report on Hofer (27 September 1949). The word used for the warrant is *steckbrieflich*. See also DCAJM–Le Blanc, box 983, Zaquin to Roux (18 February 1949). For a critical perspective on postwar justice, see Donald McKale, *Nazis after Hitler: How Perpetrators of the Holocaust Cheated Justice and Truth* (Lanham, MD: Rowman & Littlefield, 2012).

43. DCAJM–Le Blanc, Tribunal Militaire Permanent, box 983, Rose Valland, "Scholz: Adresse en Allemagne" (n.d. [1945]).

44. Amtsgericht München, Akten-Zeichen 562-46, file for Robert Scholz, Konrad Voelkl to Spruchkammer Augsburg (21 December 1948). Josef Angerer was also placed in category V. Andrea Hollmann and Roland März, *Hermann Göring und sein Agent Josef Angerer. Annexion und Verkauf "Entartete Kunst" aus deutschem Museumsbesitz 1938* (Paderborn: Wilhelm Fink, 2014), 76.

45. IfZG, ED 449, vol. 15, Lohse to Dr. Margarethe Bitter (25 March 1950).

46. NIOD, Aalders Collection, L.2824, Directoraat-Generaal voor Bijzondere Rechtspleging, Politieke Recherche Afdeling Amsterdam, Proces-Verbal against Jan Dik Jr. (11 May 1948). There is a French translation of the document in DCAJM–Le Blanc, box 984.

47. Jan Dik Jr. was not only an art dealer but a gifted restorer of old paintings (his father, Jan Dik Sr., was considered one of the best restorers in the world and worked for the Jacques Goudstikker Gallery in Amsterdam before the war). BAR-Bern, E9500.239A#2003/48, Bd. 24, Jan Dik Sr. statement (3 November 1949); BAR-Bern, E6100-24#1000/1924#75*, J. P. Beelaerts van Blekland to Schweizerische Gesandtschaft (13 February 1950); ibid., E2200.49-1970/55, J. P. Beelaerts van Blokland to Schweizerische Gesandt-

schaft, Den Haag (13 February 1950); and Adriaan Venema, *Kunsthandel in Nederland 1940–1945* (Amsterdam: Uitgeverij De Arbeiderspers, 1986), 483–88, 499.

48. MMA, Rousseau Papers, box 26, folder 4, Lohse to Rousseau (15 July 1948).

49. Notes on conversation with Bruno Lohse, Munich (15 June 1999); see also BAR-Bern, E4320B#1990/133, Bd. 1, anonymous memorandum (29 July 1943).

50. BAR-Bern, Lohse testimony from December 1950 trial. Lohse also says he has been in close contact with Wendland.

51. Notes on conversation with Bruno Lohse, Munich (8 June 1998). Many of these observations are confirmed in the ALIU report drafted by Otto Wittmann and Bernard Taper, *DIR: Hans Wendland* (Washington, DC: Strategic Services Unit, 18 September 1946).

52. MMA, Rousseau Papers, box 26, folder 4, Lohse to Rousseau (1 March 1949). I have utilized the translation from the French included here.

53. MMA, Rousseau Papers, box 26, folder 4, Rousseau to Plaut (10 March 1949).

54. AMN, R 32.1, J. Jaujard, "Activités dans la Résistance de Mademoiselle Rose Valland" (n.d.), 8.

55. See, for example, DCAJM-Le Blanc, Tribunal Militaire Permanent de Paris, box 984, "procès-verbal d'interrogatoire ou de confrontation" of Lohse (23 December 1948).

56. Michael Gibson, "How a Timid Curator with a Deadpan Expression Outwitted the Nazis," *ARTnews* (Summer 1981), 105.

57. Lohse Papers, Dr. Bernhard von Tieschowitz, "Stellungnahme zu dem Film 'Le Train'" (10 October 1964); and more generally, Christian Fuhrmeister, Johannes Griebel, Stephan Klingen, and Ralf Peters, eds., *Kunsthistoriker im Krieg: Deutsche Militärischer Kunstschutz in Italien 1943–1945* (Cologne: Böhlau, 2012).

58. AMN, R 32.1, Valland to Jaujard (23 July 1943).

59. Valland entry for 23 July 1943, in Emmanuelle Polack and Philippe Dagen, *Les Carnets de Rose Valland* (Paris: Editions Fage, 2011), 71; and Emmanuelle Polack, *Le Marché de l'Art sous l'Occupation* (Paris: Tallandier, 2019), 40–42. The French reads, "Les tableaux massacrés au séquestre du Louvre ont été ramenés au Jeu de Paume (un plein camion, environ cinq ou six cents) et brûlé sous la surveillance allemande dans le jardin du musée de 11 heures à 15 heures."

60. Rose Valland, *Le Front de l'Art: Défense des Collections Françaises 1939–1945* (Paris: Réunion des Musées Nationaux, 1997 [1961]), 178–87.

61. AMAE-La Courneuve, 209SUP, box 720, Valland to Maurice Bourdel (23 July 1943).

62. Gibson, "Timid Curator," 110.

63. Polack, *Le Marché de l'Art sous l'Occupation*, 42, 235–36.

64. Ibid., 41–42.

65. Wilhelm Arntz, "Bildersturm in Deutschland," *Das Schönste* (May–October 1962); and Kurt Fassmann, "Bildersturm in Frankreich," *Das Schönste* (December 1962), 75–82 (the letter refuting the allegations of burning art by Robert Scholz and Walter Borchers is on p. 75). See also Kurt Fassmann, "Bildersturm in Frankreich, 2 Folge: Dokumente zur Pariser Bilderver-brennung," *Das Schönste* (February 1963), 62–71. This latter article contains a document signed by Valland that lists works she claimed were destroyed. The German reads, "völlig wertloser Dinge." For more correspondence on the issue, see GRI, SC, Wilhelm Arntz Papers (840001), box 28, folders 30–37, and folder 47.

66. GRI, SC, Arntz Papers, box 28, folder 30, Konrad Voelkl to Arntz (22 October 1962).

67. Notes from discussion with Susan Ronald, Cambridge, UK (17 September 2014).

68. Susan Ronald, *Hitler's Art Thief: Hildebrand Gurlitt, the Nazis, and the Looting of Europe's Cultural Treasures* (New York: St. Martin's, 2015), 238.

69. Emmanuelle Polack notes that the three Löwenstein pictures are now listed as MNRs (Musées nationaux Récupération, or recovered works). Polack, *Le Marché de l'Art sous l'Occupation*, 42.

70. Dr. Didier Schulmann, email to author (29 May 2007).

71. Interview with Dr. Didier Schulmann, Paris (31 May 2016).

72. AMAE-La Courneuve, 209SUP, box 720, Monique and Frank Coen to Rose Valland (n.d.).

73. CASVA-NGA, Faison Papers, box 2, Rousseau to Faison (16 November 1948).

74. James Plaut, *DIR No. 4: Gustav Rochlitz* (Washington, DC: Strategic Services Unit, 15 August 1945), 12.

75. Ibid.

76. ALIU, *ALIU Final Report*, 67.

77. MMA, Rousseau Papers, box 26, folder 4, Lohse to Rousseau (15 July 1948).

78. NARA, RG 239, entry 73, box 80, Plaut and Rousseau to G-2 USFET (12 January 1946).

79. MMA, Rousseau Papers, box 26, folder 4, Rousseau to Plaut (21 March 1949).

80. DCAJM-Le Blanc, Tribunal Militaire Permanent, box 984, Faison to Lohse (20 September 1946).

81. DCAJM-Le Blanc, Tribunal Militaire Permanent, box 983, Plaut to Lohse (21 June 1948). He adds, "Rousseau, Faison and I believe that you have acted with complete integrity throughout your entire confinement. I give you my word that we are doing, and will do, everything possible to secure your freedom."

82. MMA, Rousseau Papers, box 26, folder 4, Plaut to Albert Naud (15 June

1948); a copy of this document was also found among Lohse's Papers and in DCAJM–Le Blanc, Tribunal Militaire Permanent, box 983.

83. MMA, Rousseau Papers, box 26, folder 4, Lohse to Rousseau (15 July 1948).

84. Ibid., Lohse to Plaut (23 June 1948).

85. CASVA-NGA, Faison Papers, box 2, Lohse to Faison (1 March 1949).

86. Ibid., Plaut to Lohse (16 March 1949).

87. Ibid.

88. MMA, Rousseau Papers, box 26, folder 4, Rousseau to Albert Naud (25 June 1948). Lohse also kept a copy of this letter among his personal papers until his death.

89. DCAJM–Le Blanc, Tribunal Militaire Permanent, box 984, S. Lane Faison to Albert Naud (21 June 1948).

90. MMA, Rousseau Papers, box 26, folder 4, Rousseau to Albert Naud (25 June 1948).

91. Note that the French state sold some 12,500 "heirless" artworks between 1950 and 1953. See Isabelle le Masne de Chermont and Didier Schulmann, *Le Pillage de l'Art en France pendant l'Occupation et la Situation des 2,000 Oeuvres Confiées aux Musées Nationaux* (Paris: République Française, 2000), 34–40, available at Site Rose Valland, Musées Nationaux Récupération (MNR), http://www.culture.gouv.fr/documentation/mnr/pres.htm.

92. MMA, Rousseau Papers, box 26, folder 4, Rousseau and Plaut to Albert Henraux (13 December 1948). The French side of the correspondence is in AMAE–La Courneuve, RA 583-R40, a dossier concerning Bruno Lohse.

93. MMA, Rousseau Papers, box 26, folder 4, Albert Henraux to Rousseau (7 March 1949). The French reads, "intervenir en faveur d'un des plus grands pilleurs du patrimoine artistique français."

94. MMA, Rousseau Papers, box 26, folder 4, Plaut to Faison (14 March 1949).

95. Ibid., Rousseau to Plaut (10 March 1949).

96. Ibid., Rousseau to Plaut (21 March 1949).

97. DCAJM–Le Blanc, Tribunal Militaire Permanent, box 984, Lohse to Capt. Hermann Kleikamp (31 March 1947).

98. Ibid., Lohse to Capt. Hermann Kleikamp (31 March 1947).

99. Ibid., S. Lane Faison to Craig Hugh Smyth (25 September 1945); and ibid., Lohse to Capt. Hermann Kleikamp (31 March 1947).

100. Ibid., Benjamin Ferencz, "Memorandum" (17 December 1947).

101. CASVA-NGA, Faison Papers, box 2, Plaut to Lohse (16 March 1949), with "P.S." to Faison.

102. Ibid., Plaut to Ardelia Hall (14 March 1949); and ibid., Plaut to Rousseau (14 March 1949). See also De Jaeger, *Linz File*, 7.

103. MMA, Rousseau Papers, box 26, folder 4, Plaut to Rousseau (7 February 1949).

104. CASVA-NGA, Faison Papers, box 2, Faison to Plaut (8 March 1949).

105. Iris Lauterbach, *The Central Collecting Point in Munich: A New Beginning for*

the Restitution and Protection of Art (Los Angeles: J. Paul Getty Trust, 2018), 179.

106. CASVA-NGA, Faison Papers, box 2, Faison to Plaut (8 March 1949).

107. Ibid., Faison to Lohse (17 July 1949).

108. S. Lane Faison, *CIR No. 4, Linz: Hitler's Museum and Library* (Washington, DC: Office of Strategic Services, 15 December 1945), 29–34.

109. CASVA-NGA, Faison Papers, Faison to British Land Observer, Office of the U.S. Land Commissioner for Bavaria (2 August 1951). Lohse Papers: a stamped copy of Plaut's report on Lohse, *DIR No. 6*, dated 1 May 1948, sent by Plaut on 1 May 1948, was in the possession of Lohse's Nuremberg lawyer, Hermann Ulmer.

110. MMA, Rousseau Papers, box 26, folder 4, Lohse to Rousseau (1 March 1949).

111. Dreyfus, "10 890 Tableaux," 1.

112. Ibid. See also "Quatre Dirigeants du 'Service Rosenberg,'" *Le Monde* (3 August 1950).

113. AMN, R 32.1, J. Jaujard, "Activités dans la Résistance de Mademoiselle Rose Valland" (n.d.), 8.

114. DCAJM–Le Blanc, Tribunal Militaire Permanent, box 984, Commissaire du Gouvernement, "Audience du 1er Août" (1 August 1950); and Dreyfus, "10 890 Tableaux," 6.

115. "Le Pillards Allemands devant le Tribunal Militaire," *L'Epoque* (3 August 1950). The French reads, "Lohse a toujours dit la vérité."

116. DCAJM–Le Blanc, Tribunal Militaire Permanent, box 983, "Exposé des Faits" (n.d. [1950]).

117. Ibid., Judge R. Harlin, summary (31 August 1949).

118. AMAE–La Courneuve, 209SUP, box 719, Rose Valland to Ardelia Hall (6 January 1965). The French reads, "Je regrette que les premiers interrogatoires n'aient d'ailleur pas été mieux contrôlés. Des documents postérieurs ont montré que les coupables Nazis interrogés n'avaient pas toujours dit la vérité."

119. DCAJM–Le Blanc, Tribunal Militaire Permanent de Paris, box 984, Theodore Rousseau to Colonel Josephs (18 September 1945).

120. AMAE–La Courneuve, RA 583-R40, E. Doubinsky to A. Henraux (1 August 1949).

121. NARA, M 194, Edgar Breitenbach to Stefan Munsing (1 June 1949).

122. The works are (1) Wouterus Verschuur, *Horses in a Stable*; (2) Josef Willorider, *Landscape*; (3) Friedrich Kallmorgan, *Town on a River*; (4) a seventeenth-century Italian work, *Family Portrait*; and (5) a drawing by Caspar Netscher, *Portrait of Countess Dillenburgh*. None of these works appears on the list of works in Lohse's possession in the last years of his life reproduced by Stefan Koldehoff, so Lohse presumably disposed of them earlier. Stefan Koldehoff, *Die Bilder sind unter uns. Das Geschäft mit der NS-Raubkunst und der Fall Gurlitt* (Berlin: Galiani, 2014 [2009]), appendix A.

123. AMAE–La Courneuve, RA 583-R40, E. Doubinsky to A. Henraux (1 August 1949).

124. Doreen Carvajal and Alison Smale, "Nazi Art Loot Returned . . . to Nazis," *New York Times* (15 July 2016).

125. AMAE–La Courneuve, RA 583-R40, Edgar Breitenbach to Rose Valland (30 November 1948).

126. Ibid., Rose Valland, "Affaire Dite du Trésor de Füssen" (n.d.).

127. AMAE–La Courneuve, 209SUP, box 583, Rose Valland to the Chef de CRA (18 September 1950).

128. NARA, M1947, roll 63, E. J. Doubinsky to Stefan Munsing (27 February 1950).

129. Ibid.

130. NARA, M1947, roll 63, Office of the High Commissioner for Germany, Memorandum for Records (28 February 1950).

131. Ibid., E. J. Doubinsky to Stefan Munsing (27 February 1950).

132. Presidential Advisory Commission on Holocaust Assets in the United States, *Plunder and Restitution: The U.S. and Holocaust Victims' Assets* (Washington, DC: U.S. Government Printing Office, 2000), SR-97.

133. DCAJM–Le Blanc, Tribunal Militaire Permanent, box 984, Rose Valland, "Quelques Considérations à propos de l'Interrogation de Bruno Lohse" (n.d.).

134. This point was later made by Lohse's lawyer, Konrad Voelkl, in GRI, SC, Arntz Papers (840001), box 28, folder 30, Voelkl to Wilhelm Arntz (22 October 1962).

135. Lohse Papers, Paul Koerner, "Eidesstattliche Erklaerung" (21 March 1949). The German reads, "ausserordentlich sachkundigen und befaehigten Kunsthistoriker und Kunstexperten . . . absoluten Sauberkeit und charakterlichen Zuverlaessigkeit."

136. Lohse Papers, Dr. Wilhelm Stuckart, "Eidesstattliche Erklärung" (15 September 1949).

137. Lohse Papers, Günther Schiedlausky, "Statement to Military Tribunal" (3 June 1950).

138. Lohse Papers, Robert Scholz, "Procès-Verbal" (12 July 1950).

139. Lohse Papers, Dr. Werner Koeppen, "Zeugen-Vernehmung" (27 March 1950). See also DCAJM–Le Blanc, Tribunal Militaire Permanent, boxes 983 and 984, for copies of these affidavits.

140. DCAJM–Le Blanc, Tribunal Militaire Permanent, box 984, Heinrich Hoffmann, "Declaration" (18 December 1947).

141. DCAJM–Le Blanc, Tribunal Militaire Permanent, boxes 983–84, Dr. Cornelius Müller-Hofstede (20 April 1948), Victor Mandl (n.d.), J. O. Leegenhoek (18 July 1947), Roger Dequoy (10 July 1947), Allen Loebl (29 August 1946), and Paul Cailleux (n.d.).

142. DCAJM–Le Blanc, Tribunal Militaire Permanent, box 984, Adolf Wüster, "Eidesstattliche Erklärung" (20 March 1948).

143. Ibid., Maria Almas Dietrich, "Attestation" (10 December 1947).
144. Archive of author, Valland to Captain Harlin (31 January 1955). Thanks to Philippe Sprang for the latter document.
145. IfZG, ED 449, vol. 15, Lohse to Dr. Margarethe Bitter (3 March 1950).
146. Dreyfus, "10 890 Tableaux," 6.
147. Ibid.
148. For this defense, see NARA, RG 260, OMGUS, Restitution Research Records, box 482, Hermann Ulmer to Major Klein, War Crimes Group (22 December 1947).
149. Président Roynard was listed as Conseiller à la Cour d'Appel de Paris.
150. Notes on conversation with Philippe Sprang, Paris (23 March 2017).
151. Herbert Lottman, *The Purge: The Purification of the French Collaborators after World War II* (New York: William Morrow, 1986). Note that the recently declassified records in the Dépôt Central d'Archives de la Justice Militaire in Le Blanc, which contain files of thousands of trials, will likely revise our understanding of postwar justice in France.
152. Norbert Frei, *Adenauer's Germany and the Nazi Past: The Politics of Amnesty and Integration* (New York: Columbia University Press, 2002); Lutz Niethammer, *Die Mitläuferfabrik: Die Entnazifizierung am Beispiel Bayerns* (Berlin: Dietz, 1982); and Mary Fulbrook, *Reckonings: Legacies of Nazi Persecution and the Quest for Justice* (Oxford: Oxford University Press, 2018).
153. Notes on conversation with Jean-Marc Dreyfus, Los Angeles (27 September 2018).
154. Ibid.
155. Dreyfus, "10 890 Tableaux," 6.
156. "Le Pillards Allemands devant le Tribunal Militaire." Note that some observers believed Lohse was sentenced to five years in prison that he had already served, but the documents, including the official judgment of 3 August 1950, state that he was acquitted. See NARA, OMGUS, Ardelia Hall Collection, box 270, S. Lane Faison to British Land Observer (2 August 1951).
157. For notes made by Judge Harlin, see DCAJM–Le Blanc, Tribunal Militaire Permanent, box 984, tome II/II, Juge Harlin, "Rapport de Capitaine Harlin" (3 June 1950); and AMAE–La Courneuve, 209SUP, dossier A178, Judge Harlin memorandum on Lohse and Munich CCP (1 July 1949).
158. See the "Jugement" (3 August 1950) and the "Certificat d'Élargissement" (4 August 1950) in Lohse Papers; and GRI, SC, Arntz Papers (840001), box 28, folder 47, Eric Schwinge, "Erklärung" (22 September 1950). See also Staatsarchiv München, SpkA K 1074 Lohse, Conseiller pour les Affaires Judiciaires, "Attestation" (7 August 1950).
159. Dreyfus, "10 890 Tableux,"6.
160. MMA, Rousseau Papers, box 26, folder 4, Lohse to Rousseau (1 March 1949).

161. CASVA-NGA Faison Papers, box 2, Faison to British Land Observer, Office of the U.S. Land Commissioner for Bavaria (2 August 1951).
162. Ibid.
163. Ibid.
164. AMAE-La Courneuve, RA 583-R40, dossier 62, Faison, "Interrogation of Goepel re Schloss Collection, Munich CCP" (9 May 1951). See also NARA, M 1944, roll 89, frames 99–100; and Beatrice von Bormann, "An 'Entartete' Artist in the Netherlands: Max Beckmann and the German Art Trade, 1937–1947," in Jonieke van Es, ed., *Come on, Now Buy a Beckmann Too!" Portraits of the Lütjens Family in Museum Boijmans van Beuningen* (Rotterdam: Museum Boijmans van Beuningen, 2010), 86.
165. AMAE-La Courneuve, RA 583-R40, dossier 62, Faison, "Interrogation of Goepel re Schloss Collection, Munich CCP" (9 May 1951); and MMA, Rousseau Papers, box 26, folder 15, Faison to Rousseau (16 January 1951).

Chapter Five. The Amnesia Years

1. Notes on conversation with Peter Griebert, Munich (24 September 2014).
2. Staatsarchiv München, SpkA K, 1074 (Lohse's denazification file), Lohse Bruno, Lohse to Hauptkammer München (25 August 1950).
3. See Norbert Frei, *Adenauer's Germany and the Nazi Past: The Politics of Amnesty and Integration* (New York: Columbia University Press, 2002).
4. Staatsarchiv München, SpkA K, 1074, Lohse Bruno, testimony of Karl Wolff (12 December 1947); and DCAJM-Le Blanc, Tribunal Militaire Permanent, box 984.
5. Staatsarchiv München, SpkA K, 1074, Lohse Bruno, testimony of Paul Gerstenberger (n.d. [1947]).
6. Ibid., testimony of Robert Scholz (8 September 1946).
7. Ibid., Lohse to Hauptkammer München (25 August 1950). The German reads, "dass ich keinerlei Kriegsverbrechen begangen hatte, sondern im Gegenteil grosse Verdienste um die Rettung von Kulturwerten erworben hatte."
8. Lohse was also represented in the late 1940s and early 1950s by attorneys Hermann Ulmer of Nuremberg, Erich Schwinge of Marburg, Karl Roemer from Sarrebruck, Albert Steiner of Zurich, Adrien Poe of Paris, and Albert Naud of Paris.
9. NARA, RG 260, box 86, OMGUS, "Licensing Provisions Contained in U.S. Military Law No. 52" (22 March 1949); and BHSA, MK 51491, "Anordnung über die Lizensierung der Kunsthändler vom 13. März 1947."
10. Christian Fuhrmeister, "Warum man Lügen glaubt. Kunstgeschichte und Kunsthandel 1945–2006," in Uwe Fleckner, Thomas Gaehtgens, and Christian Huemer, eds., *Markt und Macht: Der Kunsthandel im "Dritten Reich"* (Berlin: De Gruyter, 2017), 415.

11. For the Document Center in the Munich CCP, see BAR-Bern, E9500. 239A#2003/48, Bd. 24, Otto Wittmann, *Art Looting Investigation Unit: Final Mission to Europe (10 June 1946–24 September 1946)* (Washington, DC: War Department, 14 October 1946), 16.

12. MMA, Rousseau Papers, box 26, folder 15, Faison to Rousseau (16 January 1951).

13. NARA, RG 260, entry 1, box 84, Bernard Taper to Chief, MFAA Section, OMGUS (5 November 1946). It is unclear whether Bumming obtained a U.S. passport.

14. NARA, RG 260, box 486, Interrogation of Karl W. Buemming by Bernard Taper (17 January 1947).

15. See the Wikipedia entry for Theodor Fischer, https://en.wikipedia.org /wiki/Theodor_Fischer_(auctioneer) (accessed 8 June 2018).

16. BAR-Bern, E61000A-24#100/1924#72*, Testimony of Ralph Getsinger (14 May 1947); and Nancy Yeide, Konstantin Akinsha, and Amy Walsh, *The AAM Guide to Provenance Research* (Washington, DC: American Association of Museums, 2001), 261. See also GRI, SC, Otto Wittmann Papers, box 4, folder 8, Karl Buemming dossier. The OSS described Buemming as "a key in the movement of looted works of art between Germany and Switzerland" and "strongly recommended his apprehension."

17. BAR-Bern, E6100A-24/1000/1924, Bd. 7, Kuno Müller to Schweizerisches Bundesgericht (11 July 1950).

18. Ibid., Raubgutsachen Bührle/Dr. Raeber/Fischer/Eidgenossenschaft: Parteiverhör, Dr. Bruno Lohse (18/19 December 1950, Abschrift dated 22 January 1951), 17.

19. MMA, Rousseau Papers, box 33, folder 7, Lohse to Plaut (12 December 1950).

20. Ibid.

21. NARA, RG 260, OMGUS, Ardelia Hall Collection, box 270, S. Lane Faison to Eberhard Hanfstaengl ("Postscript") (11 June 1951).

22. Adam Lebor, *Tower of Basel: the Shadowy History of the Secret Bank That Runs the World* (New York: Public Affairs, 2013), 154, 188; and, more generally, Lothar Gall, *Der Bankier: Hermann Josef Abs* (Munich: C. H. Beck, 2004).

23. Lebor, *Tower of Basel*, 192.

24. Philippe Sprang, "Dans les ténèbres du docteur Lohse," *L'Oeil* 630 (December 2010); Harold Kluge, *Sündenböcke: Zur Rolle von zehn Prominenten unter der NS-Regime* (Munich: dotbooks, 2012).

25. NARA, RG 239, M 1944, roll 89, frame 109, Rose Valland to Lane Faison (August 1951). Theresa Sepp noted that Baldur and Henriette von Schirach purchased at least twelve paintings from Alois Miedl, so if Valland is correct, Quandt purchased more than a dozen works. Theresa Sepp, "Arbeitsbericht: Vorstudie zur Rekonstruktion des Besitzes von Kunst-und Kulturgut, über das Baldur von Schirach und seine Ehefrau Henriette zwischen

1935 und 1945 verfügten," *Deutsches Zentrum Kulturgutverluste* (September 2018), 115.

26. See the Wikipedia entry on Günther Quandt, https://en.wikipedia.org /wiki/G%C3%BCnther_Quandt (accessed 19 August 2017); and, more generally, Rüdiger Jungbluth, *Die Quandts: Ihr leiser Aufstieg zur mächtigsten Wirtschaftsdynastie Deutschlands* (Frankfurt: Campus, 2002); and Joachim Scholtyseck, *Der Aufstieg der Quandts* (Munich: C. H. Beck, 2011).

27. NARA, RG 239, M 1944, roll 89, frame 109, Rose Valland to Lane Faison (August 1951). The French reads, "Le Dr. Quandt s'est rendu acquérir également d'autres tableaux provenant de spoliations de biens juifs allemands par Hitler, lorsqu'ils passèrent en vente dans les Galeries de Berlin (principalement de la Galerie Leo Spik-Union)."

28. See the documentary film by Eric Friedler, *Das Schweigen der Quandts* (2007).

29. NARA, RG 260, OMGUS, Ardelia Hall Collection, box 270, Faison to British Land Observer (2 August 1951).

30. NARA, RG 260, entry 1, box 169, Plaut to Harry Conover (5 January 1946), 6.

31. NARA, RG 260, OMGUS, Ardelia Hall Collection, box 270, Faison to British Land Observer (2 August 1951); and NARA, RG 239, M 1944, roll 89, frame 109, Rose Valland to Lane Faison (August 1951); and Paul J. Heinemann statement (n.d.). The latter document was provided to the author by Philippe Sprang; it has the stamp of the Archives des Musées Nationaux, which means it is now probably in the Archives Nationales. Mr. Heinemann, a U.S. citizen, also claims that "Mr. Quandt" (whom he identifies as the "first husband of Mrs. Goebbels"), "was a member of the Einsatzstab Rosenberg and as such acted in the confiscation of art properties in Holland and Belgium." Günther Quandt was not a member of the ERR—he is not mentioned in any lists by either Germans or Allied investigators.

32. MMA, Rousseau Papers, box 26, folder 4, Lohse to Rousseau (25 September 1960).

33. Notes on conversation with Peter Griebert, Munich (17 October 2016).

34. Notes on conversation with Prof. Dr. Claus Grimm, Munich (13 June 2018).

35. Geheim Staatsarchiv Preussischer Kulturbesitz, I HA Rep 92, Kurt Reutti Nachlass, Kurt Reutti, "Erinnerungen," 197; and Jonathan Petropoulos, *The Faustian Bargain: The Art World in Nazi Germany* (New York: Oxford University Press, 2000), 246. The German is "Hofkünstler der deutschen Wirtschaftswunder."

36. BAR-Bern, E4320B#1973/17#1470*, Dr. Bürki to Schweizerische Bundesanwaltschaft (17 March 1953). For Wendland and Steiner, see BAR-Bern, E4320B#1990/133, Bd. 1, anonymous memorandum (29 July 1943).

37. BAR-Bern, E4320B#1973/17#1470*, Dr. Bürki to Albert Steiner (8 November 1951).

38. ALIU, *ALIU Final Report* (Washington, DC: Strategic Services, May 1946), 113.
39. BAR-Bern, J.1.269, 1999/82, Bd. 2, Karl Haberstock to Theodor Fischer (9 March 1948).
40. BAR-Bern, E4320B#1973/17#1470*, Dr. Bürki to Dr. Steiner (13 June 1953); Dr. Steiner to Göttler (24 October 1953); and Dr. Mäder to Dr. Steiner (28 April 1954).
41. BAR-Bern, E4320B#1990/133/17/#1470*, Lohse to Schweizer Bundesanwaltschaft (17 January 1951).
42. Lynn Nicholas, *The Rape of Europa: The Fate of Europe's Treasures in the Third Reich and the Second World War* (New York: Knopf, 1994), 424.
43. BAR-Bern, J.1.269, 1999/82, Bd. 2, Karl Haberstock to Theodor Fischer (9 March 1948).
44. Ibid., Joseph Schaefer to Theodor Fischer (14 December 1946).
45. NARA, RG 239, entry 73, box 25, Wittmann, *Art Looting Investigation Unit.*
46. Tony Judt, *Postwar: A History of Europe since 1945* (New York: Penguin, 2005), 58.
47. Peter Hayes, *Why? Explaining the Holocaust* (New York: Norton, 2017), 310 and, more generally, 308–14.
48. NARA, RG 59, Lot 62D-4, OMGUS, Ardelia Hall Collection, box 9, Ardelia Hall memorandum (29 November 1960). See also Mowenna Blewett, "Institutional Restorers, Cultural Plunder and New Collections," in Tanja Baensch, Kristina Kratz-Kresemeier, and Dorothee Wimmer, eds., *Museen im Nationalsozialismus: Akteure—Orte—Politik* (Cologne: Böhlau, 2015), 152–56.
49. AMAE-La Courneuve, 209SUP, box 417, Declaration of Wilhelm Palaisieux [Palezieux] (26 May 1947). See also J. Robert Kudelski, *"Portrait of a Young Man—*The Story of a Lost Painting" (2018), Ministry of Culture and National Heritage (Poland), http://dzielautracone.gov.pl/articles/105 -portrait-of-a-young-man-the-story-of-a-lost-painting.
50. AMAE-La Courneuve, 209SUP, box 417, Declaration of Wilhelm Palaisieux [Palézieux] (26 May 1947).
51. Jean Vlug, *Report on Objects Removed to Germany from Holland, Belgium, and France during the German Occupation in the Countries* (The Hague: Strategic Services Unit, 1945), 21. See also Dictionary of Art Historians, http://art historians.info/degenhartb (accessed 4 April 2020).
52. Diethard Leopold, *Rudolf Leopold—Kunstsammler* (Vienna: Holzhausen, 2003), 17–18. Franz Kieslinger inventoried Jewish collections in Vienna before looting art in the Netherlands. For more on Kieslinger, see Alexandra Caruso, "Raub in geordneten Verhältnissen," in Gabriele Anderl and Alexander Caruso, eds., *NS-Kunstraub in Österreich und die Folgen* (Vienna: Studien Verlag), 95–109; Sophie Lillie, *Was einmal War: Handbuch der enteigneten Kunstsammlungen Wiens* (Vienna: Czernin Verlag, 2003), 190, 200, 215, 324, 361–62, 398, 430, 527, 572, 911; and Meike Hopp, *Kunsthandel im*

Nationalsozialismus: Adolf Weinmüller und Wien (Cologne: Böhlau, 2012), 241–54, 272–93.

53. See the Wikipedia entry for Schiedlausky, http://de.wikipedia.org/wiki /G%C3%BCnther_Schiedlausky (accessed 7 November 2019).

54. Christian Fuhrmeister, Johannes Griebel, Stephan Klingen, and Ralf Peters, eds., *Kunsthistoriker im Krieg: Deutsche Militärischer Kunstschutz in Italien 1943–1945* (Cologne: Böhlau, 2012); and the entry for Reidemeister at Deutsche Biographie, https://www.deutsche-biographie.de/sfz74600 .html (accessed 7 November 2019).

55. Camilla Blechen, "Hunting the Expressionist in His Erstwhile Habitat," *Frankfurter Allgemeine Zeitung* (30 April 2001), 7.

56. See also the example of Professor Kurt Wehlte, a restorer who worked for Nazi leaders and then moved to the United Kingdom thanks to the efforts of officials at the National Gallery of Art and the Courtauld. See "National Gallery and Courtauld Knew Art Restorer Had Links to Nazis," *Guardian* (15 September 2019), https://www.theguardian.com/artanddesign/2019 /sep/15/british-galleries-nazi-art-restorer.

57. See, for example, Kenneth Alford, *Allied Looting in World War II* (Jefferson, NC: McFarland, 2012); and Kenneth Alford, *Sacking Aladdin's Cave: Plundering Hermann Göring's Nazi War Trophies* (Atglen, PA: Schiffer, 2013).

58. Staatsarchiv Coburg, SPK BA Land, H 15, vol. 2, Denazification trial of Karl Haberstock, Bruno Lohse on behalf of Haberstock (12 January 1948).

59. Lohse interview with author, Munich (21 July 2000).

60. Städtische Kunstsammlungen Augsburg, *Die Karl und Magdaelene Haberstock Stiftung. Gemälde und Zeichnungen* (Munich: Klinkhardt & Biermann, 1991).

61. Horst Kessler, ed., *Karl Haberstock. Umstrittener Kunsthändler und Mäzen* (Munich: Deutscher Kunstverlag, 2008), 96.

62. BHSA, MK 50865, Kurt Martin to Bayerisches Staatsministerium für Unterricht und Kultus (19 December 1961).

63. Tillar Mazzeo, *The Hotel on Place Vendôme* (New York: HarperCollins, 2014), 106.

64. The address of Magdalena Haberstock by 1968 was Widenmayerstrasse 25.

65. Städtische Kunstsammlungen der Stadt Augsburg, Haberstock Nachlass, HA/XI, Magdalena Haberstock to Robert Scholz (16 April 1958). She refers to a "B.L.," whom I believe to be Lohse from other correspondence in the file.

66. Kessler, *Karl Haberstock*; and Brita Sachs, "Nicht rühmen sondern aufklären. Jonathan Petropoulos sprach in Augsburg über Karl Haberstock, Hitlers Kunsthändler," *Frankfurter Allgemeine Zeitung* (14 February 2001), 52.

67. MMA, Rousseau Papers, box 26, folder 15, Faison to Rousseau (16 January 1951); and Städtische Kunstsammlungen der Stadt Augsburg, Haberstock Nachlass, HA/XI, Magdalena Haberstock to Walter Andreas Hofer (3 October 1957).

68. MMA, Rousseau Papers, box 33, folder 7, Lohse to Plaut (12 December 1950). The German reads, "persona gratissima beim Collecting Point und geht dort, sowie bei Herrn Hanfstaengl, ein und aus."

69. For Hofer in the postwar period, see Jean-Marc Dreyfus, "10 890 Tableaux, 583 Sculptures, 583 Tapisseries, 2 477 Pièces de Mobiliers Anciens, 5 825 Pièces de Porcelaine. Le procès de l'ERR et du Pillage des Oeuvres d'Art, Paris, 1950," *Histoire@Politique*, no. 35 (May–August 2018), 4, https://www.histoire-politique.fr/index.php?numero=35&rub=autres-articles&item=113.

70. Hanns Schaeffer (1886–1967) had galleries in Berlin and the Netherlands before the war and, along with his wife Kate Born Schaeffer (1898–2001), established a branch in New York in 1936. The Schaeffers were in contact with many individuals who were compromised by Nazi-looted art during the war, including not only Hofer but also Baron von Poelnitz, who had a "Breugel masterpiece" that they tried to sell to the Canadian National Gallery in 1958. Poelnitz was an associate of Karl Haberstock's. See the obituary for Hanns Schaeffer: *New York Times* (3 May 1967).

71. GRI, Schaeffer Galleries Records, series IVA, box 123, folder 10, Hanns Schaeffer to Hofer (25 December 1962); and box 172, folder 12, Hofer to Hanns Schaeffer (21 June 1960). The German reads, "Schwabischen Meister."

72. See, for example, Hofer's advertisement for a Dutch painting by Johann Dahl from 1831 in *Die Weltkunst* (26 October 1966), 1057.

73. NIOD, no. 211/3, box 5, doc. 234, Gisela Limberger to Hofer-Fritsch (28 May 1940).

74. For more on Bertha Hofer-Fritsch, see BArch-Berlin, RKK 2400, box 135, file 22; and NARA, RG 260, box 179. Bertha Hofer had contacts at the Met, including a "Miss Bartles," who had worked for Bachstitz for fifteen years in The Hague. See NARA, RG 239, roll 89, frame 68, OSS Official Dispatch (21 March 1945).

75. GRI, Schaeffer Galleries Records, series IVA, box 145, folder 13, Hofer to Hanns Schaeffer (25 October 1970).

76. Notes on conversation with Bruno Lohse, Munich (8 June 1998). See also MMA, Rousseau Papers, box 26, folder 15, Faison to Rousseau (16 January 1951).

77. Stefan Koldehoff, "Auf der Jagd nach Görings verlorenem Schatz," *Die Welt* (4 July 2010).

78. Ibid.

79. Theodore Rousseau, *DIR No. 9: Walter Andreas Hofer* (Washington, DC: War Department, Strategic Services Unit, September 15, 1945), 8.

80. NIOD, Aalders Collection, L.3349, E. E. Minskoff, "Interrogation of Walter Andreas Hofer" (12 December 1945), 5.

81. Lohse interview with author, Munich (15 June 1999).

82. Hofer valued the objects he recovered at between DM 6,000 and DM 8,000.

See BAR-Bern, J1.269, 1999/82, Bd. 2, Walter Andreas Hofer Abhörungs-protokoll (30 April 1949).

83. Note on conversation with Peter Griebert, Munich (7 June 2015).

84. "Stolen 14th C. Crucifix Panel Painting Back in Venice," *History Blog* (3 April 2013), http://www.thehistoryblog.com/archives/24059.

85. GRI, Schaeffer Galleries Records, series IVA, box 129, folder 10, Hanns Schaeffer to Gustav Rochlitz (29 December 1964). Rochlitz's address in Cologne was Severinstrasse 119 and in Füssen it was Tirolerstrasse 7. This file also references an expertise of an Italian picture by Professor Hermann Voss, further suggestive of Rochlitz's contacts.

86. NIOD, Aalders Collection, L3348, E. E. Minskoff, "Interrogation of Gisela Limberger" (9–12 October 1945).

87. Notes on conversation with S. Lane Faison, Williamstown, MA (28 December 1999).

88. DCAJM–Le Blanc, Tribunal Militaire Permanent, box 984, S. Lane Faison to Craig Hugh Smyth (25 September 1945)

89. IfZG, ZS 1162, "Vernehmung von Frl. Gisela Limberger durch Mr. Cooper" (29 July 1947).

90. See the Wikipedia entry for the *National Zeitung*, https://en.wikipedia.org/wiki/National-Zeitung (accessed 10 January 2020).

91. Notes on conversation with Bruno Lohse, Munich (21 July 2000).

92. The Datenbank des Deutschen Historischen Museums zum Sonderauftrag Linz has 997 hits for Maria Almas Dietrich. See also Staatsarchiv München, K 285, Spruchkammer Akte for Maria Almas Dietrich.

93. Anne Rothfeld, "Unscrupulous Opportunists: Second-Rate German Art Dealers as Nazi Functionaries during World War II" (PhD diss., American University, 2016), 96.

94. Ibid. See also NARA, M 1946, roll 120, ALIU interrogation of Dietrich (January–February 1946).

95. Nadine Bauer, "Die Rolle der Galerie Almas im Geflecht des NS-Kunsthandels" (PhD diss., Technische Universität-Berlin, 2016), with a description at https://www.kuk.tu-berlin.de/menue/dissertationen/laufende _dissertationen/diss_bauer/.

96. Dr. J. G. Böhler, letter to author (25 September 1998). For more on Dietrich, see her obituary in the *Süddeutsche Zeitung* (20/21 November 1971), 12.

97. For the ads for Galerie Almas and Galerie Peter Griebert, see *Die Weltkunst* (18 October 1976), 1925.

98. Notes on conversation with Peter Griebert, Munich (7 June 2015).

99. Erhard Göpel, "Die Millionendame von Picasso," *Süddeutsche Zeitung* (22 December 1964).

100. Halldor Soehner joined the Nazi Party on 10 January 1941. His membership is confirmed by his so-called Gau-Akte (Local Nazi Party File), which is housed in the Bundesarchiv in Berlin (his Nazi Party number is 8,285,179).

101. See the decision of Judge Jed Rakoff, in *Julius Schoeps et al. v. Freistaat Bay-*

ern (U.S. District Court, Southern District of New York, 13 Civ. 2048) (27 June 2014). Note that the author of this book served as an expert witness for the plaintiffs.

102. An example of a critical scholar denied access to the Göpel "Nachlass" in the Bayerische Staatsbibliothek (Ana 415) is Dr. Christian Fuhrmeister. Fuhrmeister, email to author (30 August 2016). Note also that early in the war, Erhard Göpel published a travel guide under the auspices of the Armee-Oberkommando called *Die Normandie* (Paris: Druckerei Curial Archereau, 1941). It is a very erudite mixture of guidebook and cultural history.

103. Erhard Göpel Nachlass, Bayerische Staatsbibliothek, Ana 415, Arthur Seyss-Inquart Order (16 June 1942).

104. Ibid.

105. NARA, RG 239, M 1944, roll 86, frames 573–74, "German Personnel Connected with Art Looting" (n.d. [September 1945?]). Note that under "Recommendation," it actually reads, "Same as 15": the language for the recommendation comes from entry 15, Leopold Rupprecht.

106. Catherine Hickley, "Widow of Hitler's Art Dealer, Erhard Göpel, Bequeaths Max Beckmann Works to Berlin," *Art Newspaper* (21 February 2018).

107. Hopp, *Kunsthandel im Nationalsozialismus.*

108. Bayerisches Wirtschaftsarchiv, F43, no. 421, J. Böhler to Lohse (30 June 1972).

109. Böhler Archives in the Zentralinstitut für Kunstgeschichte, card for Dr. Bruno Lohse.

110. Tessa Friederike Rosebrock, *Kurt Martin und das Musée des Beaux-Arts de Strasbourg. Museums-und Ausstellungspolitik im "Dritten Reich" und in der unmittelbaren Nachkriegszeit* (Berlin: Akademie Verlag, 2012).

111. Katrin Iselt, *"Sonderbeauftragter des Führers": Der Kunsthistoriker und Museumsmann Hermann Voss (1884–1969)* (Cologne: Böhlau, 2010).

112. BHSA, MK 74113, Henriette von Hoffmann-Schirach to Bayerischer Staatsministerium der Finanzen (1 October 1959); and Kurt Martin to BSMfUK (14 June 1960); and Catrin Lorch and Jörg Hantzschel, "Munich's Looted Art Bazaar," *Süddeutsche Zeitung* (25 June 2016). See the translation at Lootedart.com, http://www.lootedart.com/news.php?r=RWFWSS249591 (accessed 3 January 2017).

113. Lorch and Hantzschel, "Munich's Looted Art Bazaar."

114. BSHA, MK 74590, Bayerische Staatsgemäldesammlungen, "Angebotene wichtige Bilder in Auswahl, deren Erwerbung aus finanziellen Gründen undurchfuhrbar war" (n.d.).

115. BHSA, MK 50871, Reinhard Müller-Mehlis, "Stammt die Bayerische Diana von Rubens?" *Münchner Merkur* (4 January 1968).

116. "Die Pinakothek ohne Chef. Zum Tode von Generaldirektor Halldor

Soehner," *Süddeutsche Zeitung* (25 April 1968). See also BHSA, MK 74859, Hermann Voss to BSMfUK (30 January 1968).

117. Jonathan Petropoulos, "For Sale: A Troubled Legacy," *ARTnews* (June 2001), 114–20.

118. Hector Feliciano, *Lost Museum: The Nazi Conspiracy to Steal the World's Greatest Works of Art* (New York: Basic Books, 1997), 154.

119. Mario König and Bettina Zeugin, eds., *Switzerland, National Socialism and the Second World War: Final Report of the Independent Commission of Experts Switzerland—Second World War* (Zurich: Pendo, 2002), 472; Stuart Eizenstat, *Imperfect Justice: Looted Assets, Slave Labor, and the Unfinished Business of World War II* (New York: Public Affairs, 2003); and the website for Holocaust Victim Asset Litigation, http://swissbankclaims.com/Overview.aspx (accessed 15 September 2015).

120. Dalya Alberge, "Swiss Banks' Stashes of Looted Art an 'Open Secret,'" *Times* (London) (30 August 2015).

121. See the Swiss Civil Code, article 728, section 1; and Gunnar Schnabel and Monika Tatskow, *Nazi Looted Art. Handbuch Kunstrestitution weltweit* (Berlin: Proprietas Verlag, 2007), 52–61.

122. See the Swiss Civil Code, Article 728, section 1. Note that this provision does not have a retroactive effect; the five-year provision therefore applies to works held prior to 2006 (this according to a ruling of 18 April 2013 in BGE 139 III 305 at 307).

123. Feliciano, *Lost Museum*, 155.

124. Peter Watson, *The Caravaggio Conspiracy* (New York: Doubleday, 1984); and Peter Watson, *Sotheby's: The Inside Story* (New York: Random House, 1997).

125. "Steve Cohen's Modigliani in the Middle of an Art Market War: Billionaire Rybolovlev vs. Yves Bouvier," *Forbes* (12 March 2015), http://www.forbes.com/sites/afontevecchia/2015/03/12/steve-cohens-modigliani-in-the-middle-of-an-art-market-war-billionaire-rybolovlev-vs-yves-bouvier/.

126. Notes on conversation with Yves Stavridès, Paris (9 June 2016).

127. Sam Knight, "The Bouvier Affair: How an Art-World Insider Made a Fortune by Being Discreet," *New Yorker* (8 and 15 February 2016).

128. Ibid.

129. Jake Bernstein, "How the Panama Papers Exposed Secrecy in the Art Market," *Vice News* (7 April 2016), https://news.vice.com/article/how-the-panama-papers-exposed-secrecy-in-the-art-market. Among the collectors, he discusses the Goulandris family, and among the dealers the Nahmads.

130. Notes on conversation with Prof. Dr. Claus Grimm, Munich (24 September 2014).

131. König and Zeugin, *Switzerland, National Socialism and the Second World War*, 472.

132. NARA, RG 239, entry 73, box 82, Douglas Cooper, "Report of Mission to Switzerland" (28 January 1946). There are copies of Cooper's reports and memoranda concerning Switzerland in many archives, including the BAR-Bern, E9500.239A#2003/48, Bd. 24.

133. GRI, SC, Douglas Cooper Papers, box 42, "Rapport de Monsieur Paul Rosenberg sur Son Voyage en Suisse au Cours de la Première Qunzaine de Septembre 1945"; and Esther Tisa Francini, Anja Heuss, and Georg Kreis, *Fluchtgut-Raubgut. Der Transfer von Kulturgütern in und über die Schweiz 1933–1945 und die Frage der Restitution* (Zurich: Chronos Verlag, 2001).

134. NARA, RG 59, entry 1, box 23, State Department, Safehaven Report no. 229, "U.S. Investigation of Looted Art in Switzerland—Second Interim Report" (15 January 1946). See also NARA, RG 226, entry 19, box 85, State Department, Safehaven report no. 148, "Report on Progress of Current Investigation of Looted Art in Switzerland" (9 December 1945); NARA, RG 239, entry 73, box 39, John Allison, Safehaven Report no. 80, "Activities of Galerie Fischer of Lucerne, Switzerland with Regard to Looted Art" (29 January 1945); State Department, Safehaven Report no. 198, "Galerie Fischer, Lucerne" (6 July 1945); and NARA, RG 84, American Legation Bern, Economic Section, Safehaven Subject Files, 1942–1949, box 8, E. G. Rasmussen, "Subject: Looted Works of Art in Switzerland" (28 August 1945).

135. Thomas Buomberger, *Raubkunst-Kunstraub. Die Schweiz und der Handel mit gestohlenen Kulturgütern zur Zeit des Zweiten Weltkrieges* (Zurich: Orell Füssli, 1998), 331.

136. Ibid. Fifty-seven of the seventy-seven works went through Fischer's hands. See NARA, RG 260, entry 1, box 169, Plaut to Harry Conover (5 January 1946).

137. GRI, SC, no. 940109/26, Otto Wittmann oral history (13 January 1993), 109.

138. NARA, RG 84, entry 3221, box 8, Douglas Cooper, "Looted Works of Art in Switzerland" (21 January 1945), 1.

139. ALIU, *ALIU Final Report*, 13.

140. GRI, SC, Douglas Cooper Papers, box 42, Emil Bührle to Dr. Vodoz, Department of Interior, Switzerland (17 October 1945); and NARA, RG 239, M 1944, roll 92, frame 630, "Verkaufte Impressionisten" (10 April 1945).

141. BAR-Bern, E6100A-24/1000/1924, Bd. 7, Raubgutsachen Bührle/Dr. Raeber/Fischer/Eidgenossenschaft: Parteiverhör, Emil Bührle (18/19 December 1950, Abschrift dated 22 January 1951), 2–6.

142. Ibid., 5.

143. For the *Neue Zürcher Zeitung* articles on the theft of Jewish property, see BAR-Bern, E6100A-24/1000/1924, Bd. 9, Direktor Finanzverwaltung to Schwerzerisches Bundesgericht (30 April 1951).

144. Otto Wittmann and Bernard Taper, *DIR: Hans Wendland* (Washington, DC: Strategic Services Unit, 18 September 1946), 10. Charles Montag (1880–1956), who trafficked in looted art in Paris, also counted among

Bührle's advisers who could have enlightened him. See Esther Tisa Francini, *Liechtenstein und der international Kunstmarkt 1933–1945* (Zurich: Chronos, 2005), 107.

145. Ibid., 3. See also BAR-Bern, E6100A-24/1000/1924, Bd. 10, Walther Huber (Bührle's lawyer) to Bundesgericht (20 September 1949), 6–7, 15. One of the Renoirs is titled *Fischstilleben. Blick aufs Meer, Guernsey,* but it does not appear to have been Lohse's Renoir landscape of Guernsey.

146. NARA, M 1944, roll 89, frames 543–48, Militärbefehlshaber in Frankreich "Aktennoitz" (15 May 1941).

147. Thomas Buomberger and Guido Magnaguagno, eds., *Schwarzbuch Bührle. Raubkunst für das Kunsthaus Zürich?* (Zurich: Rotpunktverlag, 2015).

148. Feliciano, *Lost Museum,* 200–201. See BAR-Bern, E6100A-24/1000/1924, Bd. 9, René Wehrli, "Teilabschrift aus dem Protokoll der Vorstandssitzung der Zürcher Kunstgesellschaft" (20 May 1943).

149. Miodrag Certic and Mia Certic, "A Swiss Merchant of Death's Nazi Friends and Suspicious Masterpieces," *Daily Beast* (17 May 2015), http://www.thedailybeast.com/articles/2015/05/17/a-swiss-merchant-of-death-s-nazi-friends-and-suspicious-masterpieces.html.

150. Feliciano, *Lost Museum,* 201–5. See also the exhibition catalogue *The Passionate Eye: Impressionist and Other Master Paintings from the Collection of Emil G. Bührle* (Washington, DC: National Gallery of Art, 1990). See the great photo of Bührle seated before the Degas Madame Camus at http://www.bing.com/images/search?q=emil+b%c3%bchrle&view=detailv2&&id=4EE445DDF04C29590E859F745D91C9D9FE947190&selectedIndex=0&ccid=IK0Omk%2bj&simid=148569282604&thid=HR.148569282604&ajaxhist=0.

151. Buomberger and Magnaguagno, *Schwarzbuch Bührle.*

152. Emmanuelle Polack, *Le Marché de l'Art sous l'Occupation* (Paris: Tallandier, 2019), 54, 164–66, 227.

153. Fritz Nathan and Peter Nathan, *25 Jahre: 1936–1961* (Winterthur: Buchdruckeri Winterthur, 1961).

154. BAR-Bern, J1.269-01, 1999/82#47*, Walter Andreas Hofer Abhörungsprotokoll (3 May 1949).

155. Benno Griebert joined the NSDAP on 1 January 1932 with membership number 843,461. Benno Griebert's personnel file included "positive" evaluations of his political "reliability," including the comment, "He steps in at any time and without hesitation to help the National Socialist state." Zentralarchiv der Berliner Staatlichen Museen, I/NG, 155, Verwaltungs Oberinspektor review of Benno Griebert (1 February 1943). The German reads, "dass er jederzeit rücksichtslos für den nationalsozialistischen Staat eintritt."

156. Fanny Stoye of the Zeppelin Museum in Friedrichshain provided the author a list, "Erwerbungen von Herrn Dr. Benno Griebert und Herrn Peter Griebert, 1952–1981" (2018), which contains thirty-eight objects. See also Claudia Emmert and Ina Neddermeyer, eds., *Eigentum Verpflichtet. Eine*

Kunstsammlung auf dem Prüfstand. The Obligation of Ownership: An Art Collection under Scrutiny (Friedrichshafen: Zeppelin Museum, 2018).

157. See, for example, *Die Weltkunst* (15 December 1959), 6. Plietzsch had extensive correspondence in the postwar period with the Schaeffer Galleries: see, for example, the letter about Plietzsch's move from Berlin to Cologne in GRI, Schaeffer Galleries Records, series IVA, box 106, folder 2, Plietzsch to Hanns Schaeffer (1951).

158. ALIU, *ALIU Final Report*, 62; and the Wikipedia entry for Plietzsch, https://en.wikipedia.org/wiki/Eduard_Plietzsch (accessed 6 January 2020).

159. ALIU, ALIU *Final Report*, 62.

160. See the biographical sketch of Benno Griebert at the Staatliche Museen zu Berlin, http://www.galerie20.smb.museum/werke/958743.html (accessed 7 July 2017).

161. See the information about Peter Griebert provided by the Staatliche Museen zu Berlin, http://www.galerie20.smb.museum/kunsthandel/K28.html (accessed 7 July 2017).

162. Bührle had contact with Göring's circle during the war, for example, offering works to Göring for sale: a 28 November 1942 note from Hofer to Limberger says that four pictures by Jacques Louis David, Jean Baptiste Greuze, and Pierre-Auguste Renoir (two), were awaiting Göring's decision, and that they came from the "the property of Herrn Buehrle, Zürich." DCAJM–Le Blanc, Tribunal Militaire Permanent, box 983, Walter Hofer to Gisesla Limberger (28 November 1942). See also BAR-Bern, J1.269-01, 1999/82#47*, Walter Andreas Hofer Abhörungsprotokoll (3 May 1949); and ibid., E6100A-24#1000/1924, Bd. 10, anonymous report on Bührle and Wendland (n.d.).

163. Wittmann and Taper, *DIR: Hans Wendland*, 1; Rothfeld, "Unscrupulous Opportunists," 217–23; Howard Trienens, *Landscape with Smokestacks: The Case of the Allegedly Plundered Degas* (Evanston, IL: Northwestern University Press, 2000), 52–56. Wendland's trial records before the French Tribunal are in DCAJM–Le Blanc. See also BAR-Bern, E6100A-24/1000/1924, Bd. 7, Raubgutsachen Bührle/Dr. Raeber/Fischer/Eidgenossenschaft: Parteiverhör, Hans Wendland (18/19 December 1950, Abschrift dated 22 January 1951), 10–15.

164. See the Wikipedia entry for Gunther Gerzso, http://en.wikipedia.org/wiki/Gunther_Gerzso (accessed 18 August 2016).

165. Jonathan Lopez, *The Man Who Made Vermeers: Unvarnishing the Legend of Master Forger Han van Meegeren* (New York: Houghton Mifflin Harcourt, 2008), 241; Francini, Heuss, and Kreis, *Fluchtgut-Raubgut*, 150–54, 406–8.

166. Rothfeld, "Unscrupulous Opportunists," 210–12; and Nicholas, *Rape of Europa*, 165–66. Graupe owned pictures jointly with Hans Wendland before the war (works by Brueghel, Brower, Cuyp, and others). See BAR-Bern, E9500.239A#2003/48, Bd. 24, Byrnes to Department of State (10 April 1946). Wendland and Graupe later fell into disputes over certain

works, and it is unclear how their business relationship evolved in the post-war period. For Wendland and Thannhauser, see NARA, RG 239, M 1944, roll 93, frame 245, Federal Bureau of Investigation, Report (19 August 1944). For Wendland and Wildenstein, see NARA, RG 239, M 1944, roll 92, frame 665, Hans Wendland Declaration (4 September 1946). Wendland notes that "the firm of Wildenstein and I continually supported his [August Liebmann Mayer's] wife and child at his residence in Paris."

167. Trienens, *Landscape with Smokestacks*, 52; Simon Goodman, *The Orpheus Clock: The Search for My Family's Art Treasures Stolen by the Nazis* (New York: Scribner, 2015); 209; and Polack, *Le Marché de l'Art sous l'Occupation*, 51–52.

168. NARA, RG 84, Switzerland, U.S. Embassy and Legation Bern, Classified General Records, entry UD 3208, box 76, Charles Owsley to Mr. Hughes (25 November 1949).

169. BAR-Bern, J1.269, 1999/82, Bd. 9, Mr. Getzinger, "Memorandum of Interview with Theodore [*sic*] Fischer" (21 May 1943); ibid., E61000A-24#100/1924#72*, Testimony of Hans Wendland (7 February 1949). Nathan later retracted this story and said he didn't know anything about Fischer's holdings. See BAR-Bern, J1.269-01#1999/82#47*, Fritz Nathan to Julius Baum (20 April 1948).

170. NARA, RG 84, American Legation Bern, Economic Section, Safehaven Subject Files, 1942–1949, box 8, "Subject: "Galerie Fischer (PL) and Theodor Fischer (PL) and Their Activities in the Traffic of Looted Art in Switzerland" (n.d.); and the appended report, ibid., E. G. Rasmussen, "Subject: Looted Works of Art in Switzerland" (28 August 1945), 1.

171. The commercial attaché at the U.S. embassy in Bern also wrote to Fischer. See BAR-Bern, J1.269-01#1999/82#9, Daniel J. Reagan, Commercial Attaché of the U.S. to Theodor Fischer (28 July 1943); and ibid., E2001E# 1000/1571#1476, Bd. 127. The broadcast on the *Atlantik-Sender* was on 26 September 1943.

172. NARA, RG 84, American Legation Bern, Economic Section, Safehaven Subject Files, 1942–1949, box 8, E. G. Rasmussen, "Subject: Looted Works of Art in Switzerland: (28 August 1945), 4. Theodor Fischer was personally placed on the Statutory List on 27 September 1943.

173. For the Declaration of London (5 January 1943), see Elizabeth Simpson, ed., *The Spoils of War: World War II and Its Aftermath; The Loss, Reappearance, and Recovery of Cultural Property* (New York: Harry Abrams, 1997), 287.

174. A copy of Fischer's advertisement is in BAR-Bern, J1.269-01#1999/82#9*, Raubkunst dossier (Bundesamt für Kultur).

175. BAR-Bern, E61000A-24#100/1924#72*, Testimony of Ralph Getsinger (14 May 1947).

176. NARA, RG 84, American Legation Bern, Economic Section, Safehaven Subject Files, 1942–1949, box 8, "Subject: "Galerie Fischer (PL) and Theodor Fischer (PL) and Their Activities in the Traffic of Looted Art in

Switzerland" (n.d.). For the lists of works acquired by Fischer, see NARA, RG 239, M 1944, roll 92, frames 318–19, "Looted Works of Art at the Galerie Fischer, Lucerne" (n.d.).

177. BAR-Bern, E61000A-24#100/1924#72*, Testimony of Ralph Getsinger (14 May 1947).

178. Hofer recalled that Fischer also sent Hans Wendland to ask Hofer to take back the ERR pictures, but this appeal was also denied. See BAR-Bern, J1.269, 1999/82, Bd. 2, Walter Andreas Hofer Abhörungsprotokoll (1 May 1949); and ibid., E6100A-24/1000/1924, Bd. 7, Dr. Ernst Saxer to OMGUS (18 May 1948).

179. BAR-Bern, E9500.239A#2003/48, Bd. 24, Douglas Cooper to Leonard Woolley (10 March 1945).

180. BAR-Bern, J1.269, 1999/82#47*, Theodor Fischer to Ernst Saxer (8 April 1949); and ibid., J1.269-01#1999/82#47*, Fischer to Haberstock (3 June 1941). Note that Fischer trained with Paul Cassirer, a Jewish dealer in Berlin.

181. "Galerie Fischer Luzern gewinnt den letzten Kriegsraubgutprozess," *Die Tat* (Zurich), 22 July 1952; "Schweiz Raubkunst: Jäger und Sammler," *Facts* 16 (1997), 21–26; and König and Zeugin, *Switzerland, National Socialism and the Second World War,* 475.

182. König and Zeugin, *Switzerland, National Socialism and the Second World War,* 475.

183. NARA, RG 260, entry 1, box 169, Plaut to Harry Conover (5 January 1946), 9.

184. BAR-Bern, J1.269, 1999/82, Bd. 10, Appellationshof des Kantons Bern, ruling on *Wildenstein v. Bern Kunstmuseum* case (29 April 1952).

185. NARA, RG 226, entry 190, box 30, Plaut to Harry Conover (5 January 1946), 4.

186. BAR-Bern, E9500.239A#2003/48, Bd. 40, anonymous, "Notiz betreffend das Begehren der Galerie Fischer" (4 July 1951). The agreement was named after Lauchlin Currie, an assistant to President Roosevelt.

187. BAR-Bern, E9500.239A#2003/48, Bd. 24, Otto Wittmann, *Art Looting Investigation Unit—Final Mission to Europe (10 June 1946–24 September 1946)* (Washington, DC: War Department, 14 October 1946), 13.

188. Nicholas, *Rape of Europa,* 419.

189. Peter Feilchenfeldt, statement of 1 April 1997, quoted in Buomberger, *Raubkunst-Kunstraub,* 394.

190. Stuart Eizenstat and William Slany, *U.S. and Allied Efforts to Recover and Restore Gold and Other Assets Stolen or Hidden by Germany during World War II: Preliminary Study* (Washington, DC: U.S. Government Printing Office, 1997); and Stuart Eizenstat and William Slany, *U.S. and Allied Wartime and Postwar Relations and Negotiations with Argentina, Portugal, Spain, Sweden, and Turkey on Looted Gold and German External Assets and U.S. Concerns*

about the Fate of the Wartime Ustasha Treasury (Washington, DC: U.S. Government Printing Office, 1998).

191. Francini, Heuss, and Kreis, *Fluchtgut-Raubgut*.

192. Stefan Koldehoff, *Die Bilder sind unter uns. Das Geschäft mit der NS-Raubkunst und der Fall Gurlitt* (Berlin: Galiani, 2014 [2009]), 106, 109.

193. See the Wikipedia entry for Bruno Lohse, http://de.wikipedia.org/wiki /Bruno_Lohse (accessed 10 January 2020).

194. Anne Webber, email to author (3 April 2020).

Chapter Six. Lohse in North America

1. Thomas Hoving, *Making the Mummies Dance: Inside the Metropolitan Museum of Art* (New York: Simon & Schuster, 1993), 81–82; and Grace Glueck, "Hoving Gets Help at Metropolitan," *New York Times* (13 June 1968).

2. GRI, SC, no. 940109/26, Otto Wittmann, oral history (13 January 1993), 115. See also MMA, Rousseau Papers, box 26, folder 17, "U.S. Civil Service Commission Personnel Information Sheet" of Rousseau (2 July 1940); and the entry for Theodore Rousseau at the Monuments Men Foundation: https://www.monumentsmenfoundation.org/the-heroes/the-monuments -men/rousseau-theodore-jr. (accessed 22 August 2019).

3. Carmen Gomez-Moreng, "Of Theodore Rousseau," *New York Times* (11 January 1974).

4. Hoving, *Making the Mummies Dance*, 118, 187. Hoving says of Rousseau, "We partied, even, at times, womanized together."

5. John L. Hess, *The Grand Acquisitors* (Boston: Houghton Mifflin, 1974), 24–25.

6. Michael Gross, *Rogues' Gallery: The Secret History of the Moguls and the Money That Made the Metropolitan Museum* (New York: Broadway Books, 2009), 259.

7. Hoving, *Making the Mummies Dance*, 20–21, 50.

8. Jason Felch and Ralph Frammolino, *Chasing Aphrodite: The Hunt for Looted Antiquities at the World's Richest Museum* (New York: Houghton Mifflin Harcourt, 2011), 4–5.

9. Gross, *Rogues' Gallery*, 219.

10. Thomas Hoving, *King of the Confessors* (New York: Simon & Schuster, 1981), 74.

11. GRI, SC, no. 940109/26, Otto Wittmann, oral history (13 January 1993), 120.

12. Gross, *Rogues' Gallery*, 365.

13. MMA, Rousseau Papers, box 26, folders 8–12.

14. Ibid., folders 1, John Walsh to A. M. Rosenthal (2 January 1974). In the same file, there are a number of letters that are critical of obituaries of Rousseau, including one by Harvard professor Sydney Freedberg (7 Janu-

ary 1974) regarding the obituary that ran in the *International Herald Tribune*. See also Thomas Hoving, "Theodore Rousseau, 1912–1973," *Metropolitan Museum Journal* 8 (1973), 5–6.

15. Gross, *Rogues' Gallery*, 353.
16. Ibid., 354.
17. Ibid., 357–58; and Felch and Frammolino, *Chasing Aphrodite*, 209–15, 311.
18. Hess, *The Grand Acquisitors*, 40–41.
19. Ibid., 41.
20. Ibid.
21. Gross, *Rogues' Gallery*, 415.
22. Staatsarchiv München, SpkA K, 1074 (Lohse's denazification file), Lohse Bruno, statement of Walter Borchers (30 March 1947).
23. Notes on conversation with Bruno Lohse, Munich (21 July 2000). For thefts from the David-Weill family, see Ernst Kubin, *Sonderauftrag Linz. Die Kunstsammlung Adolf Hitler* (Vienna: Orac, 1989), 36.
24. Nancy Yeide, Konstantin Akinsha, and Amy Walsh, *The AAM Guide to Provenance Research* (Washington, DC: American Association of Museums, 2001), 235.
25. BAR-Bern, E9500.239A#2003/48, Bd. 24, Sam Woods to Honorable Secretary of State (14 October 1942).
26. NARA, RG 84, American Legation Bern, Economic Section, Safehaven Subject Files, 1942–1949, box 8, E. G. Rasmussen, "Subject: Looted Works of Art in Switzerland" (28 August 1945), 5.
27. BSHA, MK 74590, Bayerische Staatsgemäldesammlungen, "Angebotene wichtige Bilder in Auswahl, deren Erwerbung aus finanziellen Gründen undurchfuhrbar war" (n.d.).
28. MMA, Rousseau Papers, box 26, folder 7, Lohse to Rousseau (7 April 1964).
29. Hoving, *Making the Mummies Dance*, 81.
30. MMA, Rousseau Papers, box 33, folder 7, Lohse to Rousseau (7 April 1964).
31. Ibid., box 13, folder 9, list of addresses.
32. Ibid., box 13, folder 21, Rousseau notebook (n.d.).
33. For an example of Hofer's dealings in the United States, see his correspondence in the Schaeffer Galleries Papers: e.g., GRI, Schaeffer Galleries Records, series IVA, box 172, folder 12, Hofer to Hanns Schaeffer (21 June 1960) and box 123, folder 10, Hanns Schaeffer to Hofer (25 December 1962).
34. Katherine Baetjer, email to author (24 February 2014).
35. Bruno Lohse to Otto Naumann (15 September 1976). Letter provided to the author by Otto Naumann.
36. The Monts appear in the records of the Schaeffer Galleries in the GRI: e.g., series IVA, box 102, folder 4; box 105, folder 10; box 109, folder 11; box 117, folder 6; box 134, folder 9; and box 173, folder 34.
37. MMA, Rousseau Papers, box 33, folder 7, Ilse Fichtmüller to Gerhard Wedekind (31 March 1953); ibid., Lohse to Rousseau (21 March 1953); ibid.,

Radl to Lohse (24 January 1964); ibid., box 26, folder 4, Lohse to Rousseau (13 September 1959); ibid., Lohse to Rousseau (27 September 1959); and ibid., Lohse to Rousseau (23 November 1967).

38. MMA, Rousseau Papers, box 33, folder 7, Lohse to Rousseau (3 December 1952). The German reads, "bei dieser Gelegenheit evtl. auch einige Kunstgegenstände offerieren, die Sie vielleicht interessieren könnten."

39. MMA, Rousseau Papers, box 26, folder 4, Lohse to Rousseau (8 April 1959). The German reads, "etwas wirklich Bedeutendes sehe, werde ich Sie benachrichtigen. Ich nehme sicher an, dass mal etwas für Sie geeignetes dabei sein wird, denn durch mich sind in den letzten Jahren eine ganze Anzahl bedeutender Bilder in amerikanische Museen und Privatsammlungen gelangt."

40. GRI, SC, no. 940109/26, Otto Wittmann, oral history (13 January 1993), 116.

41. Ibid., 116–17. Note that Göring bought another painting, *Die Heilige Katharina*, from Hans Lange in Berlin on 1 March 1943 for RM 45,000. See NARA, M 1944, roll 89, frame 565, Lange receipt (1 March 1943).

42. Rebekah Scott, "When St. Catherine Fell into Nazi Hands," *Blade* (2 May 1999).

43. See the homepage of the Toledo Museum of Art at http://classes.toledomuseum.org:8080/emuseum/view/objects/asitem/search$0040/0/invno-asc ?t:state:flow=3959eb94–1fa7–4ed8–b98e–aaeea491d464 (accessed 1 April 2015).

44. BAR-Bern, E9500.239A#2003/48, Bd. 24, Otto Wittmann, *Art Looting Investigation Unit—Final Mission to Europe (10 June 1946–24 September 1946)* (Washington, DC: War Department, 14 October 1946), 7.

45. Alexandra Coleman (Toledo Museum of Art), email to author (7 April 2015).

46. MMA, Rousseau Papers, box 26, folder 4, Lohse to Rousseau (3 October 1959). The German reads, "ob Sie nach wie vor interessiert sind?"

47. Ibid., Rousseau to Lohse (5 March 1959).

48. Ibid., Rousseau notes (19 December 1953).

49. Ibid., Telegram from Rousseau to Lohse (2 May 1961).

50. Ibid., Rousseau to Nora Ibe (16 December 1953). Ms. Ibe was instructed to pass the information on to Lohse.

51. Ibid., Rousseau to Nora Ibe (16 December 1953).

52. Ibid., box 33, folder 7, Lohse to Rousseau (3 December 1952); and ibid., Ilse Fichtmüller to Gerhard Wedekind (31 March 1953).

53. Ibid., Lohse to Rousseau (3 December 1952).

54. William Daniels, U.S. Department of State, Foreign Service Despatch (8 May 1951); document in archive of author (originally from NARA).

55. Allied Control Authority, *The Central Registry of War Criminals and Security Suspects: Consolidated Wanted Lists* (Uckfield, UK: Naval & Military Press, 2018 [1947]), 261. Lohse is listed as "Dr. Chief-asst. of Rosenbergs [*sic*] Looting-Office," and for the "Reason Wanted" it states "Pillager"; the

document also notes that Lohse was "Wanted By" the UN War Crimes Commission.

56. David Rich, email to author (20 September 2016).

57. MMA, Rousseau Papers, box 33, folder 7, Lohse to Rousseau (21 March 1953).

58. Ibid., box 26, folder 4, Nora Ibe to Rousseau (22 October 1953).

59. Ibid., box 33, folder 7, Ilse Fichtmüller (for Lohse) to Mrs. Gerhard Wedekind (for Rousseau) (31 March 1953).

60. Mary Chaktsiris and Stephanie Bangarth, "If Ye Break Faith—We Shall Not Sleep?" Active History (8 December 2015), http://activehistory.ca /2015/12/if-ye-break-faith-we-shall-not-sleep/.

61. Stephanie Bangarth, email to author (6 September 2019).

62. Raz Segal, *Genocide in the Carpathians: War, Social Breakdown, and Mass Violence, 1914–1945* (Stanford: Stanford University Press, 2016), 65–112, specifically 96.

63. Chaktsiris and Bangarth, "If Ye Break Faith."

64. Stephanie Bangarth, email to author (6 September 2019).

65. ITS Archives, doc. no. 66496120#1, International Refugee Organization Austria, Statistical Card (22 March 1951). Thanks to the staff at the United States Holocaust Memorial Museum for their assistance in finding the documents. Note that Bangarth's name is rendered in these documents as "Stephan" (although he later spelled his name "Stephen").

66. ITS Archives, doc. no. 80905900#2, "Specialist Resettlement Service Individual Record" for Stephan Bangarth (n.d.).

67. Hilary Earl, *The Nuremberg SS-Einsatzgruppen Trial, 1945–1958: Atrocity, Law, and History* (Cambridge: Cambridge University Press, 2009), 153.

68. ITS Archives, doc. no. 66496120#2, "Action Record" (6 March 1951).

69. Stephanie Bangarth, email to author (6 September 2019).

70. ITS Archives, doc. no. 80905900#2, "Specialist Resettlement Service Individual Record" for Stephan Bangarth (n.d.).

71. Ibid.

72. See the Wikipedia entry for Palais Attems, https://de.wikipedia.org/wiki /Palais_Attems (accessed 29 August 2019).

73. GRI, Schaeffer Galleries Records, series IVA, box 104, folder 2. Bangarth corresponded in German with Mrs. H. S. Schaeffer.

74. Ibid., Mrs. H. S. [Kate] Schaeffer to Steve Bangarth (27 June 1951); and ibid., Bangarth to Dr. Hanns Schaeffer (20 June 1951).

75. *Catalogue of Highly Important Paintings by Old Masters and a Drawing by Rembrandt: The Properties of Doctor Stephen Bangarth* [et al.], auction by Christie, Manson & Woods (London: Christie's, 26 June 1964).

76. Ibid., entry for Master of the Holy Blood, *The Master with the Parrot.*

77. MMA, Rousseau Papers, box 26, folder 4, Lohse to Rousseau (15 July 1948).

78. Ibid., Lohse to Rousseau (25 September 1960).

79. See the entry from the Saint Louis Art Museum at http://emuseum.slam.org /objects/350/fowler;ctx=6edb82b5-186d-4dbo-87ca-a7779f38a4dc&idx=o (accessed 31 May 2018).

80. See, among other works, Annie Jacobsen, *Operation Paperclip: The Secret Intelligence Program That Brought Nazi Scientists to America* (New York: Back Bay Books, 2015); and Christopher Simpson, *Blowback: America's Recruitment of Nazis and Its Effects on the Cold War* (New York: Open Road, 1988).

81. MMA, Rousseau Papers, box 33, folder 7, Lohse to Rousseau (25 May 1964). The German reads, "Ich möchte Ihnen nämlich noch gern einige Bilder in Zürich zeigen."

82. Ibid., Lohse to Rousseau (7 April 1964).

83. Ibid., box 13, folder 4; and ibid., box 33, folder 7, Claus Virch to Lohse (4 June 1964).

84. Ibid., box 13, folder 16.

85. Ibid., box 33, folder 7, Lohse to Rousseau (28 December 1962).

86. Ibid., Lohse to Rousseau (n.d.).

87. Ibid., box 26, folder 4, Rousseau notes (19 October 1953).

88. Ibid., Rousseau to Lohse (5 March 1959).

89. MMA, Rousseau Papers, box 33, folder 7, Lohse to Rousseau (7 April 1964).

90. Ibid.

91. Cynthia Saltzman, *Portrait of Dr. Gachet: The Story of a van Gogh Masterpiece* (New York: Viking, 1998).

92. MMA, Rousseau Papers, box 13, folder 22, Rousseau to Lohse (20 October 1969).

93. Ibid., Lohse to Rousseau (13 November 1969).

94. See the Wikipedia entry for "Ante Topic Mimara," https://en.wikipedia .org/wiki/Ante_Topi%C4%87_Mimara (accessed 16 July 2015).

95. Notes on conversation with Bruno Lohse, Munich (21 July 2000).

96. Andrew Decker, "A Legacy of Shame," *ARTnews* (December 1984), 53–76; Konstantin Akinsha, "Ante Topic Mimara: 'The Master Swindler of Yugoslavia,'" *ARTnews* (September 2001), 156; and Iris Lauterbach, *The Central Collecting Point in Munich: A New Beginning for the Restitution and Protection of Art* (Los Angeles: J. Paul Getty Trust, 2018), 149.

97. Städtische Kunstsammlungen der Stadt Augsburg, Haberstock Nachlass, HA/I; and NARA, RG 260, OMGUS, Restitution Research Records, box 446.

98. Interview with Thomas Hoving, New York (22 October 2008). For Hoving's collecting zeal, see Hoving, *King of the Confessors*, 40–41, 47, 292.

99. MMA, Rousseau Papers, box 33, folder 7, Lohse to Rousseau (13 April 1953).

100. Ibid., Rorimer to Plaut (23 July 1957). Lohse was also described as "Deputy Director" of the ERR in the ALIU report authored by James Plaut, *CIR No. 1: Activity of the Einsatzstab Rosenberg in France* (Washington, DC: Strategic Services Unit, 15 August 1945), 2. The United Nations War Crimes

Commission described Lohse in a 1945 indictment as "Assistant Chief" of the ERR. See USHMM, RG 67, 041, reel 1, images 693–96, UN War Crimes Commission, "Charges against German War Criminals" (25 August 1945).

101. Steven Miller, *The Anatomy of a Museum: An Insider's Text* (Hoboken, NJ: Wiley, 2018), 231.

102. Hoving, *Making the Mummies Dance*, 19.

103. Ibid., 18–22.

104. Notes on conversation with Peter Griebert, Munich (7 June 2015).

105. AMAE–La Courneuve, 209SUP, box 583, Rose Valland to the Chef de CRA (20 June 1951). This letter largely concerned Lohse's claim for some insignificant pictures that he argued were wrongfully returned to France, a claim that Faison supported. The French reads, "Lohse a sur lui [Faison] la plus grande influence."

106. MMA, Rousseau Papers, box 33, folder 7, Lohse to Plaut (12 December 1950).

107. Ibid., Lohse to Plaut (25 February 1957).

108. Ibid., Lohse to Rousseau (28 December 1962). The German reads, "Mit vielen herzlichen Grüssen für Sie und unsere dortigen gemeinsamen Bekannten verbliebe ich, Ihr."

109. Ibid., Lohse to Plaut (23 November 1967).

110. Gross, *Rogues' Gallery*, 365.

111. J. E. Smith, ed., *The Papers of General Lucius D. Clay* (Bloomington: Indiana University Press, 1974), 2:615–16, cited by Kenneth Lindsay, "Official Art Seizure under the Military Cloak," *Art, Antiquity and Law* 3/2 (1996), 128.

112. Gross, *Rogues' Gallery*, 203.

113. NARA, RG 59, Lot 62D-4, box 28, Paul Rosenberg to U.S. Treasury Department (12 December 1946).

114. GRI, SC 940109, S. Lane Faison Oral History (October 1992), Richard C. Smith statement, 208.

115. For the Rembrandt, see NARA, RG 260, entry 1, box 84: Karl Emhardt to U.S. High Commissioner for Germany (27 October 1950).

116. Thomas Howe to César Mange de Hauke (9 January 1951), in NARA, RG 260, entry 1, box 76; Polack, *Le Marché de l'Art sous l'Occupation*, 222.

117. MMA, Rousseau Papers, box 33, folder 7, Lohse to Plaut (25 February 1957).

Chapter Seven. War Stories, War Secrets

1. Gerald Posner, *Hitler's Children* (New York: Berkeley Books, 1991), 218–31.

2. NARA, RG 260, OMGUS, Ardelia Hall Collection, box 270, S. Lane Faison to Eberhard Hanfstaengl (11 June 1951).

3. IfZG, OMGUS records, 17/57-3/1, Colonel B. C. Andrus to Commanding General Headquarters Command (12 January 1946).

4. BArch-Koblenz, B 323, boxes 514–16, "Ansprüche Bayerns aus der 'Sammlung Göring' gemäss KRD 50" (1948–62).

5. Philippe Sprang, "Dans les ténèbres du docteur Lohse," *L'Oeil* 630 (December 2010), 25–33.

6. Richard Sandomir, "Gudrun Burwitz, Daughter and Defender of Heinrich Himmler, Is Dead at 88," *New York Times* (9 July 2018); and Christine Toomey, "Grief Encounter," *Times* (London) (14 November 2004). See, more generally, Oliver Schrom and Andrea Ropke, *Stille Hilfe für braune Kameraden. Das geheime Netzwerk der Alt-und Neonazis* (Berlin: Ch. Links Verlag, 2002); and Norbert Lebert and Stephen Lebert, *My Father's Keeper: Children of Nazi Leaders—A History of Damage and Denial* (London: Little, Brown, 2001).

7. Kate Connolly, "Haider Embraces SS Veterans," *Guardian* (2 October 2000). Note that not all of the two thousand were former SS members: most others were in the Wehrmacht or were sympathizers.

8. Ibid. See, more generally, Deborah Lipstadt, *Denying the Holocaust: The Growing Assault on Truth and Memory* (New York: Free Press, 1993); Deborah Lipstadt, *History on Trial: My Day in Court with David Irving* (New York: HarperCollins, 2005); and Richard Evans, *Lying about Hitler: History, Holocaust, and the David Irving Trial* (New York: Basic Books, 2002).

9. David Clay Large, "Reckoning with the Past: The HIAG of the Waffen SS and the Politics of Rehabilitation in the Bonn Republic," *Journal of Modern History* 59 (March 1987), 81–83. Large notes that the HIAG "at its peak embraced only about 20,000 of the roughly 500,000 Waffen-SS survivors."

10. Lohse Papers (archive of author), "Geldquellen der neofaschistischen Parteien: Abschrift" (n.d.).

11. See the Wikipedia entry for Otto-Ernst Remer, http://en.wikipedia.org /wiki/Otto_Ernst_Remer (accessed 12 May 2015).

12. NARA, RG 239, M 1944, roll 90, frame 507, "Memorandum from War Room re Information Obtained by Interrogation of Schellenberg," "Memorandum of 26.7.45—Alois Miedl" (26 July 1945).

13. Gerald Aalders, *Nazi Looting: The Plunder of Dutch Jewry during the Second World War* (Oxford: Berg, 2004), 75–77; and Floris Kunert and Annemarie Marck, "The Dutch Art Market 1930-1945 and Dutch Restitution Policy regarding Art Dealers," in Eva Blimlinger and Monika Mayer, eds., *Kunst sammeln, Kunst handeln. Beiträge des Internationalen Symposiums in Wien* (Vienna: Böhlau, 2012), 133–53.

14. NIOD, Aalders Collection, L.3349, E. E. Minskoff, "Interrogation of Walter Andreas Hofer" (12 December 1945), 7. For primary documents on Goudstikker, see BArch-Koblenz, B 323, boxes 455–64.

15. BAR-Bern, J1.269-01, 1999/82#47*, Walter Andreas Hofer Abhörungsprotokoll (3 May 1949); and Nancy Yeide, *Beyond the Dreams of Avarice: The Hermann Goering Collection* (Dallas: Laurel, 2009), 13.

16. BAR-Bern, Dossier E2200.49-02#1970/55#203*, "Activities of Aloys [*sic*] Miedl, Art Agent" (26 September 1944); and Aalders, *Nazi Looting*, 75–77.

17. BAR-Bern, Dossier E2200.49-02#1970/55#203*, "Activities of Aloys [*sic*] Miedl, Art Agent" (26 September 1944).

18. Theodore Rousseau, *CIR No. 2: The Goering Collection* (Washington, DC: Office of Strategic Services, 15 September 1945), 150.

19. Ibid.

20. Wikipedia entry on Alois Miedl, https://en.wikipedia.org/wiki/Alois _Miedl (accessed 17 August 2016); and Nils Fiebig, *Alois Miedl. Der Bankier und die Raubkunst: Geschäfte im Schatten der Macht* (Würzburg: Königshausen und Neumann, 2020).

21. Anne Rothfeld, "Unscrupulous Opportunists: Second-Rate German Art Dealers as Nazi Functionaries during World War II" (PhD diss., American University, 2016), 145, 158, 162.

22. Aalders, *Nazi Looting*, 75–77. See also the website at the University of Geneva titled "Arthemis—200 Paintings—Goudstikker Heirs and the Netherlands" (2012), https://plone.unige.ch/art-adr/cases-affaires/200-paintings-2013 -goudstikker-heirs-and-the-netherlands.

23. Aalders, *Nazi Looting*, 76; Yeide, *Beyond the Dreams of Avarice*, 13; and *Marei von Saher v. Norton Simon Museum of Art at Pasadena*, U.S. Court of Appeals, Ninth Circuit (754 F.3d 712), no. 12-55733 (6 June 2014).

24. NARA, RG 239, Z 169, frames 708-10, "Lists of Clients in Germany to Whom Miedl (Firma Goudstikker N.V.) Offered Pictures and Other Works of Art 1941–43" (n.d.).

25. Rothfeld, "Unscrupulous Opportunists," 161.

26. Pieter den Hollander, *De zaak Goudstikker* (Amsterdam: Meulenhoff, 1998); and Alan Riding, "Göring, Rembrandt, and the Little Black Book," *New York Times* (26 March 2006).

27. For more on Dutch restitution policy, see Kunert and Marck, "Dutch Art Market 1930–1945 and Dutch Restitution Policy regarding Art Dealers"; and Nicholas O'Donnell, *A Tragic Fate: Law and Ethics in the Battle over Nazi Looted Art* (Chicago: American Bar Association, 2017), 122–44.

28. James Plaut, *DIR No. 6: Dr. Bruno Lohse* (Washington, DC: Strategic Services Unit, 15 August 1945), 8.

29. Edward Dolnick, *The Forger's Spell: The True Story of Vermeer, the Nazis, and the Greatest Art Hoax of the Twentieth Century* (New York: Harper, 2008), 84; and Jonathan Lopez, *The Man Who Made Vermeers: Unvarnishing the Legend of Master Forger Han van Meegeren* (New York: Houghton Mifflin Harcourt, 2008), 126, 158.

30. NARA, RG 226, entry 19, box 31, U.S. Embassy in London, enclosure no. 1 to despatch no. 19,750 (8 December 1944).

31. Wikipedia entry on Miedl, https://en.wikipedia.org/wiki/Alois_Miedl (accessed 17 August 2016).

32. Rothfeld, "Unscrupulous Opportunists," 168.

33. NARA, RG 239, entry 73, box 39, Foreign Economic Administration, Enemy Branch, "Looted Art in Occupied Territories, Neutral Countries, and Latin America: Preliminary Report" (5 May 1945), 20–30.

34. NARA, RG 226, entry 19, box 327, W. Walton Butterworth to U.S. Secretary of State (31 May 1945). See the records of the PCHA, http://clinton .presidentiallibraries.us/files/original/d8cd1724341e9ddea5c417069bc67 7f0.pdf (accessed 7 August 2015).

35. Grace Lichtenstein, "Theodore Rousseau Dies at 61: Vice-Director of Met Museum," *New York Times* (2 January 1974).

36. Rothfeld, "Unscrupulous Opportunists," 178–80.

37. Ibid., 180.

38. Rothfeld, "Unscrupulous Opportunists," 163–64; and Thomas Buomberger, *Raubkunst-Kunstraub. Die Schweiz und der Handel mit gestohlenen Kulturgütern zur Zeit des Zweiten Weltkrieges* (Zurich: Orell Füssli, 1998), 157. See also NARA, RG 84, American Legation Bern, Economic Section, Safehaven Subject Files, 1942–1949, box 8, "Looted Works of Art from Collections of Allied Nationals Discovered in Switzerland" (n.d.).

39. NARA, RG 260, box 114, F.S.E. Baudouin, Belgian Representative to Central Collecting Point Munich to Herbert Leonard, Chief, MFAA Section (5 August 1948). See also Peter Harclerode and Brendan Pittaway, *The Lost Masters: The Looting of Europe's Treasurehouses* (London: Orion, 1999), 148–54.

40. NARA, RG 260, OMGUS, Restitution Research Records, box 446, Testimony of Karl Haberstock (12 June 1945).

41. NARA, M 1944, roll 90, frame 507, "Memorandum from War Room re Information Obtained by Interrogation of Schellenberg," "Memorandum of 26.7.45—Alois Miedl" (17 August 1945).

42. BAR-Bern, Translation of article, "Dutch Art Sold during the War under Pressure?" *Het Parol* (Amsterdam) (3 September 1949).

43. Kia Vahland, "Vom bunten, braunen Leben," *Süddeutsche Zeitung* (4/5 March 2017), 13.

44. Notes on conversation with Peter Griebert, Munich (7 June 2015).

45. S. Lane Faison, interview with author, Williamstown, MA (28 December 1999); Yeide, *Beyond the Dreams of Avarice*, 2.

46. Notes on conversation with Dr. Bruno Lohse, Munich (21 July 2000).

47. Ibid.

48. Information provided to author by Volkmar Kabisch and Antonius Kempmann, telephone interview (9 April 2018).

49. BAR-Bern, E2801#1968/84#284*, "Extract from Letter Addressed by Hans Wendland to His Wife" (n.d.).

50. BAR-Bern, E2801#1968/84#284*, "Extract from Letter Addressed by Hans Wendland to Bührle" (n.d.).

51. BAR-Bern, E 2001E#1000/1571, Bd. 127, Marcel Malige to Reinhard Hohl (9 January 1946).

52. BAR-Bern, E2801#1968/84#284*, Daniel Reagan to Joint Commission, Bern (11 October 1946); and more generally about Wendland, ibid., E 2001E#1000/1571, Bd. 127, anonymous, "Memorandum: Wendland and Looted Art" (24 January 1946).

53. BAR-Bern, E 61000A-24#1000/1924, Bd. 10, Alexandre Sieben to Dr. Wyss (7 July 1949).

54. Billy Price, *Adolf Hitler: The Unknown Artist* (Houston: Billy F. Price, 1984), 254, listed as "N. 387.1, *The Royal Opera in Munich*, 1914 watercolor, 25.9 x 33.4, sig. l.l. 'A. Hitler.'" The painting was photographed by the Central Archives in 1939. See also Enzo Colotti, *Water Colours of Hitler: Recovered Art Works* (Florence: Fratelli Alinari, 1984); Otto Karl Werckmeister, "Hitler the Artist," *Critical Inquiry* 23 (Winter 1997); and Charles E. Snyder Jr., "The Real Deal—Adolf Hitler Original Artworks," *Military Trader* (September 1998).

55. See the homepage of the DHM at http://www.dhm.de/datenbank/dhm.php ?seite=5&fld_o=20035764 and http://www.dhm.de/datenbank/dhm.php ?seite=5&fld_o=20035765 (accessed 6 January 2018).

56. DHM, curatorial file on Dürer-workshop "*Kaiserbilder*," Dr. Sven Lüken, "Zwei Kaiserbilder aus Zürcher Privatbesitz" (September 2003). See also the excellent report by Dr. Sabine Beneke, "Bruno Lohse und die Kaiserbilder Abrecht Dürers im Deutschen Historischen Museum. Eine Spurensuche," DHM (2018), https://www.dhm.de/fileadmin/medien/relaunch /sammlung-und-forschung/Provenienzforschung/Beneke_Lohse.pdf.

57. Susanne Leinemann, "Die Dürer-Bilder, der Nazi und der Jude," *Berliner Morgenpost* (28 November 2017). The German reads, "aufregende Überaschung."

58. Dr. Sabine Beneke, email to author (22 June 2015).

59. Lynn Nicholas, *The Rape of Europa: The Fate of Europe's Treasures in the Third Reich and the Second World War* (New York: Knopf, 1994), 108–9. Nicholas adds, "[Nathan] Katz's mother was released from the Dutch concentration camp Westerbork in exchange for a picture which a high SS official wanted to give Hitler for his birthday."

60. Ibid.; Lauren Comiteau, "Nazi World War Art Claim Made," *Time* (1 October 2007); and Marlise Simons, "Heirs Make Huge Claim over Dutch Works of Art," *New York Times* (26 September 2007).

61. Leinemann, "Die Dürer-Bilder, der Nazi und der Jude."

62. DHM, curatorial file on Dürer-workshop "*Kaiserbilder*," Heinrich Zimmermann to Lohse (1 November 1955).

63. Leinemann, "Die Dürer-Bilder, der Nazi und der Jude."

64. Dr. Sabine Beneke, email to author (22 June 2015); and Dr. Brigette Reineke, email to author (13 October 2015).

65. DHM, curatorial file on Dürer-workshop "*Kaiserbilder*," Dr. Jochen Sander to Prof. Hans Ottomeyer (21 March 2003).

66. Ibid., Peter Griebert to Prof. Hans Ottomeyer (12 December 2002).

67. I am indebted to Willi Korte for the information that Griebert identified Heinz Kisters as the source of the pictures: email to author (26 January 2018). Korte has information that Hans Ottomeyer "was told by Peter Griebert that the paintings belonged to the collection of Heinz Kisters ('Schweizer Familienstiftung') which had been brought to Switzerland." Kisters helped Chancellor Adenauer build a collection and was well known in the Federal Republic: see Stefan Koldehoff, "Der Mann, der Adenauer betrog," *Die Welt* (23 January 2011), https://www.welt.de/print/wams/kultur /article12304185/Der-Mann-der-Adenauer-betrog.html.

68. Royalis Auktionen had an address at Werdenberger Weg 3 in Vaduz. Griebert used a Zurich firm called Spedition Welti-Furrer to transport the pictures.

69. Notes on conversation with Peter Griebert, Munich (7 June 2015).

70. Notes on interview with Andrew Baker, Triesen, Liechtenstein (27 June 2018).

71. For the exhibition *Kennerschaft und Kunstraub. Max J. Friedländer, Bruno Lohse und die Kaiserbildnisse Albrecht Dürers*, which ran from 24 November 2017 to 26 February 2018, see the homepage of the DHM, https://www .dhm.de/ausstellungen/dauerausstellung/kennerschaft-und-kunstraub .html (accessed 6 January 2018).

72. Leinemann, "Die Dürer-Bilder, der Nazi und der Jude." The German reads, "Ein Krimi, complex und schwierig." See also Nicola Kuhn, "Ein Dürer-Krimi im Depot," *Tagesspiegel* (12 December 2017).

73. MMA, Rousseau Papers, box 26, folder 4, Lohse to Rousseau (8 April 1959).

74. Hubert von Sonnenburg returned to the Met in 1991 as chief curator after a short term at the Bavarian State Painting Collections. See his obituary by Carol Vogel, "Hubert von Sonnenburg, a Leading Conservator of Paintings," *New York Times* (24 July 2006).

75. Information provided to author by Volkmar Kabisch and Antonius Kempmann, telephone interview (9 April 2018).

76. Gerda Panofsky, "Addenda et Corrigenda zu: Erwin Panofsky, Korrespondenz 1910 bis 1968. Eine kommentierte Auswahl in fünf Bänden," *Kunsttexte.de* (April 2011), 5–8.

77. Ibid., 6–7.

78. Ibid. The German reads, "unangemeldet, scheinbar zufällig."

79. Ibid. The German reads, "in sein Luxushotel am Central Park in New York zu senden."

80. Ibid. The German reads, "Ich zog Erkundigen ein und erfuhr, dass Lohse nicht nur Kunsthistoriker (wie er sich vorgestellt hatte), sondern auch Kunsthändler war, hauptsächlich auf dem Schweizer Markt."

81. Ibid.

82. Heinrich Theodor Musper, *Dürers Kaiserbildnisse* (Cologne: DuMont Schauberg, 1969).

83. Panofsky, "Addenda," 6. The German reads, "Ihr Trumpf war die Expertise

Max J. Friedländer (1867–1958) der besagte Tafeln inspiziert und für echte Mesterwerke Dürers gehalten hatte."

84. Lohse Papers, Heinrich Theodor Musper to Lohse (17 April 1970).

Chapter Eight. Restitution

1. The work is from the so-called fourth series. See picture 1492 in Wildenstein Institute, Joachim Pissarro, and Claire Durand-Ruel Snollaerts, *Pissarro: Critical Catalogue of Paintings* (Milan: Skira Editore, 2005), 3:903.

2. Walter Feilchenfeldt, Christie's press release (15 October 2009).

3. See James McAuley, *The House of Fragile Things: A History of Jewish Art Collectors in France, 1870–1945* (New Haven: Yale University Press, 2020).

4. Jan-Pieter Barbian, "Die Macht des Kleingedruckten," *Süddeutsche Zeitung* (18 October 2016).

5. Gottfried Bermann Fischer, *Bedroht—Bewahrt* (Frankfurt: Fischer, 1967), and a later version of his autobiography, *Wanderer durch ein Jahrhundert* (Frankfurt: Fischer, 1994). More generally, see Fritz Rebhahn, *Die Braune Jahre: Wien 1938–1945* (Vienna: Edition Atelier, 1995); and Bruce Pauley, *From Prejudice to Persecution: A History of Austrian Anti-Semitism* (Chapel Hill: University of North Carolina Press, 1992).

6. See obituary for Gottfried Bermann Fischer (1897–1995), *Independent* (27 September 1995).

7. See the reviews of *Torn Curtain*, Rotten Tomatoes, http://www.rotten tomatoes.com/celebrity/gisela_fischer/ and her biography on the IMDB website at https://www.imdb.com/name/nm0278920/bio?ref_=nm_ov_bio _sm (accessed 10 January 2020).

8. See the Dorotheum auction catalogue, *Gemälde Alter und Neuerer Meister, Katalog Nr. 459* (20–21 May 1940), object number 339, http://digi.ub.uni -heidelberg.de/diglit/dorotheum1940_05_20/0032?sid=c7ae5c443602f023c 6808e23dd5c6942.

9. Stefan Koldehoff, *Die Bilder sind unter uns. Das Geschäft mit der NS-Raubkunst und der Fall Gurlitt* (Berlin: Galiani, 2014 [2009]), 133. See, more generally, Caroline Flick, "Geschick im System. Der Kunsthändler Hans W. Lange," in *Text zum Kunsthandel, 1933–1945* (November 2011), http://carolineflick.de/aufsaetze/geschick/.

10. Melissa Müller and Monika Tatzkow, *Verlorene Bilder, Verlorene Leben. Jüdische Sammler und was aus ihren Kunstwerken wurde* (Munich: Elisabeth Sandmann, 2009), 10–27.

11. NARA, M 1947, roll 42, "Four Paintings Stolen by the Nazis: Property of Gottfried Bermann Fischer" (n.d.).

12. Ibid., Adolf Wüster to Mrs. B. B. Fischer (25 March 1950).

13. PCHA Records, 119952, Thomas Howe to Ardelia Hall (15 February 1951). A copy of the letter is in the Archives of American Art, S. Lane Faison Papers.

14. Christoph Michaud, "Christie's Stages Record Art Sale," Reuters (9 November 2006).
15. William Heuslein, "Klimt-astic Deal," *Forbes* (24 July 2006), 56.
16. See, more generally, Anne Marie O'Connor, *The Lady in Gold: The Extraordinary Tale of Gustav Klimt's Masterpiece* (New York: Knopf, 2012).
17. The letter concerning the Pissarro is in archive of author, Frédéric Schöni to Bruno Lohse (2 July 1957).
18. Cynthia Saltzman, *Old Masters, New World: America's Raid on Europe's Great Pictures, 1880–World War I* (New York: Viking, 2009), 222.
19. Notes on conversation with Walter Feilchenfeldt, Zurich (29 June 2018). Feilchenfeldt later attempted to profit from the sale of the Pissarro, approaching members of the Fischer family asking them to sign a "commission agreement." This branch of the Fischer family declined his offer, but later on, Feilchenfeldt wrote the entry for the Pissarro in the Christie's catalogue when it was offered at auction. Notes on conversation with Itai Shoffman, New York (13 February 2017). Shoffman, the son of Monika (Fischer) Shoffman-Graves, provided the author with a copy of the unsigned commission agreement.
20. Notes on conversation with Gisela Fischer, Zurich (24 January 2007).
21. Ibid.
22. Archive of author, Frédéric Schöni to Bruno Lohse (2 July 1957).
23. Notes on conversation with Milly Sele-Vogt, Vaduz (12 March 2007).
24. Hugo Macgregor interview with Maurice Philip Remy for the documentary film based on *Göring's Man in Paris* Munich (11 March 2017).
25. Notes on conversation with Thomas Hoving, New York (22 October 2008).
26. NARA, M 1947, roll 42, Adolf Wüster to Bridgette B. Fischer (1 May 1950).
27. Archive of author, Gisela Fischer to Peter Griebert (1 February 2007); and Norbert Kückelmann and Gisela Fischer to Peter Griebert (7 February 2007).
28. NARA, RG 84, American Legation, Bern, Economic Section, Safehaven Subject Files, box 8, "The Currie Agreement" (8 March 1945).
29. Conal Walsh, "Trouble in Banking Paradise as Uncle Sam's Sheriffs Ride In," *Guardian* (26 October 2002).
30. *Anstalt* has been defined as "a hybrid between a company limited by shares and a foundation"; an Anstalt "can conduct all kinds of business activities." It is also sometimes translated as "institution" or "establishment." See the Wikipedia entry, https://en.wikipedia.org/wiki/Anstalt (accessed 22 April 2020).
31. Sele-Vogt had an office at Joseph Rheinsbergerstrasse 29 in Vaduz and the second house nearby at Föhrenweg 2, which she lived in with her husband. Sele-Vogt is listed as having businesses at both properties: there are 108 *Gesellschäften* listed under the first property and 5 under the second. See the information at Betriebsprucfcr, http://www.betriebspruefer.at/index.php?option=com_content&task=view&id=1277&Itemid=353 (accessed 6 June 2018).

32. Andrew Baker, paraphrased in Rod Dozorv and Victor L. "Liechtenstein Trustee Andrew Baker Accused of Fraud" (1 June 2018), http://legallyblind.us/andrewbaker.fradud.laundering.news.060110.html.

33. "Liechtenstein Trustee Andrew Baker Accused of Fraud, Money Laundering in U.S. Courts: Gudavadze Link Seen," *FrontierNews* (1 June 2010), http://www.gudavadze.com/news.baker.fraud.gudavadze060610.html.

34. Ibid. See the Offshore Leaks Database at https://offshoreleaks.icij.org/search?utf8=%E2%9C%93&q=Miselva&e=&commit=Search (accessed 10 August 2020).

35. Nicholas Confessore, "Sea of Money," *New York Times Magazine* (4 December 2016), 31–67.

36. Notes on conversation with Milly Sele-Vogt, Vaduz (12 March 2007). For evidence of Schöni's involvement in a legal dispute, see "Zurich Bank Fights Suit," *New York Times* (13 May 1972), 43.

37. See the Wikipedia entry for "Anstalt."

38. Notes on conversation Andrew Baker, Triesen, Liechtenstein (5 June 2015).

39. Frédéric Schöni, "Todesanzeige," *Neue Zürcher Zeitung* (25 October 1981). Schöni, according to records in the Zurich Staatsarchiv, was married "at least twice": to Elly Angela Völlmin in 1937 and then later to Ghizella [*sic*] Schöni-Balint of Zollikon (a town on Lake Zurich). Staatsarchiv des Kantons Zürich (Martin Leonhard), email to author (31 August 2015). Schöni lived at Brandisstrasse 52 in Zollikon in a substantial but not exceptional house overlooking the lake. Note that Schöni moved from the Pelikanstrasse 2 address that he occupied in 1932 to Bahnhofstrasse 55 in 1961 to Färbergasse 8 in 1971. There is also a Barbara Schöni-Balint mentioned in his Todesanzeige who appears to be his wife. This may be a third spouse. The Zurich zoo inherited 378,000 Swiss francs from Barbara Schöni-Balint's estate in 2005, so she passed away quite well off financially.

40. Daniel Wildenstein, *Monet: Catalogue Raisonné* (Paris: Wildenstein Institute/Taschen, 1997), 2:215–16; and Daniel Wildenstein, *Claude Monet* (Paris: Wildenstein, 1971), 46.

41. Wildenstein, *Monet: Catalogue Raisonné*, 2:215–16.

42. Fondation de l'Hermitage, *L'Impressionisme dans les Collections Romandes* (Lausanne: Fondation de l'Hermitage, 1984), 160, 168–69.

43. Notes on conversation with Peter Griebert, Munich (17 October 2016).

44. Cnaan Liphshiz, "'Menten Affair': How Dutch Journalist Brought Down Nazi War Criminal," *Jewish News of Northern California* (24 February 2017), http://www.jweekly.com/2017/02/24/menten-affair-how-dutch-journalist-brought-down-nazi-war-criminal/ (accessed 21 July 2017).

45. Leo Müller, "Görings Kunstagenten im ZKB-Safe," *CASH* (10 May 2007); Tobias Timm, "Beraubt und betrogen," *Die Zeit* (6 June 2007); and Stefan Koldehoff, "Pissarro Lost and Found," *ARTnews* (Summer 2007).

46. Müller, "Görings Kunstagenten im ZKB-Safe."

47. Notes on conversation Andrew Baker, Triesen, Liechtenstein (5 June 2015). For the communal vaults, see Susan Ronald, *Hitler's Art Thief: Hildebrand Gurlitt, the Nazis, and the Looting of Europe's Cultural Treasures* (New York: St. Martin's, 2015), 2–3.

48. Koldehoff, *Die Bilder sind unter uns*, 137.

49. Ibid., 136, 138.

50. Notes on conversation with Walter Feilchenfeldt, Zurich (29 June 2018).

51. See ThoughtCo, http://arthistory.about.com/od/klim1/a/blochbauerklimt .htm (accessed 13 April 2015).

52. "Raubkunst-Jäger will Geld: Entdecker von Pissarro-Gemälde klagt auf Honorar," *Münchner Merkur* (7 February 2012). See also Christie's sales catalogue, https://www.christies.com/lotfinder/Lot/camille-pissarro-1830 -1903-le-quai-malaquais-5258536-details.aspx (accessed 24 May 2018).

53. "Raubkunst-Jäger will Geld."

54. Ibid.

55. Kückelmann maintained that he had an agreement with her that stipulated a payment to him of at least 200,000 euros, but that he had thus far received only 40,000 euros. In late April 2012, a judge at the Oberlandesgericht München ruled that Kückelmann was due an additional 55,000 euros. See "Raubkunst-Jäger will Geld"; and "München: Mehr Honorar für Spür-sinn," *Süddeutsche Zeitung* (1 March 2012).

56. "München: Mehr Honorar für Spürsinn."

57. In February 2008, the law firm O'Melveny and Myers released the results of their investigation. They determined that I had "adhered to applicable contractual and legal obligations in attempting to arrange the return of the painting" and that "the account of [my] actions was accurate." These find-ings were conveyed in a letter from the dean of the faculty, Gregory Hess (7 March 2008).

58. Mike Boehm, "Professor Ensnared in Case of Pissarro Looted by Nazis," *Los Angeles Times* (15 April 2008).

59. Ibid.

60. Notes on conversation with Prof. Dr. Claus Grimm, Munich (24 September 2014).

61. Archive of author, Dr. Lutz to Peter Griebert (18 March 2010).

62. Tina Naber, notes on interview with Klaus Nowitzki (22 November 2017).

63. Berel Lang, "Two Ethical Issues," in Jonathan Petropoulos, Lynn Rapa-port, and John Roth, eds., *Lessons and Legacies IX* (Evanston, IL: North-western University Press, 2010), 319–20.

Chapter Nine. Bruno Lohse and the Wildensteins

1. Alan Riding, "Mighty and Secretive Art Dynasty Goes Public to Rebut," *New York Times* (20 April 1998). Note that Hector Feliciano's book *The Lost*

Museum, which appeared in French in 1995, also contributed to the debate about the Wildensteins.

2. These documents are now at the Clinton Presidential Library in Little Rock, AR. See also Presidential Advisory Commission on Holocaust Assets in the United States, *Plunder and Restitution: The U.S. and Holocaust Victims' Assets* (Washington, DC: U.S. Government Printing Office, 2000).

3. NARA, RG 59, Lot 62D-4, OMGUS, Ardelia Hall Collection, box 9, Notes of Ardelia Hall (25 January 1954). Ardelia Hall, the Arts and Monuments adviser at the U.S. Department of State, compiled a list of over a hundred works imported to the United States by the Wildensteins between 1949 and 1954, most coming from Switzerland and many involving Schöni. For Schöni importing other art objects for the Wildensteins, see, for example, ibid., Frederich Schöni, "Consular Invoice of Merchandise" (15 November 1949) (concerning three enamels and a reliquary).

4. NARA, RG 59, Lot 62D-4, OMGUS, Ardelia Hall Collection, box 9, Invoice of Merchandise (15 November 1949).

5. Suzanna Andrews, "Bitter Spoils," *Vanity Fair* (March 1998), 240.

6. Jerry Patterson, "Wildenstein & Co.: Crossing into Its Second Century," *ARTnews* (March 1978), 94.

7. Andrews, "Bitter Spoils," 240.

8. James Tarmy and Vernon Silver, "The Ugly Battle over the Wildenstein Art Empire," *Bloomberg Businessweek* (11 July 2016).

9. Andrews, "Bitter Spoils"; and George Rush, "Jocelyne's Revenge," *Vanity Fair* (March 1998), 244–45.

10. Doreen Carvajal and Carol Vogel, "Ignorance Is Defense in a Case of Lost Art," *New York Times* (20 July 2011); Doreen Carvajal, "Prominent French Families Battle over a Missing Monet," *New York Times* (20 March 2012); and Kim Willsher, "Dark Clouds Hover over the Family Business," *Los Angeles Times* (20 February 2011), E2.

11. Kelly Crow, "For Charity, Gallery Plays Museum," *Wall Street Journal* (25 May 2007), W2.

12. Willsher, "Dark Clouds Hover over the Family Business," E2.

13. See the Wildenstein homepage at http://www.wildenstein.com/about/ (accessed 10 January 2020).

14. Daniel Wildenstein and Yves Stavridès, *Marchands d'Art* (Paris: Plon, 1999).

15. Claude Dumont-Beghi, *L'Affaire Wildenstein: Histoire d'une Spoliation* (Paris: L'Archipel, 2012).

16. Andrews, "Bitter Spoils," 240. See also Jonathan Napack, "The Wildensteins," *Spy* (October 1991), 61–68; and Eric Konigsberg, "What Money Can't Buy," *New York* (15 December 1997), 30–116.

17. Andrews, "Bitter Spoils," 254.

18. Vladimir Visson, *Fair Warning: Memoirs of a New York Art Dealer* (Tenafly,

NJ: Hermitage: 1986), 98. Visson was an employee of the Wildensteins, the "director of exhibitions" for more than three decades until 1974.

19. Nathan Wildenstein bought the Château de Marienthal in 1915, "one of the largest private houses in Paris." See Tarmy and Silver, "Ugly Battle."

20. Yves Stavridès, email to author (31 July 2016). Stavridès notes that after the death of Monsieur Georges and the transfer of the business to New York, the 57 rue la Boétie property ceased to be a formal art gallery and instead housed the Wildenstein Institute. But he adds, "And it was also a place where big clients went to see the legend (DW) [Daniel Wildenstein] before buying. For instance, Steve Wynn, the almost blind man who was running the Mirage at Las Vegas, came to see Daniel and talk with him before or after buying a painting in New York."

21. Visson, *Fair Warning*, 98.

22. Ibid., 98–99.

23. Ibid., 98.

24. Ibid.

25. Ibid., 100.

26. Ibid., 101. The Wildensteins and Paul Rosenberg were key dealers for Picasso before World War II.

27. Ibid., 104.

28. Andrews, "Bitter Spoils," 252–53.

29. Visson, *Fair Warning*, 101. The Écurie Wildenstein handles the family's racing interests.

30. Andrews, "Bitter Spoils," 254.

31. Bonnie Barrett Stretch, "Buy Boldly, Sell Slowly," *ARTnews* (October 1991), 90.

32. See the obituary for Alec Wildenstein, *Independent* (22 February 2008), http://www.independent.co.uk/news/obituaries/alec-wildenstein art dealer-and -racehorse-owner-who-divorced-in-a-blaze-of-publicity-785555.html.

33. Patterson, "Wildenstein & Co.," 94.

34. Barrett Stretch, "Buy Boldly, Sell Slowly," 90.

35. Andrews, "Bitter Spoils," 251.

36. The New Jersey collector is Jeffrey Eger: he operates an online business selling catalogues at http://jegercatalogues.com/ (accessed 27 July 2018).

37. Andrews, "Bitter Spoils," 252.

38. Ibid.

39. Visson, *Fair Warning*, 101.

40. Tarmy and Silver, "Ugly Battle."

41. GRI, SC, no. 940109/26, Otto Wittmann, oral history (13 January 1993), 119.

42. Andrews, "Bitter Spoils," 254.

43. Ibid.

44. Visson, *Fair Warning*, 102; and Andrews, "Bitter Spoils," 252–53.

45. Visson, *Fair Warning*, 103.
46. "Georges Wildenstein," *Le Figaro* (12 June 1963).
47. Alan Riding, "Art Dealers Combat Rumors of Nazi Links," *New York Times* (10 May 1999); and Vincent Noce, "Une Trouble Histoire de l'Art. L'Historien Feliciano Accuse le Marchand Wildenstein de Collaboration," *Libération* (13 May 1999).
48. Hector Feliciano, *Lost Museum: The Nazi Conspiracy to Steal the World's Greatest Works of Art* (New York: Basic Books, 1997), 61.
49. Alan Riding, "French Close Case on Art Dealer and Nazis," *New York Times* (11 October 2003). See also Claude Dumont-Beghi, *L'Affaire Wildenstein* (Paris: L'Archipel, 2012), 189–99.
50. Riding, "French Close Case on Art Dealer and Nazis."
51. Ibid.
52. Riding, "Art Dealers Combat Rumors of Nazi Links."
53. Felicia Lee, "Wildensteins Sued over Looted Art," *New York Times* (28 July 1999).
54. Visson, *Fair Warning*, 98. See also Andrews, "Bitter Spoils," 240.
55. Visson, *Fair Warning*, 99.
56. Michael Wise, "The Wildensteins—at Least for Now—Get Their Mansion Back," *ARTnews* (March 2015), 38–40.
57. Notes on conversation with Bruno Lohse, Munich (27 July 2002).
58. Bundesarchiv Koblenz, B 323/273 and 773 (the Kann collection); B 323/702 and 703 (Munich property cards), B 323/304 (ERR shipping records), and B 323/306, an ERR report titled "Such-und Verlusteliste Nr. 3" (15 December 1943). See also James S. Plaut, *CIR No. 1: Activity of the Einsatzstab Rosenberg in France* (Washington, DC: Strategic Services Unit, 15 August 1945), 17, 20.
59. Archives Nationales, AJ 40/1099, Devisenschutzkommando files.
60. Archive of author, "Concordance of the Inventory of Art Property Confiscated in Late October 1940 in the Vault of Georges Wildenstein at the Banque de France in Paris." This was not the full extent of the family's losses. Elisabeth Wildenstein, for example, a sister of family patriarch Georges Wildenstein, had thirteen pictures in the Westminster Bank in Paris, works by Boucher, Vernet, and Watteau de Lille (that is, eighteenth-century French art), that went to the ERR. Archives Nationales, AJ 40/1099, DSK Rennes to DSK Paris (9 April 1941).
61. Supreme Court of the State of New York, "Decision/Order," in *Francis Warin v. Wildenstein* (Index No. 115143/99), Barbara Kapnick (23 June 2006).
62. Ralph Blumenthal, "Panel on Nazi Art Theft Short, Experts Say," *New York Times* (3 March 2003).
63. Ibid. These allegations were repeated in Marilyn Henry, "Mixed Notices," *ARTnews* (May 2003), 53.
64. Henry, "Mixed Notices," 53.

65. Andrews, "Bitter Spoils," 250; and Alan Riding, "Collector's Family Tries to Illuminate the Past of Manuscripts in France," *New York Times* (3 September 1997); and Riding, "Mighty and Secretive Art Dynasty Goes Public to Rebut."

66. Andrews, "Bitter Spoils," 242.

67. Ibid., 242, 250.

68. Christopher Wright, *The Art of the Forger* (London: Gordon Fraser, 1984).

69. Grace Glueck, "National Gallery Buys a French Masterwork," *New York Times* (26 September 1974); and Alan Riding, "Daniel Wildenstein, 84, Head of Art-World Dynasty, Dies," *New York Times* (26 October 2001).

70. Ute Haug, "'Sucht ständig zu kaufen'—Karl Haberstock und die deutschen Kunstmuseen," in Horst Kessler, ed., *Karl Haberstock. Umstrittener Kunsthändler und Mäzen* (Munich: Deutscher Kunstverlag, 2008), 50, 284.

71. Kessler, *Karl Haberstock*, 271, 283–84. According to German art historian Andreas Hüneke—the leading expert on the "degenerate" art purges and sales—"a painting by Paul Gauguin was appropriated by Haberstock, who pocketed most of the foreign currency earnings." Andeas Hüneke, "On the Trail of the Missing Masterpieces," in Stephanie Barron, ed., *"Degenerate Art": The Fate of the Avant-Garde in Nazi Germany* (New York: Harry Abrams, 1991), 125.

72. Kessler, *Karl Haberstock*, 24–25, 275. See the correspondence in NARA, RG 260, OMGUS, Restitution Research Records, box 446; as well as Städtische Kunstsammlungen der Stadt Augsburg, Haberstock Nachlass, V/84.

73. Timothy Ryback, "'An Even Bigger Scandal,'" *ARTnews* (December 1999), 150. See also Jonathan Petropoulos, "From Lucerne to Washington, DC: 'Degenerate Art' and the Question of Restitution," in Olaf Peters, ed., *Degenerate Art: The Attack on Modern Art in Nazi Germany, 1937* (New York: Neue Galerie, 2014), 288–307.

74. NARA, RG 260, OMGUS, Restitution Research Records, box 446, Haberstock to Georges Wildenstein (11 May 1939). See also the Georges Wildenstein–Karl Haberstock correspondence in NARA, RG 260, M 1946, roll 131, frames 700–710.

75. Notes on conversation with Yves Stavridès, Paris (9 June 2016).

76. Ibid.

77. Ibid.

78. Wildenstein and Stavridès, *Marchands d'Art*, 111; and Barron, *"Degenerate Art,"* 132. Daniel Wildenstein, *Gauguin: A Savage in the Making; Catalogue Raisonné of the Paintings* (Paris: Wildenstein Institute/Skira, 2002).

79. NARA, RG 59, Lot 62D-4, OMGUS, Ardelia Hall Collection, box 17, "Special Report on the Firm of Wildenstein & Cie, Paris Art Dealers" (n.d.).

80. Ibid.; and NARA, RG 239, M 1944, roll 88, frames 673–75, Karl Haberstock, "Beziehung zu G. Wildenstein bzw. Roger Dequoy" (2 September 1945). The German reads, "Ich habe Herrn Wildenstein nur das ein Mal

in Aix besucht, als ich 1941 mit Herr Dr. Posse wieder nach Südfrankreich kam, war er gar nicht mehr da."

81. NARA, RG 59, Lot 62D-4, OMGUS, Ardelia Hall Collection, box 17, "Special Report on the Firm of Wildenstein & Cie, Paris Art Dealers" (n.d.).

82. CASVA-NGA, MSS3 (Faison Papers), box 4, "Translation of Statement of Karl Haberstock" (4 June 1945). See also NARA, RG 260, OMGUS, Restitution Research Records, box 446, Haberstock statement, n.d. [July 1945?].

83. NARA, RG 59, Lot 62D-4, OMGUS, Ardelia Hall Collection, box 17, "Special Report on the Firm of Wildenstein & Cie, Paris Art Dealers" (n.d.).

84. NARA, M 1944, roll 89, frames 541–42, Dr. Wolff Breumüller "Aktenvermerk" (19 May 1941). ALIU, *ALIU Final Report* (Washington, DC: Strategic Services, May 1946), 24.

85. NARA, RG 239, M 1944, roll 89, frames 541–42, Sonderstab Louvre, "Aktenvermerk" (19 May 1941); and NARA, RG 239, M 1944, roll 89, frame 543, Dr. Pfitzner, for the Militärbefehlshaber in Frankreich, "Aktennotiz" (15 May 1941).

86. NARA, RG 59, Lot 62D-4, OMGUS, Ardelia Hall Collection, box 17, "Special Report on the Firm of Wildenstein & Cie, Paris Art Dealers" (n.d.); and NARA, RG 239, M 1944, roll 89, frame 543, Dr. Pfitzner, for the Militärbefehlshaber in Frankreich, "Aktennotiz" (15 May 1941).

87. Nancy Yeide has twenty-eight entries for Wildenstein in her catalogue raisonné of the Göring collection. See Nancy Yeide, *Beyond the Dreams of Avarice: The Hermann Goering Collection* (Dallas: Laurel, 2009), 518.

88. For Dequoy selling to Haberstock, see NARA, RG 260, box 9, Dequoy to Haberstock (10 March 1943). Seven pictures in the Deutsches Historisches Museum database for the Führermuseum list a Wildenstein provenance (with Haberstock as the conduit), including a Nicolas Poussin rendering of Moses as a child: see https://www.dhm.de/datenbank/linzdb/indexe.html (accessed 11 November 2019).

89. NARA, RG 59, Lot 62D-4, OMGUS, Ardelia Hall Collection, box 17, "Special Report on the Firm of Wildenstein & Cie, Paris Art Dealers" (n.d.).

90. Ibid.

91. NARA, RG 260, OMGUS, Restitution Research Records, box 446, Haberstock statement, n.d. [July 1945?]. The German reads, "Herr Dequoy, eifrig bemüht war, das Eigentum des Herrn Wildenstein so gut es ging über die Zeit hinüber zu retten."

92. Ibid.

93. NARA, RG 239, Foreign Funds Control, box 7, Georges Wildenstein, "Works of Art—Weapons of War and Peace" (published in *La Republique Française* in December 1943); and "Hitler, Art 'Collector'" (1943).

94. See, for example, NARA, RG 239, entry 73, box 75, Dequoy to Wildenstein (2 May 1945).

95. Lynn Nicholas, *The Rape of Europa: The Fate of Europe's Treasures in the Third Reich and the Second World War* (New York: Knopf, 1994), 424.

96. Feliciano, *Lost Museum*, 96.

97. NARA, RG 260, box 9, Dequoy to Haberstock (24 August 1942).

98. NARA, RG 239, entry 73, box 79, "Liste der Einkäufe bei der Reise nach Frankreich von 14. Mai bis 16. Juni 1941"; Plaut, *CIR No. 1*, attachment 57: "Partial List of Purchase for Linz Made in France."

99. NARA, RG 260, OMGUS, Restitution Research Records, box 446, Testimony of Walter Andreas Hofer (14 June 1945).

100. Feliciano, *Lost Museum*, 119.

101. Ibid.

102. Ibid., 159, 196–97.

103. CDJC, CCCXCV-13, Feindvermögensverwaltung to Gruppe 1 I/2 (23 November 1942).

104. Ibid., CCCXCV-13, Dr. Hans Buwert, "Aktennotiz" (5 January 1944).

105. Ibid., DCCCXXXXIII-10, Haberstock to Kriegsverwaltungsrat Dr. Stenger (6 September 1942).

106. Ibid., CCCXCV-13, Abetz to Ministerialdirektor Dr. Michael (26 January 1944); Dr. Alfred Ringer to Dr. Michael (3 February 1944).

107. Ibid., CCCXCV-13, Dr. Kreuter to Generalkonsul Knothe (6 November 1943). Geheimrat Kreuter was a German industrialist who was romantically involved with ERR staffer Fräulein Eggemann (they fled Paris together in August 1944). Plaut, *CIR No. 1*, 53.

108. CDJC, CCCXCV-13, Dr. Hans Buwert, "Aktennotiz über eine Rücksprache mit dem kommissarischen Verwalter der Firma Wildenstein & Cie, M. Bruyer" (5 January 1944).

109. Ibid. The German reads, "In den Tage zwischen Weihnachten und Neujahr hatte Herr Bruyer auch noch den Besuch von Herrn Dr. Loose [*sic*]. Herr Dr. Loose steht weit einigen Wochen in Verhandlungen mit M. Dequoy."

110. Ibid. The German reads, "die Gestapo sei den Machenschaften der Firma Wildenstein & Cie."

111. Notes on conversation with Yves Stavridès, Paris (9 June 2016).

112. Yves Stavridès, email to author (9 June 2016).

113. See, for example, the report of paintings by Corot, Rousseau, and Fromentin shipped to Buenos Aires in NARA, RG 131, NN3-1394001, Foreign Funds Control (FFC), box 501, intercepted correspondence between Enrique Henoitt (Buenos Aires) and Georges Wildenstein (21 October 1941).

114. For the Wildensteins' annual financial statements for almost the entire war, see NARA, RG 131, NN3-1394001, Foreign Funds Control (FFC), box 501.

115. NARA, RG 131, NN3-1394001, Foreign Funds Control (FFC), box 501, anonymous handwritten note (n.d.).

116. Ibid., British embassy to J. W. Pehle of the U.S. Treasury Department

(5 July 1941). For more on these pictures, see NARA, RG 59, Dec File, box 2557.

117. NARA, RG 131, NN3-1394001, FFC, box 501, F. Williams to Wildenstein & Co. (4 November 1941); and ibid., report of Harry Kahn Jr. (23 October 1942). Note that this file documents the Wildensteins holding works on consignment for many prominent individuals during the war, including Baron Maurice de Rothschild, then in Vancouver.

118. An example may be Judith Leyster's work from 1633, *Youth with a Jug*, which was in Georges Wildenstein's collection in Argentina by 1941. See the Wikipedia entry, http://en.wikipedia.org/wiki/A_Youth_with_a_Jug (accessed 31 March 2015).

119. NARA, M 1944, roll 93, frame 240, Federal Bureau of Investigation, Report (19 August 1944).

120. Ibid., frame 246, Federal Bureau of Investigation, Report (19 August 1944) and the documents that follow (frames 238–49).

121. Ibid., frame 240, Federal Bureau of Investigation, Report (19 August 1944).

122. Andrews, "Bitter Spoils," 254.

123. NARA, RG 59, Lot 62D-4, OMGUS, Ardelia Hall Collection, box 9, Ardelia Hall to Director of Museum of Fine Arts, Boston (9 May 1955). See also "Takes Museum to Court," *New York Times* (14 September 1952). One of the enamels was titled "The Baptism of Christ" and the other, a plaque made in Cologne, "The Children of the Furnace."

124. NARA, RG 59, Lot 62D-4, OMGUS, Ardelia Hall Collection, box 9, Frédéric Schöni, "Special Information on Antiquities" (29 October 1949).

125. Ibid., Department of State Instruction to HICOG, Bonn (6 August 1954).

126. Andrews, "Bitter Spoils," 254.

127. See the summary U.S. Court of Appeals, Second Circuit, of *DeWeerth v. Baldinger v. Wildenstein* (1987), https://www.courtlistener.com/opinion/499 449/gerda-dorothea-deweerth-v-edith-marks-baldinger/.

128. Andrews, "Bitter Spoils," 250–51.

129. Mary Tabor, "Rare Ruling Leaves a Monet Hanging," *New York Times* (10 June 1994).

130. Andrews, "Bitter Spoils," 251. The painting in question is Monet's *Champs de Blé à Vétheuil.*

131. Willsher, "Dark Clouds Hover over the Family Business," E2.

132. Heather Smith, "Wildenstein Vault Holds Key to Feud over Missing Painting," *Bloomberg* (13 March 2012), http://www.bloomberg.com/news /articles/2012-03-12/wildenstein-vault-holds-key-to-feud-over-art-missing -paris-show.

133. Doreen Carvajal and Carol Vogel, "Ignorance Is Defense in a Case of Lost Art," *New York Times* (20 July 2011).

134. Smith, "Wildenstein Vault Holds Key."

135. Judd Tully, "Wildenstein's Woes and Wins," *Art + Auction* (June 2011), 35.

136. Robert Williams, "Wildenstein Fraud Trial Wraps Up," Artnetnews (21

October 2016), https://news.artnet.com/art-world/wildenstein-trial-wraps
-up-714548.

137. Ibid.

138. Carvajal, "Prominent French Families Battle."

139. Ibid.

140. For more on Douglas Cooper, see John Richardson, *The Sorcerer's Apprentice: Picasso, Provence, and Douglas Cooper* (Chicago: University of Chicago Press, 1999).

141. Georges Wildenstein, *Gauguin*, vol. 1 (Paris: Les Beaux-Arts, 1964); and Douglas Cooper, "Not All Painted with the Same Brush," *Times Literary Supplement* (19 August 1965), 712.

142. Cooper, "Not All Painted with the Same Brush," 712. See also Andrews, "Bitter Spoils," 252. Note that Cooper's was not the only negative review of the Gauguin catalogue: e.g., Merete Bodelsen, "The Wildenstein-Cogniat Gauguin Catalogue," *Burlington Magazine* (January 1966), 27-39, raises serious questions about the authenticity of certain works in the volume and criticizes the quality of many of the photographs (she links the two issues).

143. While Cooper cited twelve problematic entries in the review, in the subsequent exchanges, he estimated of the 648 entries in the study, some 130, or 20 percent, were "fallacious." GRI, SC, Cooper Papers (860161), box 10, Douglas Cooper, "Wildenstein and Cogniat vs. TLS and Cooper: The Gauguin Catalogue" (23 April 1966).

144. Ibid., Cooper Papers (860161), box 10, Douglas Cooper statement (23 April 1966).

145. Ibid. See also ibid., Cooper Papers, Cooper, "Gauguin Catalogue" (8 November 1965).

146. Ibid., Cooper Papers, Douglas Cooper, "Wildenstein and Cogniat vs. TLS and Cooper: The Gauguin Catalogue" (23 April 1966).

147. Ibid., Cooper Papers, Douglas Cooper, "Comments on the Letter of 8 November 1965 from Messrs Atkey, Sandelson," (n.d.); and Andrews, "Bitter Spoils," 252. Note that Cooper misdates the episode to 1960 (qualifying it), when it was 1955.

148. GRI, SC, Cooper Papers (860161), box 10, Douglas Cooper "Gauguin Catalogue" (8 November 1965).

149. Ibid., Cooper Papers, Daniel Wildenstein to Douglas Cooper statement (13 November 1971). The French reads, "Je suis sûr que nous pourrons faire du bon travail ensemble."

150. Ibid., Cooper Papers, Daniel Wildenstein to Douglas Cooper (27 July 1972).

151. Ibid., Cooper Papers, Cogniat to Cooper (11 April 1975).

152. Wise, "The Wildensteins—at Least for Now—Get Their Mansion Back," 38-40.

153. Vincent Noce, "Guy Wildenstein Cleared of Tax Evasion for a Second Time in Paris," *Art Newspaper* (2 July 2018), https://www.theartnewspaper

.com/news/guy-wildenstein-cleared-of-tax-evasion-for-a-second-time-in
-paris.

154. Carvajal and Vogel, "Ignorance Is Defense in a Case of Lost Art."

155. Adam Sage, "Art Dynasty Accused of Tax Evasion over Widows' Inheritance," *Times* (London) (31 May 2013).

156. Bertrand Marotte, "RBC's Bahamas Unit Caught Up in Allegations Involving Billionaire Art Dealer," *Globe and Mail* (30 March 2015).

157. "Guy Wildenstein Referred to Criminal Court by the PNF," Art Media Agency (13 May 2015), http://en.artmediaagency.com/109135/guy-wildenstein-referred-to-criminal-court-by-the-pnf/. See, more generally, Dumont-Beghi, *L'Affaire Wildenstein.*

158. Prosecutor Monica d'Onofrio, quoted by Doreen Carvajal, "Billionaire Art Dealer Is Awaiting Verdict in Tax Fraud Case," *New York Times* (20 October 2016), http://www.nytimes.com/2016/10/21/arts/design/wildenstein-tax-trial-ends-with-art-dealers-fate-in-tribunals-hands.html ?smprod=nytcore-iphone&smid=nytcore-iphone-share&_r=0.

159. Doreen Carvajal, "Billionaire Art Dealer Is Cleared in Tax Fraud," *New York Times* (13 January 2017), C2.

160. Ibid. See also Gaspard Sebag, "Dead Billionaire's Art Stash Gathers Dust amid French Tax Trial," *Private Wealth* (30 September 2016), http://www .fa-mag.com/news/dead-billionaire-s-art-stash-gathers-dust-amid -french-tax-trial-29271.html. The latter notes that "Daniel Wildenstein created an offshore trust in the Bahamas in 1998 to lodge 2,500 works from the art dealer's collection. A Royal Bank of Canada unit managed it."

161. Noce, "Guy Wildenstein Cleared of Tax Evasion." Noce added, "Regretting that no proper investigation was undertaken in the Bahamas or Guernsey, the court said it lacked the 'legal basis' for a condemnation."

162. Notes on conversation with Yves Stavridès, Paris (9 June 2016).

163. Lohse Papers (archive of author), Dequoy statement (10 July 1947). The French reads, "dissimulé des biens juifs provenant de la maison Wildenstein, 57 rue La Boétie. J'affirme sur l'honneur que le Dr. Lohse ne m'a jamais rien demandé aucune remunération."

164. Marc Masurovsky writes, "Dequoy survived the war unscathed and a rich man. Wildenstein continued to rely on his managerial experience with the firm in the postwar years." See Marc Masurovsky, "The Wildenstein Reality Check," *Plundered Art* (15 July 2011), http://plundered-art.blogspot .com/2011/07/wildenstein-reality-check.html.

165. See the entry at the Christie's sale of a Pierre Bonnard painting in 2008 at http://www.christies.com/lotfinder/drawings-watercolors/pierre-bonnard-femme-avec-mandoline-5147311-details.aspx (accessed 3 September 2015).

166. BAR-Bern, J1.269, 1999/82, Bd. 2, Haberstock to Fischer (3 August 1948).

167. NARA, RG 59, Records Central European Division 1944–53, box 5, Theodore Heinrich to S. Lane Faison (13 February 1951).

168. Koldehoff, *Die Bilder sind unter uns*, 136.

169. Esther Tisa Francini, *Liechtenstein und der internationale Kunstmarkt 1933–1945* (Zurich: Chronos, 2005); and NIOD, Aalders Collection, L3362, anonymous, "List of Swiss Lawyers in Zürich Said to Be Hiding German Assets."

170. Notes on interview with Walter Feilchenfeldt, Zurich (29 June 2018).

171. BAR-Bern, E6100 (A) 24, Bd. 10 (Dossier 2218, Hans Wendland) (4 December 1947).

172. BAR-Bern, J1.269, 1999/82, Bd. 10, Andrea Rascher to Thomas Buomberger (17 February 1998) and the supporting documentation in the file, including those concerning the litigation in the early 1950s.

173. BAR-Bern, E6100A-24#1000/1924#65*, Dr. F. Schöni to Cour d'Apel de Paris (7 April 1948); and ibid., E6100A-24#1000/1924, Bd. 10, Dr. F. Schöni, memorandum (4 December 1947).

174. See the Chagall work on Artnet, http://www.artnet.com/artists/marc-chagall/lartiste-et-lane-portrait-de-frédéric-schöni-2-FyimE1SJq_Hc3aEmXdr9uw2 (accessed 27 July 2018).

175. NARA, RG 59, Entry Lot 62D-4, OMGUS, Ardelia Hall Collection, box 9, Ardelia Hall notes (n.d.); and ibid., "Consular Invoice of Merchandise" (15 November 1949).

176. Source (who requested anonymity), email to author (17 June 2016).

177. Tarmy and Silver, "Ugly Battle"; and Andrews, "Bitter Spoils," 251.

178. NARA, RG 59, Lot 62D-4, OMGUS, Ardelia Hall Collection, box 9, note on Customs Report (23 November 1949).

179. Ibid., note on Customs Report (9 November 1954).

180. For the collection of Ernst and Gisela Pollack, including an inventory of 330 valuable objects, see Sophie Lillie, *Was Einmal War: Handbuch der enteigneten Kunstsammlungen Wiens* (Vienna: Czernin Verlag, 2003), 838–71.

181. NARA, RG 59, Lot 62D-4, OMGUS, Ardelia Hall Collection, box 9, Frédéric Schöni, "Special Information on Antiquities" (29 October 1949).

182. Andrews, "Bitter Spoils," 252.

183. Ibid., 251.

184. The exhibition ran from 17 June to 21 October in what appears to be a free-standing country house. Fondation de l'Hermitage, *L'Impressionisme dans les Collections Romandes* (Lausanne: Fondation de l'Hermitage, 1984), 160, 168–69.

185. Ibid., In the exhibition catalogue, the Pissarro is number 65; the Renoir (*La Baie de Moulin Huet, Guernsey*) is number 72; the Monet (*Vue de Vetheuil*) is number 56; the Sisley is number 96; and the Corot is number 3.

186. Notes on conversation with Prof. Dr. Claus Grimm, Munich (13 June 2018). There are other sources that also refer to the Wildenstein-Daulte relationship, such as Smith, "Wildenstein Vault Holds Key." Note that Dr. Daulte was also president and curator of the Fondation de l'Hermitage de Lausanne, 1981–95.

187. Notes on conversation with Prof. Dr. Claus Grimm, Munich (13 June 2018); and notes on conversation with Peter Griebert, Munich (13 June 2018).

188. Notes on conversation with Bruno Lohse, Munich (21 July 2000); and Yves Stavridès, email to author (17 June 2016).

189. Philippe Sprang, "Dans les ténèbres du docteur Lohse," *L'Oeil* 630 (December 2010), 29. The French reads, "les responsables de la galerie sont formels, Bruno Lohse n'a jamais travaillé pour Wildenstein."

190. Ibid., 25–33.

191. Archive of author, Peter Griebert to Alec Wildenstein (23 March 2007); Alec Wildenstein to Peter Griebert (4 April 2007); and Peter Griebert to Alec Wildenstein (23 March 2007).

192. Notes on conversation with Prof. Dr. Claus Grimm, Munich (24 September 2014).

193. Patterson, "Wildenstein & Co.," 94.

194. Andrews, "Bitter Spoils," 252.

195. Anne Sinclair, *My Grandfather's Gallery: A Family Memoir* (New York: Farrar, Straus & Giroux, 2014 [2012]), 145.

196. Thomas Hoving, *Making the Mummies Dance: Inside the Metropolitan Museum of Art* (New York: Simon & Schuster, 1993), 249–74.

197. Gross, *Rogues' Gallery*, 260; and Wright, *Art of the Forger*.

198. Gross, *Rogues' Gallery*, 259.

199. Walter Feilchenfeldt, email to author (22 August 2018).

200. Notes on conversation with Yves Stavridès, Paris (9 June 2016).

201. Ibid.

Epilogue

1. Former Berlin Document Center (now presumably in BArch-Berlin), Himmler to Mühlmann (19 September 1942), archive of author.

2. NARA, RG 260, box 435, August Prossinger report (17 July 1947).

3. Dokumentationsarchiv Österreichischen Widerstandes, Aktennummer 19031/2, Hilde Ziegler Mühlmann to Landesgericht Wien (12 March 1960).

4. NARA, RG 260, box 372, OMGUS Monthly Consolidated Field Report (February 1948); and box 435, Mühlmann, "Eidesstattliche Erklärung (2 September 1947).

5. IfZG, ZS 2211, Testimony of Professor Borodaykewycz (22 July 1953).

6. Jean Vlug, *Report on Objects Removed to Germany from Holland, Belgium, and France during the German Occupation in the Countries* (The Hague: Strategic Services Unit, 1945), 12, 34, 50, 76, 94–96, 105, 121; and CASVA-NGA, MSS8, Charles Parkhurst Papers, William Silver (Headquarters Seventh Army, Judge Advocate Section) to Commanding General, Seventh Army (30 August 1945).

7. The Mühlmann-Höttl connection, I learned later, was documented in CIA records declassified as part of the Nazi War Crimes Disclosure Act of

2000: see Wilhelm Höttl CIA 201 file, vol. 5, chief EE to Chief of Mission, Frankfurt, "Re: Hoettl Contact—Dr. Kajetan Mühlmann" (14 June 1954), archive of author. The CIA believed that Mühlmann lived in the Dachstein area. Also note that the documents are stamped "CIA Special Collections Release as Sanitized 2000."

8. For Mühlmann's acquisition of the "Aryanized" villa in 1941, see Salzburger Landesarchiv, RSTH, Rep 286, 6/1941; and Jonathan Petropoulos, *The Faustian Bargain: The Art World in Nazi Germany* (New York: Oxford University Press, 2000), 181.

9. Salzburger Landesarchiv, RSTH, Rep 286, 6/1941, Poldi Mühlmann to Gauleiter Friedrich Rainer (10 March 1941). The German reads, "dass es doch möglich sein wird, das kleine Häuschen in Anif zu erwerben, indem Sie eine Arisierung vornehmen."

10. Dr. Fritz Koller, letter to author (15 April 1997).

11. Michael Gibson, "How a Timid Curator with a Deadpan Expression Outwitted the Nazis," *ARTnews* (Summer 1981), 110.

12. BAR-Bern, E9500.239A#2003/48, Bd. 24, Otto Wittmann, *Art Looting Investigation Unit—Final Mission to Europe (10 June 1946–24 September 1946)* (Washington, DC: War Department, 14 October 1946), 21.

13. Esther Tisa Francini, Anja Heuss, and Georg Kreis, *Fluchtgut-Raubgut. Der Transfer von Kulturgütern in und über die Schweiz 1933–1945 und die Frage der Restitution* (Zurich: Chronos Verlag, 2001); Mario König and Bettina Zeugin, eds., *Switzerland, National Socialism and the Second World War: Final Report of the Independent Commission of Experts Switzerland—Second World War* (Zurich: Pendo, 2002); and Esther Tisa Francini, *Liechtenstein und der internationale Kunstmarkt 1933–1945* (Zurich: Chronos, 2005).

14. Thomas Buomberger, *Raubkunst-Kunstraub. Die Schweiz und der Handel mit gestohlenen Kulturgütern zur Zeit des Zweiten Weltkrieges* (Zurich: Orell Füssli, 1998); and Thomas Buomberger and Guido Magnaguagno, eds., *Schwarzbuch Bührle. Raubkunst für das Kunsthaus Zürich?* (Zurich: Rotpunktverlag, 2015).

15. Karl Schleunes, *The Twisted Road to Auschwitz: Nazi Policy toward German Jews, 1933–1939* (Champagne-Urbana: University of Illinois Press, 1990 [1970]). For the relationship of plunder and the Holocaust, see, for example, Martin Dean, *Robbing the Jews: The Confiscation of Jewish Property in the Holocaust, 1933–1945* (Cambridge: Cambridge University Press, 2008); Ronald Zweig, *The Gold Train: The Destruction of the Jews and the Looting of Hungary* (New York: Harper Perennial, 2003); Jan Tomasz Gross and Grudzinska Gross, *Golden Harvest: Events at the Periphery of the Holocaust* (New York: Oxford University Press, 2012); and Peter Hayes, *From Cooperation to Complicity: Degussa in the Third Reich* (Cambridge: Cambridge University Press, 2004).

16. Jonathan Petropoulos, "The Nazi Kleptocracy: Reflections on Avarice and the Holocaust," in Dagmar Herzog, ed., *Lessons and Legacies VII* (Evanston,

IL: Northwestern University Press, 2006), 29–38; Götz Aly, *Hitler's Beneficiaries: Plunder, Racial War, and the Nazi Welfare State* (New York: Metropolitan Books, 2005); and Frank Bajohr, *Parvenüs und Profiteure. Korruption in der NS-Zeit* (Frankfurt: S. Fischer, 2001).

17. Frank Bajohr, *"Aryanization" in Hamburg: The Economic Exclusion of Jews and the Confiscation of Their Property in Germany* (New York: Berghahn, 2002 [1997]), 279.

18. Hayes, *From Cooperation to Complicity*, xvii.

19. Michael Burleigh, *The Third Reich: A New History* (New York: Hill and Wang, 2001); Ian Kershaw, referenced in Richard Evans, *The Coming of the Third Reich* (London: Allen Lane, 2003), xx.

20. John Roth, *Ethics during and after the Holocaust: In the Shadow of Birkenau* (New York: Palgrave Macmillan, 2006); and John Roth and Carol Rittner, eds., *Advancing Holocaust Studies* (New York: Routledge, 2020).

21. Wilhelm Höttl, letter to author (28 February 1995). The German reads, "es lebt ja kein Eingeweihter von damals mehr, ich bin leider sozusagen der Letzte!"

22. Zweig, *Gold Train*, 210–11. See also Kenneth Alford and Theodore Savas, *Nazi Millionaires: The Search for Hidden Gold* (Havertown, PA: Greenhill Books, 2002), 300; and Burkhart List, *Die Affäre Deutsche. Braune Netzwerke hinter dem grössten Raubkunst-Skandal* (Berlin: Das Neue Berlin, 2018).

23. Eric Lichtblau, "In Cold War, U.S. Spy Agencies Used 1,000 Nazis," *New York Times* (26 October 2014).

24. Richard Breitman and Norman Goda, *Hitler's Shadow: Nazi War Criminals, U.S. Intelligence, and the Cold War* (Washington, DC: National Archives, 2011), 12, 59–71. See also Peter Hayes's critical assessment ("ODESSA was the sort of fantasy that fevered postwar imaginations conjured up") in Hayes, *Why? Explaining the Holocaust* (New York: Norton, 2017), 314; and Guy Walters, *Hunting Evil: The Nazi War Criminals Who Escaped and the Hunt to Bring Them to Justice* (London: Bantam, 2009). See also Uki Goni, *The Real Odessa: Smuggling the Nazis to Peron's Argentina* (New York: Granta, 2002); Gerald Steinacher, *Nazis on the Run: How Hitler's Henchmen Fled Justice* (Oxford: Oxford University Press, 2002); Curt Riess, *The Nazis Go Underground* (London: Fonthill, 2013); and Andrew Nagorski, *The Nazi Hunters* (New York: Simon & Schuster, 2016).

25. Albert Speer, *Inside the Third Reich* (New York: Macmillan, 1970), 545–48.

26. Lohse, letter to author (26 May 1998). The German reads, "Gerne nehme ich Ihr Angebot, bezüglich der Fotokopien der Briefe von Theodore Rousseau, James Plaut, und S. Lane Faison an. Diese fairen und sympathischen Kollegen habe ich in bester Erinnerung behalten."

27. MMA, Rousseau Papers, box 26, folder 15, Faison to Rousseau (9 May 1951).

28. See Jonathan Petropoulos, "Bannerträger und Tiroler Bergjäger: Die von den USA beschlagnahmte NS-Kunst," in Jan Tabor, ed., *Kunst und Diktatur*

(Vienna: Künstlerhaus Wien, 1994), 864–71; and Peter Adam, *Art of the Third Reich* (New York: Harry Abrams, 1992).

29. See Bess Hormats, "Art of the Götterdämmerung: The United States Army's Strange and Little-Known Collection of Nazi War Art," *ARTnews* (January 1975), 68–73.

30. See the file in NARA, Records of the Wiesbaden Central Collecting Point, M 1947, roll 39.

31. Lucian Simmons, remarks at conference, "Righting a Wrong: The Future of Nazi Looted Art Recovery in the U.S. and Abroad," at Skirball Cultural Center, Los Angeles (26 September 2018).

32. Christian Fuhrmeister, "Warum man Lügen glaubt. Kunstgeschichte und Kunsthandel 1945–2006," in Uwe Fleckner, Thomas Gaehtgens, and Christian Huemer, eds., *Markt und Macht: Der Kunsthandel im "Dritten Reich"* (Berlin: De Gruyter, 2017), 401–24.

33. NARA, M 1944, roll 92, Douglas Cooper, "Report of Mission to Switzerland" (10 December 1945).

34. Dr. J. G. Böhler, letter to author (25 September 1998).

35. Notes on telephone conversation with Bruno Lohse (16 May 2001).

36. Robert Edsel, *The Monuments Men: Allied Heroes, Nazi Thieves, and the Greatest Treasure Hunt in History* (New York: Center Street, 2009), 405. Edsel cites NGA, Rorimer Papers, Valland to Rorimer (25 June 1957).

37. Notes on conversation with Prof. Dr. Claus Grimm, Munich (24 September 2014). The German reads, "Ich bin gegen jeden Korruption. . . . die ich nicht dabei bin."

38. Lohse Papers (archive of author), Dr. Walter Borchers, "Statement to Paris Military Tribunal" (30 May 1950).

39. Tina Naber, notes on interview with Klaus Nowitzki (16 November 2017).

40. Note that Bruno's sister, Brünhilde Lohse Nowitski, had three children. Her husband, like Bruno's brother, died on the eastern front. They had lived in Hamburg until war's end. See James Plaut, *DIR No. 6: Dr. Bruno Lohse* (Washington, DC: Strategic Services Unit, 15 August 1945), 1.

41. Catherine Hickley, "Nazi Art Dealer's Will Disperses Dutch Masters, Expressionists," *Bloomberg* (12 July 2007).

42. Dr. Christian Fuhrmeister, email to author (11 November 2008).

43. Madeleine Korn wrote numerous emails to the author between 2011 and 2014 recounting her difficulties with Remy.

44. Marc Masurovsky, "'A Harvest Scene (Heuernte)' by Philip Wouwerman," *Plundered Art* (9 June 2011), http://plundered-art.blogspot.co.uk/2011/06/harvest-scene-heuernte-by-philip.html, 25–33.

45. Horst Kessler, ed., *Karl Haberstock. Umstrittener Kunsthändler und Mäzen* (Munich: Deutscher Kunstverlag, 2008), 96.

46. Stefan Koldehoff, *Die Bilder sind unter uns. Das Geschäft mit der NS-Raubkunst und der Fall Gurlitt* (Berlin: Galiani, 2014 [2009]), 138. Anne Webber and her team at the Commission for Looted Art in Europe did ex-

tensive research on Jan Meerhout's *Flusslandschaft/Anischt einer Stadt*, and assisted the Jaffé heirs in their efforts to recover the picture. Anne Webber, email to author (3 April 2020).

47. Ibid., 138–39. The German reads, "Die Provenienz des Bildes verschleïerte dessen wahre Herkunft."

48. Ibid., 139. The German reads, "Privatsammlung Schweiz" or "Schweizer Privatbesitz."

49. Ocke Rickertsen, email to author (18 July 2009).

50. Weston Williams, "Why It's So Hard to Return Art Stolen by Nazis," *Christian Science Monitor* (28 February 2017).

51. Tina Naber, notes on interview with Klaus Nowitzki (16 November 2017).

52. Notes on interview with Andrew Baker, Triesen, Liechtenstein (27 June 2018).

53. Notes on conversation with Prof. Dr. Claus Grimm, Munich (24 September 2014).

54. Anne Webber, email to author (3 April 2020).

55. Tina Naber, notes on interview with Klaus Nowitzki (16 November 2017).

56. Notes on conversation Andrew Baker, Triesen, Liechtenstein (5 June 2015).

57. Notes on conversation with Yves Stavridès, Paris (9 June 2016).

58. Notes on conversation with Prof. Dr. Claus Grimm, Munich (24 September 2014).

59. Notes on conversation Andrew Baker, Triesen, Liechtenstein (5 June 2015).

60. Madeleine Korn, email to author (22 October 2012).

61. Reinhard Müller-Mehlis, "Maler, Kunstexperte und Diplomat: Adolf Wüster starb 83jährig in München," *Münchner Merkur* (17 February 1972). The German reads, "Er wusste sehr viel und nahm vieles mit in den Tod."

62. Raul Hilberg, *Sources of Holocaust Research: An Analysis* (Chicago: Ivan Dee, 2001), 204.

For Further Reading

A complete bibliography can be found online at https://www.cmc.edu/academic /faculty/profile/jonathan-petropoulos.

Index